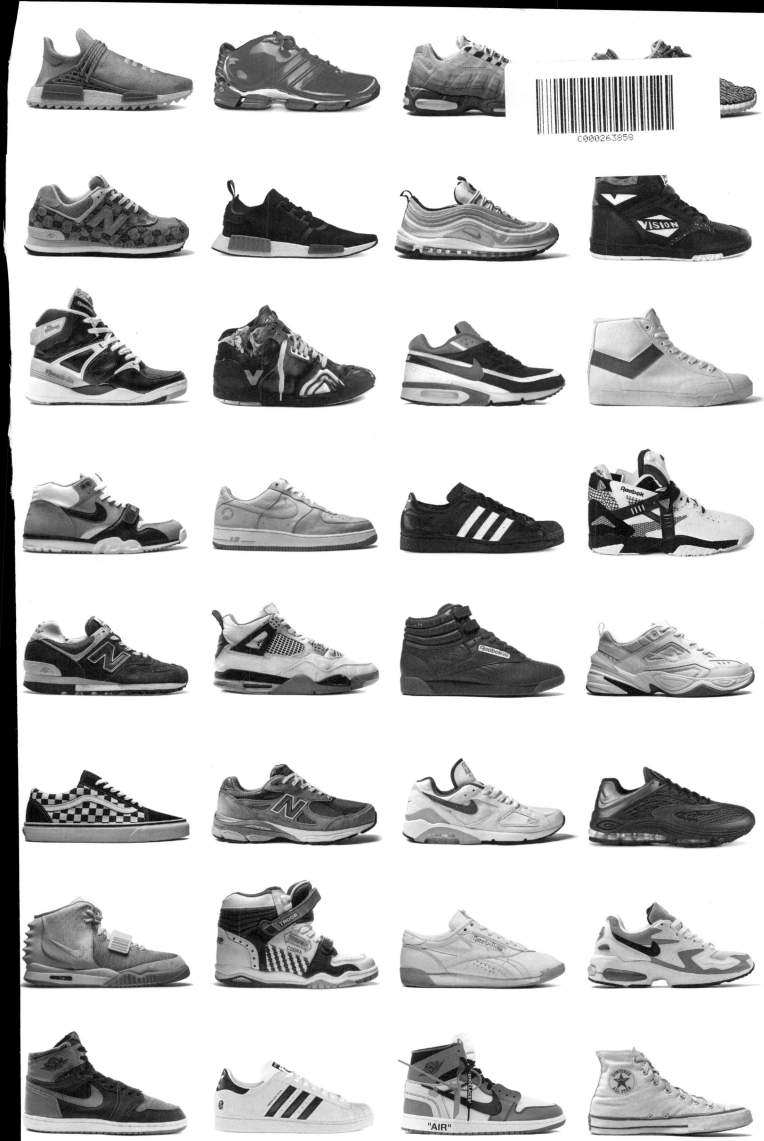

C000263858

SNEAKER
FREAKER

The Ultimate Sneaker Book

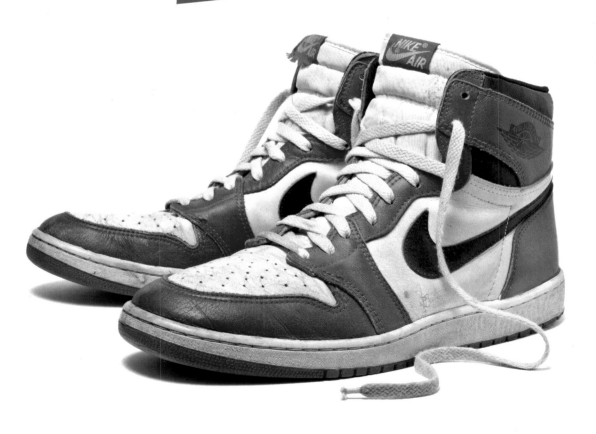

TASCHEN

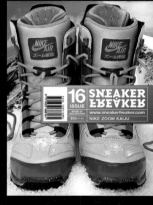

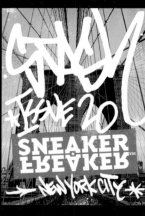
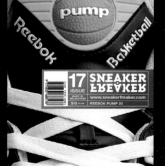

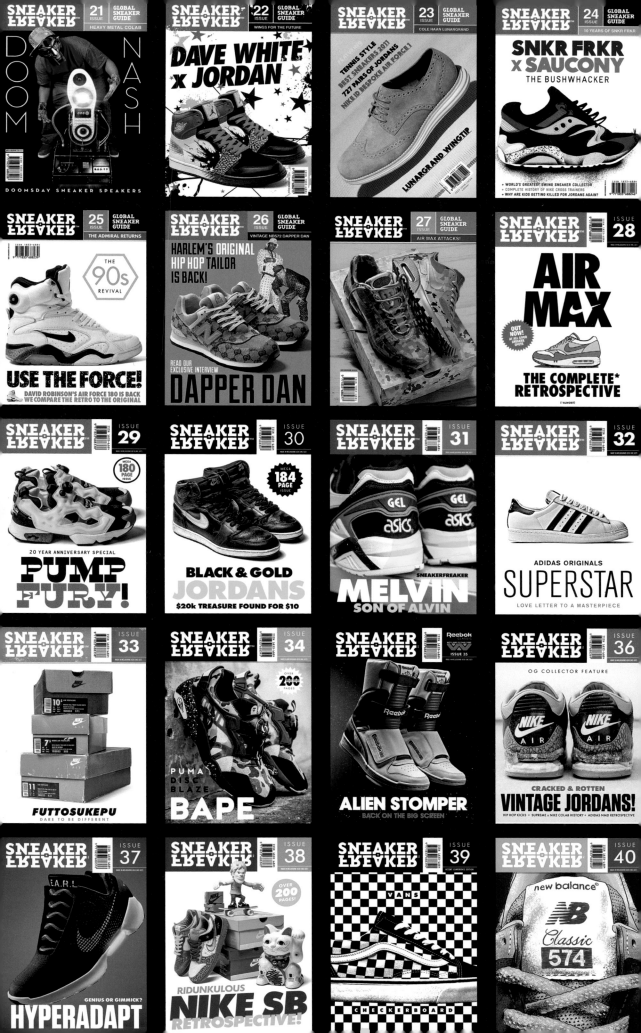

Sneaker Freaker

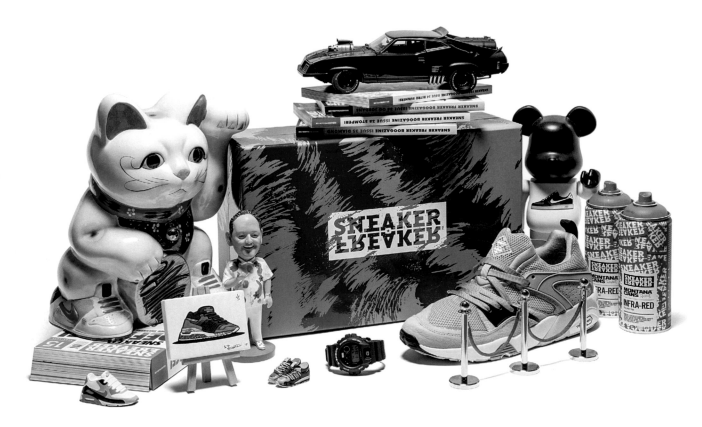

It's funny how life plays out. Imagine you're daydreaming and an idea pops into your head. It could be the wackiest scheme in the world or total genius – who knows? Do you give up before you even get started or do you... just do it? Let's say you opt for the latter. Then *bam!*, a decade and a half flies past and you're wondering what the hell happened. Obsessions will do that to you. This book is all about mine.

Back in 2002, after working in advertising, film design and fashion, I was gripped by the urge to start a magazine. My motivation was pretty simple. I wanted Nike and adidas to send me free shoes. Loads of free shoes. Enough to fill a FedEx truck! And I wanted that truck to come back every month with more boxes to add to my stash.

One week later I was the proud owner of *Sneaker Freaker*, the world's first magazine dedicated to the cult of sneakers. I had no grand plan – *still don't!* – but that wasn't important because I was now a publishing magnate. What I didn't know was that my new gig would take over my life and send me around the world hundreds of times like some globetrotting sneaker gigolo.

My dream came true, that's for sure. And I know what you're thinking right now. How many? In all honesty, I don't know the exact number, but let's just say I have enough to get me through the next decade and a half without wearing the same pair twice. The thrill of a freebie never gets old, but I still buy plenty of sneakers simply because one can *never* have too many, though storage does become an issue when you hit four figures. Besides, it's my job.

The 2000s
At the start of the millennium, the internet was a primitive frontier. Dial-up was standard, e-commerce was limited and social media was still a twinkle in Zuckerberg's brown eyes. Basic blogs kinda existed, but digital photography was a pipedream. If you really wanted to shop for cool shoes, you had to jump on a plane to Tokyo, London or New York. The 'good old days' were pretty basic in hindsight, but I look back on that lack of sophistication with misty-eyed pride. Before Google indexed the world, you had to work hard to acquire knowledge. I spent hours diligently trying to decode the sneakers that featured on album covers and in grainy VHS music videos. That sense of mystery and wonderment was a seductive motivator and still is to this day.

Way before 'sneakers' were considered the 'coolest', let alone a vocation, my collection filled several closets and made me the butt of many hilariously original Imelda Marcos jokes. (It's amazing how vivid the memories of that woman's shoe collection are!) Some were still mint in their boxes while others were trashed beyond repair, but my daily rotation was deep enough that I could go several months without wearing the same pair twice. This wasn't considered something to brag about and on the odd occasion when the extent of my habit was revealed, shock rather than awe was the reaction.

It wouldn't be right to say that I didn't think of sneakers as status symbols or that I wasn't aware of their cultural cachet, but the fact is I did not know a single person who was into sneakers the way I was. Every now and then I'd snap a neck (figuratively speaking) in a club or on the street that signified my Nikes had been noted, but that was the extent of the fraternity. I was in an underground secret society with a membership of one.

When the first issue of *Sneaker Freaker* dropped in 2002, my Motorola V70 rang off the hook. Radio stations, newspapers and magazines wanted to interview this sneaker-crazed nutjob who loved shoes so much he started a magazine. The Imelda Marcos jokes rolled thick and fast once again, much to my amusement. It was an exciting time.

More importantly, I discovered that I was not Robinson Crusoe. Hundreds of people turned up to the first magazine launch at Revolver in Melbourne. Enthusiasts came out of the closet to join the *Sneaker Freaker* online forum and engage in desktop gossip. Around the world, amateur sneakerheads with similar backgrounds to mine were also plotting professional transitions. Alife opened on New York's Lower East Side. In Berlin, Hikmet Sugoer rolled out the first Solebox boutique, just as Sneakersnstuff, Undefeated, Footpatrol, Opium and atmos were fitting out their debut doors. Credit to Fixins, Crooked Tongues and the NikeTalk forum for pioneering the digital sneaker media space.

Photo: Virginia Wood

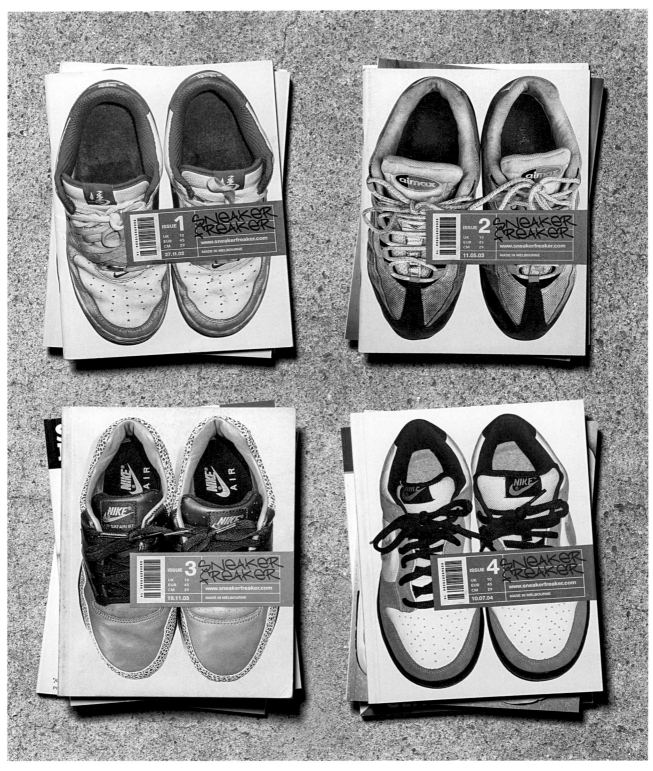

Sneaker Freaker issue 1–4

When Nike collaborated with the New York skate brand Supreme in late 2002 to create a pair of coveted 'Elephant Print' Dunks, the sense of a globally connected community was suddenly plausible. Like a contagious pop culture virus, the scene rapidly multiplied and mutated, adding otaku-level minutiae to the lexicon. Limited editions, collaborations, samples, Japan-only editions, Quickstrike, Hyperstrike, Tier Zero, knockoffs, deadstock, vintage, customs, one-of-ones, artist colabs, retailer tie-ins, player-protos and retro reissues – there was so much newness to absorb on the daily that it made heads spin and blogs roll. Soon enough, every brand had identified this new breed of 'sneakerhead' as a highly lucrative demographic.

By the time the second issue was on the press, stores like Colette (RIP) in Paris had placed orders and I was sucked into the international sneaker vortex. Jetting off to New York, Tokyo and London to attend launch events and talk turkey directly with brands was surreal. To my complete surprise, my thoughts and opinions about nostalgia and retro footwear were being taken seriously.

The Magazine

In the first editorial, I promised that *Sneaker Freaker* would be 'funny and serious, meaningful and pointless all at the same time.' Fifteen years later, I still think that might be the best expression of what I wanted the magazine to represent. For many hardcore aficionados, there is nothing remotely funny about their obsession, but I've always thought that taking the piss was the ultimate accolade. Hopefully there's also enough honest grit in these pages to remind readers that we're not victims of hyperbole, though we certainly love dishing it out with gusto!

Inspired by the DIY punk fanzine movement, the first few issues were closer to a homemade brew than a professional publication. The content was unpredictable and raw, and I look back with a certain comical detachment. Like Cher, I do wish I could turn back time and ditch that cornball graffiti font I used on the cover of the first few issues! Today the magazine is a well-oiled machine, and though there's a lot to be said for keeping things real, staying locked in that groove doesn't pay the bills for long.

2015: Sneaker Freaker x Packer x PUMA 'Bloodbath' launch NYC

2007: Issue 10 launch at size?, Covent Garden

2003: Issue 2 launch at Revolver, Melbourne

2012: DJ Sarasa at the Swap Meet

2014: Tinker Hatfield visits the SF office

2015: Sneaker Freaker x Packer x PUMA 'Bloodbath' launch NYC

Funnily enough, the first edition of *Sneaker Freaker* has become a serious collectible. Just 3000 copies were printed and nowadays they change hands for hundreds of dollars. After years of pilfering and shrinkage, there are just three copies left in the office library. The dozen boxes I had stashed under my desk for years afterwards but gave away in a mad decluttering mission? Priceless!

The first example of going deep on a story arrived in Issue 6 with Jason Le's brilliant Steve Van Doren interview (page 597). Steve's memories of the ups and downs at Vans were heartfelt, and I resolved to be more ambitious with the scope of the magazine's anthropological storytelling. Unexpectedly, I was finding the business of how sneakers are made, marketed and sold to be endlessly fascinating. Being an industry insider was a revelation.

Another key milestone was ticked off in mid-2006. I was desperate to join the collaboration club but hadn't the faintest idea how to apply. Thanks to Mark Godwin at Lacoste, we popped our cherry with the Missouri tennis trainer. Black suede, grey nubuck, white mesh and a sprinkle of mint pops is a classic combo that has

thankfully stood the test of time. On a hot August night, the Alife Rivington Club's courtyard was packed with a cabal of industry identities and LES hustlers. Just 24 pairs were given away, with another 200 pairs released globally a few weeks later. It was supremely satisfying to 'make it' in New York.

Since then, *Sneaker Freaker* has designed sneakers with everyone from adidas to ASICS and Diadora. Detours into accessories and knick knacks came with G-SHOCK, Montana Cans and Medicom. We've also written and designed books for Nike, New Balance, PONY, Casio, Reebok and Globe.

The fact that *Sneaker Freaker* is based in my hometown of Melbourne, Australia, is something that many readers likely never realised. Running a global business from Down Under is not the most logical idea, but if *Sneaker Freaker* has demonstrated anything, it's that nothing is impossible if you just do it. (Sorry!) Our geographical isolation simply makes the magazine's global success even weirder. At one point we opened offices in Germany, Spain and Russia and published several editions in those languages.

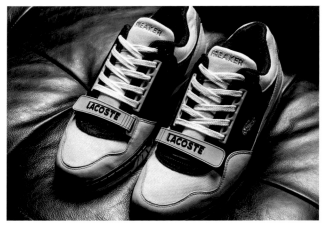

2006: Sneaker Freaker x Lacoste Missouri

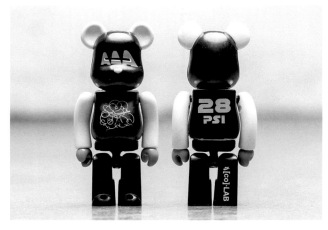

2007: Sneaker Freaker x Nike x Medicom Bearbrick

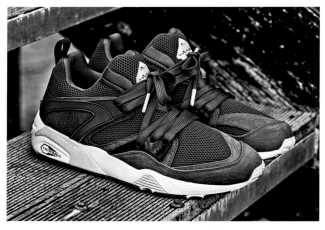

2015: Sneaker Freaker x PUMA Blaze Of Glory 'Bloodbath'

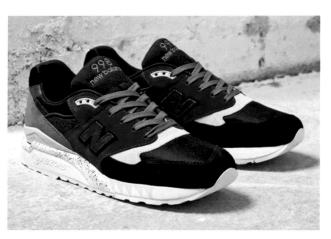

2013: Sneaker Freaker x New Balance 998 'Tassie Devil'

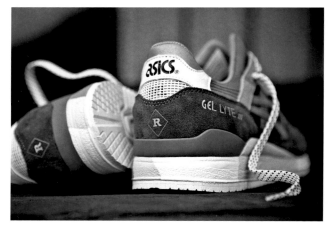

2010: Sneaker Freaker x ASICS GEL-Lyte III 'Alvin Purple'

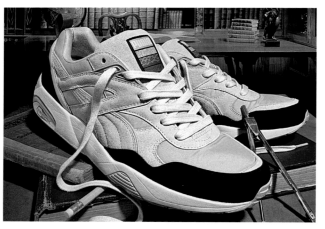

2010: Sneaker Freaker x PUMA R698 'Geography Teacher''

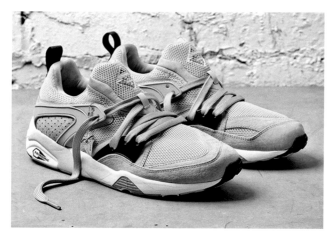

2013: Sneaker Freaker x PUMA Blaze of Glory 'Sharkbait'

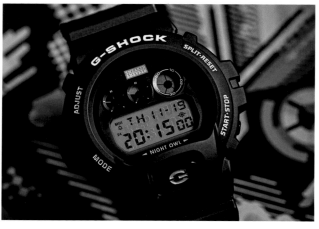

2015: Sneaker Freaker x G-SHOCK DW-6900 'Nightowl'

2016: Sneaker Freaker x Diadora V7000 'Taipan'

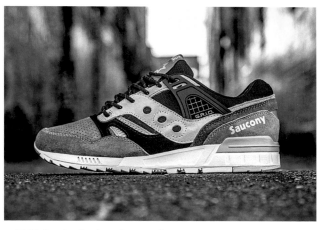

2015: Sneaker Freaker x Saucony Grid 9000 'Kushwhacker'

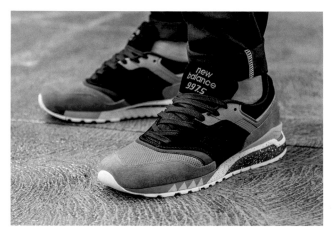

2016: Sneaker Freaker x New Balance 997.5 'Tassie Tiger'

2014: Sneaker Freaker x ASICS GEL-Kayano 'Melvin'

2016: Sneaker Freaker x BespokeIND x Nike AF-1 'Melbourne Rules'

2009: Sneaker Freaker x AIAIAI Earbuds

2013: Sneaker Freaker x adidas Torsion Integral

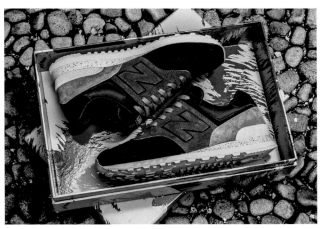

2018: Sneaker Freaker x New Balance 574 'Tassie Devil'

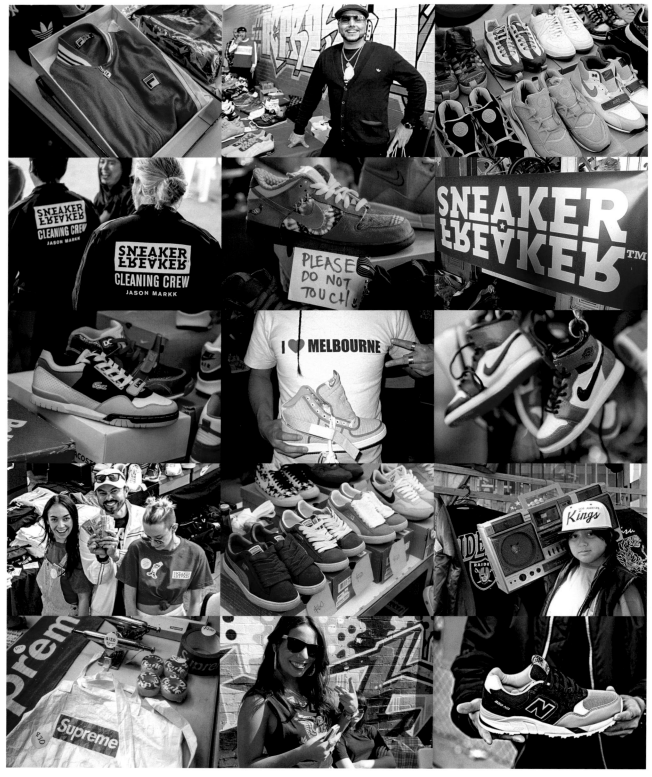

2003–2018: Sneaker Freaker Swap Meet

When Kobe Bryant's people inquired about acquiring the company several years ago, I couldn't stop smiling for weeks.

The Book
You could say this book has taken 15 years to complete, but that's not entirely correct. Work actually started back in 2012 as part of the magazine's tenth anniversary plans, but at that time books were widely seen as an obsolete business model and the project stalled. The prognosis hasn't improved for many daily newspapers, but I'm pleased to report that a cult magazine with a niche audience can still flourish in these digital days. And thanks to mavericks like Benedikt Taschen, there are still companies out there that are willing to publish epic anthologies.

Work resumed in 2017. The first draft came in at a ridiculous 1100 pages, which was carefully whittled down to a svelte 664-page package. (What we couldn't squeeze into this edition, we've put on ice for the second volume.) Stuffed with dense insider knowledge, hundreds of photos and my own obsessional observations, I hope this will be regarded as the definitive source of sneaker knowledge and more than worthy of its billing as *The Ultimate Sneaker Book.*

Starting with a deconstruction of Kanye West's Yeezy empire, each chapter rollicks backwards through a hundred years of sneaker history. Some of the older magazine content required a spritz to bring things up to speed, though we carefully preserved the charm of the original prose.

Air Max, Air Force, Airwalk, All Stars, Dapper Dan, Michael Jordan, Reebok Pump and Nike Skateboarding are all fastidiously documented, along with side-steps into obscure treasures like Troop, SPX and Vision Street Wear.

There are a few regrets. Some great magazine features simply could not be shoe-horned into this book no matter how hard we tried. The burden of being a committed completist is a heavy one. The world will just have to wait for volume 2.

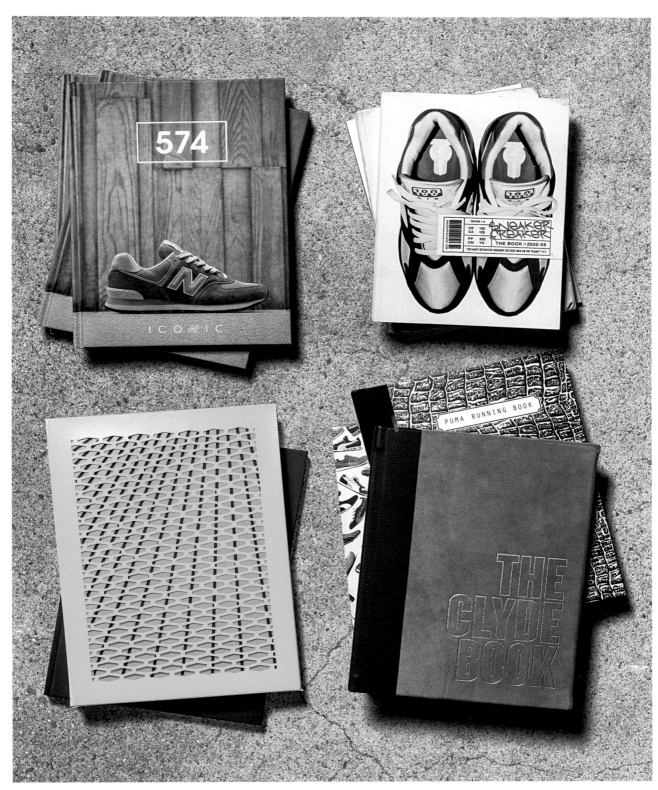

Clockwise from top left: SF x New Balance *574*, *Sneaker Freaker The Book, 2002–05*, SF x PUMA *The Clyde Book*, SF x Nike *Genealogy of Innovation*

Cheers

To all the interviewees, writers, photographers, scenesters, sneakerheads, hypemonkeys, retailers, resellers, party animals, *Sneaker Freaker* forum members and anyone who has ever bought a copy of the mag – this book is for you. Thanks to all the staff at *Sneaker Freaker*, especially Tim Daws who managed the book production, and copyeditors Olivia Finlayson and Matthew Kennedy. Dan Purnell supplied dozens of uncredited photos. It has been an epic marathon to bring this book to life.

To all the Australians in the industry who helped *Sneaker Freaker* prosper over the years, cheers cobbers! To all the footwear designers and the marketing folks who approved our invoices, praise be to you. This book also serves as my personal tribute to OG shoe dogs like Phil Knight, Tinker Hatfield, Steve Van Doren, Mark Doherty, Paul Litchfield, Steven Smith, Paul Fireman, Sinisa Egleja and Jim Davis. Their street-smarts and feisty spirits have made the industry what it is today.

Last but certainly not least, I dedicate this book to my amazing wife, Virginia, and our three children, Sonny, Claude and Marlowe. I hope they have forgiven me for all those last-minute long-haul business trips. Hopefully all the free sneakers made up for the no-shows at family events. :)

Strange, isn't it, that a few bits of leather and suede sewn onto a slab of rubber and wrapped in nylon thread could mean so very much to so many.

Keep your laces loose!

Woody
Sneaker Freaker Founder

Sneaker Moments

2002
Collaborations
p.20

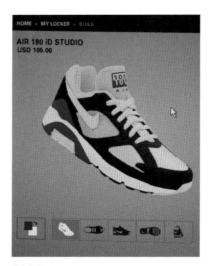

2004
NIKEiD
p.22

2005
adidas SS35
p.25

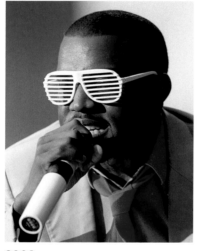

2009
Kanye West
p.30

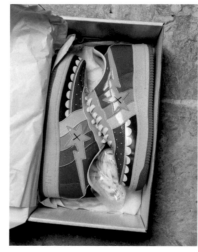

2010
Bapesta
p.32

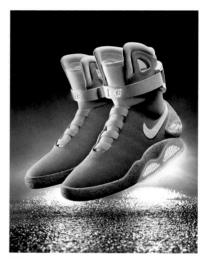

2011
Nike McFly
p.34

2015
adidas Futurecraft
p.44

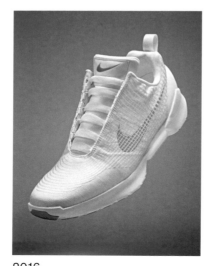

2016
Nike HyperAdapt 1.0
p.46

2017
Virgil Abloh x Nike
p.48

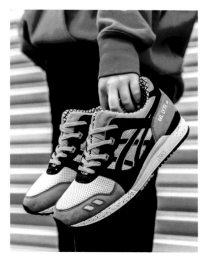

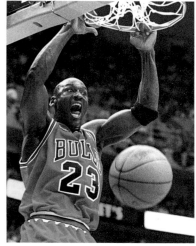

Sneaker History

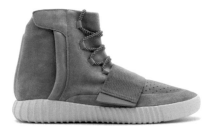
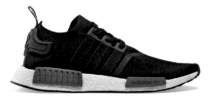
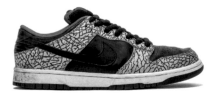

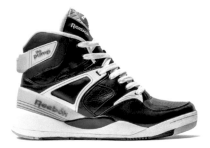

Reebok Pump

The Greatest Story Never Told

p.147

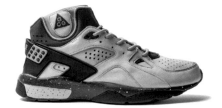

Nike ACG

All Conditions Gear

p.182

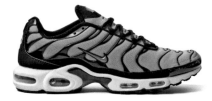

Nike Air Max

The Ultimate Airmaxtravaganza!

p.212

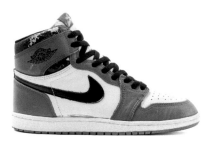

Jordan Brand

It's Gotta Be The Shoes!

p.348

Troop/SPX

In Full Effect

p.390

Dapper Dan

The Original Hip Hop Tailor

p.416

Starter

Slam The Hat!

p.490

PUMA Clyde

Ice Cold Swagger

p.504

Product of New York

Roberto Muller

p.532

Converse All Star

Chuck Taylor

p.618

Sneaker Advertising

The Nike Guy
Bill Sumner

Alter Ego
Chuck Kuhn

Just Do It
Bob Peterson

Sneaker Index

Book Credits

Team

Editor
Woody

Design
Tim Daws

Photography
Dan Purnell

Senior Editor
Olivia Finlayson

Copy Editor
Matt Kennedy

Writers

Adam Jane
Anthony Costa
Anthony Gilbert
Beedubs
Craig Leckie
Iceberg
Gary Warnett
Jason Le
Matt Williams
Nick Santora
Oliver Georgiou
Olivia Finlayson
Rob Marfell
Sarah Jane Owen
Steve Duck
Vinny Tang
Woody

Illustrations

James Rogers
Matt Stevens

Photography

3peat LA
Air Max Chronicle
Alan Weaver
Angelo Anastasio
Ant Tran
Bill Sumner
Bob Peterson
Bryant Naro
Chuck Kuhn
Craig Litten
Dennis Branko
Errol Thomas
Hugues Lawson Body
Jamel Shabazz
James Whitlock
Janette Beckman
J Grant Brittain
Julian Loh
KK Bestsellers
Lucas Allen
Made for Skate
Overkill
Peter Rad
Rick Kosick
Ricky Powell
Stadium Goods
Stan Chan
Steven Prince
Tyree Dillihay
Virginia Wood

Interviewees

Andrea Corradini
Beedubs
Bill Sumner
Bobbito Garcia
Bob Peterson
Chanica Kist
Chris Robinson
Chuck Kuhn
Clive King
Clyde Frazier
David Beckerman
David Forland
Dee Brown
DJ Senatore
Eric Meyer
Iceberg
Jeff Staple
Mike Rhodes
Nate Wallace
Paul Litchfield
Roberto Muller
Sandy Bodecker
Shigeyuki Kunii
Sinisa Egelja
Steve McDonald
Steve Van Doren
Tinker Hatfield

Thanks

Sneaker Freaker Staff

Adam Jane
Ben Carey
Boonmark Souphanh
Cesca Benson
Dan Purnell
Hans DC
Matt Williams
Olivia Finlayson
Rob Marfell
Tim Daws
Vinny Tang

Thanks

Adolf Dassler
Arthur van der Kroft
Bruce Kilgore
Charlie Morgan
Chris Aylen
Chuck Taylor
Drieke Leenknegt
Frank Rudy
Gavin Francis Thomas
Jeanne Huang
Jim Davis
John Elliot
Kris Hall
Liam Harris
Mafia
Mark Doherty
Mark Gale
Mike Lapilusa
Mike Packer
Phil Knight
Rudi Dassler
Sam Smallidge
Sarah St George
Simon Pestridge
Steve Douglas
Steve Roach
Terry Ricardo
Trevor Hunter

Collector Contributions

Annie Xia
Ben Weaver
Damian Sim
Chanica Kist
Chicks With Kicks
Chris Robinson
Iceberg
JD Eje
KICKSTW
Gabriel Remonte Gomez
Nate Wallace
Nicholas Solome
Matt Williams
Ross Wilson
Scott Purdey
Tyree Dillihay

Special Thanks

Benedikt Taschen
Bobbito Garcia
Brett Chittenden
Carl Grebert
Erin Narloch
Gary Warnett
Kanye West
Mark Godwin
Martin Holz
Nick Santora
Pascal Prehn
Teresa Tayzon
Victor Novettipolae
Wieden+Kennedy

Dedication

This book is dedicated to
the memory of Jack Cummins,
who always pointed me in the
right direction.

Sneaker Moments

The last 15 years of sneaker history have produced more intense creativity and progressive leaps than the entire preceding century. Once reserved purely for athletic pursuits, sneakers transcended the realm of fitness in the 1960s to play a vital role in professional sport, street fashion and suburban culture. In this chapter, we look back at the people, partnerships and technological breakthroughs that coalesced over the past decade and a half to create the modern sneaker scene. From the rise of the Dunk SB to adidas Futurecraft and the maniacal influence of Kanye West, this is the ultimate highlights reel.

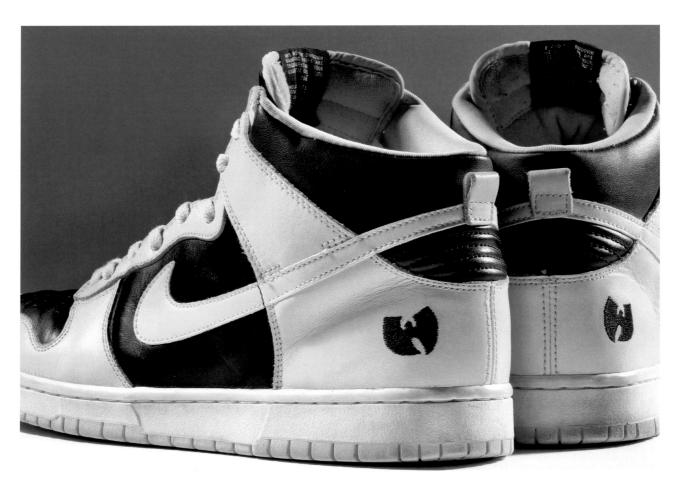

1999: Wu-Tang Clan x Dunk High

2001: Alphanumeric x Nike Dunk Low (Friends and Family)

2002 Collaborations

FEATURE REFERENCE

Nike Skateboarding
Page 108

The modern era of sneaker collaboration began in 1999 when Nike tapped the unlikely duo of Junya Watanabe and the Wu-Tang Clan. The addition of the Wu logo to create a 'Killer Bee' Dunk High in a classic Goldenrod colourway unintentionally set the template for the next decade and beyond. Nike + dope logo = hype! Let's not forget that Coca-Cola also collaborated on Nike's Kukini runner in 2000. Shortly afterwards, Alphanumeric, Chocolate, Zoo York and Stüssy Dunks would lay the foundations for Nike SB's domination.

One colab from 2002 is regarded as the most significant in sneaker history. With their Midas touch, it's no surprise that Supreme, the dons of NYC streetwear, were involved, but what is surprising is how ridiculously simple the recipe was. The use of Jordan III 'Elephant' print on a pair of Dunk SBs sent the hype-o-meter straight into the stratosphere. What was shockingly original then now seems played out, but that's the beautiful thing about living in the moment. Let's stay there for a minute. The first Supreme Dunks are the embodiment of what a colab should be – the synthesis of two brands with a zeitgeist-zapping idea that adds up to something a helluva lot more heavy-duty than the visual sum of its parts.

Momentum was building globally and 2003 was the breakout year for colabs. Seminal releases including the adidas x BAPE Superstars, Real Mad Hectic x Stüssy x NB580, Stash's 'Nozzle' AF-1 and all-blue Air Max BW, Futura's Blazer and the 'Viotech' Air Max 1 by atmos all set high-water marks for eclectic creativity and pulverising desirability.

Fuelled by the earliest sneaker blogs like Crooked Tongues and Nike Talk – not to mention a little magazine called *Sneaker Freaker* – the colab business model was officially off and running, ushering in a new generation of sneaker aficionados and unprecedented interest in footwear. The rest is history, but you'll need to read this book to find out how it all went down. • *Woody*

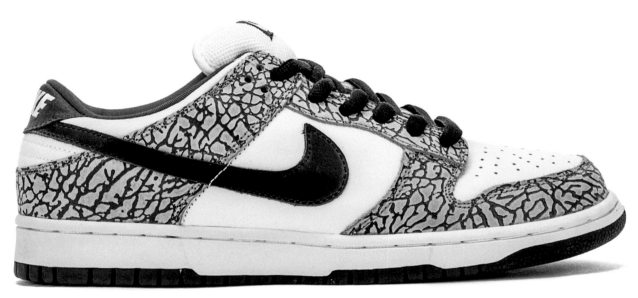

2002: Supreme x Nike Dunk Low Pro SB

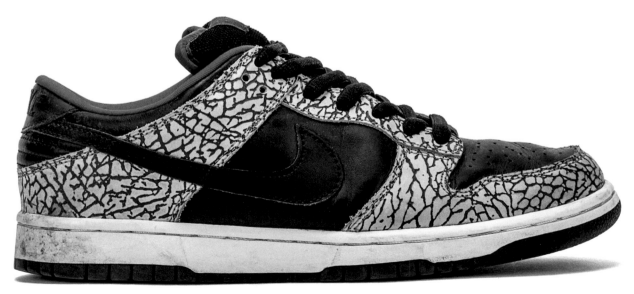

2002: Supreme x Nike Dunk Low Pro SB

Photos: James Whitlock

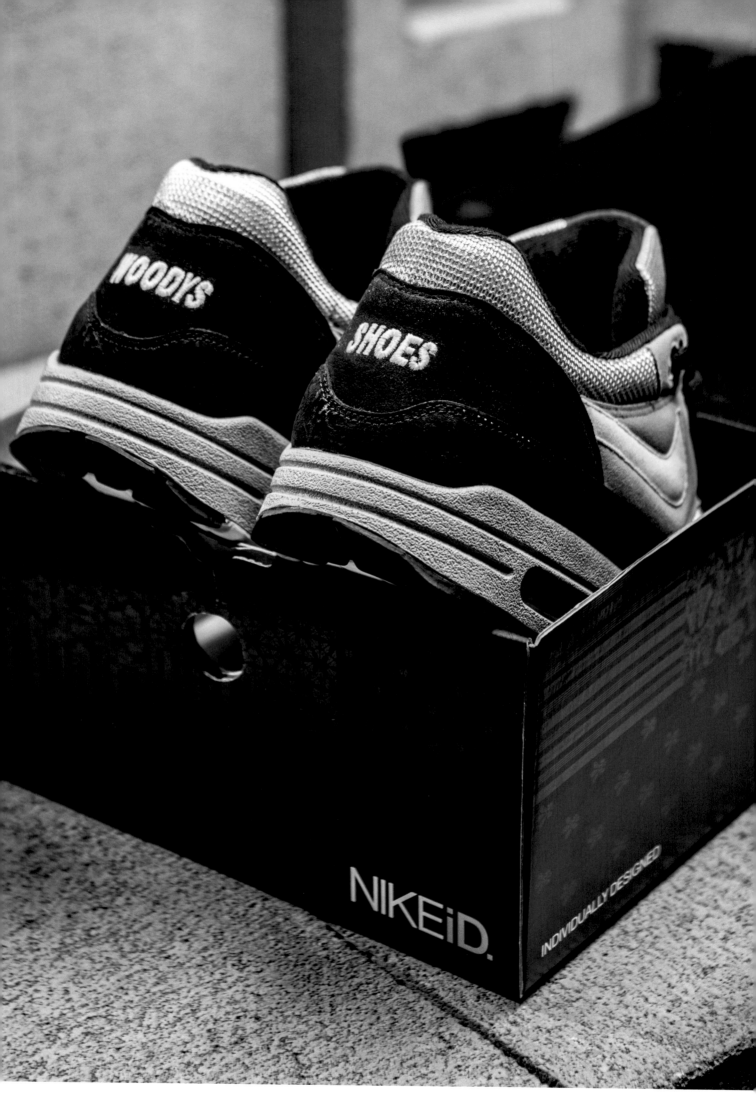

2004 NIKEiD

Vans may have made one-off shoes for Californian customers as far back as 1966, but NIKEiD perfected the concept of making customised sneakers available to the masses. Launched in 1999, Nike's online desktop design system was highly selective in the early years. To avoid confusing punters and to keep factory workers from losing their marbles, colour choices and materials were kept deliberately tight. New models and options joined the iD inventory with each season, but they didn't stick around long. Limited edition became the new norm, leading to fever-pitch FOMO with each new addition to the palette. If you were an educated user, you could pick the season in which any NIKEiD shoe was made simply by colour selection and model.

In 2004, Nike opened their '255 Elizabeth Street' experiential space in New York. Loads of significant events went down there, but the joint was generally used as a NIKEiD studio for so-called 'influencers' (not that the word was invented then). Anyone who was anyone could hit up 255 to bust out a batch of unique Nikes when they were in town. With madcap colour combos and sweet materials, some of the iD shoes made in this era had serious street clout.

NIKEiD reached its pinnacle with the birth of the Bespoke program in November 2008. Based in the rear of Nike's Mercer Street store in NYC, Bepoke was a one-on-one sneaker design experience. A consultant was on-hand to guide initial discussions through to a sketch, before hundreds of colours and materials were considered. Unlike the standard iD system, there was no computer simulation and the possibilities, while not exactly infinite, were expansive. Loopwheeler fleece, elephant print, reflective 3M, iced-out soles, asymmetrical blocking, sandalwood lasts and a bewildering variety of eyelets were available. Like a classy degustation menu, each step in the process was savoured as a juicy part of the creative feast. At $800 a pop back in 2008, NIKEiD Bespoke was not cheap, but it was definitely a memorable experience.

Today, almost every brand has their own custom sneaker program and NIKEiD, with hundreds of customisable items available online, is now mainstream. As long as you have a lazy thousand bucks in your pocket, you can still whip up a pair of Bespoke Nikes from NikeLab 21 Mercer. Just call +1 212 226 5433 to make your reservation. • *Matt Williams*

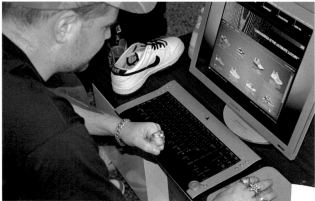

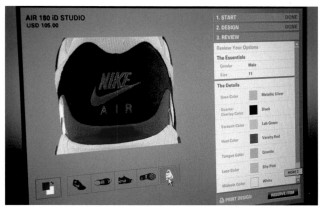

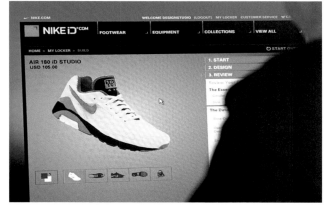

2004: Artist Dave White using NIKEiD at 255 Elizabeth Street, NYC

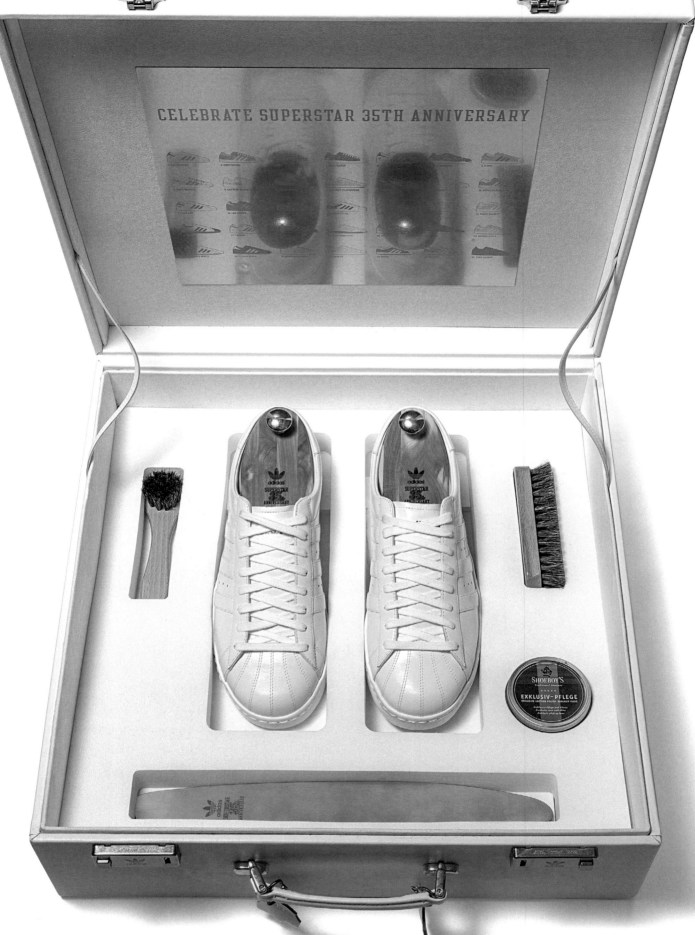

2005: Superstar #35 edition

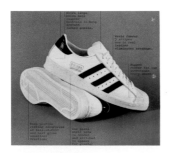

FEATURE REFERENCE

adidas Superstar
Page 570

2005 **adidas SS35**

Championed by Run-DMC and universally loved in all four corners of the globe, the Superstar is one of those rare sneakers that transcends class and creed. Some 35 years after it debuted, adidas decided to throw a massive year-long party, inviting artists, bands, musicians, retailers and seven cities to conceptualise their very own Superstar.

Timeless in classic off-white with black stripes, the #1 model was rightly reserved as an homage to Adi Dassler. However, it was the #35 edition that popped the cork for premium packaging. Reportedly made in Switzerland, the shoe was housed in a briefcase featuring a gold SS35 plaque engraved with the full anniversary lineup. Sandalwood lasts, leather polish and golden shoe horns accompanied the shoes, which were crafted from the most pristine white leather ever seen on a sports sneak.

Treasure hunts held in Berlin, London, New York, Los Angeles and Hong Kong encouraged fans to make like Sherlock and track down these remarkable shoes. If adidas were willing to go to this much trouble for the 35th, we can't wait to see what they have planned for the Superstar's big 5-0! • *Matt Williams*

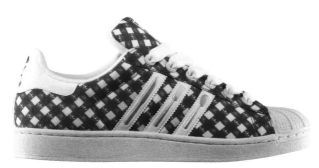

Upper Playground

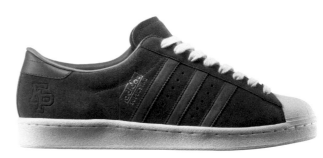

Footpatrol

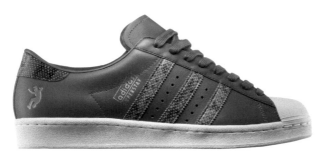

Union

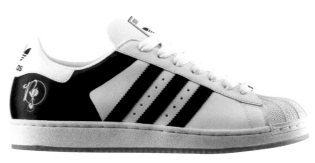

Rocafella Records

Underworld

UNDFTD

Neighborhood

Adi Dassler

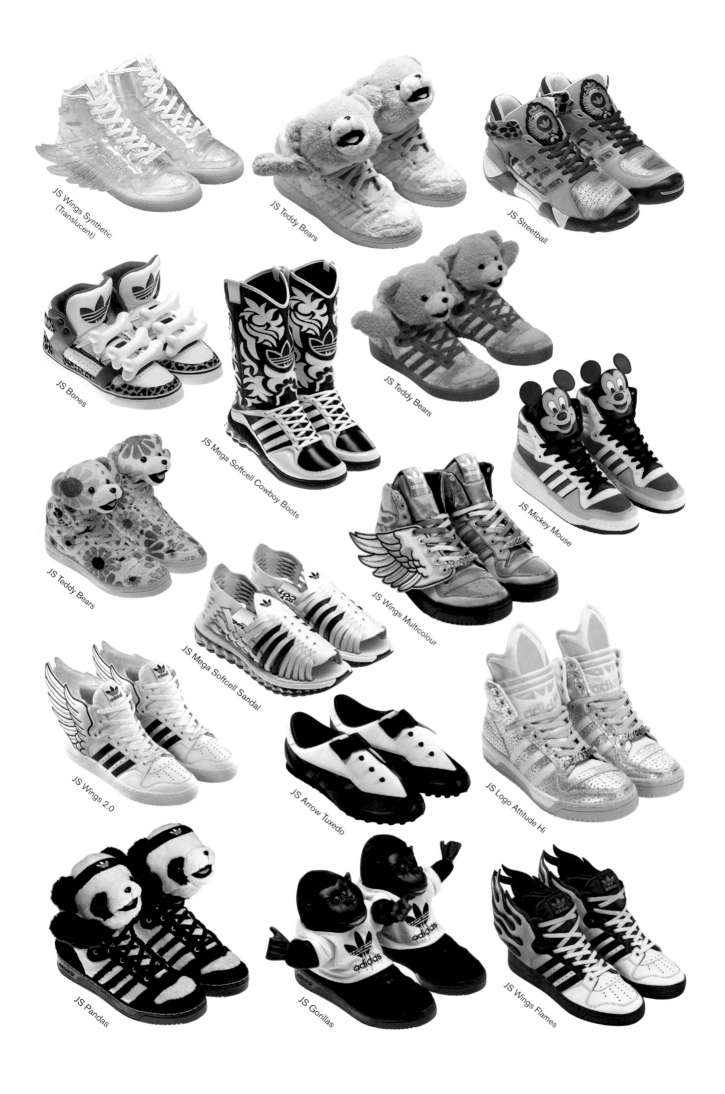

JS Wings Synthetic
(Translucent)

JS Teddy Bears

JS Streetball

JS Bones

JS Mega Softcell Cowboy Boots

JS Teddy Bears

JS Mickey Mouse

JS Teddy Bears

JS Mega Softcell Sandal

JS Wings Multicolour

JS Wings 2.0

JS Arrow Tuxedo

JS Logo Attitude Hi

JS Pandas

JS Gorillas

JS Wings Flames

2006 Jeremy Scott x adidas

As fashion's preeminent pop culture shock-trooper, Jeremy Scott has been responsible for the most outrageous footwear the world has ever seen. From Superman sequins to panda bears, faux-Flintstone bones and fluoro snakeskin, Scott's signature smash-up aesthetic showed no mercy to sacred cows. Hardcore sneakerheads may have been outraged by his heretical approach, but Scott inspired a devoted following among plushophiles and fashion-forward funsters.

The uber-playful tone might have been all too easy to ridicule, but the JS range posted significant numbers for a good few years and its commercial success shouldn't be downplayed. Released in a mind-boggling array of concepts, the JS Wings model in particular was embraced with gusto in North America's urban enclaves. Back in 2011, Jeremy Scott was given the ultimate bad boy co-sign from Lil Wayne. Fresh from a stint in Rikers Island on drugs and weapons charges, Weezy rocked the iconoclastic Teddy Bears during his performance on BET's New Year's Eve Party broadcast. As we look back and ponder what the hell Jeremy Scott was thinking, there's simply no way you can ignore the sheer audacity of his outré vision. Salute! • *Woody*

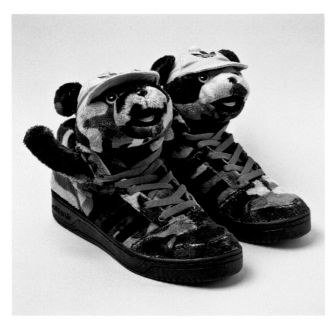

2012: JS Camo Bears

2010: *Sneaker Freaker* Issue 19

Photo: Hugues Lawson Body

Jeremy Scott

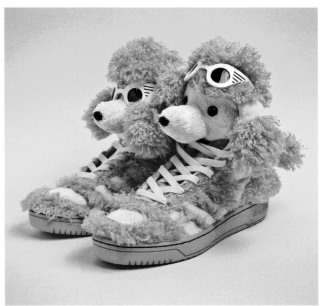

2012: JS Poodles

2007 **Patta x ASICS**

As the bells chimed to bring in 2007, retro runner vibes from the late 80s and early 90s were welcomed by the industry as the perfect vehicles for collaboration. A good year before adidas celebrated their ZX family with a Unimog full of special makeups, Patta was asked to sprinkle a little bit of fairy dust over the ASICS GEL-Lyte III. At the time, this was seen as an unlikely and somewhat incongruous partnership, but it would turn out to pay serious dividends down the track.

The result was pure fire. Patta's GL3 was carved from an exquisitely blocked mix of vivid green and red nubuck with perforated toe boxes. The localised storytelling wasn't overly literal or corny, and the intricate detailing really kicked things up a notch. Speckled midsoles and a pattern of Xs were nods to the three St. Andrew's Crosses on Amsterdam's flag. They were not, as some sneaker perverts have speculated, a reference to the red light district of Patta's home town. Released in very tight numbers, Patta's GEL-Lyte III didn't just snap necks, it stopped traffic on the Damrak and made sneakerheads faint on the spot.

This wasn't Patta's first rodeo, but it was their big league debut with a major brand and set them up for future projects with Nike and adidas. It wasn't the first colab for ASICS either (that honour goes to Tristan Caruso's Proper store in Long Beach, California), but it certainly established the GEL-Lyte III's credentials as a serious contender, culminating in the monster 25th anniversary in 2015. Not many individual collaborations have had such a profound impact on a single sneaker model's fortunes.

In 2010, Patta collaborated with ASICS again, this time on the GEL-Saga. Revisiting the original colour scheme, the Saga was politely received but failed to spontaneously combust like its predecessor. Subsequent projects haven't come close to the hype of the original release, demonstrating just how elusive the whole caper can be.

This selection may raise eyebrows but there's no doubt this partnership unlocked the destiny of both brands and established a powerful new formula for designing collaborations. Without Patta's contribution, who knows what might have become of the GEL-Lyte III? • *Woody*

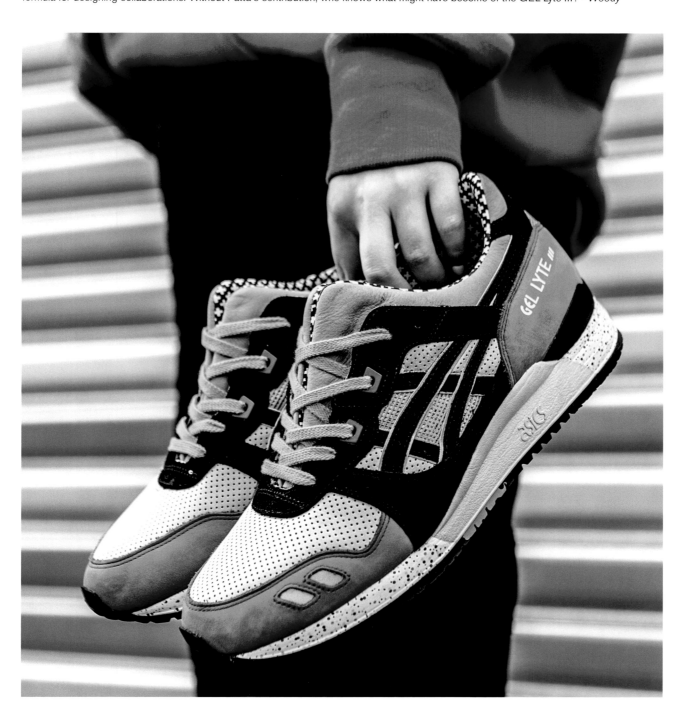

2008 Jordan CDP

Jordanmania hit a nouveau peak in 2008. Five years after Michael Jordan last set foot on court, and a solid decade since he'd hung up his Bulls jersey, the Jumpman was still flying off shelves. It was also 23 years since the release of MJ's first signature shoe.

Jordanheads sensed that 2008 was going to be big, but they weren't ready for *how* big – and nor were their bank accounts. On top of countless must-cop retro editions and the beautifully crafted Air Jordan XXIII, Jordan Brand unleashed an almighty haymaker in the form of the Countdown Pack concept.

Eleven packs were released in total, each comprising two flagship Jordans from the Air Jordan I right through to the Air Jordan XXII. The kick in the nuts was the fact that both shoes tallied up to the magical number 23, forcing diehards to emerge from their retro bubbles and dig double-deep to get their hands on the coveted crowd-pleaser releases.

The pressure was immense. Countdown Packs delivered old faves like the Air Jordan IV 'Bred' and never-before-retroed OG colourways like the Air Jordan VI 'Carmine'. Late-model Jordans with updated colour schemes were also seen for the first time since their original release.

For every happy winner there was a disgruntled Jordan enthusiast who felt ripped off for having to pony up for a double pack they never wanted to invest in. Thanks to a deluge of collectors snapping up 'Black Cement' Air Jordan IIIs, a flood of unwanted Air Jordan XXs hit sales racks the day after release, many of which still linger on the Bay to this day! Regardless, 2008 was the pinnacle of Jordanmania and memorable for many reasons. • *Matt Williams*

FEATURE REFERENCE

Michael Jordan
Page 348

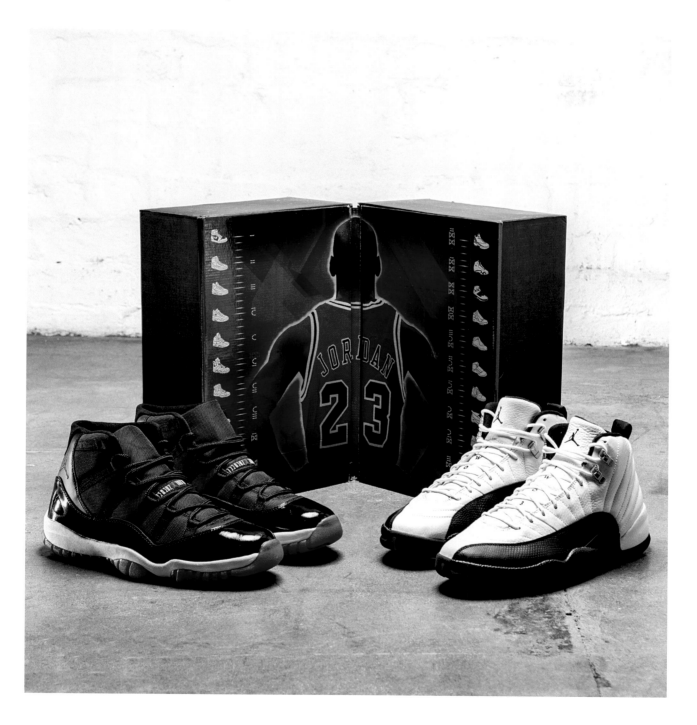

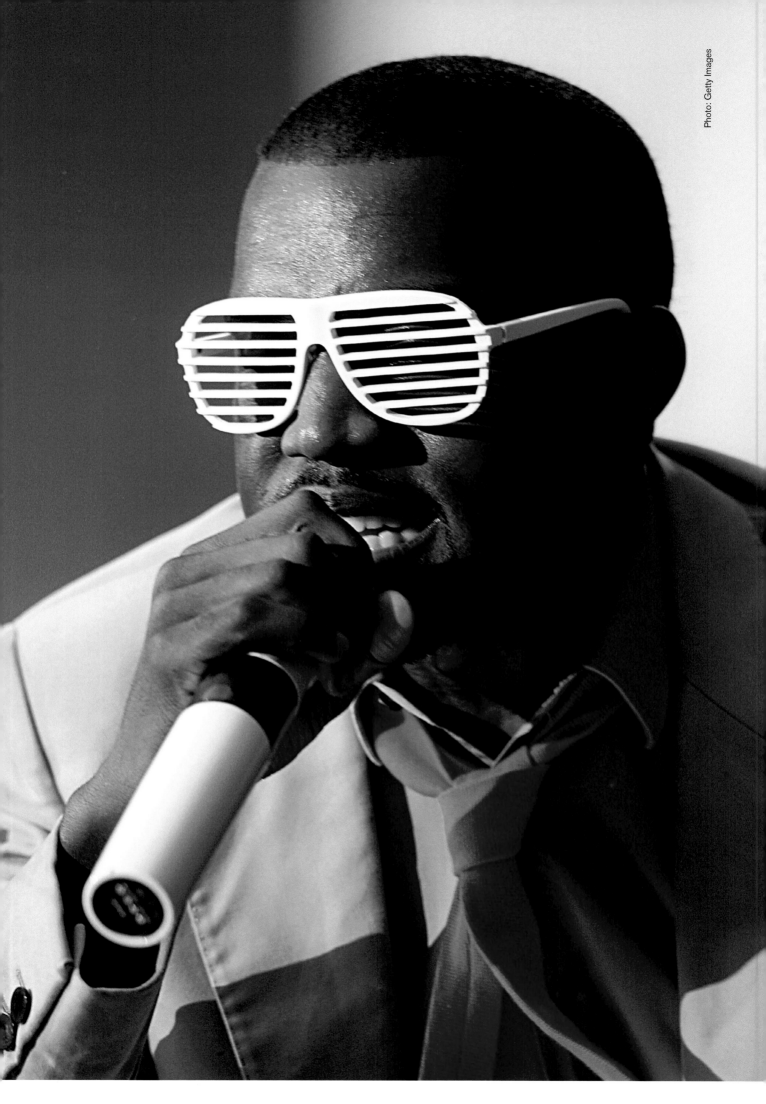

Photo: Getty Images

2009 **Kanye West**

FEATURE REFERENCE

The Yeezy Effect
Page 56

When Kanye's first strap-happy Nike debuted in 2009, the sneaker world was mesmerised by the sheer audaciousness of the package. Run-DMC aside, it's hard to think of another hip hop artist who has put their name to a sneaker with any real substance. Even the omnipotent JAY-Z's S. Carter range was little more than a sideshow at RBK. And yet here was Jigga's precocious understudy harnessing the full powers of the Nike juggernaut to catapult his signature sneaker into a stratosphere usually reserved for the most exalted athletes.

Not only was Kanye clambering for the prestige afforded exclusively to his royal highness Michael Jordan, but in a further act of sacrilege, he even threw a Jordan III sole straight into the Yeezy's mondo-mélange. With its knee-scraping ankle padding, pillowy tongue and mammoth Velcro wrap, there was nothing subtle – or sporty – about the Yeezy's steez. It was the ultimate symbol of cockily manicured excess, and the mania that met the shoe on release was matched only by an eBay price that quickly reached bubble status.

Three years later, the Air Yeezy's inevitable sequel arrived. The shoe was slammed by the all-knowing social media swarm, yet Yeezy fever was as contagious as ever. Maybe there was some wily foxing going on in the FB comments, because those hating hardest seemed destined to be first in line on release day. In comparison, Kanye's previous collaborations with A Bathing Ape and Louis Vuitton barely sparked a flicker of interest.

As for the shoe, the lineage between the Air Yeezy II and its older sibling is obvious. The Yeezy II was built on an Air Tech Challenge II base, providing just enough athletic DNA for the design to bridge the sports–fashion divide. The translucent soles still glowed in the dark and the trademark strap reappeared, albeit without the same jumbo dimensions.

Perhaps casting himself as a mystic seer in the same vein as Sun Ra or Bambaataa, Kanye – apparently on Molly Meldrum's advice – went big on Egyptology references, dotting the upper with hieroglyphics, pyramid-shaped ventilation holes and the falcon-headed deity Horus, who peered out from the tongue's rubber badge as an extension of *Watch the Throne*'s themes.

The shoe's most striking feature was its series of moulded rubber ridges protruding from the heel. Like a membrane stretched taut over an alien spine, it gave the Yeezy II an other-wordly, animalistic look. Just as the original Yeezy was inspired by the sky-high tongue and jumbo straps of Japanese brand ATO's Cow Hide Boot, the Yeezy II's heel sported parallels with the Batman-suit vibes of Hussein Chalayan's Urban Mobility experiments for PUMA.

Cynics dismissed the Yeezy II as a fabricated concept with a tenuous connection to anything other than a fashion cash-in. Indeed, it's impossible to separate the shoe from the egotistical antics of its namesake. Whether you think Kanye West is the most iconic musician alive or a pampered pop poser will likely determine how you feel about his Yeezy line. • *Anthony Costa*

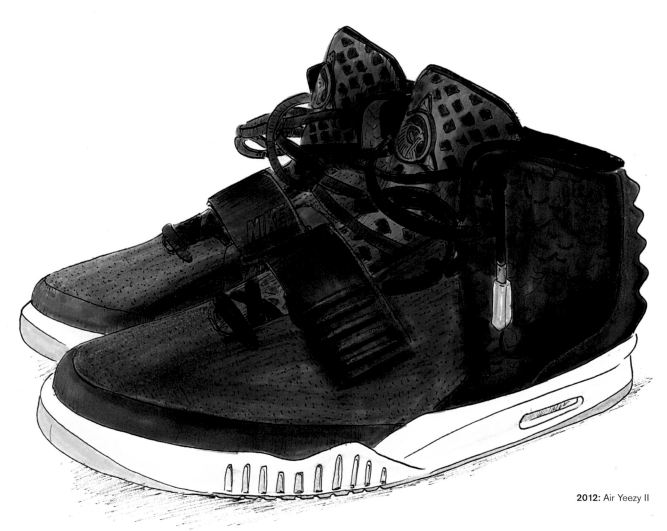

2012: Air Yeezy II

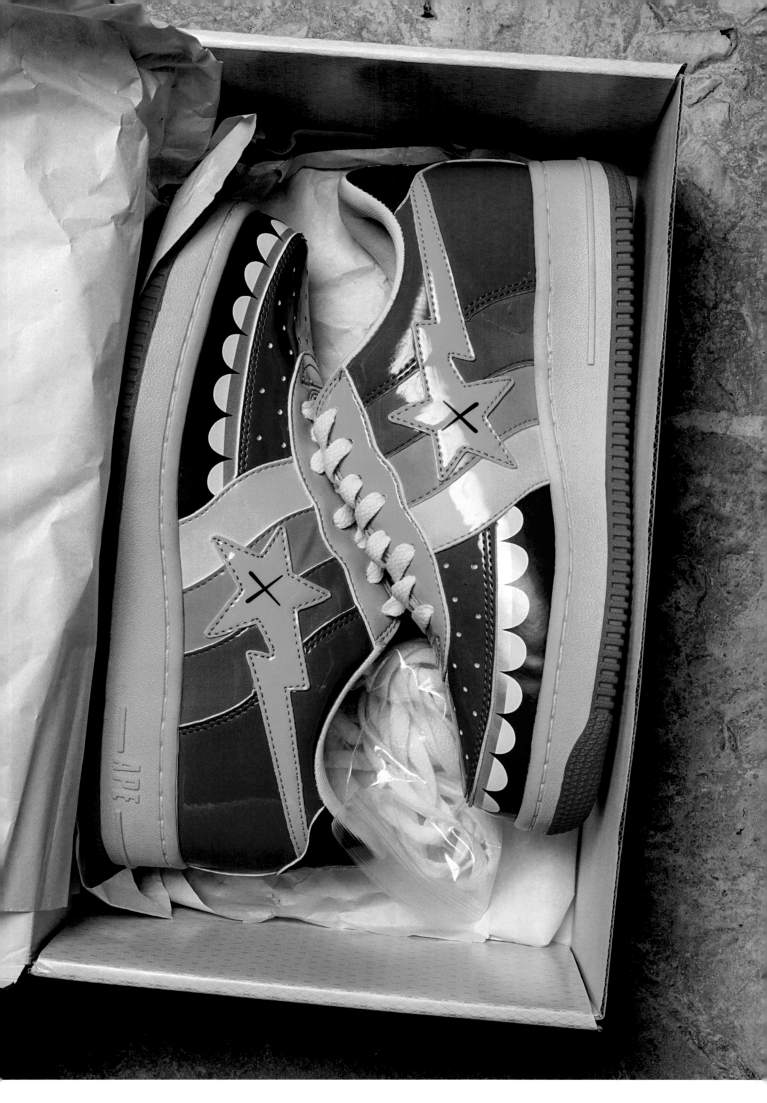

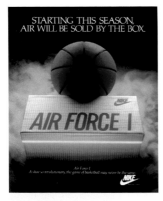

FEATURE REFERENCE

Nike Air Force 1
Page 426

2010 **Bapesta**

Founded by Nigo in 1993, A Bathing Ape, better known as BAPE, practically invented the concept of high-end Japanese streetwear. Back in the early days, pre-internet and prior to global e-comm, the brand carried an almost mythical status. The only cool cats repping the brand had been to Japan and, through some highly secretive process, managed to get out of the country alive with some BAPE gear in their luggage. Along with denim by Evisu, BAPE carried the highest credit rating of any streatwear brand.

From the shark hoodie to their Baby Milo range, BAPE's graphics are simple, playful, imaginative and original. But when it comes to their footwear, things are not so clear cut. Let's state the bleeding obvious: the Bapesta is a stitch-perfect knockoff of Nike's Air Force 1 that simply lacks Air in the soles and a Swoosh on the side. BAPE – presumably – would claim the Bapesta is an homage and they are just paying respects to a legend, but when you stack it all up, it's a flimsy defence at best.

Why didn't Nike take legal action against BAPE? That will always be one of the great sneaker mysteries. It's not as if Nike are shy of a scorched-earth cease and desist, so there must be a loophole that BAPE was able to exploit in their favour. Over the years, the only rumour I heard was that a collaboration deal soured and the Bapesta was part of a revenge pact. True or not, in the years since, BAPE has collaborated with adidas several times, but have never worked officially with Nike.

Let's go back to 2010. Bapesta hype was more infectious than Ebola. Watching Pharrell and Nigo in grotesque all-over yardage prints and huge bling-bling jewellery may seem cringeworthy now, but at the time they definitely spawned a cult following. Bapesta colabs with Kanye West, KAWS and Daft Punk added to the Harajuku-cool mystique. At the peak of this 'insane clown posse' period, a series of ludicrously bright and fruity patent editions drop-kicked the Bapesta into even more rarefied air. Using eight or more popping colours on the shoe was not uncommon.

Rather than pursue legal recourse, Nike did the next best thing. Cultural theorists would love the postmodern idea of the world's biggest brand stooping to copy a brand that was copying them, but that is exactly what played out. Reading from Nigo's playbook, Nike released a series of ludicrously bright and fruity patent Air Force 1s that drowned the market in lookalike product.

As the GFC cratered the American economy, a dark shadow fell on fashion and street style. Zany colour combos and *plastique fantastique* materials suddenly looked juvenile, and the Bapesta's influence faded quickly. But there's no doubt the shoe was highly influential for a while there, and more than worthy of this dedication. • *Woody*

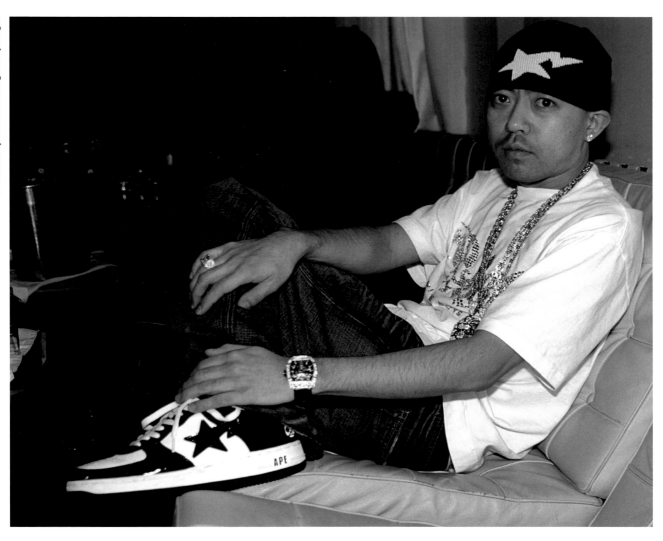

Photo: Johnny Nunez/WireImage/Getty Images

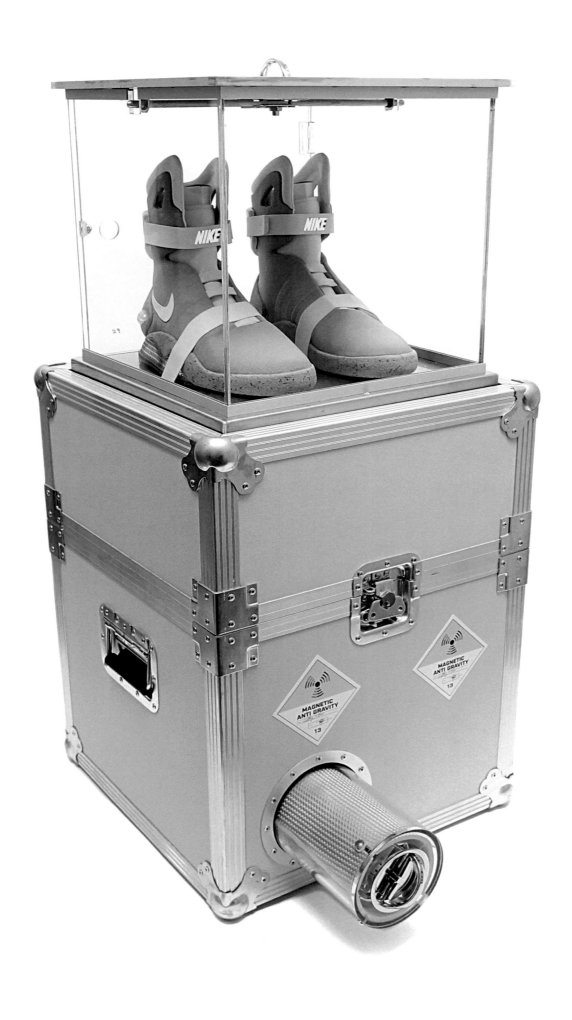

Photo: 3peat LA

2011 Nike McFly

If there is one moment when sneaker culture went so supercalifragilistically ballistic that it rocketed into mainstream consciousness, it's this. Rumours had circulated for months, but when news officially broke that Nike would release the shoes worn by Marty McFly in *Back to the Future II*, hardcore nerdburgers, film buffs and sneakerheads lost their minds. For a good few weeks, it seemed like every person on the planet (and beyond) was talking about the crazy self-lacing sneakers.

Known as the Nike Mag, the shoes were packaged in a blinding yellow, magnet-sealed, flip-top, cardboard box. Labelled with 'Magnetic Anti Gravity' tags, they came accompanied by a battery charger, Tinker Hatfield's illustrated instructions, a metal licence plate with a unique serial code and a DVD with the *Back to the Future II* trailer. A UPS sticker stating the package had been shipped from Hill Valley, California, was another example of the superb detailing built into the project.

Some 1500 pairs of Nike Mags were auctioned on eBay from September 8, 2011, with proceeds going to the Michael J. Fox Foundation. By the time the e-dust had settled, the highest price paid was $9959 and a total of $4.7 million had been raised, making it easily the largest charity auction of all time.

A further 10 pairs were sold at Nike events around the globe. The ultimate prize for BTTF nerds, this edition came nestled inside a yellow road-case styled after the plutonium containment chamber in the original film. Auctioned off at the Montalban Theatre in Hollywood, Tinie Tempah forked out a staggering $37,500 to take them home!

More than just a fluffy feel-good exercise in marketing hoopla, the McFly campaign was a hyper-viral pop-culture phenomenon. Thanks to Nike, Parkinson's research was advanced in a tangible way and the world was shown a positive example of what can be achieved with immense goodwill and imagination. • *Matt Williams*

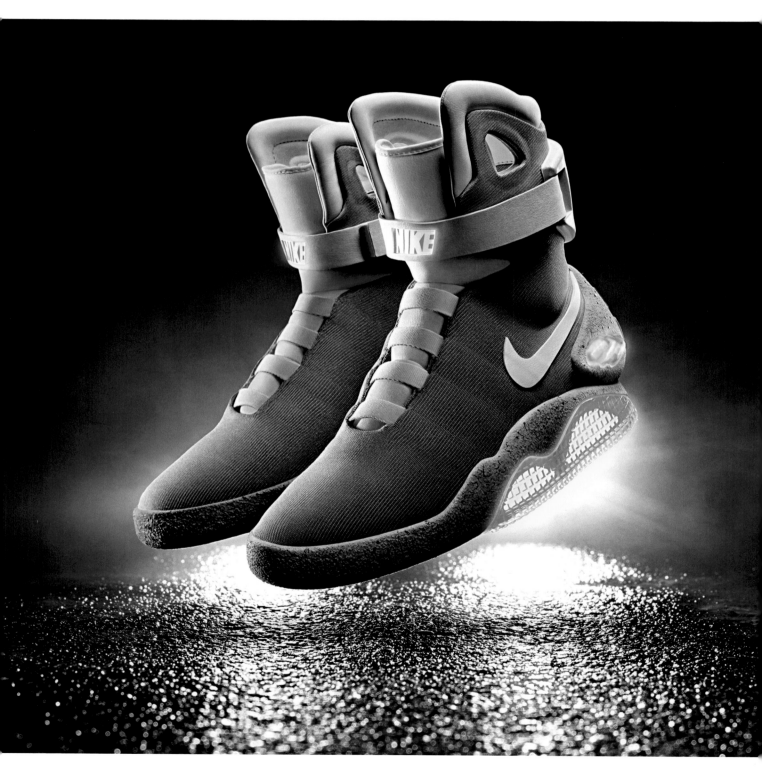

2012 Flyknit vs Primeknit

The sneaker industry is rife with thievery. Every day of the year, ideas for cushioning concepts, micro details and complete designs from the ground up are reimagined into 'new' forms. It's a murky area and a legal minefield. At any given time, there are likely at least a dozen lawsuits going on over footwear trademarks, though most will never become public news.

In the case of Flyknit versus Primeknit, who stole what, when, and from whom – or whether two brands simply had the same idea at the same time – is still unclear. The ensuing legal skirmish is just one of the many Nike and adidas have fought over the years. When the stakes are as high as hundreds of millions of dollars, it's no surprise both sides lawyered-up hard and went into battle.

Announced in early 2012 at a media event in NYC, Nike lauded Flyknit as a game-changing innovation. Normally it's the cushioning or shock absorption technology that warrants headlines and patents, but in this case, it was all about the ingeniously form-fitting and super-lightweight knitted upper.

Meanwhile, over in Herzogenaurach, adidas were scheming on their own version. The adiZero Primeknit launched a few months after Flyknit as part of the brand's London Olympics campaign. It caused an immediate ruckus, but not just because of its £220 price tag. To say adiZero and the Flyknit Racer are similar is an understatement.

Nike immediately sought an injunction but adidas claimed they had been working on the idea for three years, which does seem likely. As a Nike press release said at the time, 'We have a strong heritage of innovation and leadership in footwear design and development. Our patents are the foundation of that leadership and we protect them vigorously. In this case, the injunction helps protect the innovative Nike Flyknit footwear technology introduced in February, 2012.'

Somewhat surprisingly, adidas won the initial court case, though the ruling meant the brand could only sell the adiZero in Germany. Nike may have been first to release and market the concept, which influenced many to believe it was solely their idea, but this fact alone was not enough to secure the points.

Ultimately, after a huge amount of legal posturing and several court cases in different jurisdictions, both sides claimed victory in this battle royale. Judgements in Europe and the USA ruled that Nike's patent was invalid, simply because knitting had been around since grandmas were invented. Case closed.

Since that decision came down in 2014, Flyknit and Primeknit have both become standard issue and consumers could care less about the patent dispute. In adidas' case, Primeknit (usually listed as 'PK' on product codes) is most commonly associated with UltraBOOST and PureBOOST, which between them have racked up sales well into the millions. Nike have used Flyknit liberally across their product portfolio from the Hyperdunk Flyknit to the Mercurial range of football boots, and even retro styles like the Air Max 1 Flyknit. • *Woody*

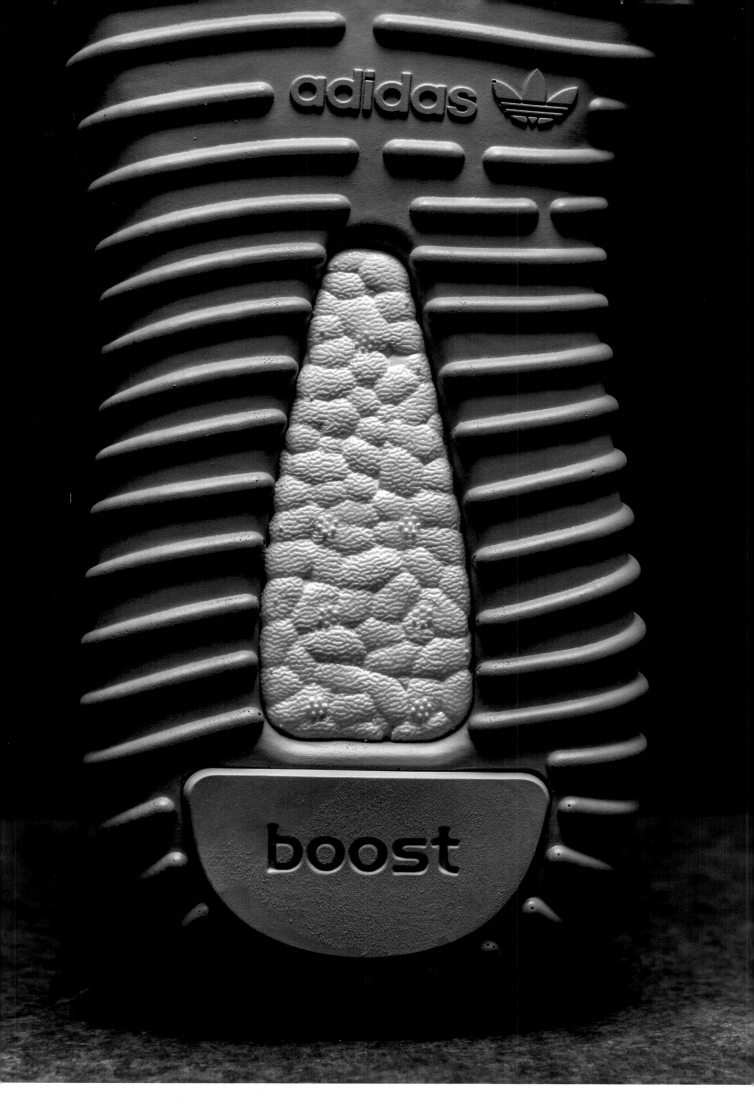

2013 adidas BOOST

FEATURE REFERENCE

adidas NMD
Page 92

Since running shoes were invented, the sliver of soft material between the foot and the earth has been the focal point for designers and athletes looking for an edge. The concept of harnessing 'energy return' from a springy midsole has always been at the core of product development.

In the early years, research focused on foam compounds like EVA (ethylene vinyl acetate) and PU (polyurethane). Each new recipe still had fundamental flaws – they were either too soft, too hard, too brittle or way too unstable. Experiments with chemical compounds and pressure moulding – which gave us Phylon, for example – were positive advancements, but the new foams were still overly sensitive to the effects of temperature and the rapid depletion of that elusive springiness. Researchers knew the full potential was yet to be realised.

When adidas revealed their new cushioning system back in 2013, they had high hopes for the simple foam pellet compound known as BOOST. And rightly so. Introduced via the EnergyBOOST, the tech went on to redefine the brand. BOOST was actually a coproduction between adidas and BASF, one of the world's largest chemical companies. With their combined expertise, the pioneers were able to create a new form of TPU (thermoplastic polyurethane) with a unique polymer structure.

Research into energy return has never been about finding springier rubber – that part is easy; it's all about fine-tuning the reaction process. If the foam springs back too quickly, the lack of stability produces a wobbly effect underfoot that leads to unpredictable outcomes. In other words, a softer ride isn't always best. The foot still has to plant solidly on the ground.

This is where BOOST's inherent characteristics are so crucial. The material is made by moulding together handfuls of small TPU capsules, allowing each unit to retain its shape, step after step – something that's impossible to achieve with one big slab of foam. Just as importantly, BOOST doesn't compress and flatten out over time, it keeps its cushioning capabilities intact. It's an ingenious solution to a complex question that has been driving footwear designers crazy for decades.

EnergyBOOST was a runaway success, so much so that adidas couldn't produce the compound quickly enough. As production increased, so did demand, and BOOST was reconfigured to suit all kinds of adidas performance footwear. Crazylight took BOOST to the rim, Y-3 used it to bounce down the catwalk, and the RG3 saw the foam appear on the football field. It was the start of the BOOST takeover!

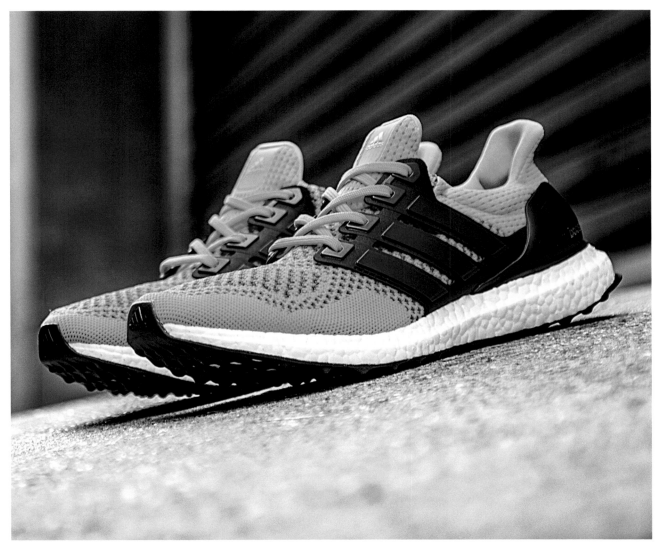

2015: UltraBOOST

adidas BOOST Evolution

Busenitz PureBOOST

Crazylight BOOST 2015 Mid

Yeezy BOOST 350

EnergyBOOST

EQT Racing 93/16 BOOST

Hu NMD

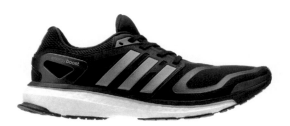

OG EnergyBOOST

NMD Runner PK

Y-3 Yohji BOOST

PureBOOST ZG Raw 4M V2

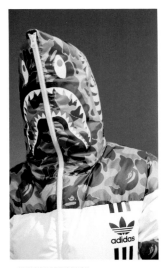

FEATURE REFERENCE
adidas NMD
Page 92

The BOOST-bottomed NMD became an unstoppable force, keeping footpaths lined with camp chairs as collectors waited patiently for nights on end. Basketball heroes like the Harden Vol. 1, Crazy Explosive and D Lillard 2.0 all repped BOOST, as did the Ace 16 UB, adidas' laceless football boots. The brand's Terrex sub-division has explored new frontiers for BOOST with a series of trail runners and hard-wearing wilderness wares. Even traditional sneakerheads enjoyed a taste of the action with the EQT Support 93/16, a classic silhouette that sat atop a springy bed of BOOST.

Of course, we can't mention the B-word without the K-word. The Yeezy BOOST 750 may have debuted in 2015, but as the years passed, the Three Stripes worked toward delivering on Ye's promise of 'Yeezys for all!' As if one megastar wasn't enough, adidas also dropped Pharrell Williams' Hu NMD in a plethora of bright colourways, another BOOST-equipped signature shoe that tends to sell out before most people can even click through to the checkout.

One of the biggest conversations surrounding early BOOST releases was focused on the stark white finish. In the beginning, BASF struggled to find a colour compound to match the elasticity and memory of the foam, which kept BOOST in all-white until 2016. Then came the aptly named 'ColorBOOST', which created staggering buzz. If the 'Pitch Black' NMD was a little on the dark side for your liking, then you may have preferred the channel of light that burst forth from the arch of the PureBOOST X. The model introduced a form-fitting floating arch support that created a gap between the upper and the midsole.

In 2018, adidas celebrated five years of BOOST with a rerelease of some OG favourites such as the first EnergyBOOST. The brand's frontrunning foam has also been working hard for the environment, forming the basis of adidas' collaborative work with Parley for the Oceans on a line of shoes that utilises recycled ocean waste. Beyond that noble initiative, the brand's future-focused Speedfactory is heavily invested in using a new suite of technologies to push BOOST even further. With so many variations available across all adidas' fields of play, it's clear that BOOST is here to stay. The OG release is now considered a landmark moment in sneaker history – ground zero for the game-changing technology. • *Adam Jane*

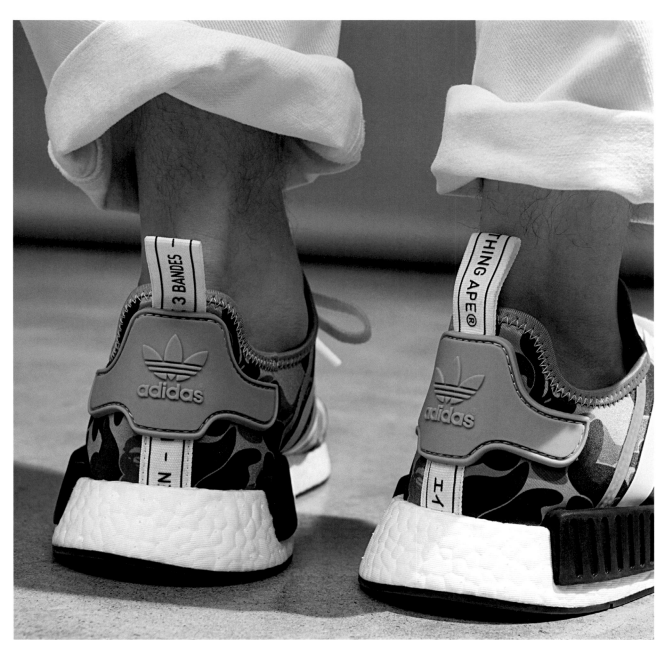

BAPE x NMD_R1

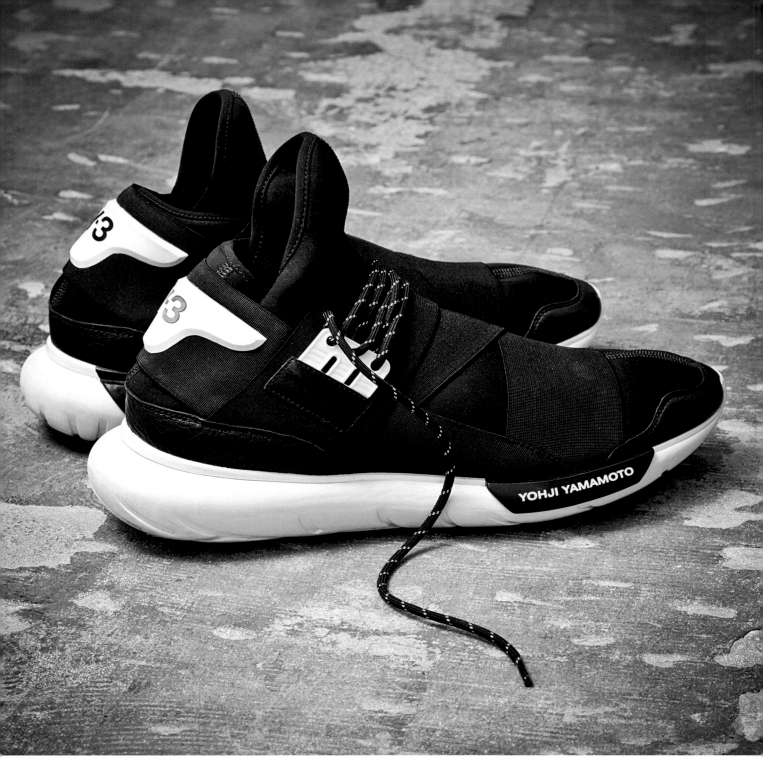

2014 **Y-3 Qasa**

As hip hop fused its lips to the teat of high fashion – *praise be to Kanye!* – the philosophical notion of 'fashion sneakers' progressed from a sneakerhead's idea of a sick joke to an official movement that had every self-confessed fashionista clambering aboard the brandwagon. PUMA snapped up Alexander McQueen and Hussein Chalayan, while adidas signed Jeremy Scott, Stella McCartney, Raf Simons and Rick Owens to their own sub-label designer deals. But let's not forget that Yohji Yamamoto's Y-3 (Y for Yohji and 3 for the Stripes) deal with adidas paid its dues for a solid decade before the gaggle of modern usurpers arrived.

It may have taken 10 years, but Yamamoto's range from 2013 marked the moment that everything came to boiling point. The collection was a stunning mix of angular contours, subtle textural transitions and inventive colour-blocking. It might not have been sporting sneakers as 'we' know it, but it was an outlandishly original vision delivered with panache and perfect timing.

Plucked from that range, the Qasa exemplified the feel-good super-futurism of the moment. Essentially a ninja sock on 'roids, the design flaunted a neoprene bootie and layer-upon-layer of black webbing above bulbous soles and a subtle Yamamoto callout on the midfoot widget. ZX-esque plastic lace clips added a hint of adi-heritage to the soufflé.

More than just a basic list of components, there was something ineffably righteous about the Qasa. Classical yet 21st century, the design struck a chord with everyone from ath-goths to savvy sneaker mavens and idiot style savants. While it never reached top-seller status, the Qasa's influence was visible everywhere at adidas from the Tubular range to the genre-busting, market-crushing NMD franchise. And it's no exaggeration to say that every sneaker brand was 'inspired' to some degree by the Qasa. 'Nuff respect due! • *Woody*

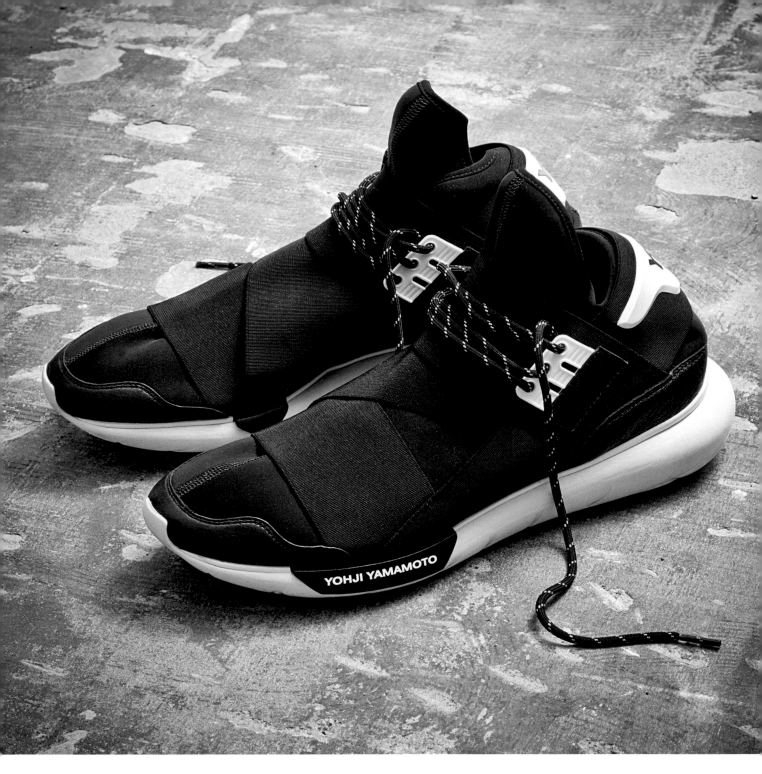

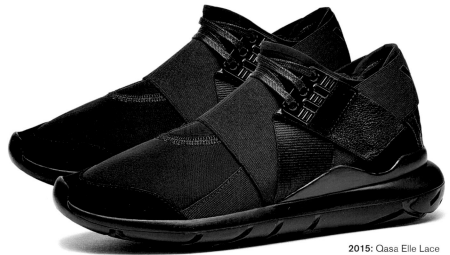

2015: Qasa Elle Lace

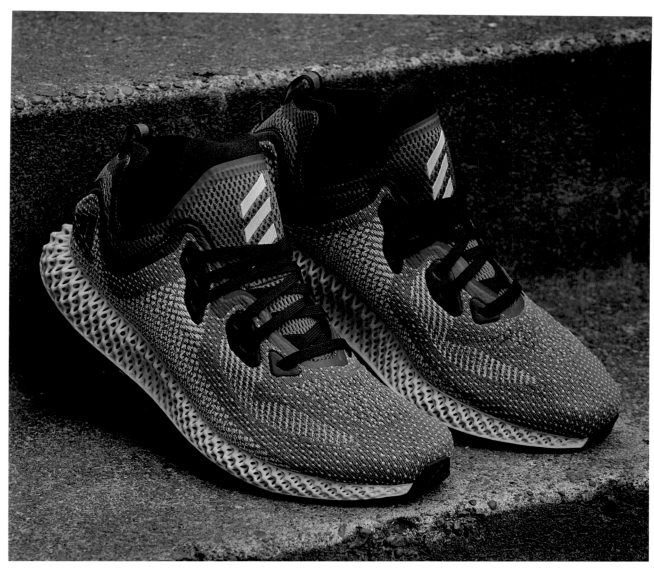

2018: AlphaEDGE 4D LTD

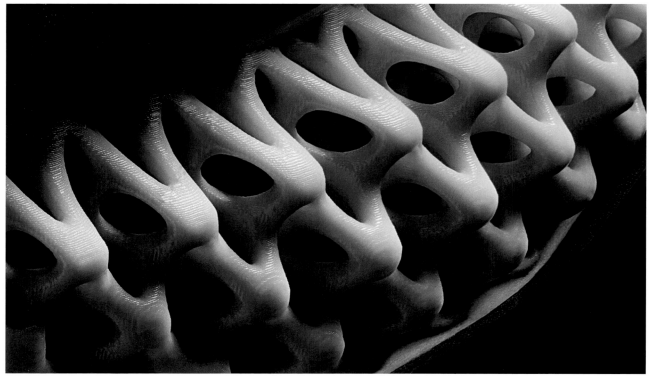

2017: Futurecraft 4D sole unit

2015 adidas Futurecraft

Innovation has been the focus at adidas since Adi Dassler started the company in 1949. In more recent times, the charge has been spearheaded by Futurecraft, the company's experimental research hub.

Futurecraft's existence was announced at the end of 2015 with the launch of the Futurecraft 3D, a cageless Primeknit upper atop striking 3D-printed midsoles. The shoe was a work of art and a technological tour de force, with intricate interconnected lattices providing the revolutionary cushioning. A month later, adidas unveiled the Futurecraft Leather, a classic Superstar created using a new manufacturing technique that milled the shoe's uppers from a single piece of leather. The process reduces unnecessary bulk for a form-fit and minimises the use of toxic adhesives for a double win! Limited to a micro-run of 45 pairs, they certainly didn't stick around when they dropped at Dover Street Market in New York, London and Tokyo.

December of the same year saw adidas return to 3D printing, this time pairing the tech with equally forward-thinking innovation led by Parley for the Oceans. Using reclaimed ocean waste, the design used recycled midsoles in rippling oceanic blue with a stripped-back grey Primeknit upper, proving that you don't need to sacrifice style at the altar of sustainability. The design kickstarted an ongoing partnership between adidas and Parley that has since brought numerous models to market with uppers made from up to 95 per cent recycled ocean plastics.

Transitioning into 2016, adidas blasted innovation once more in the form of Futurecraft Tailored Fibre, a manufacturing development intended to give athletes the on-track edge. The process allows for bespoke uppers that cater to individual needs by cradling the foot for unparalleled comfort.

An almost-autonomous robot-led production facility called Speedfactory was unveiled the same year. First off the line was the Futurecraft M.F.G. (Made For Germany), a project that combined the ARAMIS technology used in AlphaBOUNCE with a unique support system created using strips of fused material. All 500 pieces were snapped up super-fast. The final chapter that year was Futurecraft Biofabric, a partnership with AMSilk. Woven from Biosteel fibre, the shoe is completely biodegradable.

But by far the most exciting innovation to burst from the secretive Futurecraft foundry is adidas' 4D printing technology. The brand's top engineers have created soles using something called 'Digital Light Synthesis' – a process that uses next-level science, oxygen and light to program a liquid polymer into a latticed structure. The finished product is reminiscent of the 3D-printed soles of earlier years, but uses a softer material for smoother, more finely tuned comfort and support. The technology has slowly crept into the brand's public offering, with releases such as the UtraBOOST-inspired model from early 2018 and the Daniel Arsham colab that followed. Even if we had giant crystal balls, there'd be no telling what adidas have in store for the coming years, but we'll certainly keep an eye on anything that flies the Futurecraft flag. • *Adam Jane*

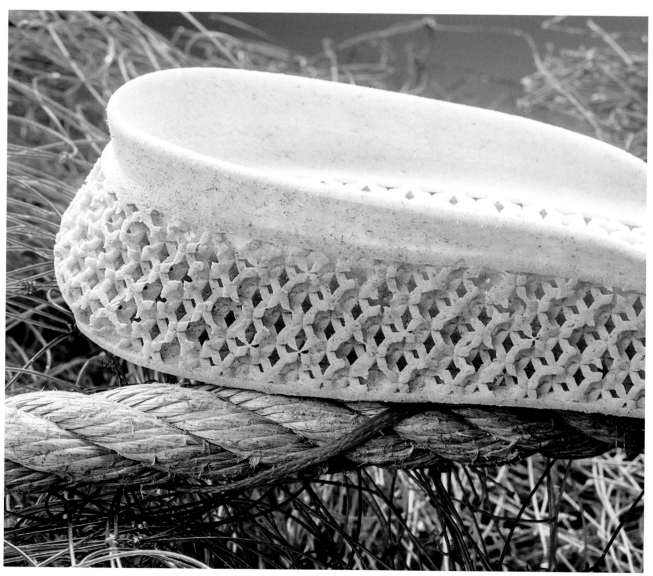

2015: Futurecraft 3D by Parley

2016 **HyperAdapt 1.0**

Nostalgic Gen-Xers and film boffins were able to keep their priceless Nike Mags on ice because self-lacing sneaks finally materialised in 2016. The HyperAdapt 1.0 was a byproduct of the work done at Nike by Tiffany Beers to get the Mag's complex electronics up to speed. Powered by a system called E.A.R.L – 'Electro Adaptive Reactive Lacing' – HyperAdapt was purpose-built from the ground up. Heel sensors automatically set the system in motion, allowing athletes to make micro-adjustments using buttons on the side of the shoe to tighten and loosen grip. The system also memorises the owner's perfect comfort level settings to deliver a simple, hands-free user experience.

Constructed using Nike FlyWeave and FlyWire, the upper also features dazzling LED lighting in the heel and undercarriage for eye-popping futurismo. The battery reportedly survives two weeks of regular use and only requires three hours for a full recharge using a magnetic puck. The glowing blue 'MT2' widget tucked under the midsole is a nod to the collaborative partnership between Nike CEO Mark Parker, Tinker Hatfield and Tiffany Beers.

As the 1.0 suffix suggests, this is only the beginning of Nike's exploration into adaptive cinching systems. HyperAdapt was described in Silicon Valley-speak as a 'platform' by Beers, while Tinker Hatfield has hinted at an imminent 2.0 upgrade, saying, 'Wouldn't it be great if a shoe could sense when you needed to have it tighter or looser? Could it take you even tighter than you'd normally go if it senses you really need extra snugness in a quick manoeuvre?'

Gimmick or gobsmacking genius, Nike pitched HyperAdapt as a shoe for athletic endeavours, but time will tell whether the technology becomes standard issue. In the meantime, enjoy this glimpse into 2025. Yes indeedy, where we're going, we don't need laces! • *Woody*

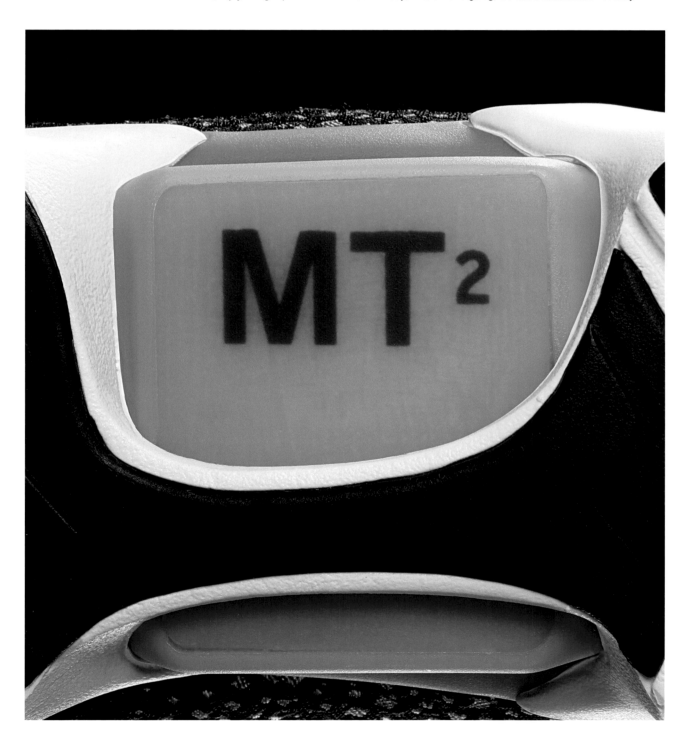

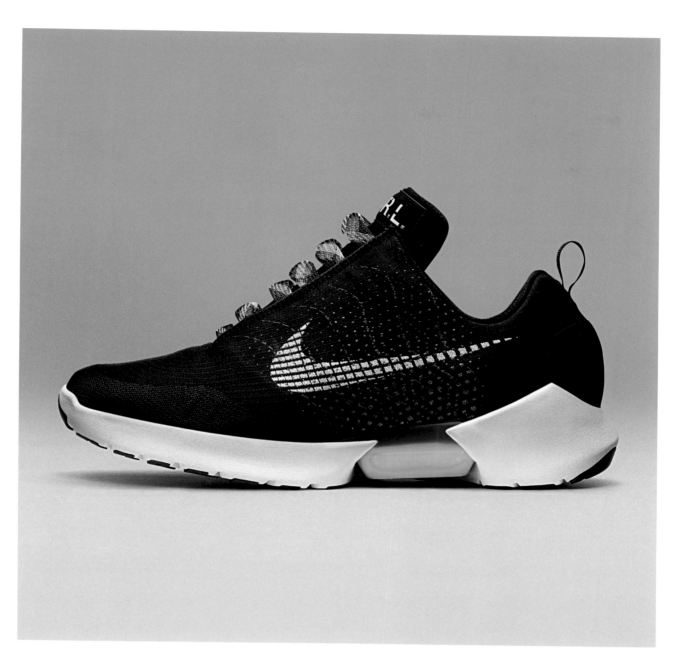

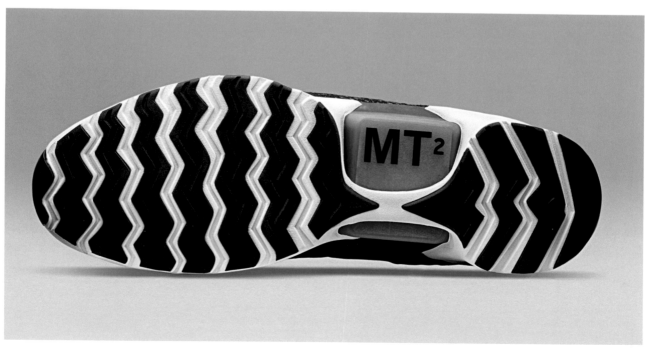

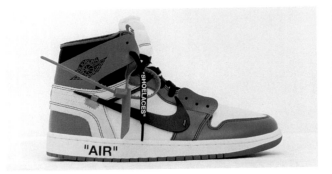

2017: Virgil Abloh x Air Jordan 1 (The Ten)

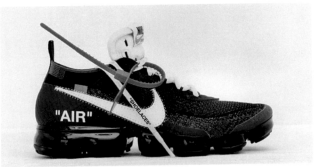

2017: Virgil Abloh x Air VaporMax (The Ten)

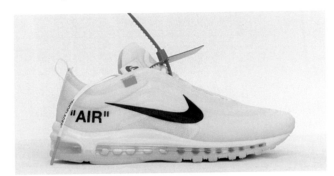

2017: Virgil Abloh x Air Max 97 (The Ten)

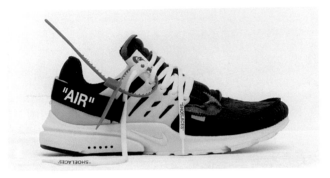

2017: Virgil Abloh x Air Presto (The Ten)

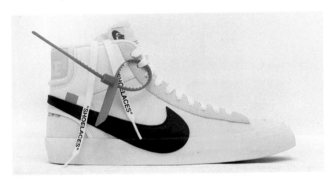

2017: Virgil Abloh x Blazer (The Ten)

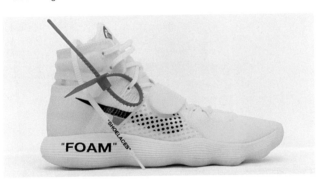

2017: Virgil Abloh x React Hyperdunk 2017 (The Ten)

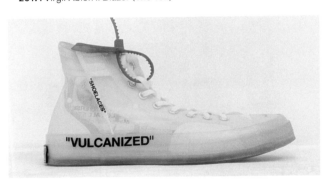

2017: Virgil Abloh x Converse Chuck Taylor (The Ten)

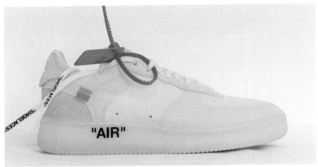

2017: Virgil Abloh x Air Force 1 (The Ten)

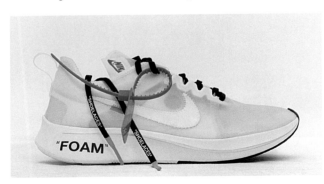

2017: Virgil Abloh x Zoom Vaporfly 2017 (The Ten)

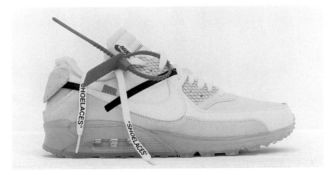

2017: Virgil Abloh x Air Max 90 (The Ten)

2017 Virgil Abloh x Nike

Virgil Abloh's 'The Ten' collaboration with Nike is undoubtedly modern sneaker culture's *pièce de résistance*. The chaotic hype and subterfuge was intense. Leaks, misinformation, botched release plans and a bloated timeline all added up to a mutant beast of a project that consumed everything in its path. If you were a sneakerhead in 2017, 'The Ten' is the one that will define your obsession.

A grainy shot of an Air Force 1 leaked in November 2016. Soon after, images of an Air Jordan 1, Blazer, Air Max 1 and VaporMax added to the confusion. Were they all real or was Nike sticking with the cream of the crop? Did naked stitching and factory-style labelling denote a sample or was this the final product? Speculation was fuelled by Abloh's rapid ascent to superstar status. He featured in documentaries, gave lectures, opened for rap shows, was nominated for a CFDA fashion award, and was pegged as Givenchy's potential new creative director. Not even a jibe about unoriginality from Raf Simons dented his stature.

It took until August 2017 for Nike to confirm that 10 sneakers would indeed be released. Five 'Ghosting' models and five 'Revealing' models with broader palettes were in the works. Nike's Presto, Hyperdunk, VaporFly, Chuck Taylor and Air Max 97 were drafted to join Virgil's squad. In reality, the ambitious release schedule misfired. Nike's SNKRS app had to postpone 'The Draw' and the Chuck Taylor became jammed in the chamber indefinitely.

Scarcity heightened collectors' senses, and when all but the Chuck eventually hit the streets, the craziness was overwhelming. 'The Ten' was like nothing else and far more original than Raf could ever have dreamed. Virgil accompanied the release with a string of 'Nike Off Campus' lectures that inspired wannabe designers to pick up X-ACTO knives and get creative with their kicks. A barrage of one-off homages by sneaker customisers like BespokeIND and Shoe Surgeon revealed another dimension to Virgil's burgeoning influence.

In Beaverton, cogs began to turn when we learned that lightning would strike thrice. The cycle began again, buoyed this time by a persistent mumbling that Virgil was heading to Louis Vuitton. Unlike the Givenchy hoopla, these rumours held weight, and in March 2018 Virgil was announced as the first African-American artistic director of LMVH menswear.

'The Ten' couldn't have come at a better time for Nike. Just when they were skirting irrelevance, Virgil's design savvy and guerrilla marketing shoved the brand back in front of a younger demographic. While it's not yet clear whether doubling down on the collection will dilute demand and diminish the original shoes' legacy, 'The Ten' is still the yardstick by which all future collaborations will be measured. • *Rob Marfell*

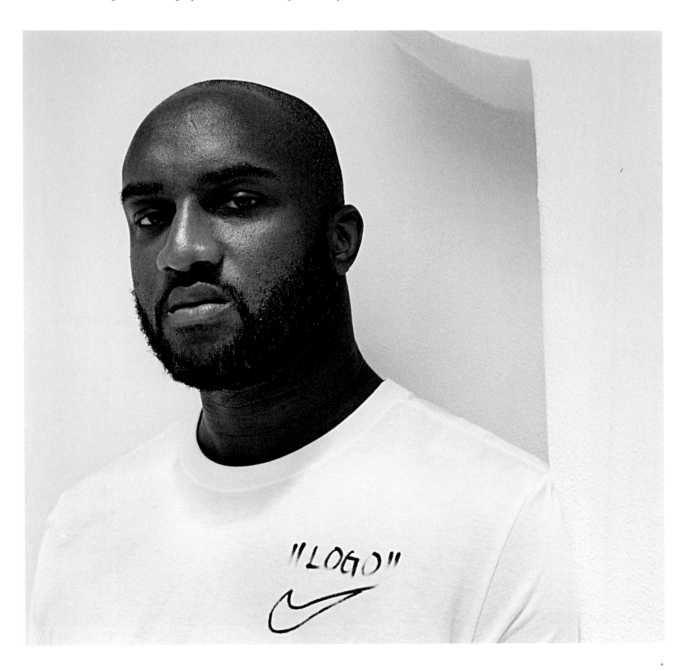

<small>2018</small> Nike vs adidas

After Kanye abandoned the good ship Swoosh, Nike's aura began to lose its shine. The ubiquitous application of juicy BOOST cushioning to the adidas lineup in 2013 was the single biggest factor, but there's no doubt the Three Stripes' crafty influencer-driven brand strategy synced perfectly with the dreams of the new-gen millennial sneakerhead. Building momentum across the entire portfolio was the key to adidas' ascension. NMD, Y-3, Raf Simons, Spezial, James Harden, Pusha T, Pharrell, Parley for the Oceans, Futurecraft and even old chestnuts like the Stan Smith and Superstar formed a formidable highlights reel. Team Trefoil was suddenly hotter than a Carolina Reaper.

Over in Beaverton in 2015, Nike looked tired and deflated. The basketball category was flatlining and a reliance on regurgitated retro releases did not enthrall youngins craving crazy newness. The Ultra range of cheap-ass classics was a shameful episode in Nike history and their rep for innovation was suddenly burned toast. The generational change in perception was highly visible across *Sneaker Freaker*'s social channels. Some of the comments made no sense at all but there they were: kids were commenting that Nike ripped the Presto from the UltraBOOST and that Stan Smith personally invented tennis kicks. It was a startling turnaround and a huge victory for the Trefoil. The once-mighty sneaker Goliath was on its knees and begging for mercy.

In September 2017, the unthinkable happened. Perennial bronze medallists adidas jumped over the Jumpman to assume the number two footwear brand position in North America. The stats did not deceive. Nike's stock price dipped to $50. Meanwhile, adidas was storming the charts, rising from €54 in 2014 to over €200 in early 2018, a remarkable burst that would have delighted investors.

Towards the end of 2017, the first cracks in adidas hegemony appeared. Nike pounced on the NBA sponsorship deal and revamped their basketball roster. The first glimpses of Virgil Abloh's project started bubbling away and the cutting-edge Air VaporMax tech brought Visible Air back to prominence. With co-signs from Travis Scott and ACRONYM's Errolson Hugh, even the Air Force 1 started to look fresh again.

As 2018 rolled around, to be frank, adidas was flat-lining. The hits factory had dried up, leaving half-baked concepts like Deerupt and Prophere to shoulder a heavy burden. It was a thrilling ride while it lasted but the golden run was over. Coincidentally, Nike were suddenly back in the game – bigger, bolder and swaggier than ever – as they rolled out an armada of new concepts and refried hits.

The Air Max 270's big bubble butt snatched teenager attention away from NMD and BOOST, while nostalgists lapped up the atmos Air Max 'Animal 2.0' pack. Even Jordan Brand had their moment in the spotlight when Justin Timberlake laced up Jordan IIIs for the Super Bowl halftime show. Meanwhile, over in the Nike Running department, the new Epic React was building steam. With a compelling cushioning story and a fresh colour palette, the self-proclaimed 'BOOST-beater' promptly sold out all over the globe. It was exactly the kind of mainstream homerun Nike needed to claw back market share. The sleeper hit was Sean Wotherspoon's Air Max 1/97 hybrid. Picked for production via a peer-driven popularity contest in 2017, the corduroy-clad collaboration ruled Instagram feeds with an iron fist. Unlike the standard Nike starvation distribution policy, the Wotherspoon was greeted with raffles and campouts everywhere from Foot Locker to the coolest boutiques. Wotherspoon's vision was vindicated and Nike was back in the game.

And so the sneaker wars go on. Ground won today is easily lost tomorrow. Nike may have wrested back control from adidas, but for how long? Attention spans are shorter than ever and the cycle of life for any new design has gone from a few years to a few measly months. As history has shown, nothing lasts forever in the sneaker game. • *Rob Marfell*

Photo: Solebox PR

2018: Sean Wotherspoon x Air Max 1/97

Illustration: James Rogers

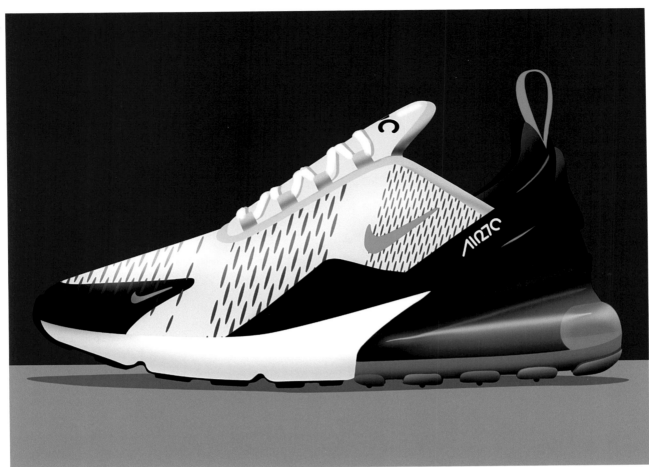

2018: Air Max 270

2018: Nike Epic React

2018: PUMA Thunder Spectra

2014: New Balance 990v3

2018: Nike M2K Tekno

FEATURE REFERENCE
Yeezy Wave Runner
Page 90

2018 **The Dad Shoe**

The 90s renaissance left no mood stone unturned. FILA, Polo, Tommy and Ralph – it's as if the old firm never left!

In 2017, a revival of the decade's penchant for chunked-out footwear flipped the game on its balding head. With its generous girth and dorky sole, the 'dad shoe' snuck into mainstream fashion through the side door. Its most extreme mutation, Balenciaga's absurd Triple S, fast became one of the world's most desirable sneakers. The New Balance 990 added 'dope' to its vocab and Nike's Air Monarch, which had been quietly mowing lawns and minding its own business for almost 20 years, began carpooling with Raf Simons' Ozweego. When Kanye – the indisputable master of hype – started serving up dad-bod sneaks, we were all forced to 180 on our once unflappable understanding of cool. It's been a confusing ride and our feet look all the funnier for it, but it's simply fashion's way of saying, who's your daddy? • *Olivia Finlayson*

2017: Balenciaga Triple S

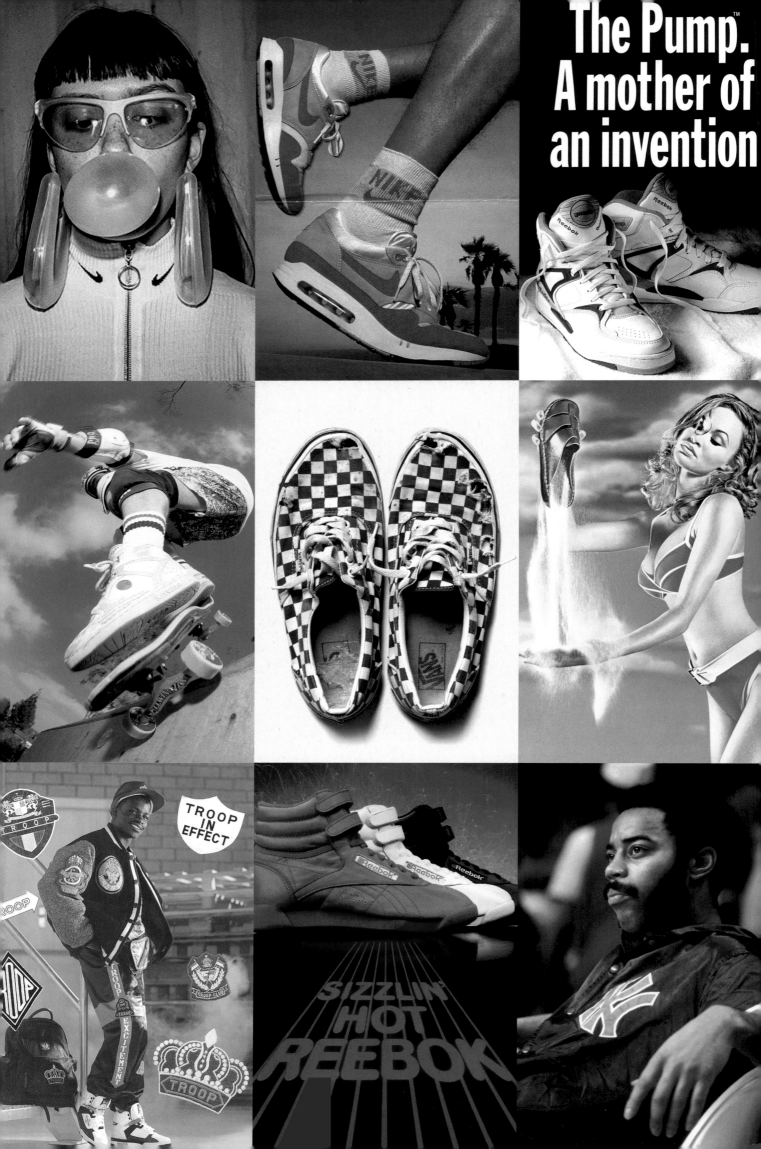

The Pump.™
A mother of
an invention

Sneaker History

The sneaker biz has come a long way since Chuck Taylor convinced Converse to rename their Non-Skid basketball shoe in 1934. As technology and manufacturing techniques progressed, the evolutionary process rapidly escalated in the early 1980s. Nike's Air Force 1 and Reebok's Freestyle arrived in 1982, followed in 1985 by the first Air Jordan. In 1987, Tinker Hatfield introduced the world to the Air Trainer 1 and the revolutionary Air Max franchise. Just two years after that, Reebok perfected their bladder-busting Pump basketball concept and Nike inducted ACG as a category in its own right. This incredible golden era also produced high-octane brands like Troop, Vision Street Wear and Airwalk. Grab the keys, it's time to unlock the *Sneaker Freaker* vault as we trace the transformative history of the footwear industry.

20

YEEZY

EDITOR'S NOTE: WOODY

In 1983, a promising college athlete by the name of Michael Jordan – a lifelong adidas fan BTW – was wooed by the tenacious upstarts at Nike. Though he was desperate to don the Three Stripes in the NBA, MJ was ultimately seduced by the barrels of cash, fame and power promised in his Nike contract. Exactly 30 years later, history would be repeated, though this time the high stakes didn't involve an athlete's signature, it was rap royalty's loyalty on the line. When Kanye West ditched his deal with the Swoosh for a lucrative slice of adidas pie, the impact would be far more profound than anyone could have imagined. Here's how the Yeezy went down.

The Sneaker Freaker Guide to Yeezy

The sneakersphere interweb crashed like Skylab when a 'leaked' image surfaced back in November 2014. Taken by a cheeky airborne paparazzo in economy class, the abstract suede moonboot did in fact turn out to be the Yeezy 750, the first ballistic shot fired in the collaboration between Kanye West and adidas. Rewind. A year previously, Ye's stunning defection from Nike looked like an odd move to outsiders, but the timing would prove to be impeccable. The unprecedented deal gave Kanye the absolute creative freedom he craved, but it also laid the foundations for a stunning recalibration of the Nike vs adidas dynamic.

Photo: Craig Barritt/Getty Images

The old me, without a daughter, might have taken the Nike deal because I just love Nike so much. But the new me, with a daughter, takes the adidas deal because I have royalties. I have to provide for my family.

Kanye West

The Yeezy Effect

COLLEGE DROPOUT

Words: Rob Marfell

Back in 2004, Kanye West was fizzing with mercurial confidence. 'My thing is, how can I possibly be overly confident? Look at my accomplishments!' Along with offering near-irrefutable proof that time is a flat circle (at least in terms of Kanye-isms), the quote – from a 2004 interview – harks back to the beginning of Ye's footwear career. Overwhelmed with self-love on the grandeur of *College Dropout*, Kanye was sketching designs for a new sneaker while proclaiming that he'd be bigger than Michael Jackson. It would take a decade, but that idle banter manifested into the framework for modern sneaker hype and informed a corporate distrust that drove Kanye to land one of the most significant sneaker deals of all time.

We're somewhere in 2013–2014 and Kanye is at his volatile best. His relationship with long-term beau Nike is fractured. While touring and promoting *Yeezus*, he fires numerous shots across Nike's bow and talks shit about Mark Parker for talking shit about Yeezys. Rumour has it Nike try to pacify the *enfant terrible* by offering him two collections comprising 30 shoes per year, but Kanye feels he is being shafted. Frustrated, he goes to Sway Calloway (from the radio programme *The Wake Up Show*) but he certainly doesn't have the answers.

Finally, in his umpteenth boiling rant for the season, Kanye reveals to the world that he's bailing on Beaverton. He's sitting with Hot 97's Angie Martinez on his right and newlywed Kim Kardashian on his left, and he is talking straight from the heart. 'The old me, without a daughter, might have taken the Nike deal because I just love Nike

so much. But the new me, with a daughter, takes the adidas deal because I have royalties. I have to provide for my family.' It's official. Kanye West is not only leaving Nike, he is taking up residence at adidas.

Curiously, a year passes after Kanye declares his new allegiance. What is he working on? What will it look like? Is it a recycled Y-3 Qasa prototype? Or maybe a Rick Owens reject found in a skip behind Nic Galway's office marked 'too crazy for public consumption'? Perhaps adi-alumni Raf Simons might lend a hand and guide Kanye through the tribulations of theatrical shoe design in the 21st century. Or will it be a Jeremy Scott remix with the *College Dropout* mascot perched on the tongues instead of hairy pink poodles?

Photo: Michel Dufour/WireImage/Getty Images

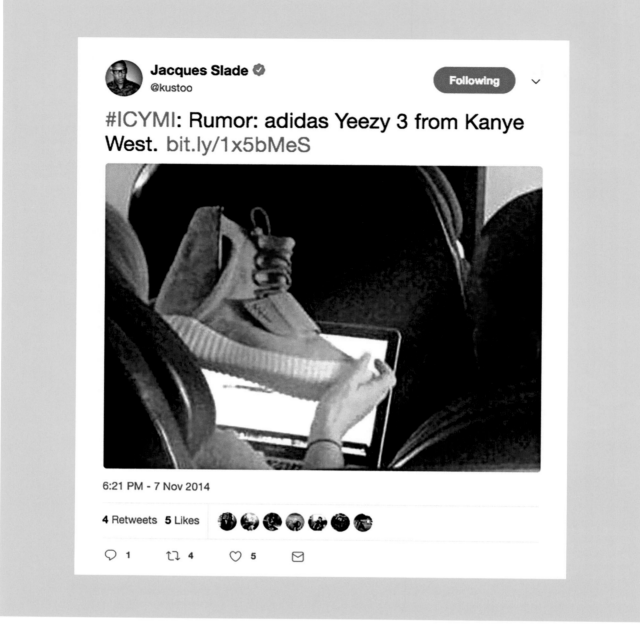

Jacques Slade ✓
@kustoo

Following ∨

#ICYMI: Rumor: adidas Yeezy 3 from Kanye West. bit.ly/1x5bMeS

6:21 PM - 7 Nov 2014

4 Retweets 5 Likes

♡ 1 ↻ 4 ♡ 5 ✉

2014: The 'leaked' paparazzi image that announced the Yeezy 750

When the first images of Kanye's grey suede moonboot leak a month later, confusion reigns. It's a different look, kinda cool, but kinda awkward. For starters, it's barely a sneaker; it's a boot with no obvious adidas affiliation and a rotund ridged sole unit that defies belief. This is not what anyone was expecting. *Quelle horreur!*

The Yeezy BOOST 750 sold out in less than a second.

Since that day, the creative partnership has flourished and produced enough fruit to put resellers' kids through college. The drama and colossal hype behind Yeezy has also provided some of sneaker culture's most thrilling moments and enough wayward trends to keep hypebeasts happy for three lifetimes. But to understand why Kanye's presence in the shoe game is a blessing, we have to go back to day one and dial the story in.

Day One
Wading through Kanye's sneaker database, it's more muddy waters than crystal-clear shallows. Timelines overlap and speculation is rife. Grommets will tell you that Kanye's first sneaker was his Nike Yeezy. Seasoned enthusiasts will tell you it was his 'College Dropout' Bapesta or maybe even the rare Air 180 samples. To an extent, the latter two are both right. The 180 predated the Bapesta by

a year, but was never released to the public. This makes the Bapesta Kanye's first official release, even though it took until 2009 for the last of them to appear on shelves at Chicago's RSVP Gallery.

If you ask his barber though, he'll tell you a different story. According to Ibn Jasper, Kanye designed a mashup for Reebok back in 2003 based on a Louis Vuitton tennis shoe and the Air Max 90. The shoe was 'allegedly' released without consent, and after a legal stoush the whole thing was dropped like a hot potato. As if that's not bizarre enough, when adidas acquired Reebok in 2011, the design was repurposed and christened the ZX 800DB in honour of David Beckham. It's a crazy tale that makes little sense, but Jasper remains adamant.

There are other fabled incidents. A Rod Laver Vintage with a bear logo that emerged on Instagram in 2016 actually dates back to a 2006 meeting in which adidas were trying to cook up a collaboration deal. According to Gary Aspden, boss of adidas' Entertainment Division at the time, Kanye had expressed interest in working on a shoe, but what he really wanted was a design deal that incorporated his fledgling Pastelle label. For whatever reason, the deal tanked.

Later, in 2008, Reebok S. Carter samples with the same furry face surfaced and then promptly disappeared – that is until a few pairs mysteriously popped up on the shelves at Sportie LA.

ibnjasper • Following

Kanye combined elements this LV
tennis shoe and the Air Max 90 to
design his first sneaker for REEBOK
in the S. Carter era almost 10 years
ago... Adidas has brought the design
back in the ZX850... You can get
them @ Barney's !!!

ibnjasper In 2005-2006 that LV tennis shoe
was the best High End sneaker on the market,
and the Air Max 90 was @ it's peak with all
the different colorways it came in...
Combining High End elements with street
sensibility is something that Kanye has
become a MASTER of, and this was one of
the 1st examples of that from him in the realm
of product design...
#MomentsInDesignHistory

Load more comments

chrisrrod Perfection by Master Ye... 👌
@mark____ @joelxnunez

nickafigueroa For sale

ooze354 I had the all brown version of the lv
sneaker. Straight fire. Does anybody
remember the name of the shoe

thatuncutraw Ibn, are you saying Kanye

1,053 likes

MAY 20, 2014

Add a comment...

ibnjasper • Following

Sent: Tuesday, June 19, 2012 09:49 AM
To: kanye west
Cc: don c; virgil abloh
Subject: Yeezi x Adidas

Well, technically, you already have an Adidas shoe...

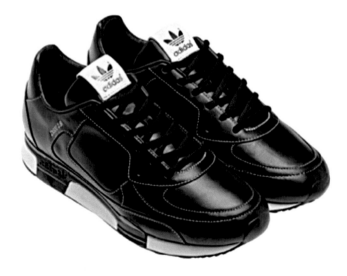

ibnjasper 2012

Load more comments

nthngonanthony Ooooh ok
@BANNEDESIGN

dalwayswins @ibnjasper aw ok
understandable cant wait to see the new shit

escobar312 These were not created by Ye
they were mad z800s

escobar312 By

patrickrollins @escobar312 they are a
recreation of the shoe he designed at reebok

gurvindersingh @chendo____

mr_hillxx @1ivan7 Ye been ahead

sucker4fashion @ibnjasper really taking us to
school today....#SonOfTheTeacher 😎🙌

thatuncutraw @mr_hillxx @mikeamazinn how
is that "ahead", exactly? I love Kanye and am

945 likes

MAY 20, 2014

Add a comment...

2012: Ibn Jasper laid out the whole Reebok x Vuitton x Air Max 90 x ZX 800 x Beckham debacle in a series of Instagram posts

Kanye designed the shoe for Reebok in 2003. JAY-Z connected Kanye and Reebok after the success of his S. Carter shoes... I was there. I have the files to the shoe design. It's the first shoe I ever worked on... Reebok released the shoe without Kanye's permission. I saw it in a mall in LA... I took a pic of it and sent it to Kanye's lawyer. Kanye sued Reebok for breach of contract... Reebok pulled the shoe and cut Kanye a check as a settlement... adidas bought Reebok a few years later and James Bond, with his great taste and vision, selected that shoe design from the archive not knowing who designed it, because it was designed for Reebok. James Bond [Undefeated co-founder], chose the design for the updated ZX 800DB for David Beckham and put it on a runner sole. When Kanye designed it, it was on a tennis shoe sole like the LV tennis shoe that inspired it, but the upper is EXACTLY the same... The original ZX 800 from 1986 up to Reebok's acquisition is a completely different shoe than the one Kanye designed... After adidas acquired Reebok the ZX_800/850 became the shoe that Kanye designed, but put on the adidas runner sole.

Ibn Jasper

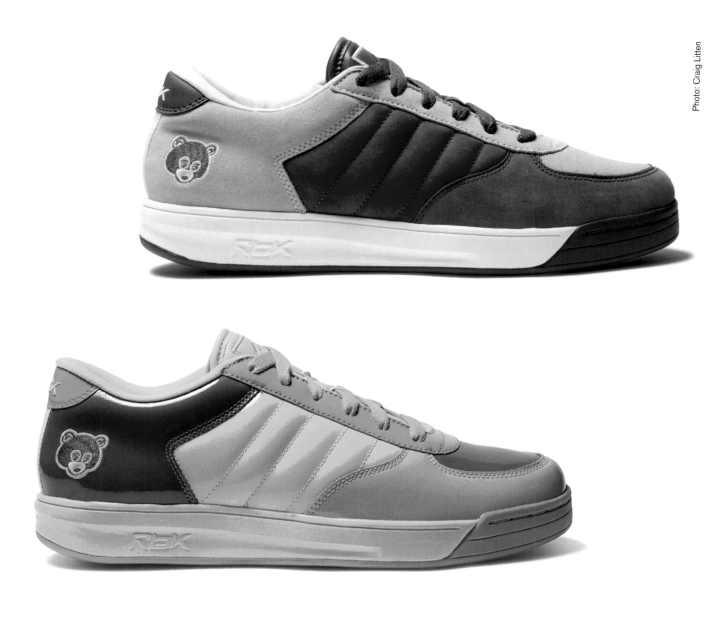

Photo: Craig Litten

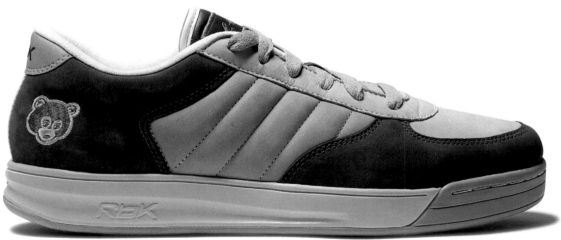

2008: Kanye x Reebok S.Carter Low 'College Dropout'

An odd detour in Kanye's sneaker career, the S. Carter 'College Dropout' is a relic of JAY-Z's forgettable Reebok collaboration series from 2003. JAY-Z was the first non-athlete with a signature sneaker deal and personally connected Kanye with Reebok. The four colourways are all period-specific to Ye's early colour palette. For whatever reason (good taste, presumably), all four shoes were cancelled, making these samples exceedingly rare. A few promo pairs, however, did make it out alive. According to urban legend, one lucky punter found them on the shelves at Sportie LA. Today, these anonymous Reeboks manage to look gaudy, bland and weird, so they're strictly for Kanye completists, though resale prices remain surprisingly high.

2007: Kanye x BAPE 'College Dropout'

This Bapesta was Kanye's first sneaker to hit retail. Repping the iconic bear logo and a colour scheme that paid dues to his album art, the design merged Kanye's formative styling with his newfound fixation on Japanese streetwear. The Bapesta returned to shelves when the Kanye-affiliated RSVP Gallery opened in 2009, but they've long since disappeared into collectors' treasure troves.

Photo: Stadium Goods. For more info, visit stadiumgoods.com

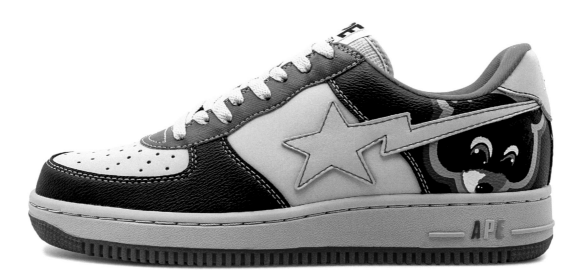

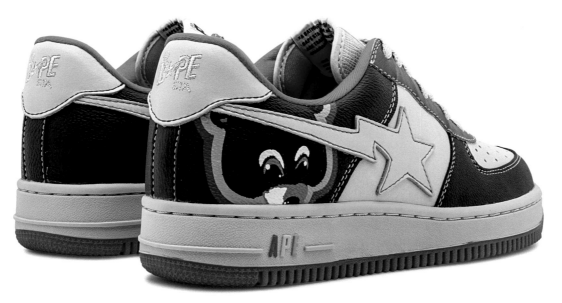

The Big Guns

Kanye's couldabeen sneakers from the era paint a picture of a free agent yearning to plant his footwear flag in terra firma. Wanting desperately to be taken seriously as a designer, the lack of faith he was feeling from brands left Ye disillusioned. Enter the big guns at Nike. Though blessed with more cachet than any other brand, Nike had never given a non-athlete a signature deal; however, they were looking to diversify their exposure and appeal to a new type of consumer. Kanye's name was top of the list.

With the first adidas deal scuppered, Kanye and Nike begin courting each other with public displays of mutual admiration. December 2006 sees Kanye, Nas, Rakim and KRS-One celebrating the Air Force 1's 25th anniversary in NYC. The legendary rappers take to the stage and perform 'Classic (Better Than I've Ever Been)', an Air Force 1 anthem released by Nike Records. The track is so rooted in the early-2000s that when you search for it in Google the suffix is '.mp3'. It's around this time that the Nike Air 180 sample appears stamped with the Dropout Bear's head. Kanye starts meeting Mark Smith, Nike's creative director of special projects, in secret. They sit for hours at a time, with Smith designing footwear to perform on stage and Kanye conceptualising sneakers 'made for a person walking on a space planet!'

By mid 2007, word gets around that Kanye has signed the Nike deal, but no official confirmation follows. In February 2008, Ye hits the Grammy's stage wearing what look like athletic biker boots with crimson piping and translucent outsoles. He quivers through a heartrending performance of 'Hey Momma', dedicated to his late mother, and receives a standing ovation. The audience is in tears but hypebeasts' eyes are smiling. Kanye's feet have not gone unnoticed – the first wave of Yeezy hysteria is about to unleash.

After the success of the Nike Yeezy and Yeezy II, Kanye was energised, but behind the scenes, frustrations with Nike were escalating. The project was moving too slowly and the deliberately restrictive distribution was not only stymying Kanye's creativity, it was an affront to his popularity. As he said at the time, 'Nike would make you believe it was my fault that you couldn't get them, but that was not the case… I'm going to create more than you think any musician in the history of time ever could have.'

Within Camp Kanye, the conclusion was obvious: Ye would always be an outsider at Nike.

•

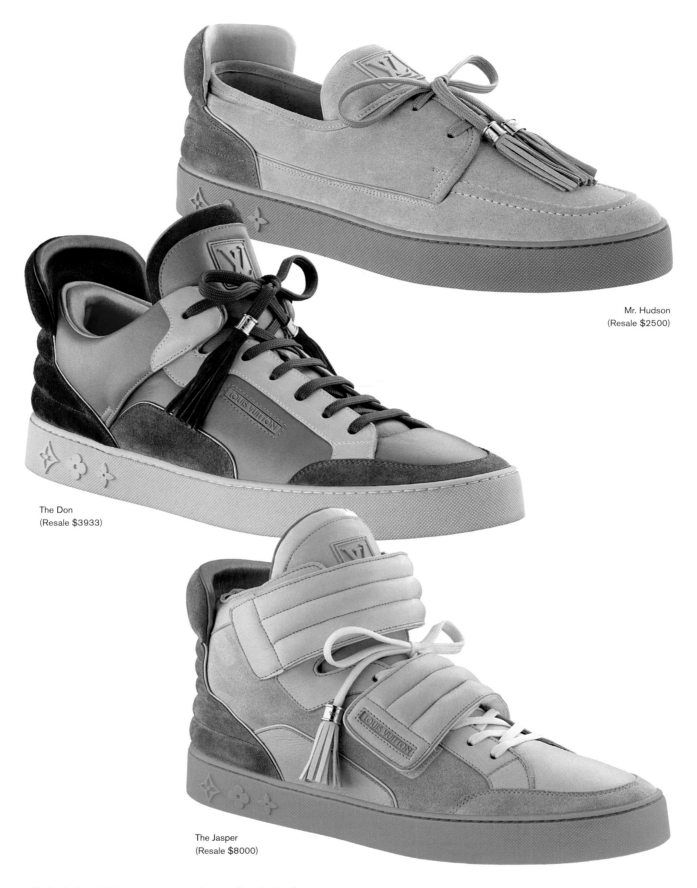

Mr. Hudson
(Resale $2500)

The Don
(Resale $3933)

The Jasper
(Resale $8000)

2009: Kanye x Louis Vuitton

The Louis Vuitton colab was peak Kanye. 'Who do you know with two thumbs in their own Louis shoe?' he asked rhetorically in an online video. (The answer was: 'This guy!') So enamoured with LVMH that he called himself the 'Louis Vuitton Don', Kanye likely regarded this project as his crowning achievement. Of the three models, one was named for his music partner Mr. Hudson, another for his longtime barber and creative consultant Ibn Jasper, and the third for Yeezus himself. The pink and grey combo was a strong look and though many sneakerheads baulked at the $1000 retail price, any resellers who ponied up on release day would today be very happy with their investment.

I couldn't do a collection without including the ladies. I used to shop for the perfect sneaker for my girlfriends. The luxe sneakers were usually too busy and the Keds and Vans weren't luxe enough. It may not seem like it sometimes, but I do it for the hood! I go hard! I begged them to make these!

Kanye West

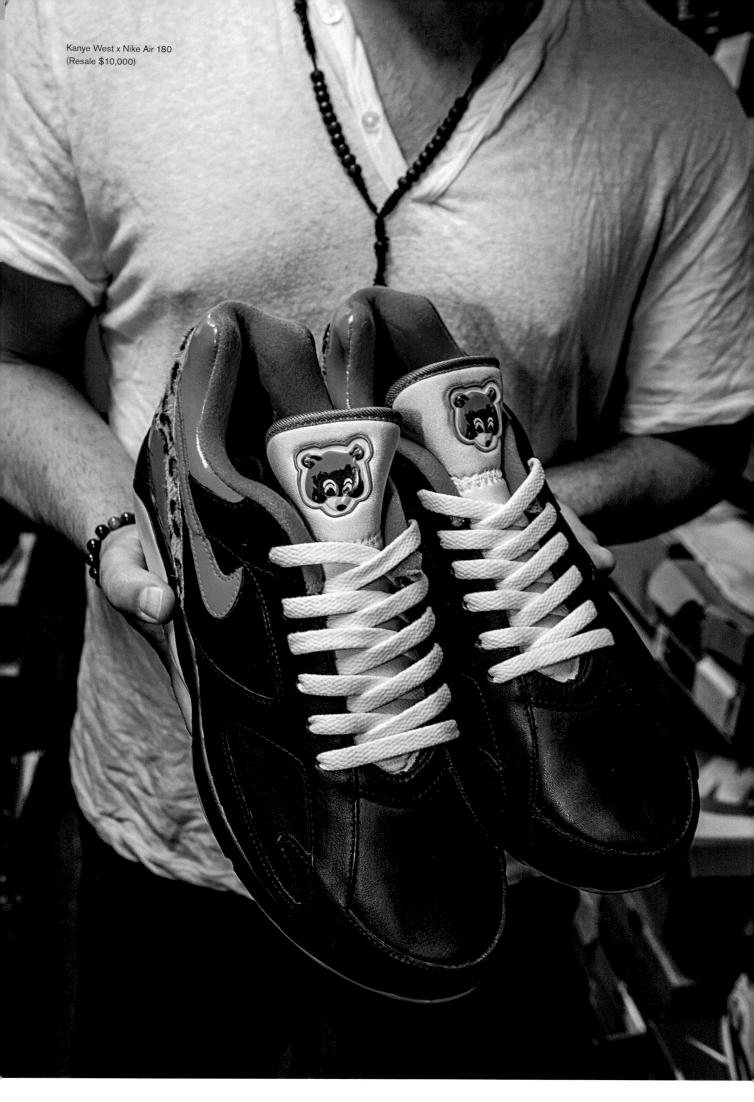

Kanye West x Nike Air 180
(Resale $10,000)

The Wonder Years

YEEZY COME, YEEZY GO!

Words: Anthony Costa **Photo:** Andre Ljustina by Virginia Wood

When Kanye's first strap-happy high-top debuted in 2009, the sneaker world was mesmerised by the sheer audaciousness of the package. Run-DMC aside, it's hard to think of another hip hop artist who has put their name to a sneaker with any real substance. Even the omnipotent JAY-Z's S. Carter range was little more than a sideshow at RBK. And yet here was Jigga's precocious understudy harnessing the full power of the Nike juggernaut to catapult his signature sneaker into a stratosphere usually reserved for the most exalted athletes.

Not only was Kanye gagging for the prestige afforded exclusively to his royal highness Michael Jordan, but in a further act of sacrilege, he even threw a Jordan III sole straight into the Yeezy's mondo-mélange. With its knee-scraping ankle padding, pillowy tongue and mammoth Velcro wrap, there was nothing subtle – or sporty – about the Yeezy steez. It was the ultimate symbol of cockily manicured excess, and the mania that met the shoe on its release date was matched only by an eBay price that quickly reached bubble-status five seconds later.

Glimpses of the Air Yeezy II arrived through a 'mysterious' paparazzi campaign that was curated as fastidiously as Ye's Lanvin sweat pants. Nike and Kanye are no rookies when it comes to courting media attention. Kanye is already one of the most photographed people on the planet and getting hitched to Kim Kardashian didn't do any harm to his profile. In contrast to the shock-and-awe spectacle of the Nike Mag promotion, the Yeezy II was a deliberately slow tease and the community was completely entranced by the tantalising way the story unfolded.

One of the nuttiest moments came when a rumour started that the shoe would release at House of Hoops in Beverly Hills.

Without even a solid release date, the campout started and kids piled on until the queue was around the corner and out of sight. When it was announced that the release date was at least five weeks away, rather than go home, most bunkered down to sit out the marathon. In comparison, Kanye's previous collaborations with BAPE and Reebok barely sparked a cinder of interest, though his Louis Vuitton joints did attain cult status.

Three years after the Air Yeezy launched, the inevitable sequel finally arrived. Despite the shoe being largely slammed by the all-knowing social media swarm, Yeezy fever was as contagious as ever. Kanye's ability to inspire both love and hate is an unparalleled phenomenon. The *Sneaker Freaker* Facebook page lit up with comments labelling the shoe 'fugly', 'total genius' and like 'a Zoom Tre entered puberty, acne kicked in, it grew a rubber mohawk and got even shitter.' Perhaps there was some serious foxing going on, for those hating hardest seemed destined to be first in line on release day.

The lineage between the Air Yeezy II and its predecessor is obvious. Instead of being welded to a Jordan sole, the Yeezy II is built on an Air Tech Challenge II base, providing just enough athletic DNA for the shoe to bridge the sports/fashion divide. The translucent soles

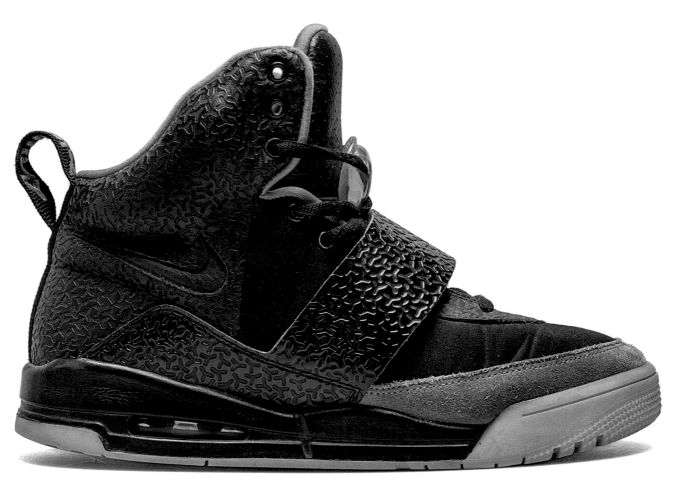

2009: Nike Air Yeezy 'Blink' (Resale $3525)

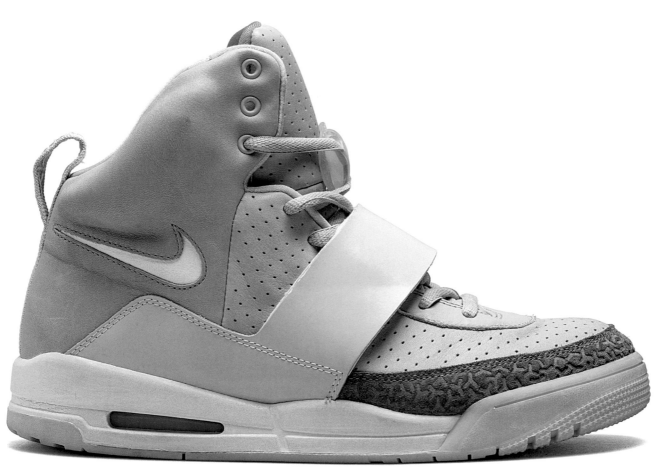

2009: Nike Air Yeezy 'Net' (Resale $2453)

2009: Air Yeezy

Kanye's rookie Nike design is regarded as the one that lit the fuse on his budding sneaker empire. Three complex colourways dropped in the space of three months, with collectors unsure which one was the standout. Underpinned with full-grain leather and patent straps, the chunky design featured glow-in-the-dark soles for boosted late-night pizzazz. Cushy 'collar pods' reached up the shins, drawing inspo from the double-strapped Ato Matsumoto sneakers Kanye donned in his 'Stronger' video. Hype for this Yeezy was certifiably nuts, but the best was just around the corner.

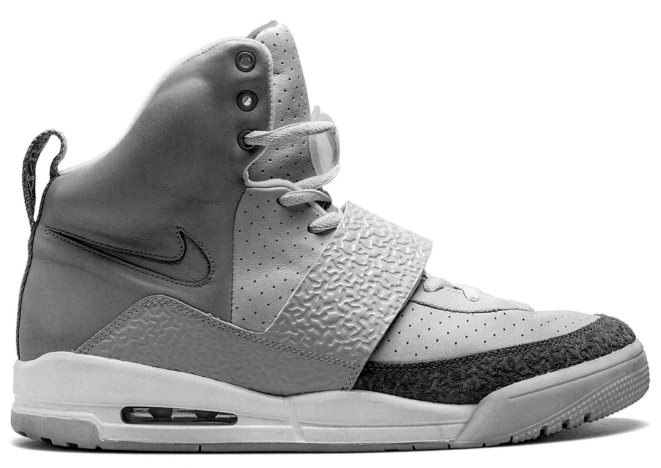

2009: Nike Air Yeezy 'Zen Grey' (Resale $2575)

2009: Air Yeezy launch @ Qubic, Auckland

2009: Air Yeezy launch @ size?, London

Photo: Tyree Dillihay

Above – 2009: The Air Yeezy II campout in Los Angeles started five weeks before release day

Right – 2009: The *Sneaker Freaker* Issue 15 cover featured custom screen-printed Yeezy soles that glowed in the dark. When Kanye blogged the image, our e-com system crashed and the inventory oversold by hundreds of copies. Dealing with all the customer complaints was awesome. Thanks Ye!

15 ISSUE

SNEAKER ★ FREAKER

MADE IN MELBOURNE

$10 (inc gst)

www.sneakerfreaker.com

NIKE AIR YEEZY x KANYE WEST

ISSN 1833-6884

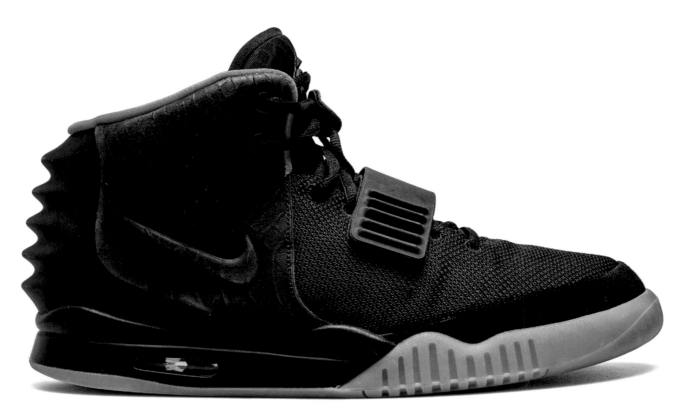

2012: Air Yeezy II 'Solar Red' (Resale $4223)

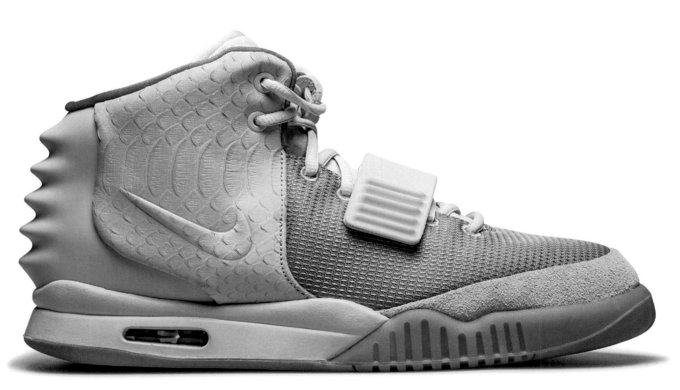

2012: Air Yeezy II 'Wolf Grey' (Resale $3356)

still glowed in the dark and the trademark strap was back, albeit without the same jumbo dimensions.

Perhaps casting himself as a mystic seer in the same vein as Sun Ra or Bambaataa, Kanye has – apparently on Molly Meldrum's advice – gone big on the Egyptology references, dotting the upper with hieroglyphics, pyramid-shaped ventilation holes and the falcon deity Horus peering out from the badge nestled on the tongue. The protector of the king, the Horus seal might be interpreted as an extension of the themes present in *Watch the Throne*.

The most striking visual features are the moulded rubber ridges protruding from the shoe's heel. Like a bony spine stretching through a taut membrane, the Yeezy II has an animalistic look, as though the shoe is a living, breathing creature. Just as the original Yeezy was inspired by the sky-high tongue and straps of Japanese brand ATO's Cow Hide Boot, the Yeezy II's heel clearly has parallels with the Batman-suit-look of Hussein Chalayan's Urban Mobility experiments for PUMA.

Cynics dismissed the Yeezy II as a fabricated concept with a tenuous relationship to anything other than a fashion cash-in. Indeed it's hard to separate the shoe from the egotistical antics of its enigmatic namesake. Whether you think Kanye West is the most iconic musical artist of today or a pampered pop poser likely

2012: Air Yeezy II

Looking at the three-year gap between the Air Yeezy I and Air Yeezy II, it's not surprising Kanye and Nike were experiencing 'creative differences'. Nevertheless, the final product is still lauded as Ye's finest. The Yeezy II was built on the Air Tech Challenge II midsole with a spinal heel that recalled Batman's armoured suit. Egyptian symbols added mysticism, but if these Yeezys were godly, they were wholly Old Testament. Like Kanye at the time, the model was markedly more aggressive than anyone anticipated. When it dropped in 2014, the infamous 'Red October' rounded out the trilogy and set a new benchmark for desirability. Mooted as a peace offering from Nike, the release was too little too late – Kanye had already moved on to bigger and better things.

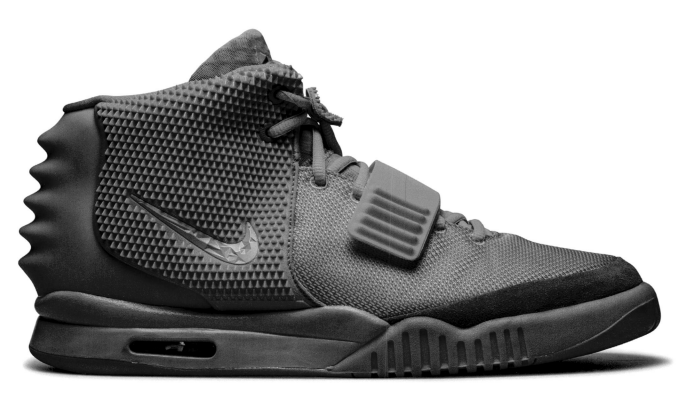

2013: Air Yeezy II 'Red October' (Resale $5578)

determined your feelings towards the Yeezy II, which is a shame. For all its intricate details and obvious influences, there's something about the design that elevates it far beyond facile hipster flamboyance. Sure, it's obviously contrived, but what hyped shoe isn't? Despite Nike's protestations, sneakers are street fashion and the Yeezy II is at the nexus of that connection.

The pandemonium that accompanied its release was utterly predictable but fascinating to watch. Like Kim Kardashian's ass, the Yeezy II was big, bold and breathtaking in both scale and desirability. It was a far cry from the conservative black canvas vulcanised shoes that dominated the scene in 2009, and for

that reason alone we should be thankful. Sadly, it also signified the end of Kanye's relationship with Nike. Perhaps it was always destined to end in acrimony, but who knows where things might have ended up if these two titans had chilled their egos.

As one door closed, another was about to open. Kanye was ready to step into an even brighter spotlight.

•

The Three Stripes

BANG ON THE MONEY

Words: Rob Marfell **Photos:** adidas

During the final months of the Nike deal, Kanye becomes chummy with Jon Wexler, VP of global entertainment and influencer marketing at adidas. In 2013, they meet with Herman Deininger (adidas CMO) and Dirk Schonberger (adidas creative director) during a *Jimmy Fallon* rehearsal. Far removed from his *College Dropout* days, the businessman who greets adidas this time is a honed machine. Armed with a recent Fendi internship and the world's most hyped sneaker in his quiver, Kanye is now inches away from realising his sneaker dreams.

Having spent time in Paris speaking with fashion houses in attempts to cast the kernel of his Yeezy brand into existence, all he got out of it was a provocative hit record. As he ranted to Zane Lowe at the time, 'I've been taking 1000 meetings, attempting to get backing to do clothing and different things like that. Getting no headway whatsoever. It was just that level of frustration. This is what frustration fucking sounds like!'

Team Trefoil took note and this time they met Kanye with open arms. As Wexler remembers it, the negotiations culminated in Kanye flicking him a text saying, 'The world changes now!'

In early 2015, the world found out how. The Yeezy BOOST 750 dropped in February and was met with mania reserved for the WWF in fly-over states. Kanye's struggles with Nike's elitism still irked and he didn't want to cultivate the impression that he was above his fans. When the first pairs entered the adidas store in New York, Kanye was carrying them. Taking it back to his days working the floor at the Gap, Ye got down on one knee to lace up customers like a hypebeast Jesus washing the feet of his disciples.

Proving they weren't all talk and no action, adidas released Yeezys in quick-fire succession. The Yeezy BOOST 350 dropped in June in a 'Turtle Dove' fabrication, followed by 'Pirate Black', 'Moon Rock' and 'Oxford Tan'. When chiming bells signalled the start of 2016, there were six adidas Yeezy BOOSTs doing numbers on the reseller boards and the 350 had taken out 2015's Sneaker of the Year award. Better yet, the ancillary Duckboots and apparel from Yeezy Season 1 and 2 built the Art Institute of Chicago's case for giving Kanye an honorary doctorate.

Still floating in a state of limerence, Kanye proved just how smitten he was when he dropped 'Facts', an elated, told-you-so missive aimed at Nike and delivered as an audible victory lap.

This is the official vacuum-sealed invite to the Yeezy launch at NYFW.
They were selling for up to $1000 on eBay after the event!

Kanye West x adidas Originals 'Yeezy Season 1' Runway

2015 – New York Fashion Week

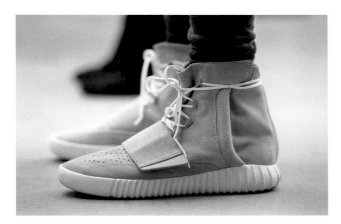

Yeezy BOOST 750

Puff Daddy and JAY-Z

Beyoncé and Kim Kardashian

Yeezy 950

Yeezy Season 1

Kardashians

Yeezy Season 1

Alexander Wang and Rihanna

I want to apologise to all the kids and parents that can't get the shoes currently because there's only 9000, and 'cause they're $350 and they're out of anyone's price range. I know you can run up on this kid and take his Yeezys but just be patient because we'll make more Yeezys. Everybody who wants to get Yeezys will get Yeezys. adidas has promised me that. When I was growing up, kids wanted Jordans, kids got killed for Jordans. Now that I'm in a position, I'mma make sure everyone gets Yeezys.

Kanye West

2015: Yeezy BOOST 750

After leaving Nike at the altar and signing with adidas, radio silence prevailed. Fans were gagging for something new to fiend over, but more than a year passed before Kanye's first Three Stripes design hit shelves. The public's reaction to the Yeezy BOOST 750 was genuine shock. The awkward grey suede moonboot indicated that Kanye's attentions had shifted from Harajuku streetwear to Le Corbusier lamps. The Yeezy Season 1 launch held during NYC Fashion Week brought all Ye's heavy-hitter buddies to the front row, though reviews from the prissy establishment fashion crowd were 'mixed' to say the least. Though the 750 was definitely a smash with fans, there was a sneaking suspicion that the whole thing was a triumph of celeb-infused hype over real substance. Black, grey/gum and brown/gum versions followed, but Kanye's focus quickly narrowed and the shin-hugging 750 faded from release calendars.

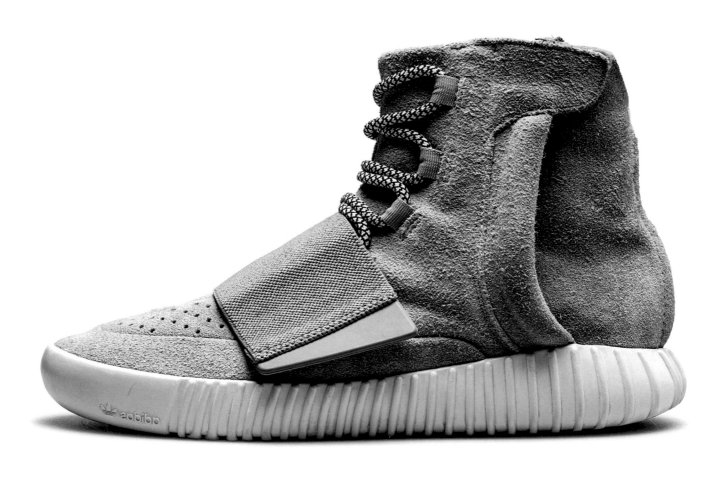

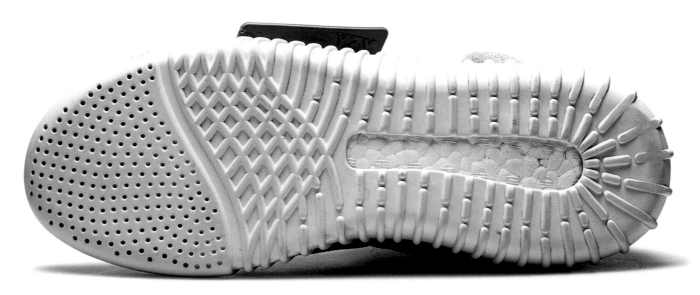

Resale $2494

2015: Kanye hands out the first Yeezy BOOST 750s at the London adidas store

'Nike out here bad, they can't give shit away' and 'If Nike ain't have Drizzy, man they wouldn't have nothing' was heard banging out of clubs and car windows for months. But the true melding of minds came in February 2016 when Kanye plugged in his aux at Madison Square Garden to debut Yeezy Season 3 simultaneously with his much-anticipated *The Life of Pablo* magnum opus. At one point, the crowd burst into a 'Fuck Nike!' chant, which Kanye quelled, adding 'people come to Madison Square Garden to see me play one-on-no-one!' It was an echo of the argument he offered Nike whenever they refused him the same privileges they offered their big-name athletes.

The nectar was sweet, but like Kanye said, he took the adidas deal to look after his family first and foremost. The most significant partnership ever created between an athletic brand and a non-athlete would produce a Yeezy-branded entity comprising footwear and apparel across street-style and sport. Kanye also told *Vogue* magazine he'd like to open the first Yeezy store near his home in California. The infrastructure Kanye rapped about in 'Facts' was no longer a metaphor, it was a promise to make his dreams a bricks-and-mortar reality.

The Yeezy line grew as quickly as Ye's family. Nearly 20 different sneakers hit stores over 2016 and 2017. The 350 spawned a V2

update and three different pairs alone dropped on 2016's Black Friday. Releases such as 'Beluga 2.0' and 'Blue Tint' hit the streets in significant quantities. There still weren't enough pairs for everyone – as Ye had famously told Ryan Seacrest there would be – but things were moving in the right direction. Yeezys for tots, teased by Nori West, the budding style icon, also hit the playground.

The most salient Yeezy update came with the Wave Runner 700, a pioneer of the 'dad shoe' phenomenon. Set beside Balenciaga's cartoonish Triple S, the 700 was refined and palatable. Copycat models soon surfed the wave all the way to the bank, enhancing Kanye's status as an innovator and design leader.

Perhaps more poignant from adidas' point of view was the Yeezy BOOST Cleat. In September 2016, the football boots gave Kanye his Jumpman parallel when they were thrown out of the NFL. Just like the NBA did to 'certain red and black Nike basketball shoes' worn by Michael Jordan, the ban was justified by team uniform violations. Ironically, the boots were worn by Houston's wide receiver DeAndre Hopkins in a victory over Kanye's home team, the Chicago Bears.

During this time, a huge shift in the footwear industry transpired. Nike and Jordan Brand sales were falling fast and the perception of brand superiority was slipping. The addition of BOOST cushioning

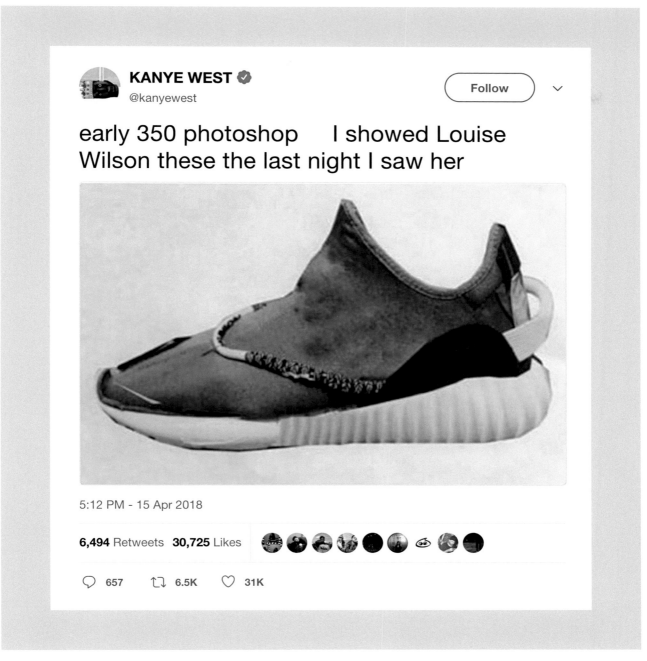

KANYE WEST ✓
@kanyewest

Follow ⌄

early 350 photoshop I showed Louise Wilson these the last night I saw her

5:12 PM - 15 Apr 2018

6,494 Retweets **30,725** Likes

💬 657 ⟲ 6.5K ♡ 31K

2018: Kanye tweeted this early mockup of the Yeezy BOOST 350

to the adidas line – and to the Yeezys – was suffocating the Swoosh. To those on the street, it was clear that Kanye was instrumental in the success. Some leading industry analysts saw things differently. One curmudgeon desk jockey emphatically denied Ye's influence by saying that Yeezys made up too few sales to move the adidas needle one way or the other. The views sparked headlines but were quickly shot down.

Points were tallied for Kanye hyping widely distributed models like the Tubular Shadow and Tubular Invader, along with his personal embrace of the Energy BOOST and UltraBOOST. Paparazzi shots of Ye wearing those two models alone were priceless to adidas. The arrangement's other benefits became apparent with a huge spike in adidas Instagram engagement and the rise of fan groups like Yeezy Mafia, who completely upended the way publishers reported sneaker releases. The viral Yeezy Season 6 marketing campaign that used a posse of social-network elites to put the Yeezy 500 in front of millions of faces was further proof of Kanye's clout.

In September 2017, Kanye's halo effect contributed to a major upset when adidas ousted Jordan to become the number two footwear brand in the United States. Speaking with *GQ*, Cowen Group analyst John Kernan affirms Yeezy's role. 'When you have

a product with scarcity, it puts people in a more premium mindset, which means they'll be more willing to pay full price for other categories.' To put it simply, Yeezy hype created a warm glow for the entire adidas lineup.

Plotting Kanye's journey from sketching sneakers in *College Dropout* interviews to corporate saviour for a German sports giant is a blockbuster tale. But this epic story doesn't end there. Since Kanye's early days of intensive media therapy, he has been reminding us all of his genius and comparing himself to da Vinci and Steve Jobs. But like Leonardo – who was sponsored by the Medici family – Kanye couldn't do it all by himself. He needed adidas to bankroll and mastermind the infrastructure. Now it's time to sit back and see whether Ye delivers the next *Mona Lisa* or whether he paints himself into a corner to enjoy his *Last Supper. Bon appétit!*

•

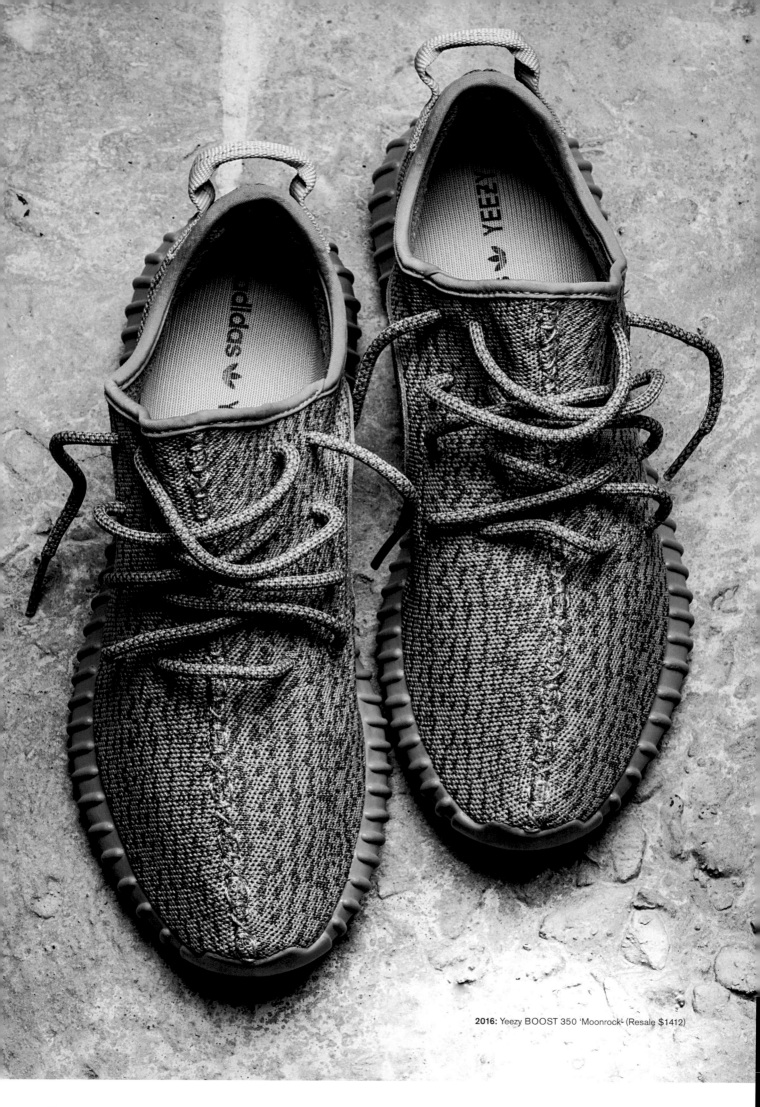

2016: Yeezy BOOST 350 'Moonrock' (Resale $1412)

2015: Yeezy BOOST 350

Some four months after Ye hand-delivered the 750 to early birds at adidas stores, the Yeezy BOOST 350 arrived in a mottled 'Turtle Dove' scheme. The low-top futuristic design immediately won over fans who hadn't vibed on the 750's towering proportions. The global buzz set the stage for what would become the Yeezy line as we know it. By the time 2016 was through, 'Pirate Black', 'Moonrock' and 'Oxford Tan' versions had fattened reseller pockets, won Kanye the unofficial Sneaker of the Year award and provided much-needed validation for his vision. Ye wasn't crazy – the world was crazy for not listening!

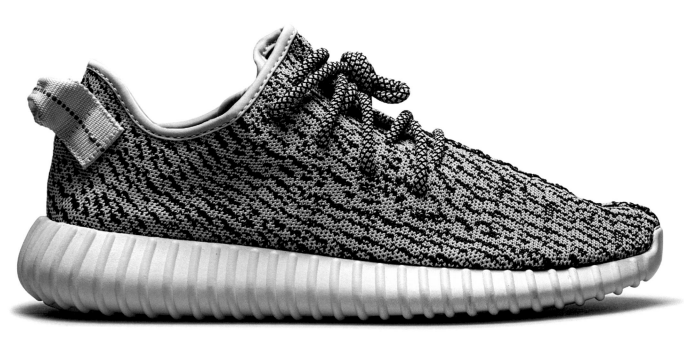

2015: Yeezy BOOST 350 'Turtle Dove' (Resale $2126)

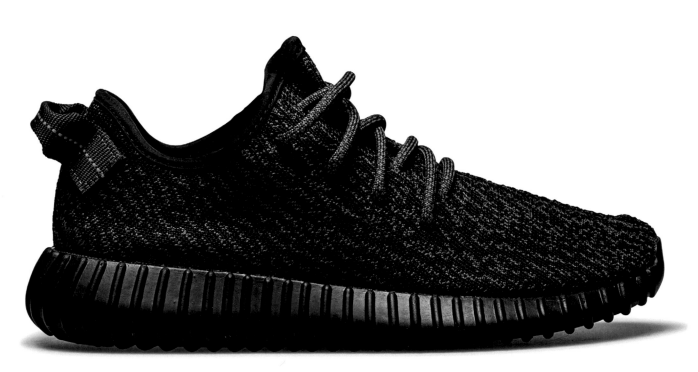

2015: Yeezy BOOST 350 'Pirate Black' (Resale $1328)

2016: Yeezy BOOST 350 V2

As he did with *The Life of Pablo*, Kanye decided that just because his product was already on shelves it didn't mean the evolutionary process was over. Unfazed by glittering awards and solid sales, he continued to tinker with the Yeezy BOOST 350 until he arrived on the V2, a remix that featured an elevated profile, burlier midsoles and a new knit pattern that allowed for more nuanced colour ideation. The inaugural 'Beluga 2.0' gave the Yeezy line its first self-referential colour scheme, and the onslaught of releases that followed balanced limited hype against increased distribution. We're not at a stage where everyone who wants Yeezys can have them, but if there's one model that can make that grandiose plan hatch, it's the 350 V2.

2017: Yeezy BOOST 350 V2 'Semi Frozen Yellow' (Resale $701)

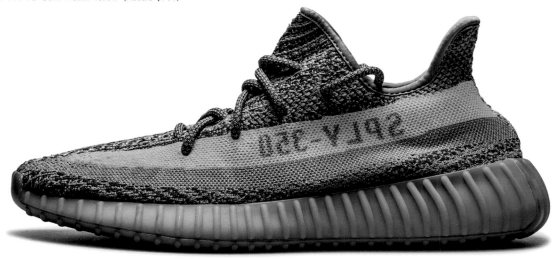

2016: Yeezy BOOST 350 V2 'Beluga' (Resale $929)

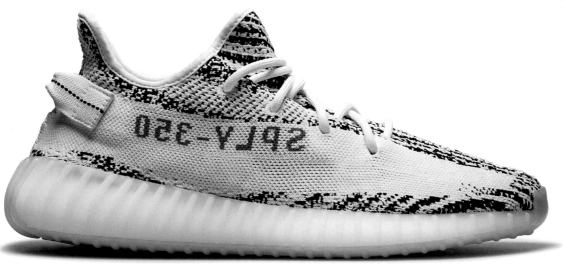

2017: Yeezy BOOST 350 V2 'Zebra' (Resale $608)

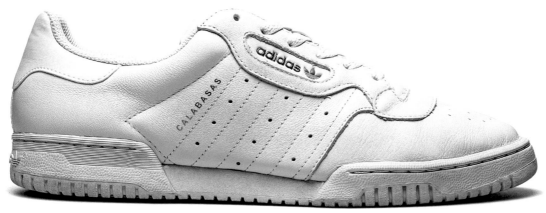

2017: Powerphase 'Calabasas White' (Resale $230)

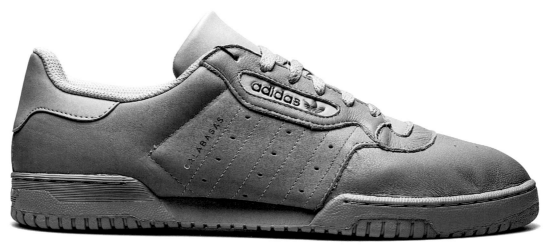

2018: Powerphase 'Grey' (Resale $159)

2018: Powerphase 'Core Black' (Resale $132)

2017: Yeezy Powerphase

When an all-white Yeezy Powerphase dropped in March 2017, the sneakerweb was quick to label it a copy of Reebok's Workout. In reality, it was a retro of adidas' own 1986 Powerphase gym shoe. Repping the most accessible RRP of any Yeezy didn't do the Phase any favours, and though it was worn by numerous influencers, the model never managed to gain traction. The Calabasas print on the sidewall is a nod to Kanye's family home in California.

2018: Yeezy Desert Rat 500

The voluptuous Yeezy 500 arrived with one of the most simple and effective marketing campaigns in recent history. Porn stars, celebs and digital influencers wearing Yeezy Season 6 apparel were shot paparazzi-style getting out of cars, exiting gas stations and strolling LA streets. The 500, which featured prominently in the viral snaps, was a sight to behold. Lashings of suede and mesh sat above bulbous midsoles rounding out a rotund silhouette only Ye's most devoted disciples could vibe on. Knowing this, Kanye made the 'Super Moon Yellow' version available only to those who also purchased an exclusive $760 apparel combo. Conversely, the 'Blush' 500 was available to anyone with a heartbeat and a credit card. According to Yeezy Mafia, more than 60,000 pairs were allotted to the States and Europe alone.

2018: Yeezy 500 'Blush' (Resale $523)

2017: Yeezy Wave Runner 700

2017: Yeezy Wave Runner 700 (Resale $516)

The Wave Runner crashed onto the rocks of sneaker culture when — without warning — it became available for pre-order on Yeezy Supply in mid 2017. Leaks had left many punters less than enamoured with the shoe's adventurous looks and many passed on the $300 investment. However, when pairs finally shipped months later, most regretted their petulance. The 90s-inspired design anticipated the bubbling 'dad shoe' frenzy, with everyone from fast-fashion Zara to high-end Balenciaga jumping on the chunk-wagon. In April 2018, Kanye felt compelled to fire up Twitter for the first time in a year to fire shots at the Swoosh for copying the Wave Runner, posting a picture of Nike's M2K Tekno captioned 'Yeezy 700 vibes' followed by a string of mocking emojis.

adidas NMD

Published in *Sneaker Freaker* Issue 36, July 2016

EDITOR'S NOTE: WOODY

All the think-tanks, trend forecasting and consumer feedback in the world can't guarantee a new sneaker will be successful. The timing of the launch has to be spot-on. It can't be too early in the fashion cycle, but arriving late to the party is even lamer. The shape has to be dynamic and unique, but not so crazy that it scares mainstream taste. The texture, colours and general vibe, not to mention the marketing campaign, have to come together in one graceful symphony. Sometimes brands just nail the magic formula. It doesn't happen all that often, but when a design like the adidas NMD comes along and rewrites the book, it's a beautiful thing to behold.

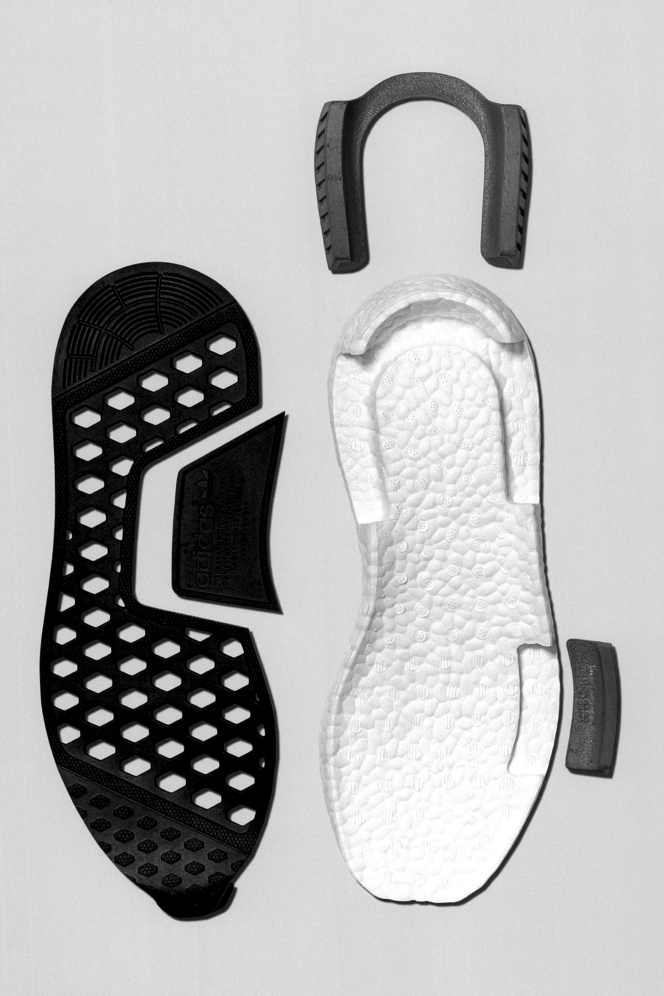

2015: NMD Runner PK 'OG'

ADIDAS NMD RETROSPECTIVE

Tapping millennial demand for thrilling on-feet newness, adidas' NMD unlocked a sneaker box full of magical secrets. It was a stunning design-driven coup that shocked the footwear game and smashed the standard retail playbook. Highly coveted by hardcore sneaker nerds and novices alike, each sold-out edition added a layer of hype to the legend, culminating in the 'Pitch Black' NMD that rocketed to $5000 value on the resale market. Less than two years later, the show was over and NMD was DOA.

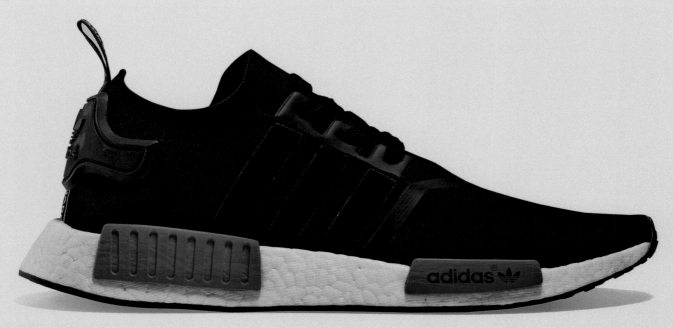

2015: NMD Runner PK 'OG'

Launched in New York City on December 9, 2015, NMD made a somewhat mysterious and low-key debut. No one at the event knew quite what to make of the oddball curiosity. The stretchy runner featured familiar adidas BOOST cushioning, but the real stars of the show were visible-from-the-moon midsole widgets, loosely inspired by adi-heritage swiped from the Boston Super, Rising Star and Micropacer. Loud and proud, the tag-team panels gave the shoe an appealing cartoonish energy. In hindsight, there's no doubt about it, the NMD absolutely nailed the delicate equilibrium of conservatism and quirkiness.

As Nic Galway, VP of Global Design, reveals in our interview, NMD was merely one component in an all-out company assault that hit a bullseye with young consumers. Instead of relying on retro chestnuts like Stan Smith, Superstar and Gazelle – all certifiable hits through this same period – the resurgence of adidas was based

on the adoption of modern aesthetics. After UltraBOOST, Tubular, Y-3 and the spectacle that is Yeezy, NMD was simply the right shoe at the right time. Sneaker palates were jaded by the surfeit of endless recycled designs. It was time for something new – and fast.

As NMD releases proliferated, supply could barely satisfy demand, resulting in prices for the OG edition creeping well into four figures on the secondary market. This was unparalleled territory for a general release, but what was most surprising about NMD's initial success was the absence of celebrity endorsement. The distribution strategy was also unique, with as many as 18 different colourways dropping on one day – an unprecedented move that seemed only to ramp up interest. Conversely, the number of collaborations was deliberately underplayed, with Nice Kicks, BAPE, Mastermind and Neighborhood among the tight group allowed to put their spin on the shoe.

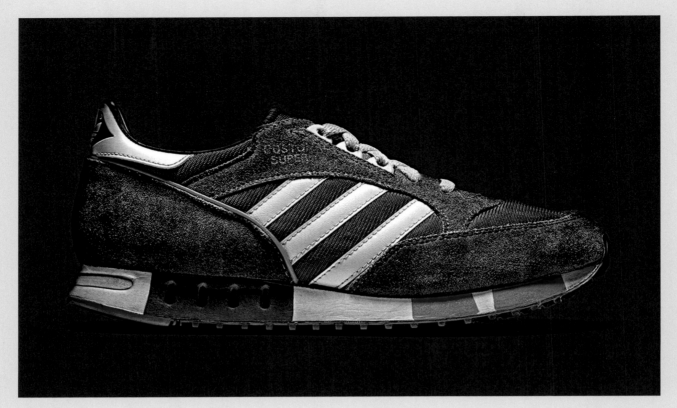

Boston Super

Rising Star

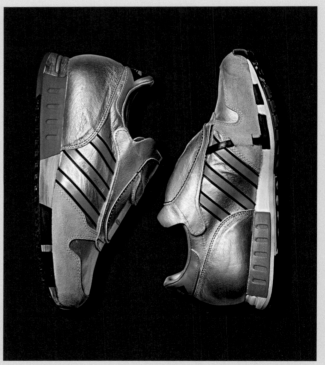

Micropacer

Within a year, spinoff models arrived in an attempt to build a franchise around the nameplate. Trail hikers, laceless uppers, mid-cuts, rubber cages, debranded options and the Hu NMD with Pharrell added designer depth to the roster.

While initial releases attracted global campouts and complex raffle scenarios ordinarily reserved for ultra-hyped Jordans and Nikes, NMD's run as the top banana lasted less than two years. Swamped by its own ubiquity and a distribution policy that suddenly teetered on saturation, retail demand crumbled and the franchise gracefully exited the scene. It was a stunning demise. It's impossible to know whether NMD could have stayed at the top with a longer-term strategy, but its place in sneaker history remains secure.

Back in mid-2015, at the height of the boom, we pondered whether we'd look back and acknowledge the birth of BOOST and NMD as equivalent to the introduction of the all-conquering Nike Air. With the benefit of rose-coloured Wayfarers, that was clearly wishful thinking. The unfortunate thing about hyperbole – and hubris – is that it has a habit of coming back to bite you on the ass. Regardless of our non-Nostradamus prognostications, enjoy the retrospective. NMD may be a charred memory these days, but not many sneakers have managed to fly this close to the sun.

•

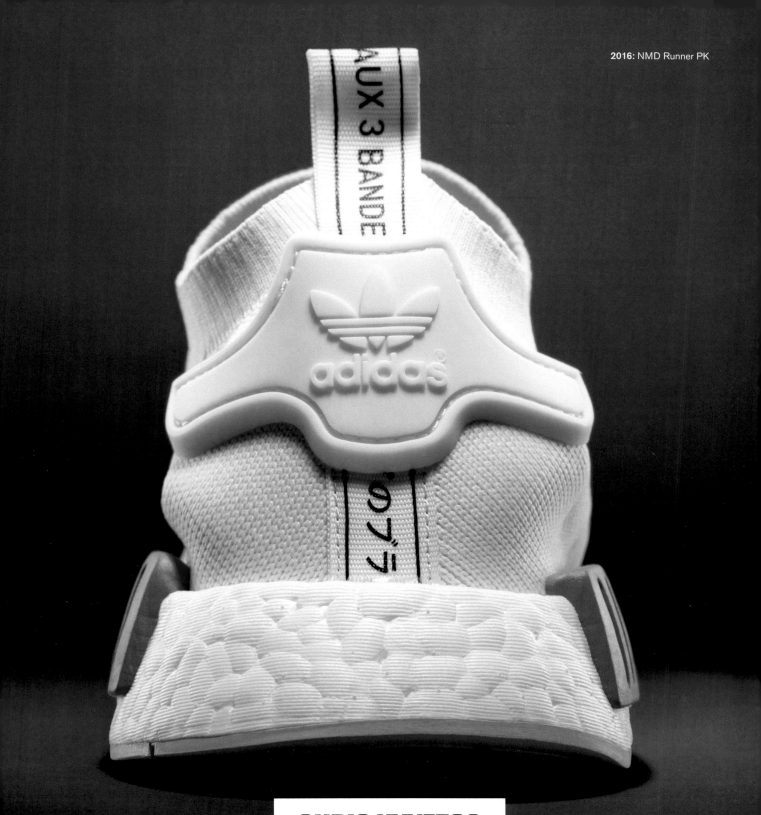

CHRIS KYVETOS

Sneakerboy, Melbourne

When I first saw the NMD, I remember thinking that this was the Air Max 1 for kids who were born in the late 90s. The design language, the knitted uppers, the adidas branding, plus the glow from Kanye – NMD was exactly what the next generation of sneakerheads was hungry for. If adidas had maintained the NMD legacy the way Nike did with Air, they'd own all these kids the way Nike owned my era. I don't buy into the argument that sneakers aren't lifestyle products and that they're purely for performance. When was the last time Don C walked out onto a court?

NIC GALWAY

VP Global Design

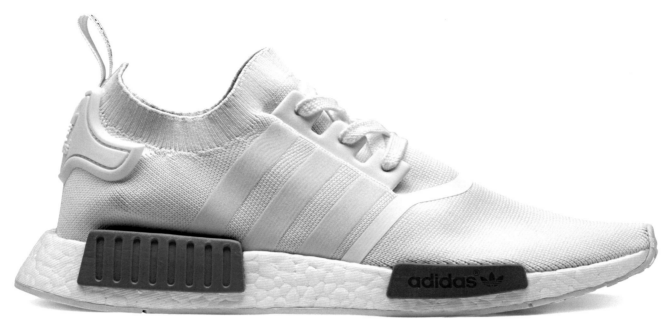

2016: NMD Runner PK

As VP of global design at adidas, Nic Galway and his team have defined and continually redefined the adidas Originals aesthetic. Under his brilliant direction, the renaissance steadily built momentum. From the minimalist purity of the Y-3 Qasa to the futurism of Tubular – not to mention bringing Kanye's footwear dreams to life – Galway was on a red-hot winning streak that flipped the industry on its head.

Looking back over the past 10 years, the NMD delivered the biggest *kaboom* of just about any new model. Would you agree?
It's been incredible. At adidas, it's all about how we can shake things up. NMD was when it all came together on a much bigger platform. It's something that we really believed in, but what was most rewarding was seeing how it was adopted into the culture. That's when a design truly comes to life.

When you say 'adopted into the culture', how do you quantify that?
We're not that interested in how many we sell – we're much more interested in how it's perceived. Who wears it? Who buys it? Why? To see this generation of kids who have really got behind it, it's interesting because it's something we can build upon. These kids are excited to see where we're going next.

Agreed. One of the amazing and peculiar things about this shoe is that it has really hit the 15–20-year-old age bracket. Why do you think that is?
I think there's a desire for something new. There aren't many brands that can do what we've done. I've always felt that we're one of the few companies who really challenge the way that things are done. When you do that, people notice.

That's what's great about NMD: we built it for a lifestyle rather than for a look. People wear it many different ways and not necessarily how we would have expected.

Do you think these kids responded to the shoe because they wanted something that belongs to them and not something that is reheated leftovers of someone else's youth?
Maybe. Our approach was this idea of past informing future. Taking familiar elements of the past not as a reissue, but rather recreating them in a new aesthetic. I think what's important with NMD is that we connect with people who then become curious about adidas as a brand.

I wanted to ask you about those little widgets on the side of the shoe. Have you got a name for them?
No, we don't have an official name for them. [Laughs] Blocks, plugs, widgets... they get many names. I like to look at a shoe, put it away, shut my eyes and then see what I remember. Those adidas runners from the 80s, it's all about those midsole blocks. It was kind of this naive way of building technology that at the time was cutting edge, but by today's standard is very basic. What I really love about them is their authenticity. We knew there was an opportunity to try tuning the shoes for stability as well as cushioning. That was the step we wanted to take from PureBOOST to NMD, and that's why they are there. And of course, they create this iconic look. You can see the shoe from 200 metres away and know that it's adidas. I've always been inspired by how many elements you can remove and still see the brand that they came from. But those blocks aren't just embellishment, they are there for a purpose.

Was there any pressure to remove those blocks by conservative elements at adidas?
Maybe a few years ago that discussion would have happened. But the success we've had – albeit small in volume, but big culturally – has given us immense confidence. We had great success with the Stan Smith and Superstar, but we wanted to connect our history and our legacy with a new generation. I don't think you do that by being conservative, you do it by making a statement. NMD was built completely without compromise. The unproven technology stretched some people, but it has definitely proven itself.

It's not the only success at adidas – there's Y-3, Tubular and Yeezy.
It's definitely a great time to be at adidas. There's a real level of confidence creatively, and it stretches way beyond product. The way we launched NMD, the way that we were thinking of it beyond being a sneaker and thinking instead of how it interacts with our lives – that is really important.

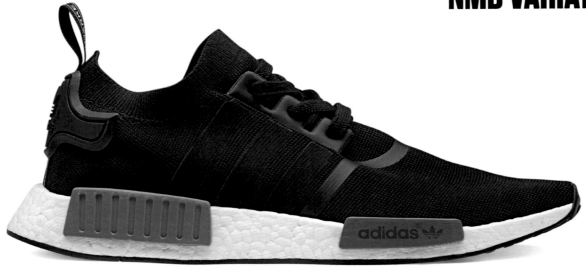

2015: NMD Runner PK

2016: NMD Runner PK

2016: NMD_XR1

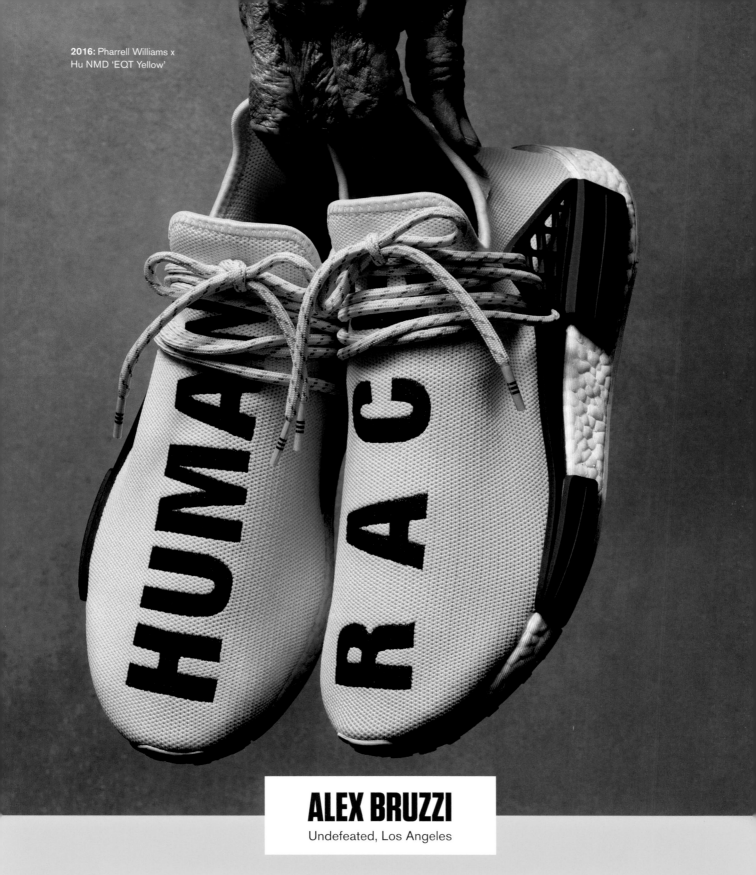

2016: Pharrell Williams x
Hu NMD 'EQT Yellow'

ALEX BRUZZI

Undefeated, Los Angeles

There's a couple of key reasons why NMD was such a huge success. First and foremost, the design was exciting and really well executed. Secondly, adidas launched it with German-style precision, releasing the OG in only a few shops around the world. Trends are a tricky thing, but NMD showed that sneaker collectors were willing to support new design. You have to give them credit – adidas saw a shift coming in sneaker culture and they adjusted their strategy perfectly. Gone are the days when retro product sold out solely because of heritage. The consumer is smart, and they can tell when something has creativity and honesty behind its design.

adidas NMD 'Pitch Black'
URBAN UTILITY PACK

With 2016 officially crowned as 'Year of the NMD', adidas sent their loyal Three Stripes devotees into total freak out mode with the announcement of the 'Pitch Black' project. Rocking a glitched-out knitted upper and all-black BOOST soles, just 500 pairs were produced, with 100 given away through Snapchat. The rest were gifted to friends and family, and prices immediately went through the roof with eBay recording multiple auctions in excess of $5000. For a select group of ultra-connected individuals, the 'Pitch Black' NMD arrived as part of an 'Urban Utility' ensemble, designed to house the essentials for life in the concrete jungle. The case itself was desirable in its own right, but the stealthed-out accessories it held launched the hype around this release into orbit. A sleek aluminium Rimowa Topas Multiwheel 45L suitcase was kitted out with an Oral-B electric toothbrush, Porter Travel Pouch, SIGG Traveler water bottle and a Type-2L carabiner. Earplugs were thrown in for good measure, presumably to drown out the social media outrage emanating from envious sneakerheads. It became the new standard by which all packaging is now judged. Touché adidas!

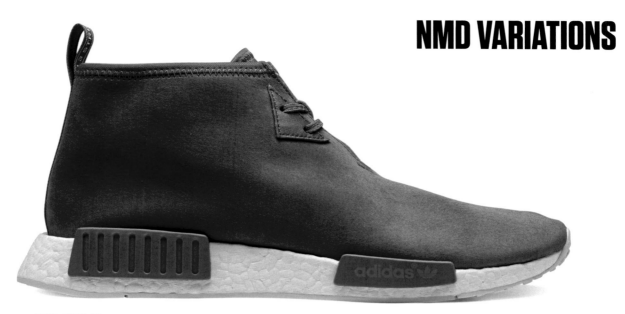

2016: NMD_C1

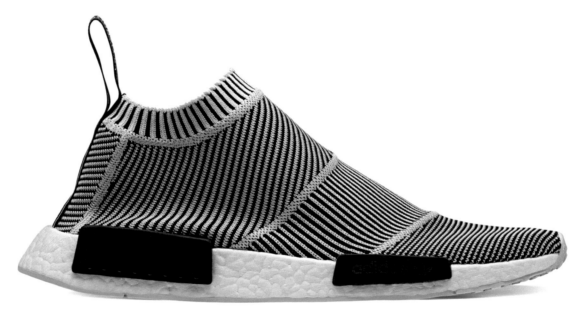

2016: NMD_CS1 PK

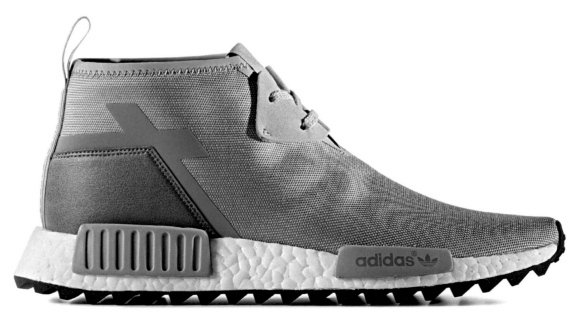

2016: NMD_C1 TR

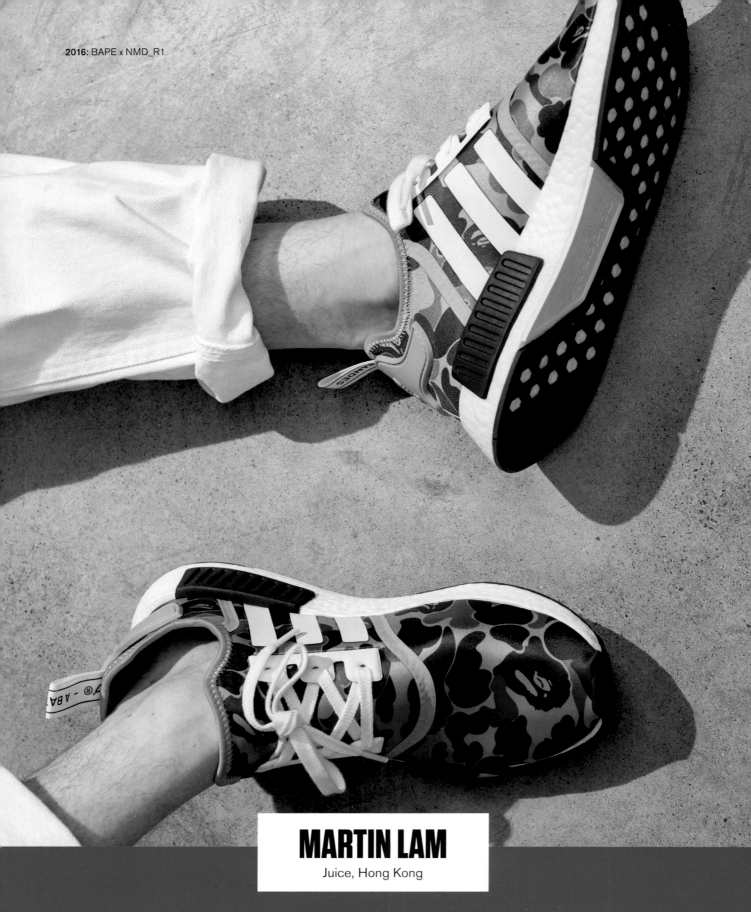

MARTIN LAM

Juice, Hong Kong

The new sports-fashion style by adidas that combines old design concepts with new technology like Primeknit and BOOST has really been a great success in Hong Kong. The launch of NMD created a big noise and the shoes instantly sold out. NMD doesn't just attract sneakerheads, it brings totally new customers to Juice, which is great. adidas is quickly regaining market share and is winning the 'cool' battle. I think the NMD hype will go on for a long time!

2016: Mastermind Japan x NMD_XR1

I know you're a very humble person, but in all seriousness, was NMD all your idea or do you need to share the credit with others?
I absolutely need to share the credit. I've worked with many great designers externally, and what I learned on every one of those projects is that a team is always stronger than an individual. Being around Kanye, for example, he always surrounds himself with interesting people. If you can work that way, you'll always make better product. It's not about being democratic with the process; rather, it's about getting the best ideas out. It's what I built in my previous role with Y-3, and it's what we're building now with Originals – and we're seeing the results of that. You start to get an 'adidas Originals' feel as opposed to an individual feel.

NMD has been credited as short for 'Nomad' – is that correct or was that a clever afterthought?
When we started, we bounced a lot of ideas around. We wanted to create something that wasn't too descriptive. On one hand, we wanted to fuse past and future; on the other hand, we wanted to talk about, 'Well, if a shoe was designed in the 80s, what did your life look like in the 80s and what does it look like today?' The opportunities we have now – how easy it is to travel and how much information we have access to – didn't exist back then. That's where this idea of exploration came from. I really love the NMD name. To me, it harks back to the ZX series. If we give it a real name, then I think we're limiting something, which I'd rather not do.

You must be conscious of putting too many units into stores and flooding the market. Is distribution something you worry about personally?
For me, it's more about engaging with the consumer. Of course, you shouldn't put too many out so that they sit in stores – that's definitely not anyone's ambition. Equally, you want people to be able to get a hold of it. We have multiple colourways of that shoe for that reason – we want to keep the momentum. It's sometimes tempting when you have a success to try and protect it, but I think our place right now is to say that the success came from confidence.

How do you feel when you see campouts for four or five days? Does it give you a real thrill, or do you think those kids should be at home doing something more productive with their time?
We all have hobbies, and we all have things that inspire us. It's not for me to comment – my energy goes into the design. Of course I don't want people to have to wait too long, but on the other hand it's an endorsement that we've found a note that's in tune with what people are looking for. I like the idea that we'll look back on this period and see that we really shook things up – not just as a brand, but with the culture and the consumer.

Given the links to the Micropacer, I was curious as to why the shoe launched in black with blue and red highlights. Was there ever a silver sample that was closer to the Micropacer?
No, there wasn't. That's an interesting story actually. The shoe started life as the 'Boston BOOST'. We'd worked on the idea of taking the iconic blocking from the Boston Super and mixing it with BOOST. They were very interesting, but they were a bit too literal. So we had a conversation about not just linking it to the Boston, but rather linking it to an entire era. We started looking at shoes that had those memories of the 80s – the Boston Super, Micropacer and Rising Star. It took it away from being an interesting study on the Boston to being a new shoe, and that's when NMD came into its own.

You've been in the background for years, now you're the visible face of adidas design. Do you feel like a bit of a rock star now?
I don't know. [Laughs] I'm 17 years at adidas, and I feel the same as I did when I started. I love talking about design, and if someone comes up to me and wants to talk about sneakers then I've got all the time in the world.

•

2018: Hender Scheme x NMD_R1

2018: Pharrell Williams x Hu NMD (Holi Chunder)

2018: Juice x NMD Racer

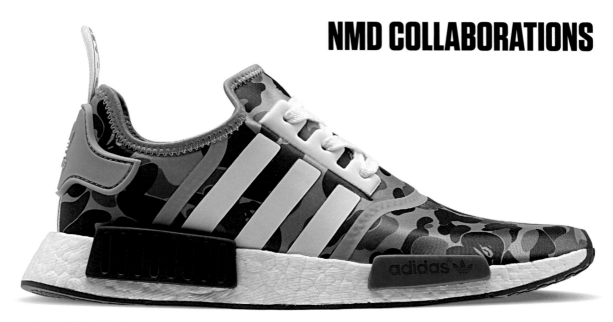

2016: BAPE x NMD_R1

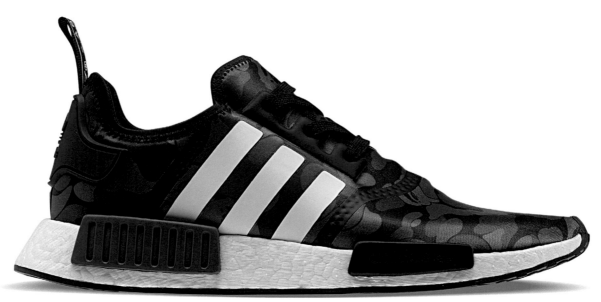

2016: BAPE x NMD_R1

2018: Neighborhood x NMD_R1

15 Years of Nike SB

Published in *Sneaker Freaker* Issue 38, May 2017

EDITOR'S NOTE: WOODY

No history of the modern sneaker game could be close to comprehensive without a detailed analysis of Nike's skateboard division. Artfully manufacturing hype around the Dunk – a basketball model from the mid-80s – Nike SB created a global phenomenon that kick-started campouts and sneaker collector mania. With resale prices reaching ridunkulous heights for many early collaborations, Nike SB defined sneaker culture until its prominence began to fade after a decade at the top. I owe a huge thanks to Sandy Bodecker and all the collectors who helped bring this Nike SB retrospective to life.

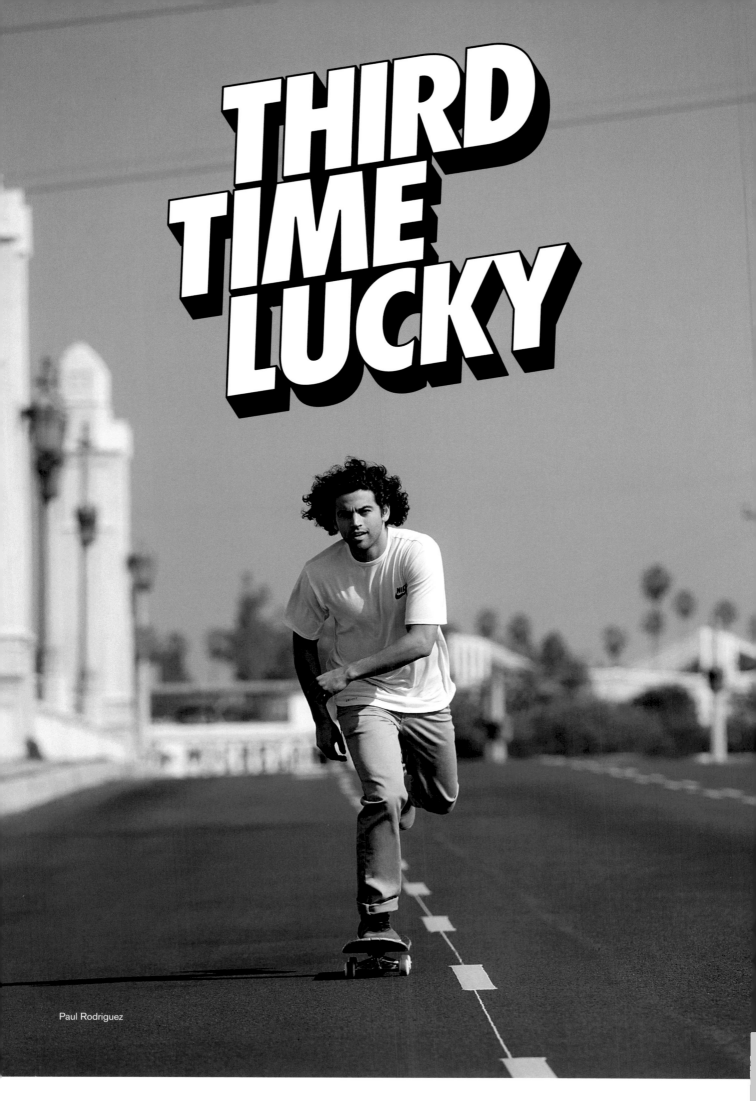

THIRD TIME LUCKY

Paul Rodriguez

WORDS Matt Williams

Founded back in 2002 – incidentally the same year as *Sneaker Freaker* – Nike SB is now a permanent fixture in stores around the world. Under the direction of Sandy Bodecker, Nike SB jacked a mainline straight into the heart of the sneaker zeitgeist. Taking the collaboration model to the max, the Dunk SB became the definition of hype – with compounding interest driving global campouts and introducing the cursed 'reseller' into sneaker vernacular.

2002: Nike Dunk Low Pro B 'Olive'

Nike's first crossover with skate culture came by accident in the 70s. Tennis and basketball models like the Blazer, Bruin and All Court were surprisingly capable and often superior to the skate-specific footwear available at the time. The brand's skate presence would wax and wane until the early 80s, but by the time 1985 rolled around, two new basketball shoe designs planted seeds that would be crucial to the foundation of Nike SB.

The Dunk's basic leather upper and supportive ankle collar were perfect for skaters. At a time when almost every skate shoe was vulcanised, the Dunk's use of cup soles, which were sewn to the uppers, was a major point of difference. Though the Dunk was soon infiltrating skate parks, it was the Air Jordan 1 that had the most profound impact. Structurally almost identical to the Dunk, the AJ1 benefited from the addition of Air cushioning and the gleaming endorsement of Bones Brigade members Steve Caballero, Mike McGill and Lance Mountain – who famously repped 'Bred' AJ1s in *The Search for Animal Chin*.

By 1987, the bloated Air Jordan 2 was imminent and stores began liquidating its outdated predecessor. Unwanted AJ1s were priced to clear at $19.99 and skaters hoovered them up. Unfortunately, the perfect skate shoe at an all-time budget price was short-lived – as was Air Jordan's presence in skate culture. Once MJ started racking up rings, the shoes grew bigger, bulkier and significantly more expensive.

The AJ1 made a surprising return to shelves in 1994, however this 'retro' experiment was instigated at least a decade too early. The general public didn't see any point in wearing out-of-date kicks, while the performance potential of a decade-old silhouette was less than appetising. The AJ1 hit sales racks once again and Jordan

Brand refrained from dabbling in remakes until the start of the new millennium, when MJ's retirement and a flashpoint of cyclical fashion ignited a global fascination with retro footwear.

In the meantime, the skate community had adopted another surprising silhouette from Nike's roster – the GTS. While sold and marketed as a tennis shoe, the model garnered significant skate press praise. This organic acceptance set the wheels in motion and Nike started devising a strategy to establish a skate division. They were the biggest sportswear brand in the world. Surely skateboarding was just another sport they could add to their repertoire – how hard could it be?

In 1995, Nike sponsored the debut X-Games. The following year, advertisements in *Thrasher* heralded the arrival of the Air Choad, among other questionably named sneaks, complete with Foot Locker logos.

Subsequent print ads posed the question, 'What if all athletes were treated like skateboarders?' and featured abstract imagery that attempted to empathise with negative perceptions of skaters. Unsurprisingly, the target market was less than impressed with the bulbous, lumpen shoes. Plus, there was another problem. At a time when most of the legit skate brands were created by skaters, for skaters, the very idea of a corporate behemoth like Nike muscling in on the scene was culturally untenable. Nike's first skate range was a total bonehead bust.

Skating catapulted deeper into mainstream consciousness as the decade wore on, fuelled by the growing coverage of ESPN's X-Games and the Tony Hawk's Pro Skater videogame. In 1999, Nike finally brought back the Dunk, along with a Dunk Pro B

1996: Nike Air Snak

1996: Nike Air Choad

2004: Zoom Air E-Cue 'Yasutaka'

2007: Zoom Tre 'Safari'

variation that introduced puffy tongues. Elsewhere at Nike, official collaborations based on the Dunk with Wu-Tang Clan, Alphanumeric and Stüssy were a stroke of genius that would pay handsome dividends in the years to come.

Nike's skate dreams persisted. The ultra-gimmicky Ovidian, which featured a removable upper that could be flipped inside-out to hide evidence of skate damage, was yet another cockamamie project that failed miserably.

Undeterred, Nike regrouped in 2001 with the purchase of Savier, a Portland-based skate brand that was still in start-up mode. Savier may have been independent, but they still had free access to Nike tech such as Zoom Air, and their highly innovative designs focused on durability. In a less-than-subtle dig at their Nike overlords, the brand released an inflammatory Swoosh-less version of the Air Trainer 1 as a pro-model for team rider Tim O'Connor. Also on the Savier team were Stefan Janoski and Brian Anderson; they both jumped ship to Nike SB eventually. Unfortunately, Savier was no saviour, and Nike shut it down abruptly a few years later.

ORANGE BOX
Frustrated and unaccustomed to failure, Nike bigwig Mark Parker turned to a trusted lieutenant to spearhead one last crack at the skate concept. Sandy Bodecker, a highly regarded Nike lifer, took on board all the prior experiences and focused on building bridges in the community rather than burning them to the ground. Understanding the industry's aversion to Nike's encroachment, every aspect of SB was devised with insider input from skate retailers, skate media and even other skate brands. This time around, Nike SB's shoes would only be sold in core skate shops. Genius!

SB's hand-picked skate team was another masterstroke and included the likes of Danny Supa and Reese Forbes, who were encouraged to design their own debut Dunks. This first wave of releases in 2002 – known as the Orange Box series – was a sell-out and hype surged as the skate world and the newly minted sneakerhead movement started to converge. Collaborations with Supreme, Zoo York and Chocolate were hits that cemented SB's renegade status. Bodecker's business strategy was sound. It may have taken close to a decade – and untold millions – but SB was finally the overnight skate success Nike had craved.

SILVER BOX
The sophomore lineup ditched the generic orange Nike shoebox for long-overdue purpose-built packaging. The Silver Box period is universally praised by collectors for its originality and creativity. With only colour designations on the box to tell many of the shoes

apart, the community stepped in to name each model with creative gusto. Designed by newly recruited team rider Todd Jordan, a green Dunk became known as the 'Hulk', while a pair of olive Dunk Lows with neon laces were nicknamed 'Jedis' as a nod to Yoda's light saber. The names weren't always positive though. One Dunk was christened 'Barf' due to a vomitous combination of bright blue, dirt brown and forest green.

Some of the designs flirted dangerously with trademark infringement, which only added to SB's emerging outlaw mystique. While the 'Homer' Dunk Low (shout to *The Simpsons* fan Matt Jenkinson) skirted around the legality of 'inspiration' by using a subtle colour play, the 'Heineken' Dunk was one design that stepped on toes. Released in June 2003, the green, white and black Dunk Low was striking, but the red star on the heel was a red flag to the brewer's lawyers, who immediately went into cease-and-desist mode. Pulled from shelves, the 'Heineken' Dunk is one of the rarer releases of this era and still commands big bucks. For years afterwards, *Sneaker Freaker* received annual letters from a Dutch law firm demanding we stop calling the shoe by its nickname, something we found highly amusing and of which we took absolutely no notice.

The Silver Box era also marked the introduction of the E-Cue and URL. These cutting-edge designs were two of the most high-tech and durable skate shoes of their time. However, perhaps handicapped by the success of the Dunk, they struggled to find mainstream acceptance and remain a footnote to SB's early ingenuity.

PINK BOX
The Pink Box era is defined by collaborations with skate shops and music icons. San Francisco's HUF store designed a cracked leather Dunk High with tie-dyed inlays in reference to their hippie hometown, while London's Slam City Skates favoured rubber toe caps and Swooshes that wore away to reveal bright blue leather underneath. SB again risked controversy with a Tiffany-inspired design from Diamond Supply Co. that repped faux-gator overlays. Eclectic musical collaborations with the Melvins, Unkle and De La Soul were also released, the latter featuring lenticular graphics from the cover of *3 Feet High and Rising*. Loaded with creativity and lavish detailing, each was a revelation and closer to works of art than pieces of footwear.

Outside the Dunk, SB would reflect on previous endorsement lessons by signing the baby-faced Paul Rodriguez to a multimillion dollar contract in 2005. The lucrative deal made Rodriguez the first Nike skater to receive his own pro model. Known as the Zoom Air Paul Rodriguez – but better known as the 'P-Rod 1' – the design earned praise for its skateability and robust styling. Colabs with

2000: The Ovidian offered an amazing 'three shoes in one' – shame they were all butt-ugly!

Futura 2000 and Stash helped the cause, as did the 'J-Rod', an inspired edit by Nike designer Tinker Hatfield. The use of elephant print, not to mention a Jumpman on the tongue, ensured this was one of the most coveted releases of the era.

Of all the Pink Box releases, the 'Pigeon' Dunk Low set the bar highest for hype. Designed by Jeff Staple and sold exclusively in NYC, this was the final release in the hyper-limited 'City Pack' series. Just 30 pairs were available through Staple's Reed Space location in Manhattan. Attracted by the lure of fast money, sneakerheads and street hustlers swarmed the store. The NYPD were called to keep things under control and greeted by a mini riot in the making. The scene made the front page of the *New York Post*, launching sneaker culture well and truly into mainstream consciousness. To this day, the infamous 'Pigeon' Dunk sold at Reed Space still changes hands for five figures.

With wider society now exposed to Dunk-mania, interest in sneakers escalated. Already hefty prices on the secondary market went through the roof as a new generation of sneakerheads joined the cult. With high demand and short supply, bootleg manufacturers stepped in to take advantage and the market was soon swamped with counterfeits of laughable quality. In response, forums like 'N-SB' produced comprehensive 'legit checks' to identify telltale signs of forgery.

The hype, however, wasn't all negative. Peripheral creative elements coalesced adding heft to the idea that sneaker culture was about more than just the shoes. In June 2005, artist I Have Pop revealed a guerrilla installation that secretly placed concrete Dunks out the front of sneaker boutiques including Undefeated, Solebox and DQM. Another artist, Gabriel Urist, made tiny replica sneaker necklaces out of gold. Acclaimed painter Dave White

also came to prominence in both art and sneaker circles for his expressionist interpretations of Dunks. Exhibitions such as Sneaker Pimps brought music, footwear and art together into a 'sneakerpalooza' package that would travel the world spreading the gospel. Streetwear brands also took note and labels like KIKS TYO, Sneaktip and Mike plundered the culture.

In late 2005, a wave of Brazil-exclusive Dunks arrived. Originally housed in a cream and brown box distinguished by the letters 'EMB', the series started with simple colours like a 'Miami' make-up and a 'UNLV' low-top nicknamed 'Ultraman'. As the years progressed, the Brazil shoes became increasingly elaborate, particularly the third series in 2008. Designed with input from Brazilian SB team riders, Cezar Gordo, Fabio Cristiano and Rodrigo Petersen, the collection paid tribute to the classic Sony Walkman. Numbers on these are crazy limited.

BLACK BOX

The Black Box era posed a few challenges for Nike SB. Speculative interest by sneakerheads was starting to overshadow Bodecker's original skate-only manifesto. More likely to be stacked in a pile awaiting eBay than shredded in skateparks, an apparent increase in Dunk production numbers was slowly devaluing SB's credit rating, and a bunch of releases ended up heavily discounted.

Stylistically, several designs in this era were also accused of excessive embellishment. The use of patent leather and faux-fur was criticised for being not just corny, but antithetical to the very idea of skateboarding. Colabs with Dinosaur Jr., MF DOOM and obscure Dutch band C-Mon & Kypski kept SB's music connection alive, but only a handful of Black Box releases – including the

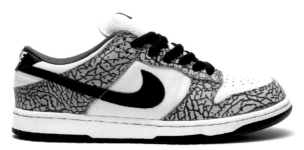

2002: Supreme x Nike Dunk Low SB 'White Cement'

2003: Dunk Low SB 'Heineken'

2004: Dunk Low SB 'Homer'

2004: Dunk Low SB 'Jedi'

2005: Dunk Low SB 'Pigeon'

2007: Dunk Low SB 'What The Dunk'

'SBTG' by Singaporean customiser Mark Ong and the aesthetically appealing 'Send Help' by Todd Bratrud of Consolidated Skateboards – delivered the sellouts seen in previous generations.

To their credit, SB continued to innovate. A spiritual successor to the E-Cue, the Zoom Tre was able to withstand relentless punishment and is still regarded by many as the greatest performance skate shoe of all time. The design was improved further in 2008 during the Gold Box period with the release of the Zoom Tre A.D. Despite fine-tuning the original's shortcomings – in regards to flexibility and fit – the Tre was retired unceremoniously shortly afterwards.

GOLD BOX

SB had always gone heavy with the so-called 'inspired by' releases that mined pop culture, but the Gold Box era's distinct lack of collaborations – just two in its first year – starved the hype train. However, as 2007 came to a close, Nike launched the next-gen in spectacular fashion. To promote their first feature-length skate flick, *Nothing But The Truth*, SB dialled in a commemorative release, aptly named 'What The Dunk'.

This jaw-dropper was a mishmash of nearly every single noteworthy release from SB's first five years. From hemp to tweed to denim, this shoe had it all – and then some. While early opinion was divided – especially after fakes emerged before the shoe was officially revealed – chaos ensued once it was revealed that the numbers were stupid limited and the shoe would only drop in the nine cities hosting the film's premiere. 'What The Dunks' now command four-figure price tags, more than nearly every hype release they paid tribute to!

BLUE BOX

The Blue Box arrived in 2009. The Dunk was almost at the end of its hype cycle and skate style was rapidly changing. SB team rider Stefan Janoski was pondering plans for his own radical low-tech pro model. Sporting a vulcanised sole with classical boat-shoe styling, complete with leather laces and minimal padding, the design was an intentional throwback.

In an interview with The Berrics, Janoski outlined his vision: 'I wanted function over protection. Companies made amazing skate shoes before they knew they were making skate shoes. Then when they decided they wanted to make skate shoes they'd add stuffing to the tongue, padding up the bottom and basically take out all the good parts and ruin it!'

The Janoski was a monster homerun and it quickly surged to become one of Nike's bestselling models of the time. Other Nike pros including Omar Salazar and Brian Anderson also released signature models, but nothing would ever compare to the number-crunching success of Janoski's humble boat shoe.

Skate veteran Eric Koston shocked the industry in 2009 when he walked away from his freshly inked endorsement deal with Lakai to sign with SB. Knowing he was a major fan of the LA Lakers, SB reached out to Nike Basketball to produce a once-in-a-lifetime colab with Kobe Bryant. Two versions of the Eric Koston 1 were created. One featured an upper inspired by the Zoom Kobe VI, the other was an extra-special version that fused a Kobe VI upper to the Koston 1 sole unit. Limited to just 24 pairs, this hyperstrike release came packaged in a functional wooden humidor.

Koston would go on to have a legion of shoes attached to his name, including several Air Max-inspired designs, but none of them were able to find a memorable groove. In 2016, the Koston 3 Hyperfeel was released fitted with an extended sock device, polarising fans with its awkward profile.

Aside from changes to the tongue padding, the core construction of the Dunk SB remained unchanged until 2011, when a complete overhaul was ordered. The Dunk NT ('new tooling') introduced heel lining pods, injected Phylon midsoles and a completely reengineered outsole design.

TAPED BOX

SB switched to the Taped Box design in 2011. It was around this time that restrictions dictating SB could only be sold exclusively through dedicated skate channels were lifted. Hype around the Dunk had largely subsided by this stage, although a few well-received releases arrived in the Taped Box, including an official colab with Levi's and a revisit of Supreme's original Dunk Low. It was becoming clear that Nike SB had lost the superstar sheen it had enjoyed in its early days.

2005: *New York Post*

2003: Nike Zoom Air E-Cue print ad

Eric Koston

Paul Rodriguez

Box Variations

Mar 2002–Dec 2002

Mar 2003–Sept 2004

Sept 2004–Dec 2005

Feb 2006–Sept 2007

Oct 2007–Mar 2009

Apr 2009–Jun 2012

Jul 2012–Dec 2013

Dec 2013–Present

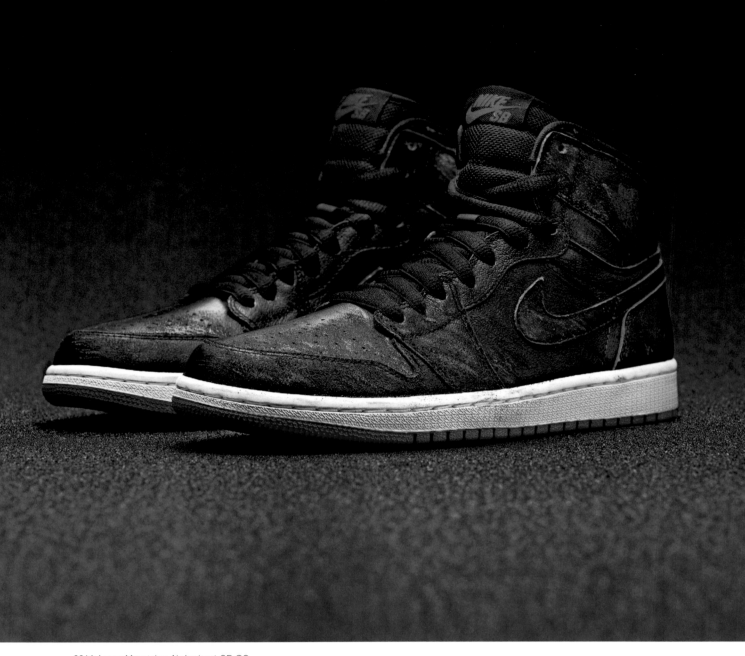

2014: Lance Mountain x Air Jordan 1 SB QS

TIFFANY BOX

In 2014, SB turned over a new leaf. Having entered the Tiffany Box era, the label reflected on its history in a bid to recapture the spark. The first half of the year delivered a number of unexpectedly hyped releases such as a high-cut rerelease of Diamond Supply's 'Tiffany' Dunk. They also revisited a missing part of Nike's skateboarding history by finally introducing the Air Jordan 1 to the official SB lineup. One pair was designed by Dogtown legend Craig Stecyk, while the other two revolved around Bones Brigade legend Lance Mountain. The classic 'Bred' and 'Royal' Jordan colourways were mismatched and covered in paint as a paean to the AJ1's glory days in the 80s. Paying respect to that shoe's history was a significant moment.

From a performance perspective, SB continued to experiment with the Dunk. In 2015, at the request of team rider Ishod Wair, a new variant reduced the inner padding. In 2017, the biggest overhaul yet produced the Zoom Dunk Elite Low, which completely reengineered every aspect of the shoe. Fifteen years after SB's birth, the Zoom Dunk Elite Low made its debut in the same low-key grey and blue colourway featured on the first Dunk SB sample.

EPILOGUE

Hype around Nike SB these days is a shadow of what it once was. While original releases still fetch insane collector prices, the days of week-long campouts and fashionable shoe riots are long gone, replaced by an army of sneaker-bots and faux raffles on Instagram. We can't help but lionise those thrilling Orange Box days when everything Nike SB touched turned to gold. Far from wrecking the skate industry, Bodecker simply reimagined its creative potential. Nike SB is the OG – the sneaker *don dada* – that brought storytelling through product design to life and perfected the collaboration model.

The 'Pigeon' may have long since flown the coop, but before it did it pooped out a magical egg that would crack open to reveal sneaker culture in all its flawed glory. Enjoy our massive Nike SB retrospective!

•

2003: Reese Forbes Nike SB
vinyl figure by Medicom Toy

SANDY BODECKER

Nike SB has always referred to 'skateboarding', but it was another 'SB' that drove the brand's direction right from the start. Sandy Bodecker was a few decades into his career at the Swoosh when Mark Parker tasked him with establishing the brand's skate division. The enduring success of SB is credited to Bodecker's creative ingenuity – and his utmost respect for the skate community itself. Back in 2003 at the height of SB madness, *Sneaker Freaker* quizzed Bodecker in a revealing interview. On the eve of Nike SB's 15th anniversary, we again sat down to reflect on its crazy rollercoaster ride to date.

2001: Alphanumeric x Nike Dunk Low (Friends and Family)

Whose idea was it to re-enter skate?
The real reason Nike decided to get back into skate was mostly due to the less-than-successful efforts from Savier. I wasn't involved in that, so I can't really comment on what happened, but I was approached by Mark Parker and asked if I would be interested in starting Nike Skateboarding. I was assured that we would be given the support, time and independence to do it properly, so I signed on – just me and a desk!

It's amazing that the first SB sneakers are already 15 years old. Has the anniversary given you some perspective on the whole craze? Those early Dunks are practically vintage by now!
When you start something from scratch, you never really look forward 15 years and go, 'Yup, that's where we'll be and this is the impact we'll have!' One of the things that time gives you is the luxury of perspective and hindsight. So, with all that's been happening around the anniversary, I've been able to take a step back and revisit things in more depth and gain some clarity on the impact of the last decade and a half. I have tried to remain objective about the impact that SB has had on the skate and collector communities, as well as the role the early SB crew played, but I'm proud of what we created and deeply grateful to all our early supporters for giving us a chance. If I had to choose one word to describe the journey it would be 'humbling'.

I think it's fair to say the skate industry was super critical of Nike and there was a popular chorus of 'This will wreck the industry!' That's clearly been proven incorrect.
There is no denying there was a pretty strong negative vibe about Nike when we started, and many of the reasons for that were valid. In hindsight, I think it helped us not get ahead of ourselves. We spent a lot of time listening to the core community of skaters, shops and the media – and doing our best to understand both the biggest negatives and what value Nike could bring to skateboarding. Bringing back the Dunk was a direct result of these conversations, and the collaborations and storytelling that emerged were fuelled by these discussions. The introduction of the 'collector' to the skate shops in the beginning definitely helped some core retailers survive challenging times, and we received many emails and calls thanking Nike for our efforts.

Anything you'd change if you had your time over?
I can say with 100 per cent certainty that Nike SB has been a positive for the skate industry. I'm sure some very core folks will still debate this, but for 15 years we have supported, helped energise and stayed committed to skateboarding at all levels. In the early days we would talk about the need to respect the past and embrace the future. If you want, you can compare it to Nike's famous tagline, 'There is no finish line.' Skateboarding is always evolving with new tricks,

2003: The Holy Grail of SB collecting, the 'eBay' Dunk was auctioned off for charity in 2003, with a winning bid of $26k!
The anonymous winner received a pair in their size, while the original sample was destroyed by chainsaw.
Good luck trying to locate the only pair in existence – let alone add it to your collection!

new environments, new creative connections and new products – essentially there is no finish line because skaters are always creating a new future. I think Nike, along with many others, played a part in stoking the creative fire. If I could go back and change anything, I guess it would be the brief period of time when I think Nike SB lost a bit of connection and core commitment. With that said, I think the current crew is getting things back where they should be.

Just prior to SB's launch, Dunk colabs with Stüssy, Alphanumeric and the Wu-Tang Clan hit the street. Did that inspire the SB business model?
Those early Dunk colabs were pre-SB. Our business model was just being fully committed to the core skate community – as humbly as we could – by admitting where Nike had made mistakes in the past. We spent a ton of time in the community listening and learning, basically asking for the chance to do it right this time around. I also made it clear to our internal team that, while we would remain humble, we would also be proud of the Swoosh and that we wouldn't try to hide who we were. There was, and still is, value in what Nike can contribute to the skate industry if we do it the right way.

The template you set is clearly responsible for the current hype around sneaker collecting and the proliferation of collaborations. Do you take some credit for the fact that SB altered the course of the entire industry?
I think we can take some credit for being part of the generation where the lid came off the Pandora's box of sneaker collecting. There were a number of independent but loosely connected movements happening, and the time was ripe for things to come out from the deep underground to broader acceptance. The role that Nike SB played was really around elevating sneakers – in this case the Dunk – as a canvas for creative storytelling. We were able to make things more personal and more deeply connected, first to the skate community and then to the broader collector community. I think we helped introduce the idea of sneakers as 'currency' both culturally and financially. This had never happened before and is one of the foundation pieces of where we are today.

The 'Pigeon', 'Paris' and 'FLOM' Dunks remain some of the most expensive sneakers on the secondary market. Are you amused/disappointed/pissed that so many of the SBs from that era are still unworn collectibles?
Ahhh yes, the great debate – to skate or not to skate? Personally, I'm a skate 'em all day, every day. We always said that every shoe we put out should be skateable and that's what they were made for. On the other hand, if someone chooses to collect them then that's their choice. The only thing I used to have a problem with was when collectors bought multiple pairs and denied access to kids who wanted to skate the shoes. That never felt right.

Did you see the reseller market as a necessary evil or something that would ultimately be a negative force?
I never minded the queues as they indicated we had done something right, but I was never a fan of resellers. I do feel it was a negative element in the beginning and has only gotten worse as technology and demand has grown. You like to think there's an easy or equitable answer out there, but lots of folk much smarter than me have all taken cracks at solving this issue. I guess it's an aspect we'll have to live with.

Is there an all-time crazy SB moment that still blows your mind?
There are lots of stories around colabs – good and not so good. The 'Pigeon' Dunk had a couple of things going for it. The design, which came out of NYC, was introduced at the height of early SB madness and picked up by the mainstream media. Plus it had dope colours and materials – the perfect storm! One of my favourite moments was when we did the Dunk Golf collection, which included pants, shorts, shirts and socks. It dropped in late spring and one day we saw in the news that Tiger Woods had gone into a skate shop, seen the product, bought some at full retail and then wore it the next day in a Pro-Am event. The crew was pretty stoked about that! There have been so many stories over the years so it's hard to pick between them, but for me it has always been about making a connection, eliciting emotions and making someone laugh or remember a moment. It's about great storytelling.

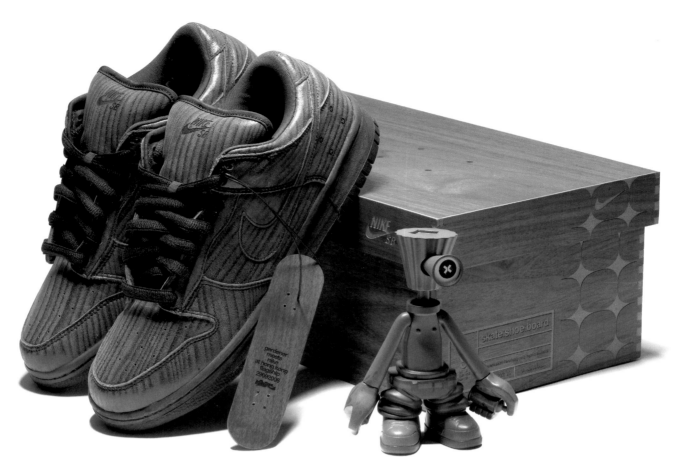

2006: Michael Lau x Nike SB Dunk Low Pro

Most of the releases have stood the test of time, though some pretty crazy stuff was released like the 'Three Bears'. Anything you'd like to publicly confess?
I don't really believe in regrets. I think it just hinders creativity and innovation. I'm of the school that believes most of our greatest successes and innovations started with failure, and that it's what you learn from failure that determines whether you succeed in the future or not. Not every colab we did was successful, but we tried our best to learn from what didn't connect and not make the same mistake again.

You recently shared a few unreleased samples on social media. Must be a few killer ones that didn't make the cut for whatever reason.
I can't tell you an exact number that didn't make the cut. Some were promo only, some we were legally advised not to pursue, and there were some where I or someone on the team just tried something or made a one-off specially for an event or an individual. I did a Dunk for Ichiro Suzuki breaking the single-season hit record because I was a big fan. Unfortunately, it just never panned out. The 'Freddy Kruegers' were shut down before we'd even finished talking about it. My favourite was the 'eBay' Dunk because we sawed the sample into pieces live at a trade show and ended up raising $26k for charity.

Here's a super nerd SB question. A few of the old shoes have a colour code listed as 'Paul Brown' – was that an SB in-joke?
Well, I'm a nerd, no doubt about that, but it escapes my fading memory where the colour name Paul Brown came from. I do remember that I used to make up colours prior to SB like Purple Haze and Zane Grey, though we stopped the practice after the writer's estate sent us a cease and desist letter.

In 2004, you spoke of the E-Cue as the 'highest performance skate shoe out there,' and said that we'd look back on it as a benchmark. Was the Dunk obsession ultimately responsible for SB's inability to break a true skate performance model?
Performance in any sport is ultimately defined by the folks that use the products every day for their intended purpose. Some sports or

activities are more comfortable with change and trying new things. Skate, in this respect, is a bit more conservative than football or basketball, for example. When pursuing innovation, you need to provide something demonstrably better than what is currently being used. Skaters have very specific needs when it comes to boardfeel, flip touch and to a lesser degree, protection from the ground and the board. They are also very conscious of how the shoe looks on the foot, especially toe-down when riding on the board. It's a challenge, but one we are constantly working on as materials, technology and construction methods advance. As I mentioned, there is no finish line for innovation, so sometimes you make smaller incremental improvements, and less frequently you come up with something truly revolutionary. But that's what makes it so much fun!

The crazy hype and excitement around SB was mental. The scene was tiny then, more of an underground society than a commercial beast. Do you think we'll ever see anything that ridiculously exciting in the sneaker industry again?
What happened at that point in time with SB was unique and groundbreaking, and I don't think it will be easily duplicated. But somewhere out there, small communities and crews are creating and innovating and thinking differently, asking questions that have no answers today but will in the future. I look forward to seeing what comes next, whatever it may be.
•

THE
ORANGE
BOX

WORDS Matt Williams **PHOTOS** Ant Tran

As Nike SB prepared for kick-off, only a select number of dedicated skate spots were authorised to stock the first releases, each carefully vetted by the SB retail team. Consisting of 15 Dunks and a solitary Blazer, the original lineup featured regular Nike branding on the tongue and was shipped in the standard-issue box that housed all Nike products at the time. The first assortment became known as the Orange Box generation. Subsequent SB releases were shipped in silver packaging, followed by pale pink, black, gold, blue, cardboard and mint, with the different hues defining each era. With an impeccable combination of originality, credible collaborations and pro-skater influence, the first wave set the bar high. Nike SB was well on its way!

Originals

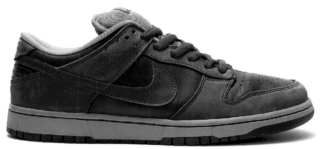

Street value $400

'Shark' Nightshade/Team Red/Shark (October 2002)

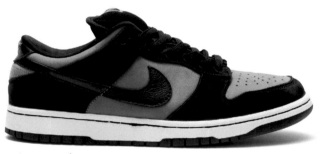

Street value $600

'Flash' Orange Flash/Black (September 2002)

Street value $525

'Loden' Dark Loden/Black (October 2002)

Street value $425

'Wheat Hi' Maple/Bison/Wheat (September 2002)

Forgoing the rider input and collaborative conventions upon which the brand was established, SB chose to remove the training wheels and ride out the fifth wave of Dunks under their own steam. The lineup consisted of three Dunk Lows, which became known as 'Shark', 'Flash' and 'Loden', along with a 'Wheat' Dunk High. Utilising basic suede and leather in colours ranging from natural olive to hazard orange, this quartet solidified the diversity of Nike SB. While they lacked the crazy hype of earlier SB releases, they were nevertheless much appreciated. Strangely, they have since become some of the hardest to track down in deadstock condition. Perhaps they were actually skated, rather than hoarded by collectors? Like the 'Paul Brown' before it, the 'Wheat' Dunk High came equipped with a fat padded tongue. While it added a level of extra cushioning, the fat tongue was dropped as a standard feature by the time the Silver Box era rolled around – though it continued to live on through the Dunk Low and a handful of special releases.

All shoes from the collection of Nate Wallace.

Paul Browns

Street value $400

'Paul Brown' Dunk Obsidian/Outdoor Green/Paul Brown (June 2002)

Nicknamed 'Paul Brown', the first Dunk High SB featured a massive puffy tongue and an all-suede blend of earthy hues. The obscure moniker was derived from the official colour name, as written on the box. But who was Paul Brown? No one seems to remember!

Street value $225

'Paul Brown' Blazer Paul Brown/Mesa Orange (2002)

Another baller from Nike's past, the Blazer was named for the Portland Trail Blazers and is the only non-Dunk in the original lineup. Suede and tumbled leather in 'Mesa Orange' and 'Paul Brown' was a fairly conservative combo, and the Blazer remained an anomaly at SB. This original release featured an extra layer of material that extended around the rim of the shoe, just like the original design from 1972.

Colabs

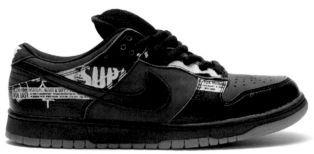

Street value $1250

'Zoo York' Paul Brown/Black (June 2002)

Street value $1250

'Chocolate' Anthracite/Black (June 2002)

Released as part of the third drop, these Dunks were the first official SB collaborations. The 'Chocolate' Dunk was designed by team rider Richard Mulder. Since Mulder was sponsored by Chocolate Skateboards, the shoe also featured the brand's signature graphic embroidered on the heel, making this, in essence, a three-way tie-up. Likewise, Danny Supa's long association with Zoo York Skateboards was honoured with a brown Dunk that flaunted unique stencil graphics. Both shoes are exceedingly rare, resulting in resale prices that have remained sky-high.

Street value $1850

'Supreme' Black/Black/Cement Grey (September 2002)

Street value $1500

'Supreme' White/Black/Cement Grey (September 2002)

These two Dunks marked the beginning of a long-running relationship between Supreme and the Swoosh. Inspired by the 'Black Cement' and 'True Blue' versions of the Air Jordan 3, they were also some of the first non-Jays to feature the iconic 'elephant' print. As rumours began to circulate about the release, Jordan nuts, sneakerheads, streetwear nuffies and core skaters were frothing by the time the shoes dropped in September, 2002.

According to Bodecker, 2000 pairs were produced, though sources close to Supreme reported that just 1250 total units – 750 pairs in black and 500 in white – were created. Regardless, these Dunks quickly found their way to a hungry resale market for four figures. From this point onwards, hype for Nike SB was real!

Team Riders

Danny Supa

Street value $900

'Supa' Safety Orange/Hyper Blue/White (March 2002)

Nicknamed the 'Supas', this package was created by original SB team rider Danny Supasirirat – better known as, you guessed it, Danny Supa. Raised on the streets of NYC, Supa proudly repped his hometown by embracing the signature palette of the city's most beloved sports teams – the Knicks and the Mets.

Richard Mulder

Street value $500

'Mulder' White/Orion Blue/White (March 2002)

Also on the SB squad, Richard Mulder represented the City of Angels – via the Los Angeles Dodgers – with his Dunk. Featuring an optical white make-up with a crisp 'Orion Blue' Swoosh, this was a deceptively simple combination – but the 'Mulders' are not without their fans.

Street value $2250

'Denim Forbes' Denim/Denim (December 2002)

Produced by Reese Forbes, this double-denim Dunk left the edges intentionally frayed for a messed-up aesthetic. With a limited release of a reported 444 pairs, the 'Denim Forbes' are considered the most valuable of all the Orange Box releases. Priced out of reach for most fans, Nike SB at least gave young'uns a chance when they released a high-top version in 2017.

Reese Forbes

Street value $425

'Wheat Forbes' Wheat/Twig/Dune (March 2002)

Also designed by Reese Forbes, these caramel-coloured Dunks were silky smooth and totally creamy. All-suede uppers and grippy gum outsoles delivered maximum traction and flexibility – if you were willing to put them to their proper use!

Street value $200

'Gino One' Obsidian/Light Graphite/Obsidian (March 2002)

Gino Iannucci

Street value $150

'Gino Two' Black/Black' (May 2002)

When presented with the opportunity to design his own shoe, Gino Iannucci had simplicity in mind. 'I've always been attracted to dark colours and I wanted the upper and the bottom to be the same,' he explained. The result was a stealthed-out Dunk that featured perforated black leather with suede overlays and charcoal accents applied to the Swoosh, outsole and inner lining. Originally released in March 2002, the 'Gino' Dunk Low was reprised as the 'Gino 2' in May, this time with a totally blacked-out scheme.

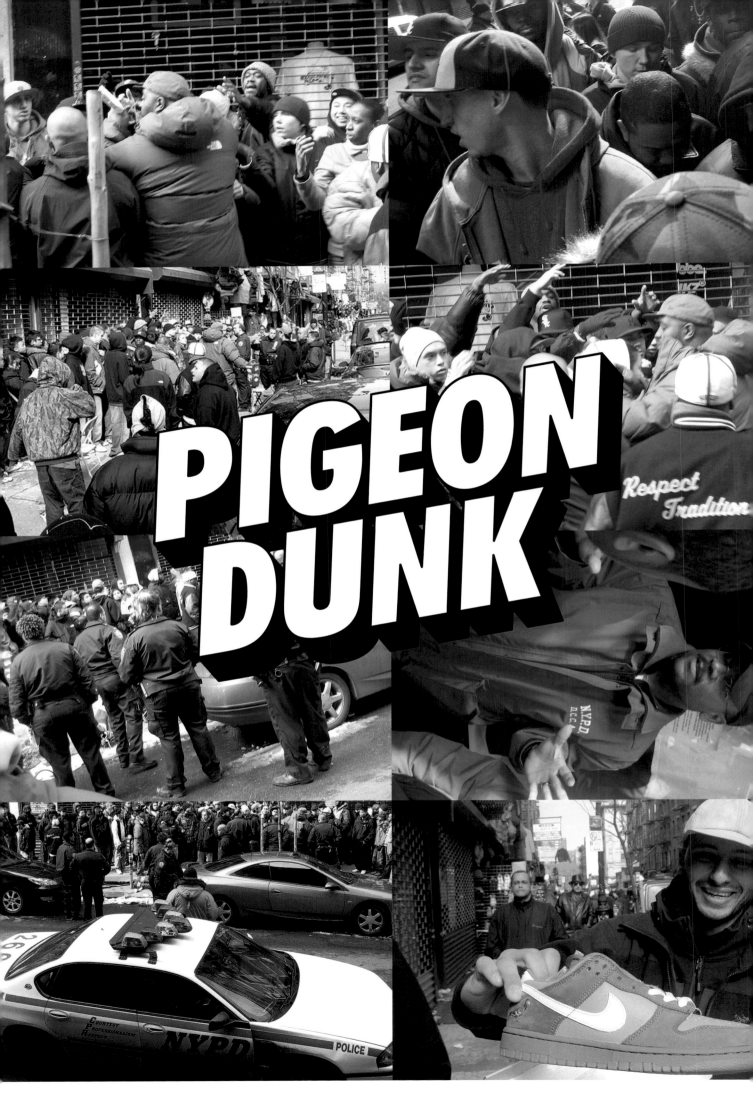

PIGEON DUNK

INTERVIEW Woody

PHOTOS Jeff Staple

One of the defining moments for Nike SB was the release of the New York 'Pigeon' Dunk in February, 2005. The melee made front-page news in the *New York Post*, cementing the Dunk's notoriety and foreshadowing sneaker culture's relentless drive into mainstream recognition. This interview with Jeff Ng (better known as Jeff Staple) appeared in *Sneaker Freaker* not long after the dust had settled. Today, the Reed Space is no longer operational, but Jeff is still out there spruiking the day the 'Pigeon' caused a mini riot.

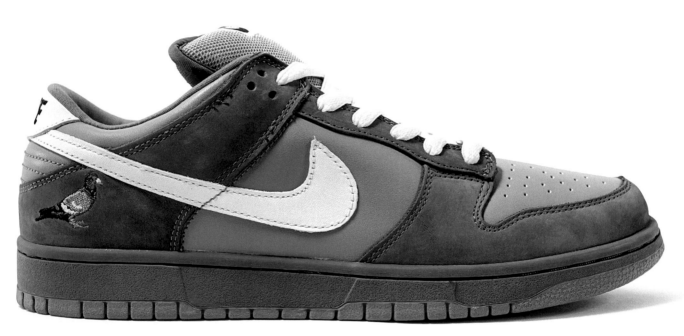

2005: Dunk Low SB 'Pigeon'

How's New York?
The city is culturally dead right now. And I might add the weather here supremely sucks.

You own the store Reed Space and Staple Design. How do they relate?
Staple Design owns and operates The Reed Space. Reed Space is a store and an art gallery and we also do special launches. For example, we launched the Nike Considered line as well as the 'Pigeon' Dunk. Staple Design is primarily a design firm and small independent creative agency. That's our bread and butter. We also do a small clothing line [that would go on to become known as Staple] for some stupid reason. Just for shits and giggles, I guess.

How did the 'Pigeon' Dunk come about?
My good friend Marcus used to run things at Nike SB. He asked us to create an NYC Dunk to align with the White Dunk show. Of course, it was a great honour. To be able to bless the seminal skate shoe and represent our home town all in one project was a dream come true. After sitting around and thinking for a while about what best represented New York, the pigeon kept coming up.

It's something innate to New Yorkers. And something you wouldn't necessarily relate to the city if you didn't in fact live here.

For the record, how many 'Pigeon' Dunks were released?
Nike made 150 for the world and another 30 pieces for five shops – Rival, Supreme, Recon, KCDC and Reed Space. The 30 we had featured a lasered 'Staple' logo and each was individually numbered.

Tell us the story about the days leading up to release?
It was pretty crazy. We had kids sleeping outside in tents four days before the release. There was a snowstorm as well so I was pretty impressed and dumbfounded at the same time. For the most part, the kids were calm and orderly. I thought it was going to be chill.

At what point did you realise there was a major problem?
When I left work the night before, there were maybe 20 kids waiting outside that night. It wasn't until I came to work the next day that I realised there was a problem. About 100–150 kids were pressed up against our front gate and it looked like a Manchester United game was going on inside. About a dozen cops were already there. The NYPD were like, 'What the fuck is going on here?'

SNEAKER RIOT

PIGEON POOPED: Cops try to control the crowd of people waiting on line trying to snare a pair of Nike Pigeon (NYC) Dunk sneakers on Orchard Street yesterday after a riot broke out. Nike made only 150 pairs of the shoes, which were going for $1,000 on eBay.

Lower E. Side rumble over Nikes

By RACHEL SKLAR
and LEONARD GREENE

Talk about sneaker wars.

Customers on the Lower East Side were duking it out in the street yesterday over a limited-edition Nike Pigeon (NYC) Dunk skateboarding shoe.

Not even Big 'Twoine — the 300-pound bouncer hired to keep order — was able to control the dozens of "sneakerheads" who rushed the door at The Reed Space store at 10:30 a.m. yesterday.

When tempers flared, cops were called to restore order.

It was all in the name of target marketing and the desire to be the first.

"It was kind of crazy," said Nico Reyes, a store manager.

Reyes said a fight broke out after a bunch of people tried to skip the line that snaked outside the Orchard Street store.

Dozens of people had camped out for two or three days in freezing temperatures and a snowstorm in hopes of snaring one of what were only 150 pairs manufactured.

Cops said no arrests

Nike Pigeon (NYC) Dunk
by Staple Design

■ Nike's suggested retail price: $69

■ The Reed Space's price: $300

■ Highest eBay price: $1,000

■ Total pairs made: 150

were made in the scuffle, although a man was cuffed, and cops found a knife and a baseball bat at the scene.

Although 70 people were waiting, only 20 people walked away with the prize, a pair of the rare Dunk skateboarding shoes with an exclusive New York twist — a pigeon on the heel.

Although Nike's suggested retail price is $69, The Reed Space sold its small supply for $300 a pair. Sneakerheads are selling them for as much as $1,000 on eBay.

Staple Design, which owns and operates The Reed Space, was tapped over a year ago by Nike

to design the shoe, and chose a pigeon to represent New York.

"It's innate to New Yorkers," said Jeffrey Ng, Staple Design's founder and creative director. "No other bird in the world will let you walk that close to it. It's tough, and it's brave."

Gabriel Paulino, 22, of Jamaica, Queens, waited for two days, driving home only once to change and eat.

But in the melee for tickets, he came away empty-handed.

At least one sneakerhead walked away with a unique souvenir, Ng said, when a real pigeon left its mark on his shoe.

SHOE FRENZY: Two sneakerheads get caught up in yesterday's fracas for Nike Pigeons.

2005: *New York Post*

128

2005: One of 30 happy 'Pigeon' owners

Did you ever, I mean ever, in your wildest dreams think it would go as crazy as it did?
Never. I was totally shocked.

It's funny now but were you scared at all?
I was scared the whole time. There was no way we could satisfy everyone. We had 30 pairs! I had a security team, the NYPD, my staff – nothing could make these people happy. We were seriously, without any exaggeration, on the verge of a full-blown riot.

I heard the cops were giving out summonses for trespassing and weapons were found?
About 10–20 arrests were made. I must say the NYPD was so dope about the whole thing. They were very understanding and helpful. After the crowd cleared, we found machetes and baseball bats.

I also heard they made everyone get a cab home because thugs were waiting for kids on the other side of your store?
Yeah, the Lower East Side of New York is no joke. There were thugs on all four corners waiting to grab kicks from kids. The cops saw this so they called a fleet of cabs to our back door so kids were escorted right into a cab and off they went. One kid didn't have enough for the fare and the cop paid for him. That's the NYPD servicing the community if you ask me!

Does it seem funny to you that anyone would pay $2000 for a Dunk with a pigeon on it?
No. To each his own. That kid who paid two g's for a 'Pigeon' probably doesn't understand why someone would pay $3 million for a Picasso. Everyone has their fix.

What was Nike's reaction to all this?
Some people loved it, some people hated it. Thing is, some people thought we orchestrated and planned the whole thing. It was on the cover of the *New York Post* the following day, so I guess people thought we paid for that as well. Trust me, my life was in danger for most of that day. I don't need press that badly. I just tell people at Nike who were pissed, 'Would you rather that cover have a Reebok on it?'

What does the 'Pigeon' say about sneaker culture in 2005?
It's reaching critical mass. It'll be interesting to see if anyone can top this. I'm not tooting my own horn or anything, I'm just saying I wonder if this is the nail in the coffin for sneaker culture. Or will it continue to be bananas?

It's nice to have peeps go so nuts to get your shoes, but did it make you feel sick as well?
Yeah it did. When those kids were sleeping outside in a snowstorm, I felt bad. I wanted to buy everyone a pizza. Then I realised, wait, these guys are waiting here so they can drop $300 on sneakers. They can buy their own damn slice!

Can you hook me up with a pair? I know you guys got spare pairs under the table somewhere. C'mon, help a brother out!
I'm disappointed I didn't save one pair on ice. I just have the one pair I wear. I guess I felt like if I did, I would jinx myself and we would never be able to do another Nike collabo. I'm very superstitious.
•

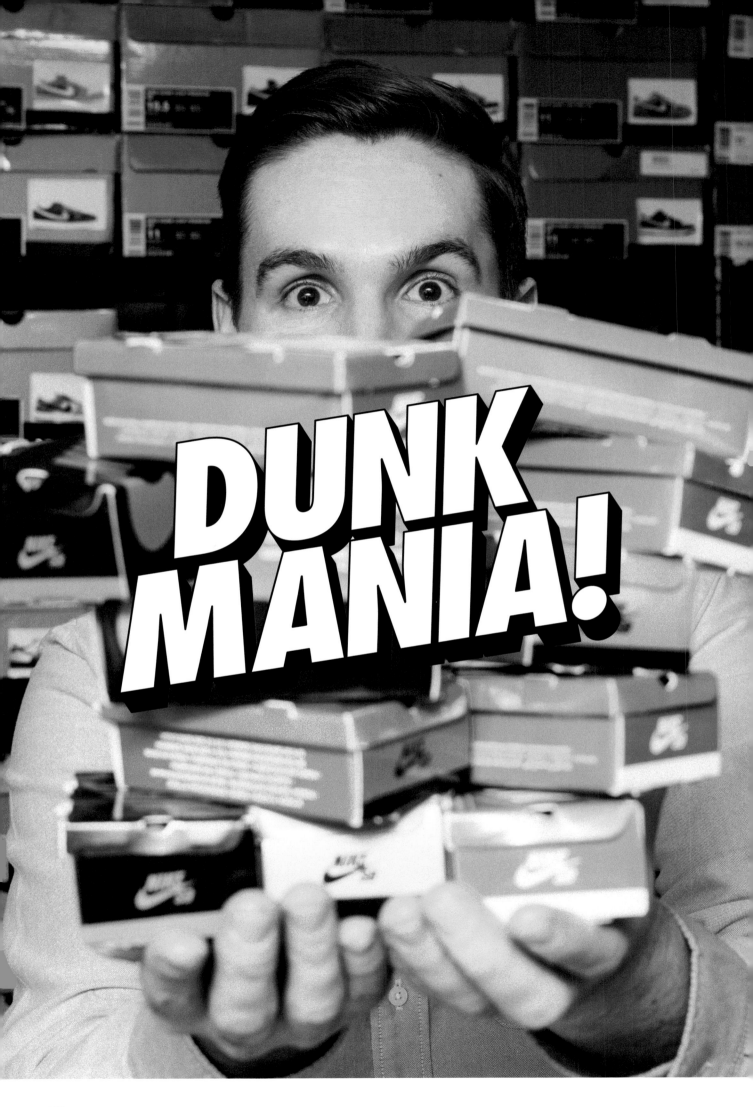

DUNK MANIA!

INTERVIEW Matt Williams PHOTOS Ant Tran

Having powered through a decade and a half of creativity, the SB catalogue is now a sprawling compendium of eras, models, styles and variations. Indeed, there are now hundreds and hundreds of SB releases, shattering our dream of a complete retrospective. While the thought alone now seems ludicrous, Nate Wallace has given it a fair crack. Known online as _nate_w, this passionate Scottish sneakerhead has amassed a colossal stash that spans every generation. We invited Nate to reminisce about his one true love.

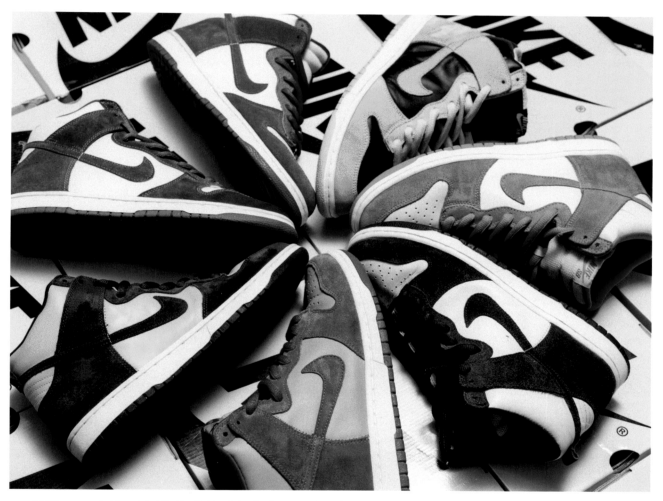

2005: Nike resurrected the original 'Be True To Your School' colourways with an SB makeover

Quite the collection of SBs you've got here.
You could call it that. It's over 550 pairs and counting. I've been buying SBs since around late 2004. It all started with a pair of 'Shimizu' Dunk Highs. I was already a fan of the Dunk and just thought the 'Shimizu' was a great-looking sneaker, but I didn't know about its significance. Around 2006, that all began to change. I started to look into things a bit deeper, reading up on the inspiration behind the shoes. I was instantly hooked and have been ever since.

They were the golden years.
The execution and material choice was second to none. Hype was crazy back then too. You could only get SBs from your local skate shop and if they didn't have them, you would have to scramble and call other stores around the country, hoping they would accept orders over the phone. Things are a lot different nowadays. Hype isn't like it was back then. A lot of the collectors that were around when I started have moved on to other brands or sold off their collections entirely.

There isn't quite the same buzz for newer releases as there used to be either. The shape of the Dunk has changed a lot from the early years and releases are also more readily available. Collectors tend to go after older pairs that they either couldn't get at the time, or that were released before they started collecting. Personally, I would like to see Nike SB go back to selling exclusively at skate stores and also collaborate more, like in the early years.

So, what has kept you loyal to SB after all these years?
My love of Dunks. Aesthetically, it's the perfect silhouette and nothing comes close. There is such an extensive back catalogue and they are still coming out with great colourways and concepts, maybe not as often as I would like, but with releases like the 'Box Series' and 'Denim Forbes' Dunk High, things are promising. There is still a great tight-knit community of collectors that exist on Facebook and Instagram. For the most part, they share the same qualities as the old forums from back in the day.

2007: Top-tier Nike SB stockists received this ceramic 'maneki-neko' statue to promote the 'Money Cat' Dunks

The 'What The Dunk' set a new standard for crazy mismatched materials

Nike SB produced socks to match many of their Dunk releases

Nate's rare figurines of SB team riders Reese Forbes, Eric Koston and Gino Iannucci

2006: Nike SB's 'Three Bears' colab with Japan's Medicom delivered 'Baby Bear', 'Mama Bear' and 'Papa Bear' Dunks together with matching Be@rbricks in 50%, 100% and 400% sizes

With over 550 pairs of Nike SBs, Nate's collection is meticulously organised

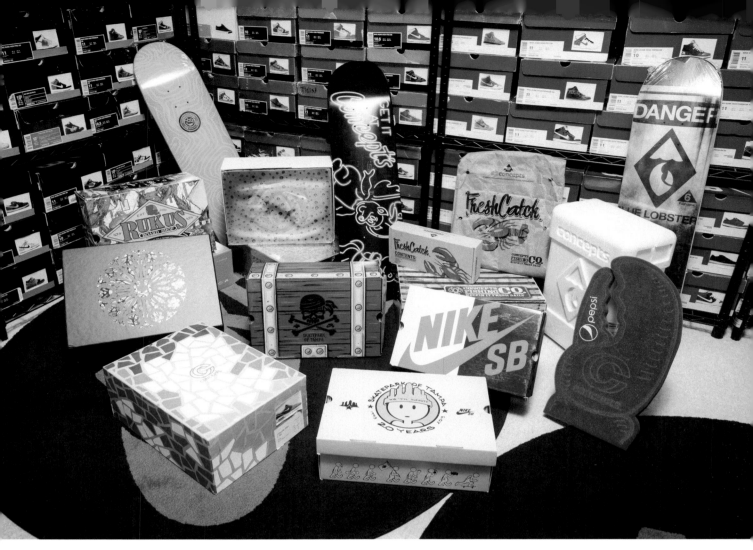

Nike SB loved investing in ornate packing concepts

Surely you must be close to a full set?

I wish! I have the complete Orange Box series from 2002 with the original 16 releases, which was no easy task to achieve – at least not in my size. It took years of hunting to track down a pair of 'Denim Forbes'. I searched eBay, forums and Instagram every single day and never saw them show up in larger sizes. I've also nearly completed both the Silver Box and Pink Box Dunk sets – I'm just missing two pairs from each. I have the majority of Dunks from the Black Box and Gold Box eras as well. From the Blue Box era onwards, it gets a lot trickier. They started to release multiple Dunks every month, as well as a lot of Japan-exclusive GRs. It's almost impossible to keep track of.

Any plans to fill the gaps and call it a day?

The 'City Pack' is the main set I would love to complete, but I can't see that happening anytime soon. I need the 'Paris' and 'Pigeon' pairs to finish it off and they don't come cheap. I also need the 'FLOM' Dunks to finish off the Silver Box set, but they're even harder to find! I still need to pick up a pair of the 'Medicom 3s' to complete the Pink Box set, but other than that, I think I've completed most of the sets I was looking for. Eventually, my dream is to own a complete collection of every released Dunk from the Orange Box to the Gold Box era.

Your shoe room is OCD intense. Are the shoes all worn on the regular?

Admittedly, I'm a little bit obsessive when it comes to keeping the collection in order. I arrange them by box series first and then by model. Years ago, I purchased a little Polaroid Bluetooth printer which I use to print pictures of each shoe to attach to the box. That is a lifesaver. I've always been a strong believer in wearing my shoes. Don't get me wrong, I have a lot of respect for people who keep their pairs deadstock, but the enjoyment for me – especially after the hunt of finding and obtaining a pair – is lacing them up and wearing them. The only pairs I still have deadstock are doubles or pairs that I simply haven't got around to wearing yet.

Must be hard to pick a fave on that basis.

The Orange Box is my favourite series, hands down, because that's where it all started. In my opinion, it's also the most consistent series in terms of easy-to-wear colourways and the quality of materials. The fat tongues on the Dunk Highs are also a plus. If I were to pick my favourite pair though, I'd have to pick the 'friends and family' version of the recent 'Denim Forbes' Dunk High. Someone from Nike SB sent me a pair to coincide with the 15-year anniversary of the brand. The fact that Nike SB actually reached out to me is still surreal and makes them special to me.

Do you have a favourite SB model besides the Dunk?

That's a tough question actually, as I love a lot of non-Dunk models that SB has put out. Looking at my collection and the amount of pairs I have, I guess it would be the Janoski first, with the Blazer a close second. I actually remember when the Janoski first surfaced. I didn't like them at all. It wasn't until I went into my local skate shop to pick up a pair of Dunks that I tried them on and was immediately sold. After that, I was picking up nearly every colourway for the first couple of years.

Even with a collection this big, you must still be hunting for a grail?

That word holds a lot of different interpretations when it comes to sneakers. For me, it's the pair that, regardless of how much money you have, is essentially unobtainable. The 'eBay' Dunk is the ultimate SB grail. They were auctioned off back in 2003 and sold for nearly $30,000 to an anonymous bidder. Even if I had the money, I wouldn't know where to look!

•

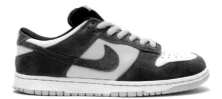

2003: Dunk Low SB 'Buck'

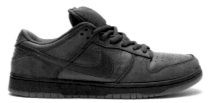

2003: Dunk Low SB 'Barf'

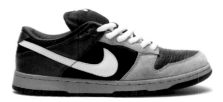

2003: Dunk Low SB 'Futura'

2003: Dunk High SB 'Hulk'

2003: Dunk Low SB 'Heineken'

2004: Dunk High SB 'Lucky'

2004: Dunk High SB 'Unlucky'

2004: Dunk High SB 'Sea Crystal'

2004: Dunk Low SB 'Jedi'

2004: Dunk Low SB 'Hemp Pack – Bonsai'

2004: Dunk High SB 'Tweed'

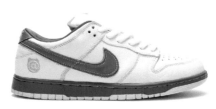

2004: Dunk Low SB 'Medicom 1'

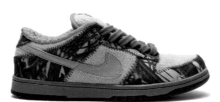

2004: Dunk Low SB 'Hunter'

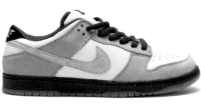

2004: Dunk Low SB 'Homer'

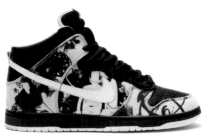

2004: Dunk High SB 'UNKLE'

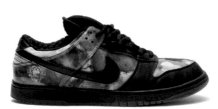

2005: Dunk Low SB 'Pushead'

2005: Dunk Low SB 'Stüssy'

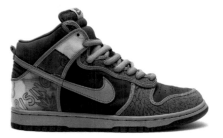

2005: Dunk High SB 'De La Soul'

2005: **Tiffany Dunk**

2005: Diamond Supply Co. x Nike Dunk Low SB 'Tiffany'

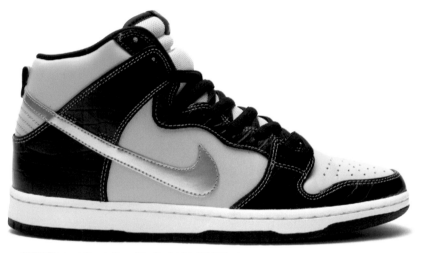

2014: Diamond Supply Co. x Nike Dunk High SB 'Tiffany'

Back in 2005, SB connected with other skate industry icons to produce the 'Team Manager Series'. Real Skateboards, Alien Workshop and Stüssy were part of the gang, along with SB's own Hunter Muraira, who designed a Zoom Team Edition. However, it was the 'Tiffany' contribution from Diamond Supply Co. that really went mental. Sporting a heavy dose of inspiration from high-end jeweller Tiffany & Co., including silver Swooshes and a not-quite-trademark-infringing 'blue' upper, these gator-infused Dunk Lows were an instant sell-out that quickly found their way to eBay listings at a significant premium. Nicky 'Diamonds' Tershay later stated that the colab was a major turning point and that without it, Diamond Supply Co. 'probably would have never broken away from the stigma of just being another skate brand.' In 2014, the Diamond Dunk returned as SB's first retro release. Remade as a high-top, demand was still loco. Skate shops were inundated with interest, with the 561 store in Florida announcing a marketing ruse designed to keep hypebeasts at bay – they would only sell to customers that could bust out a legit kickflip on demand! The 'Tiffany' is definitely one of the most-loved SB concepts of all time.

2007: **What The Dunk**

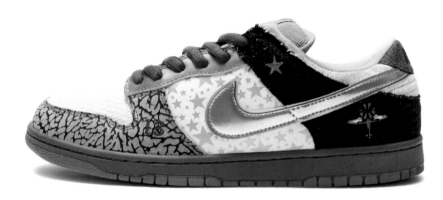

The 'What The Dunk' was produced in 2007 to commemorate *Nothing But The Truth*, Nike SB's feature-length skate film. A mashup of the craziest shoes made during the sublabel's first five years, this was a hilarious dose of overkill. Elements included the neon 'Jedi' laces, elephant print, tie-dye, baseball stitching, plaid and a phalanx of logos, including a 'Raygun' alien and pigeon, plus the numbers '7' and '13' from the 'Lucky' and 'Unlucky' Dunks. Tipping the scales towards total insanity, the left and right shoes were different, making this easily the most bonkers visual statement in SB history. Like the 'City Pack' before it, 'What The Dunk' was only released in cities that coincided with the tour promoting the film. Curiously, the design was spotted in counterfeit form long before the official version was even acknowledged, creating mass confusion among collectors who originally dismissed it as a grotesque Frankenstein!

2005: Dunk Low SB 'Medicom 2'

2005: Dunk Low SB 'Slam City'

2005: Dunk Low SB 'Rayguns – Away'

2005: Dunk High SB 'T-19'

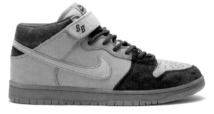

2006: Dunk Mid SB 'Wheat'

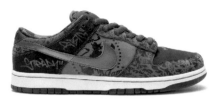

2006: Dunk Low SB 'SBTG'

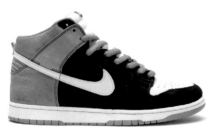

2006: Dunk High SB 'Send Help'

2007: Dunk High SB 'Dinosaur Jr.'

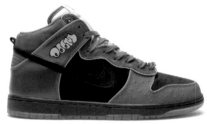

2007: Dunk High SB 'MF DOOM'

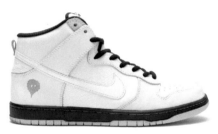

2007: Dunk High SB 'Brazil Custom Series 2 – Rodrigo Gerdal' (Brazil Exclusive)

2008: Dunk Low SB 'Newcastle'

2008: Dunk High SB 'Shoe Goo'

2008: Concepts x Nike Dunk Low SB 'Red Lobster'

2008: Dunk High SB 'Thrashin'

2009: Concepts x Nike Dunk Low SB 'Blue Lobster'

2009: Dunk Low SB 'Ms Pac-Man'

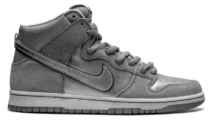

2010: Eric Koston x Dunk High SB 'Thai Temple'

2010: Dunk High SB 'Skunk'

2010: Dunk High SB 'Huxtable'

2011: Dunk High SB 'Cheech & Chong'

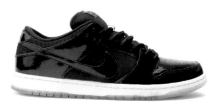

2011: Dunk Low SB 'Space Jam'

2012: Dunk Low SB 'Pushead 2'

2012: Levi's x Nike Dunk Low SB 'Hyperstrike'

2012: Levi's x Nike Dunk Low SB (Bleached Custom)

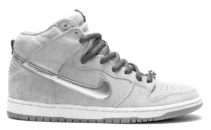

2012: Concepts x Nike Dunk High SB 'When Pigs Fly'

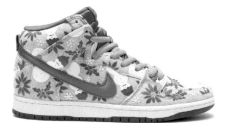

2013: Concepts x Nike Dunk High SB 'Ugly Christmas Sweater'

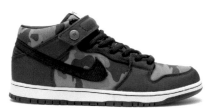

2013: Dunk Mid SB 'Made for Skate'

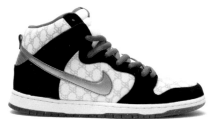

2014: Black Sheep x Nike Dunk High SB 'Paid in Full'

2015: Fast Times x Dunk Low SB

2015: Dunk High SB 'Cork'

Other SB Models

2002: Zoom Air URL 'Supa'

2006: Air Zoom FC 'Denim'

2006: P-Rod 1 'Stash'

2007: P-Rod 2 'J-Rod 2'

2011: Eric Koston 1 'Kobe Bryant'

2012: Zoom Stefan Janoski 'Vino Rosso'

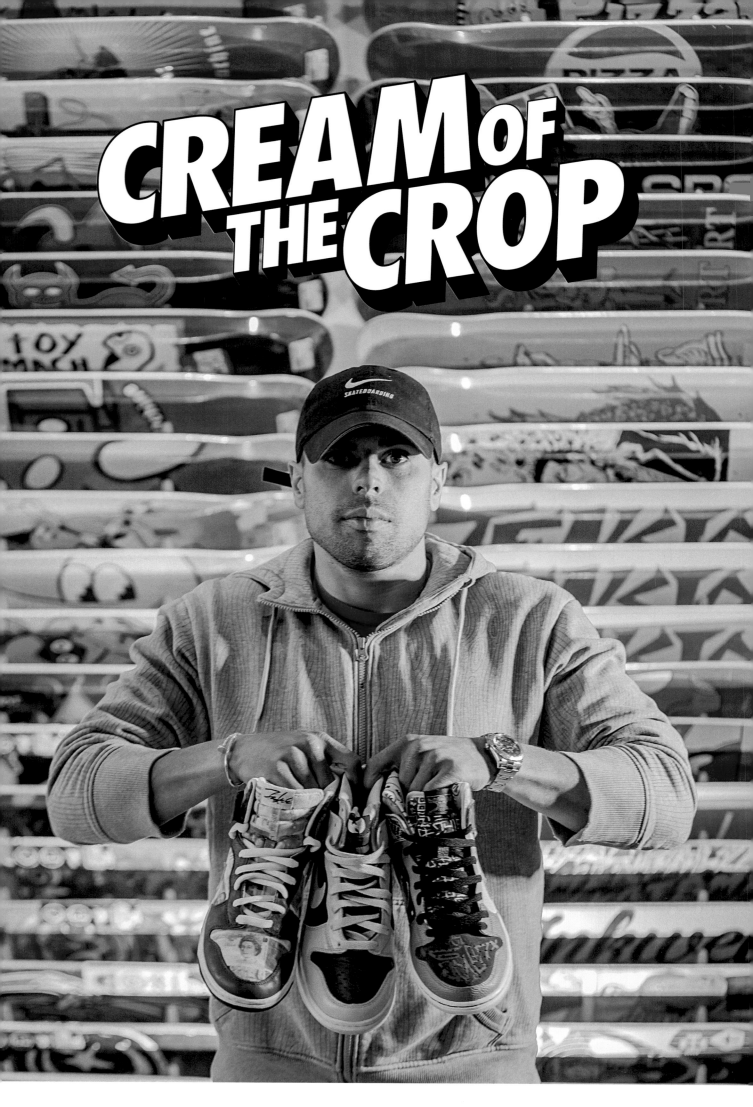

CREAM OF THE CROP

INTERVIEW Matt Williams **PHOTOS** Stan Chan

Nothing beats the sheer elation of busting out kicks that nobody else has. Well, maybe there is one thing: busting out a pair that nobody has even seen. That has gotta be the ultimate in one-upmanship! For New Jersey's Chris Robinson, collecting sneakers is way more than a hobby. Going by the alias *sbcollector*, Chris lives up to his handle with a jaw-dropping stash of samples and uber-exclusives that even *we've* never laid eyes on. Looking through his collection is mind-boggling. Now the owner of his own skate shop, Branded, Chris invited us to take a look at some of his most prized and unique pairs. Time for Nike SB 101 to commence!

2015: Just 11 pairs of 'What The Doernbecher' Dunks were auctioned off for charity, selling for as much as $23k a pair!

You own a skate shop and one of the best SB collections in the world. We heard you don't skate?
You're right, I don't skate at all. [Laughs] I used to when I was real young, but I stopped when I got older.

So, what got you started on this journey?
I don't come from money, so as soon as I got a job and started making money, I started collecting sneakers. I would go to the store and just go crazy. I'd buy too many sneakers to even wear. It started with Air Force 1s and then I really got into Jordans as well. I had some pretty amazing pairs, like the 'Vibe' AF-1s and 'PlayStations' too. Though, by 2006, I started getting bored.

My friend had told me about a pair of Dunks called the 'Mork & Mindys'. I was intrigued, as I used to watch the show as a kid. Not knowing anything at all about SB at the time or where to buy them, I started asking around and found out that my local skate shop would be carrying them. It's actually the very same shop I own today. I begged the owner to make sure he held me a pair as soon as the shipment came in. Thankfully he did.

I'll never forget opening the box and noticing instantly the strong resemblance to Robin Williams' character on the show. I was even more blown away when I flipped them over and saw the rainbow outsole, just like Mork's suspenders. I was automatically hooked. I ended up selling off all my Air Force 1s so I could buy more SBs!

City Pack

This is the epicentre of the hype explosion that sent the Dunk SB skyrocketing into four-figure territory. A globetrotting exercise, the 'City Pack' sent the Dunk on a world tour that was limited to a minuscule 202 pairs per colourway. The story begins with the release of the 'London' Dunk in 2003. Sold through Footpatrol, the shoe was an appropriate blend of drab grey suedes with the River Thames embroidered in blue across the heel.

The following year, the 'Tokyo' Dunk was timed to celebrate the arrival of the *White Dunk: Evolution of an Icon* exhibition. Featuring a pristine, all-white canvas upper, the minimalist design was notable for the absence of Nike branding (aside from the Swoosh). The third release arrived in 2005, just as the exhibition made its way back to Europe. The 'Paris' Dunk featured a collage of imagery by French painter Bernard Buffet, with no two pairs alike. The final Dunk in this quartet was designed by Jeff Staple. Themed after the city's ubiquitous airborne pest, the 'Pigeon' made the front page of the *New York Post* after riots erupted among thirsty sneakerheads who had salivated over the sky-high prices paid for other 'City Pack' Dunks. The 'Pigeon' was sold only at a handful of NYC skate shops, but it's the 30 individually numbered and laser-engraved pairs released through Reed Space that remain hotly coveted. The pair owned by Chris is number 11 of 30.

2003: Dunk Low SB 'London'

2004: Dunk Low SB 'Tokyo'

From customer to store owner, bet you didn't expect that! Do you see things differently since becoming a retailer?
Nike SB always gears everything towards the skaters, which is understandable because they're skate shoes after all. But I own a skate shop with a skate park right behind it and I swear I've never in my life seen one kid skate in a pair of Dunks.

Never?
Not once. I mean, I'll go out to dinner with the skaters and they're wearing Dunks. It's like their go-to casual shoe – but they never skate in them.

Right now, Janoskis are still big. So are Blazers and Bruins. A few guys used to skate in the Classic, but SB has since got rid of those. I've been to street league and I've seen the Nike SB team skate the Dunks but I've never heard an actual kid say, 'Hey, I'm gonna skate these Dunks!'

You do know this article is about the Dunk, right?
I know! They've actually tried to slim the Dunk down a lot over the years to cater to skaters, but they're still not skating them. It's just not a skate shoe.

With a collection like yours, I don't think we'd be skating them either! [Laughs] What's your rarest pair?
If you're talking most expensive, then that'd be the 'What The Doernbechers' by far, but I wouldn't say they're my rarest pair. Some of the samples I own are the only known pairs in existence.

Such as...
The 'Off Spray' and 'Joker' Dunks, which are tied for first place as my favourites. I wanted them for so long. After about eight years of waiting, the people who owned them were finally ready to part ways. I've also been told that the only other people who own pairs of the original 'Entourage' prototype with the blue Swoosh are Mark Wahlberg and one of the show's other producers. The laser-

engraved 'Pigeon' Dunks were actually the hardest pair to track down. There were only 30 pairs made and sold to the first 30 people in line at Reed Space on the day of release. I am still yet to see a pair in my size, which is a US9, so I had to settle for a 9.5. I'm pretty lucky though. About 90 per cent of SB samples are a size 9, so I'm fortunate to be able to wear almost all of them. As long as I can get doubles, I have a pretty strong practice of 'one to rock and one to stock'. However, there are a few singles that I've still worn. I like the fact you don't have to worry about SBs falling apart after a decade, unlike a lot of the old runners.

Must be a hard decision when you've got the only pair in the world. What got you started on collecting samples?
I love the samples because they are simply some of the rarest shoes ever made. I used to check the sample thread on 'N-SB' daily to see all the latest leaks. When I saw the 'Loon' and 'Gucci' samples for the first time I just knew I had to own them one day. From that moment I was hooked. Since then, I have owned almost every SB sample out there at one time or another. I have had to sell a few from time to time, but I try to keep them all. I wish I had kept my 'Iron Maiden' and 'Deftones' samples, but I have my eyes open and I'm sure I will get them back one day.

It's all about the waiting game. Where do you get all this stuff?
From wherever I can. Outlets, eBay, sneaker shows – it's all luck of the draw. Sometimes, when I've been really lucky, I've met someone who either knows someone who works or used to work for Nike. I would honestly attempt to buy any Nike SB sample I come across. It's an addiction!

We can tell! [Laughs] You've got four pairs of the infamous 'Heaven's Gate' Dunk Highs – that's insane.
A sneaker as limited as that is so rare that if you tried hard enough you might be able to own the majority of pairs in existence. I owned seven pairs at one point, but I sold a few. Personally, I don't

2005: Dunk Low SB 'Pigeon'

2005: Dunk Low SB 'Paris'

2005: One of 30 limited edition Dunks

understand why they made a Dunk in memory of a mass suicide, but I do love the colourway. I honestly just love samples and wouldn't mind owning every pair of every sample. One of the hash tags I use on Instagram is #nikesbhoarder, because I love to hoard multiples.

Why so much love for samples?
A lot of shoes are much better in sample form than the released version, like the 'Entourage' Low samples, which actually feature *Entourage* branding. Other pairs like the 'Peacock' and 'Goofy Boy', where they changed the materials slightly, just look much better than the released versions. However, in some cases the released versions actually came out better than samples, like the 'Donatello' edition. Even the 'Freddy Krueger' Lows that were never released look better than the original prototype, so it does vary. Even in cases where the sample wasn't altered aesthetically, you still find that the sample is made with much better quality materials.

Speaking of the 'Kruegers', are there any canned samples you wish had actually come out?
I think all of them are amazing, but honestly, I'm happy that they haven't brought any of them back besides the 'Loon' and 'Neon J' pack. It's their mystique as unreleased samples that cemented their place in SB history. Back when they were samples, those pairs would trade hands for thousands of dollars, but after release you could find them all over eBay for 50 bucks, which I feel takes away from SB as a whole. People want to be unique, which is why they pay so much to obtain them – to make sure they are the only person with a certain style. Retroing an iconic sample just doesn't sit well with collectors, whether they have that specific shoe or not.

Sounds like this happened to you.
I actually purchased a pair of 'Loons' for a lot of money some years back, but thank god I sold them way before the retro dropped. It is a risk because Nike can ultimately do whatever they want. I just hope that they see retroing works when they do the high

to low conversions, like with the 'Tiffanys'. It keeps the original unique. Bringing back samples – or even just older SBs in their original form – ruins the fun of collecting. People want something way more if they can't have it, and like the 'Undefeated' and 'Eminem' Air Jordan 4s, shoes that are iconic still have an effect on the entire brand. They will forever induce hype for the brand as a whole among the collectors, and I believe it's the same with some of the more unobtainable Nike SB samples.

Is there a sample that still eludes you?
My ultimate grail is the scrapped 'Supreme' Dunk Low. They were similar to the 'Supreme' Dunk High released back in 2003, but instead of gold stars, they feature the Nike logo repeated in gold with a Swoosh underneath. I've got the released versions, but I like the samples more because they are super limited. [Laughs]

I'm sure they'll set you back a bit. What are SB prices like nowadays?
SB goes up and down like crazy. Three years ago 'FLOM' Dunks were going for $10k and now you can't even sell them. 'Paris' Dunks were going for the same money too, but some dude just offered me three pairs for $6k each. SB fluctuates so much. I think part of that is because SB is a lot more mainstream now. You can find them in stores everywhere, whereas SB used to be sacred to skate shops. Anyone can get a pair nowadays and they're practically all general releases. It takes away the charm and the demand. Some of my samples that I paid $3k or $4k for, I would never get that money back.

Would you ever sell them?
No. I bought them because I wanted them. My collection is still growing and I don't have any plans to stop collecting SB!

•

Freddy Krueger

Intended to release in 2007 as part of a horror movie pack that also included a 'Jason Voorhees' Dunk High and 'Dawn of the Dead' Air Trainer 1, these Dunks were 'allegedly' based on horror icon Freddy Krueger. Sadly, New Line Cinema, who own the rights to *A Nightmare on Elm Street*, were pissed when they found out about this unofficial tribute. A cease and desist was dispatched, but unfortunately for Nike the notice arrived just after the shoes had been shipped. The entire production run was destroyed, but a few pairs still managed to find their way out of the system, reportedly from a Mexican skate shop that flipped them way early. Another batch with oil-stained uppers was 'allegedly' saved from a fiery demise by a savvy Nike employee. What we do know is that two 'Freddy Krueger' versions exist. Chris also owns the early prototype, of which only a handful are known, while the retail version can be identified by the knitted sweater-like upper and blood-splattered overlays.

Geoff McFetridge 'MOCA'

Heaven's Gate

Every Nike SB is designed to shred, but you'll need a massive set of cojones if you plan on hitting the half-pipe in these limited-lifespan Dunks! Produced for the launch of the *Art in the Streets* exhibition at the Los Angeles Museum of Contemporary Art (MOCA), just 24 pairs were created by artist Geoff McFetridge. Each was assembled from a unique piece of the artist's work, which was applied to reinforced paper. The pairs were auctioned off for charity, with all proceeds donated to the MOCA Foundation. Alas, the pair Chris owns is a size too big, so he's unsure if he'll ever wear them out and about. Once it rains, these are done!

Even though it was never officially released or endorsed by Nike, the most controversial SB product was the 'Heaven's Gate' Dunk High. Inspired by the cult of the same name, the shoe was designed by SB skater Todd Jordan. In 1997, the cult's members committed mass suicide in a misguided (to put it mildly) attempt to board an extraterrestrial spacecraft trailing Comet Hale-Bopp. The bodies were found covered by purple cloths, dressed in matching uniforms and black and white Nike Decades – which is one model the Swoosh definitely has no plans to retro anytime soon! It is still unclear whether Nike was even aware of the shoe's sinister background. When Todd Jordan disclosed the story in an interview, the release plans were immediately scrapped and only a handful of samples made it out alive. Chris currently owns four pairs.

Charlie Brown

Another Dunk rumoured to have suffered from legal issues, this mid-top duo are Charlie Brown-themed samples, with the zigzag stripe resembling the polo shirt worn by the cartoon character. Other rumours suggest that they were based on Homer Simpson, as a symbolic reference to his distinctive hairline. Regardless, neither pair saw the light of day. Chris supposedly has the only two in existence! D'oh!

OFF! Bug Spray

These garish Dunks bear an uncanny resemblance to the palette of OFF! bug spray. They were allegedly slated for release around the same time as the 'Mosquito' Dunk Low, though the reason for the shoe's cancellation remains unknown. To Chris's knowledge, this is the only pair in the world.

Entourage

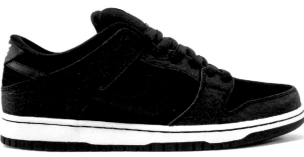

To celebrate the final season of *Entourage* in 2011, the 'Lights Out' Dunk was gifted to the show's cast and crew. That's obviously rarified Air, but Chris has gone one step further – unearthing this variation with bright blue branding on the Swoosh and heel. Only three pairs reportedly exist! The others are owned by Mark Wahlberg and another of the show's producers. A second version was released to the public a few years later with the gum outsoles and *Entourage* branding deleted. That pair is known within the SB community as the 'Nontourage'.

Joker

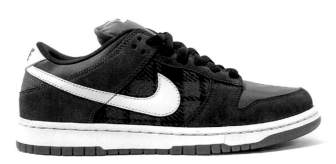

The story goes that these Dunks were based on the Batman villain and were timed to release at the same time as *The Dark Knight*. However, after the controversy around Heath Ledger's untimely death, the release plan was junked for obvious reasons. The version with the black midsole is made from denim, while the other is a combination of nylon and suede. As Chris told *Sneaker Freaker*, he missed out on these Jokers the first time around and it took another five years to track them down!

2004: Futura x Nike Dunk High SB 'For Love or Money' (Friends & Family)

2006: Stones Throw x Nike Dunk High SB 'Quasimoto' (Friends & Family)

2006: Dunk Low SB 'White Purple Pigeon' (unreleased sample)

2006: Dunk Low SB 'Jason Voorhees' (unreleased sample)

2006: Dunk High SB 'Don Quixote' (unreleased sample)

2006: Dunk Mid SB 'Peacock' (unreleased sample)

2008: Made for Skate x Nike Blazer SB (24 pairs worldwide)

2008: Michael Lau x Nike Blazer SB 'White BMX'(Friends & Family)

2009: NJ Skate Shop x Nike Dunk Low SB 'Toxic Avenger' (unreleased sample)

2009: Concepts x Nike Dunk Low SB 'Yellow Lobster' (Friends & Family)

2009: Dunk High SB 'Purple Haze' (unreleased sample)

2009: Michael Lau x Nike Zoom Stefan Janoski 'White Gardener' (Friends & Family)

2010: Dunk Low SB 'Black/3M' (unreleased sample)

2012: Dunk High SB 'Raging Bull' (unreleased sample)

2012: Dunk High SB 'Pushead 2' (unreleased sample)

2015: Dunk High SB 'What The Doernbecher' (11 pairs worldwide)

Reebok Pump

Published in *Sneaker Freaker* Issue 16, August 2009

EDITOR'S NOTE: WOODY

Ask any kid from the early 90s and they'll all tell you the same thing – Reebok Pumps were the absolute business. Retailing at over $340 where I grew up, they were slightly out of my league, but that's a whole other story. The inflatable widget is still the most ingenious gimmick in the history of footwear, but the Pump's complex engineering was never truly appreciated until this rollicking interview with Paul Litchfield was published. With Dominique Wilkins, Michael Chang, Dee Brown and even Greg Norman pumping up and airing out, supersonic sales growth propelled Reebok back to number one. Just be careful if you call legendary shoe-dog Litchfield 'obstreperous' – he has the memory of an elephant and a famous left hook!

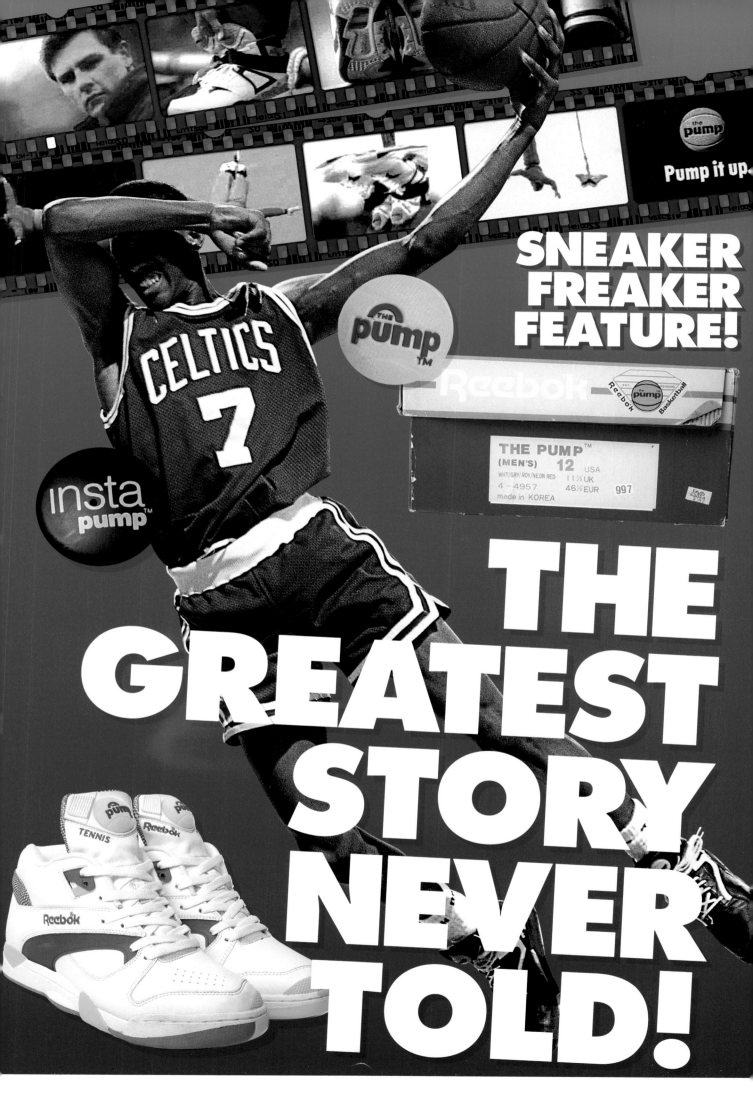

SNEAKER FREAKER FEATURE!

THE PUMP™
(MEN'S) 12 USA
WHT/GRY/ROY/NEON RED 11½ UK
4 - 4957 46½ EUR 997
made in KOREA

THE GREATEST STORY NEVER TOLD!

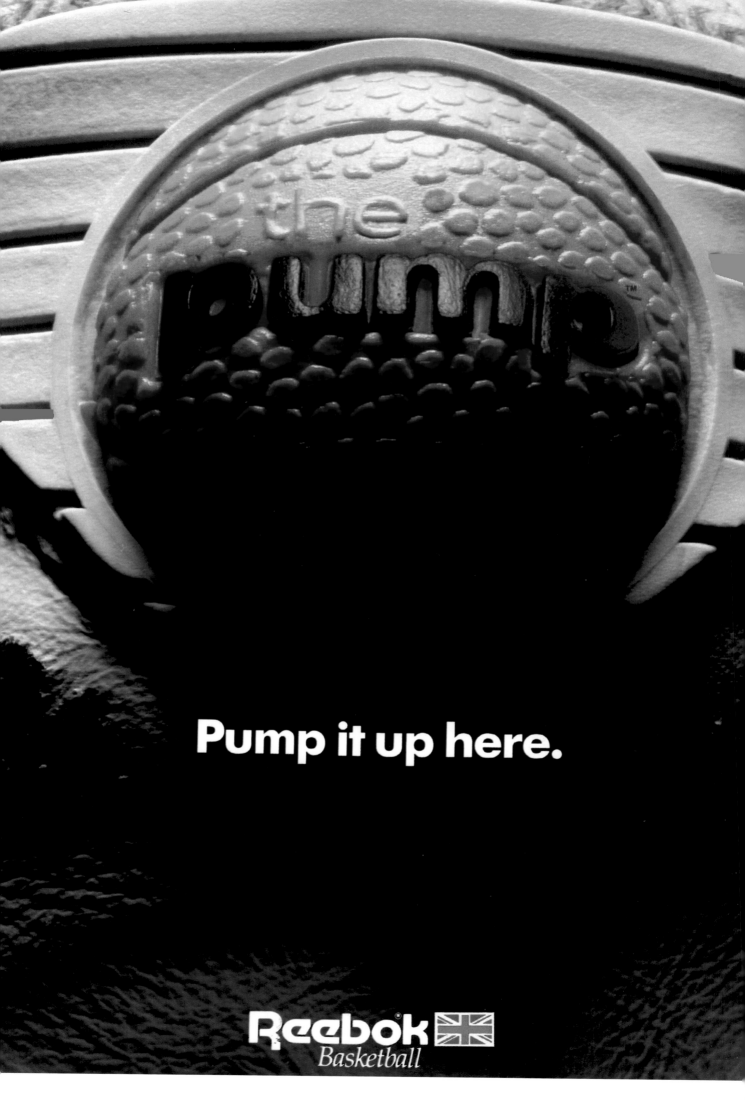

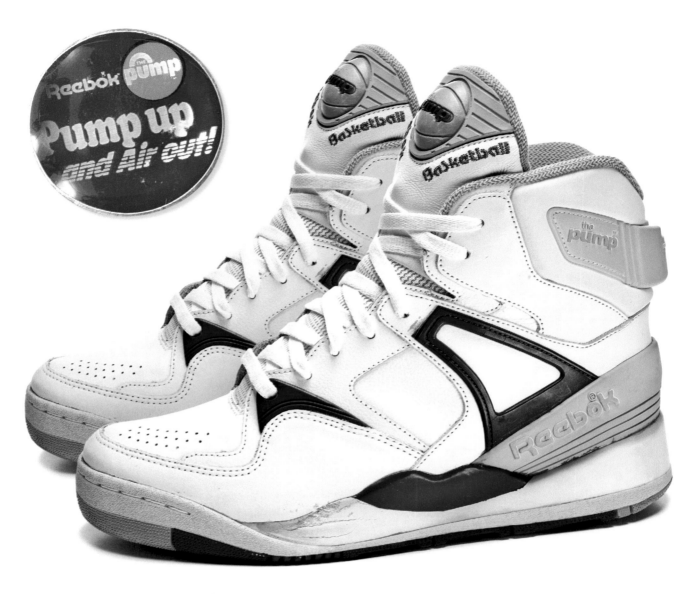

1989: The Pump (production prototype)

KICKING BACK, BROWSING THIS FINE PUBLICATION WHILE SPORTING YOUR VULCANISED, TONAL NUMBERS, YOU MIGHT HAVE FORGOTTEN JUST HOW MADCAP THE TAIL-END OF THE 1980s WERE. IN A 1991 EPISODE OF *THE SIMPSONS*, NED FLANDERS GETTING A 'WHERE'D YOU GET THOSE?' FROM HOMER IN REFERENCE TO HIS GIMMICK-PACKED ASSASSINS WAS PARODY, BUT ONLY JUST. THINGS WERE CRAZY. THIS WAS AN ERA WHEN BIGGER WAS INDISPUTABLY BETTER. YOU DISAGREE? YOU MUST BE POOR THEN. BIG HAIR, BIG PHONES, BIG-BUDGET MOVIES, SMALL RESTAURANT PORTIONS AND BIG BILLS. YEP, FANS BEFORE MESSAGE BOARDS WERE SPOILT FOR CHOICE AS OPPOSED TO BOGGED DOWN BY THE LOOMING RETRO AVALANCHE.

You see, no one wanted old! Things shifted so fast that to look back would have gotten you lapped. Sure, model names were repeated, but they had to be brand new updates that incorporated the latest gimmickry. Being told that something was merely encapsulated wasn't good enough! Like a bastardisation of Bruce Lee admonishing a pupil, people didn't want to think – they wanted proof!

Nike had finally allowed us to 'see' that Air wasn't a placebo, giving the wearer a false sense of shock-absorb immortality in 1987. adidas brought us Torsion in 1988 (twinned with Soft Cell) and the beauty was the ability to touch, prod and straight-up gawp at futurist footwear. The byproduct of this escalating madness was supremely

visible, though functionally questionable. Remember Filas that converted via a removable collar? Converse's Energy Wave (a more wearable precursor to the terrible React Juice) complete with cutaway to prove the marbled foam was there? Obviously you recall PUMA's Disc system with added Trinomic, but how about Wilson's robotic Eminence model? K-Swiss's Formula 18? adidas pioneered with the removable plug and inserts for a 'custom' fit nearly a decade before, and their Micropacer concept was remarkably forward-thinking; but by 1993 their Tubular technology – for all the runner's good looks – had taken a decidedly pumped detour into inflatable cushioning.

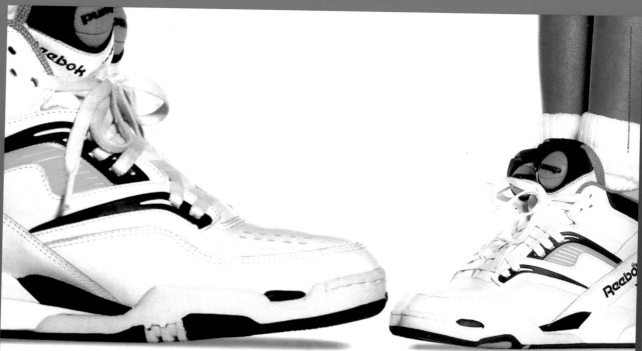

You may not be big enough to play Dominique Wilkins. But you're big enough to wear his shoes.

We've taken Dominique's favorite shoes (size 13), and customized them especially for kids• (boys', size 12½ through 6). So look out big guy.

Dominique Wilkins

1991:
Pump
AXT Mid

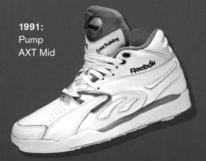

1991:
Pump
Aerobic Lite

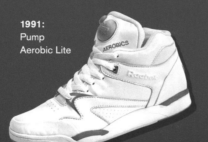

1990:
Court Victory

String Tension: 64 lbs.

Grip Size: 4½.

Right Foot: 21 Pumps.

Left Foot: 16 Pumps.

THE PUMP™ Court Victory. A fully customized fit. Even for odd-sized feet.

If your interest in sports extends beyond tennis, then you're probably already aware of THE PUMP™ basketball shoe.

Well, now the benefits of this revolutionary technology have been built into a tennis shoe.

By squeezing the ball on the tongue, an air-bladder inflates around the mid-foot area to give both feet a perfect, personalized fit.

The net effect, aside from being extremely

comfortable, is an amazing degree of lateral and medial support and stability.

So you'll be able to move around the court with total confidence.

And move you will. For THE PUMP™ Court Victory tennis shoe is surprisingly light, due to a midsole of Hexalite technology. A honeycomb material that offers maximum cushioning with minimum weight. While the outsole gives you

glue-like traction, thanks to an exceptionally durable compound called Dura Trac Plus.

All of which means that you'll spend less time thinking about your feet. And more time thinking on them.

Reebok

Michael Chang

152

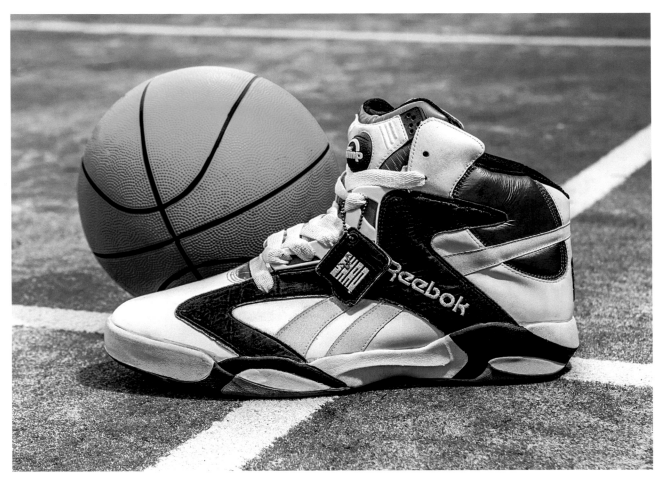

1993: The Shaq Attaq promo edition was made to match Shaq's size 20 feet

'YOU CHOOSE WHO WILL LOSE A PAIR OF SHOES,
WORD, THE ONES WITH THE REEBOK PUMPS GET
THEIR RUMPS REARRANGED FOR THEIR CHANGE,
NOW THEY'RE DOWN IN THE DUMPS.'

1991: Del Tha Funkee Homosapien, 'Hoodz Come in Dozens'

THE BATTLEGROUND

This colossal story, however, focuses initially on two brands.
Nike were upstarts during the 1970s, but in the early 80s, Reebok
exploded with a focus on women that blindsided the Knight brigade.
Prior to Pump, many won't recall hardwood and Reebok in the same
sentence, but some solid models like the Pro Legacy made noise,
not to mention the 'Bok pilfering Nike athletes such as the Celtic's
Danny Ainge (later seen in the Pump 'Talking Heads' commercials)
and the late Dennis Johnson. By 1987, Reebok was a certified
phenomenon, overtaking Nike with a 26 per cent market share
of the athletic shoe sector. Nike's aggressive 'Just Do It' campaign
saw them reclaim dominance eventually, but before that happened,
Reebok built a new weapon for their armoury. Several actually.
The irony was that both brands were using the same volatile
cocktail, albeit in different oxygenated formats.

THE EIGHTIES

Reebok's Paul Litchfield was the man challenged by the perennially
pushy Paul Fireman to make the Pump concept work. The idea was
easy to grasp. Pump would use inflatable chambers that pump up for
a custom fit. The reasoning was logical: no two feet are alike, and the
variation can be a big hindrance in competition. Beyond performance,
the notion of 'customisation' – even at this basic inflate/deflate level
– is hugely appealing to consumers aesthetically.

Litchfield's challenge was to encapsulate and brand this technology
without it becoming too far-out and extra-terrestrial, and to do so on

a reasonable budget and in an insanely short timeframe. It was
far from an easy gestation. Stressful too. Teaming up with
Massachusetts-based firm Design Continuum in 1988 brought
additional expertise. The biggest issue was how to keep the air
stable in the flexible film pouches.

By the time the 1989 Sporting Goods Manufacturers Association
conference took place on February 10, a demo version of Pump was
exhibited. At this point, Reebok's Energy Return System (ERS) was
on the market and rumoured to be backed with 'The Revolution Is
Over' as a tagline. ERS was partnered with a 'mysterious inflating
technology', although oddly, it wasn't the mooted star of the show.
Reebok still alluded to the mysterious 'Dr. Detroit' shoe that carried
a mini-trampoline in its sole, which sounds not entirely dissimilar to
LA Gear's Catapult technology (LA Gear also created the craptastic
'Regulator' Pump knockoff).

Other ideas touted included a model that would change colour
with the insertion of cartridges, and Hexalite, the honeycomb padding
apparently used in space shuttle seating.

At this point, Nike were in the process of releasing the clunky
Air Pressure, which used a special air-filled accessory to inflate the
ankle area. On November 24, 1989, Reebok's 'The Pump' ('A new
idea that's going to fly') hit shelves. Complete with a 'deflate' button
on the heel, the sneaker's basketball valve branding was instantly
appealing and the $170 price tag was lofty enough to confer
aspirational status. It's still a crazy price all these years later, but
remember, kids, this was the 80s and bigger was infinitely better.

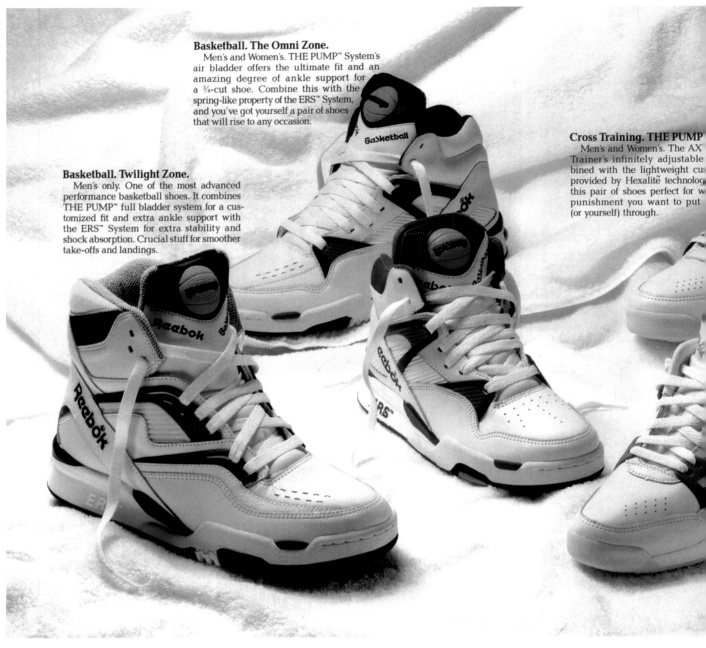

Basketball. The Omni Zone.
Men's and Women's. THE PUMP™ System's air bladder offers the ultimate fit and an amazing degree of ankle support for a ¾-cut shoe. Combine this with the spring-like property of the ERS™ System, and you've got yourself a pair of shoes that will rise to any occasion.

Basketball. Twilight Zone.
Men's only. One of the most advanced performance basketball shoes. It combines THE PUMP™ full bladder system for a customized fit and extra ankle support with the ERS™ System for extra stability and shock absorption. Crucial stuff for smoother take-offs and landings.

Cross Training. THE PUMP
Men's and Women's. The AX
Trainer's infinitely adjustable
bined with the lightweight cus
provided by Hexalite technolog
this pair of shoes perfect for w
punishment you want to put
(or yourself) through.

1990: Reebok Pump line-up

THE NINETIES

As 1990 dawned, Reebok excitedly welcomed consumers to a new decade. The first Pump model headlined a deep roster including the Omni Zone, Twilight Zone and the SXT Pump, the star of a new range known as Sports Conditioning. This is where things heat up. A patent for a 'Reebok Athletic shoe having inflatable bladder' was submitted by Paul Litchfield and team, filed on September 27, 1990, and issued on 19 May, 1992. The patent covers an athletic shoe with 'an inflatable tongue or bladder for a more secure fit to the user's foot. The bladder may include a plurality of chambers with a valve to selectively inflate the chambers.'

A patent submitted by Bruce Kilgore and company for Nike, (which listed them as the inventors of a 'Shoe bladder system') is more specific, covering a dual-chamber switchable system. Was this ever implemented, seeing as the Pressure system seemed confined to the ankles of three Nike shoes? Was it a tactic to stall the Pump's growth as a technology? Did Nike abandon further plans? Who knows.

The end result saw Reebok snatch market share immediately. Nike downplayed the Pressure's lack of success by pointing to an apparently small run of just 35,000 units, and claimed the lack of advertising was on account of the target audience being players with ankle problems. That didn't stop Reebok infamously putting the

inflatable boot in their banned TV spot depicting a bungee jumping Nike guy plummeting to his apparent doom, while the Pump wearer stayed safely shackled. Genius.

Dominique Wilkins of the Atlanta Hawks was an early adopter of the Basketball Pump, and in the following months, different bladder designs allowed the technology to be added in a less bombastic 'robo-shoe' style. Why not shift to another type of court? Michael Chang was duly added to the Reebok roster. Chang was an appealing proto of the Energizer Bunny – fast and relentless – and the youngest-ever male winner of a Grand Slam singles title (at 1989's French Open). His signature model became known as the Court Victory and contained Hexalite as well as a nifty tennis ball trade on the usual basketball Pump mechanism. The same year saw the release of the Twilight Zone (one of the finest basketball shoes of the time), which streamlined Pump DNA. Getting the Chicago Bulls' John Paxson and Horace Grant on the books didn't hurt either.

In 1991, Nike's implementation of Pressure on their Force 180 and Air Command Force (endorsed by David Robinson and Woody Harrelson as 'Billy Hoyle') felt a little tokenistic, arguably ruining the silhouette of both shoes. This was the final year of Pressure, but for Reebok, Pump escalated into cross-training (CXT and AXT), off-road (OXT 'Off-road vehicles for your feet!'), golf shoes, walking shoes, aerobics shoes and running. The Pump Running Dual was the perfect

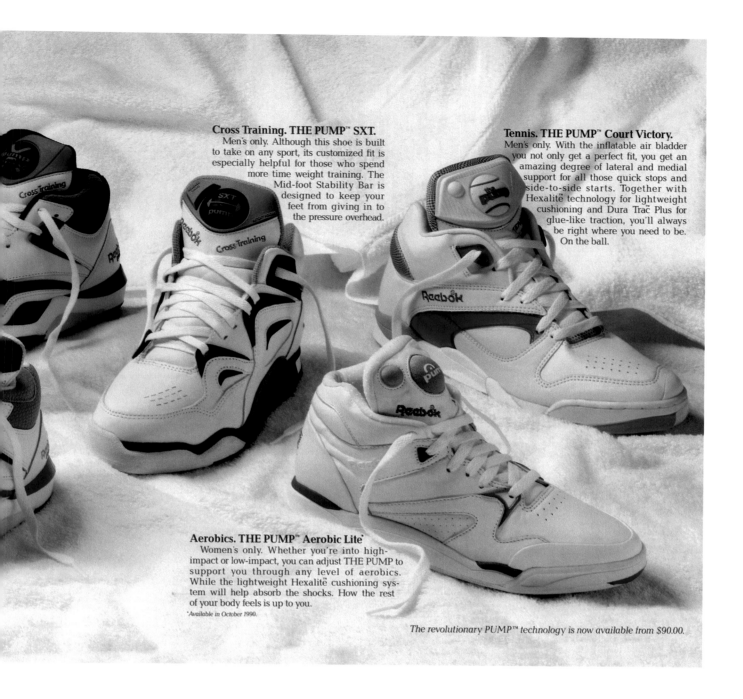

Cross Training. THE PUMP™ SXT.
Men's only. Although this shoe is built to take on any sport, its customized fit is especially helpful for those who spend more time weight training. The Mid-foot Stability Bar is designed to keep your feet from giving in to the pressure overhead.

Tennis. THE PUMP™ Court Victory.
Men's only. With the inflatable air bladder you not only get a perfect fit, you get an amazing degree of lateral and medial support for all those quick stops and side-to-side starts. Together with Hexalite technology for lightweight cushioning and Dura Trac Plus for glue-like traction, you'll always be right where you need to be. On the ball.

Aerobics. THE PUMP™ Aerobic Lite`
Women's only. Whether you're into high-impact or low-impact, you can adjust THE PUMP to support you through any level of aerobics. While the lightweight Hexalite cushioning system will help absorb the shocks. How the rest of your body feels is up to you.
`Available in October 1990.

The revolutionary PUMP™ technology is now available from $90.00.

example of how the technology could be pared down. At this point, six modes of support were on offer: full-foot, midfoot, collar, arch, footbed and the more elaborate Dual Chamber, which required a switch on the heel to differentiate between bladders.

THE NO-LOOK

Shots were being fired as Reebok athletes happily aired-out their opponents as well as Nike in the ongoing 'Pump Up and Air Out' campaign. Chang happily hurled away Agassi's Tech Challenge III, dismissing him as a 'Rock 'n roll tennis guy!' Dominique Wilkins managed to reference both Michael Jordan verbally and David Robinson subliminally as he sent the Command Force skyward for all the wrong reasons. Even golfin' Greg Norman got in on the action and sent Curtis Strange's Nike golf shoes packin' ('Oh, and Curtis? Don't be so Strange!'). Recruiting Portland Trail Blazers legend Bill Walton was another tactically ballsy move on Reebok's part.

Sometimes, however, a single action can achieve more than any marketing budget. On 9 February, 1991, relatively unknown Celtics guard Dee Brown took on Shawn Kemp (a fan of the Nike Ultra Flight who later landed at Reebok and was given the Kamikaze model in the mid 90s) in the NBA Slam Dunk Contest. Improvising, Dee opted to pump up his Omni Zone IIs on court before springing into action in front of a global audience. Having already taken the title on judge's

points, he unleashed the now legendary 'No-Look Dunk' as a finale. By treating the shoes as an accessory to his win in the name of showmanship, Dee became the Pump's own action hero.

There was another push later that year. Check out Macaulay Culkin in rap-mime mode in Michael Jackson's 'Black Or White' video. Reebok's worldwide sales increased by 26 per cent to $2.7 billion. No one at Reebok needed to cover their eyes at the end of that tax year.

THE SHAQ

In 1992, it was all about expansion. Dee's win scored him his own D-Time model as part of the Above The Rim collection, while the Blacktop outdoor basketball range – with pieces like the Battleground maintaining capo status over cheaper Hexalite-only designs – coincided with Nike's development of similar models like the Raid. Chang's sophomore Court Victory II model was also strong, gracing the feet of Busta Rhymes during Leaders Of The New School's 'difficult second album' period.

Reebok had fresh plans too. Orlando Magic's seven-foot-one-inch monster known as Shaquille O'Neal was snapped up and laced with his very own Pump in 1992. The Shaq Attaq was badged with a dunking monogram and saw Shaq groomed as a potential Jordan-scale franchise. The shoe was particularly smooth, softening

1989: The Pump packaging

'GET LOST, I BREAK YOU OFF SOMETHING I'M PUMPIN' LIKE A REEBOK, WITH A PUMP, FROM THE JUMP AND YOU WAS NOTHIN!'

1994: Method Man, 'Biscuits'

1991: Michael Chang

the harder edges of previous Pumps. It helped that Shaq's larger-than-life approach wasn't just physical – he dropped his debut hip hop LP (the first of five albums) the following year. Wearing the Paydirt for training, Emmitt Smith of the Dallas Cowboys was another endorsement (though Reebok also made the Throwback cleat).

A carbon fibre material called Graphlite was introduced via the Pump Graphlite – a serious running shoe endorsed by rival decathletes, Portland's Dan O'Brien and North Dakota's Dave Johnson.

The hip hop gloss gave Pump shoes added legitimacy, and nowhere was this more evident than in the first 10 minutes of Ernest Dickerson's (Nikehead Spike Lee's cinematographer) film *Juice*, where Q, played by Omar Epps, tries on pairs for his younger sibling's approval.

On the performance side, complacency leads to loss of momentum. Pump was about to be slimmed down as neoprene and sock-style fits became commonplace, and the footwear world became decidedly lighter. InstaPump was an evolution. For tech-heads, all eyes were on the tennis and running designs that would carry the second-gen Pump tech. Pitched at the serious athlete, the InstaPump Spike was lighter, slimmer and functioned via an external canister that used carbon dioxide cartridges. It was a risky move, not least because prices were set to be extremely high, but also because the design required blister-packed hardware to inflate. Notably, the 1993 issues of Shaq's inaugural pro model maintained the basketball Pump mechanism but carried optional InstaPump, as did the official Shaq Attaq II.

Between 1994 and 95, Shaq's models maintained the InstaPump, but Shawn Kemp's Kamikaze opted out. By 96, showcase performance models like Allan Iverson's Question took an excess of newly honed Hexalite but avoided Pump. The same year, Shaq's mesmerisingly weird Shaqnosis eschewed Pump technology on the retail version, yet he chose InstaPump for his own higher versions. And when the

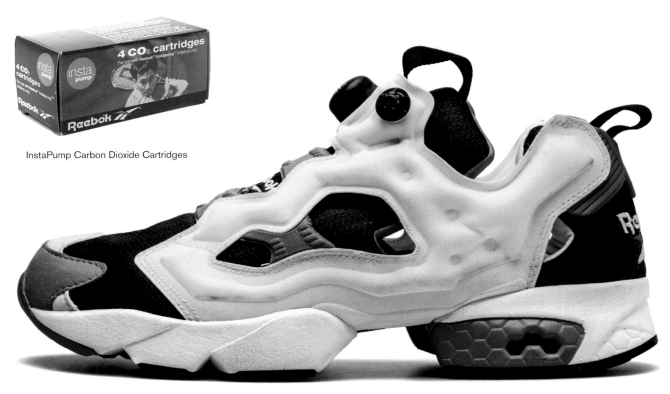

InstaPump Carbon Dioxide Cartridges

1994: InstaPump Fury

'YOU KNOW THE BUMP JUMP CAN DAMAGE YOUR RUMP, AND DUMP HOOCHIES IN A LUMP AND LEAP HIGHER THAN A REEBOK PUMP.'

1993: CL Smooth, 'One In A Million'

Answer, Iverson's 1997 follow-up, opted to use DMX, the writing was on the wall. The final Shaq Reeboks released around that time featured a Hexalite sole as the technical star. Pump's golden era was expiring.

THE FURIOUS PUMP
The best designs are often misappropriated performance pieces that push the envelope. When the InstaPump Fury launched in 1994, it was little more than an inflatable frame, taking design cues from the specialist InstaPump releases of the previous year. This was a shoe so modern that even the weight of a pair of laces was deemed excessive. Who needs laces when you can pump-fit your shoes?

A trademark colourway is always a clincher for cult classicism, and for the InstaPump Fury, red and citron yellow fit the bill nicely. Beyond the early adopters of SoHo et al, the Fury seemed to target a trend audience, even though it was billed as a serious track prospect at launch.

The great 'lost' Pump is also a member of the Fury fam. With its built-up midsole for road running, the sturdy Fury Road is a thing of beauty. The InstaPump Fury garnered appeal among a burgeoning collector community, but as an example of sneaker design's offbeat side (Maharishi Snopants, Terra Humaras in *Vogue* in 1997/98), it was embraced immediately in Asia and released annually in fresh colours, including a version commemorating the Hong Kong handover in 1997.

Even Jackie Chan was graced with his own Reebok colab (with import prices even more ludicrous than the model's already heavy retail fee). Chanel's impossible-to-find silver and grey InstaPump Fury with interlocking Cs remains the grail of grails to Reebok collectors.

THE FINAL CHAPTER
The Pump 2.0 debuted in 2004 on the Fury 2 and ATR basketball shoe. The new G-Unit Pump also indicated that Fiddy and crew were intent on bringing back a little of that 1991 style aspiration. Even skater Stevie Williams opted for Pump on his DGK Pump pro model in 2006. Reebok's retro programme ground out some Pump highlights including colabs with Rolland Berry, John Maeda, the Commonwealth store in Virginia, Boston's own Bodega, Ubiq in Philly, and, of course, atmos – the Jedi shoe masters of Tokyo. The Reebok Pump Omni Hex Ride, designed with NY retailer Orchard Street, also indicated that Pump was still a viable performance aid.

Will we ever see another period of creativity, sneaker brand warfare and bizarre one-upmanship like the first chapter of the Pump story? Doubtful. Things are shrewder, safer and positively blander in comparison. The Pump system and all the attention surrounding it deserves much, much more than to remain a footnote in accounts of just how outrageous the late 80s and early 90s were. This was the boomtime for Reebok, and the results were some of the most exciting shoes of the decade.

•

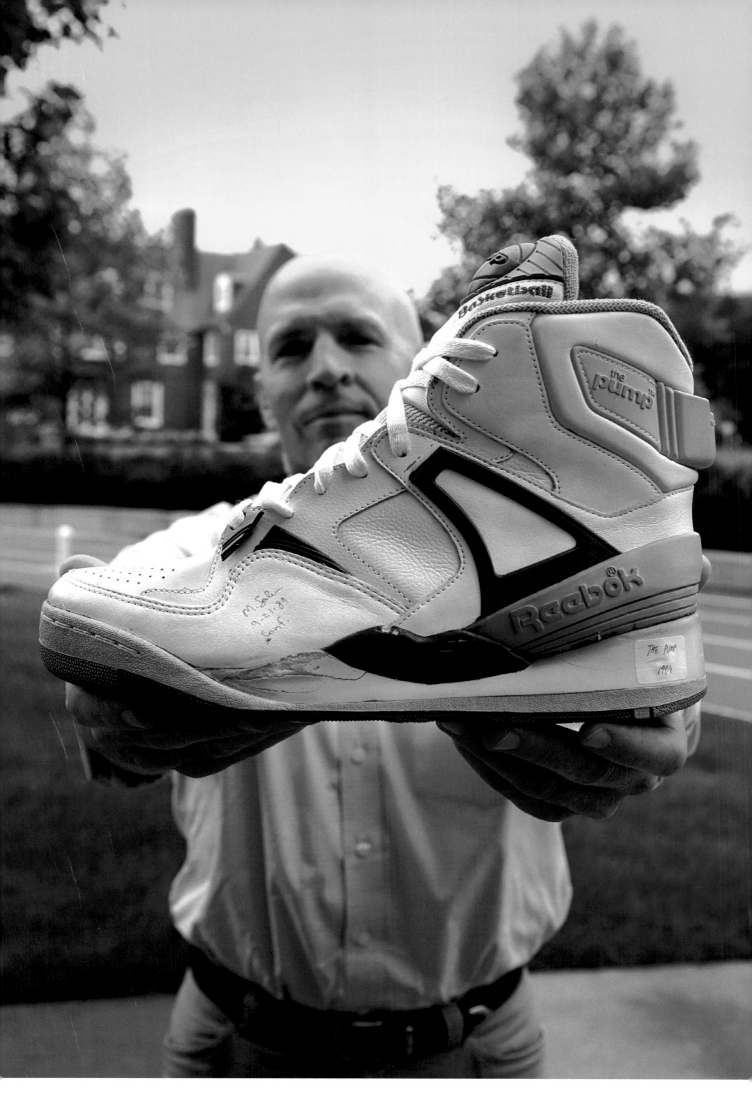

PAUL LITCHFIELD

THE ARCHITECT

One of the great privileges of working at *Sneaker Freaker* is spending quality time with the wily old veterans of the shoe biz. After decades in the trenches, they're usually obstreperous, charismatic and wildly entertaining. In the case of Reebok, Paul Litchfield is all that and a corporate treasure to boot. After joining the firm in 1985, Litch was the project manager for Pump and also oversaw the development of Hexalite and ERS. Challenged by Paul Fireman to 'make Pump work' within a few measly months, Paul accepted the gauntlet and helped push Reebok to become the world's biggest footwear brand by the late 80s. Take some time to absorb the inner workings of the Pump's progenitor.

What did you do before you got into the shoe business?
Before I got into shoe biz I received my undergrad degree in biochemistry and my masters in exercise science and muscle biochemistry. I did some research up in Aberdeen, Scotland, on human performance through funding from oil companies out in the North Sea. I also did a bunch of research for Nike, believe it or not. I then came back to work on my PhD and as a result of academic politics, I ended up walking away. I had an interview with this really small company in the Boston area called Reebok where there were six people in the R&D department. We had a great time playing hoops and it was the most casual, fun interview I'd ever had. I was like, 'All right, I'll try this!'

Were you into the shoes or was it the office vibe?
I was a bit of an athlete, but I wasn't a shoe maven or anything like that. I was familiar with Nike because I had done some undergrad classes and I knew about the human performance side, but I wasn't a shoe dog; I just thought that maybe I could parlay my education into making better shoes.

You mean as a designer?
More the engineering side of things. In the shoe business you have designers, who are the stylists, then you have what they call developers, who do the building. I'm more of an engineer, although

not by education. What I found was that I actually understood chemistry pretty well. So I worked with Goodyear Rubber and DuPont and the resin companies to make use of plastics, which are a big part of the business, from outsoles to reinforced supports and straps on uppers. I was never a designer but I understood and respected the process.

So about the time you join, this small company starts making the Freestyle aerobics gear?
The Freestyle actually started in about 1982. It was a high-tech ballet shoe that women could do aerobic dances in. When I joined in 85, it was starting to take off. In 86 and 87 it was like a rocket!

Freestyle is one of that decade's biggest success stories. For such a small team, you created a juggernaut pretty quickly.
Yeah, it was – it was wicked intense! Reebok was always pretty lean and Paul Fireman was famous for saying, 'You've got a shoe design and you've got a factory; what do you need anything in the middle for?' That was us, we built the stuff! [Laughs] Towards the end of the 80s we launched the Energy Return System (ERS) and the Reebok Advanced Group consisted of exactly three members.

Do you mean they advanced from two to three when you joined?
Exactly! It was pretty funny. We networked well.

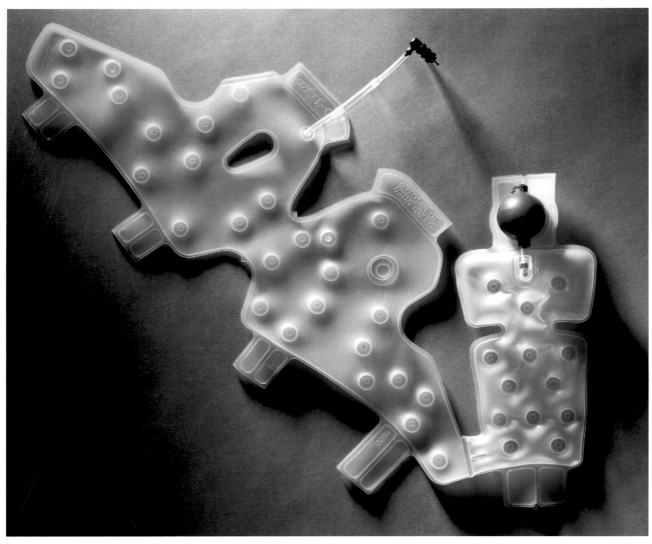

The Pump inflatable bladder

The first computers are right about then as well.

Oh yeah. Absolutely. But we worked on everything by hand. It was funny because when I first started it was Telex and then it was faxes. So what you'd do is you'd handwrite your sample requests with all of your notes and then you'd take them to the fax machine. We actually had departments where people would spend two, three, four hours a night feeding paper into the machine! We had it scanned and sent over to our counterparts in Asia. Then you'd take these big wads of paper and you'd carry them on a plane and make shoes.

Faxes don't last forever.

Hell no! Let me show you something. Yeah. Check this out! They're all yellow! It's like invisible ink! These are all my faxes. Every single meeting I ever had at Reebok I made notes and I kept it all. Look at this! Isn't it incredible?

(Interview adjourns for 15 minutes while the folders are examined.)

What were the 80s like for you personally? Did you have the big hair? What were you into?

A lot of bad hair, now I'm bald as a stick! But it was funny, being at Reebok was really cool because we were popular and we couldn't make the shoes fast enough. Whatever we made seemed to be a hit. When we went from aerobics into the basketball marketplace in North America, it was a success. People were clambering to be part of the company, whether they were employees or retailers or athletes. It was really cool.

Did you have a sense of reality about this time? You had to survive each week no doubt, but it must've been a blast.

You had to survive every hour in this place! It wasn't like a threat to life or limb, but it was a relentless pace and it was crazy. And Paul Fireman, if nothing else, was never satisfied. It was always like, 'OK great, now next! OK, great, now next!' It created an environment of significant intensity. It was cool to be part of it but it was also pretty draining.

If you look at the overall period of shoe design, the acceleration of ideas and technology was frenetic. adidas had Torsion, Reebok had Pump and ERS and Nike had Air. What is it about that decade that created such intense rivalry?

Yeah, I think so as well. Athletic gear was clearly the moniker of the day; it was like cell phones are now, so there was an appetite for that from the consumer. It was a flat-out race to see how technical your shoes were and how much value you could put in them. When I did the Pump in 1988 as the project manager, we also had Hexalite and Graphlite. We had the second generation of ERS as well, so we created four new technologies out of a really small group.

You make it sound like Pump was just another one of your ideas.

It was funny because it wasn't until Paul Fireman held it up at one of the trade shows – I think it was ISPO in Munich – and said, 'This is the Freestyle of the 90s!' that the idea took off. Like you said, the Freestyle was the definition of success, and Paul created this critical mass of enthusiasm for the models.

Where did the Pump idea originate?

When Paul Fireman bought Ellesse, they had a ski boot with this pumping mechanism and it had big brass fittings and stuff like that. Somebody said to Fireman, 'Hey, you should put this contraption on a shoe!' but for a while there it languished and no one took it seriously. It looked like an iron lung...

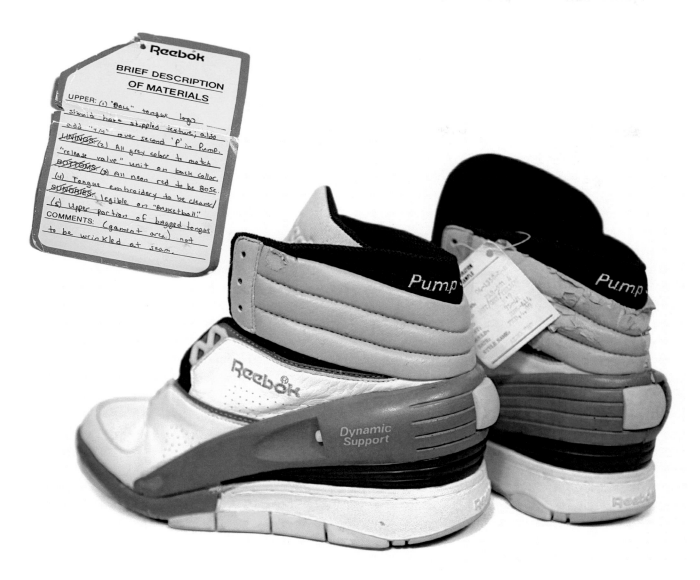

1988: Pump Shot (original prototype)

Sounds medieval.
Yeah, yeah, yeah! It was just a rough prototype idea. If you look back in the US patent literature, there are all kinds of inflatables and pumps.

The 1890s I think is the first reference in the patent. That did strike me as odd.
Yeah, 1892. Exactly! That keeps you pretty humble because it's like, 'Did you invent the Pump? Oh yeah! Apparently not!' I was given the task – the unenviable task – to make a shoe out of it. We were looking to make a customisable-fit shoe and we looked at foams and straps and ended up settling on a Pump mechanism that was hollow so you could change the shape by inflating it.

We didn't have spare designers and development people, so a local Boston design firm and I basically worked on making the first Pump shoe in early 1988.

Was it always called Pump?
No, not at all. We had a bunch of different names and a lot of them were around 'air' or 'custom'. It wasn't called the Pump until much later in the process, and when we finally got down to launch this thing, it turns out a shaving cream company had a thing called the Pump! So from a legal perspective, that's why it's always 'The Pump by Reebok'. I mean it was pretty seat-of-the-pants until you ran into a problem and then you had to get through somehow.

There's two really distinctive things about the shoes. One was the name and the other was the basketball logo which doubled as the mechanism. The manual pumping system was crucial to its success. When we first did the shoes, we just looked at how to make bladders. There weren't many people that made the kind of dynamic air bladders that we wanted. You could do an air mattress that might

float around the pool, but that always leaked eventually. We ended up working with a medical grade company that made blood bags and intravenous bags and things like that.

Tell me about the first prototypes. They look pretty far out!
The Pump Shot and the Pro Pump were the first shoes that we showed at the Atlanta Super Show in February of 1989. I worked on them with Duncan Scott and the guys at Design Continuum. This is the pump on the back of the heel and this little valve is the same as a bicycle tyre. They were a colossal pain in the ass. The Pump bladder itself goes up the tongue and around the whole shoe and then around your ankle. When you pumped it, you could feel it! Now this Pro Pump had a little valve that basically closed and then opened up like a dimmer switch. This one actually had a heel pump. So you stepped on it and like a little bellows, it pumped up the bladder. We did a bunch of testing at local high schools, and believe it or not, kids didn't like the auto-pump because it was slow and subtle. What they liked was pumping up their shoes before they got on the court.

Wasn't the Nike Air Pressure also at the Super Show?
Yes it was! At the same time, while we were showing this stuff, Nike were showing their shoe called the Air Pressure. They showed it under glass where you couldn't touch it and with the bright lights it looked like a rock star!

So how did you feel seeing their shoe?
I was horrified! At the time, we had this secret room where you could come in and try our shoes on and people were really excited. We were getting high fives already! But I was horrified because they weren't totally finished.

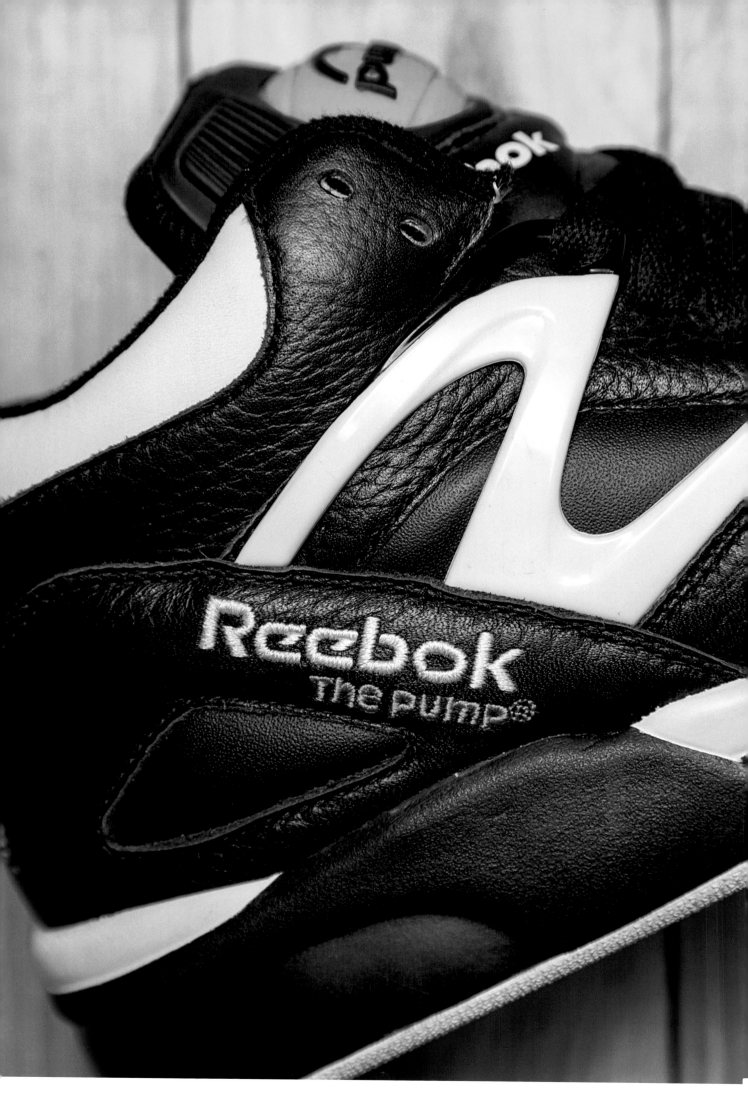

162

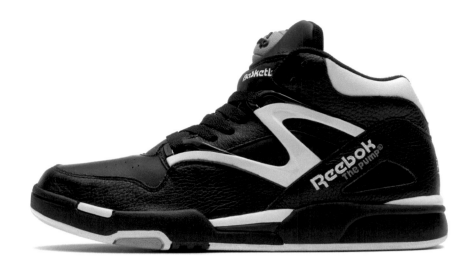

When Dee Brown dunked that ball,
it was wicked cool! Shawn Kemp and
Dominique Wilkins were there as well.
You gotta remember that Dee's
a relatively little guy – he's like six foot
one or something – and these other
guys were big dunk monsters!
When Dee gets it centre court and all
of a sudden puts the ball down, bends
over and starts pumping up his shoes,
everyone went nuts! Then the best part
about it was his 'No-Look Dunk'! I've still
got a big poster of it up in our lab.

PAUL LITCHFIELD

Banned Pump bungee ad. Check out the extreme close-up of the Nike Air soles as the jumper goes over the edge of the bridge! The soundtrack used an eerie wind whistling in the canyon and a classic heartbeat to build the tension. The voiceover is serious: 'It fits a little better than your ordinary athletic shoe!' No shit! This ad was banned most places for reasons no one can remember.

Life is short. Play hard. Classic Skysurfer ad with Patrick De Dayardon wearing his famous wing suit and The Pump SXT model. Built on the same principles as the bungee ad, the message that Pumps stick to your feet was not hard to miss.

I had actually just given the designs to our senior designer, Paul Brown, who had also done Freestyle. In less than a week, he came back with a shoe drawing that looked exactly like the Pump. And as soon as I saw it, I'm like, 'That's it!' Paul was the one who said, 'We'll make it look like a basketball!' That was the huge breakthrough we needed. I'm not a designer but you know when something's right. Our shoe was elegant, it was simple and it was stylish.

Agreed. It's tactile as well. Using the basketball as the pump was genius.
Absolutely! As soon as we made this shoe [picks up the first The Pump sample], we used a rubber material that basically felt like a basketball. You pumped it up and then when you released the air, it came out and made a hissing sound.

They look gigantic by today's standards.
Well at the time, high-tops were high-tops and they hadn't invented the mid-cut yet. Nowadays I don't think they make a true high-top ball shoe anymore, they're all mid-cuts to me. That was just the working height of the day. It's simply the evolution of style.

What was the reaction?
OK, so February 1989. The selling cycles were big back then, so Fireman said, 'We're going to have this shoe by the holidays!' And I'm like, 'Are you out of your mind?' Paul was pretty clear that if I was picking up a pay cheque in December, it was because this thing was done. It was big-time pressure! But Fireman was the kind of guy who could throw out these impossible deadlines and yet somehow you thought you could do it. We went at it really, really hard and by September of 1989, we had about 7000 pairs on order. Foot Locker did it as a favour to our VP of sales, I think. It was $170 on the shelf. It was an inflatable shoe, they must've thought we were nuts.

Why did they cost $170? This is 20 years ago…
Yeah, no kidding. Basketball shoes at the time cost about $100, and when you included the Pump, it went up to $170 because it was a whole new technology threshold. I think that's why there was such trepidation. We had the right balance of value and interactiveness and you had to aspire to go get it! You had to beg your mum and

dad or work quite hard to get that extra money. When you bought a pair of Pumps, you were pretty much the cat's ass at the time.

Or you stole them.
Yeah exactly. That happened too! Remember, I used to make them and that made me totally cool.

Why do you think The Pump survived and the Nike version didn't?
As you said, these are big shoes and the Nike had this even bigger goiter on the back of your foot. No disrespect, but it looks peculiar. They also had a butterfly pump which pushed against your achilles. With ours, you didn't have to bring anything with you to pump the shoes, and at the time, Reebok was considered cool.

Did the production run smoothly?
No! Check this out! This is just a little anecdote. The bladders were made here in Massachusetts and they were tested for three hours, then again for 24 hours before being sent to Korea. The factory inflated the Pump bladder and tested it again, then they stitched it into the shoe and inflated it again to make sure that no one had sewn through them.

So the bladder's been inflated five, six times to make sure that these things don't leak. When we get the first shipment a few weeks later, I get a call from our warehouse saying that none of these things inflate. I get down there and it's like someone has poked a hole through every single one of them. As it turns out, the shoe factory decided to use a sewing machine (without the needle) to test the Pump mechanism. It seemed to make sense, but the sewing machine damaged the mechanism so that after this final inflation test, the Pump would not inflate the bladder again.

Disaster. How did you fix the problem?
We had to take every single pair of Pumps, take the stitches off, pull the Pump out and put a new one back in and sew it back up: 7000 pairs! Like we haven't done enough for this Pump thing already?

You did them all by hand?
Probably about six of us, yeah. It wasn't a small number of shoes, believe me. Then we had to make sure that they worked, so it was pretty intense.

1989: **NIKE AIR PRESSURE**

When Reebok launched the power punch that was 'Pump up and Air out!', Nike was also working on a near-identical inflatable concept. At $180, the Air Pressure was a clunky punker that was an even more expensive gimmick than its rival at the 'Bok. While the shoe never came close to the popularity of Pump, there's one thing it had over its rival: the skyscraping red-top sneaker box. Rocking up to the blacktop with this futuristic 'Tupperware' casually slung over your shoulder made you a king! However, using the kooky hand-pump apparatus to squeeze the shoes onto your feet must have been a deflating experience – especially compared to Pump's cool tongue widget. Nearly three decades later, original Air Pressures have all succumbed to dreaded sneaker rot. Thankfully, the plastic box has survived the journey and they're still freely available for around $100 on the 'Bay. At the start of 2016, out of nowhere, the Air Pressure finally received a retro release – big box included – and its adjusted-for-inflation price tag of $300 once again left it out of reach for all but the most diehard heads. Still, this is an interesting moment in sneaker history and the first example of premium packaging being used to help launch a shoe.

1988: Pro Pump (original prototype)

Is it cool to have a patent to your name?
Well it's nice, but it's just part of the process. Once you submit the application, there's a lot of legal channels it has to go through before the final patent comes out. It's just a footnote really, it's not like a celebration of anything. It protected our domain and represented the accumulated knowledge that we all gained. It's how you put it all together that makes it unique and that's the most important thing – the blend of all these ingredients in our Pump system.

Many people consider Pump a gimmick. What do you say?
Oh yeah sure, absolutely. I'm sure it's a punchline in some ways, but I would say we took a mass-manufactured shoe made on a last that was an average shape and we made it custom fit anyone's foot. All feet, left and right, are slightly different and our intention was to fill all the voids between your foot and the shoe, so it becomes properly fitted. That's what this Pump bladder does! It works and people can call it a gimmick if they want, but it works.

I don't think they see it as a negative, it's more just the convivial nature of it.
There's definitely a fun aspect and an interactive aspect as well. But comfort is all part of performance and I think Pump is all those things.

What did your athletes think of them?
When we gave them to our athletes, we gave them instructions on how many times they should pump it up, but we found out pretty quick that some people pumped it 10 times and some people pumped it 80 times. And then they'd pump it just to hear the air release! It became this cool little fad and it really caught on.

I know you weren't involved in the marketing, but I did want to ask you about the impact Shawn Kemp, Dominique Wilkins and most importantly Dee Brown and Michael Chang had.
They were huge! Don't forget Boomer Esiason, Doc Rivers and the late Dennis Johnson. These guys were huge ambassadors for the Pump. I think Dominique pumped his up 50, 60, 80 times and

he just really liked them. If it wasn't for our athletes enthusiastically endorsing Pump, if it wasn't for our advertising and marketing folks putting together important messages at the same time, who knows? Everything converged at the right time and it made it seem like it was bigger than life, and then all of a sudden it really took off.

The Pump advertising is still powerful now. The trash talking is funny and showing a competitor's shoes in ads is something you don't see these days.
Oh yeah, it was funny as hell. We did this whole bungee thing and then ended up pulling it because some kids were trying something like it at home. It's so in-your-face! He bends down, they're bungeed up, look at this, it's so cool. He pumped up his shoes! This was when bungee jumping was a really big deal. Let me show you...

[Paul plays the ad on his laptop.]

The ad is so quiet. It's not overblown with loud sound effects or anything.
Yeah, yeah! And then you're thinking, what the hell's going on? I wasn't involved with the filming of that but I thought it was so hip.

Do you remember Dee Brown's 1991 dunk?
Absolutely. I watched it on TV. When he did that, it was wicked cool! Shawn Kemp and Dominique Wilkins were there as well from memory. You gotta remember that Dee's a relatively little guy – he's like six-foot-one or something – and these other guys were big dunk monsters! When Dee gets it centre court and all of a sudden puts the ball down, bends over and starts pumping up his shoes, everyone went nuts. Then the best part about it was his 'No-Look Dunk'! I've still got a big poster of it up in our lab.

What about Greg Norman? He was never a trash talker but he dissed Curtis Strange.
Exactly. Greg was always very open, always had a smile and something nice to say. It was always in good humour. He was a great spokesman for Reebok.

1991: Pump Runner (original prototype)

1992: Pump (unreleased)

Hello, I'm your tennis shoe.

The new Club Pump from Reebok features THE PUMP™ technology for an all-around custom fit. A Hexalite™ midsole for cushioning. A Goodyear® Indy 500® Plus sole for durability. And simple, classic, understated styling so you can be as subtle as possible when you crush your opponent like a grape.

© 1991 Reebok International Ltd. All rights reserved. REEBOK is a registered trademark, and THE PUMP and HEXALITE are trademarks of Reebok. GOODYEAR is a registered trademark of The Goodyear Tire & Rubber Co. INDY 500 is a registered trademark of the Indianapolis Motor Speedway Corp.

1991: Reebok Club Pump

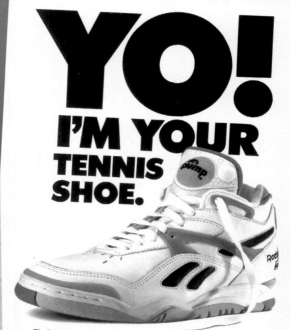

YO! I'M YOUR TENNIS SHOE.

The Reebok Court Victory II comes with THE PUMP™ technology for an all-around custom fit. A Hexalite™ midsole for cushioning. A Goodyear® Indy 500® Plus sole for durability and a bunch of plastic things in loud colors that not only lend support but also distract your opponent so you can beat his brains in.

© 1991 Reebok International Ltd. All rights reserved. REEBOK is a registered trademark, and THE PUMP and HEXALITE are trademarks of Reebok. GOODYEAR is a registered trademark of The Goodyear Tire & Rubber Co. INDY 500 is a registered trademark of the Indianapolis Motor Speedway Corp.

1991: Reebok Court Victory II

Shaq isn't the only player in the league wearing his shoe.

High abrasion rubber for increased durability.

Herringbone tread pattern for added traction.

THE PUMP™ system for custom fit and support.

Extended graphlite arch bridge for lightweight support.

Radically sculpted sole cavea to reduce weight.

Shaquille O'Neal. Shaq. 300 pounds of rim-wrecking force. On March 13th, Reebok® introduced the Shaq Attaq.™ A shoe built for the way Shaq plays the game. For the way Shaq dominates the lane and clears the boards. It's built for the man who's made the greatest impact on the game in the last 20 years. Not to mention the impact he's made on other players.

1993: Reebok Shaq Attaq

168

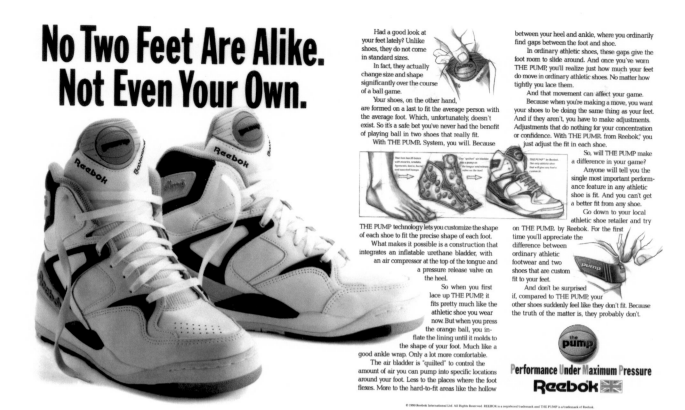

No Two Feet Are Alike.
Not Even Your Own.

Had a good look at your feet lately? Unlike shoes, they do not come in standard sizes.

In fact, they actually change size and shape significantly over the course of a ball game.

Your shoes, on the other hand, are formed on a last to fit the average person with the average foot. Which, unfortunately, doesn't exist. So it's a safe bet you've never had the benefit of playing ball in two shoes that really fit.

With THE PUMP. System, you will. Because

between your heel and ankle, where you ordinarily find gaps between the foot and shoe.

In ordinary athletic shoes, these gaps give the foot room to slide around. And once you've worn THE PUMP, you'll realize just how much your feet do move in ordinary athletic shoes. No matter how tightly you lace them.

And that movement can affect your game.

Because when you're making a move, you want your shoes to be doing the same thing as your feet. And if they aren't, you have to make adjustments. Adjustments that do nothing for your concentration or confidence. With THE PUMP. from Reebok, you just adjust the fit in each shoe.

So, will THE PUMP make a difference in your game?

Anyone will tell you the single most important performance feature in any athletic shoe is fit. And you can't get a better fit from any shoe.

Go down to your local athletic shoe retailer and try

THE PUMP technology lets you customize the shape of each shoe to fit the precise shape of each foot.

What makes it possible is a construction that integrates an inflatable urethane bladder, with an air compressor at the top of the tongue and a pressure release valve on the heel.

So when you first lace up THE PUMP, it fits pretty much like the athletic shoe you wear now. But when you press the orange ball, you inflate the lining until it molds to the shape of your foot. Much like a good ankle wrap. Only a lot more comfortable.

The air bladder is "quilted" to control the amount of air you can pump into specific locations around your foot. Less to the places where the foot flexes. More to the hard-to-fit areas like the hollow

on THE PUMP. by Reebok. For the first time you'll appreciate the difference between ordinary athletic footwear and two shoes that are custom fit to your feet.

And don't be surprised if, compared to THE PUMP, your other shoes suddenly feel like they don't fit. Because the truth of the matter is, they probably don't.

Performance Under Maximum Pressure
Reebok

© 1990 Reebok International Ltd. All Rights Reserved. REEBOK is a registered trademark and THE PUMP is a trademark of Reebok.

1990: Reebok The Pump 'No Two Feet'

Were you still involved in Pump when Shaq came aboard?
Oh yeah, I met Shaq when he was being signed. He came up here with his mum and dad and we met him. Shaquille O'Neal's a big guy, he's a big man. I'll show you some of the shoes we made for him. They're colossal! He was a super-serious athlete but also good for a laugh. He was bigger than life.

What was it about the 80s that created this competitive culture? You guys got a little bit cocky as well – you really hammered Nike.
A little bit? Not a little bit, I think a lot! [Laughs] I wasn't involved with the advertising, but there was a lot of showmanship in the industry at the time and it was a lot of in-your-face friendly fire. It's like Coke and Pepsi, or Microsoft and Mac with their 1984 ad. Everybody went at each other pretty hard.

Did it ever get personal?
Absolutely. Reebok was the biggest athletic footwear company in the world. You never took the time to stop and rest on your laurels because Fireman wouldn't allow it, but it was pretty cool. We wore our Reeboks pretty proudly. Actually, most of the athletic shoes at the time were made in Pusan, Korea. It's only four to five million people and in the 80s, it was the athletic footwear capital of the world. You had a whole bunch of expats, mainly Americans and Germans, and only two or three hotels that could accommodate westerners comfortably. There were never any dust-ups, no fisticuffs – well none I can really mention – but it was healthy rivalry!

The InstaPump is still a striking piece of modernism. Were you involved in the development?
Oh yeah, absolutely. Check this out. Paul Fireman wanted one of our athletes to go to the Olympics and run the 100-metre dash and get to the starting line, inflate their shoes and take off! And so we're like, 'How the hell are we going to do that?' Me and Steven Smith, my advanced concepts designer, were at this annual bicycle show called the Inter Bike in Anaheim, California. There was a thing called Insta-flate, which you used if you got a flat tyre during a bike race. You'd replace the inner tube and then insert this CO2 cartridge and it would dump all the gas and you could take off. We saw these guys Geoff Bleaker and Tony Hollis from Innovations In Cycling and they're like, 'Go for it! Do what you want!' You'd basically stick the nozzle

in and watch this thing instantly inflate. Fireman was really, really happy with that and everybody was super psyched.

That Pump Fury to me was a benchmark shoe, up there with the first Pump with the orange ball. Rather than taking a Pump bladder and then sandwiching it inside an existing shoe, we took everything off except for the bladder itself. A lot of this material is there just so that you wouldn't see people's socks or their feet!

Pump kept evolving and still is, but at some point, it seemed to lose people's imagination. Would you agree?
Absolutely, without a doubt. As a matter of fact, when we launched the Fury, it wasn't that successful at first because it was so peculiar. It was a good running shoe, but it was peculiar. It had no laces, it was a wild colour, it had no arch and people were asking, 'What the hell is that thing?!'

In hindsight would you have put an arch in it?
No, I wouldn't change it at all. You put the Pump Fury on the shelf, particularly at the time, and 50 people would look at it and go, 'That's the coolest thing ever!' Fifty people would look at it and go, 'That is the ugliest thing I've ever seen!' But 100 people would notice it, and that's important.

It's also one colour combination that Reebok definitely owns.
Without a doubt. I'm not a designer, but I listened to Steven's opinion on that and thank god we did.

Getting Jackie Chan on board didn't hurt either.
Absolutely, he's way cool! That shoe's got its own cult following. I'm pretty proud to have worked on that one.

Given what you achieved with Pump, did you ever feel you've done everything you possibly can with a sports shoe?
Once I start patting myself on the back, I'm going to hang up my boots, because clearly you think you know it all. We're proud of what we're able to produce and if people buy into it, that's very cool. Hopefully that will keep me amused enough to keep striving and make things more interesting.
•

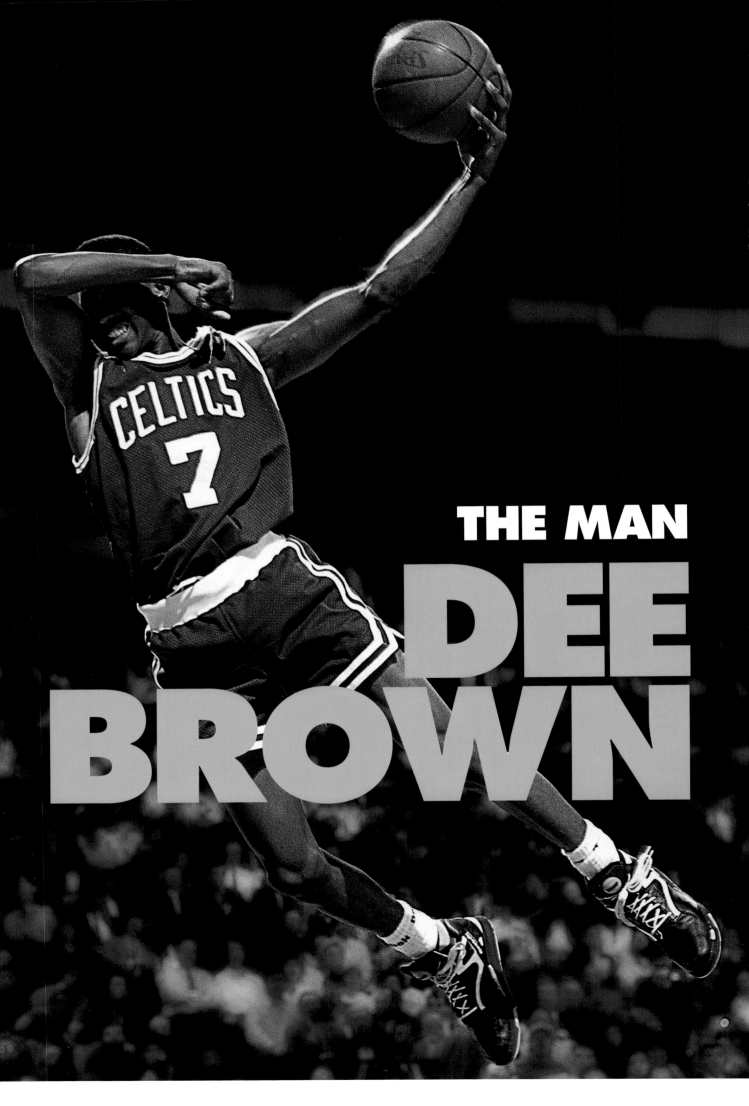

THE MAN

DEE BROWN

Way back in 1990, the legendary Boston Celtics drafted an unknown from Jacksonville, Florida. Within 12 months, this raw-boned rookie named Dee Brown would have a starring role in one of the great moments in basketball, not to mention the history of sneaker marketing. The Slam Dunk contest is the first thing anyone thinks about when his name comes up, which is an interesting legacy in itself. The next 28 minutes was a history lesson in perseverance and insight. As Dee says, 'This isn't a rags-to-riches story', but it is a story about what it takes to beat the odds.

Take me back to the beginning. How does the Dee Brown story start?

Well, I'm from Jacksonville, Florida, originally and in my senior class, I was the only African-American. People thought that since I went to an all-white high school, I wasn't that good and I didn't get any scholarship offers, so I decided to stay at home and go to Junior Community College first. I had a 3.7 Grade Point Average, so it wasn't my grades or anything, I just didn't get any scholarships to Division 1 schools. I had a great summer playing All-Star games and then all of a sudden I went to a couple of camps and broke all the scoring records and the coaches were sitting there saying, 'Has anybody signed this kid yet?' Jacksonville University had just gone to the NCAA tournament and that was my hometown so I always wanted to go there. They didn't offer me a scholarship until a week before school started. I wasn't a McDonald's All-American, I didn't go to all the camps, I just stayed home. I might have been All-State and 'Player of the Year' in the county, but because I went to an all-white high school, nobody thought I was any good. But I got there in a roundabout way.

How did you end up in the draft then?

Again, nobody knew who I was. I didn't have Carolina, Duke or Stanford on the front of my jersey. And just like in high school, I had to play in an All-Star game in the summer called the Orlando Classic, which was right before the Chicago pre-draft. So I went down there and grinded everybody up again and it was all the guys who were supposed to be drafted higher than me because their school was on TV. I made the All-Tournament team and I won the dunk competition during that All-Star game. All of a sudden I went from a guy that maybe was getting drafted to almost being a lottery pick. I was thinking to myself, 'Four years ago I was in high school, and now I have a chance to get drafted in the first round and walk across the stage to meet David Stern!'

What was it like arriving at the Boston Celtics?

When I got there, they had 16 championships – and talk about history. I'd go to practise in my rookie year and every day – not every other day, but every day – on the sidelines would be Red Auerbach, Tommy Heinsohn, Bob Cousy, John Havlicek, Jo Jo White, Sam Jones and KC Jones. Eight of the top players in history are on the sidelines and I'm playing with the others – Kevin McHale, Robert Parish, Larry Bird and Reggie Lewis! You talk about history? You can't slack, you can't talk about being tired, it was just the best situation for a young player. The first time I had been away from home was when I went to Boston. The first time I'd seen snow was when I got to Boston! But I had a lot of veteran guys that protected me and made sure that I went down the right path. It kept me grounded from day one.

You were a last minute call-up to 1991's Slam Dunk contest, weren't you?

You know, Rex Chapman did his thing, but before the contest he was throwing up! People don't know that. Rex was nervous. I was a rookie playing with the Celtics and we had the best record in the league. Chris Ford was the All-Star game coach, so I felt like I was a part of the festivities. I was having a good time, I was young and everyone was asking Shawn Kemp if he was going to win the dunk contest and if I was his little brother because we had the same haircut. I thought to myself, 'I'm going to show everybody! They're going to remember me now!' That kind of got me hyped up a little bit. I was a late addition and at that time everybody wanted to be in the dunk contest. That's how it was back then, you had to be chosen.

When did you first see the Pump sneakers?

Well I was under contract with Reebok, so I was already wearing the Pumps during the season. As you know, Reebok is in Boston, right down the street, and they were bringing all the new stuff and had me try on shoes to see how I liked them. They gave them to me a month before All-Star break.

I always wanted to know whose idea it was to Pump up the shoes on court?

It was my idea. It was just something that I thought of off the top of my head. I knew that Rex Chapman was the home favourite so I had to get the crowd on my side, to get them excited. I pumped my shoes during the first round and the crowd loved it. It's entertainment so I had to put on a show! Reebok didn't tell me to do it. I wasn't trying to get a contract; I was already under contract. I was just trying to have fun. It was all a show and 20 years later here we are talking about it! Not a lot of guys are recognised by their shoes. I don't care what level anyone played, but at one point, only two guys had shoes – me and Michael Jordan – and there is nothing wrong with that picture.

I hadn't thought of it like that. You also did a Reebok commercial, the King Kong Jam!

You know what's crazy about that? Do you know how hard it is to do a commercial in New York City with a Celtics jersey on? Man, I had people screaming at me and they had to shut down 5th Avenue, because we did it right in front of the Empire State Building! Taxi drivers were screaming for me to leave and I had people yelling at me because the Knicks and the Celtics have a big rivalry. Man, it was crazy! That's when commercials were fun and other than MJ himself, there weren't any shoe commercials.

Give me a final reflection on your career.

I've always been an underdog and when I reflect on that it just shows you what persistence and hard work will get you. Sometimes you can be in the right place at the right time and I just felt that I was prepared for it. I had the opportunity to showcase my skills in front of a lot of people and I did it in front of scouts, coaches and fans. Even the dunk contest – I did it! That's just the way I went about it. It makes you work harder, it makes you humble and it makes you appreciate it. I never felt I was entitled to be an NBA player, I was *honoured* to be an NBA player. You wanted to interview me and people want to talk about my career, Pump shoes and the dunk contest and I appreciate it because I know what it takes to get there. I fought the odds and got there! I didn't come from the hood and I wasn't in the streets. My family was a middle-class family, so I can't give you a rags-to-riches story, but what I had to do was work. If there was an obstacle, then it's all about how you dealt with it, as a ball player and as a man. The dunk contest is part of my legacy, how I got there is part of my legacy, and what I have done afterwards, by helping kids learn how to play ball with camps, is part of my legacy.

Is there a word or a phrase that represents you?

Humble and blessed. If you ask anyone about Dee Brown, they'll say he's a humble guy. There is a purpose for everything, and I think that humble is a word that describes me best.

•

INTERVIEW: Woody PHOTOS: Lucas Allen

DJ SENATORE

DJ SENATORE

REEBOK PUMP

The history of Pump wouldn't be complete without a collector waxing lyrical about their stash. We tracked down a polite New Jersey aficionado by the name of DJ Senatore. With a house full of vintage relics, not to mention all the recent colab releases, DJ was generous enough to reveal to us the extent of his addiction. With provenance of his 160+ pairs now confirmed, we are delighted to crown DJ Senatore the World's Greatest Pump Collector! And he ain't stopping to exhale anytime soon.

Hey Mr. DJ, tell us where you're at.
I grew up in Fords, New Jersey. Lived there all my life. Got into Pumps at the start of this decade and it just snowballed. Some people call me the biggest Reebok Pump collector in the world. I always had nice shoes as a kid. My parents spoiled me so I always had all-new Nikes and in freshman year at high school I started hardcore collecting and now it's come full circle.

Tell me about your Pumps because I gotta say, we know a lot of people and we can't find anyone packing as much Reebok heat as you.
I got started back in 2001, I think, when they did a retro of the Omni Lite. Foot Locker had three colourways and one was white with royal blue and orange. It just reminded me of the original shoe so much. Then they started doing limited editions and it just took off for me. I was picking up samples on eBay and then I got into original vintage and it's just mayhem. That's all I do all day, well not all day, but you know, I'm always searching, especially for something I've never seen before.

Why Pumps?
Pump goes back to when I was a kid; I remember Dee Brown but it was just the look of them. They look retro and original and they just

caught my eye and eventually down the line I realised that nobody else really was into collecting them like I was. Everybody goes on about Jordans and Air Max and whatever but I thought, 'Well, I like this, why not go hard!' And that's where I am today.

In my experience, we all start out small and build it up and then at some point you realise you're nuts deep. Where are you at?
That's the thing, no one can actually remember how and why they got so far into it. To be honest, I'd probably say maybe the last two years is where I tipped, and since I had the store I realised that this was getting to another level. My business partner always says, 'Enough with the Nikes! If you want to do something, be the best!' And I gotta admit he was right.

How far back do you go with your vintage?
The oldest pair I have is the original of The Pump, which is 1989. That's as original as it gets.

How are they holding up?
Pretty good. Most Pumps hold up better than any other vintage shoe I've seen. You get a couple of things like the plastic straps that are a little fragile, but for the most part the soles and everything are intact. The leather is still awesome.

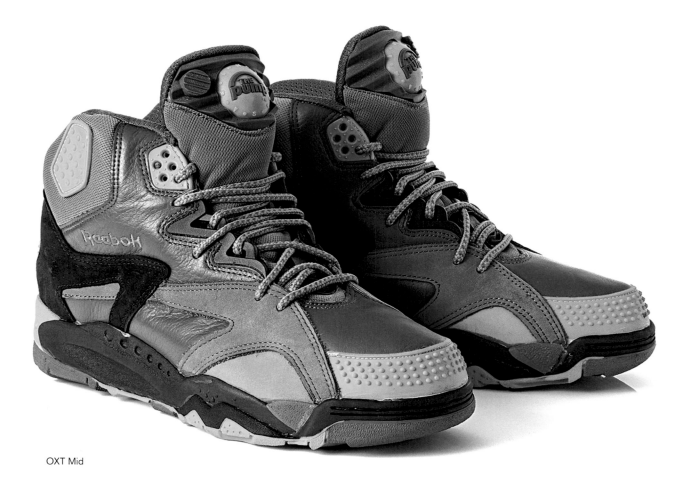

OXT Mid

What's the grail?
The grail used to be the green Alifes. I keep talking about this Double Pump that I lost on eBay and they are definitely evading me. You know what I don't have? I don't have a 'Bringback', the last retro. They go for about $500.

Really? The 'Bringback' retros from a few years back?
Yeah. Hopefully I'll get my hands on them one day. There are a lot of Japanese releases I can't get my hands on either, just because they won't ship to the US. I've got some connects now that I'm working on, even though the exchange rate is killer.

I see you have some unreleased samples as well.
Yeah, I do have a couple. I picked up the hybrid Twilight Zone on eBay; it has a TZ upper with a football cleat bottom. Got the prototype tag on it and everything. I don't know the story behind it, they were never released.

Which other models are you particularly proud of?
I love the Pump Arsenal, which I've only seen once in my time. What else? The Alife colab in the tennis ball green; I have five pairs and it's probably my favourite. The LCS has a pump that pumps up the sole, it actually gives you a little lift. I can go on.

Please do...
I just got the Shaq Attaqs. Both original colourways cost me a pretty penny but are well worth it. The Ubiq colab with the Court Victory Pump is cool. I think just 48 pairs were made. It was actually tough to get because they wouldn't sell them to me over the phone. The Dee Brown anniversary pairs that I had signed. Last time I counted I was up to about 160 pairs of Pumps.

I'm a little worried that I'm blowing your cover. Are you cool with it?
I get a little nervous about that too, now that it's all coming out. When I first started buying Pumps on eBay I was getting originals for fifty bucks, maybe a hundred. I was getting samples without even breaking a sweat. Now I watch these auctions and they're just sky-rocketing, but what can you do?

It's probably Reebok staff buying them back to make retros. [Laughs]
Don't laugh. I met one of the guys out in Germany who buys up all the retros and I was like, 'You're the guy who loses eBay auctions to me!' So maybe he's the one now beating me up because they're going to $500. Some I've seen get put up and within two hours it's up to a couple of hundred. So somebody's out there.

Were you a Shaq fan?
Shaq I definitely remember being with Orlando Magic. He was this massive guy coming to play basketball, the biggest we'd ever seen. I always remember I'd go into Athlete's Foot in the mall and look at the size 20 in the window and think I could fit my whole body in there.

I got those.
You have the whole pair? I don't have a pair. I've never seen an actual pair. You have the whole pair?

They look like a giant canoe, something you could paddle down a river in.
Imagine how big the rest of him is, I mean he's huge! [Laughs] I've seen one pair on eBay but it was totally destroyed so that would be a cool thing to have. I'll have to keep my eye out for them.

I noticed there's no Pump runners or Pump Furys in the collection. Are you strictly a high-top man?
All I know is the Dual Pump and I don't do them or InstaPumps. There's a ton out there and I think if I get into that, I'm spreading myself too thin money-wise. So I'll stick to basketball style like the Court Victory and Omni Lites, stuff like that.

Where do you keep all your shoes?
Believe it or not I keep them all in my bedroom. I pretty much have a whole basement area to myself so it's just my bed and a TV and my walls are lined with storage shelves. People always ask me why I don't keep them in a storage unit and it's just no fun at that point. Sometimes you just want to take out a pair of shoes and look at them, maybe you haven't seen them in a while. I always wanted to

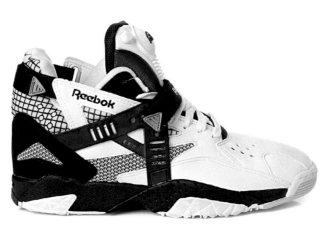

Arsenal

The Plateau

Battleground

Paydirt

Central Park

Shaq Attaq

LCS

Volley Low

Altus

(Unreleased Sample)

D-TIME

SXT Mid

Omni Zone III

Vertical II

Total Control (Greg Norman)

BlackTop

SOMETIMES I THINK 'WHAT AM I GOING TO DO WITH ALL THESE PUMPS?' BUT WHO CARES! I HAVE ALL OF THEM AND I'LL GIVE THEM TO MY KIDS. I'VE BEEN DOING THIS ALL MY LIFE REALLY AND THAT RUSH WHEN YOU FIND SOMETHING YOU'VE NEVER SEEN BEFORE IS STILL THERE.

DJ Senatore

have a nice little set up in my house but I always get nervous about dust and sunlight and the yellowing and cracking of the soles. For now they're all just in their boxes.

Do you ever think it's weird that you're collecting something that you can't wear, can't even look at that often and that at some point in time might completely disintegrate into a pile of rubbery glob?
I do. I often think about that. I always think I'm keeping all these deadstock shoes and what if eventually they break down from being old and that's a tough thing! Luckily I can get a pair to wear and enjoy and a pair to collect. But, I don't know, it's just... it's an odd thing that I've been doing this for so long and it's still cool to get that new pair and you just can't wait to get it in the mail. Something about Reebok, it never gets old.

There's also something about collecting that's satisfying in a perverse way. It's almost like the more money you put into it, the more you scratch that itch.
Yeah, feed the beast! Sometimes I think, 'What am I going to do with all these Pumps?' But who cares? I have all of them and I'll give them to my kids. I've been doing this all my life really and that rush when you find something you've never seen before is still there.

You went to Berlin as a guest of Reebok to show off your collection. It must be quite odd to be so young and blown up as the ultimate Reebok collector?
Yeah! It's cool to me because I see all these famous rappers who are known as the Air Force 1 guy or whatever and they get to do all these awesome parties and stuff. For me it's just cool to have people recognising you as the guy who collects Pumps. They get excited to meet you and look at your shoes and all this stuff you have, it's just a cool experience.

How was it to meet Paul Litchfield? He's a character.
Meeting Paul was pretty surreal. It was the coolest thing I've ever done. I was lucky enough to have dinner with him for probably an hour and a half and I just sat there in awe listening to everything he said. I couldn't believe I was sitting there talking to this guy.

What does your mum think? Presumably she indulged your childhood demands and now you've been flying around the world.
Absolutely. When I started she would get mad because at Christmas time she wanted everything to be a surprise, but once I started getting into this shoe thing she didn't know where to get them so I would have to go on eBay. She realised it was becoming a lifestyle and she said to me, 'Who would ever have thought that me buying you all these shoes for Christmas would actually turn out to do you good!' She can't believe it. So it's cool. Most parents would put a stop to that and say you're wasting your money.

You don't sound like you're about to stop anytime soon?
I keep trying, there's a couple that have evaded me but there aren't too many I've missed out on. I do have a lot of sneakers, that's true. I just love these Pumps. I don't know what it is, I can't stop. I got a watch list on eBay and if I can get them for a good price they're gone! I'm amazed when something pops up that I don't have. How many Pumps did they put out in the 80s and 90s? I don't even know!
•

25 YEARS

Nobody did it bigger than the 'Bok! With its sky-jacking stance, inflatable tongues, ERS cushioning and that rippling symphony of big-ass branding, the Pump is seriously heavy artillery. Back in 2014, Reebok celebrated the 25th anniversary by giving retailers in their top-level Certified Network carte blanche to remix the original.

OG Pump

OG Pump

Bodega (Boston)

Major (Washington, D.C.)

Social Status (Pittsburgh)

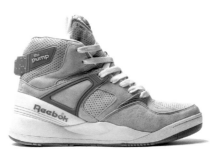

Sneaker Politics (New Orleans)

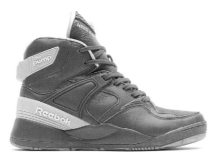

Shoe Gallery (Miami)

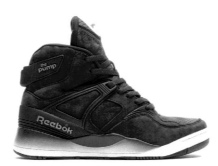

Limited Editions (Barcelona)

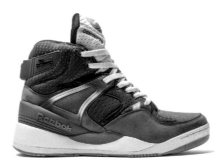

Concepts (Boston)

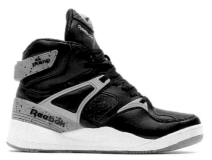

Highs and Lows (Perth)

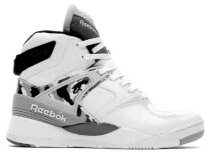

Invincible (Taiwan)

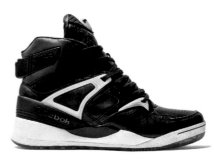

Burn Rubber (Detroit)

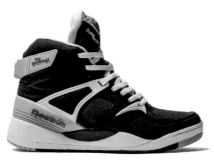

atmos (Tokyo)

mita sneakers (Tokyo)

Hanon (Aberdeen)

Sneakersnstuff (Stockholm)

Kasina (Seoul)

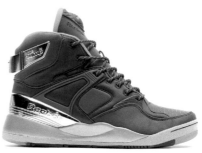

Limited Edt. (Singapore)

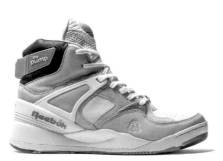

Footpatrol (London)

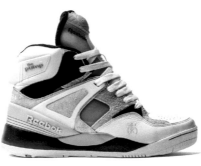

24 Kilates (Barcelona)

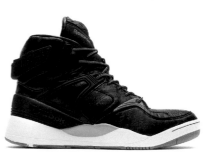

Solebox (Berlin)

Packer Shoes (New Jersey)

Crossover (Johor)

Titolo (Zurich)

INSTAPUMP FURY COLABS

In honour of the InstaPump Fury, Reebok teamed up with the cream of the world's best independent sneaker boutiques to present their interpretation of the ultimate iconoclast. From polka dots to flowery wallpaper and woollen knitwear, the results were spectacularly creative. Here's a selection of our favourites from 2014.

Highs and Lows (Perth)

Concepts (Boston)

Hanon (Aberdeen)

Social Status (Charlotte)

Shoe Gallery (Miami)

Solebox (Berlin)

Limited Edt. (Singapore)

Stash (NYC)

Sneaker Politics (New Orleans)

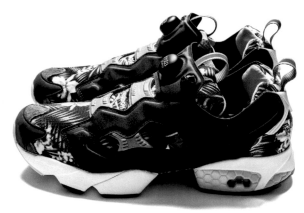

Invincible (Taiwan)

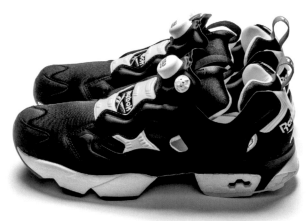

Titolo (Bern)

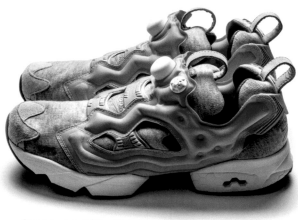

Sneakersnstuff (Stockholm)

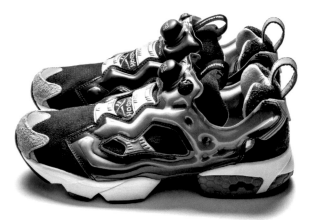

Footpatrol (London)

Major (Washington, D.C.)

Nike ACG

Published in *Sneaker Freaker* Issue 14, November 2008

EDITOR'S NOTE: WOODY

Nike is best known for pavement pounders and hardwood heroes, but the company has a solid track record of sprinkling some showbiz on the staid world of brown 'outdoors' shoes. With blazing colour combos and non-conformist contours, ACG (All Conditions Gear) models like the Aqua Sock, Mowabb and Air Revaderchi exemplified Nike's irreverent and unorthodox approach. Back in 2009, I spent an amazing week on the press junket of a lifetime, camping with the ACG crew in Moab, Utah. The 25-year anniversary celebration might not have subsequently materialised, but the campfire chats still warm the soles of my boots. Today, ACG is more of an inner-city tech-fashion experiment than a legit sub-label, but as these first-hand accounts reveal, the freewheeling spirit imbued in ACG came right from the top at Nike.

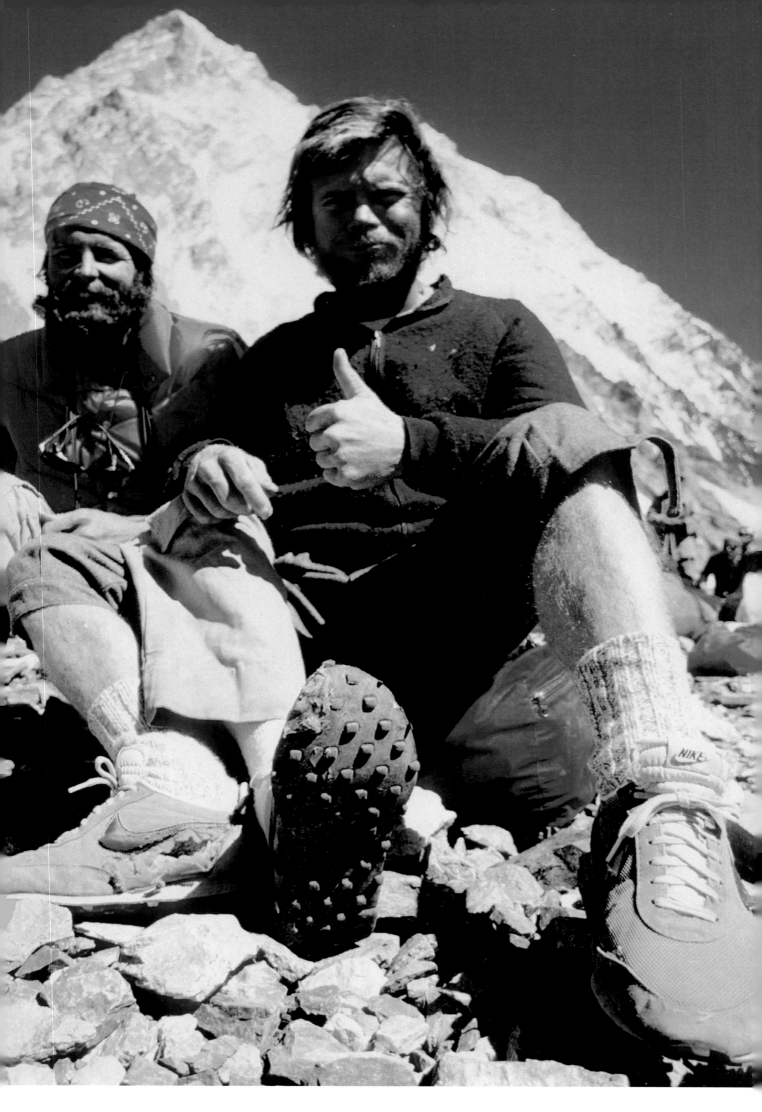

Opposite: John Roskelley at K2,
the world's second-highest mountain,
Himalayan ranges

ALL CONDITIONS GEAR

Nike's traditional upper echelon of Air Force, Air Max and Air Jordan tends to hog the limelight, so it's easily forgotten that some of the most pioneering sneaker design work comes from a department with the least-known name. ACG – or All Conditions Gear – is a mini-brand within a mega-brand that has always punched way above its weight.

In 1981, as part of their first foray into the outdoors, Nike released the Lava Dome, Approach and Magma. But it was close to another decade before ACG became a category in its own right. For such a rich source of designer gems over the years, the sub-label has always been underappreciated. Even within Nike, ACG struggled for recognition and resources. As far as I can tell, the ACG lineage has never been officially documented. Until now.

Back in 2008, after pestering Nike to create a retrospective to usher in ACG's 20th anniversary, I was invited to spend a few glorious days in Moab, Utah, as part of an ACG research expedition. The epic stone canyons and cloudless skies of Moab are pure Americana at its best. This wild part of the Midwest is famed for its hiking trails in Fiery Furnace park, not to mention more climbing, bouldering and mountain bike routes than you could poke an Aqua Sock at. For city slickers,

Moab is as awe-inspiring as the outdoors gets. As you've probably guessed by now, it's also the intentionally misspelled inspiration for one of Tinker Hatfield's most ambitious designs, the Air Mowabb.

Watching the petite French climbing champion, Liv Sanzos, bouldering from a few yards away was an amazing insight into the skill of these crazy-brave athletes. And chatting freely with Tinker around a campfire at night as he told risqué stories about the early days of Nike was merely icing on the mudcake. And to think some people call it work!

There's no doubt Nike designers have had the freedom to push the outer limits of design, construction and materials. As you'll read in our interview with Andrea Corradini, versatile footwear in a lightweight package has been ACG's ethos from day one. From the rugged Air Revaderchi to the aggressive Wildedge, the fusion of form and

ACG 'Snowpatch Spirit' Jacket

function has produced a trademark tech aesthetic that added a new dimension to the conservative outdoors business. Fuelled by the inherent pioneering spirit, ACG's trademark colour combinations like rubine and maize gold have always resonated deeply with urban audiences.

With a roll-call that includes the Wildwood, Escape, Air Moc, Aqua Sock, Vulgarian, Okwahn, Terra, Pocket Knife, Ashiko and Zion, the performance bona fides of ACG cannot be disputed. Of course, there were boatloads of forgettable out-of-town brown shoes released over the years, but history has always favoured the bold, so we'll give ACG a pass on these minor misdemeanours.

Then there's ACG apparel, which leads the charge for technical innovation in everything from super-light spray jackets to cutting-edge cycling gear and no-sew winter warmers. ACG's impact in this area is best illustrated by Nike's commitment to an environmentally sustainable manufacturing mode. The process actually began with Nike Considered, an ACG project that aimed to dramatically reduce the use of adhesives and solvents, as well as increase use of recycled materials. While it's tempting to be cynical of a multinational catching 'green fever', Nike's commitment to Considered runs deep, with every manufacturing detail scrutinised for improvement.

Sometimes you need to shine a little Maglite deep into the cracks. ACG's time in the spotlight is long overdue and this feature will give you an insight into all the classic hits and a few side-splitting stories that illustrate why it's Nike's most mischievous category. And to think it all started back in the late 70s when a bunch of rabblerousers called Tinker, Monty and Mark used to get loose as a caboose in the great outdoors.

•

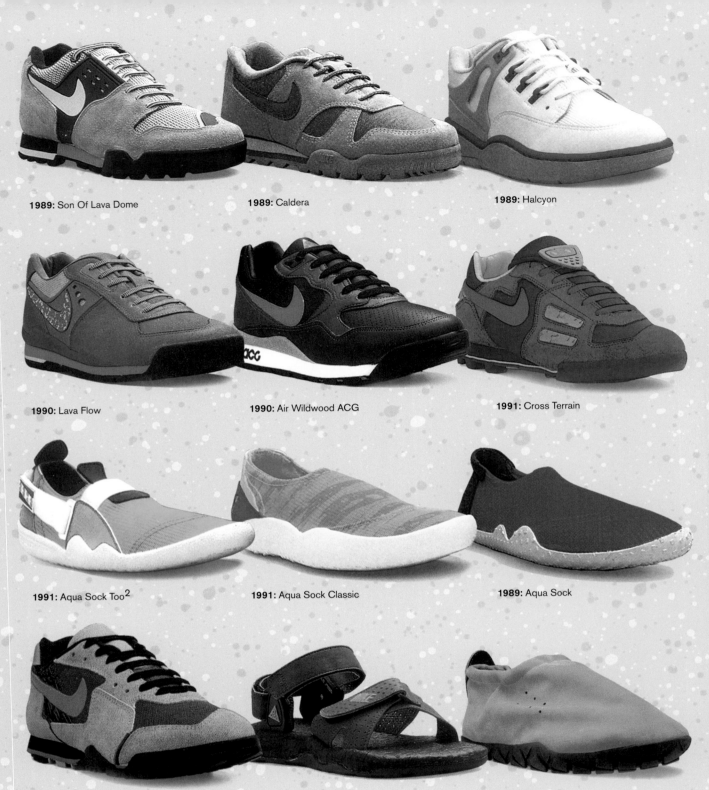

1989: Son Of Lava Dome

1989: Caldera

1989: Halcyon

1990: Lava Flow

1990: Air Wildwood ACG

1991: Cross Terrain

1991: Aqua Sock Too²

1991: Aqua Sock Classic

1989: Aqua Sock

1992: Terra Mac

1993: Air Deschutz

1994: Air Moc

1994: Air Mowabb II

1995: Zion

1996: Terra Tor

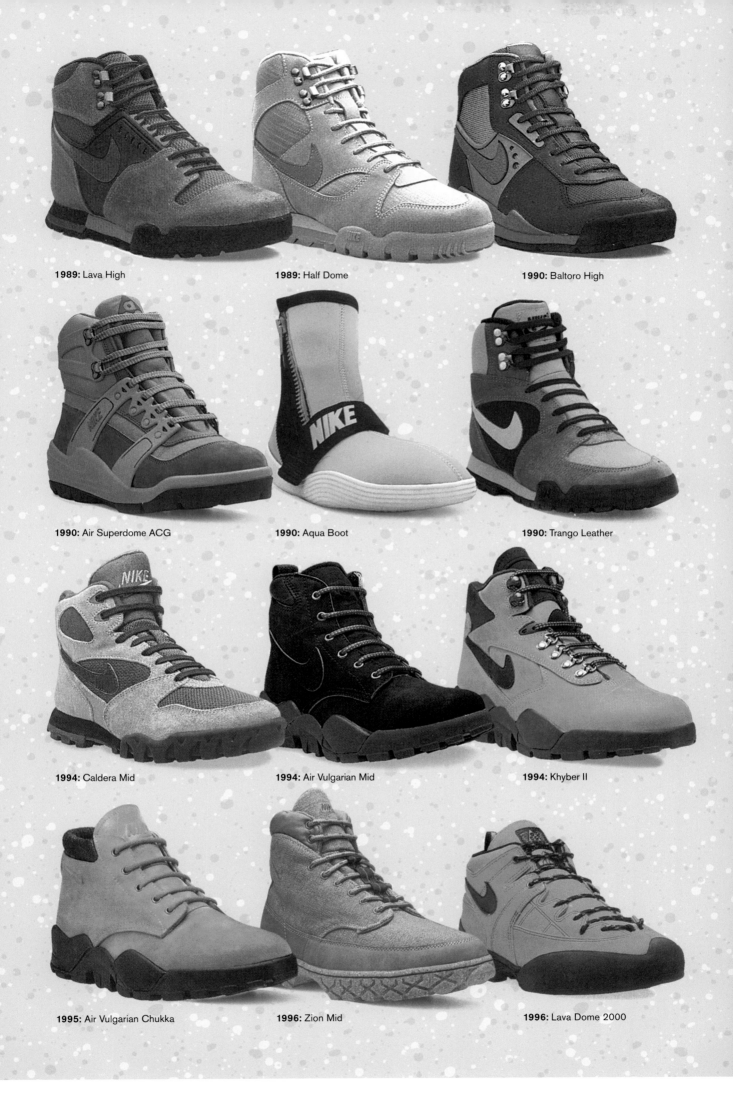

1989: Lava High

1989: Half Dome

1990: Baltoro High

1990: Air Superdome ACG

1990: Aqua Boot

1990: Trango Leather

1994: Caldera Mid

1994: Air Vulgarian Mid

1994: Khyber II

1995: Air Vulgarian Chukka

1996: Zion Mid

1996: Lava Dome 2000

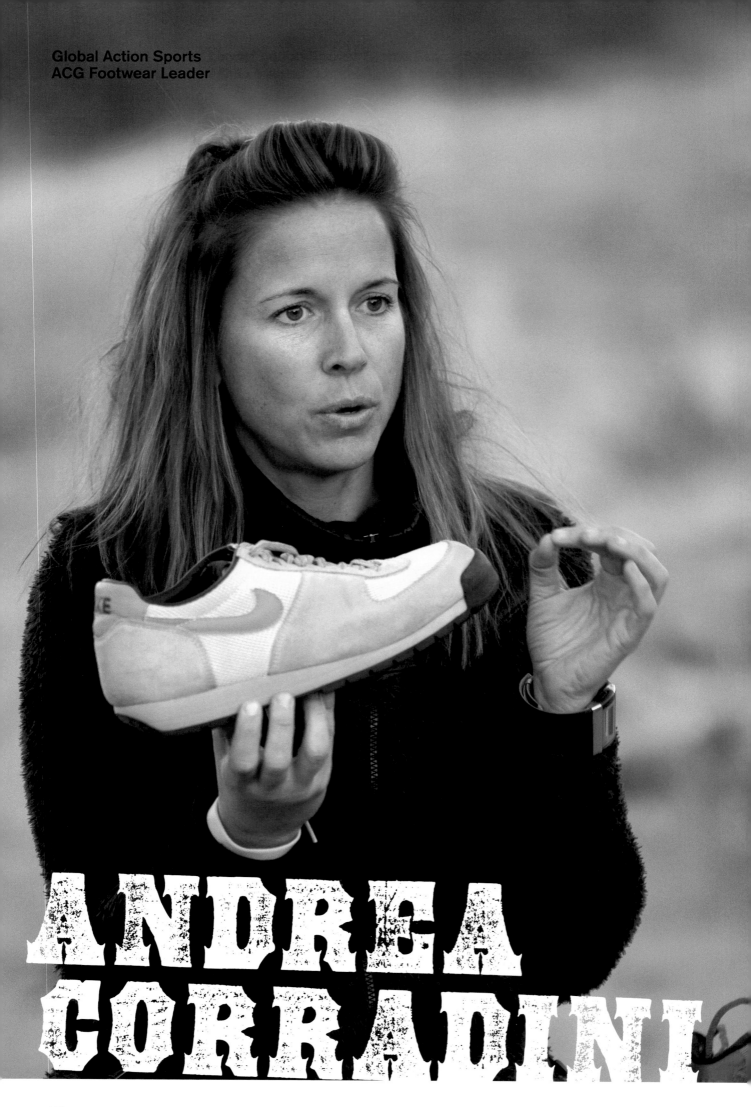

ANDREA CORRADINI

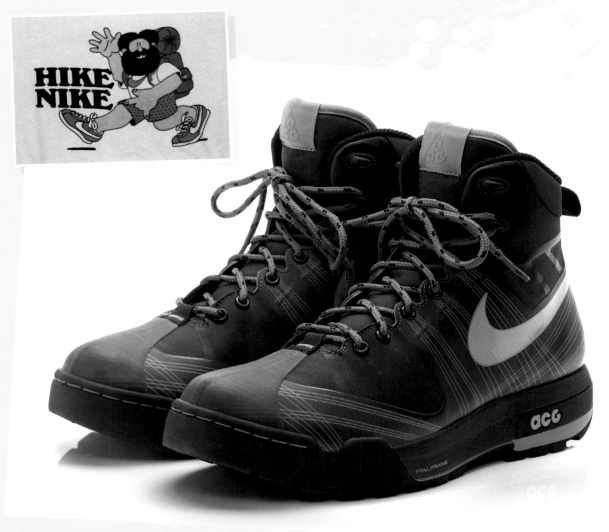

2009: Ashiko Boot

As a 15-year veteran of the ACG development team, Andrea Corradini knows more about the history of the label than just about anyone. Fresh from a day walking the Fiery Furnace trail, we sat down at sunset to find out why pushing boundaries is the rule, not the exception, at ACG.

It's great to see ACG back in the limelight. It feels like the label has been in the shadows for a while. Why is that?
Mark Parker has a great quote that says, 'If we're in it just to dabble, we do ourselves more harm than good.' ACG began because a group of crazy outdoors-loving Nike guys saw a niche, and the opportunity to create something not only better than the competition, but also disruptive for the industry. Our consumers have stayed with us through the years because, visible or not, we've kept the innovation going. Now, we're bringing it to the forefront again and making sure every piece has that attitude and edginess that consumers expect.

Do you think the lack of a 'household name' athlete like Tiger or LeBron has kept ACG from recognition in a wider context?
Honestly? No. The outdoors is such a massive playground. Who would kids aspire to be? A hiker? A climber? A base jumper? It's the versatility that counts, so to tie the outdoors to a specific athlete would be meaningful for only a niche group of consumers. We have some incredible athletes around the world and in their vertical sports they are tremendous assets – their voices are extremely valuable.

The Lava Dome and Magma were released by Nike way before ACG's official birth in 1989.
If you go back to the late 70s, the only options in outdoor footwear were stiff and heavy European boots. That's great for hardcore

mountaineers, but not everyone wanted that type of product. Around the same time, two phenomenal climbers sent us pictures of themselves hiking to K2 Base Camp in Nike LDV runners. It was validation that Nike could bring something more to the industry, so we launched our first pack of shoes, which included the Magma, Lava Dome and the Approach.

Most probably know the Lava Dome but my favourite is the Magma. It looks like a boot. It smells like a boot. But when you pick it up it feels like a sneaker. It uses lightweight foam instead of a heavy rubber cupsole, which revolutionised weight reduction. The upper's simplicity and use of waffle lugs on the outsole make it so awesome. And the colour? The brown inspired by dirt and rock with the red laces pouring like hot magma from the inside of the shoe is so dramatic!

I wasn't aware of the significance of Roskelley's K2 mission and how that lightweight story became pivotal to ACG.
Yeah, the goal of the expedition was to reach the summit unaided by oxygen, which Roskelley ultimately did. They needed to move fast so they took off their heavy boots and donned the LDVs, which were completely shredded by the time they got there, but they had served their purpose.

The amazing picture they sent us with their huge smiles and the big thumbs-up was seen as an opportunity at Nike. With just a bit more durability, hiking boots could be just as fast and nimble as sneakers.

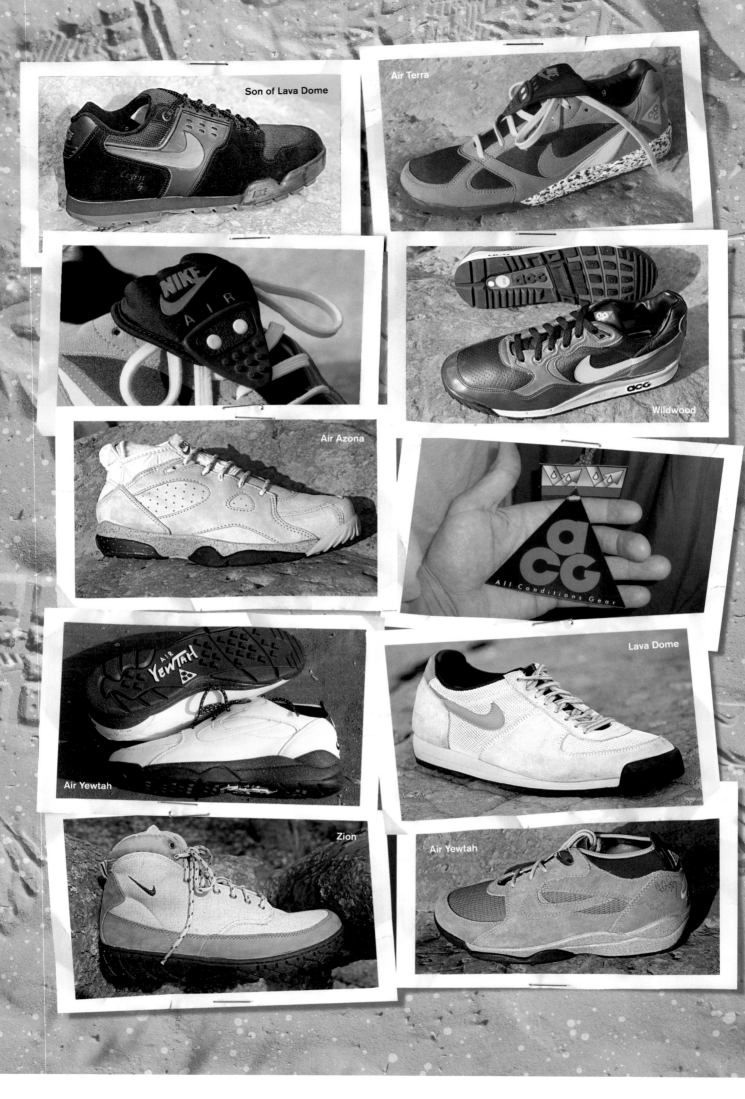

Son of Lava Dome

Air Terra

Wildwood

Air Azona

ACG
All Conditions Gear

Lava Dome

Air Yewtah

Zion

Air Yewtah

192

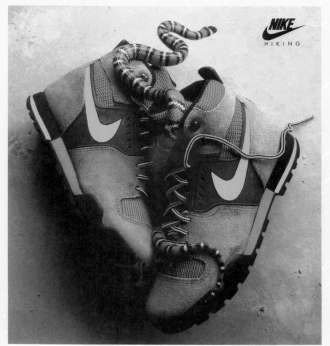

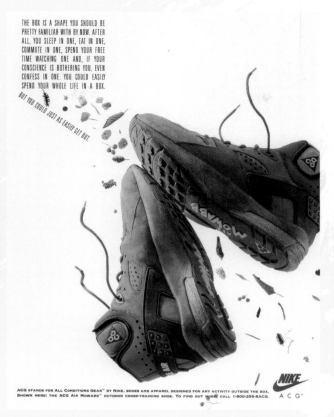

WORN TO BE WILD.

You want a hiking boot that isn't afraid of the wild life? Take on the Son of Lava Dome, offspring of the first lightweight boot ever made. It's tough, it's durable, it's as lightweight as it gets. If you wanted tame, then stay out of the woods.

Women's Lava High (above) Men's Lava High Son of Lava Dome

THE BOX IS A SHAPE YOU SHOULD BE PRETTY FAMILIAR WITH BY NOW. AFTER ALL, YOU SLEEP IN ONE, EAT IN ONE, COMMUTE IN ONE, SPEND YOUR FREE TIME WATCHING ONE AND, IF YOUR CONSCIENCE IS BOTHERING YOU, EVEN CONFESS IN ONE. YOU COULD EASILY SPEND YOUR WHOLE LIFE IN A BOX.

BUT YOU COULD JUST AS EASILY GET OUT.

ACG STANDS FOR ALL CONDITIONS GEAR™ BY NIKE. SHOES AND APPAREL DESIGNED FOR ANY ACTIVITY OUTSIDE THE BOX. SHOWN HERE: THE ACG AIR MOWABB™ OUTDOOR CROSS-TRAINING SHOE. TO FIND OUT MORE CALL 1-800-255-8ACG.

Son of Lava Dome

Air Mowabb

Does it get harder to maintain that irreverent ACG edge?
Great question. I would say the sense of humour that guys like Tinker and Monty Mayko have is what drove the brand's irreverent cadence. Some of the stories I've heard are hysterical, though probably not fit for publication. Tinker was actually one of the critical players in relaunching the spirit of ACG. He gave us four words that every product needed to convey: fun, fast, simple and Considered. They work in harmony and if you take one away it changes everything. So, is it harder now that we're bigger? No. We're still nimble, we're still making it happen.

OK, let's jump back to 1989, ACG's first proper year. What's that first range famous for?
We'd done some amazing products prior to 1989 like the Air Escape, but it was the launch of the integrated collection that really catapulted the birth of ACG. Although the Air Pegasus was the first shoe to bear the ACG mark, the Air Wildwood felt more versatile than a pure running shoe. You gotta love the midsole's bold ACG branding. A lesser-known design from that period is the Aqua Sock. From an apparel standpoint, the Makalu jacket, Snowpatch Spire jacket and the Cervino Gore-Tex parka each became iconic in their own right.

Vulgarian boots got me through several muddy festivals without trench foot. Every sneaker guy I know has one model that totally bugs them out on aesthetics alone. What is it about ACG that creates such a radical outlook?
I also have a fond memory of my Vulgarian boots. I was working in the Park City factory store when they arrived and the entire staff wore them every day for at least a month. I also remember the first time I saw the Escape II, I hit the floor and bugged out! Perhaps because there is no single activity in mind, our designers don't limit themselves. The Mowabb is the perfect example. It's so futuristic, yet so relevant to the beauty of Moab at the same time. Pushing boundaries is the rule, not the exception, at ACG.

Another interesting aspect has always been the contradiction of shoes designed for the outdoors being adopted by urban kids. How do you explain this?
I could approach this in so many ways, but I don't think it's a contradiction. I believe the urban kid respects ACG because of its authentic, disruptive positioning, not despite it. Our gear has to excel on the mountain, on the trail and in the water, but it has to look cool when you're hanging out with your friends in the city. That's our unique strength.

Fair enough! You guys must feel pretty chuffed that Considered started as an ACG project and has become central to Nike policy.
It's an honour. It's all about doing the right thing. We will continue to push the boundaries of Considered in ACG, because we're dedicated to it. Look at what running has done with the new Air Pegasus. And the Jordan XXIII? Insane! Considered models will run across just about every Nike category this spring from soccer to our entry-level running shoes. It's what we do.

The Ashiko boot looks like a classic.
There is no way to talk about it without giving props to Peter Fogg. This is a perfect example of what we do best: taking innovation to places no one thought possible. Flywire was being used on track spikes, road running shoes and basketball shoes, so why not in a boot? The outsole is aggressive yet low profile with ascending and descending traction and sticky rubber. The lines of the midsole are super clean and were inspired by the Son of Lava Dome tooling from years back. But instead of an EVA wedge, it's Phylon. Air in the heel, Zoom Air in the forefoot. The upper is almost seamless, so your chances of a blowout are virtually eliminated and the Flywire gives it that ultimate lightweight strength and support through the midfoot and heel. And it's Considered. It's a beauty.

And finally, what is your favourite ACG memory?
I've been at Nike for almost 15 years and I've been connected to ACG for every one of them. But my greatest memory is actually way before that when I was a student and we had a ski race in Jackson Hole. I walked into this little outdoors shop and I couldn't take my eyes off this amazing shoe. It was grey with accents of pink and purple. It kind of looked like a running shoe, but had lugs and outriggers so I thought it had to be for hiking. I picked it up and was amazed by how light it was. I bought that Caldera on the spot and have been hooked ever since. I still have it. The collar foam is all crumbled and the whole thing is old and beat to crap but that's where it all started for me. It's personal.

•

2006: Nike Considered Humara

2005: Nike Considered Air Mowabb 2

2006: Nike Considered 2K5

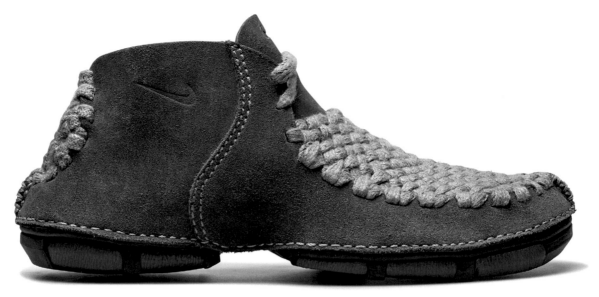

2005: Nike Considered Chukka

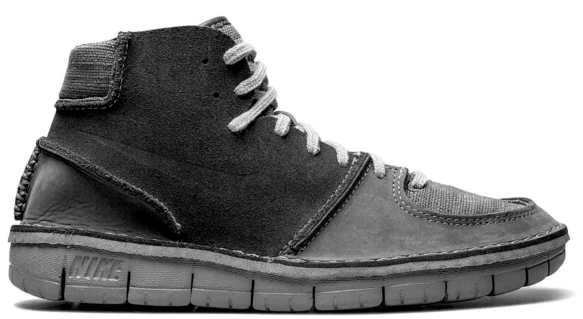

2005: Nike Considered Mid

Nike Considered

Nike Considered was a design initiative championed by their Innovation Kitchen research department in the early 2000s. Constructed from as few individual components as possible, the experimental designs used eco-conscious Nike regrind rubber, hemp laces, woven uppers, bamboo off-cuts and vegetan leather. To reduce the energy used for transportation, materials had to be located within 200 miles of the factory. Minimising solvent usage was another prime consideration. Unlike standard-issue Nikes, the soles of Considered shoes were easily disassembled for recycling.

As seen in this selection, the restrictive brief produced a defiantly un-Nike aesthetic that was more crunchy granola than super slick sportswear. Driving commercial success was clearly not the priority, though there's no doubt the shoes had a unified point of view.

In 2007, Considered was merged into ACG, with the Water Cat and Soaker making it into production. Today, the name Considered no longer exists in its own right, but many of the innovative ideas have been incorporated into Nike's manufacturing practices.

TINKER HATFIELD

Monty Mayko

Tinker Hatfield

Mark Parker

Best known for designing the first Air Max runner and many of the most loved Jordans, Tinker Hatfield was also a prolific contributor at ACG. From our campsite in Moab, Tinker explains his Mowabb design philosophy and why he loves life in the great outdoors.

What does being in the outdoors mean to you?
I think being in the outdoors is about conquering your fears, doing something that you've never ever done before and all the rest of it. But I think it's also about getting away from your daily life, having fun with your friends and doing something that maybe you don't do all that often. The outdoors can do that for you. For instance, we could come to Moab a week later and this could be quite a different experience.

Do you remember who came up with the name ACG?
I don't remember who came up with the three letters. I suspect it was one of those collaborative meetings in a bar someplace and somebody probably blurted it out. I do remember when we started talking about developing outdoor products as a sort of sub-brand and using that as a platform to tell stories. The reason I always say Nike is in the storytelling business is that if products don't have meaning, if you can't attach it to something in your life, then they're really just sneakers and socks and jocks. They may be cool objects of desire for a little while, but they won't have much of a life beyond that. The reason we hire all these brilliant athletes is because it's a great way to tell stories.

Did you rely on your personal experiences to bring new insights to the ACG shoes you worked on?
I think it's important for people to go out and look for inspiration that helps them to understand the culture. There's a culture around running that can drive you towards a solution – not just performance, but a style solution. And I think the same thing is true in the world of the outdoors. You can develop these visions in your head of understanding the sport, but it's also about how people hang out, what they do in between playing the sport. And those things can sometimes bring unique differences to products; I'm talking stylistically and maybe attitude-wise rather than all-out performance.

How did you get away with designing the Mowabb?
So I'm thinking, well, we've got this ACG project, so I'm going to design a shoe like no other. And being the fool that I am, I think I'm going to get away with it even though that's not always the case at Nike. I had built up some political clout from previous projects and I think it's a mistake if you don't take advantage of that to do things

no one's ever done. Anybody can come along and just keep doing the same old stuff. That is not my nature, I don't believe it's the nature of Mark Parker and I don't believe it's the nature of Nike. We are really interested in being leaders, not followers. The Mowabb was born of my repeated trips to Moab, Utah.

I can see why you come here. It's spectacular.
I came to Moab mainly because of a guy named Monty, a longtime Nike employee who would come here with a few of his friends. We're talking about people who were doing extreme things, really hard rock climbing and dangerous mountain biking and even more dangerous bar hopping at night, all that kind of stuff. Moab is this perfect place to do it. So we came here and we climbed and we biked on the Slick Rock and Porcupine Trail and the Poison Spider Mesa and numerous times we nearly died and were given up for dead.

During that time, I was inspired by the area and started to design an outdoor shoe that was more like a Native American moccasin. If you really think about it, in this neck of the woods, the very first outdoor athletes were Native American tribes. So I just drew this picture of a fish really fast and I started thinking about trying to design an outdoor cross-trainer, a shoe you could just do anything in. I was also thinking about how shoes work on a bike pedal, how they should work as you step on a rock and wobble a bit – all of the little issues that you have to go through in your mind to design something multipurpose.

Moccasins have no outsole, they're leather on the bottom and on the upper. That's partly because they didn't have rubber, but it's also because they didn't really need it – the shoe actually conforms to the surface it's on rather than dig into it. And that was a big revelation. No one had ever designed an outdoor shoe like that. I thought I was really on to something and I started thinking about the colours of fish, the nearby Colorado River and the Green River that runs through here.

The speckled midsole on the Mowabb has become a Nike staple. Was that the first time it was applied to a Nike sneaker?
Yeah, that was the first time we used the speckle. It wasn't an easy thing to get down and we had to spend a lot of time in Asia working with the factories trying to figure out how to actually achieve it in mass production.

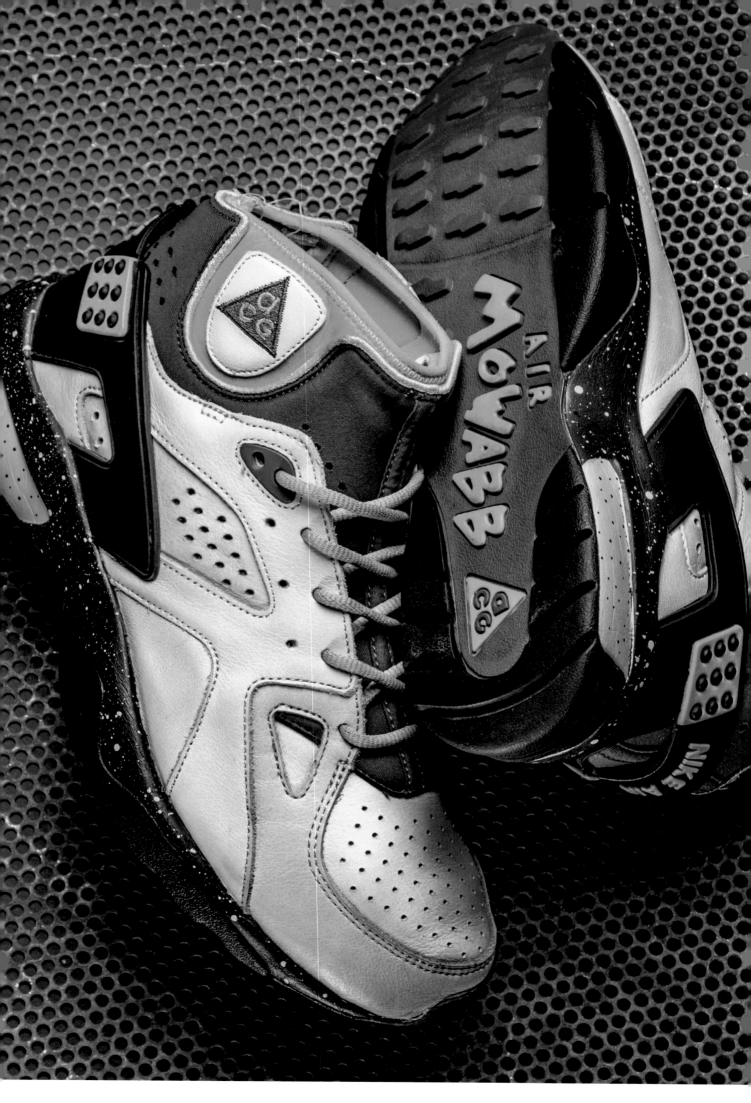

'Lawnmower Man' graphic

Irreverence justified

Air Mowabb design sketch

Air Mowabb t-shirt graphic

You had to stand there with them and actually flick paint on it?
Well, the first few samples were sort of artistically done individually, and then they figured out how to splatter paint in order to make lots of them. That's another part of this process that most people don't know about. Once you come up with all these crazy ideas and you end up with a sample, then you've got to go to some factory in a foreign country and actually try and communicate your idea. Then they tell you stuff about how to make things producible en masse, things you don't know about.

Was the Revaderchi a relative of the Mowabb?
Actually, Steve McDonald came back to me with a new version of the Mowabb. He had a few additional ideas that he called the Air Revarderchi. I think that's just a super-funny name. If you look at it, the way it's spelt there, it's a joke.

I know, I'm laughing!
Good! The Air Revaderchi was technically part of the Huarache line, but truly, it was an evolution of the Air Mowabb. I like to give Steve McDonald plugs because he's still doing fantastic work for us today and he also really helped invent Nike's Considered approach to product design. He had a few different ideas about the outsole and how it worked, which is why this shoe is a fun one to talk about even though it didn't sell a huge amount. They are what we call niche products but they help set the tone for every other shoe. They're the leading edge of the product development process. And again, I think it was an interesting and unique approach to shoe design – no one really had caught up to us at that time.

What was the Lawnmower Man all about?
The outdoors can be gnarly. You can be climbing a mountain, bombing down a single track on a mountain bike and dropping off ledges. You can be mountainboarding with big rubber wheels and doing

crazy stuff. But I've never lost sight of the fact that some guy who goes out and mows his lawn every Sunday morning is actually doing an outdoor activity. We just thought it was funny to lump that person in with all the other things that go with the outdoors. I think it's self-effacing, it says you don't have to be a super-athlete or a super-crazy person to have fun in the outdoors. If you're rock climbing and you make a mistake, it's very serious, but sometimes you make mistakes and it's no big deal. It should be about fun. So that's why there's the Lawnmower Man.

Out of all the ACG shoes, which is the most influential?
Well, it's easy to say one of the crazier designs like the Mowabb. But it's not like you could go into small-town USA or just anywhere in the world and see the Mowabb on the shelf. It was a shoe for people in the know, people who were interested in unique things. More widely, the most influential might be the kind of product that meets the market on a much bigger scale, which is hard to do. Not long after the Escape II there was a shoe called the Mada. Do you remember it?

Sure, it's plain and brown and outdoorsy looking. Pretty nondescript really.
Well a guy named Sergio Lozano, who still works for us and is a fine designer, took the Escape II and the Mowabb and sort of turned it into the everyman's shoe. I think it was influential because it took these ideas and turned them into product that anybody in the world could go and buy. We sold millions of those and I think that had a big impact on the way all outdoor shoes are still designed today. If you look at all the outdoors brands, they all have components inspired by the Mada.
•

Tinker is to blame for starting the crazy name thing with his misspelled Air Mowabb, but Air Astotle was my favourite. Most were just phonetic spellings that had double meanings or just gave us a good laugh. Air Azona also stands out and I'm still proud of that shoe. I made them leather so you could snowseal the uppers to keep the water out. I made them for the famous Yosemite solo climber, Peter Croft. He did some of his historic Sierra Ridge traverses in a pair of Air Azonas that used super sticky rubber.

Steve McDonald

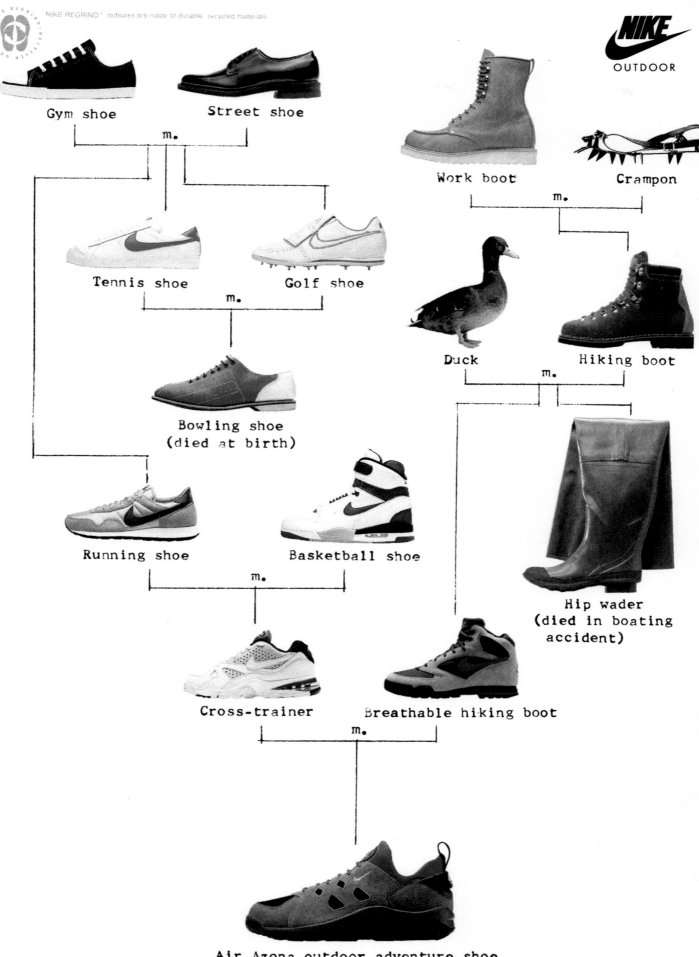

NIKE REGRIND™ outsoles are made of durable, recycled materials.

NIKE
OUTDOOR

Gym shoe

Street shoe

Work boot

Crampon

m.

m.

Tennis shoe

Golf shoe

Duck

Hiking boot

m.

m.

Bowling shoe
(died at birth)

Running shoe

Basketball shoe

Hip wader
(died in boating
accident)

m.

Cross-trainer

Breathable hiking boot

m.

Air Azona outdoor adventure shoe
Evolution does its thing again

CIRCLE NO. 33 ON READER SERVICE CARD

2003: Air Mowabb Light

2007: Terra Sandal (Considered)

2007: Air Max Superdome (Reissue)

TOP TEN REASONS
to start TEN outdoor cross-training.

10. Last stream you saw was on a bottle of **BEER.**

9. Big fat guy at gym started wearing **ZEBRA SKIN TIGHTS.**

8. No **HOT DOG** vendors on trail.

7. Less likely to run into people you owe **MONEY** to.

6. Few **FOREST CREATURES** have cellular phones.

5. Thumper's zany sense of **HUMOR.**

4. No **BAUHAUS** architecture in nature.

3. Deer doo is smaller than **DOG DOO.**

2. After one hour on **STAIRCLIMBER** you're still on the same floor.

1. The new **AIR ESCAPE** outdoor cross-training shoe from Nike.

NIKE
AIR

The Air Escape can take you scampering up mountains, dashing along trails, pedaling across ridges, or over the river and through the woods to Grandma's house. You get the idea.

For more information on ACG, All Conditions Gear outdoor cross-training footwear and apparel, call 1-800-255-8ACG, OK?

AIR ESCAPE

ESCAPE

Tinker Hatfield

One of ACG's earliest shoes was the Escape. I'm proud to talk about the Escape because it was a Mark Parker project. Mark is the coolest guy ever and he is now our CEO. Yet as a suit, as a big-shot guy, he is someone who came up through all different levels of Nike and has learned the entire business. I think that's one reason we continue to do well.

The original Escape is really just a running shoe with a beefier outsole wrapped up for added durability. It's a running shoe on steroids. It was also, in my opinion, the very first lightweight outdoor product in the industry that was purposefully done. I think it was brilliant.

Mark Parker had an insight. He understood running, he liked to be outdoors, and he simply said: 'Hey, if we take one of our running shoes and beef it up, it'll probably last longer if we go running around in the outdoors being chased by bears and stuff like that!' At this time, there was no such thing as ACG. There was no outdoor marketing per se, it was just a good product idea. We didn't build a million pairs, they were simply shoes that you had to know where to go to find them. This was the first insight as to what Nike could do in the outdoors.

ESCAPE II
Tinker Hatfield

The Escape II was an evolution of the first Nike Escape, but if you look at the design lines, it's definitely reminiscent of the Mowabb. This was a lower-priced shoe, a little more conventional, but still lightweight and still able to do a lot of things in the outdoors. We sold boat loads of these! Sometimes, even as a crazy designer, I still feel like I should try and make some money for the company so I design products where we tone down details, make them a little less controversial and a little more wearable for the average person. The Escape II came in a mid-cut as well as a low-cut.

POCKET KNIFE
Sergio Lozano

Back in the day we ran things a bit different in the design team. Most of us worked on multiple categories, which was cool because you'd share ideas and learn a lot about different sports and how shoes were built. All the footwear designers would actually sit in a room and have spirited weekly meetings. We voted to have a 'marketing-free' product session and everyone would submit ideas. I remember designing a climbing machine for one of these sessions that would simulate a rock wall, but that's another story! The ideas were critiqued and we'd decide which ones we would build. This is how we developed the Pocket Knife.

When hikers venture off on a multiday adventure, they set up camp and explore. If you're wearing a heavy pack you need load-bearing boots to get you in, but once you're there you don't want to wear clunky boots. Enter the Pocket Knife. It was designed to be a simple, collapsible and versatile pair of outdoor sneakers that you could simply slide into a pack.

The cool thing is that we made them and they worked. The bummer was that some Nike people thought the idea was too niche. Fortunately, one of the marketing guys in ACG at the time, Patrick Seehafer, really wanted to see it happen and convinced the powers that be to make a very limited quantity. They sold well and stayed in the line, selling just enough until the numbers grew sufficiently. What I loved about the Pocket Knife was that climbers adopted it and used the shoe for its intended purpose. Imagine that!

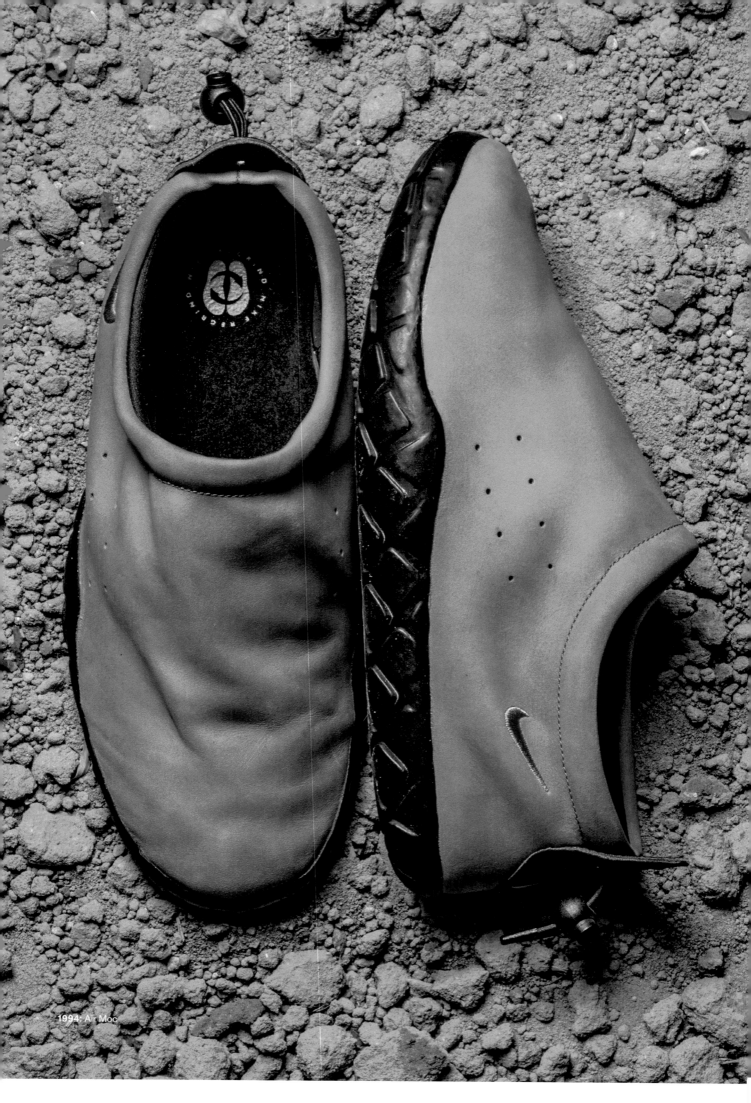

1994: Air Moc

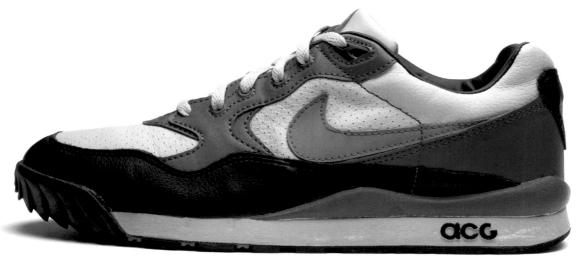

1990: Wildwood

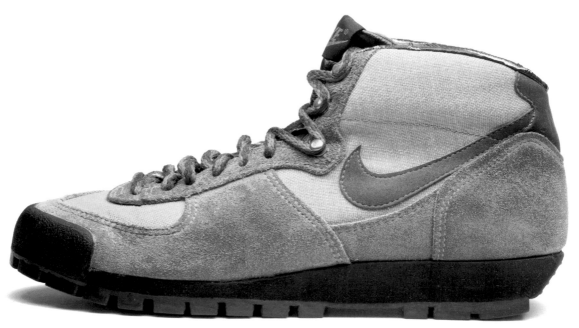

1991: Air Approach

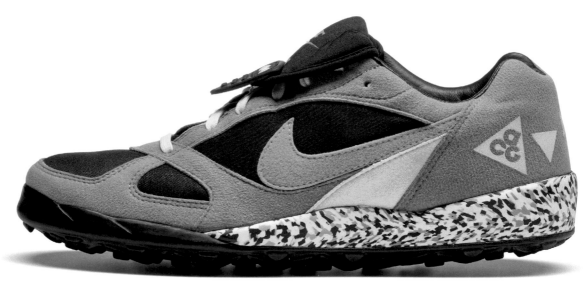

1992: Air Terra

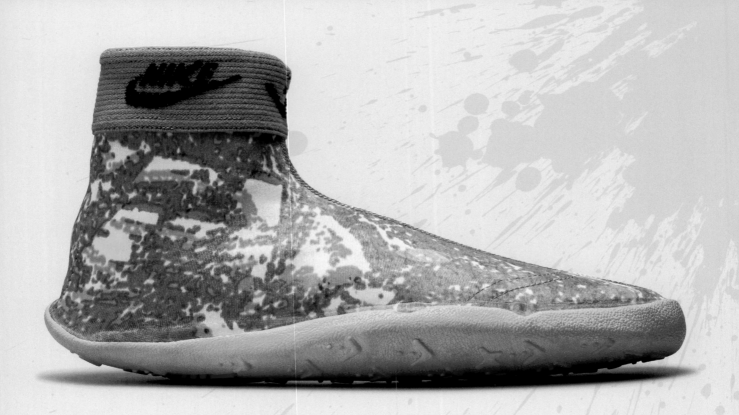

AQUA SOCK

Tinker Hatfield

Geoff Hollister is a genius. He was one of the original Nike employees and although he was not a trained designer, he was a very clever guy. He was one of the people at Nike who would go out and help sign athletes to wear new Nike products. His Aqua Sock insight was a major breakthrough.

The Sock Racer was this stretch-upper, minimalist running shoe. Ingrid Kristiansen set a world record in the women's marathon wearing the Sock Racer. Geoff thought this sort of stretchy sock-shoe would work on the beach, on a boat, and around the pool, so he basically put a shoe together based on that idea. Nike sold millions of pairs and it was renamed the Aqua Sock. In yet another interesting innovation from Nike, the shoe was all about minimalism. If you know anything about products for the water in the outdoors, you'll know this particular product has been imitated many, many, many, many times.

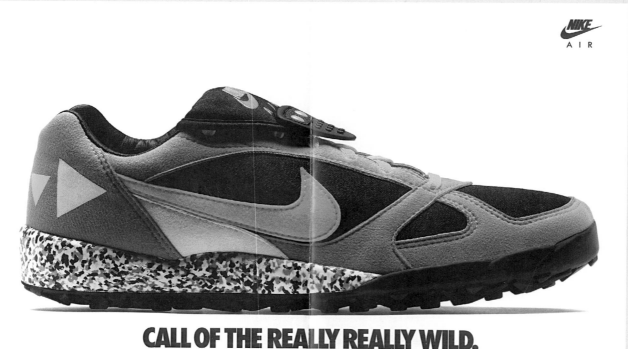

CALL OF THE REALLY REALLY WILD.

This is the Air Terra trail running shoe from Nike. Civilized, it ain't. It's got an outsole that's beveled like a mountain bike tire to take you over rocks and branches. It's got Nike-Air® in the *For more information on the Air Terra call 1-800-255-8224.* heel for extra cushioning. It's even got a deflector shield under the forefoot so you won't bruise yourself on any bear or deer. Now put your tongue back in your mouth and go try on a pair.

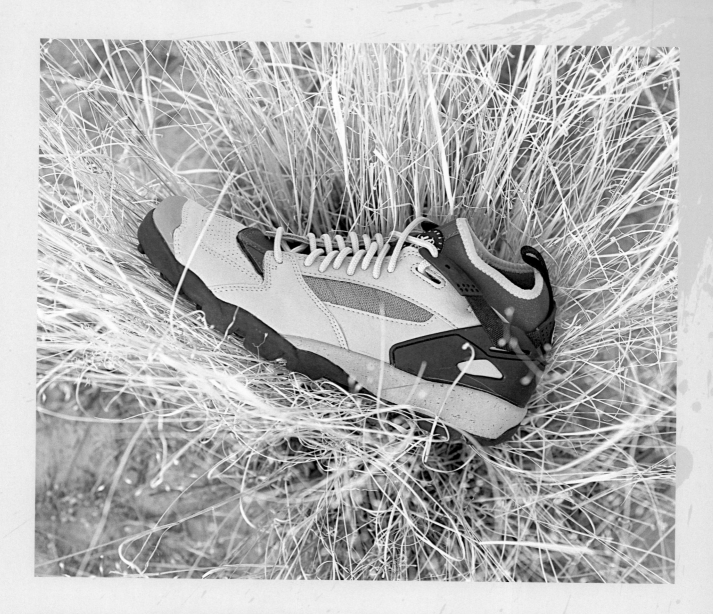

AIR REVADERCHI

Steve McDonald

I was doing a lot of trail running back in those days and I mostly wore either regular running shoes or the Escape, both of which worked fine. The problem was, on steep trails when I ran downhill, my toes would painfully jam into the ends of my shoes. The first thing I tried was a simple integrated toe-bumper which worked well when I accidentally booted rocks. I had some nice black and blue toenails to show for that and I didn't want to jam them again.

In addition to the toe-bumper, I came up with a lacing system that wrapped round my entire ankle, locking my heel to the back of the shoe so it couldn't slide forward no matter a hill's steepness or how hard I booted something. I used a new co-injection process for the top eyelet to make sure it could hold up to abuse. It worked! We put everything but the kitchen sink in the first Air Revaderchi. The outsole came directly from mountain bike tyre technology with a tread that squirted the mud out the sides and stuck to the trail by conforming to whatever surface it came in contact with.

We also built a thin plate between the outsole and the midsole to prevent sharp rocks from poking your foot. Hardcore trail running geeks loved the Air Revaderchi but they were a tad too extreme-looking for the general public. I guess the name was appropriate because they came and went. *See you later!* A lot of ideas we started back then are valid today and are still used on many good trail shoes.

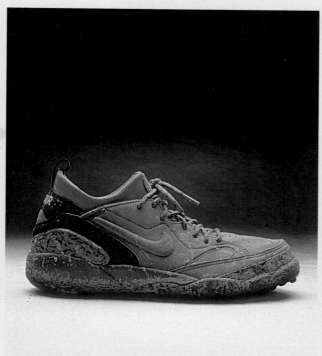

Air Revaderchi SQ

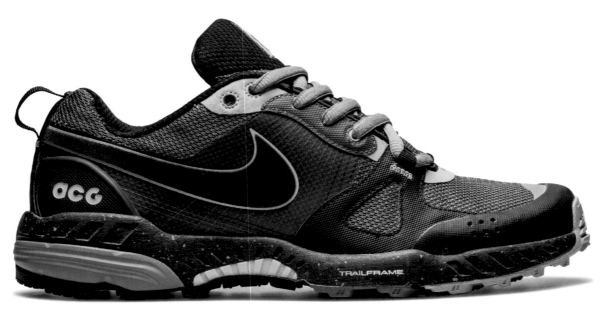

2009: Morizaba

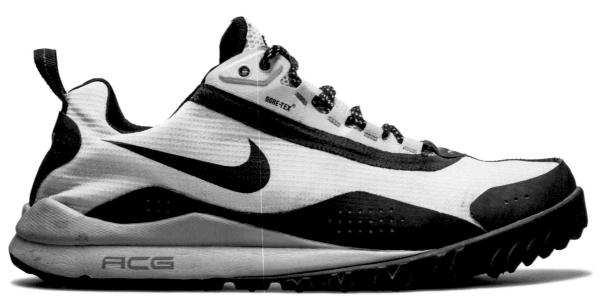

2007: Wildedge

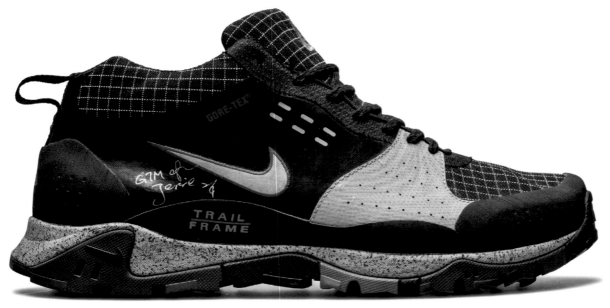

2009: Air Salbis Mid GTX (Unreleased sample)

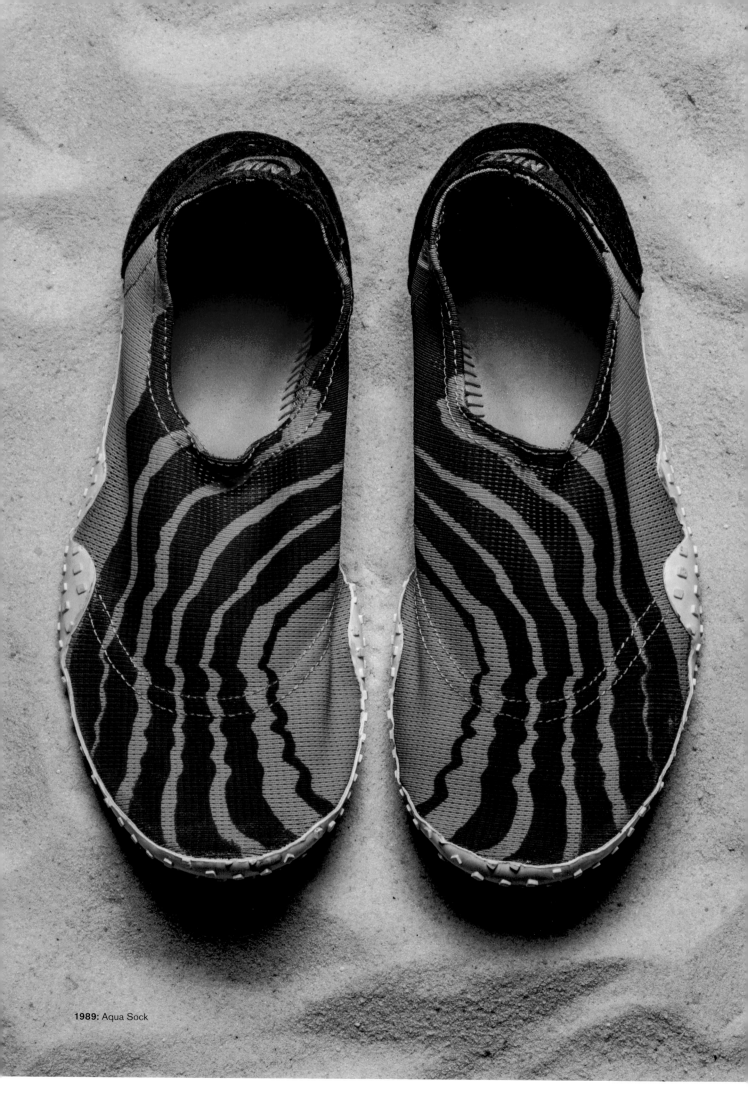

1989: Aqua Sock

Nike Air Max

Published in *Sneaker Freaker* Issue 28, August 2013

EDITOR'S NOTE: WOODY

At 72 pages deep, the original magazine version of this Air Max feature was a brain-boggling feat of endurance publishing. Released in 2013, *Sneaker Freaker* Issue 28 sold out in one weekend thanks to the online frenzy over its classic cover. Funnily enough, I look back now and see only what could have been added to make this even more of a completist masterpiece, but as I recall, we had to tap out or we'd have gone mad. Our candid interview with Nike's Air Max designer, Tinker Hatfield, still ranks highly today. Preternaturally averse to self-censorship and unable to toe the corporate line, Tinker is a unique character and indisputably the most celebrated sneaker designer of them all.

AIR MAX

THE COMPLETE* RETROSPECTIVE

(*ALMOST)

SNEAKER FREAKER

PRESENTS

AIR MAX

THE COMPLETE* RETROSPECTIVE

(*ALMOST)

From the wild red streak that is the original Air Max 87 to the 'Infrared' 90, the bombastic bubbles of the 93 and the modern masterpiece known as the 95, Nike's Air Max line is a multipronged weapon of mass distinction.

As we pondered these modern marvels, we got to thinking about the past three decades and how Air Max had somehow floated off into late-90s obscurity. The more we thought about it – and the more research we did – the more we were confronted with a paralysing question: what is an Air Max? Sure, everyone knows about the big-time players, but somewhere in this evolutionary tale the category mutates and definitions skew.

Questions kept stacking up. Can you actually run in Air Max? Is the Air 180 part of the fam? How about other big-window models such as the Structure, Tailwind and the Stab? What exactly does Air Max2 mean and how do Triax and Tuned Air fit into the puzzle? And most crucially, whatever happened to the big-bubble version of the OG Air Max 1? As you can appreciate, the original premise for this feature expanded exponentially until it became a labyrinthine mountain of Max. This was one sneaker summit that simply had to be conquered.

We headed immediately to Nike's HQ in Portland, where we recorded an extraordinarily candid interview with Tinker Hatfield, designer of the original Air Max. We were also supremely fortunate to be granted entrance to the official Nike archive where we unearthed some long-lost Max gems. Thanks to friends across the globe, we also tracked down every known version of the 'Infrared' 90 and the 'Persian' BW. You'll also get a comprehensive look at every obscure Mad Max delicacy – and believe us, there's plenty of spicy humdingers in the closet. Piece by piece, bubble by bubble, this retrospective slowly came together. Behold the epic Airmaxstravaganza!

Written by **WOODY** and **OLIVER GEORGIOU**

Thanks to Tinker Hatfield for his entertaining company and the extraordinary design of the OG Air Max, Mark Tomashow, Nelson Farriss & David Forland @ Nike, Demetria and Chester @ Nike PR, David Wasserman @ Nike JP, everyone at the Nike Archive, the late Frank Rudy for his inspiration, all the collectors including Chanica, Dirty Soles, Iceberg, BeeDubs and Kunii-san from Mita, Brendan Evans, Busy P, Matt Stevens, Dr. Google, Marc from Overkill, Air Max Chronicles, Dennis Branko and Jonathan House for photos, and everyone else who wrangled shoes for us including The Big Guy, Sebby, Robbo & Alex C. And of course... thanks to Nike for being Nike. Here's to the Max!

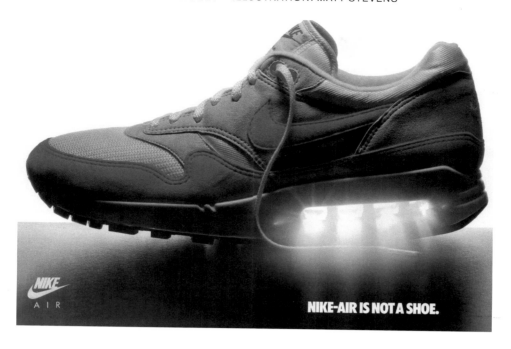

NIKE-AIR IS NOT A SHOE.

INTERVIEW

TINKER HATFIELD
AIR MAX ARCHITECT

(PORTLAND, OREGON)

Tinker Hatfield started with Nike in 1981 as a corporate architect. By 1985, his background as an all-round athlete had him knocking on the door of Nike's footwear design department. Luckily for us all, they let him in and gave him a new job. Armed with a supreme will to win and brilliant insights into storytelling through product design, Tinker's curiosity and wild creativity produced the revolutionary Air Pack in 1987. Nike was struggling at the time, but once the Air Trainer 1 and the first Air Max hit the streets, the entire sports industry was recalibrated. There's only one way to start this story and that's a pilgrimage to Nike HQ to talk Max with the man himself.

Where was Nike at, and where were you at personally, in 1987?
My recollection is that Nike was going through a period of flattening growth and sales. We had technical running shoes, but there wasn't anything fresh and different about them. The only thing propping us up at the time was the Air Jordan line; I mean, we sold a lot, but we relied on it too much. So the company wasn't doing too well and there were some big layoffs. I'd been around Nike for about five years. I had been the corporate architect and was just getting into shoe design.

We were starting to develop a bigger cushioning airbag and I was watching the technical people work on it (a team that included Air Force 1 designer Bruce Kilgore, and engineers like Tom McGuirk). Around that time, I took a trip to the Centre Pompidou in Paris. It was cool because the outside design was all about showing the inside. So I came back from Paris and I drew this shoe that basically eliminated part of the midsole and I showed it to Mark Parker and a few other folks. I remember Rob Strasser [Nike executive] said to me and Mark, 'You guys better do something because this company is going down!' He then put some horsepower behind our group to go ahead and develop a shoe with Visible Air based on my drawing.

You make it seem like a straightforward process.
Not really [laughs]. People in Nike marketing at the time – and I shall not name any names – were absolutely dead against the development of the Air Max for two reasons. One was political – those same people tried to get me, Mark Parker and a few others who developed the shoe fired. I actually thought it was kind of fun, because I wasn't getting paid that much anyway, so I thought if I get fired, what the heck! I've always had a bad attitude towards being told what to do, and I was often looking for a fight in those days. The second reason why people were against the Air Max in general was more practical. I remember being in meetings where people said, 'That's not going to work, people are going to put holes in that airbag and we're going to get all these returns! And no one's going to buy them anyway because the shoes aren't going to hold up!' I wanted to prove those people wrong.

You certainly did that. How did it play out?
Well, we were working outside the normal process. Marketing people and the product line managers were going out and spending a lot of time listening to retailers, which was normal. I think that's why Nike actually got a bit complacent and stale in its product line and one of the reasons why we were flattening out in that 1984–86 period. Rob was willing to place a bet on me and Mark to just shake the whole tree.

There was a huge backlash against the fact that he was allowing two or three people to completely ignore the whole system that Nike had in place – which I loved, because I never paid attention to it anyway and I still haven't to this day.

AIR MAX.

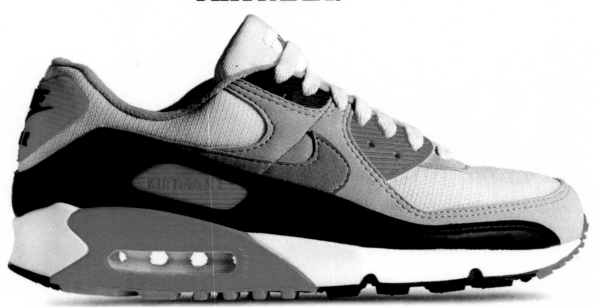

The new Air Max.® With more Nike-Air® cushioning. More plush padding. More support.

1991: Air Max print ad

But back then I wasn't in a position to wield any clout; I was just like, 'OK, we're just going to do this and if we get fired, we get fired!' I mean, we literally had hate notes put on our doors! We called ourselves 'The Speed Group' because we were working fast. Somebody came in one morning before Mark and I showed up, and on each of our doors was a big yellow sticker that said 'speed bump'.

Stuff like that was happening, and I know that behind the scenes there were two or three vice presidents who were actively promoting our exit. Rob and then Nike creative guru Peter Moore – who both left the company a couple of years later – pretty much told those guys to leave us alone. To Rob's credit, he was betting the farm on us because Nike was going through all these layoffs, and frankly, there wasn't anything else terribly exciting on the drawing board.

The Air Max is such a familiar object these days; it's hard to imagine how shocking it was.
Actually, the very first drawing I did was a little bit more modern and streamlined, but as we got into development, the decision was made to go ahead with a more standard look. I didn't think it was cool enough, so I decided to run that red tip all the way round the shoe. It's what we call the 'rand' – the bright red band that wraps around the shoe – which basically became a visual metaphor for 'Look at me, I'm red! And look at me a second time, I've got a hole in the side!' It became a frame for the midsole that had this huge hole exposing the new technology.

I remember a review out of Great Britain where the guy got a little bit cheeky and said that the shoe felt pretty comfortable, but he just couldn't deal with the fact that there was this big red stripe around the side. It was too outrageous for him.

The Safari might have given him a heart attack.
I think he was a technical kind of shoe reviewer and he just didn't understand the Air Max. That was part of the problem with many Nike shoes: almost all of them at the time were white and grey or white and navy. I think it had a lot to do with the fact that the marketing and product line managers were spending too much time listening to the lowest common denominator line of thinking, which was like, 'Don't put any weird colours on there because we'll sell more if it's just white and grey.'

Sad to say, but bland sells.
Exactly. That gave me more reasons to be the asshole that I was and still am! Mark was cool with it because we were in it together. He got actively involved in helping finish the shoe and making sure it was technically appropriate for real runners. In the end it was heavily promoted because of the way it got lumped in with a bunch of other shoes that I came up with; we called it the Air Pack and it included the Air Safari, Air Revolution, Air Trainer and the Air Sock. After that, I felt like I had carte blanche to continue to shake up the shoe world. I drew a whole bunch of shoes that were all somewhat avant-garde compared to what we had in our line.

It all came together with the advertising campaign with The Beatles music. In those days, the product design group and the marketing people typically aligned to work out the advertising. It was mostly print ads back then, but Nike's very first TV ads were around the Air Max, Air Trainer and the Air Safari and it was all about revolution. I was in all those meetings where all that stuff was decided.

Is that when you realised it was a winner?
Actually, it was when we got the first Air Max sample. Mark and I had spent weeks in Asia trying to figure out how to develop the shoe. I remember sitting on a plane with Mark and we didn't want anyone else to see it because we were fresh out of the factory. I'd look at it and he'd look at it and we'd look at each other and go, 'Man, this is wild!' I remember us both pretty much thinking the same thing: 'This is crazy, but this is going to work, and people are going to go nuts!' Sure enough it just exploded.

What effect did that explosion have for everyone directly involved in the project?
I don't think Mark and I were sophisticated enough to understand the ramifications of what we were doing. We were just trying to help Nike out of a slump and we had an idea. Mark's now the biggest executive in the whole industry; I'm somewhat less than that, but all of our careers were launched pretty much as soon as that shoe hit the market and the advertising started.

The success of the Air Pack with the Air Max leading the way created not only sales for Nike and helped turn the company around

AIR EVEN MORE MAX.

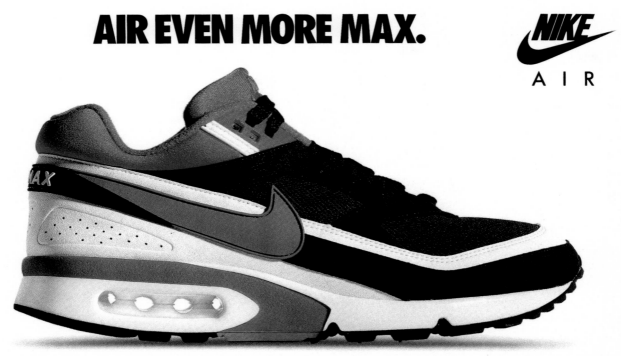

More comfort. More of that great Air Max ride. More attitude. What more could you want?

when it was vulnerable, but it also opened the door for others at Nike to think and act more freely and explore new ideas – including me. We felt that if the Air Max worked like that, then man, let's get crazier with new ideas, new colours, materials and technology. It was a renaissance of sorts. We hired more designers and people who were skilled at doing more than just utilitarian performance design. They were actually bringing stories and content and a kind of romance to design rather than just meat and potatoes. That was really cool.

I assume you had some clout after the Air Max gamble paid off.
We did, because it translated into dollars right away. Sometimes that doesn't happen. You can do something new and different, it might be ahead of its time and not catch on, but then maybe it does a little bit later. Man, Air Max was an instant hit. Yeah, there were a few sketchy reviews and people didn't understand the Air Trainer very well either, but in the market place they totally got it.

In the Air Max video that was made a couple of decades ago, there's some VHS-looking footage that looks like it was staged with you and some other Nike guys talking about the evolution of the shoe. What was the context of that footage? I've never heard it explained.
That's so funny. We looked so young and stupid, now we're old and stupid. It's so stylistically dated.

It looks like an episode of *Cheers*.
Exactly! I wasn't working in Beaverton; I was in downtown Portland, because Peter Moore had asked me to create a special place to work rather than be out in Beaverton with all the corporate types. We were in a warehouse above this novelty store that was selling balloons and whoopee cushions and stuff like that, right by Jeld-Wen Park, the soccer stadium. Peter rented the place and I converted it into a loft-like design space for about 30 people. Mark never worked there, although he was in and out a lot because we were hatching ideas in a sort of parallel universe. We were trying hard not to be part of the Nike machine. Anyway, right across the street was a bar called the Bullpen. We'd go there for lunch and have a few beers after work or whatever, and the decision was made

to actually make a video about Air Max technology [to be filmed in the Bullpen]. We didn't have a script, but we had all rehearsed our roles. They had me hold up my drawings and say something like, 'Hey, what if we cut a hole in the side of the shoe and we actually showed the airbag?' Then they'd cut to somebody else who'd say something. It was totally staged, but it wasn't unlike some of the silly unprofessional meetings that we normally had. We didn't know what we were doing most of the time, so it was pretty funny.

You had a drawing of an early Air Max version in the video. There's almost a little bit of the Free and the Flow there. It looks like it had a piece missing in the heel and a neoprene toe.
Yeah, it was definitely more radical. Sometimes I think when you are trying to be innovative, your first step is to go a little bit further out and then pragmatism and reality sometimes have to pull you back. My first drawings were much more modern, futuristic and streamlined.

Air Max has been around for over 25 years; can Nike credit its longevity to the purity and success of the first Air Max model?
When I started to design the second, third and fourth Air Max, some of them were radically different. It was basically like creating a new brand. When you get to that point, you can think of it as a franchise that needs extra attention and marketing and a continuous push, all those things. Subsequent versions of the Air Max are some of the most popular shoes ever produced. I travel all over the world and I see them everywhere in different colours.

People don't run in them so much anymore, but it was fun for me to design the first several years' models; I felt like I was the one who understood the original concept. I could then expand on it, and all the while the technical team were continuing to make the airbags bigger and more interesting, so it kind of took on a life of its own.

As the original designer, how do you separate the first model from those that came after it?
I'm not sure how to answer your question other than to say that each Air Max was an interesting exercise in how to maintain the franchise while pushing the envelope. It's easy to create yet another reason to be conservative. When I was designing the shoes every year, I was going, 'OK, gotta do something new and different and exciting and

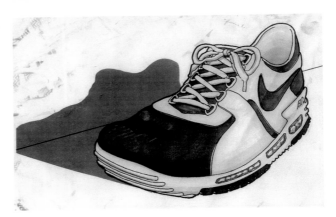

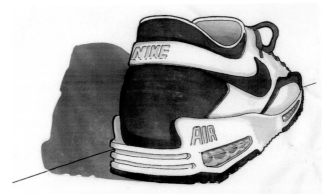

A youthful Tinker discussing Air Max in a Nike video. The first design would eventually release in 2015 as the Air Max Zero

1986: Tinker's original Air Max sketches

make it perform better!' but I was also wary of not becoming the very people I was revolting against because I was trying to protect the sales numbers at the same time. It's a double-edge sword.

I don't know if I have a favourite because they were coming fast and furious, and I was just working on them all the time. By my last one, which I think was in 1994, I was getting kind of burned out. The Air Max 95 was done by Sergio Lozano. He came in and did one that was clearly not a running shoe. I don't remember talking to him too much about it. I handed him the project and said, 'You know what, it's time for someone else to be doing the Air Max'. He took it in a non-runner direction; that upper was not meant for running. With all those layers overlaid and the stitching, it was a fashion statement. That's not the way you design a good running shoe, but it was really cool looking.

The Air Max 97 was another that was unique and colourful and layered up. It wasn't a running shoe either. I always tried to stick somewhat close to the whole notion that the Air Max is a serious running shoe. Sergio didn't have that restriction. I can't speak for all the Air Max models that have happened since then, because I don't keep track of everything that goes on, but some of the recent ones have become serious running shoes again.

Well, Tinker, thanks for causing trouble all these years and long may you continue to do so. I have one last question: what would Nike be like without Air Max?

Well, you know, it's always fun, I've been having a good time talking about Air Max. But yeah, that's a good point, and you can probably ask that same question about many other Nike products. Air Max was a really important left-turn away from where we were headed. I guess you can take two paths: continue trying to please everyone, or the other path where you still want to be successful, but you do it your own way. That's what I felt like we did.

Now it's easier to look back and say, 'Well that's a real seminal point, a very important moment in time for the footwear industry and maybe even the sports world,' but I don't think we thought of ourselves as being that important. We were just trying to win, and trying to win with shoes that were unlike any other shoes. It totally exploded. Nike just took off like a rocket ship. What can I say?

∞

CAN WE TALK?•

You may have heard reports that NIKE is being sued by the Beatles.

That's not exactly true.

NIKE, along with our ad agency and EMI-Capitol Records, is being sued by Apple Records. Apple says we used the Beatles' recording of "Revolution" without permission.

The fact is, we negotiated and paid for all the legal rights to use "Revolution" in our ads. And we did so with the active support and encouragement of Yoko Ono Lennon. We also believe we've shown a good deal of sensitivity and respect in our use of "Revolution," and in how we've conducted the entire campaign.

So why are we being sued? We believe it's because we make good press. "Beatles Sue NIKE" is a much stronger headline than "Apple Sues EMI-Capitol for the Third Time." Frankly, we feel we're a publicity pawn in a long-standing legal battle between two record companies.

But the last thing we want to do is upset the Beatles over the use of their music. That's why we've asked them to discuss the issue with us face-to-face. No lawyers, critics, or self-appointed spokespersons.

Because the issue goes beyond legalisms. This ad campaign is about the fitness revolution in America, and the move toward a healthier way of life.

We think that's a message to be proud of.

1988: As the legal battle raged over the use of 'Revolution', Nike was forced to explain their side of the argument via press ads such as this

Filmed in grainy black and white, the 'Revolution' TV campaign was a masterpiece in editing visuals to music that could easily have been shown on MTV in the company of Madonna and Bon Jovi's clips. Amateur athletes were sandwiched between Nike greats such as Jordan and John McEnroe. The context was simple: sport and fitness were fun. To promote the revolutionary nature of Air Max, Nike licensed The Beatles' song 'Revolution' for a reported $500,000. Yoko Ono was stoked that John Lennon's music was reaching a wider audience, but the three surviving band members were less impressed and filed a lawsuit for $15 million that also dragged in Nike's agency Wieden + Kennedy, Apple Records and Capitol Records. It's hard to fathom by today's standards, but using music by The Beatles to promote Nike was widely considered blasphemous in 1987 – the sense of moral outrage was also heightened by the counter-culture stance of Lennon and his 'revolutionary' lyrics. The lawsuit was settled in 1989 and the details remain confidential to this day.

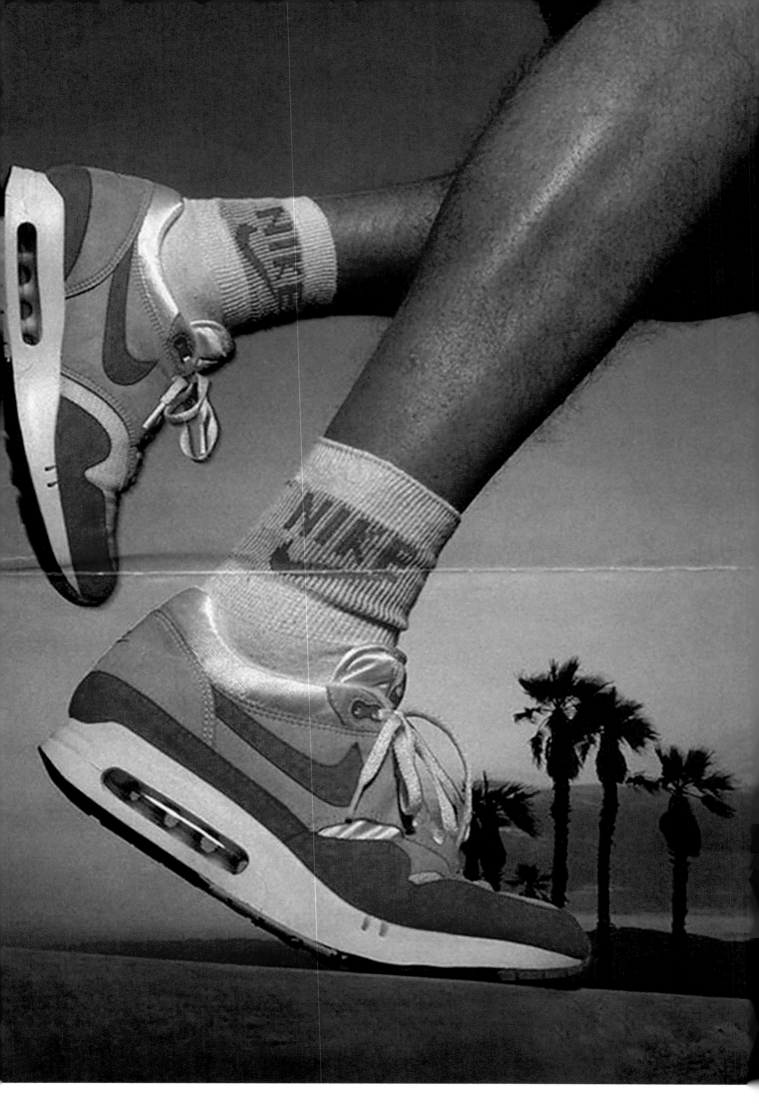

I remember sitting on a plane with Mark Parker and we didn't want anyone else to see it because we were fresh out of the factory. I'd look at it and he'd look at it and we'd look at each other and go, 'Man this is wild!' I remember us both pretty much thinking the same thing: 'This is crazy, but this is going to work, and people are going to go nuts!' Sure enough it just exploded.

TINKER HATFIELD

AIR BAGS

Since aerospace engineer Frank Rudy first proposed the use of 'encapsulated air' for cushioning in the mid 70s, the concept has undergone countless adaptations. From single to dual-pressure, blow-moulded to full-length, Tuned to Tube, here's a selection of our favourite fun bags.

1978: Air Tailwind
THE FIRST AIR BAG

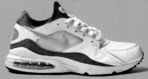

1993: Air Max 270
ALSO USED FOR
AIR MAX 1994
AIR MAX BURST 1994
AIR MAX LTD 2002

1990: Air Max
ALSO USED FOR
AIR MAX BW 1991

1987: Air Max 1

1994: Air Max²
ALSO USED FOR
AIR MAX 1995

1996: Air Max
ALSO USED FOR
AIR MAX 1997 ALT. RELEASE

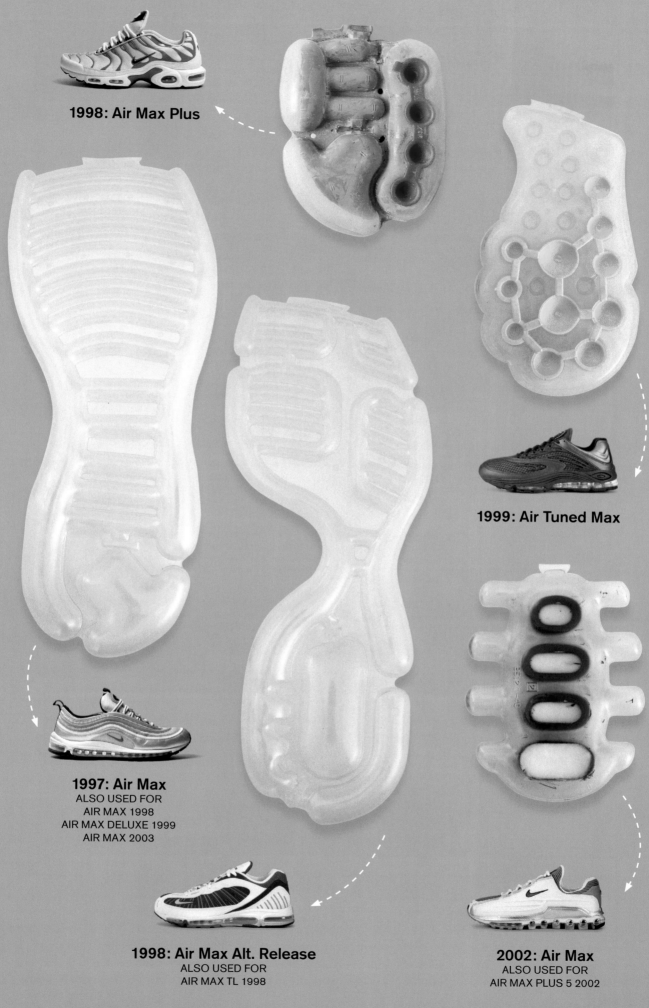

Airbag photos: Air Max Chronicle / KK Bestsellers

1998: Air Max Plus

1999: Air Tuned Max

1997: Air Max
ALSO USED FOR
AIR MAX 1998
AIR MAX DELUXE 1999
AIR MAX 2003

1998: Air Max Alt. Release
ALSO USED FOR
AIR MAX TL 1998

2002: Air Max
ALSO USED FOR
AIR MAX PLUS 5 2002

1986/7: Nike Air Max 1
The gigantic Air Max bubble confirms this was one of the earliest production models from 1986.
Don't even think about vintage pairs, these are beyond unobtanium.

AIR MAX 1
THE FIRST OF ITS KIND

Air was inserted into the Tailwind runner as early as 1978, but it was another decade before Nike unleashed the technology's true potential. Seeing is truly believing, and Tinker Hatfield's idea to open up the midsole to inquiring minds was a masterstroke that heralded a new era of Nike supremacy. With its glowing red band, chunky rump and explosive airbags, the Air Max 1 unwittingly launched a franchise that is still going strong more than 30 years on.

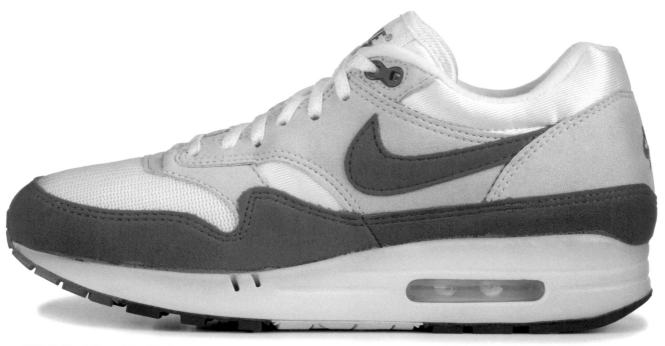

1987: Air Max 1 (Neutral Grey/Red)

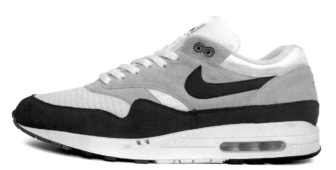

1988: Air Max 1 (Navy Blue)

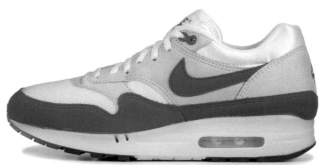

1987: Air Max 1 (Light Royal Blue)

INTERVIEW
DAVID FORLAND
POPPING THE MYSTERY
OF THE BIG BUBBLE

As Air Max aficionados have long known, there are actually two original versions of the Air Max 1. The first appears to have been manufactured in 1986 and features a gargantuan bubble in the heel. The second version sports a few subtle midsole modifications such as a slimmed-down Air unit.

We always assumed this discrepancy was due to production issues, but as everyone knows, relying on internet gossip is not enough. To clarify the mystery of the big bubble, we travelled to Nike's Portland HQ and caught up with the man who's worked in Nike's Cushioning Innovation Group since 1985, David Forland.

'When we first launched the Air Max, it had a larger window and the Air unit was much taller. The shape of the unit also changed during the initial months of production. I haven't looked back in the records for the exact timing, but from memory, it was switched within a few months of the launch. During testing of the units at the original height, cracks were developing in the windows – especially in cold-weather areas of the country. We quickly redesigned the unit to a slimmer height and corrected a couple of other issues that were plaguing manufacturing. The changeover happened during the actual production of the shoes. A few years later, after more R&D, we developed a material that allowed us to make bigger Air-sole units and larger windows, like in the Air Max 180.'

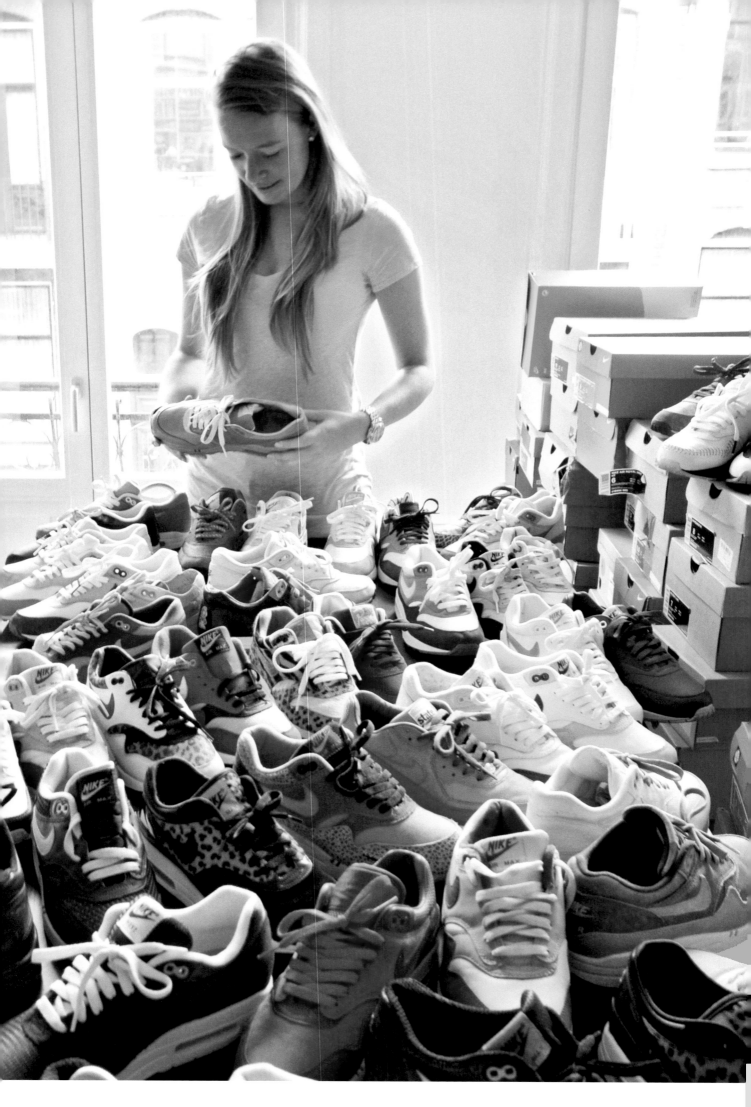

AIR MAX 1 COLLECTOR

CHANICA

(AMSTERDAM, NETHERLANDS)

PHOTOS: DENNIS BRANKO

Transitioning from track to street, the Air Max 1 developed a diehard following, particularly in Europe where it became a street style staple. On the lookout for an AM1 collector to floss our feature, we tossed around a few names. But when we were introduced to Chanica we were blown away by her sweet collection and dedication to the cause. It was also the first time we'd met someone whose name rhymed with *Sneaker Freaker*! What's more, Chanica isn't some nerd-hustler-wannabe, she's a legit fiend with an unquenchable thirst for bubbles. As she says, 'It's just Air Max 1 love!'

What's your earliest Air Max memory?
My teacher in elementary school had the red mesh AM1s from 1999 as well as the blue SCs, and I was so impressed by the airbags. I thought he could jump really high because of them! Years later, I saw a boy from my old school wearing the 'Animals' and it was love at first sight. He told me that it was impossible to find a pair as they were limited editions from atmos. An exclusive sneaker with animal print all over them? Designed by a shop in Japan? I *needed* them! I found out about online sneaker communities, exclusive releases, stores and auction sites. So that's where the hunt began. One year later, I found them [the 'Animals']. A Dutch girl was selling a deadstock pair in my size with all the OG trimmings. I was so happy! They were my first Air Max 1s.

Why do you love these chunky Nikes so much?
I love the simplicity of the shoe. The shape, the soles with the nipples, the airbags, the thick tongues and midsoles – everything is just perfect. They're comfy, and because they exist in so many colourways you can always match them with your outfit. I can't describe my feelings, it's just Air Max 1 love. It's sporty, but not cheap-sporty, you know what I mean? It's simple, but classy in its own sporty way.

I know what you mean. How did your collection evolve?
During my year-long hunt for the atmos Air Max, I learned there were a lot of other colourways. So after I hunted down the 'Animals', I wanted to find the 'Beast' pack. The excitement when I finally picked up the pair I had been hunting for months was an awesome feeling. I wanted more, more and more – it became my passion.

I search the web for at least three hours every day. Find someone who might have that pair you want, make sure you check every website (because you can't sleep on a pair!), and so on. It's an addiction. I have maybe 15 pairs left to find and those are the ones that I've never seen in my size. I collect only the Air Max 1s from before 2007 – except the Pattas and atmos, of course – and some other nice 'old-shaped' AM1s. The most important thing for me is the shape, then materials, then colourway. There have been some great colours lately, but the shape is so off that I won't buy them. I'd be happy like a little kid if I finally come across the last 15 pairs I want.

How do you see the difference between the AM90 and the AM1?
For me, the 90s are more manly. It's a rougher model because of its sharp and square shape. That's how I see it. I really love some of the 90s, like the 'BRS' and 'Homegrowns', but I think AM1s look better on girls than 90s. I see the AM1s as a classy model, while the 90s are just rough. In my opinion, the AM90 'Infrared' is always the best summer sneaker a man can wear. Short pants and Infras is so sexy! I hope all the men of Amsterdam are reading.

Are you feeling any of the new-school Max models such as the Max 90 Current, Hyperfuse, Vac Tech, Engineered Mesh and the vintage treatments?
I'm not really feeling the Air Max Currents, but they look comfortable so it's probably a good workout shoe. I like the Hyperfuse 90s and AM1s, as they bring back the old shape and the latest colourways look good. I hope there will be more Hyperfuse releases. The Vac Tech is one of my favourites of all the new models; I love the fabrics and quality, especially from the 'Wheat' series. I like the AM1 'Mint Vac Tech' release too; it's an awesome colourway with crazy materials.

Are you happy with the availability of sizes?
Most of my Air Max are men's sizes and I'm happy that they often start from a size 6, so I fit into them. Many of my girlfriends want to wear Air Max that are men's releases too, but they have smaller feet, so it sucks for them. On the other hand, Nike make some nice Air Max for women. Unfortunately, most of the retailers only have one or two pairs in the smaller sizes, so they often sell out immediately. It would be nice if Nike would make some extra pairs. Hopefully someone at Nike is reading.

Has your sneaker addiction ever affected your relationships?
Haha, no! I talk a lot about sneakers, so it's better to have a partner who understands what I'm talking about and is as excited as me, rather than a partner who just smiles and doesn't understand why I'm jumping around my room when I find another pair of Air Max. I helped my ex-boyfriend score some heat once. He was proud of my crazy hobby and he never really complained.

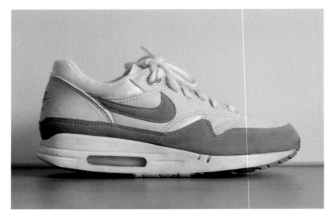

1987: Air Max 1 'OG Blue'

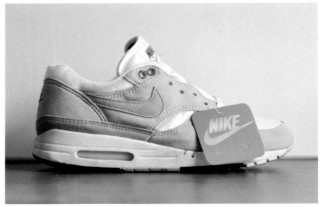

1988: Air Max 1 'OG Aqua' (Women)

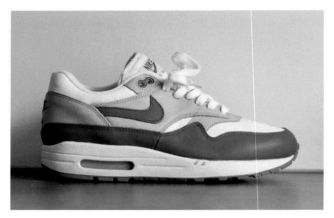

1998: Air Max 1 'SC Blue'

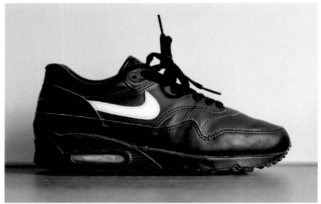

1993: Air Max 1/90 (Hybrid)

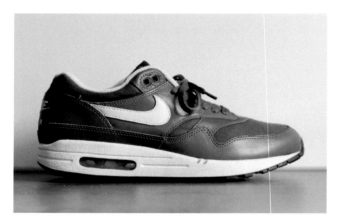

2004: Air Max 1 'Miller Pack'

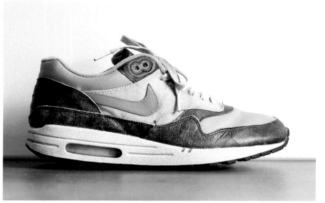

2004: Air Max 1 'Wash Pack'

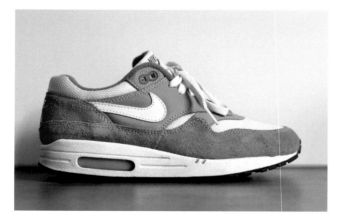

2003: Air Max 1 'Curry'

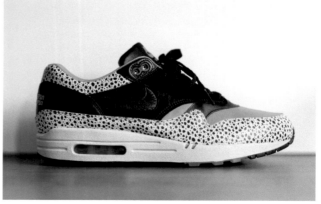

2008: Air Max 1 'Keep Rippin' Stop Slippin'

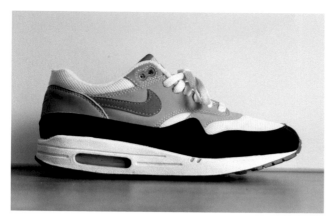

2003: Air Max 1 (Chili)

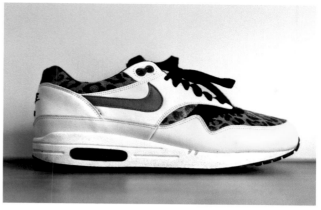

2006: Air Max 1 'Yellow Safari'

2003: Air Max 1 'Forest Green'

2004: Air Max 1 'Book of Ones'

2003: Air Max 1 'Shima Shima II'

2005: Air Max 1 'Blue Ribbon Sport Powerwall'

2005: Air Max 1 'Lemonade Powerwall'

1996: Air Max 1 'Carolina Blue'

2003: atmos x Air Max 1 'Safari'

2006: Kid Robot x Air Max 1

2006: Ben Drury x Air Max 1 'Hold Tight'

2006: Air Max 1 (Hazelnut)

2007: HUF x Air Max 1 'Hufquake'

2007: Air Max 1 'Terra Huarache'

2013: atmos x Air Max 1 'Desert Camo'

2007: atmos x Air Max 1 'Beast Pack'

2002: Air Max 1 'Storm'

2003: atmos x Air Max 1 'Viotech'

2006: atmos x Air Max 1 'Elephant'

2005: Parra x Air Max 1 (Amsterdam Hyperstrike)

2006: CLOT x Air Max 1 'Kiss Of Death'

2006: atmos x Air Max 1 'Animal Pack'

2003: Air Max 1 (Sport Pink)

2003: Air Max 1 (Maize)

2004: Air Max 1 'Urawa Reds'

2003: Air Max 1 (Grape)

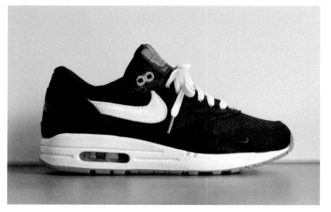

2009: Patta x Air Max 1 'Lucky Green'

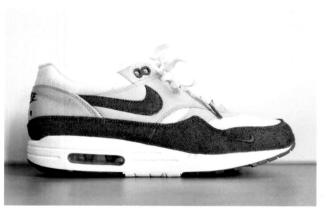

2009: Patta x Air Max 1 'Purple'

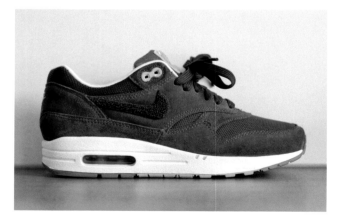

2009: Patta x Air Max 1 'Burgundy'

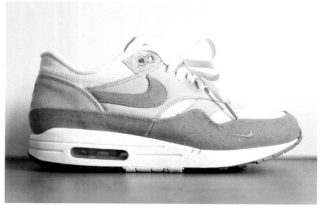

2009: Patta x Air Max 1 'Chlorophyll'

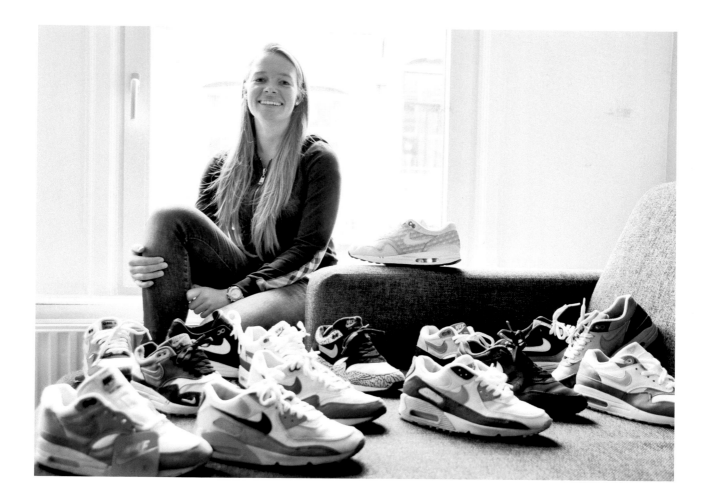

Maybe only some rules like, 'tonight no laptop', or on holidays he'd say, 'If I go to the gym, you have time to update your sneaker things, and when I come back, no internet for the rest of the day.' I'm fine with that as long as I don't sleep on my grails. I've never had a boyfriend who was really into sneakers, but maybe my next one will be.

Look out! OK, hypothetical: you see a pair of original AM1s in a secondhand store in primo condition. How much do you pay?

For a pair of OG AM1s in my size and in good condition, I think 600 is the highest I will go – except for the 86s with the big Air window. To me, those OGs are worth the most; for an Air Max 1 collector, they're a must-have. Even though I can't wear them anymore, they'd have more personal value than say 'Kid Robots' or 'Amsterdams.' They're a piece of history!

Fave colourway?

I love the AM1 'Sport Pink' colourway. The light grey and baby pink with white comes together in the perfect way, and the pink Air and lacelocks are the ideal finishing touches. I also love the AM1 'BRS' and the 'Pink' pack from 2006.

Best Air Max hunting story?

I went to London with a close friend for some shopping and girl time. On the second day of our journey, I checked an English sneaker forum and there was a guy selling his Air Max 1 'Amsterdams' in my size and in London. I was the first person who messaged him, so we organised a meetup for the next day. I was so excited, as I had been looking for a deadstock pair in my size forever. I didn't get much sleep that night. The next day, I went to the place we agreed and there they were, 'Amsterdams' in my size, right out of the blue – I couldn't have been happier.

Are you still looking for any particular pairs?

The OG red AM1s from 1986. The OG blue AM1s from 86, AM1 OG LE Mesh, AM1 Teal, AM1 Caves, AM1 San Francisco, AM1 Eminem, AM1 Albert Heijn, AM1 +41s, AM1 Patta Corduroy, AM1 Dave White, AM90 BRS and DQM Bacon, red and black Supreme Blazers and

OG Jordan 3 True Blues, Fire Reds and OG Jordan 4 Fire Reds. So yeah, I am looking. Any help is welcome!

Who rules? Parra v Patta?

I like Parra's work, but Patta without a doubt! It's the best sneaker shop and it's in my hometown. Not only do they get all the exclusive releases, but they get them in small sizes. Like the Yeezy IIs started from a size 6! It couldn't be better for me. Their clothing line is always innovative and good quality, and they're always nice and helpful. I love Patta!

'Kid Robot' v 'Homegrowns'?

Hard question, as I like the general version as well as the Hyperstrike version of each. I would go for 'Kid Robots' though, as I like AM1s more than AM90s. Also the quality of the 'Kid Robots' is better than the 'Homegrowns' (the suede on their mudguards rips fast if you wear them often). But if I judge only on the history of both pairs, I would go for the 'Homegrowns' in honour of the Dutch hip hop scene!

atmos 'Safari' v 'Hufquakes'?

Easy: atmos 'Safari'! The fabrics and the colours are insane. And then the gum soles and different Swoosh colours make it even more delicious. I'm glad I found a second pair this year so I can rock them! I only wear an exclusive pair if I've doubled up. 'One to rock and one to stock' is my number one rule.

And finally, why is Amsterdam such a big Air Max town?

There are a lot of sneaker shops in Amsterdam and they almost all sell Air Max, so 1 + 1 = 2. I think in Europe it's just more of a runner culture, whereas the USA has basketball and skating, so there are Jordans and Nike SB. It's not only Amsterdam where a lot of people wear Air Max, it's all over Europe. And Air Max are embraced by women nowadays. They're comfortable and they come in every colour you can think of. Why wouldn't you love Air Max?

1989: Air Max Light (Aegean Blue)

AIR MAX LIGHT
RARE TREASURE

Released in 1989, smack bang between the hot buns of the AM1 and AM90, the Air Max Light (aka the Air Max II) goes down in history as a tasty (and somewhat mysterious) filling in our classic Air Max sandwich. The masses had acquired a taste for the AM1's good looks, prompting Tinker to give his sophomore effort a more brooding disposition. As the name suggests, the second-gen edition also dropped weight by replacing the midsole foams with a harmonious marriage of polyurethane in the heel and Phylon in the forefoot, with thermoplastic straps deployed for strategic support. BRS1000 waffles enhanced the outsole's durability and a variable-width lacing system allowed for multiple cinching options.

Despite its tidy design loaded with technological advances, the Light has always kept a low profile in the Max franchise. That's no diss, it's just that the Light is truly enigmatic – a rare treasure that was buried for decades until Nike resurrected it in 2007 as a JD Sports UK exclusive. Since that time, we've been blessed with a stack of sweet schemes including the Mowabb-inspired 'Urban Safari' edition released by size? in 2013.

1989: Air Max Light catalogue

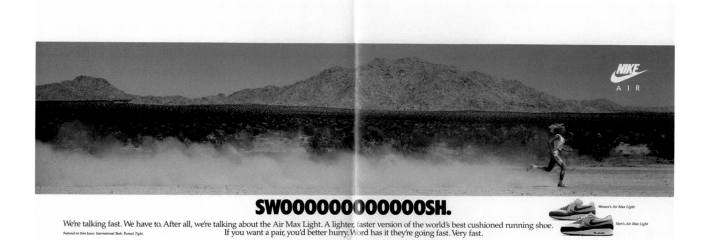

SWOOOOOOOOOOOOSH.

We're talking fast. We have to. After all, we're talking about the Air Max Light. A lighter, faster version of the world's best cushioned running shoe. If you want a pair, you'd better hurry. Word has it they're going fast. Very fast.

Featured on Kim Jones: International Tank; Pursuit Tight.

1989: Nike 'Swoooooooooooosh' print ad

1996: Air Max Light 2

1997: Air Max Light 3

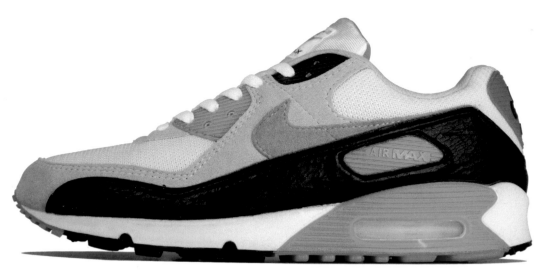

1990: Air Max 90 OG (Radiant Red)

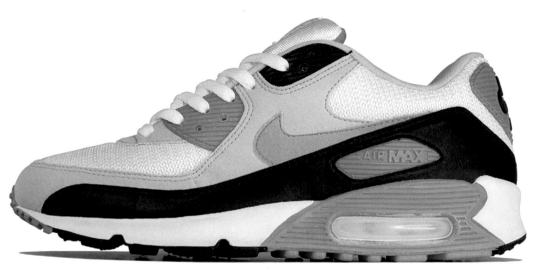

2002: Air Max 90

AIR MAX 90
INFRARED

The Air Max 90 is technically known as the Air Max III. Perfecting the vision he'd started with the Air Max 1, Tinker gave the model a faster look with forward tapering panels of synthetic microsuede, duromesh and leather. A thermoplastic Nike 'love heart' was added to the heel – a unique pop that came to symbolise the model itself. Mythology also plays a role here. The AM90 first dropped in colours known as 'Laser Blue' and 'Radiant Red'. Contrary to popular wisdom – and despite its present-day nickname – the OG AM90 was never officially referred to as the 'Infrared' until its reissue in 2003.

Almost three decades since the AM90's inception, countless retros, collaborations and hybrids sustain demand for this beefy old runner. For many heads, the 'Infrared' 90 is the quintessential Air Max, the most perfect of them all, and it's hard to argue with that. Thanks to our friends Iceberg and Overkill in Berlin, we tracked down every pair released over the years.

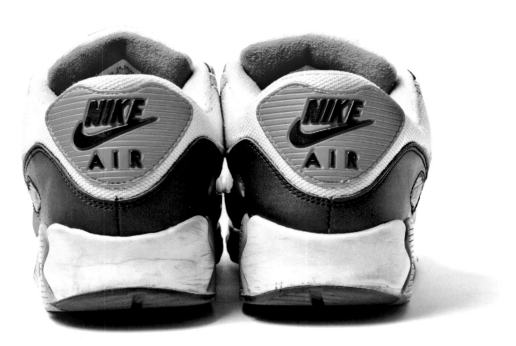

Photo: Overkill (Berlin) Sneakers: Iceberg

2005: Air Max 90 'History of Air'

AIR MAX 90 COLLECTOR

ICEBERG

(LEIPZIG, GERMANY)

Hey Iceberg, nice to meet you. Tell us a bit about yourself.
Nice to meet you too! I'm 40-something years old, I live in Leipzig, Germany, and I think Jordan Geller is a bitch.

What's your earliest Air Max memory?
Back in 1993, I saw the Air Max 93 and the massive Air bubble on its heel for the first time – it was love at first sight. The 'Menthol Blue' Air Max 93 was the first Nike sneaker I bought. I had worn only adidas runners before, but this was the day that everything changed.

It's amazing you have a complete set of 'Infrared' AM90 retros. Which edition was the hardest to find?
Getting samples happens mostly by accident, so I would say it was the OG in 'Radiant Red'. I saw a few pairs on eBay over the years, but I was never willing to pay the enormous prices. In the end, it was the last of the Infras missing in my set, so I had to take them. I didn't want to take the chance of them never coming back.

What is it about the 'Infrareds'? Has there ever been a better colourway?
In my opinion, the AM90 'Infrared' is the greatest shoe ever. I like the shape of the Air Max 90, how it looks on the foot, and I really love simple colourways. White, grey and this awesome kind of red is an unbeatable combination. The OG 'Laser Blue' is sick too, and there were a few nice retros in the early 2000s. But there can be only one: the 'Infrared'.

It hasn't always been called 'Infrared'. What are some of the other box names?
I've heard different colour names of the 1990 OG. You have called it 'Radiant Red' and others call it 'Hyvent Orange'. But the tag on the

box says 'H RD', which in my opinion means 'Hot Red' – and indeed, this red is really hot! The first retro that released in 2002 said 'Mx Orange', so the first time the AM90 was actually called 'Infrared' was in 2003.

Good to know. 'Radiant Red' is listed in the Nike catalogue, but these things are never 100 per cent. The OG is very fragile, how do you store them?
I bought them a few months ago, so I can't tell you the secret of their condition. Most of my vintage shoes are stored in a room without heating or climate control, but there's a bit of humidity in the air and that seems to preserve the elasticity of the soles.

How do you feel about the new techniques that Nike have applied to Air Max such as Vac Tech, Hyperfuse and Engineered Mesh?
Not my cup of tea, I like it old school. Straight mesh FTW!

You must have some great Air Max hunting stories.
Too many! Good ones and bad ones, but the worst was when a guy from China offered me three pairs of the 'Homegrown/State Mag' AM90 Hyperstrikes. This guy lived near a Nike factory where a lot of samples are produced. He always sent messages and photos when he got new stuff and I bought a lot of sneakers from him. One day he asked if I wanted three pairs of 'orange Air Max 90s'. A few hours later he sent me a photo. I just had a quick look – I was on my way to an appointment, so I was preoccupied. I left my house, and when I was on my way I realised which 'orange ones' they were. The problem was, I had no chance to get back to him until a few hours later. I think you know the end of the story: the shoes were sold already. By the way, the price was $600 for all three pairs together.

∞

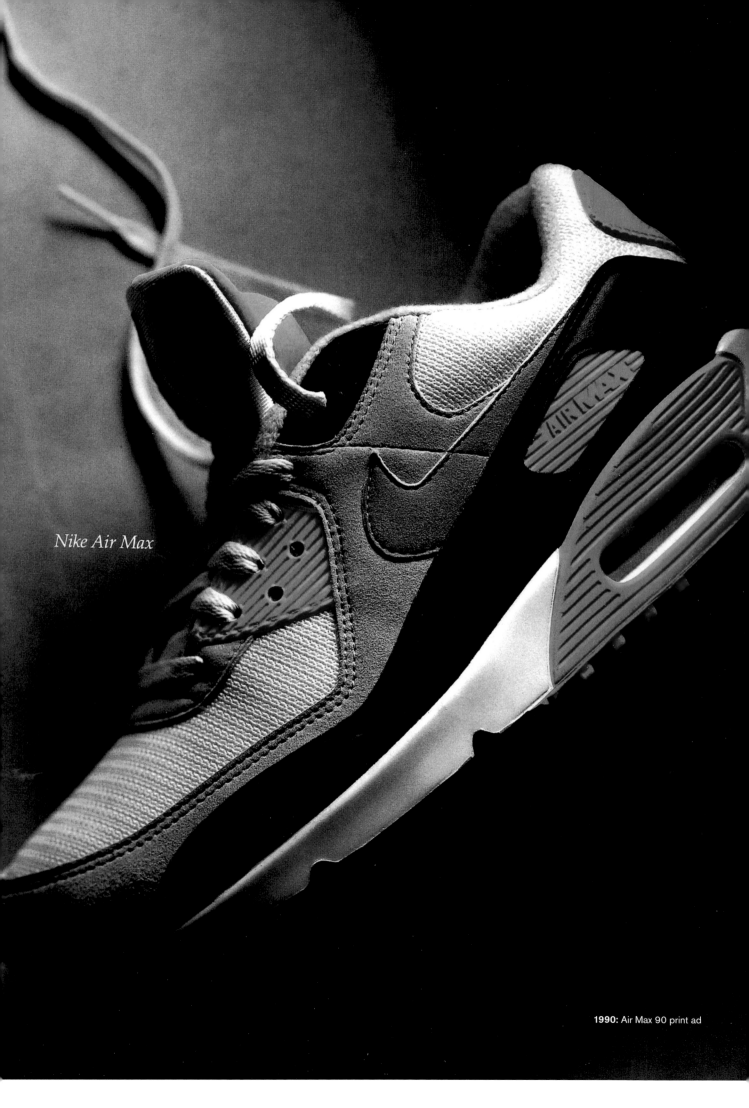

Nike Air Max

1990: Air Max 90 print ad

2003: Air Max 90

2003: Air Max 90 sample

2005: Air Max 90 'History of Air'

2006: Air Max 90 'One Time Only'

2008: Air Max 90

2008: Air Max 90 Premium 'Ostrich'

2008: Air Max 90 Current Hybrid

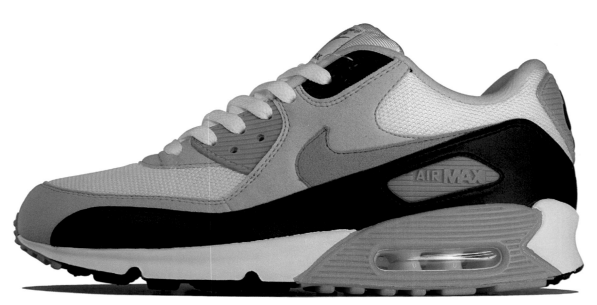

2009: Air Max 90

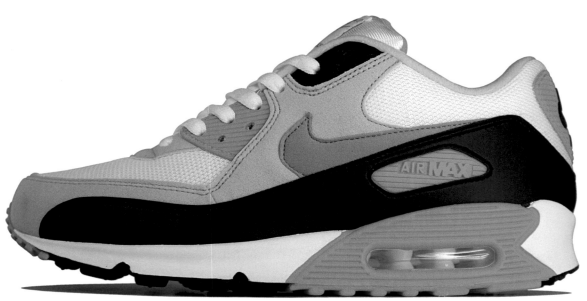

2010: Air Max 90

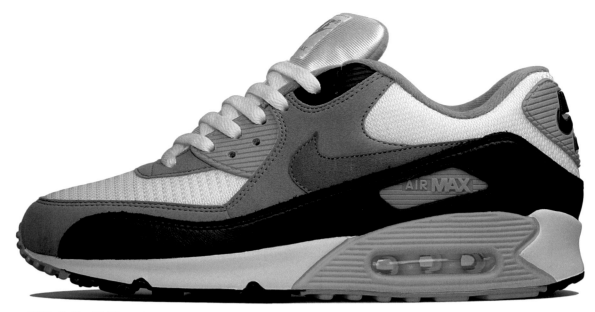

2012: Air Max 90 'Vintage'

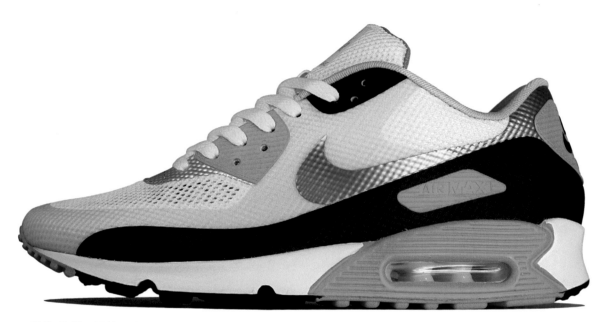

2012: Air Max 90 Hyperfuse

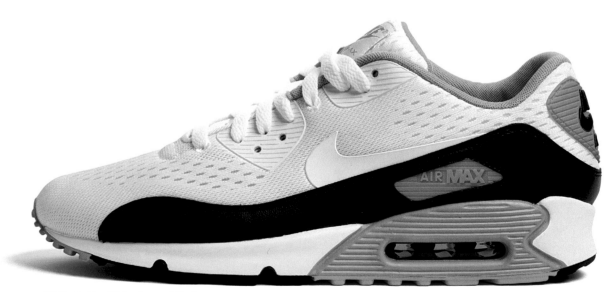

2012: Air Max 90 Engineered Mesh

Photo: BEEDUBS

1991: Air Max BW OG 'Persian'

AIR MAX BW
THE BIG WINDOW

The Air Max BW was released in 1991 as part of the Nike International series. The shoe's 'BW' suffix refers to the heel's striking 'Big Window' bubble. Although the BW – also known as the Air Max Classic – has released in a barrage of colours over the years, the OG 'Persian Violet' edition remains its signature scheme. Born in the shadow of the Air 180 and the Air Max 90, the BW did well to cement its place in the history books. The shoe inspired a loyal following that is unique within the Air Max pantheon, and there is no greater Persian fiend than *Sneaker Freaker* forum member *Beedubs*.

The OG Air Max BW Persians came boxed with a Nike International catalogue that featured tech specs on the shoe and photos of the matching Nike cap and tracksuit.

AIR MAX BW COLLECTOR

BEEDUBS: PRINCE OF PERSIANS

(PERTH)

1991 was a good year. Michael won his first ring, the Terminator learned some new slang, I celebrated my first birthday and a shoe was released that would shape my future. My first memory of the Air Max BW arrived 13 years later, thanks to my brother – aka 'One of Perth's most notorious graffiti artists', according to *The West Australian* newspaper – who brought a pair home from a local sports store. I'll never forget that shoe and the way he beat them into the ground.

I followed in his GFL (Graffiti For Life) footsteps. Air Max were a crucial part of the uniform, and that's where my love affair began. I started to collect all different types of shoes, but I was hooked when I discovered the Persian BW. I got my first pair in 2006, and from there, it was on. Polo kits came and went, but the Persians stayed.

As my passion grew and my knowledge increased, I decided I'd own all the different versions someday. Before you could spell hoarder backwards I was 10 pairs deep! Currently, I own two deadstock Persians from 1991 with all the trimmings and both in my size. To me these are works of art and I treat them as such. One day I hope to display them like the masterpieces they are in my very own sneaker store. They're the complete package. The OG Nike box with the orange lid and grey stripes has to be the greatest of all time, and the Nike International Collection brochure is the icing on the cake; a luxury, I might add, that is no longer afforded to collectors of contemporary releases.

The second release is the purple whale of the Persian family. Released in 2000 as a UK exclusive, this retro stays true to the OG with its black tongue lining. The late-90s black and red Nike box is another nice touch. Although the bubble isn't as big as that of its predecessor, the shoe's elusive nature and faithful reproduction quality makes it the best retro of the five created so far.

The third arrived in 2003 and is pretty much identical to the pair from 2000 (bar the black tongue lining). This retro, however, saw the return of the Big Window and a slightly improved shape. While it's not on quite the same level as the OG, it is an improvement on 2000's pair. This release can be obtained easily if you look hard enough. It's my favourite retro, which is why I've got four pairs.

The fourth release from 2005 is the James Hird of the Persian family. While the shape and tongue aren't as strong as the 2003 edition, the midsole paint's ability to not crack under pressure gives them a quality not found in any other pair. I ended up giving both of mine away, as they weren't the right size (anyone with a US11.5 hit me up!). One pair went to a mate for his birthday and the other went to my brother (who again beat them into the ground, proving people can show love and respect in very different ways).

The fifth release from 2008 is what I call the fugly sister of the family (the one that only looks hot when the good-looking sister moves away). The shape is nice but the tongue and bubble leave a little to be desired. For this reason, my pair will stay in the box until I've exhausted all other options.

As for the 2013 release, hmmm, what can I say? I tried a pair on for a laugh, and honestly, I thought I'd stepped into the Midland Brick factory. Sad to say, but my BW obsession ends after 2008. It was around that time that they were infected with the dreaded square-toe disease caught, presumably, from a close relative in the Air Max family.
⊂⊃

2003: Air Max BW

2000: Air Max BW

2005: Air Max BW

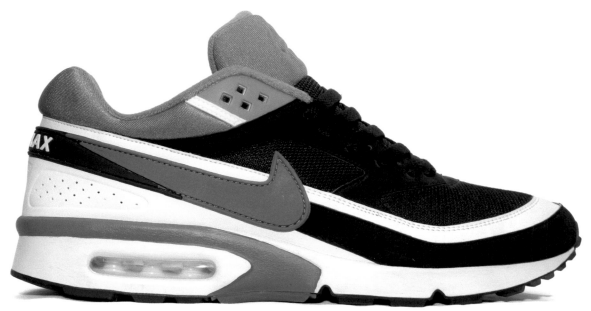

2008: Air Max BW

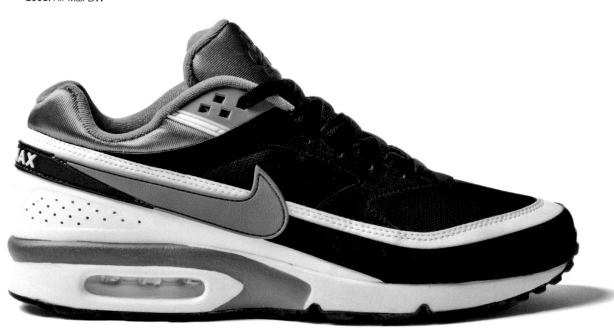

2013: Air Max BW

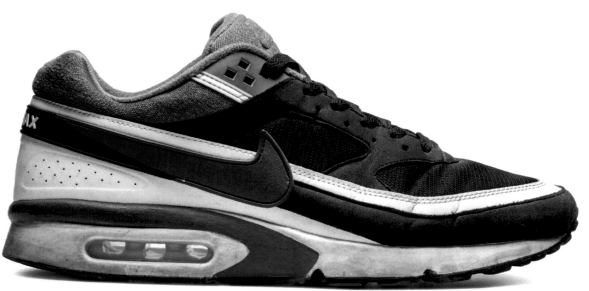

2016: Air Max BW

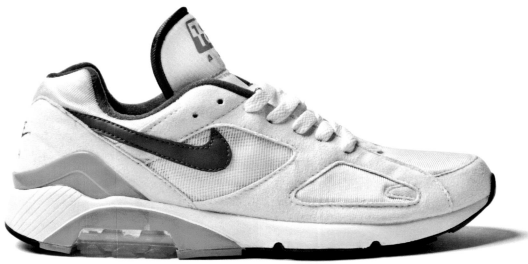

2004: Nike Air 180

AIR 180
ULTRAMARINE

Released at the same time as the Huarache and Air Max BW, the Air 180 was immediately up against stiff competition from within Nike. Some don't even consider it part of the Air Max family; though to our mind, it's definitely a worthy chapter in this epic story. Regardless of categorisation, Bruce Kilgore and Tinker Hatfield's design was another intellectual exercise in Visible Air's application, as the 180 nomenclature was derived from the 180-degree visibility of the transparent unit.

One of the Air Max franchise's strengths has been the unique colours applied to first-gen models, and the 180 was no exception: 'Ultramarine' was another clean winner. A white microsuede foundation lent a virginal edge that highlighted the shoe's technology, but it was a nightmare for clean sneak freaks. And while the 180's upper offered a lighter touch than previous Air Max models, we've always felt that its componentry created an awkward, slightly unfinished veneer.

In a surprise twist, Avia was convinced that the 180 infringed several of their patents, and consequently, their lawyers filed suit. Nike immediately countersued. Newspaper clippings confirm the matter was settled in 1991. Inconsistencies with the 180's tongue labels used over the years are also mysterious. We did our best to track down a proper OG version for photos, but the 2004 pair is the closest we came to the real deal.

As Yoko knows, music by The Beatles elevated the models in the first Air Pack to instant rock star status. It's curious then to wonder about the impact of the 180's promotion. Nike's advertising agency, Wieden + Kennedy, engaged illustrator (and notorious Hunter S. Thompson collaborator) Ralph Steadman, as well as designers Alfons Holtgreve, Takenobu Igarashi, Charles S. Anderson and André François to produce a strikingly gothic series of images in foldout poster format. The TV campaign by Industrial Light & Magic (aka Lucasfilm) and schlock-horror director David Cronenberg added another tripped-out dimension. Employing creative collaborators in this way would prove to be a solid 20 years ahead of its time, and it remains one of Nike's most underground creative campaigns.

1991: Nike Air 180 print ads

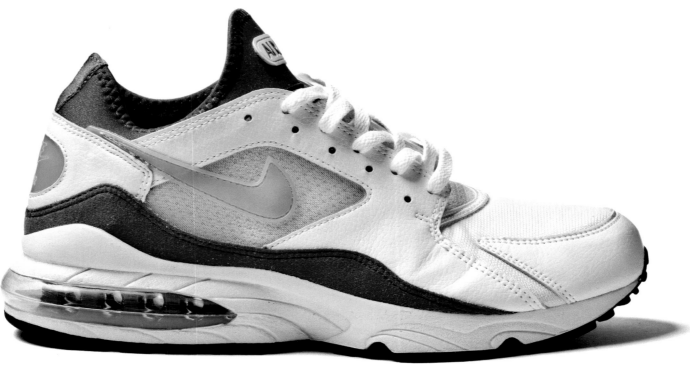

2003: Air Max 93 (Chlorine Blue/Voltage Purple)

1993: Air Max 93 (Laser Blue)

2003: Air Max 93 (Black/Grey)

2003: Air Max 93 (Ultramarine)

AIR MAX 93
BUBBLE BUTT

Nike's Air Max 93 introduced a mega bubble-busting heel and neoprene-sock-bootie combo that many consider to be the most exquisite Air Max of all time. Wrapping the entire heel, the 93's curvaceous airbag design was bigger and more conspicuous than ever, but perfecting it posed a series of unique technical challenges for Nike's engineers. Removing the structural support around the airbag would compromise the shoe's inherent stability and leave it prone to blowouts. A totally new kind of airbag was needed to legitimatise the 270-degree bubble concept.

To solve the puzzle, Nike aligned with Tetra Plastics and explored a new technique known as blow moulding. After three years of innovative tinkering, the shoe was passed as roadworthy by Nike tech and the 270 bubble was duly applied to other models including the Burst, Air Force Max and Air Max LTD.

Fast-forward to today: sadly, vintage OG Air Max 93s are universally unwearable – the bags have simply fizzled out. We're yet to see a pair that has survived without the dreaded foggy-bubble blowout. The shoe was retroed only a few times over 20 years, until 2018 delivered a close-to-flawless remake. Long live the 93!

TREAD LIGHTLY. DRIVE RESPONSIBLY OFF ROAD. PLEASE BUCKLE UP FOR SECURITY. © 1993 LAND ROVER NORTH AMERICA, INC.

Now there's an air suspension system for every size budget.

The very technology that created a revolution in running shoes is now creating one in Range Rovers.

It's called air suspension.

And beneath the rugged chassis and opulent interior of the 1993 Range Rover County LWB, you'll find it doing things coil spring suspensions just can't do.

Like monitoring the vehicle's height 100 times per second. Muting road and cabin noise to substantially lower levels. Providing a smoother ride on a variety of surfaces. As well as five different height settings to suit a variety of conditions. It can even be lowered enough to make getting in and out easier.

Of course there are also over 80 additional improvements to speak of.

Like a new 4.2 liter V-8 engine. Electronic traction control. And a 108" wheelbase that makes this the roomiest Range Rover ever built.

Why not try one on for size by calling 1-800-FINE 4WD for the nearest dealer?

Granted, these new County LWBs are hardly inexpensive.

But considering how sturdy and comfortable they are, we think you'll end up wanting a pair.

 RANGE ROVER

1993: This amazing Range Rover press ad we discovered on eBay is proof of just how effective Nike's harnessing of Air as a cushioning commodity had become. Linking the suspension on the world's foremost luxury SUV to the performance of the Air Max 93 must've seriously thrilled Phil Knight. Will we ever see this type of advertising happening again?

Photos: Air Max Chronicle / KK Bestsellers

2002: Air Max Burst 'Storm'

1996: Air Max Burst 2

1999: Air Max Burst 4

AIR MAX BURST
BLOW OUT

Nike have had a lot of fun toying with the word 'Air' over the years. Shoes like the Air Apparent, Air Conditioner, Air Azona and Air Revaderchi are proof that some 'Air Sole' in Beaverton has a sense of humour. Given Tinker Hatfield fought hard to prove that the first bubble wouldn't pop, naming this model 'Burst' must have been a highly amusing in-joke. Featuring the same sole unit as the AM93 and AM94, the Burst wasn't particularly revolutionary; and though a tidy effort overall, the model never found an explicit fan base. Check out the pics of the Burst's subsequent editions – these are two seriously obscure Nikes.

1994: Air Max 94 (Laser Blue/Grey Mist)

AIR MAX 94
REMEMBER ME?

In terms of evolution, the Air Max 94 was a relatively minor upgrade. The 'Purple Punch' scheme is reminiscent of the BW, but the design's inheritance of 93's fabulous bubble butt is its best feature. We'd never seen one IRL until we nabbed this 'Laser Blue' pair on the 'Bay recently. If you too are scratching your head and wondering why you don't remember this model, turn to page 259.

STABILITY/STRUCTURE

AIR MAX ST
1992

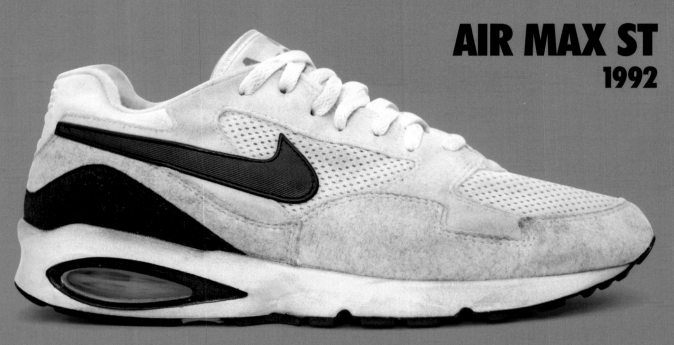

While the premise of Air Max was to deliver unparalleled comfort and cushioning, it was never intended to be suitable for all types of athlete. For over-pronators (those whose feet roll inwards when running), Nike modified Max technology to enhance support by helping the foot stay balanced through its natural gait. In 1992, the Air Max ST (an abbreviation of Structure) featured an adapted Max unit in the heel, and extra support was delivered through the medial side's cleverly designed teardrop window.

AIR STAB
1988

Nike's Air Stab (an abbreviation of Stability) was the first model to offer pronation support in tandem with Max cushioning. A saw-toothed TPU footbridge 'stability' unit was strategically inserted in the midsole, while the jagged 'window frames' propped up the shoe's sidewalls when under load.

AIR STRUCTURE
1991

A precursor to the Air Max ST, the Air Structure filled a niche – a design for those who wanted the cushioned Max experience, but needed additional support. A broader-fitting shoe than the average Air Max, the Air Structure featured a downsized medial side window and was boxed with a set of optional anatomical arch supports.

AIR MAX TRIAX
1997

The Triax legacy began in 1994 as a multi-sport/cross-training package. With stabilised Max cushioning, the Triax never quite made it to elite franchise status, but it lives on today as the Structure Triax line. Classic models to release under the Triax banner include 1996's Atlanta Olympic edition.

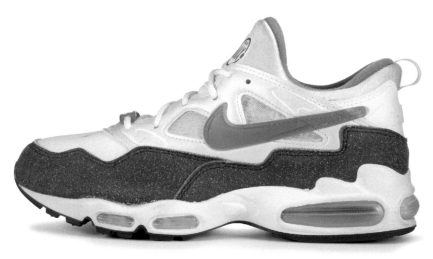

Air Max2 prototype with visible forefoot Air pre dating the AM95.

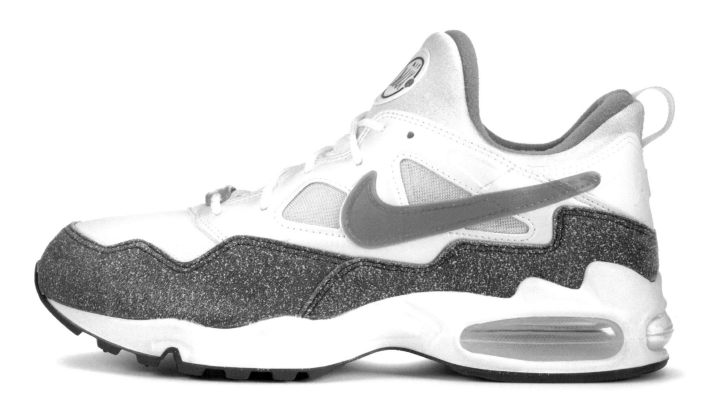

AIR MAX2

Nike ramped up the Max range by adding a dual-pressure, multi-chamber airbag to the heel of the Air Max2. The flanking outer chambers came loaded with a pressure rating of 25 psi for enhanced stability while – for the ultimate blend of custom cushioning – the central and rear bags harnessed just five psi. Up above, the meshular-neoprene, Huarache-like bootie continued where the AM93 left off, and came wrapped with a wavy, layered exterior of straight-up 90s funk. The Air Max2 heel unit was used in the AM95, adapted slightly for the AM96, and eventually made its way across to basketball and cross-training categories.

First published *Sneaker Freaker* Issue 28 – August 2013

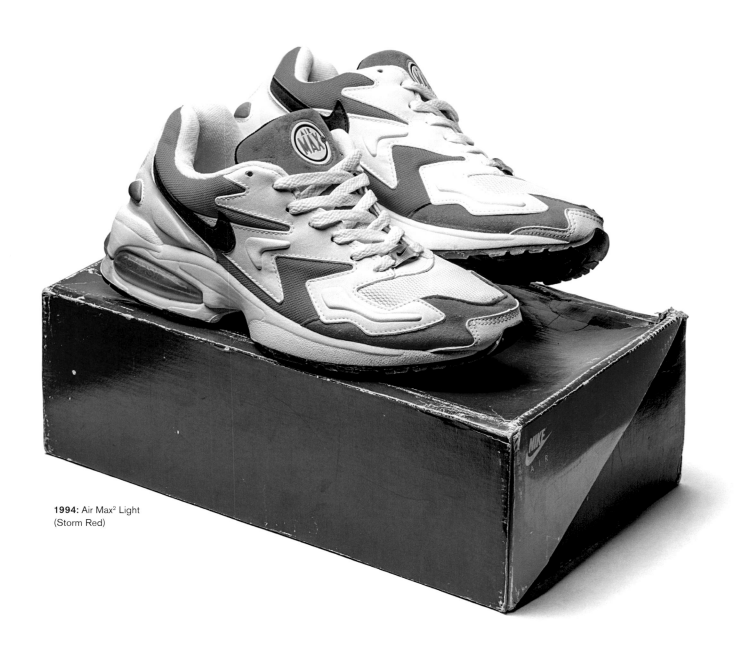

1994: Air Max² Light
(Storm Red)

AIR MAX² LIGHT

The Air Max² Light tiptoed onto the dancefloor as the AM²'s nimble-footed partner in crime. While it featured the Air Max²'s dual-pressure Air unit, the Light's dietary differences came into play with a hollowed-out footbridge, slimmed-down midsole, Duralon forefoot outsole and a toned-down upper (sans bootie), which tallied up to a certifiable weight loss.

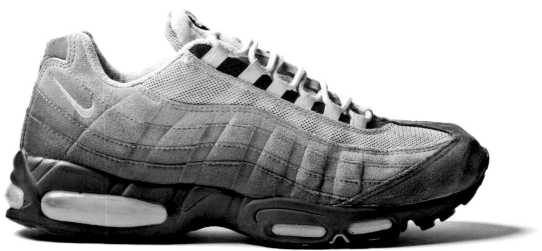

1995: Air Max 95 (aka Air Total Max)

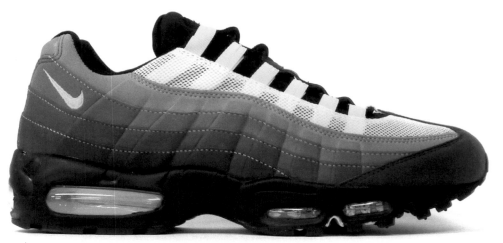

2013: mita sneakers x Air Max 95 'Prototype'

AIR MAX 95
FUTURE SHOCK

When Tinker handed the Air Max design reins to Sergio Lozano, filling the master's shoes was always going to be a challenge. But Lozano was clearly not intimidated. The young gun delivered a spectacular design that marked a radical stylistic move away from the pretence of running to a quasi-fashion bubble sculpture. The Air Max 95 wasn't your everyday Air Max: it was future-shock direct from planet Freakoutazoid!

When the big, bad, neon yellow and fifty-shades-of-grey beast hit shelves, everyone went certifiably nuts. From the panelled upper to the forefoot's Visible Air and black midsole, the AM95 smashed all the rules. Not all 'mad professor' sneaker designs hit homeruns, but the shoe channelled pent-up demand for futurism, and arrived at precisely the right time for early adopters. Not surprisingly, the 95 was greeted most warmly in Japan, where reseller prices skyrocketed on the back of celebrity endorsement. Tokyo kids were paying north of $3000 for pairs a decade before internet resellers entered the game.

At the peak of Air Max 95 madness, Japanese style magazine *Boon* featured an interview with Lozano, and showed an unreleased 95 sample with a black tongue and black lining. That obscure photo lodged in the memory of a young sneaker freaker named Shigeyuki Kunii. Years later, Kunii-san joined Tokyo's mita sneakers, and as he rose through the ranks, the memory of the black-tongued double-bubbles never deserted him. Nearly 20 years later, Kunii-san brought the unreleased sample to shelves with mita sneakers' hugely successful 'Prototype' release. We caught up with Kunii to find out how he fell in love with Nike's neon game-changer.

SHIGEYUKI KUNII MITA SNEAKERS

(TOKYO)

The Air Max 95 has been more popular in Japan than anywhere else in the world. Why do you think it attracted so much attention?
The Air Max 95 is so special in Japan because it represents a big turning point in the Japanese sneaker scene. Before the 95, Japan was following American and European trends, but when the 95 was released we started building our own sneaker culture. After the Air Max movement took off, we felt like the scene had turned 180 degrees. From followers, we became leaders. Things like the CO.JP (Concept Of Japan) started, and the SMUs (Special Make Ups) that were created in Japan brought attention from around the world for the first time.

Do you remember the initial reaction to the Air Max 95?
When sports store owners first saw it, they had negative things to say. Their evaluation of the 95 in the running category wasn't very high, but it caught the attention of a few sneaker boutiques and influencers. Months after the first release, the 95s were featured in a few fashion magazines, which prompted interest and news began to spread. After the 95 featured in *Boon*, it really blew up. Once sports stars and idols were seen wearing the shoes in commercials, the supply could no longer accommodate demand, which resulted in skyrocketing prices. I bought my first pair of AM95s before I began working at mita sneakers. I was actually trying to become a racer, so I picked up a pair of 95s for training. On my first day working at mita, a reissue was released and there was a long line at the shop. Thinking about it now brings back strong memories. I definitely have a deep personal connection with the model.

How do you see that link between sport and fashion in relation to the Air Max 95?
Manufacturers create sneakers with categories in mind, but sometimes a buzz happens in a different place and they become popular for something outside of their original purpose. We all know that lots of fashions or subcultures link with sneakers. The same thing happened with the Air Max 95; it gained more attention in the fashion scene than it did as a running model. During the 70s and 80s, running and court shoes sometimes crossed into fashion, but most new high-tech running shoes never made it into magazines. After the Air Max 95 was released, high-tech runners became popular fashion items and gained appeal with collectors. The 95 was successful in changing people's perception of sneakers.

In 2004, mita collaborated with Nike on the AM95 'Neo Escape', which was then revisited with the 95+ BB 'Neo Escape 2.0' edition. Tell us a little about these projects.
One of my strongest memories of collaborating with Nike is the 2004 Air Max 95 'Neo Escape'. When we revisited the concept with the BB edition, some sneakerheads remembered the original model, but for the younger generation it was like introducing something new. The BB edition had the function of a contemporary shoe with the latest technology, and reusing our 2004 collaboration's colourway allowed people to experience the evolution of the model.

How did the 'Prototype' colab happen?
When I heard in 2013 that Nike were going to refocus on the Air Max series, I immediately wanted to be involved and help reignite buzz in the scene. In regards to the 'Prototype', the model is based on an unreleased 95 sample. Since I first saw the image all those years ago, I'd always wanted to make it available to the public. When Nike started pushing the Air Max series again, the timing was perfect. This time, I wanted to release a product that would wow sneakerheads old and new. That was more of a priority for me than thinking about how many people would line up on release day or how premium the price would be.

Are Japanese kids vibing on Air Max 95s again?
When I'm out on the street, I can see a lot of people wearing Air Max again. Of course sneaker freaks are wearing them, but now that famous models and magazines are influencing the market again, fashion-savvy people who follow European trends are wearing them too.

Finally, we have to ask: what's your favourite Air Max of all time?
It has to be the Air Max 95. It's more than 20 years old, but I can still feel Nike's innovative identity in the shoe. If I'd never seen these shoes, I wouldn't have become interested in the culture, and I wouldn't be working at mita sneakers today. Now I communicate with people all over the world through sneakers. The 95 created a huge turning point in my life.

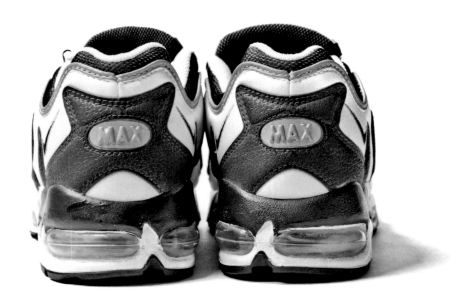

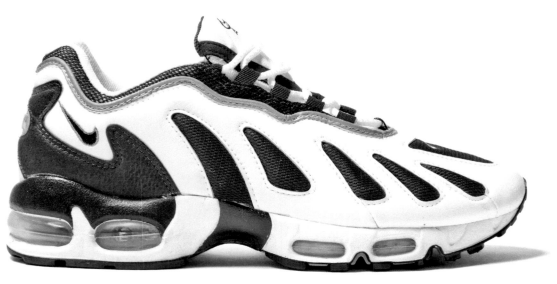

1996: Air Max 96 (White/Scream Green)

AIR MAX 96
SCREAM GREEN

The Air Max 96 was a hard-hitting follow-up to Sergio Lozano's AM95, but the shoe has never received 1:1 retro love from Nike, and has long since disappeared into Max oblivion. Under the hood, the AM96 delivered similar tech tooling to the AM95. Upstairs, a dual-layer wavy motif was employed to cut a free-flowing figure. Signature 'Scream Green' and 'Dark Concord' colourways may not have been as mind-blowingly original as previous Max editions, but the AM96 still projects a unique vision of Max style.

AIR MAX 97 (ALTERNATE RELEASE):
The Silver Bullet wasn't the only Air Max released in 1997; Nike also released this obscurity.

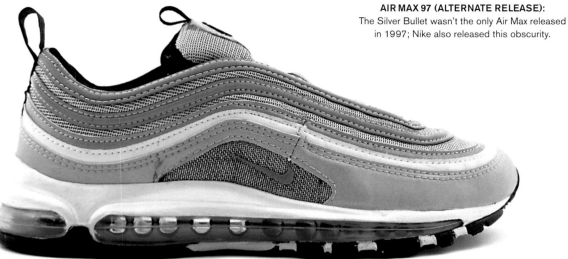

1997: Air Max 97

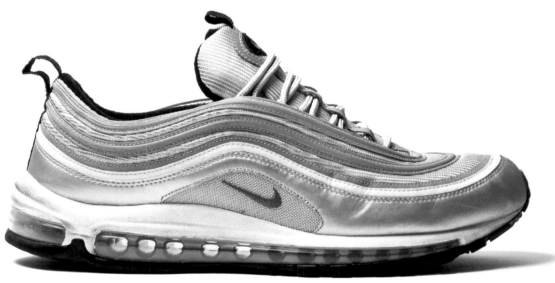

2009: Air Max 97 Reissue

AIR MAX 97
SILVER BULLET

As you glide through our Airvolutionary timeline, pause for a moment on the Air Max 97 and soak up the sci-fi vibes of this sleek sidewalk surfer. Designer Christian Tresser famously cited Japan's Shinkansen bullet trains as his design muse. Taking cues from AM95's layers, the AM97 was spliced with a wafer-thin polyurethane midsole and a new full-length Air unit that provided the cushiest ride to date. A healthy mix of metallic silver mesh and reflective 3M was added to enhance nighttime visibility. 'Varsity Red' hits on the OG were a warning to tailgaters: these Air Max 97 'Silver Bullets' are dangerously fast!

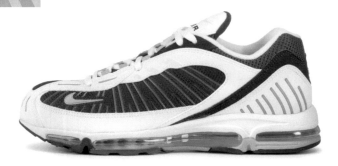

AIR MAX 98 (ALTERNATE RELEASE):
Researching this feature produced many curious discoveries,
such as this alternate version of the Air Max 98.

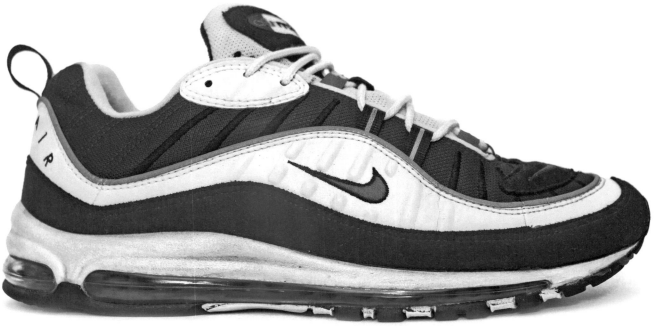

1998: Air Max 98 (Varsity Royal/Comet Red/Obsidian) 'Gundam'

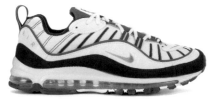

1998: Air Max 98 (Deep Orange/Varsity Maize)

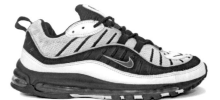

1998: Air Max 98 (Atlantic Blue/Metallic Silver)

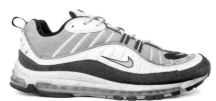

1998: Air Max 98 (Cement Grey/Citron)

AIR MAX 98
GUNDAM STYLE

An unsung hero in our eyes, the Air Max 98 was born in a truly techsperimental era. Alongside its TN cousin, the AM98 came juiced with so much flavour that it was like swallowing a pack of Pop Rocks with a jalapeno chaser. Bedded comfortably on the same full-length, dual-pressure airbag as the 97, Nike added sharpened baby Swooshes from heel to toe and a wavy strip of 3M piping for 360-degree reflectivity.

Photos: dirty soles

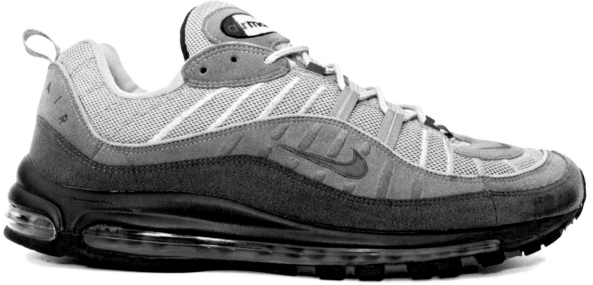

2000: Air Max 98 (Cool Grey/Varsity Red)

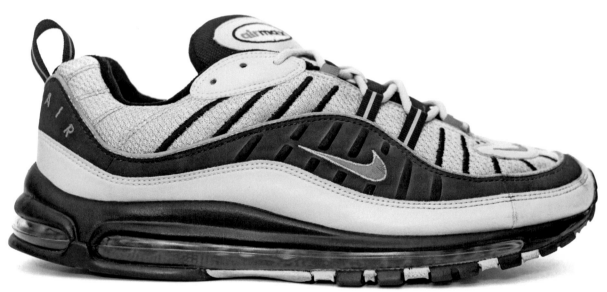

2000: Air Max 98 (JD Sports Exclusive)

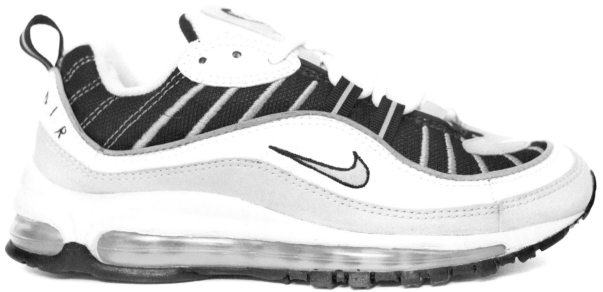

1998: Air Max 98 (Concord/Medium Grey/Varsity Maize)

TUNED AIR BAG
Note the supportive red 'hemis' air pods.

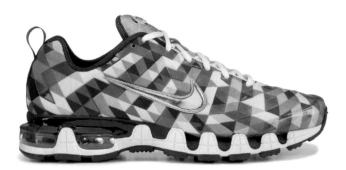

AIR MAX TUNED TEN:
Celebrating a decade of Tuned Air, Nike dropped this
wild Olympic edition for the 2008 Beijing Games.

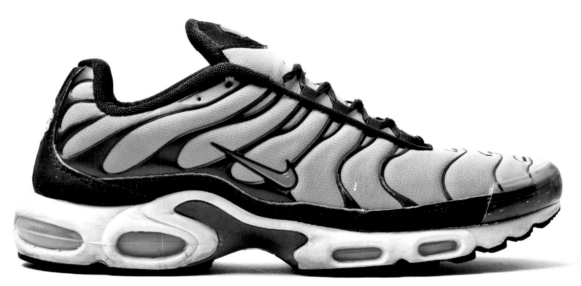

1998: Air Max Plus 'Orange Tiger'

AIR MAX PLUS
TIGER STYLE

Just when we thought things couldn't get more hectic, Nike dropped an atomic sneaker bomb in the form of the Air Max Plus – known on the street as the TN. With its teched-out kinetic design harnessing an all-new cushioning system, the TN rang a bell that has ears still ringing today. Certain shoes have attracted bad-boy reputations, largely on account of the company they keep; in the TN's case, it's definitely the go-to shoe for ne'er-do-wells. Indeed, the TN's somewhat thuggish personality is highly prized in certain urban enclaves.

While the TN's aura overshadows the shoe's design, not everyone understands the technical definition of Tuned Air. Essentially, it's a blow-moulded unit coupled with rubber hemispheres placed strategically in the sole to provide support. Adding the 'hemis' allowed Nike to take the pressure down and deliver a softer ride without compromising stability.

But the TN's big story is its spray-fade upper. As the AM95 introduced a fresh method of colour-blocking, the TN's gradient upper was a revelation and the original 'Orange Tiger', 'Grey Shark' and 'Hyper Blue' gradients remain eye-popping today. In a lifetime of Foot Locker exclusivity, the TN has dropped in countless make-ups; however, Tunedheads had to survive without an OG retro until 2013. Patience was rewarded when Nike rocked planet TN by resurrecting the OG 'Orange Tiger' in super limited numbers. Eshay to the Max!

1999: Air Tailwind 4

2000: Air Metal Max IV

2000: Air Tailwind 5

2001: Air Max Specter

2000: Air International Max

2001: Air International Max

2000: Air Max Alesco

2002: Air Max Multiple

2000: Air International Max +

2002: Air Max Elite R

2002: Air International Triax

2002: Air Max Majikan

2002: Air Max Tailwind 7

2003: Air Metal Max VI

2002: Air Max Dolce

2004: Air Max Tailwind 9

2002: Air Bohemian 2

2008: Air Max 180+ III

2002: Air Max Octane

MAD MAX

Air Max began as a wild concept, became a shoe, and exploded into a franchise, but there's more to this story than just the A-Team. The 'maximum volume' Nike Air unit has been applied to dozens of offbeat and obscure models. Here's a platter of silhouettes that have flown the Air Max flag over the years.

ONE TIME ONLY

An exercise in applying the 360 sole to a brace of Nike heritage uppers, the 'One Time Only' pack was split four ways. It included a Clerks series referencing earlier Nike colabs, an OG pack of Air Max icons, four 'baroque' leather options and a series of monotone Footscapes. The latter provided the most striking visual statement, adding a menacing rake to its traditional-yet-next-century woven construction. The Footscape 360 was also an early example of Nike Considered, a design-focused ethos that aimed to reduce material wastage and eradicate use of adhesives, among other eco-minded initiatives.

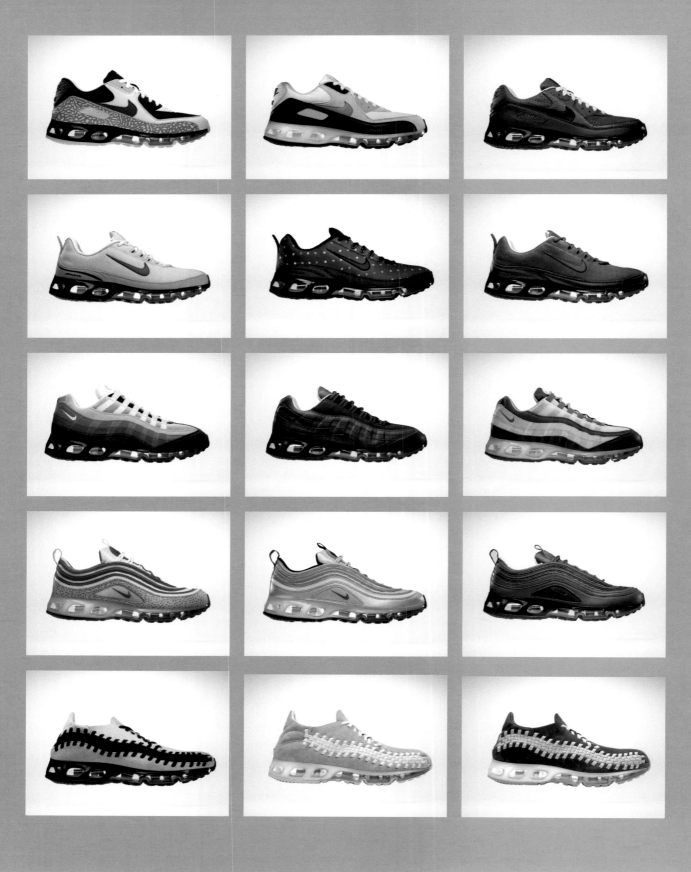

2006: Air Max 360 OG (Metallic Silver/Anthracite/Varsity Red)

AIR MAX 360
DEGREE OF DIFFICULTY

As the franchise evolved, each incarnation took on ever more futuristic contours and cushioning principles. The pinnacle, at least in a numerical sense, was destined to be the Air Max 360 – the first to feature a 360-degree airbag. Unfortunately, the complexity of the caged midsole delayed the shoe considerably and disrupted the release's immense build-up. The upper's sharply debossed design was a classy evolution, and the unique 360 sole was certainly compelling, but it was an unforgiving structure that many found lacking in hospitality. The 360 is remembered as a flawed gem – a rare blip on the Air Max timeline – and the result of an uncompromising approach to evolutionary progress.

AIR MAX TL

Looking back at 1998, it's blatantly obvious that it was a magical year for Nike. The Air Max TL (AKA Total) featured full-length Air cushioning with added flex-grooves for a whippy ride. Up top it was embellished with insect-like 3M and thermoplastic detailing.

AIR MAX 2000

At the turn of the century, Nike's Alpha Project was in full swing, the Presto had just hit the scene and Sydney was popping bottles for the Olympics. Launching off the back of the late-90s technical onslaught, the Air Max 2000 veered away from the bells and whistles of its TN, TL and Deluxe predecessors, and opted for more conservative attire. The sole unit was a toned-down reworking of the Air Tuned Max, while the upper came embellished with a cross-hatched rubber weave applied over a simple two-piece blend of lightweight synthetic and breathable mesh. The only thing holding the AM2000 back from greatness was an eye-catching colourway.

AIR MAX 120

Designed by Richard Clarke, the Air Max 120 arrived fully loaded with options including a spider-webbed cage, jewelled Swooshes, MX Air, Burst Air 270 bubbles, 3M detailing on the toes, and, of course, a rework of that delicious sunrise gradient. Two decades after this towering inferno was released, and it still looks utterly futuristic. Thanks to the power of the TN, the Air Max 120 was somewhat surprisingly rereleased in 2015.

AIR TUNED MAX

With the Y2K bug buzzing, Nike extended the Tuned Air concept with a shimmery insect of their own. As per Nike's strategy at the time, the Tuned Max is one of several late-90s models devoid of Swooshes, producing an eerily anonymous effect. Delivered in a clutch of colourways, the OG 'beetle-shell' edition in 'Charcoal/Celery/Saturn Red' remains the fan favourite.

AIR MAX

AIR MAX 2001

AIR MAX 2002

AIR MAX DELUXE

AIR MAX 2003

AIR MAX 2004

AIR MAX 360 III 2008

AIR MAX 2009

AIR MAX 2010

2001–2018

AIR MAX 2011

AIR MAX 2012

AIR MAX 2013

AIR MAX 2014

AIR MAX 2015

AIR MAX 2016

AIR MAX LD-ZERO (HIROSHI FUJIWARA)

AIR MAX 2018

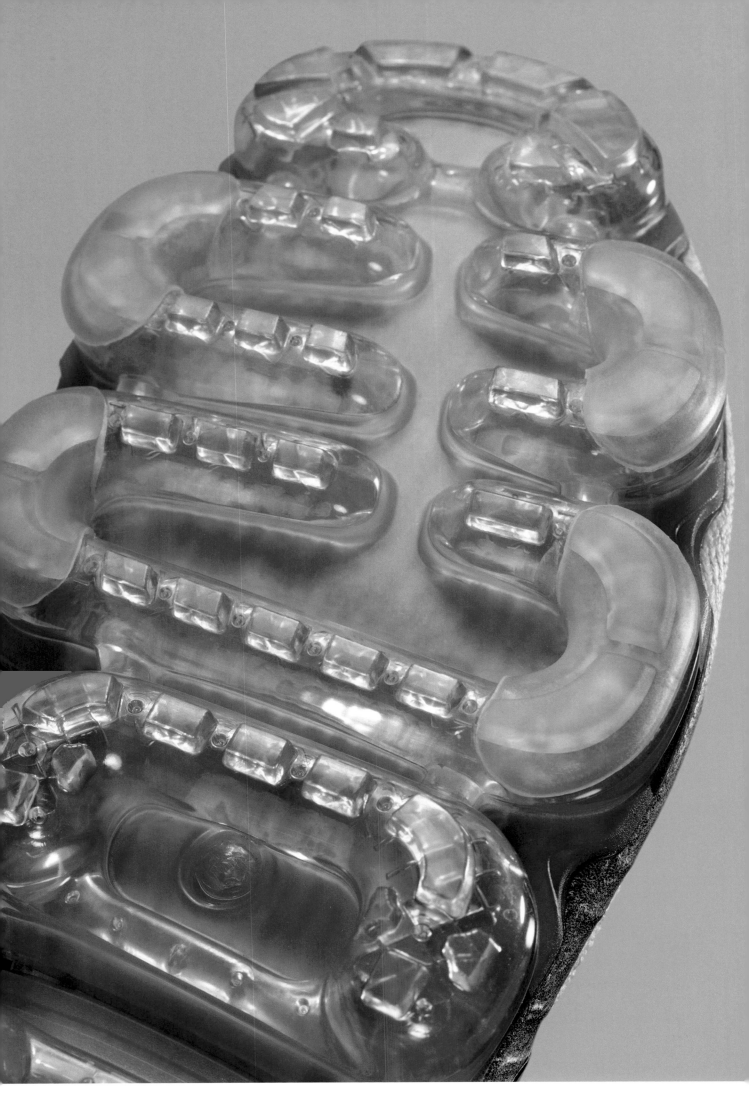

2017: Air VaporMax

2017: Comme des Garçons x Air VaporMax

AIR VAPORMAX
SAVING THE BEST FOR LAST

Released in 2017, the Air VaporMax was a revolutionary addition to the Air Max family. Its Flyknit upper barely caused a ripple thanks to its attention-stealing, full-length, entirely exposed Air unit. Segmented into unique pods, the sole delivered modular flexibility similar in theory to that of the Nike Free. The result was a wildly futuristic and ultra-lightweight runner with maximum energy response. Iridescent Swooshes and gradient colour-fades on the pressurised airbag was a dynamic one-two combination that redefined the bold philosophy of Max – again. To launch the Air VaporMax into orbit, Nike appointed Comme des Garçons. The Japanese label took a low-key, high-fashion approach, delivering a laceless vision that boosted sock-fit into sci-fi territory. The Air VaporMax was a feat of advanced industrial engineering that totally refreshed Nike's on-foot roster.

2018: Air Max 270 (Dusty Cactus)

2018: Air Max 270 (Ultramarine)

AIR MAX 270
PARTY AT THE BACK

In 2018, the Air Max franchise deviated unexpectedly. Instead of delivering a logical performance-based successor to the Air VaporMax, Nike detoured into future-fashion territory and debuted the lifestyle-focused Air Max 270. Referencing the AM93's heel-mounted 270-degree airbag design – with additional cues sourced from the 180 – the Air Max 270 was all about that big-ass bubble. At 32mm high, the redesigned unit is by far the biggest heel displacement in Air Max history. The first non-performance Air Max wasn't the shoe everyone expected, but it was a confident signifier that, after a few lean years, Nike was back in business. Who knows where Air Max will end up, but one thing is certain: this story ain't over!

Cross-Training

Published in *Sneaker Freaker* Issue 24, May 2012

EDITOR'S NOTE: WOODY

Timing is everything. In 1986, Reebok released the Workout for fitness freaks fiending for five shoes in one. The multiskilled model may have been the prototype Cross-Trainer, but when Nike dropped the Air Trainer 1 in 1987, it was game over for the Reebok. Endorsed by tennis bad boy John McEnroe, Tinker Hatfield's tough and tactical design epitomised the era's 'too much buff is never enough' mantra. New Balance, ASICS and Reebok hit the gym to 'roid up their roster, but they never quite managed to capture the spirit of the times. In 1989, Wieden + Kennedy, Nike's longtime advertising agency, harnessed the superhuman prowess of Bo Jackson to launch the legendary 'Bo Knows' advertising campaign. The category may have fizzled out a few years later, but the Cross-Trainer's macho legacy lives on in Nick Santora's feature.

THE COMPLETE HISTORY OF

CROSS T

STORY: NICK SANTORA

POWER
ATHLETIC EQUIPMENT
AIR IMPACT SYSTEM

PM 16L

RAINING

MAN DOES NOT LIVE BY ONE SPORT ALONE

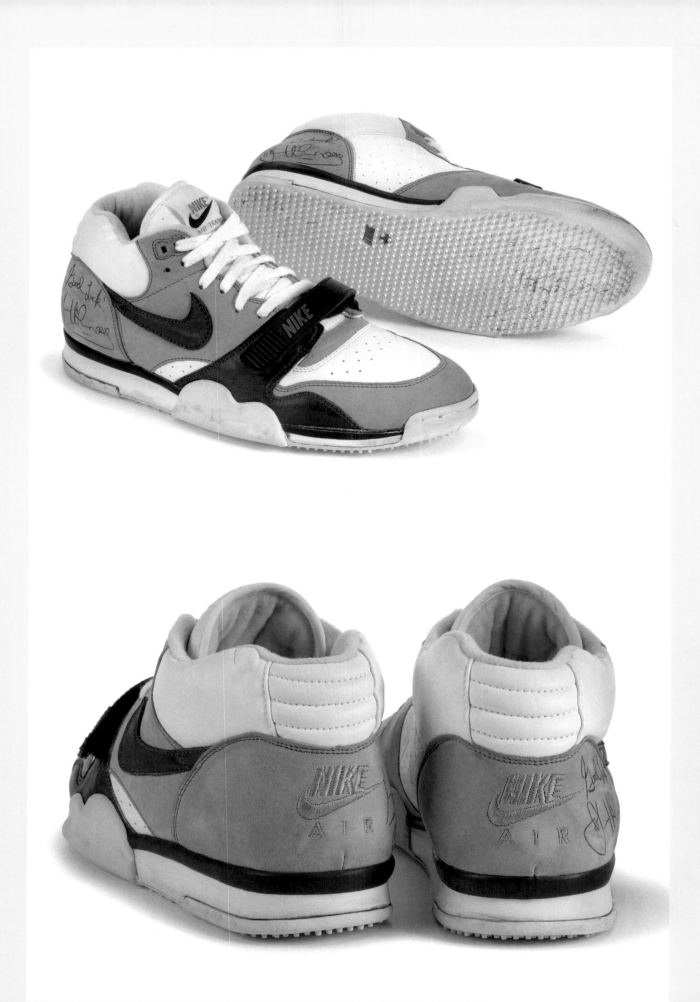

John McEnroe's personal pair of Air Trainer 1 with custom tennis soles

On his way to work out at the Metro YMCA in Portland, Nike designer Tinker Hatfield found himself unhappily pondering the contents of his gym bag. Hatfield was tired of packing one pair of shoes for basketball, one for running, one for weights and another for racquet sports. Thereabouts, a metaphoric fluorescent tube flickered and went off inside his head. Hatfield immediately went back to his office to design a hybrid that could do the job of four sneakers in one. Nike execs were unconvinced initially, but with the support of a young Mark Parker (Nike's future CEO), Hatfield emerged victorious from the battle with a stunning prototype called the Air Trainer 1.

NOW IT'S YOUR TURN.

What we've been trying to tell you is simple: Man does not live by one sport alone. And neither does woman. So get out there and cross-train. And do it in the Nike Air

Trainer. It's the first shoe designed for cross-training. And the first one that can handle the demands of any cross-training program without giving up one iota of

comfort or protection. The Air Trainer has ample support and cushioning for a three to five mile run or any aerobics class—activities where proper cushioning is

needed to lessen your chance of injury. And nothing cuts those chances like Nike-Air® cushioning. It reduces your odds of shock-related injury to the

bones, muscles, and tendons of the lower leg. But the Air Trainer is stable enough for any court sport. A wide forefoot and a unique footframe hold your

foot in place during any and all lateral movements. With the Air Trainer, it's apparent we have the right shoe for cross-training. You bring the right attitude.

1987: Air Trainer 1

The birth of cross-training as we know it begins in the mid 1980s, but its roots can be traced back to the 1960s, when the notion of physical wellbeing entered American consciousness. President John F. Kennedy was a major advocate for the benefits of youth fitness and even wrote an article on the topic for *Sports Illustrated*.

In 1962, Oregon track coach – and future Nike co-founder – Bill Bowerman travelled to New Zealand to spend time with Arthur Lydiard, the famed Kiwi athletics guru. Lydiard was the first to promote fitness through road running, something he referred to as 'jogging', which was a unique idea at the time. After his stint in New Zealand, Bowerman brought Lydiard's concept back to Oregon where he helped spread the gospel of exercise with his imaginatively titled, 1966 book, *Jogging*. Bob Anderson published the first edition of *Runner's World* magazine the same year.

This moment is significant because it was the first time running was marketed as an actual sport. Amateur running clubs were formed around the country and as their popularity spread, a whole new genre of sportswear and equipment was created to serve the

athletes, many of whom were obsessed with the idea of completing a marathon. Demand for technical runners would explode in the early to mid 70s, with New Balance, ASICS, Saucony, adidas and the newly formed Nike competing for the hearts of long-distance practitioners.

THE BUFF YUPPIES

Skip to the early 1980s, however, and the solitary nature of pounding the pavement was beginning to decline in popularity. In its place, health clubs were sprouting up with personalised fitness programmes designed for the newly christened demographic known as 'young urban professionals'. Yuppies had a taste for status symbols and aggressive individualism. While long-distance runners had been defined by their scrawny physiques, yuppies prized a different form of body dysmorphia. Hairless chests, bionic biceps and rippling six-pack abs made them look like glossy Ken dolls.

Perhaps it was a delayed reaction to *Pumping Iron*, a 1977 docudrama about the world of bodybuilding featuring Arnold Schwarzenegger, but at some point, society also began to equate

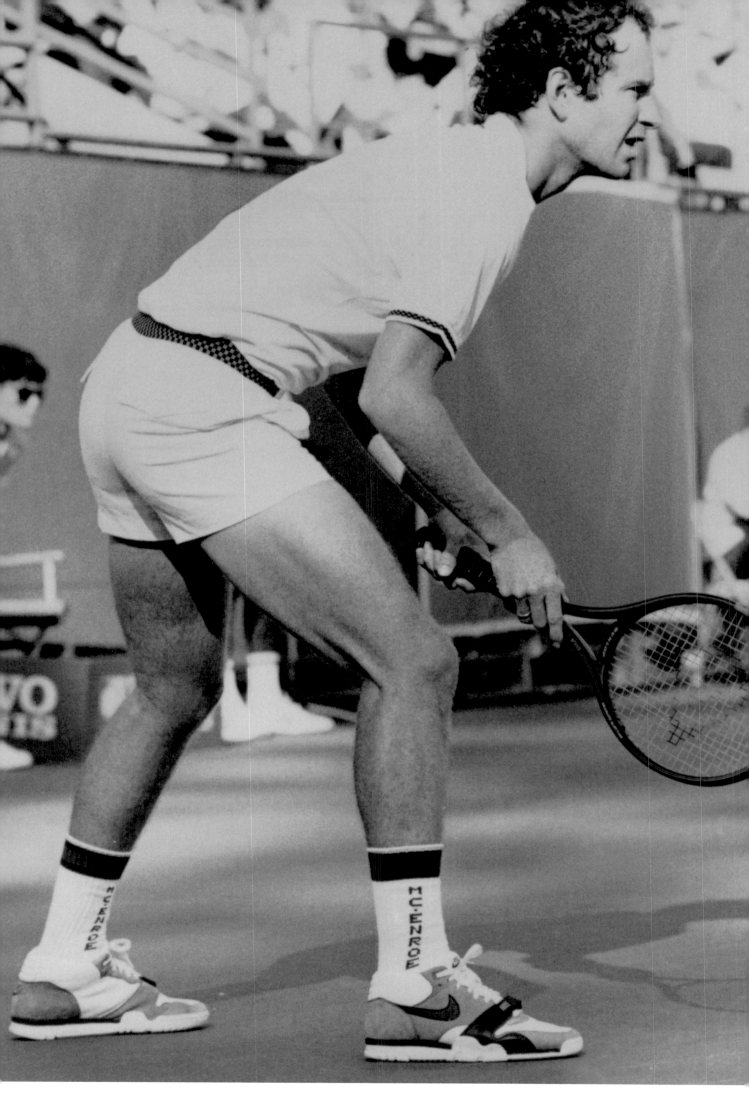

I gave McEnroe the Air Trainer 1 and told him, 'These are for you to do everything else but play tennis in. They're not tennis shoes.' So he looks at them and goes, 'These look pretty good. They're different.' The next thing I know, this son of a bitch is wearing the shoes at Palm Springs in a tennis tournament. And he says 'Nike got me some new tennis shoes. They finally made a decent tennis shoe!' So I just about shit. I called McEnroe and he says, 'That's the best tennis shoe you assholes ever made!' I said 'McEnroe, it's not a tennis shoe!' He said 'It is now!'

Peter Moore

THIS MAY BE THE ONLY PLACE IN YOUR CLUB WHERE THESE SHOES WON'T PERFORM.

They will perform in the weight room, exercise class, on the track and racquetball court. The Reebok Workout Mid-Cut is the one shoe designed to take you through your toughest fitness routine and give your feet all the support and cushioning they need.

Technical features of several sport-specific shoes are combined in the Workout. Our patented H-strap and ¾ height offer outstanding support for weight training. The maximum cushioning and forefoot flexibility make these suitable for light running. Heel and toe wraps provide lateral stability for court sports. And, our notched back tabs allow your feet to flex more freely.

When you work out, put your feet into the Reebok Workout Mid-Cut.

Also available in leather Low-Cut, for men and women. Leather/mesh Low-Cut for men only.

Reebok 🇬🇧
Because life is not a spectator sport.™

©1986 Reebok International Ltd.

1986: Reebok had the fitness concept covered in 1986; they just didn't have the multi-skilled Bo Jackson on their team. Billed as a sneaker that would 'perform in the weight room, exercise class, on the track and raquetball court', the Workout had the credentials, but it was no match for Nike's macho Air Trainer 1 when it debuted a year later.

1990: Reebok CXT Plus

1989: Reebok SXT

1989: Reebok CXT Ultra

1989: Reebok CXT

1987: Reebok Pro Workout

1991: Air Trainer E Lo

2014: Air Trainer 1 'Chlorophyll' (reissue)

2005: Air Trainer III 'Terra Sertig'

The Air Trainer TW from Nike. It's for cross-training. It's breathable. It's fully washable. It's perfect for traveling. But why not use it, get it dirty, and find all this out for yourself?

Women's Air Trainer TW

Men's Air Trainer TW

For information on starting your own cross-training program, write: Nike Fitness, 9000 S.W. Nimbus Dr., Beaverton, OR 97005.

1988: Air Trainer TW (Totally Washable)

1987: Air Trainer 1

1989: Air Trainer III SC

1989: Air Cross Trainer Low

1989: Air Cross Trainer High

1988: Air Trainer III SC

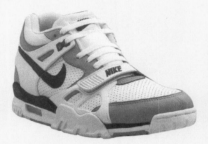

1988: Air Trainer III SC

1988: Air Trainer TW

1989: Air Cross Trainer

1990: Air Cross Trainer Low

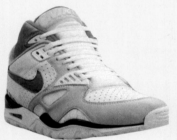

1989: Air Trainer SC II High

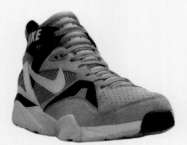

1991: Air Trainer Max

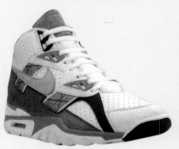

1990: Air Trainer SC

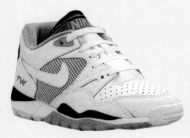

1990: Air Trainer TW

1989: Air Trainer TW

1989: Air Trainer SC

1991: Air Trainer SC Low

1991: Air Trainer TW Lite

1988: Cross Trainer High

1994: Air Trainer Huarache

1994: Air Trainer Accel Mid

1991: Air Trainer TW Lite

1993: Air Trainer Vengeance

1993: Air Trainer Accel

1993: Air Trainer Accel Low

1994: Air Trainer Accel Low

1994: Air Edge

1993: Air Trainer Circuit

1993: Air Trainer Accel

1993: Air Trainer Accel Mid

1993: Air Carnivore

1994: Trainer Lite

1993: Air Trainer Accel Low

1993: Air Pace Trainer

1993: Air Trainer Huarache

1993: Air Trainer Platinum Low

1993: Air Trainer Platinum

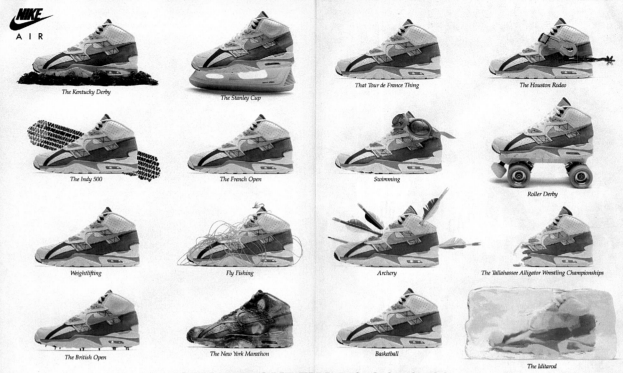

The Kentucky Derby • The Stanley Cup • The Indy 500 • The French Open • Weightlifting • Fly Fishing • The British Open • The New York Marathon

That Tour de France Thing • The Houston Rodeo • Swimming • Roller Derby • Archery • The Tallahassee Alligator Wrestling Championships • Basketball • The Iditarod

CAN ANYONE FILL BO'S SHOES?

Can we talk about the Nike Air Trainer®SC? It has Nike-Air.® It has flexibility. It has lateral sup port. It has lots of fancy colors. It has your name on it. If that name happens to be Bo Jackson.

1990

a buffed body with the notion of being a winner. If you were in shape, you were successful in life, and that meant you could also afford the time and money to exercise in state-of-the-art facilities. Looking like Mr. Universe was a new concept driven by boundless vanity and would become one of the enduring symbols of the decade.

REEBOK

The most popular activity at health clubs was aerobics for women, personified by Olivia Newton-John's song 'Physical' and Jane Fonda's workout videos. Braided headbands, neon leotards and leg warmers quickly became quintessential fashion accessories. In 1982, Reebok created the Freestyle, the first athletic shoe manufactured and marketed specifically for women. The Freestyle's epic popularity changed the footwear business virtually overnight and Reebok's annual sales leapt from just over $1 million in 1981 to $66 million in 1984, with over half the sales coming from one shoe alone. In 1986, sales skyrocketed to $400 million. Crushing the opposition, Reebok's Paul Fireman must have felt totally vindicated by his decision to focus on his female customers. Over at Nike, the famously combative Phil Knight was plotting revenge.

AIR TRAINER 1

As noted in the introduction, everything changed in 1987 when Nike rolled out the Air Trainer 1 and instantly articulated a masculine mentality in design, function and performance. Cross-training had arrived as a big-time category, and as the world was about to find out, sneaker design and marketing had just been taken to the next level.

Nike knew they had to make a profound impact, enlisting their advertising agency Wieden + Kennedy for the task. The 'Just Do It' slogan was about to become a global mantra, and when Nike purchased the rights to use 'Revolution #9' (owned by Michael Jackson at the time), Nike controversially became the first company to use an original Beatles tune in a commercial. Music fans were outraged. Paul McCartney and every sneaker lover in the free world was gobsmacked as cross-trainers and the concept of 'Visible Air' was introduced in monotone with amateur athletes appearing alongside John McEnroe and a jovial Michael Jordan. You say you want a revolution? Well, there it was on the feet of Nike's star performers.

The Air Trainer 1 was unlike anything seen in the sneaker world at that point. It was a hybrid design with roots in tennis and basketball, but the differences were noticeable enough for consumers to immediately understand the shoe's multidimensional personality. The three-quarter height provided stability while the black forefoot strap added a layer of support and straight-up badass appeal in the looks department. That tough and technical stance – juxtaposed with premium leather, grey nubuck and forest green accents – allowed the Air Trainer 1 to flex perfectly at the gym, in the street and on court. It was truly four, and maybe even as many as five, shoes in one.

A unique design alone rarely launches a single sneaker into its own franchise category, but with the Air Trainer 1, Nike had the perfect product for the moment. Technology, design, marketing and athletic performance had converged with the simultaneous launch of Air cushioning, the cross-training concept and the first Air Jordan. The future was so bright Joel Goodsen was still wearing shades.

McENROE KNEW

The Air Trainer 1 was off to a flying start when the model received a boost via an accidental affiliation with tennis bad boy John McEnroe. Legend has it that McEnroe was given the shoes reluctantly by Nike staffer Peter Moore who expressly told him not to wear them on court. Never one for orthodoxy, McEnroe immediately donned the shoes in a game, telling Moore: 'That's the best tennis shoe you assholes ever made!' Soon enough, the Air Trainer 1 would also be seen on fellow Nike athletes Andre Agassi and Mats Wilander. Worldwide exposure in professional tennis tournaments was the final vindication needed to legitimise the cross-training category.

BO KNOWS

By 1989, McEnroe and Agassi would become spokesmen for the new cross-trainer-inspired Challenge Court tennis line. A new face was therefore needed to front the campaign and with Bo Jackson on their books, Nike had the perfect bod for the job. Jackson was a mythically talented athlete – the first man to play both professional baseball and football in alternate seasons.

Michael Jordan could fly, but Bo could do it all. He was a freak of nature blessed with superhuman speed and power.

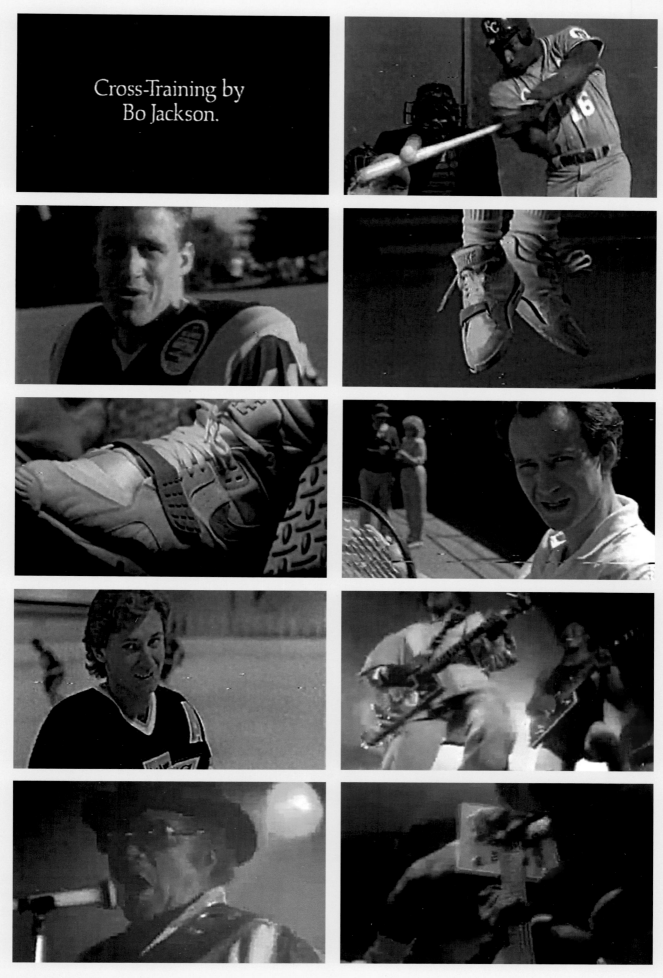

Above: 'Bo Knows' Nike TV commercial

First published *Sneaker Freaker* Issue 24 – May 2012

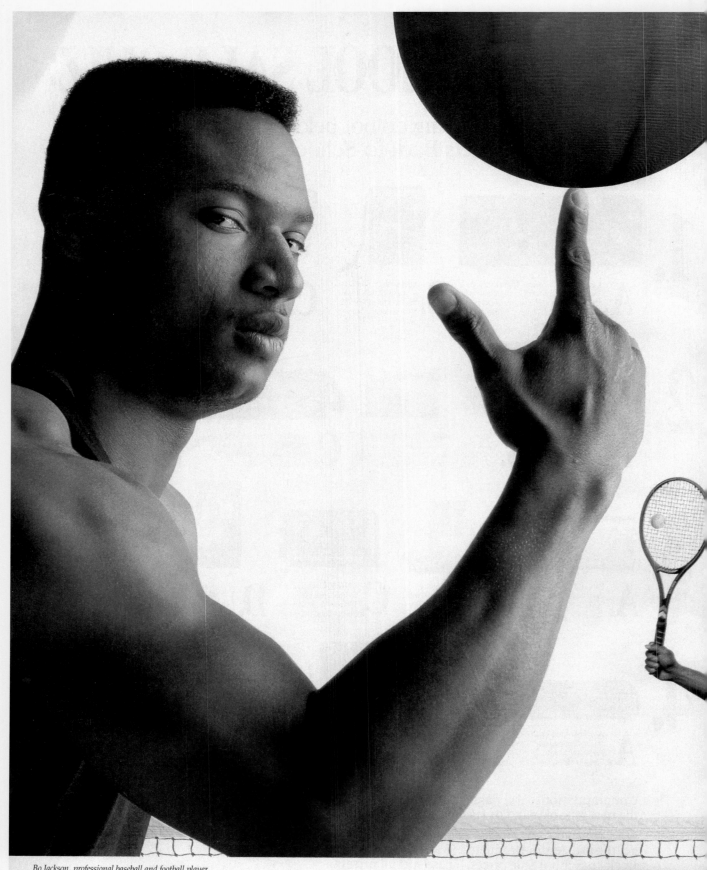

Bo Jackson, professional baseball and football player.

THE JA

See Bo cross-train. See Bo cross-train in a shoe with Nike-Air® cushioning and plenty of supp

For further information on Nike Cross-Training products call 1-800-344-NIKE, Monday through Friday, 7am-5pm Pacific Time.

1990

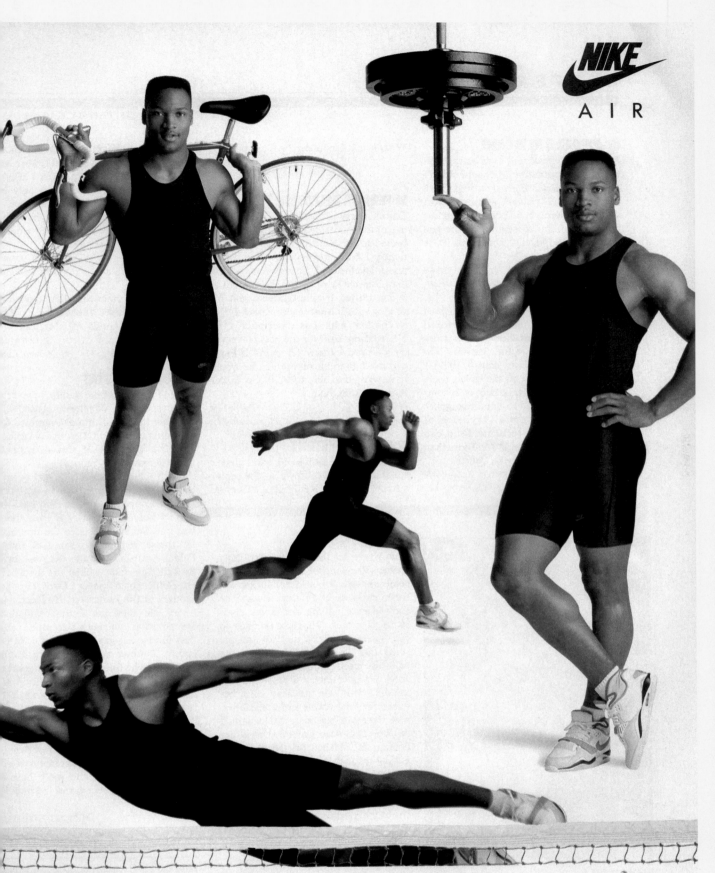

SON 5.

e Bo cross-train in the Air Trainer SC. See if you can do everything Bo can do in it.

Air Trainer SC

Before.

After.

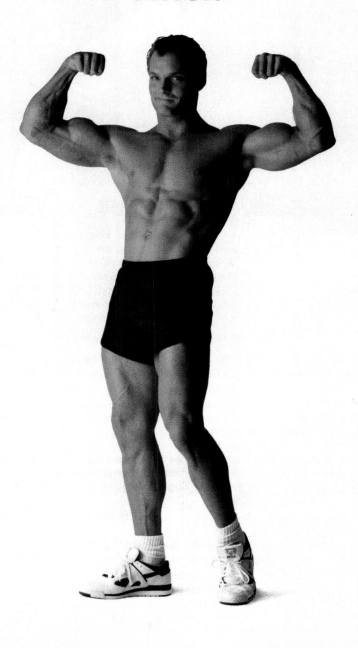

© 1989 Reebok International Ltd. All Rights Reserved. Reebok is a registered trademark of Reebok International Limited.

1990

Introducing the Cross-Training System by Reebok.

Three shoes designed for any kind of workout, starting with what you do best.

AXT. The first shoe for runners who also want to lift weights and play court sports. Leather and mesh uppers for lightness. Forefoot sidewall wrap for stability. You can run, and you won't have to hide.

speed
$$V = \frac{2\pi R}{C} N$$

power
$$P = \frac{W}{t}$$

SXT. The first shoe for weight lifters who also want to run and play court sports. Midfoot and ankle straps for maximum support. Wide base ensures maximum stability for you, and total insecurity for everyone around you.

CXT. The first shoe for court players who also want to run and lift weights. Midfoot strap for medial support. Midfoot sidewall for lateral support. Good for adjusting the attitude of that poor geek who beat you in tennis last week.

force
$$F = ma$$

The physics behind the physiques.™

Reebok

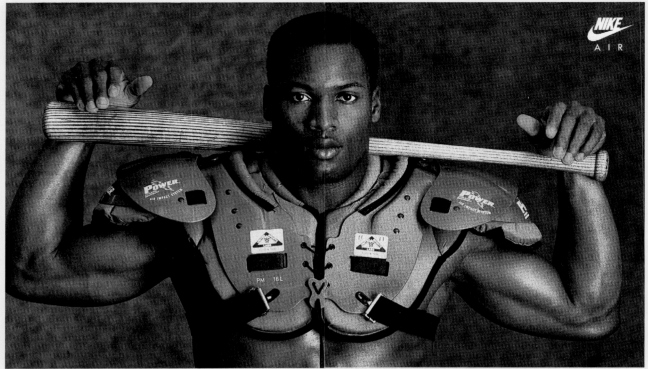

IF BO JACKSON TAKES UP ANY MORE HOBBIES, WE'RE READY.

Who says Bo has to decide between baseball and football? We encourage him to take up the Nike Air Trainer SC. A cross-training shoe with plenty of cushioning and support

everything from basketball to cycling. And to train for them all in for a number of sports. Or should we say, a number of hobbies?

For information on starting your own cross-training program, write: Nike Fitness, 9000 S.W. Nimbus Dr., Beaverton, OR 97005 or phone 1-800-344-NIKE.

Air Trainer SC

1990

Wieden + Kennedy captured Bo's virtuoso duality with the famous 'Bo Knows' campaign, which was extrapolated into several TV spots and dozens of press ads. Jackson was seen excelling in basketball, golf, hockey and tennis with the final punchline an appearance on stage with Bo Diddley. Awestruck by the sporting savant's guitar playing, 'Bo, you do know Diddly!' became the tagline that completed the circuit. Another TV spot featured the classic line 'Bo don't surf! That's what you think, dudes!' before his image is multiplied several times over onto different athletes, confirming his claims to all-around sporting perfection.

By now the Air Trainer line was several seasons deep and its extensive use of Velcro straps, punchy colour combos and tech materials was perfectly in step with 90s fashion. Design and technology, combined with brilliant advertising, had ensured Nike's ruthless dominance of the category.

PUMP & DUMP

In an effort to cash in on the Freestyle's flame, Reebok introduced the sleek Workout and Ex-O-Fit as part of a new Fitness line for men. Though creditable, the shoes were a tad feminine to really kickstart the cross-trainer category. Later efforts such as the SXT, CXT and AXT had a more macho stance suited to the times. Worn by baseballer Roger Clemens and Emmitt Smith from the Dallas Cowboys, the Paydirt was another notable Reebok from this era.

Other brands clamoured to enter the cross-training game, with some great but not particularly memorable styles coming from ASICS, Avia, Saucony and Converse, but it was the big guns Nike and Reebok that maintained their fierce rivalry throughout the peak years of cross-training.

By 1992, trends started to shift again. Neon colours had run their course and sophisticates craved more subdued hues and hiking-inspired Euro-style. The Gap was selling khaki pants by the truckload and exercise shifted from the gym to outdoorsing under a clear blue sky. Nike's ACG (All Conditions Gear) category was the new kid on the block and trail running became the new category to watch.

In 1995, Nike brought a little attention back to cross-training with Deion 'Prime Time' Sanders, who just like Bo Jackson excelled at both baseball and football. Baseballer Ken Griffey Junior was another cross-trainer endorsee, with his chunky Air Griffey Max showing

just how far the category had come in terms of design and style. However, by this point, there was too much crossover between the technology and aesthetics of basketball, running and cross-training for it to maintain legit status as a distinct franchise.

While it's no longer on the cutting edge of sports marketing, the cross-training category still exists. Whether you're at Wal-Mart or the NFL Combine, cross-trainers could range from pro-style turf trainers to your grandfather's New Balance. Chunky generic shoes in size EEE like the NB608 are technically listed in the cross-trainer catalogue, but the emergence in performance style like Nike's Free and Lunar series can also be considered a throwback to the Trainer 1, even if they look more like runners than tennis shoes with outriggers and glamorous forefoot straps. Throw in Vibram's abstract Five Fingers model for today's fungus-phobic hipster gymrats, and you have a category that is utterly diverse in style and context.

Truthfully, cross-training was a concocted, marketing-driven title given to a category that Nike needed in order to drive attention to its investment in technology. Expressed through pop culture, using athletes as entertainers, cross-training was exactly what Nike needed to steal market share back from Reebok and reclaim their number one status. The synergy between product, fashion trends and a legendary advertising campaign are the trademark and enduring legacy of this awesome chapter in sneaker history.

•

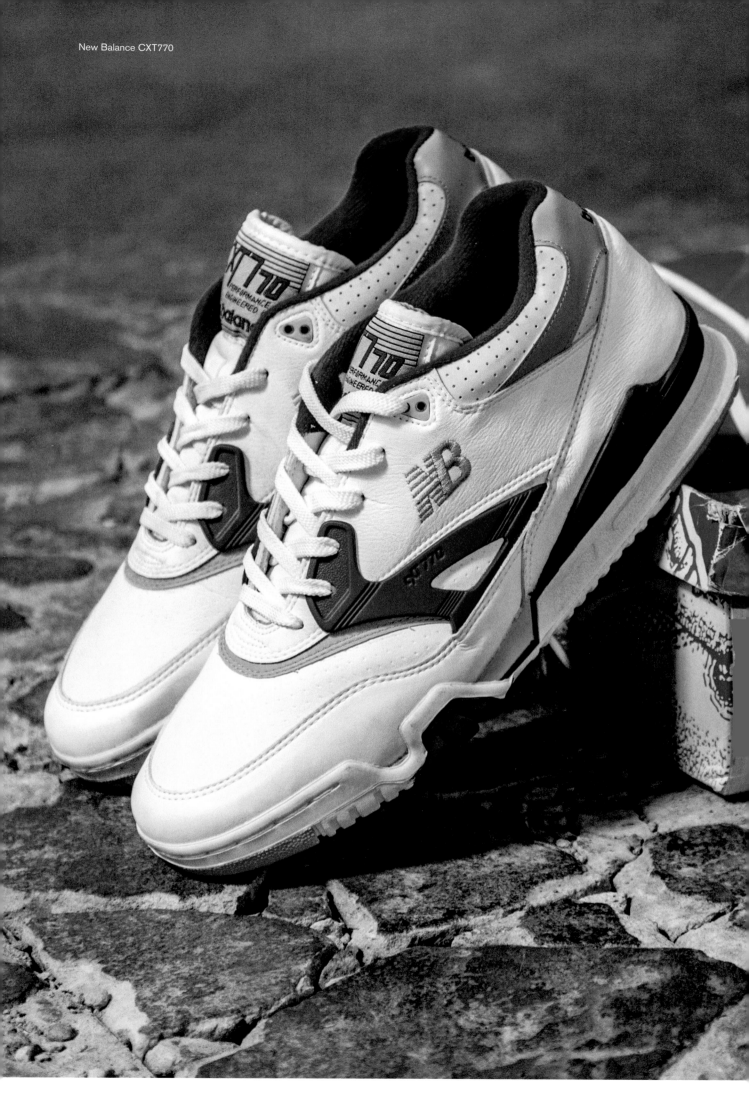

Airwalk

Published in *Sneaker Freaker* Issue 10, July 2007

EDITOR'S NOTE: WOODY

All these years later, this feature still evokes tender memories. Back in 2007 I spent an intense So-Cal weekend with Sinisa Egelja gasbagging about our shared love of muscle cars and skate shoes. If I remember correctly, the original interview came in at well over 35,000 words. Though I didn't totally appreciate the underlying dynamic at the time, recalling his role in catapulting Airwalk from a Del Mar skate park to global domination was a deeply emotional experience for Sin. His untimely death a few years later was devastating for everyone who knew and loved him. As you'll read in this feature, Sin was a unique character and an irreverent genius who left behind an immense creative legacy. Vale Sinisa Egelja!

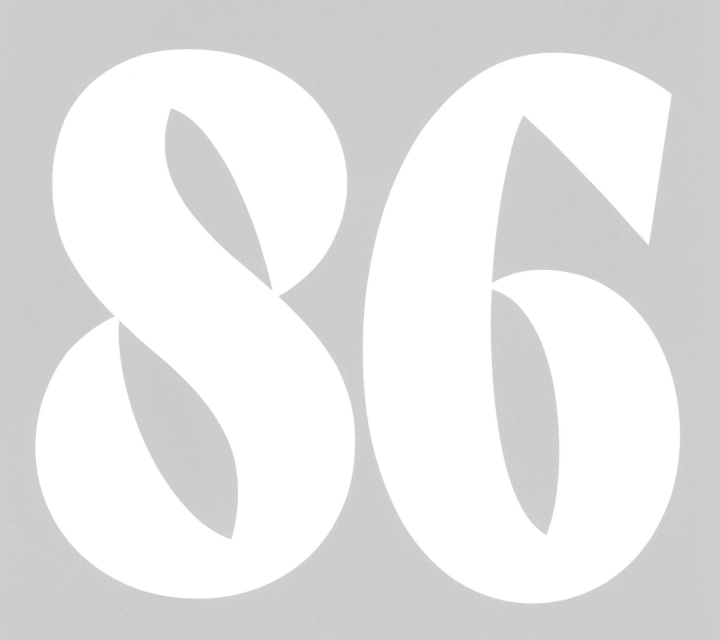

The True History
of Airwalk

INTERVIEW WITH
Sinisa Egelja

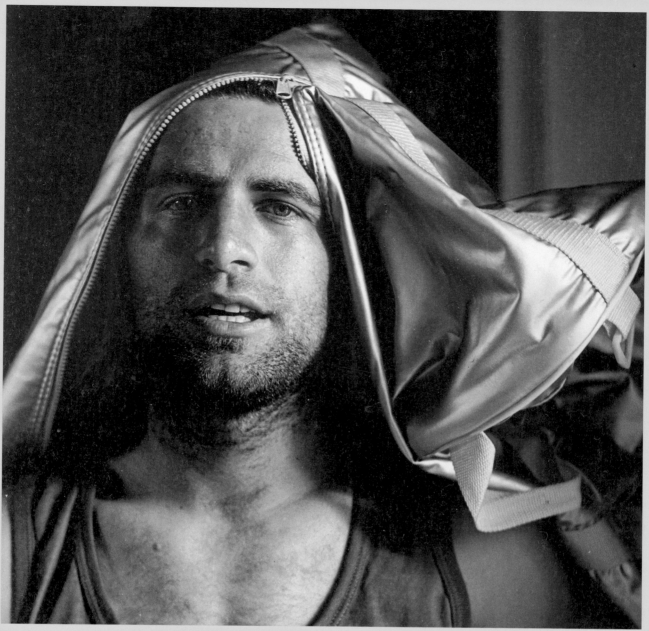

Sinisa Egelja

From its origins as an upstart startup in 1985, Airwalk evolved rapidly
into a $200 million beast that sponsored skaters, surfers, BMX riders,
base jumpers, boogie boarders and a young Tony Hawk. Epitomising the
mid-80s vibes, Airwalk's early shoes favoured vulcanised construction and
heavy-duty graphic prints, before the high-top roster expanded under the
Prototype banner. Category diversification may have been the key to the
brand's supersonic growth, but ventures into casual shoes, snowboots and
daggy brown loafers alienated their hardcore skate audience. The once
white-hot behemoth – and at one point third-largest sneaker brand in the
US behind Nike and adidas – entered a downward spiral that it couldn't
snap, before eventually being sold for a song. Sinisa Egelja was the first and
virtually last employee of the original Airwalk company. This is his story.

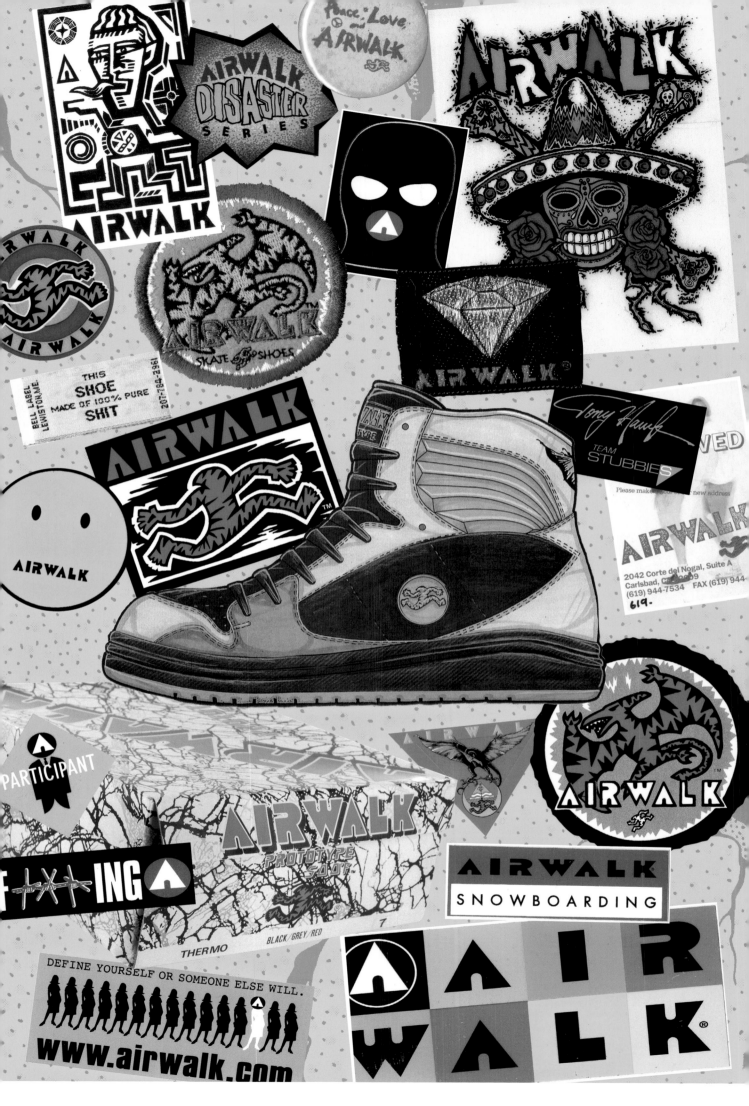

1985: First Airwalk catalogue

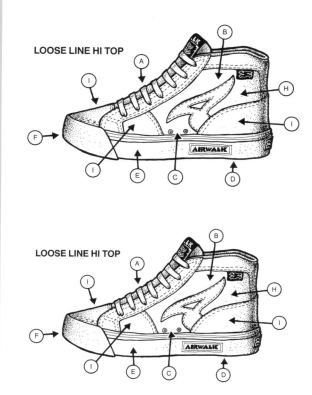

How did you get hooked on skateboarding?

Well, I got my first skateboard probably in third grade. I was surfing at Manly in Sydney one day and my leash broke. On my way to the surf shop I saw this quarter pipe – this is probably around 1979 – so that same day I traded my surfboard in for a skateboard. From that point on, skateboarding was the only thing I wanted to do. Most of the inspiration came from American magazines and Aussie skaters. Occasionally some US guys would come over and that was amazing because they had such a different style. I somehow convinced my mum and dad to let me just go over to the US in the middle of the school year. I guess I was 17 or so.

By yourself?

By myself! I'd never been anywhere outside Australia. I just had a map from *Skateboarder* magazine of all the parks and figured out how to get around by public transport, though half the parks weren't even there anymore! I ended up meeting a lot of the same people I saw in the magazines. When I came home my parents wanted me to finish school so I did that, though I was still skateboarding every day. As soon as I finished, I figured out a way to go back and this time I stayed at Del Mar instead of LA because my friends Brad Shaw and Dave Mock went over and said Del Mar's the coolest place to hang out.

Did you have ideas of being a pro?

I think I might have. One day I was at this half-pipe and when I dropped in, I just couldn't breathe at all. I found out later that when I was about 10, I jumped into a swimming pool and chipped my tail bone and my spine started growing weird, which was the start of scoliosis. The chiropractor told me I really should give up skateboarding. But I wanted to go to the US, not necessarily thinking about being pro or anything; I just wanted to get better because when you're with great riders you're going to learn more.

How did you start at Airwalk?

I started working at a skate park and one day a friend of mine Sonny says to me, 'This guy came in and he's thinking about starting a shoe company and needs some help. Do you wanna go talk to him?' I was like 'Shit, yeah!' I wanted to work on shoes, because I knew at that time Vans shoes had these areas where the little toe would

rub and it would take two weeks to wear in. We had to use Band-Aids because we'd get blisters and our feet would bleed like crazy. So the next day I went into Bill Mann's office and we start talking and he asks me a bunch of questions. I told him I knew Tony Hawk and a lot of pro riders and that got him excited. He asked me about shoes and I told him the positives and negatives of Vans and other brands. Then he asked me about school. I said, 'Oh yeah I went to school in Sydney and finished electronic engineering.' He looks at me and goes, 'What's that got to do with shoes?' And I'm like, 'Nothing!' That was pretty funny.

Do you know what inspired Bill to start Airwalk?

At the time, Bill was doing unbranded shoes for customers like Sears. Actually, what got him started was his son. Mac started skateboarding and goes to him, 'Dad, you know, you could make a better shoe than Vans. These shoes suck!' Mac was pretty picky. He liked the Vans grip but the shoes wore out way too fast. Finally, Mac, and Bill's wife, convinced him to try it. Bill looked at the idea and he ended up taking pictures of skaters knee-sliding and doing all these crazy tricks down at the park.

He went down the skate park and took photos?

Yeah. But he didn't talk to the kids, he didn't do anything creepy, he was just standing at the fence like a spy so he could understand it all. And he brings this shoe out to show me and it's pretty simple. He's really excited and I could see that he put effort into it and I appreciated that he wanted to make a better shoe. So I look at the toe and it's hard plastic, not rubber for knee-sliding. As soon as I looked at it, the first thing I told him was that if you ran up the ramp and your toe hit it, you would slip and smash your teeth against the concrete or the ramp. That was it. I started work the next day.

He must have been an interesting character.

Yeah he was. I had full trust in him from the beginning. I really liked Bill, he was fun. He was a shoe-dog. I was the first person hired for Airwalk.

Sounds like you were thrown in the deep end?

I didn't know anything, but I was pretty confident about what was wrong with skateboarding shoes at the time. They asked me about

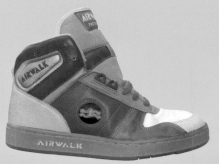

13 Colour (prototype)

Sonic

Turbo

Prototype 620°

Prototype 620°

Prototype 600°

Prototype 540°

Deck shoe

First Airwalk lace guard

where the seams met and what hurt and we talked about how important the rubber compound was. Lenny Holden did his best to get the rubber grippy and durable, but I knew what I didn't know – I figured that they knew and they'd ask me questions. Some of the models were pretty generic. Bill never said, 'This is a Vans!' He said, 'This is a deck shoe!' The Slip-On and Lace-Up models are really old and that's just what they were called, even to this day. They were around way before Vans.

Do you know how the company came to be called Airwalk?
Garry Davis was the assistant art director for *TransWorld* and I think he came up with the name. Tony Hawk was on the team and he did the trick known as the Airwalk, and he kind of suggested Airwalk be the name and everyone was pretty much into it. We gave Garry six pairs of shoes and a duffel bag as his reward. What a bargain! [Laughs]

Does that make Tony Hawk the first Airwalk rider?
Actually the first rider we got was Billy Ruff. Bill Mann asked me who should we get and I said, 'Billy Ruff has his head on really well, I think he'd be a really good salesman.' I guess Tony was the team's second skateboarder. At that time, he was talking to PUMA. I don't know if they had an interest in him or whatever, but I said, 'Dude, you don't want to ride for PUMA, they're not into skateboarding and Airwalk is a skateboard brand and we're going to make better shoes than Vans!' I don't know exactly when this was, but I know he was riding for Stubbies.

Stubbies? The Aussie work shorts?
Nah! Stubbies in Cali were board shorts. He wore the surf stuff and he didn't ride for them too long. No one will understand Australian stubbies here in California; you can't explain it if you didn't grow up with it. So anyway, at that time I was basically helping with development and doing the marketing, team promotions, helping with advertisements in the magazines – all these different jobs.

That's a big job for a rookie kid.
Well, when we started we didn't have 500 shoes right away. Anyway, it got to the point where I didn't know how to layout ads and I was living with Grant Brittain who was the photo editor of *TransWorld* and Cynthia Cebula, who became the first Airwalk graphic designer and art director.

Did Cynthia do the Airwalk logos?
Yeah she did. Originally we had the pterodactyl head on the shoe. The shitty thing was everyone always looked at it and thought it was the 'A' for Airwalk, but really it's the side profile of a pterodactyl opening its eye. Cynthia also designed the 'Ollie the Running Man' logo as well.

It's funny how those logos stick in your mind. So what happened next?
Lenny went over to Korea and made all these shoes with the prints in a mad rush at the last second. We got the samples back and there was some stuff that wasn't done, so we basically went to the

AIRSTAR SERIES
（エアースター　シリーズ）　**¥6,800**

#8201 **BARBED WIRE**（バーブドワイヤー）

#8202 **I.D.**（アイディー）

#8203 **WALKABOUT**（ウォークアバウト）

#8204 **BLOTTER**（ブロッター）

#8205 **KAMIKAZE**（カミカゼ）

#8206 **HAVOC**（ハボック）

#8207 **OBLIQUE**（オブリック）

#8208 **BLACK**（ブラック）

#8209 **WHITE**（ホワイト）

Japanese catalogue

first trade show with hundreds of drawings that were displayed in picture frames. I'd never been to a trade show in my life. All I knew was that we had all these shoes and we had a bunch of pictures and I'm the one that's supposed to tell 'em about skateboarding and the marketing side of it. It was weird because I'd never even been to New York. Basically the show was so well received that afterwards we were all on a high. Bill didn't expect the reaction – we did a million dollars' worth of business at that first trade show! Bill was super psyched.

A million dollars is um, let me see… that's a lot of $30 shoes.
Actually I think the shoes were around $50 retail. Yeah, so that's easily tens of thousands of units straight off the bat. All I know is, and as far as I was told, we did a million dollars' worth of business, however that was calculated. You know, when your boss is fucking wigging out and super stoked, that's when you know it went well.

What happened next?
We had to look at what we needed. There were these lace savers that Dale Smith made. I don't know where he got the idea from, but it was a flap of leather that had a Velcro piece on the backside that was stitched at the bottom and you slipped it through to cover all the laces. One of the biggest problems on concrete and ramps was that you'd knee-slide and eventually with the heat and friction, the laces would break. I saw what Dale was doing and I told Bill we needed to stitch the thing to the shoe so we don't have to thread the Velcro under the laces and that's where the Airwalk lace saver came from. That was huge for the company. People looked

at lace savers as a fashion thing, but it was actually purely functional for protecting the laces.

Did that spark your interest in design?
The lace saver was the big key for me because that's where I first really started to understand aesthetics and what I liked. After all the input and knowledge from Bill and Lenny telling me why this idea won't work because of this reason and that reason etc., I had built up my knowledge of footwear basics. And remember at that time, things were pretty limited. It's not like it is today, because so many things hadn't been invented.

What was Vision up to at this point?
Yeah, I'm not exactly sure when Vision came out with footwear but they were definitely there. It was pretty much Airwalk, Vision and Vans back then. Pierre André was working on Etnies around 1986 as well. I have a lot of respect for him. A lot of my friends rode for Vision. There was competition for sure, but it wasn't like it is now. Vision also had the full package of skateboards, clothing and all this other stuff. They demanded all their riders wore the Vision uniform if they didn't have a different board sponsor.

Does that explain why Airwalk never did boards?
We just felt it was wrong because Airwalk was a shoe company. We did some accessories like bags and clothes, but we just knew that boards were wrong. It wasn't about money. Plus the other thing was, if we made boards, we couldn't have all the riders on the team.

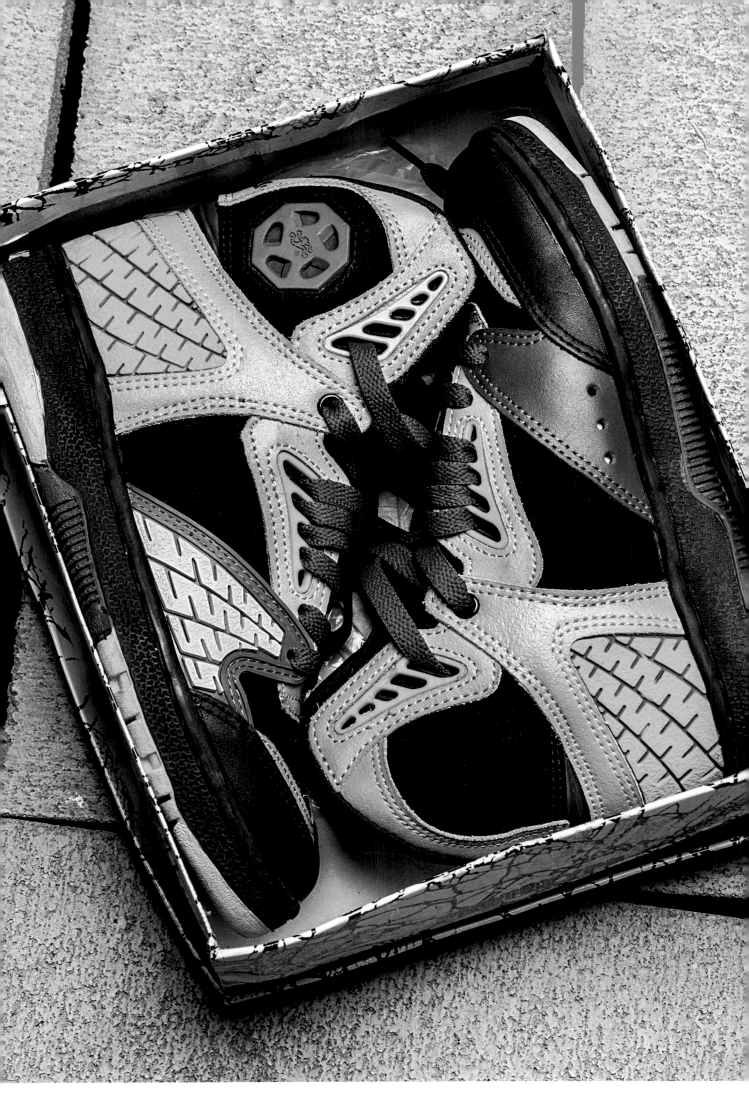

AIRWALK®

PROTOTYPE™ 620°F SERIES

Well, they're your feet. Down at the bottom of your legs just below your ankles. It's kinda hard to get around without them.

At Airwalk we know a lot about feet. We make great shoes that help feet do pretty much anything feet do with shoes on. And when it comes to action like skateboarding, freestyle biking and court sports, Airwalk feet perform unheard-of feats.

With our new Prototype series we're into leather. Not just your boring, everyday, nurse-white leather but bright-colored, eye-catching, full-grain leather. Put together to look good and last a long time.

Prototypes—sturdy leather high-tops for action sports. Your feet will like them and so will you.

AIRWALK® PROTOTYPE™ 620°F SERIES

3 COLOR SPECIAL HIGH ABRASION OUTSOLE

EXTRA THICK HIGH ABRASION RUBBER TOE INSERT FOR INCREASED DURABILITY.

OUTSOLE TRED DESIGN FOR MAXIMUM TRACTION.

BUILT IN MIDSOLE CAVITY SYSTEM FOR MAXIMUM FLEX AND SHOCK ABSORBTION.

EXTRA DEEP REINFORCED FLEX BARS FOR MAXIMUM FLEX AND INCREASED FOREFOOT MOBILITY FOR ALL ACTION SPORTS.

INSIDE AND OUTSIDE RIBBING TO INCREASE MIDFOOT FLEXIBILITY.

MAXIMUM SURFACE AREAS THROUGHOUT TO INCREASE STABILITY.

EXTRA THICK HIGH ABRASION RUBBER HEEL INSERT FOR BRAKING DURABILITY.

ENLARGED TEXTURED SIDE WALL FOR BETTER OLLIE GRIP.

DOUBLE SPEED LACING SYSTEM FOR EXTRA SECURE LACING.

FLEX NOTCHES FOR LATERAL FLEX.

DOUBLE THICK DURABLE FULL GRAIN LEATHER FOR HALF PIPE SLIDE PROTECTION.

RAISED EXTRA THICK HIGH ABRASION RUBBER TOE INSERT FOR INCREASED PROTECTION AND DURABILITY.

HEAVY TEXTURED RUBBER OLLIE GRIP.

INSIDE 3 POINT VENTING SYSTEM FOR MAXIMUM AIR FLOW.

SOFT PADDED DOUBLE COLLAR FOR DURABILITY AND EXTRA COMFORT.

THICK RUBBER ANKLE PROTECTOR.

DEEP ARCHILLES NOTCH FOR PRESSURE RELIEF.

HIGH FREQUENCY WELDED VINYL LATERAL FLEX POINT.

HEAVY TEXTURED HEEL SUPPORT.

HIGH ABRASION RUBBER HEEL INSERT FOR BRAKING DURABILITY.

LEATHER HEEL AND ANKLE STABILIZER FOR BETTER SUPPORT AND PROTECTION.

Prototype 620° F

In Australia, we used the word 'vic' as in victim and it became a kind of a joke, as in fashion victim or whatever. Not always super negative. My friend Brad started calling me Vic and I'd call him Vic as well. Then I was saying we should do a new line and Vic became Victor Novettipolae, which in Yugoslavian means 'new shoes'. Not many people got that.

Sinisa Egelja

THE RETURN OF VICTOR

VIC'S BACK, AND HE'S BACK WITH A VENGEANCE!
The Upper-Class Champion of the Sporting World has returned from his extended vacation and he's in the prime physical condition of his life! Watch him as he performs a "Reverse Louganis" at the personal training facility of his former student, Tony Hawk. You can still write to VIC for stickers by sending one dollar and a self-addressed, stamped envelope to: Victor Novettipolae, c/o Airwalk, P.O. Box 227-9000, Carlsbad, CA 92008.

Victor Novettipolae
Upper-Class Champion
of the Sporting World

Hadjifotos

AIRWALK

'Vic's Back' press ad

Pterodactyl and Ollie the Running Man logo by Cynthia Cebula

Following the success of the first range, was it a case of the difficult second album syndrome?
I wasn't thinking that at all. I was figuring out what team riders to get and how to keep them happy plus do the marketing and photos and all that. I remember Chris Miller started wearing the first Jordan and he was one of our top skaters. He said, 'Sin, I don't like your shoes but these Jordans I like!' I started wigging out because he was riding for us and wearing Jordans and I'm like, 'Fuck!' He wouldn't wear Jordans at contests, just when he was practising. So I told Bill, 'We've got to make something rad for Chris to wear,' and Bill says, 'I'm not really familiar with cement shoes, I just know how to make vulcanised shoes really well'.

Lenny said he would design it in Korea so I said, 'We need something with ankle protection for when the board hits you.' They asked me what should we call the shoe and I said we should call it the 'Prototype' for now and figure it out later. When Lenny brought the shoe back I was totally blown away. It was so rad. I knew Chris was going to love it and the name just stuck.

I thought we had jumped ahead of Jordan since it was much better for skating. One of Bill's biggest mistakes was letting Lenny go. He was so fucking hardworking and I learned a great deal from him. After we started growing, Bill hired Walter Telford. He was really technical and everything was done by hand. I mean, every blueprint. He knew about shoes 100 per cent and it was all done on paper, nothing was ever done on a computer.

Walter's influence is obvious in some of the more radical-looking shoes.
If you look at the Airwalk stuff, some of it was pretty crazy. Walter definitely understood rubber moulding, but at that time, we were just freaking out because no one had never seen anything like it. Walter was a great designer but I had no clue where he got most of his ideas from, although I understood some things later on when he showed me his inspiration came from hub caps and stuff like that. That was when I realised that you didn't have to look at other shoes for inspiration.

What did the store buyers say?
The buyers were actually pretty stoked, that wasn't the problem. I would say, 'Walter, I think this is really cool but I don't think the

skaters are going to really like it.' Walter didn't believe me. Bill wouldn't believe me either. So I'd bring skaters in and wouldn't say a word. I'd stand aside and they would go straight for the crazy shoe and go, 'That is so awful!'

I remember one shoe that never came out. It had these silicon ovals on the toe area and I just looked at it and remember thinking that if we made this shoe we were fucking doomed. One of the skaters picked it up and goes, 'Does this shoe have a disease? It looks like it has some kind of ringworm?' This scenario happened a few times until I had their complete confidence. I loved a lot of the stuff that Walter did, but I knew that if we put these shoes in the line, skaters would be bummed.

Some of those designs have aged well. Some haven't.
When you look at the shoes now, they're some of the raddest you'll ever see but we weren't used to stuff looking like this back then, so it was shocking. When you look at the 540 or the Velocity models, they were not as bright or as busy and everyone liked them more. The more out-there shoes would've been detrimental to our skate image and that's how I looked at it. But Walter knew what he wanted and he knew his shit. I remember my first trip with him to the factory. I realised you've just got to make sure you're adamant about what you want and if you don't know, you'll come back with crap. He was definitely, definitely, pushing the limits and when I look back and see what other people were doing at that time, he was crazy. He was putting a lot of rubber detailing on there that was not cheap.

Sounds like Bill was actually encouraging you guys to go for it.
Bill was a shoe-dog and his goal was to make the shoes as fucking cheap as possible to be honest. It was the biggest battle with him, but I don't recall him telling Walter to tone things down. Walter was – I'm not sure of the right word – his own man. He would listen to everyone that had an opinion and then he would fix it. I trusted him. My concern was purely whether skateboarders were going to like what he was doing. Bill just wanted to give kids a good quality shoe at a good price.

One thing people love about Airwalk was the sense of humour. Did that originate from you?
I definitely brought that to the company. It just came from being Australian and the way we like to joke around. Not being too

Tony Hawk 540°

gimmicky or acting like a clown, but I thought humour was necessary and if you don't have it, it just gets old. My job was a dream come true. I was picking the American pros to put on our team and paying 'em, which no one else was doing besides Vision. Maybe Vans was, but Vision and Airwalk were the ones that pushed it.

How did Victor Novettipolae come about?
In Australia, we use the word 'vic' as in 'victim' and it became a joke, as in 'fashion victim'. It wasn't super negative. My friend Brad started calling me Vic and I'd call him Vic too. Then I said we should do a new line and Vic became Victor Novettipolae, which in Yugoslavian means 'new shoes'. Not many people got that. So then I had Vic – which was me – in photos doing these crazy tricks. I would bolt the skateboard to the ramp to get the shot. None of the tricks were physically possible, but somehow Vic did 'em! We did one where I rode a boogie board in the half pipe. I put a wetsuit on, put the leash around my wrist and then I put the skateboard down and placed the boogie board perfectly on top with no pads so I couldn't fall. The ad said 'Victor Novettipolae. World-class pool bodyboarder champion'. We put that in a surfing magazine and guys would write in and say, 'Who the hell is this guy? What is this sport? This guy is a kook!' People had no clue. It was an inside joke and everyone was always waiting for the next Vic ad.

Didn't Vic have a fan club?
I think Jamie Meulheusen or Roger Scarbosa in our art department said we should start a fan club (as a joke) with me as the first member. When kids started writing in to get their membership card we ended up dropping the thing because so many people actually wanted to join. It was pretty funny. The biggest problem was that the Vic shoe was horrible. It was really stiff and it hurt. So that was a bummer. Everyone was stoked on everything, but the shoe was crap.

Nice of you to give yourself a signature shoe! [Laughs]
It's not like I got paid for it at all and the thing was, it wasn't about me, it was about the character. Dan Sturt was shooting the photographs and we did a lot of stuff together, so he was instrumental in the campaign. It was fun and people always used to tell me to bring Vic back. But we definitely should have focused a little bit more on the shoe.

I wanted to ask you about the other team riders. Tony Hawk is on board, then you pick up Danny Way, which a lot of people might not remember. Who else did you have?
It was ridiculous! At one time we had pretty much everyone. Obviously I wanted to get Steve Caballero and it was really close at one point. I was scared of talking to Cab – he was ingrained in Vans at that time. The Vision team was pretty locked in and I had respect for all my friends that worked there, like Gator. It didn't really feel right to steal 'em. There were times when I thought about it, but you also don't see a lot of Vision riders that went to Airwalk unless it was a later period. Not that Vision was necessarily cooler, it's just they had so much to offer that we didn't have, like boards and wheels. I don't think Vision would have been stoked on one of their riders wearing Airwalk. I also had a lot of respect for Brad Dorfman who owned Vision, and Eric Meyer, who was their design director.

Do you remember Tony Hawk's first signature shoe for Airwalk?
Yeah. The main thing I remember is that it took us so long to give Tony his shoe that we were afraid of bringing it out because of what everyone would think. We developed it way before Etnies did their first signature model. They say they did it first, and I'm not claiming that they didn't, but we didn't care if we were the first or the second or the eighth, we just cared that the shoe was right.

When did you decide to go into BMX? Base jumping was another area I remember Airwalk was involved in.
BMX was something I never really did but when we went by the dirt track I would always say to myself that when I quit skateboarding, that's what I'm going to do. We were pretty much the first people to sponsor dirt jumping. I don't know what they even call it now; I guess it's basically freestyle. The thing that Bob Haro started was so much cooler because it had more of a resemblance to skateboarding and what they were doing was pretty nuts. I had a lot of respect for those guys.

Kids were riding pools early on, but BMX vert was starting to get popular, so I went to a contest and that's where I met Spike Jonze, Andy Jenkins and Mark Lewman. Those guys were all skateboarders that got into bikes. Then we sponsored Matt Hoffman who was one

AIRWALK

ACTION SPORTS FOOTGEAR

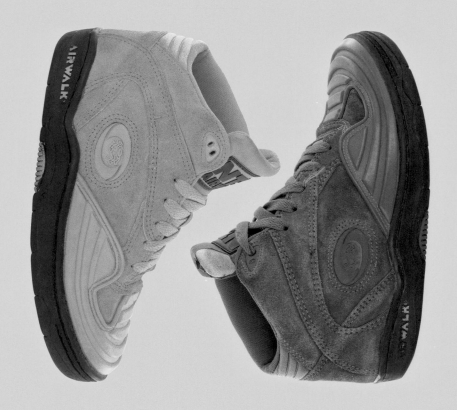

I remember this quote: 'Tony Hawk will never be as popular as Michael Jordan!' We were forced to move the office to Pennsylvania, which was the dumbest idea ever. We starting hiring all these great designers and we're growing fast, then all of a sudden we're in Foot Locker and everywhere, but these new brands start popping up.
All of a sudden, people start talking about Airwalk and asking was it cool anymore? To cut a long story short, basically we only had five shoes that were successful. Foot Locker started thinking that we're not cool and skateboarders started quitting because we're not hardcore and it just started going down.

Sinisa Egelja

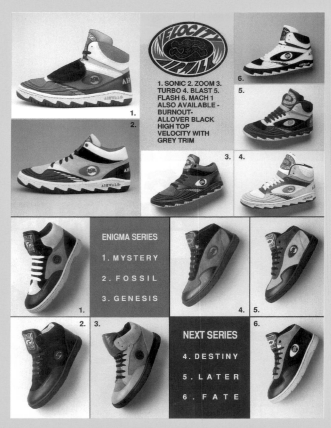

Airwalk Velocity

Donavon Frankenreiter

of the craziest guys. After that I was totally hooked and it became a battle with Vision over who was going to sponsor whom.

Then we got into surfing and bodyboarding. That was a really questionable thing and it was hard for me because I'm a surfer. We were also the first company to get into extreme sports. We took base jumping on like we owned it, because that was something we just thought was really fucking nuts.

Airwalk made a lot of brown suede boots and even weird sandals for surfers.
Yeah, basically the shoe I wore in high school was a ripple-soled desert boot and that's what all the cool people wore. We called them Rollers. They were heavy duty. Basically, we took that concept as our first casual shoe. We made them in Spain and sold millions of them.

How did Airwalk get into snowboots?
On my first trip to Korea, I'm kind of freaked out. I'd never been to Asia and we go to land in Pusan, which was a military and commercial airport. We went to the factory, which happened to be probably the largest factory ever built. It had 100 production lines. Everyone went off to do something and I'm sitting in this room that looked like a prison with a cabinet full of snow boots. So we brought them back to the office and Walter designed the first Airwalk boots for snowboarders. He made them look really different and they were so much better. At one point we were the number one snowboot brand in the world. I know in one year we did 500,000 pairs. We were at the top of that game for a long time.

Did you think of this expansion as the key to the future of the company?
All I was doing was giving suggestions about what I wore in school! Like brothel creepers. I would say to Lenny, 'Let's make creepers because they're really cool, they might come back and this is what I wore!' I always had my reasons for everything. We started doing shoes for women because riders wanted something they could give to their girlfriends or their mums.

So when did things start to go downhill?
We started doing snowboots, then got into apparel and everything was going great. Then there was a restructure that went from this

huge team down to five people which was basically like starting from scratch. When Walter left, our new president, Lee Smith, looks at me and says, 'Can you do this?' I had never designed a shoe because I used to give my ideas to Walter and he'd draw it up. I found a drafting table because I thought that's what I was supposed to do, even though I didn't know where to start. I had no schooling in design except for some art classes. So I looked at Walter's files that he gave me and guessed that if I Xeroxed a bunch of outsoles, I could trace around them. Later on I found out that's pretty much the way most designers worked. Now it's all done on a computer but not in those days.

How long did it take you to get your confidence?
I only had weeks to get the first designs to Korea so there was no choice but to figure it out! I went to the warehouse and picked out everything that people had chucked out that I thought was OK. So I see this girls' shoe left over with this whack sole that was just horrible. I took that pattern and tweaked it, and it became the One Shoe, Airwalk's largest-volume shoe of all time. It sold over seven million pairs! Lee and I figured the gym was pretty popular as well, so we created the Airwalk Jim, another of our more popular shoes. So at the point I started getting a better feel... are you laughing at something in the catalogue?

Just looking at the names: Jim Hendrix, Jim Hoffa, Jim Cricket.
Jim Stewart, Jim Olsen. We named our shoes messed up things, which was funny. I don't want to claim anything because we weren't necessarily the first, but a lot of companies were using numbers or codes at that time. The Jim shoe was rad. I wanted to do a Jim Jones one but everyone's like, 'No Sin, you can't do that!' I remember suggesting we do a tennis version made out of tennis ball material! Then we made a shoe out of basketball material. Then for the soccer shoe, we tried to do a couple of things but it never really turned out, so I basically took the stitching and just put that on a cool pattern. I think the baseball shoe was made out of baseball glove material.

Does your fashion sense explain the multicoloured Airwalks?
Actually that was just a prototype. The design came from a theoretical question where we wondered how many colours we could put on

Barker B

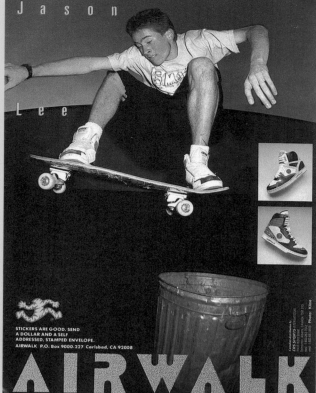

Jason Lee

Airwalk 340°

Airwalk advertising by Lambesis

NEW JIM
BASKETBALL

From its simulated basketball textured uppers to the high top construction, the Jim high truly embodies the game.

Matt Hoffman

Airwalk Arctics

a shoe and if the factory would make it. They did. It was 13 colours which was a little too much but we were stoked. But if you look at it now, like you were saying, it's rad. It's exactly what brands are doing now. We did so many different colourways but none that crazy.

You also had the NTS model, which stood for 'not the same', the idea being that you bought a yellow left foot and a right foot in green.
That was what I was hoping would happen. But the actual idea was that I always wanted to do shoes in one colour on every panel. At that time I don't think everything was right up to speed as far as technology because with all these different materials from suede to PU to rubber to embroidery, it was almost an impossibility to get that right. You could probably do it in sampling, but no factory would be able to make them look good. Everyone in the industry knew how hard it was to do an all-over yellow shoe. And everyone also knew that you cannot sell yellow shoes. It's just fact.

And did it sell?
Yeah, it did pretty well, but the thing that really helped it was the REM guy.

Michael Stipe?
He came to the trade show with some guy who knew about skateboarding. Anyway, he comes up to me and he says, 'Hey, I love your shoes, I want to have a yellow and a green on each foot!' So I brought him both and then I gave the other half pair to my friend. I didn't tell him that's what I wanted people to do. It wasn't like the success of the One or anything, but it did OK.

Airwalk peaked in the mid 90s. That advertising campaign was a huge deal.
That idea actually started when I told Dan Sturt to go dress up the skate and surf pros and get them to play croquet or tennis and make it funny. Dan comes back with these pictures and I was super stoked. Then Lee brings in Chad Farmer from the Lambesis Agency. So we went over the product and he liked where it was going because we weren't just doing skate shoes; it was all this casual and active product with a twist. I showed him the catalogues we had done with Dan and the tennis and croquet stuff plus the saturated images that I had shot. Chad took what we gave him and came up

with what we called the 'Youthful Vigour' campaign. He did a good job. He used that really saturated photography. That's when we did the lipstick girl with the patent leather shoes and the guy with the laces on his head.

Did that have a positive effect?
Oh yeah. The product was king. If the product wasn't right, then the campaign wasn't going to work. It was perfect timing, the shoes were just right on.

The campaign became famous again recently due to Malcolm Gladwell's *Tipping Point*. Does your version of events match the one described in the book?
No comment.

Ah... OK. You obviously had your share of influences but do you feel that some of the stuff that you did was blatantly swiped by other brands?
Oh yeah, for sure. We caught people stealing shoes out of our trade show booth. They had shoes that were identical to Airwalk, basically the One model with their logo on the shoe. Copying is flattery or whatever, but when you work on something so hard, you don't want someone to steal it. I tried to do it as little as I could. What was rad was looking at a company that had nothing to do with footwear and you'd see an idea. I remember one time I was looking at a snowboot with a rad shape so I made a low-top sneaker on a snowboot last. Later I saw this brand with the exact same design. I can't think of the name...

Northwave?
Northwave, yeah! Honestly, I'm sure of this, I know I made that shoe and a couple of people in the office said it's too wide, it's crazy, it's not going to work! So we ended up making it on a narrower last. They may have seen it in our factory. Oh, yeah. Northwave was huge.

By this time Airwalk isn't really a skate brand anymore is it?
Yeah, obviously not. A skate shop's not going to want sandals and we knew that. But we wanted to make all types of shoes. We loved shoes! When we did the Job shoe, that was literally to wear to your job. We knew people would rather wear Airwalk than crappy brown leather shoes.

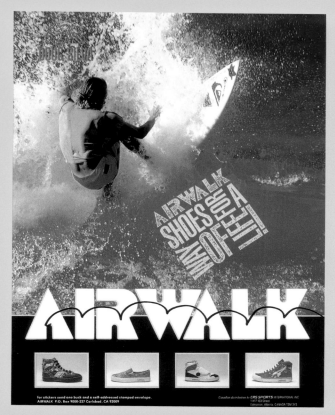

Doug Silva

Danny Kim

Do you have any comment on Airwalk's demise?
Greed, coffee and a man who hated skateboarding and action sports. Management wanted to turn Airwalk into a stale brown shoe company. I remember this quote: 'Tony Hawk will never be as popular as Michael Jordan!' We were forced to move the office to Pennsylvania, which was the dumbest idea ever. We starting hiring all these great designers and we're growing fast, then all of a sudden we're in Foot Locker and everywhere, but these new brands start popping up. All of a sudden, people start talking about Airwalk and asking was it cool anymore? To cut a long story short, basically we only had five shoes that were successful. Foot Locker started thinking that we're not cool and skateboarders started quitting because we're not hardcore and it just started going down. The other skate shoe companies were leveraging their way in through our mistakes.

Sounds like a death spiral.
Yeah, and a lot of things were starting to get weird. Everyone was in panic mode and a rumour started that they wanted to sell the brand. That was probably the worst time in my life, you know, it was just hard because you could see what was going to happen. I said to people we need to push this line forward, but even if we did push, you know, would it have mattered? Maybe. But when you know something's going to happen and it does, you can't really say 'I told you so.' It doesn't really fix the problem. I learned that the hard way.

You obviously left at some point.
Well, they sold the company. I left soon after the new management arrived.

You were there for 16 years.
Yeah.

How did you feel?
It was like someone in my family died, maybe like I had died as well. I was devastated. I couldn't sleep. It was really hard because I was part of building something and then someone destroyed it. Lee was fired and that was really hard for me. He was a real president. He didn't do anything wrong. He was trying to fix things and he was battling on with his feet and hands tied.

Are you able to think fondly of the good times and forget about bad times?
Yeah, it took a long time to get over the nightmare at the end. When you're hanging on only because you think that they're going to sell, I felt bad about that, but I shouldn't have worried. I should have left much earlier, but you want to believe in people. I had faith, even though I made a lot of mistakes because of that faith. I get excited thinking about all the good times, the people and how it was fun making the shoes as a team. I was allowed to make anything I wanted. I've never known anyone that's had as much freedom, which in itself is enough to make me happy.

How do you feel about the skate industry now? It's pretty bland compared to your era.
Yeah, maybe they're all afraid to do something different and get called out, because if you look at the product, you kind of know where it came from. But is that bad? It's not like someone really needs to reinvent the skate shoe. Maybe that's what skateboarding has to be. It's not like they're not innovative or creative. I think that they have to evolve themselves to be what skateboarding wants and that's what they're doing.

Maybe it's just nostalgia, but when I look back at Airwalk and Vision in the 80s, there's so much fun and optimism. It's so fucking serious now.
Yeah. It was a time when a lot of skaters were wearing whatever crazy stuff they wanted. I mean, look at Vision. I'm not going to go wear MC Hammer pants and a fanny pack now, but there was a short time when Gonz and Mike Vallely – icons of skateboarding – wore stuff like that. Gonz was riding for 'Life's a Beach', he wore these crazy prints like the Jetsons. That whole era didn't last for long; it changed so fast. To me it seemed that people wore what they really wanted to and didn't care what other pros thought of them. Now it seems like the uniform is determined by a few, stays a lot longer and looks a lot tamer.
•

Vision Street Wear

Published in *Sneaker Freaker* Issue 19, August 2010

EDITOR'S NOTE: WOODY

Vision Street Wear has to be the ultimate example of the boom'n'bust cycle endemic to the skate industry. Founded by Brad Dorfman in the late 70s as Vision Sports, it wasn't until 1986 that Vision Street Wear was incorporated to focus on skateboarding. With a famous stacked logo by Greg Evans and Eric Meyer's street-level design vision, Vision exploded like a hand grenade. Sales went from nowhere to a swashbuckling $100 million before the brand imploded into bankruptcy a few years later. Though their skate shoes never developed to their full potential, the graphically overloaded Vision vibe was hugely influential, as Eric Meyer's brilliant interview reveals. Less sometimes is more, but in the case of Vision, too much was never enough.

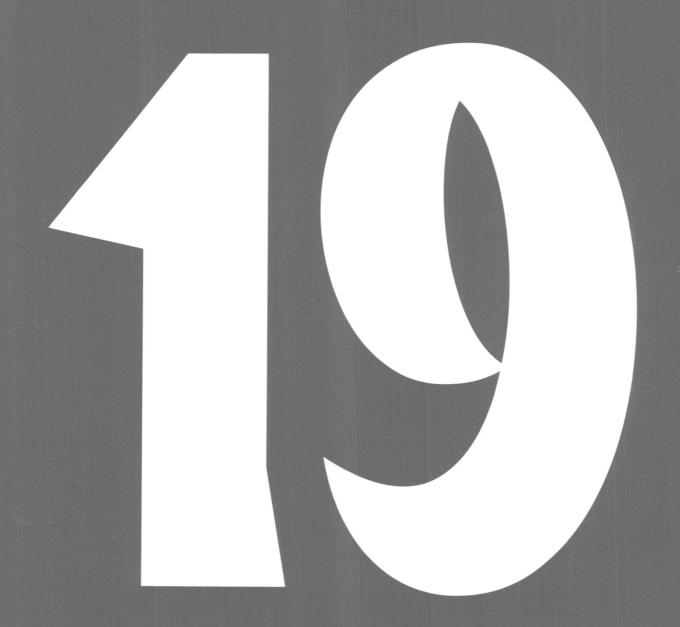

IT'S EASY TO LOOK BACK WITH A SMIRK AT THRIVING SUB-
CULTURES IN THE 80s, PARTICULARLY THE OSTENTATIOUS
SKATE SCENE. AND FEW BRANDS EPITOMISED THE DECADE'S
OVERBLOWN DAY-GLO AESTHETIC QUITE LIKE VISION STREET
WEAR. ARMED WITH AN INGENIOUSLY SIMPLE LOGO,
VISION STORMED SKATE PARKS AND MALLS THE WORLD
OVER, USHERING IN A SHORT-LIVED ERA WHERE SKATERS
LIVED LARGE AND LOOKED LIKE ROCK STARS. THE BRAND'S
ULTIMATELY DOOMED STORY IS A FABULOUS TALE OF LUST,
GREED, CREATIVE MAYHEM AND WILDLY EXPONENTIAL
GROWTH. IT'S ALSO A BRUTAL CORPORATE LESSON THAT
WAS EQUALLY APPLICABLE OVER AT AIRWALK AND STARTER.
WHAT GOES UP MUST COME DOWN, AND IN VISION'S CASE,
THE LANDING WAS A BITCH.

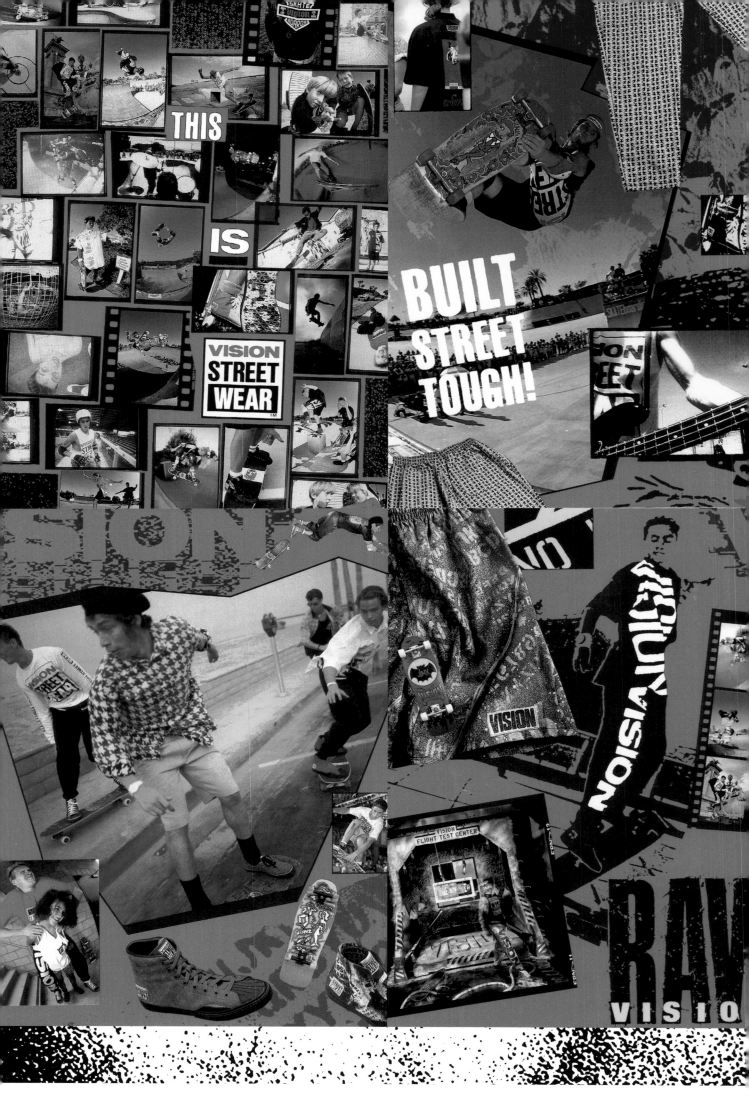

THIS IS

BUILT STREET TOUGH!

VISION STREET WEAR ™

Photo: Made for Skate

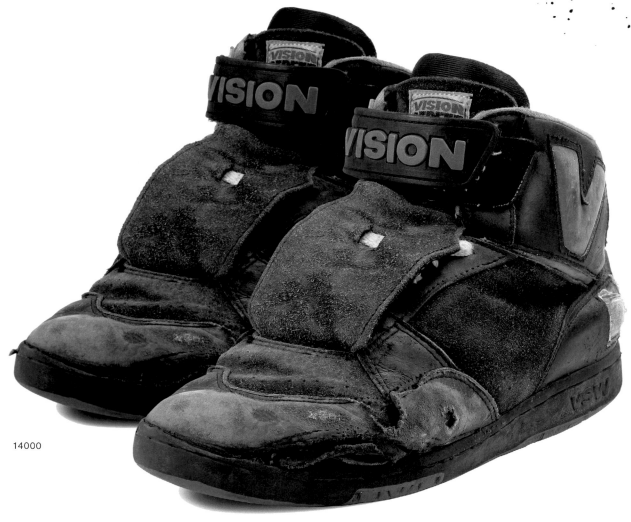

14000

CALIFORNIA GARAGE

Our story begins in the mid 1970s – like all good brand histories softened for the purposes of myth making – in a California garage. Lou Ann Lee and brother Louis 'Brad' Dorfman started out making padded shorts for skaters. Over the next decade the company evolved into an action sports powerhouse, generating more than its fair share of iconic imagery, not to mention some respectable footwear.

While Shawn Stussy's surf-centric approach might have pre-empted the christening of Vision Street Wear, Dorfman's wild hunch about the skate lifestyle's potential proved prescient. He assembled a posse of talented designers who developed a seminal visual sense of the Skate Lifestyle™, one that for a few years managed to be seen as totally rad without triggering fear in soccer moms. Dorfman was already a man who knew the value of a craze. His single-minded drive and gigantic ambition enabled him to gamble his gut instincts into a $90 million company by the close of the decade.

OBNOXIOUS

The first classic Vision graphics rolled off the production line in 1982. Rippers, Shredders and Animal Skins – obnoxious imagery that rode a burgeoning zeitgeist with a cock-sure confidence – conferred an aesthetic on the world that reeked of Vision.

Kids around the world clocking ads in magazines would marvel at the self-assured statement that the brand offered. Skulls, Psycho Sticks, punk bands and a young oddball by the name of Mark Gonzales typified the brand's renegade outlook.

Beyond that, the kaleidoscope swirl of Rogowski's 'Gator' model dominated the era. From 1984 to 1988, the shape would change, but the song remained the same. Rogowski was notoriously cocky. A certified asshole, he was a poster-boy for the brash new player and success was instantaneous. Gator's debut deck sales hit 45,000 units. The grisly end to Gator's story – which includes being convicted in 1991 for the horrific rape and murder of 21-year-old Jessica Bergsten – is best told by Helen Stickler in her brilliant documentary *Stoked: The Rise and Fall of Gator*.

While there's little point attempting to argue that Vision 'created' streetwear, they certainly were the first to throw the label around – literally and liberally. Vision was also one of the first brands to infiltrate the sweet spot between music and action sports, creating events such as the Vision Skate Escape featuring Tony Hawk, Christian Hosoi and the Red Hot Chili Peppers. The musical link was further enhanced when a Vision deck somewhat incongruously featured dead centre on the cover of INXS's multiplatinum-selling album *Kick*.

Photo: Made for Skate

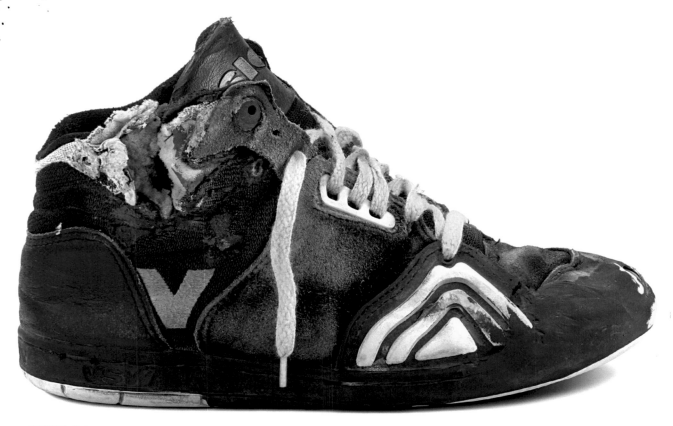

18050 'Nylite'

THE LOGO

The Vision Street Wear box logo by Greg Evans is, at first glance, a seemingly innocuous piece of design. According to legend, the triple deck of type was intended for use as a t-shirt label. Dorfman wasn't exactly smitten, but Evans made a few minor changes using old-fashioned Letraset and the logo was duly approved. Through a remarkable series of serendipitous events, Vision's logo then proceeded to launch on an orbit so steep it caused vertigo. In today's terms, it would be deemed a viral success, spawning multiple parodies such as Victim Street Wear. Unfortunately for Dorfman, it was also one of the first logo designs to be methodically bootlegged on an international scale.

Emboldened by seemingly insatiable appetites, the VSW logo literally grew in size and stature as both its meaning and exposure were amplified beyond 11. Obnoxiously loud attire suddenly became a licence to ill. There'd always been matching shirts for key graphics, but no doubt about it, Vision Street Wear was a money-making machine. Half-and-half coloured shirts, oversized tees, pants, fanny packs – even berets 'Built street tough and tested street tough!' – were finished with the mysterious 'Thrash-washed and dyed' process, becoming serious objects of desire in the process.

THEY WORK FOR ME!

Vision's footwear chapter is relatively brief but tinged with moments of genius. Strangely, the overwhelming memory of Vision shoes is more basic than their clothing – simple canvas colours with VSW slapped on the heel – presumably the logo was all that was required to sell such standard fare. As Gonzales scrawled across the advertising: 'They work for me!'

As Airwalk entered the market, bringing an element of tech to the scene with their armada of beefy foot covers, Vision took the one-upmanship seriously. They launched the DV8, DV9 and 18000 models, as well as the 18051. Street skating was evolving to a McRad soundtrack and Vision seemed flexible in every direction.

The aforementioned DV8 model, with its tricked-out air of the perennially appropriated Jordan I (as worn by Lance Mountain and Gonzales among many others), plus other models with customisable options and lace guards, seemed genuinely serious attempts. Custom make-ups for team riders like Duane Peters let the graphic pattern spill all over the shoe.

Noisy kids with brattish attitudes were one thing, but when the legendary Ray Barbee made the Vision Suede Hi in black/white look good in Powell's *Ban This* and *Public Domain*, it afforded extra credibility. Most famously, the Suede and Canvas Hi models carried the Vision 'Ollie Pad', which was submitted for patent in 1987 and credited to Louis B. Dorfman. As a side note, one-time Vision rider Pierre André Senizergues later founded Etnies – check the ollie patch on Pierre's original model!

Dorfman seemed to have both the Midas touch and a golden eye, but his knack for spotting creative talent might be his enduring legacy. Hiring designers like Greg Evans, Eric Meyer, John Grigley, Andy Takakjian and Tom West created a crack team at a time when the Xerox was considered a technological tour de force. Signing skaters like Gonz who could handle a Sharpie also paid dividends. Indeed, a quick look at the companies founded by ex-Vision employees makes for a dynamic list: Etnies, Simple, Split, Lucero, Blind – even a young Steve Rocco was inspired to start World Industries after being terminated at Sims, a subdivision of Vision. A few years later, Rocco would have the last laugh as Vision lost sight of their own relevance, but that's also another story.

BASICS™ CLOTHING IS IN THE HERE & NOW. ITS REALISTIC... ITS GOOD FABRIC, GOOD VALUE & NO BULL. WE'VE WORKED VERY HARD TO BE ABLE TO CREATE AN AMERICAN MADE FUNCTIONAL PRODUCT AT A SAVINGS OF 20 - 40 PERCENT BELOW OUR COMPETITION. WE HOPE THESE LOWER PRICES ENABLE YOU TO MAKE A SALE THAT YOU OTHERWISE MIGHT MISS. YOU RETAIL GUYS ARE ON THE FRONT LINES & YOU KNOW WHAT'S WANTED... SO WE'VE BEEN TRYIN' OUR BEST TO HEAR YOU. HOPEFULLY WE'RE ACCOMPLISHING WHAT YOU NEED... KEEP TALKING.

BASICS™ IS FOR THE GRASS ROOTS SHOPS WHO KNOW WHAT'S HAPPENNING... NOT FOR THE BIG GUYS... THEY DON'T HAVE A CLUE... WE'VE SENT YOU THIS CATALOG 'CAUSE YOU'RE AT THE LEADING EDGE & YOUR CUSTOMERS COME TO YOU FOR THE FRESHEST STUFF...

WITH BASICS™ WE HOPE TO RE-GAIN YOUR TRUST & INCREASE YOUR SALES.
THANKS
US AT VISION

(9)

catalog #3 HOLIDAY '91

THER SHORTS

SPENT 6 YEARS IN COLLEGE STUDYING GRAPHIC DESIGN... CAN YOU TELL?

NEW VISION® UNDERWEAR STYLE #00000

JUST KIDDING

THRIFTSHORTS STYLE #MHG3565 $12⁷⁵

LIGHTER WIEGHT PLAIDS & SMALL PRINTS PSUEDO GOODWILL - SORTA SALVATION ARMY --- BUT YOU'LL NEVER FIND THEM THIS COOL. FULL ELASTIC WAIST - THICKER THAN "THE GAP" BUT THINNER THAN THESE.
S, M, L, XL

KNEE LENGTH

BURLIES STYLE #MHG3561 $13⁷⁵

SAME TYPE OF PRINTS & SMALL PLAIDS AS THE THRIFTSHORTS BUT IN HEAVIER FABRICS - FULL ELASTIC WAIST... CHAIN LOOP - HARD TO KEEP THESE IN STOCK CAUSE EVERYONE BUYS 'EM
S, M, L, XL

LONG LENGTH

SOLIDS STYLE #MHG3500 $12⁷⁵

WE'VE GOT THESE BABIES DOWN TO A SCIENCE! BIG POCKETS... CHAIN LOOP... ONLY THE BEST TWILL COLORS FULL ELASTIC WAIST... EASY IN/EASY OUT YER MOM WILL NEVER CATCH YOU!
S, M, L, XL

LONG LENGTH

Hip Pack Plaids STYLE # AS 80009

WE TAKE THE SAME PLAID FLANNELS AS OUR SHORTS & PANTS... THEN SEW ON THICK SUEDE EMBOSSED BASICS PATCH! $5⁰⁰ each

(6)

SHIRTS

● **BASEBALL JERSEY** STYLE #MRG0620 $19⁰⁰

LIGHTWIEGHT PINSTRIPE TWILL. VISION BASEBALL LOGO ON FRONT & BACK - WHITE WITH SUPER DARK BLUE PIN STRIPES & BLACK & GREY LOGOS - THE RIGHT LOOK - THE RIGHT FABRIC - THESE LOOK TRULY AUTHENTIC. M, L, XL

● **LOGO·A·NO·NO** STYLE #MNG6020 $9⁰⁰

ASSORTED COLOR (ALL COOL) T-SHIRTS WITH 1"x1" EMBROIDERY THAT SAYS NOTHING - NO SLOGAN... NO LOGO... JUST ART. S/S 100% COTTON S, M, L, XL
BY SAYING NOTHING YOU SAY EVERYTHING - THESE MOVE!

CURVY HOODED PULLOVERS

TWO STYLES: ① WITH CHEST PRINT
FLEECE 80% - 20% STYLE #MF41102
COTTON/POLY ② WITH SLEEVE PRINT
STYLE #MF48650 $16⁸⁰ SALE!
XS, S, M, L, XL
A VISION CLASSIC STAPLE

● **HOODED S/S T-SHIRT** $15⁵⁰

WE HAVE A LIMITED SUPPLY OF THESE HOODED TEE'S.
OVERDYED INTO COOL COLORS WITH STYLE #MNG5010
TINY EMBROIDERY LIKE THE
LOGO-A-NO-NO S, M, L, XL

● **LONG SLEEVE STRIPE LOGO-A-NO-NO**

YARN DYED STRIPE 100% COTTON JERSEY SHIRTS OVERDYED INTO COOL NEW COLORS $18⁰⁰
& EMBROIDERED WITH "ART" ONLY STYLE #MNG6621
M, L, XL

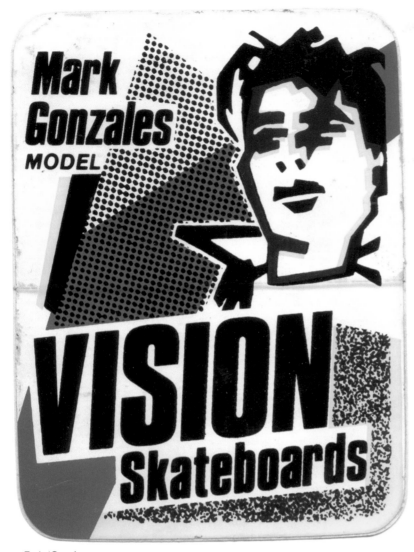

Early 'Gonz' promo

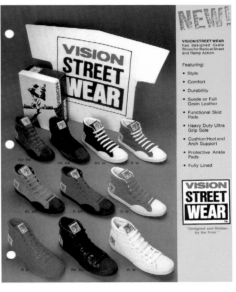

1987: INXS *Kick*

Vision was 'Designed and Ridden by the Pros'

REBEL YELL

It's almost quaint that a small shoulder tattoo could seem like a rebel yell during Vision's heyday, and the scene was, at least in those distorted early video copies, all high fives, headbands and power chords! Alas, even good things must end. Change is incremental, and in this case, a new era ushered in an evolution for skateboarding. By 1988 the Beastie Boys and the Cure had decks, and even Freddy Krueger had his own plank.

Things had gone too far, but Vision Street Wear was still shifting units. The definitive paean to the skate excesses of the late 1980s, *Gleaming the Cube* (in which Rogowski was a stunt double) incorporates plenty of Vision gear. The logo is also prominent in the fondly remembered 1989 flick *The Wizard*, which was sponsored by Nintendo.

To watch a flailing Gator trying to street skate in *Stoked* exemplified the downturn for Vision. As his career faltered, it was a cruel irony that – regardless of the exploits of Barbee and company – Vision Street Wear had placed all their chips on what suddenly seemed like yesterday's news. H-Street's seminal skate video, *Hokus Pokus*, broke barriers and life was suddenly less dependent on the Day-Glo aesthetic. Pared-down footwear like Vans Chukkas appeared and it immediately felt like a progressive passing of the style baton.

The same year, Mark Gonzales started Blind (a defiant dig at the name Vision) and their first VHS effort known as *Video Days* was a definitive statement of a Vision-free version of the next decade. Pushed aside by skaters in favour of a new breed, Vision was a victim of its own superlative superstardom.

Quality had never been an issue and the designs remain seared on the retinas of anyone who had even the faintest interest in skating or street culture, but Vision was left staggering and punch drunk at street level. Having grown to something like 800 staff fuelled

by year-on-year double-digit growth, amid a mixture of lost favour and general industry downturn, Vision's decline into bankruptcy was as rapid as its ascent to the summit.

BURN OUT

They say it is better to burn out than fade away and perhaps that is true for the legend of Vision Street Wear. Whether it was the logo blazed across chests or in the case of the footwear, a patented ollie pad, Vision Street Wear defined their decade, and in doing so created an intense corporate cult of personality, the likes of which may never be seen again. Lay it at the feet of Gen Y or put it down to an avalanche of hand-held digital distractions, but it seems inconceivable that today's tweens 'n teens will ever experience such zealous feelings of hormonal camaraderie towards a skate brand.

All of this makes for a pointed comparison with today's ultra-conservative scene, in which matter-of-fact khakis, check shirts and black canvas footwear rule. Vision's preoccupation with lurid excess followed by self-immolation precedes the outbreak of garish post-BAPE clothing by 20 years. It's also interesting to note in our interview with Vision designer Eric Meyer that he was working on a range of muted tees and sweats called Vision Basics right as the company went up in smoke. Eric's next move was to found his own successful footwear company with the startlingly symbolic name of Simple. Beige is king once again and it feels like 1991 all over again!

•

ERIC MEYER

DIRECTOR OF DESIGN

ERIC MEYER WAS EMPLOYEE NUMBER 001 AT VISION STREET WEAR. ODDLY ENOUGH, HE GOT HIS START AFTER WRITING A LETTER TO BRAD DORFMAN, BOLDLY PUTTING FORWARD HIS OWN 'VISION' FOR THE SKATE COMPANY. AS DIRECTOR OF DESIGN, MEYER WAS INSTRUMENTAL IN CRAFTING THE BRAND'S SIGNATURE APPAREL AND FOOTWEAR MODELS.

1711 WHITTIER AVE., DEPT. E17, COSTA MESA, CA 92627 (714) 645-2644

LET'S GO BACK TO THE 1980s. PRIOR TO THE LAUNCH OF VISION STREET WEAR, WHAT SORT OF FASHION IMAGE WAS THE SKATE INDUSTRY PROJECTING?

Skate style didn't really exist as a fashion statement yet. It was totally a hardgoods business back then, which meant boards and wheels and trucks. T-shirts were primarily marketing devices for the hardgoods! Skate style was team-related, so when you were at a contest you dressed in your team's colours – your Vans matched your team shirt and your athletic socks and helmet. This was different to how skaters dressed on the street, where you just wore a scrappy t-shirt and maybe a bandanna around your neck with shorts like Ocean Pacific or Gotcha, or maybe a Stüssy sweatshirt or Schroff. Unless kids had a board company tee, there was no identity for the skater group outside of brand logos. There was no definitive skate 'style' because with punk and new wave, skaters were buying a lot of clothing in thrift stores, like old man tweeds and herringbone suit pants, which we cut off to make long shorts.

HOW DID YOU COME TO WORK AT VISION?

I studied graphic design and architecture in college. I still skated and knew there was a hole in the market for skate clothing. Stüssy was getting huge with a combo of NYC and California style, although it wasn't really surf-based. Schroff and Bash had fallen off the planet. At this time, Vision made shorts with pads in them for your hips and butt, which were really stupid and puffy. They were called Madrats and were the first true skateboard shorts I know of, other than some Hobie stuff in the early 70s. Madrats were dumb but I knew there was an idea there, so I went down to Orange County to see if there was any room at Vision for me. This was 1986 or so.

WHAT HAPPENED WHEN YOU GOT THERE?

Well there was no job right away, but I saw they were making Vision shoes just like Converse high-tops, but with an ollie pad on the side so the grip tape wouldn't wear out your canvas. They also had some Shelltoe-inspired high-tops with the same ollie pad. The Vision Street Wear logo had just been drawn up by Greg Evans and they had some pink and yellow and baby blue shirts. I flipped out when I saw that stuff and wrote Brad Dorfman a long letter on my typewriter in the back of my VW bus. I told him to get away from the surf style and look at the street! He didn't respond so I took a job working for a vacuum cleaner company. One day I got a call from Brad telling me I had the job. I told him I was already employed and he laughed. I lied about my salary a bit and he offered me more to come work for him at Vision! I told him I didn't know anything about pattern making or sewing and he said what he needed were the ideas. So that was that. Vision Street Wear officially separated from Vision Sports and I was employee number one.

WHAT WAS THE STARTING POINT FOR VSW?

What we really needed was to show all the kids who weren't hardcore skaters how to look like a skater! It couldn't be too dark or hardcore, so we softened it enough that 'mom' wouldn't be afraid and she would throw down cash to make her kid happy. Simultaneously, the demographics were kicking in big time. We gave this huge group of instant teenagers exactly what they wanted: baggy clothes you could skate in. Supergraphic logos were coming in then and although I hated that stuff, it was super popular.

Brad Dorfman,

To advertise StreetWear effectively you need to express through your advertising the lifestyle that the pseudo skater wants to live. The ideal ad would be a photo journal of the life that StreetWear wearers live. Photos of skating in alleys and abandoned industrial areas, ramp photos, ditch and empty pool photos, as well as crowd shots and photos with beautiful skate bettys. Your customer wants to be or is a skater. He wants to be known as someone who lives the rad skater's life. In your advertising you need to heavily focus on this lifestyle.

~~A grouping of photos would be your best bet.~~ Look at Ralph Lauren... he uses five or six full page ads in a row to express the young and wealthy lifestyle of "Polo" wearers. In Banana Republic's advertising there are many small illustrations and safari photos along with the garmet giving the overall impression of the African safari lifestyle.

With Vision StreetWear it is not so much the clothing that the kids are after, it is the relationship of the clothing to the skate lifestyle. You need to show that lifestyle being lived in StreetWear clothing.

The kid needs to think:

"StreetWear is worn by rad skaters-
When I buy StreetWear I'll look like a rad skater."

If the cut of the clothing follows somewhat along the lines of the surfwear industry... If the patterns of the fabrics are somewhat consistant with the textures and colors seen in Thrasher and Transworld... And if the advertising hits on the relationship between StreetWear and rad skating...

I think StreetWear will be very successfull.

340

I SAW THEY WERE MAKING VISION SHOES JUST LIKE CONVERSE HIGH-TOPS, BUT WITH AN OLLIE PAD ON THE SIDE SO THE GRIP TAPE WOULDN'T WEAR OUT YOUR CANVAS. THE VISION STREET WEAR LOGO HAD JUST BEEN DRAWN UP BY GREG EVANS AND THEY HAD SOME PINK AND YELLOW AND BABY BLUE SHIRTS. I FLIPPED OUT WHEN I SAW THAT STUFF AND WROTE BRAD DORFMAN A LONG LETTER ON MY TYPEWRITER IN THE BACK OF MY VW BUS. I TOLD HIM TO GET AWAY FROM THE SURF STYLE AND LOOK AT THE STREET!

ERIC MEYER

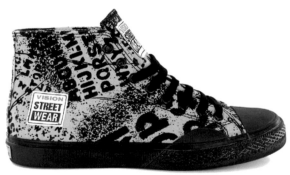

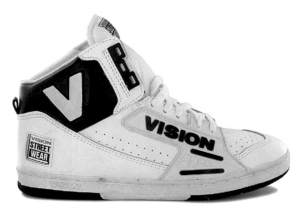

Photo: Made for Skate

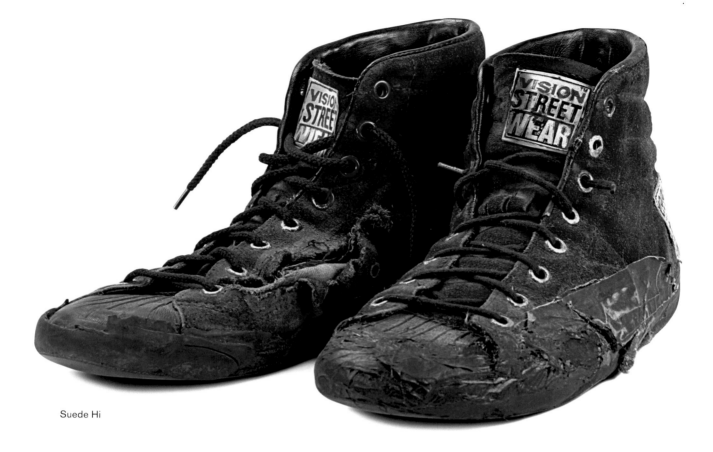

Suede Hi

IT WAS OBVIOUSLY A FREEWHEELING SETUP.

Brad Dorfman is one of the most creative entrepreneurs I have ever met. He just had amazing guts to go in directions nobody had ever thought of. He would meet some kid and see their art and just bring them into the fold. I learned from him to not be afraid of the edges of society. We would go find tattoo artists, graffiti artists and edgy musicians and ask them to create designs. Vision had a huge team and guys like John Grigley, Marty Jimenez and Mark Gonzales were fantastic artists as well as excellent skaters.

HOW QUICKLY DID IT TAKE OFF?

In the beginning we found a niche that needed filling. Skateboard fashion as a specific style had never existed prior to Vision Street Wear, so we really had the tiger by the tail. Brad managed to leverage and finance it all and whip everyone into a frenzy with his energy. This gave us a huge head start on everyone who wanted to try and claim skate fashion.

We basically *were* skateboard fashion and we were growing radically. Ten times growth annually. We would just add zeros onto the previous orders for things when they sold out. We would order 4000 pairs of shoes, then 40,000 pairs, then 400,000 pairs.

THAT KIND OF GROWTH USUALLY ENDS IN TEARS.

Well it's funny you should say that. At the time I felt that we should be focusing on the smaller shops, which would mean abandoning the major stores, which is fine in theory, but the cash needs of the company simply couldn't afford this luxury. I didn't really agree with the massive growth or with the massive logo identification,

but the logo was fuelling the growth and the growth is what paid our salaries. Kind of a mutual addiction, I suppose. I was killing myself trying to get everything done. We had hundreds and hundreds of products. We had our own advertising agency, a production sewing shop, silkscreen shop, wood shop and huge warehouses. It was a massive organisation. Each of these entities grew fantastically fast as the skateboarding demographic hit the steep climb of the bell curve.

Then we took on the license for MTV Clothing. In hindsight, MTV was one of the straws that broke the camel's back. It just overstretched the brains trust to have to develop so much product and marketing for so many entities.

HOW DOES A BRAND GO FROM BEING TOTALLY COOL TO TOTALLY UNCOOL? IS IT JUST A BYPRODUCT OF BEING TOO BIG?

Skaters as a whole like to be individualists. So while we at VSW had all the alpha skaters in the beginning, we slowly lost them, one by one. They started other brands or left for smaller companies.

SOUNDS LIKE YOU WERE UNDER SERIOUS PRESSURE?

In early 1990 I reached a boiling point and quit. I kept in touch with Brad and eventually he hired me back in mid 1991 and we built a small sub-brand called Vision Basics. Great idea, but in the end he had to let me go because all his money was stuck in the warehouse in the shoes that nobody wanted! The idea of Basics was something that I felt was next – it was a reaction to the 1980s excess, personified by Reaganomics and the birth of yuppies.

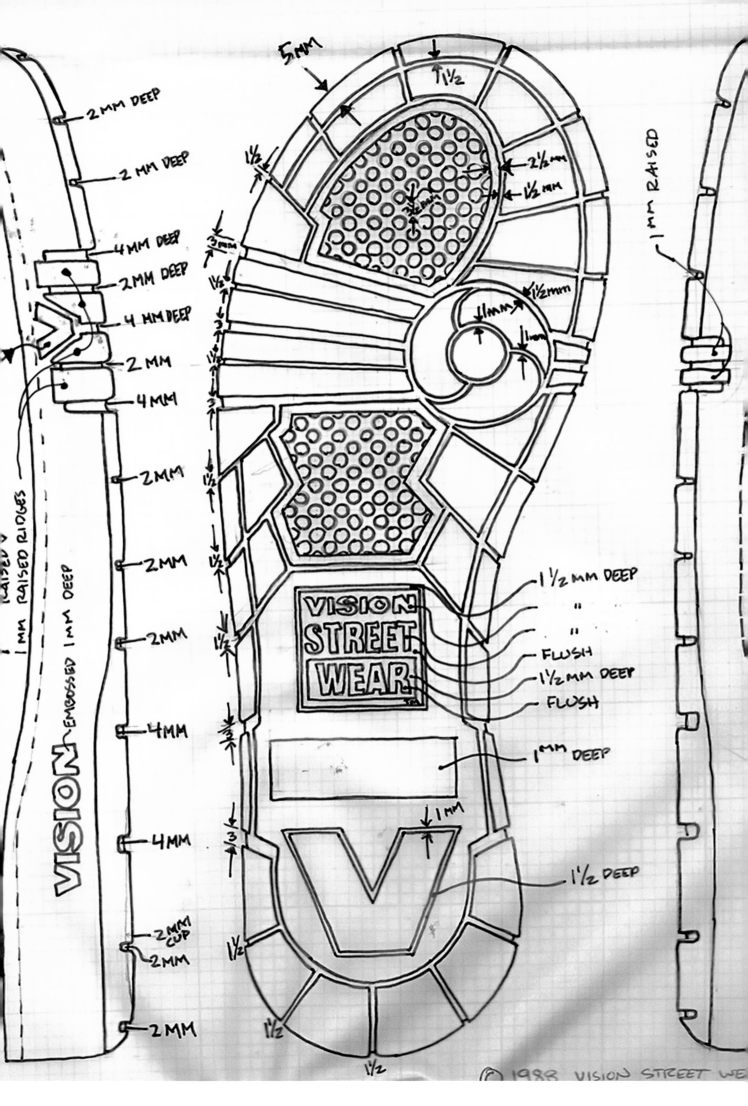

2 MM DEEP

2 MM DEEP

4 MM DEEP

2 MM DEEP

4 MM DEEP

2 MM

4 MM

2MM

2MM

2MM

4MM

4MM

2 MM CUP

2MM

2MM

RAISED V
1MM RAISED RIDGES

VISION EMBOSSED 1MM DEEP

5MM

1½

1½

1½

3

1½

3

1½

1½

1½

1½

3

3

1½

1½

1½

2½mm

1½MM

1½mm

1mm

1mm

2mm

VISION
STREET.
WEAR.

1 MM

1½ MM DEEP

"

"

FLUSH

1½ MM DEEP

FLUSH

1 MM DEEP

1½ DEEP

1 MM RAISED

© 1988 VISION STREET WE

VISION 18050

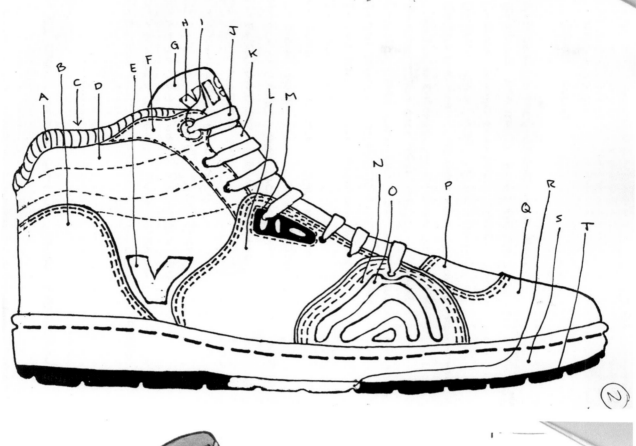

VISION 18050 "BROWN"

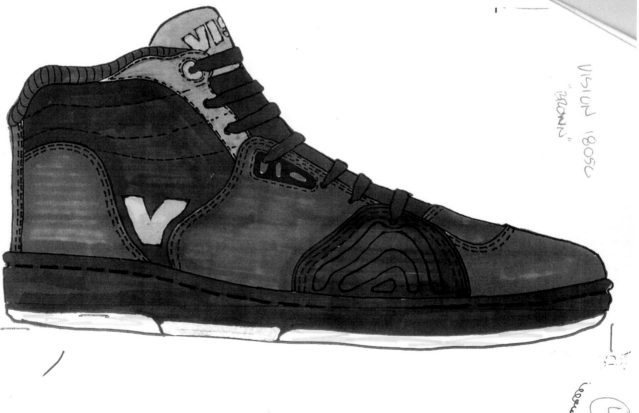

Above: These design sketches show how basic the industry was back in Vision's era.
Just draw the outline of the shoe, colour it in and send it to the factory!

Left: Eric's original sole design drawing for the DV9 is from 1988. The model was later renamed
the 15000 as Vision had an incredible 1000 different style codes in their product system.

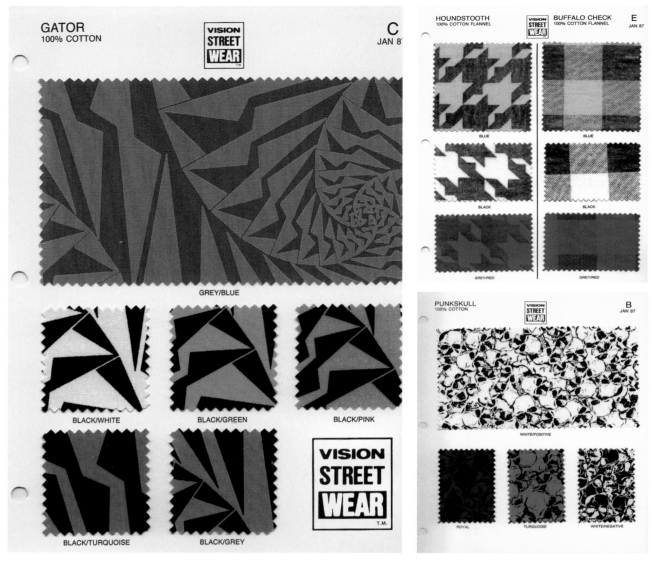

Vision fabric swatches

FOR ALL THE DRAMA THERE MUST HAVE BEEN SOME GOOD TIMES TOO.

We were all skaters for the most part and there was a lot of competition to push the limit, especially with the graphics. We were trying new things, destroying images and typography. David Carson from *Ray Gun* magazine gets a lot of credit for this, as well as Neville Brody in the UK who designed *The Face*. But skateboarding, I think, really pioneered this type of look, and Vision was right in there.

John Grigley, Greg Evans, Marty Jimenez – none of these guys got much credit, but together they pushed the limits and the art of action sports was partially redirected by them away from fluffy-smiley-happy surf photos. Street skating was taking over where Freestyle had left off, just as Vert was losing its dominance.

THE SKATE TEAM MUST HAVE BEEN A HIGHLIGHT?

To have Mark 'Gator' Rogowski, Mark Gonzales, John Grigley and Ken Park screwing around in a ditch somewhere and see all the locals just totally in awe, well, it was crazy. I remember one time Gonz was sitting in my van and there were a ton of local kids street skating. We were at a really long raised kerb, about 150 feet long. Mark had never been to this place before and nobody really knew he was even there. So out he pops and skates way down the street, then he turned around and started pushing as fast as he could toward the kerb. It was totally waxed and smooth and he was weaving around parked cars and cutting on and off the sidewalk, and then he hops 50/50 onto the very beginning of the kerb at full speed. He slid the entire length, hops off at the end with nary a look around and goes back to my van. That was one of the funniest moments

I can remember in skateboarding. There were about 15 local kids just sitting there with stupid expressions on their faces. Nobody had ever done that before! Mark was a hero for these kids and he just blew their minds without even blinking.

WHERE DID THE INSPIRATION COME FROM FOR THE GRAPHICS? SOME OF THE WORK STILL STANDS THE TEST OF TIME.

I got inspiration from the strangest places. One day I found a white VSW logo t-shirt in a mud puddle in the parking lot. It had been there for a week or two and was totally greasy and muddy with tyre prints on it. It looked pretty cool all scungy so I went looking for a place that did dye treatments. We ultimately had to take black shirts and tie them up in knots and bleach them. Then we would hang them on clotheslines and spray them with diluted bleach to create a splatter. In the end they would look really horrible but totally cool! So then we would silkscreen the VSW logo on them. They sold like crazy! We ended up making shorts, pants and shirts in this way. It was huge! All from a shirt in a pothole in a parking lot. We called it 'Thrashdyed' and each garment had a tag that said 'Don't wash this with anything else or that will get thrashed too!'

VISION LET YOU GO WHEN THEY OUTSOURCED THEIR CREATIVE DEPARTMENT.

I got laid off on Friday December 13, 1991. Adding up the dramatic growth, the switch from core skate shops to department stores, the dilution of the VSW brand, the diversification into MTV and other licensees, the slow loss of our pro skaters and key employees,

NEW VSW HIGH TECH SHOES

DV8

- Molded Shell Sole
- Padded Collar
- Molded Ankle Strap
- Leather and Suede Construction
- Molded High Impact Insole
- New In or Out Lace Saver

DV8 SHOWN WITH
LACE SAVER OUT

DV9

- Molded Shell Sole
- Padded Collar
- Leather and Suede Construction
- Molded High Impact Insole
- New In or Out Lace Saver

DV9 SHOWN WITH
LACE SAVER IN

VISION.

Lace Saver Patent Pending
Unique design may be worn in for normal
fashion wear or out for function while skating.

FUNCTION AND FASHION

VISION STREET WEAR INC., 1395 SOUTH LYON ST., SANTA ANA, CA 92705
SALES OFFICES: **(800) 854-7370** (ORDERS ONLY PLEASE)
DIRECT FAX LINE: **(714) 972-2181**
CORPORATE OFFICES: **(714) 972-1044**

3
SEPT 88

DV8 and DV9 showing the optional 'lace saver'

Vision's range for women = No Fuzz Perms!

the huge inventory of shoes, huge overheads, the oversaturation of our brand and logo... it was just too much. I would say that this abandonment started in 1988 and was in full swing with the secondary 'beta consumers' by 1990. Vision was simply too big to be a cool skateboard company anymore. Nothing was going to change it.

YOU WENT ON TO START THE CLASSIC SHOE BRAND, SIMPLE. IT SEEMS LIKE YOU FLIPPED TO THE POLAR OPPOSITE OF THE BRASH VISION LOOK.

After I left Vision for the second time I started Simple. Shoes are way easier to make than clothing and they are a lot more profitable. At this time, Airwalk and Vans were the only competition in the action sports industry. Since each of them had their own troubles in 1992 for various reasons, I could see there was a gap for Simple. I never called Simple a skate shoe company as I didn't want to be pegged to any particular style. I didn't want a stereotype attached to the shoes. We never showed a person wearing our shoes in the advertisements – we just showed the shoe and let the consumer draw his or her own conclusions. I always liked the plainer stuff.

DORFMAN SOUNDS LIKE A CHARACTER. IT'S IMPRESSIVE THAT YOU STILL SPEAK SO HIGHLY OF HIM.

Brad was just unafraid. If he liked what you were doing, he just ran with it and he would go deep. He never waited to see whether it was a success or not, he just ordered huge when he had a good feeling about something. This was his biggest talent. He wasn't the best designer or an artist, but he knew when he saw something

that would work and he backed it up quickly with lots of people and money. He was super strong-willed and would push us to the extreme. This energy is primarily what made Vision Street Wear so successful. It was too much for some people, but without it, Vision would not have been what it was.

HOW DO YOU LOOK BACK ON THE BRAND NOW?

Vision Street Wear was an anomaly I think. Based on the knowledge that there was this huge niche that needed filling in the skate market, we created a feast of graphic design. It just so happened that it evolved during the late 80s. It was loud and driven by huge logos, just like everything else at that time. I am not proud of the big logo stuff, they were just a fad we worked with, but I am proud to have helped launch a category that continues to evolve. Twenty-five years ago, there was no such thing as skate style and now look at it.

•

Jordan Brand

EDITOR'S NOTE: WOODY

Michael Jordan's signature shoe deal with Nike is arguably the most historic moment in sneaker history. From the cultish love of the number 23 to the iconic 'Chicago Bulls' colour combo, the superstar athlete sparked a 34-years-and-counting footwear phenomenon. For many sneakerheads, Air Jordan is the only brand in the game.

19

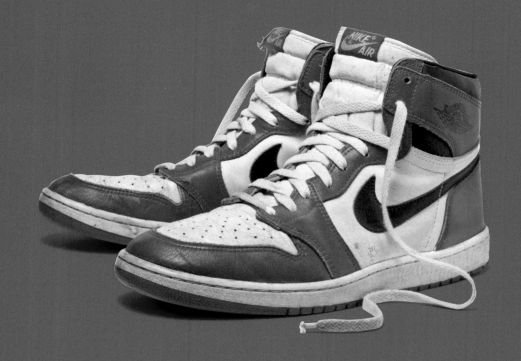

THE SNEAKER FREAKER GUIDE TO JORDAN I THROUGH TO XXIII

Words: Vinny Tang

Phil Knight famously proclaimed that he wasn't in the shoe business – he was in the entertainment business. Luckily for Phil, when Nike signed Michael Jordan in 1984 they secured the greatest entertainer the NBA has ever seen.

That landmark deal has since become basketball folklore. Nike agreed to pay the rookie player a vertiginous $500,000 per year – plus stock options! Fine print stipulated that Nike could walk away if sales didn't reach the ambitious total of $4 million by the end of the third year. Fuelled by MJ's charisma and effortless showmanship, cash registers racked up over $70 million in sales just two months after the first Jordan shoe was released in 1985. If basketball is defined by statistics, the numbers on these boards may just be the most impressive of Jordan's career.

The 'Air Jordan' brand would go on to become the most influential partnership in the history of basketball – and sneaker culture. Endorsed by the hood, MJ embodied the spirit of the nascent hip hop generation. As each new Jordan model released, layers of mythology and product storytelling added cultural depth to the brand.

While its success will always be anchored by the GOAT's greatness, Jordan Brand's pivot to embrace fashion has kept the company relevant with kids who never saw him play in the NBA. By precisely engineering supply and demand, Nike continues to orchestrate Jumpman hysteria to the tune of $3 billion annually.

From the unforgettable classics to the odd misfire, enjoy the key stats and milestones from the AJI through to the AJXXIII. *It's gotta be the shoes!*

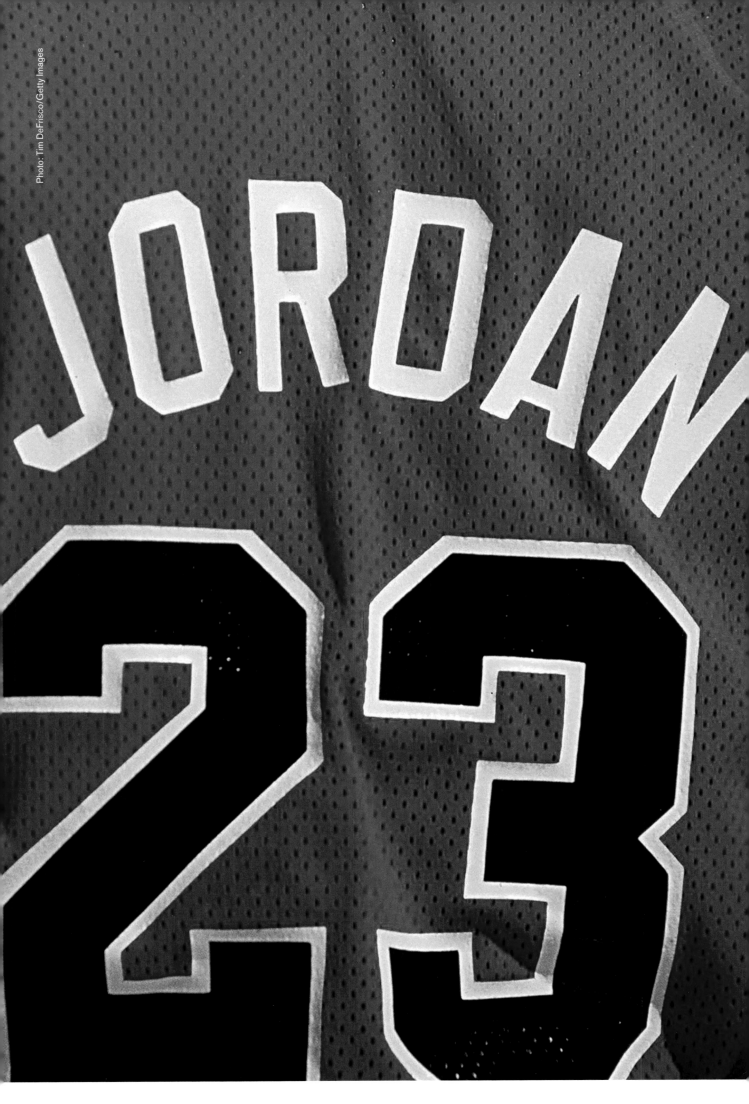

Photo: Tim DeFrisco/Getty Images

ORIGINAL RELEASE
APRIL, 1985

DESIGNER
PETER MOORE

COLOUR
BLACK / RED

ORIGINAL PRICE
$65

STYLE CODE
4281

JORDAN I

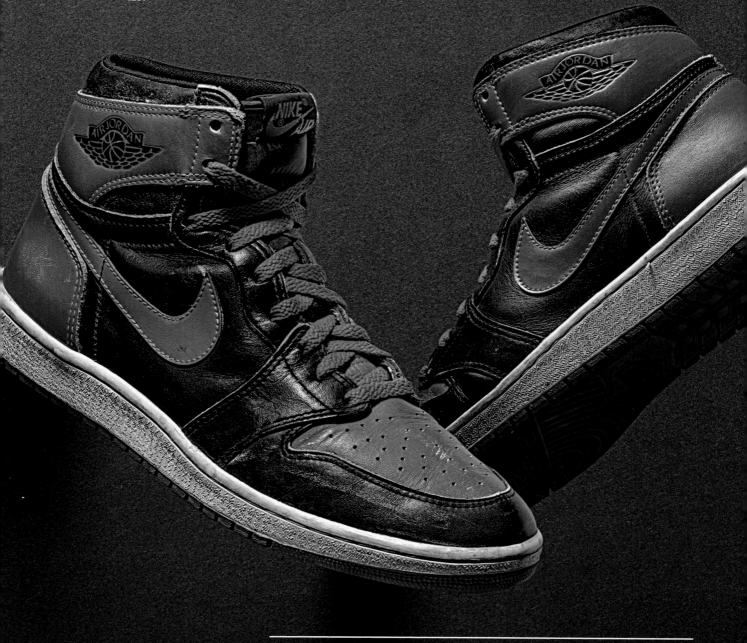

Peter Moore's Air Jordan I design was a pastiche of design elements from Nike's basketball catalogue, but that doesn't mean the model lacks its own identity. Far from it. The upright stance and traditional panelling made it the perfect vehicle for Bulls-inspired colour-blocking and visual storytelling. And thanks to the masterfully crafted 'Banned' mythology that grows with every reissue and retelling, the AJI's outlaw mystique has become deeply ingrained in the sneakerhead psyche. Released in dozens of colours and countless variations – including a version for golfers – the Air Jordan I was also adopted by skaters such as Lance Mountain, who still regards it as the most perfect skate shoe ever made.

Nike was right. Jordan was a freak athlete capable of astonishing physical feats. By the end of 1985, Michael Jordan was well on his way to redefining basketball style.

1985: Jordan I 'Black Toe'

1985: Jordan I 'Chicago'

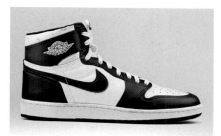

1985: Jordan I (White / Black)

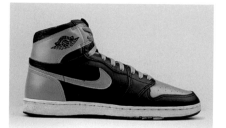

1985: Jordan I 'Shadow'

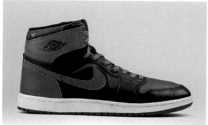

1985: Jordan I 'Royal'

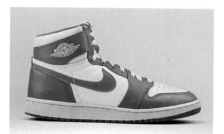

1985: Jordan I (White / Dark Powder Blue)

1985: Jordan I (White / Natural Grey)

1985: Jordan I (White / Metallic Orange)

1985: Jordan I Low (White / Natural Grey)

1985: Jordan I Low (White / Metallic Blue)

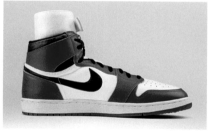

Jordan I (Black / Red) (Unreleased)

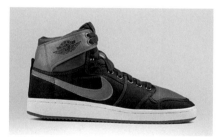

1986: Jordan I KO 'Bred'

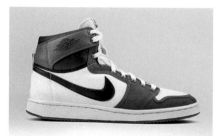

1986: Jordan I KO (White / Black – Red)

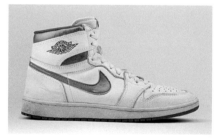

1986: Jordan I (White / Metallic Dark Red)

2001: Jordan I 'Royal'

2001: Jordan I 'Bred'

2016: Jordan I 'Reverse Shattered Backboard'

2016: Jordan I 'Top 3'

1987: Jordan II (White / Red)

1987: Jordan II Low (White / Red)

Jordan II Prototype (Unreleased)

1994: Jordan II Low (White / Red – Black)

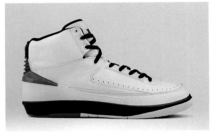

1994: Jordan II (White / Red – Black)

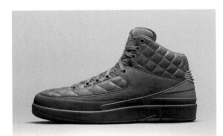

2015: Just Don x Jordan II (Bright Blue)

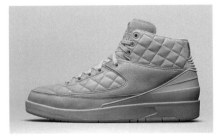

2016: Just Don x Jordan II (Beach)

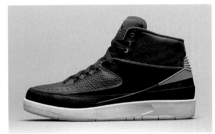

2016: Jordan II 'Radio Raheem'

2016: Jordan II 'Alternate 87'

2016: Jordan II 'Wing It'

2016: Jordan II 'Quai 54'

2016: Jordan II Low 'UNC'

2016: Jordan II Low 'Gym Red'

2016: Jordan II Low 'Chicago'

2017: Just Don x Jordan II (Arctic Orange)

2017: Jordan II 'Converse Pack'

JORDAN II

ORIGINAL RELEASE
NOVEMBER, 1986

DESIGNER
**PETER MOORE /
BRUCE KILGORE**

COLOUR
WHITE / RED

ORIGINAL PRICE
$100

STYLE CODE
4361

The Air Jordan II was Nike's first foray into luxury sneakers. Crafted in Italy from premium leather with faux lizard texture, Bruce Kilgore's sleek design was a radical departure from the first Jordan. As a signifier of MJ's rising stature and independence, the Swoosh was controversially removed from the shoe. However, MJ wasn't the biggest fan of his sophomore sneaker. The sole unit was apparently a tad stiff and he wasn't convinced by the nouveau styling. Despite his personal misgivings, the Air Jordan II carried Mike to a 3000-point season that still stands as the highest average points per game of any player in the modern era.

With a hefty $100 price tag back in 1986 – almost double the price of the AJ1 – the AJII struggled to find a loyal following. To this day, it is still regarded with bemusement by Jordanheads.

JORDAN III

ORIGINAL RELEASE
JANUARY, 1988

DESIGNER
TINKER HATFIELD

COLOUR
WHITE / CEMENT

ORIGINAL PRICE
$100

STYLE CODE
4365

In 1987, Michael Jordan's contract with Nike was up for renegotiation. After the Air Jordan II's lukewarm reception, the partnership was on the rocks and pressure to nail the next design was intensifying. With a grand total of *one* sneaker design to his name, rookie designer Tinker Hatfield – previously employed as Nike's corporate architect – stepped up to the plate. It was a brave call on Nike's part, but the move would pay dividends for years to come. Tinker not only smashed the Air Jordan III out of the park, he also convinced Mike to stay with Nike.

The mid-cut silhouette was poetry in motion and the addition of Visible Air (from the first Air Max runner) to the sole was revelatory. Inspired by MJ's flamboyant style, the new Jumpman logo and 'elephant print' gave the shoe an all-important telegenic presence.

The AJIII ushered in a bold new era. Jordan earned his first MVP nomination and the cult campaign featuring Spike Lee as Mars Blackmon laid the cultural foundations for Jordan's superhero persona. To this day, the 'Black/Cement' Air Jordan III is regarded by many sneakerheads as the quintessential Jordan.

1988: Jordan III 'Black Cement'

1994: Jordan III 'White Cement'

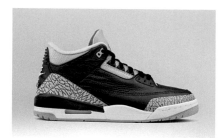

1994: Jordan III 'Black Cement'

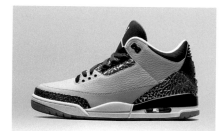

2014: Jordan III 'Wolf Grey'

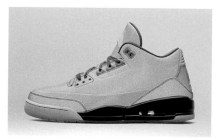

2014: Jordan III '5lab3'

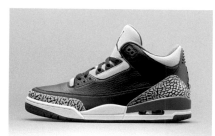

2016: Jordan III 'Sport Blue'

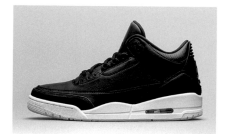

2016: Jordan III 'Cyber Monday'

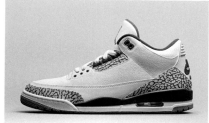

2016: Jordan III 'True Blue'

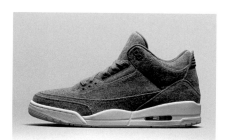

2016: Jordan III 'Wool'

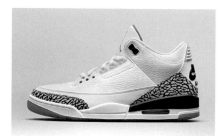

2018: Jordan III 'Free Throw Line'

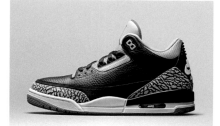

2018: Jordan III 'Black Cement'

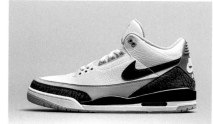

2018: Jordan III 'Tinker'

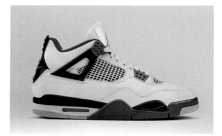

1989: Jordan IV (White / Fire Red – Black)

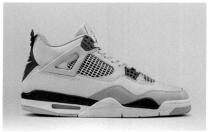

1989: Jordan IV (Off White / Military Blue)

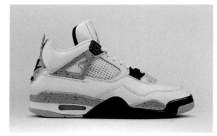

1999: Jordan IV (White / Cement)

1999: Jordan IV 'Oreo'

2015: Jordan IV 'Legend Blue'

2015: Jordan IV 'Teal'

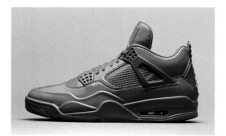

2015: Jordan IV '11lab4'

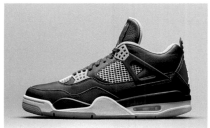

2016: Jordan IV 'Dunk From Above'

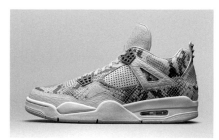

2016: Jordan IV 'Snakeskin'

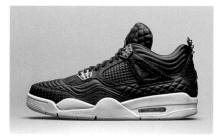

2016: Jordan IV 'Obsidian'

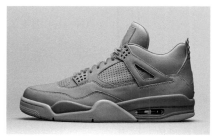

2016: Jordan IV 'Ginger'

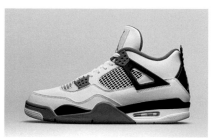

2017: Jordan IV 'Motorsport'

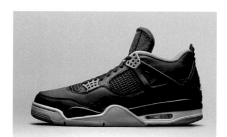

2017: Jordan IV 'Alternate Motorsport'

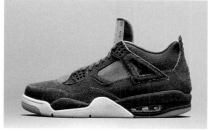

2018: Levi's x Jordan IV

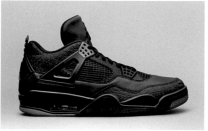

Jordan IV (Black / Red) (Unreleased)

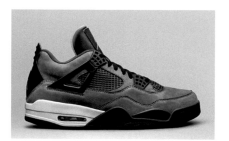

Undefeated x Jordan IV (Sample)

JORDAN IV

ORIGINAL RELEASE
FEBRUARY, 1989

DESIGNER
TINKER HATFIELD

COLOUR
BLACK / CEMENT GREY

ORIGINAL PRICE
$110

STYLE CODE
4363

With his reputation enhanced thanks to the Air Jordan III's stellar success, Tinker Hatfield continued to push boundaries. The addition of rubber sidewall netting and ankle-wrapping 'wings' gave the Air Jordan IV a progressive, teched-out profile. Performance credentials aside, Tinker's visual medley once again blew away the competition.

The Jordan IV starred in dozens of big game performances, but the most memorable moment came in Spike Lee's film *Do The Right Thing*, when Buggin' Out (played by Giancarlo Esposito) confronts a Celtics fan who steps on his new 'Cement' Air Jordan IVs. In more recent times, collaborations with Undefeated, Levi's and KAWS have produced some of the rarest and most desirable Jordans of all time.

JORDAN V

ORIGINAL RELEASE
FEBRUARY, 1990

DESIGNER
TINKER HATFIELD

COLOUR
**BLACK / METALLIC
SILVER**

ORIGINAL PRICE
$125

STYLE CODE
4281

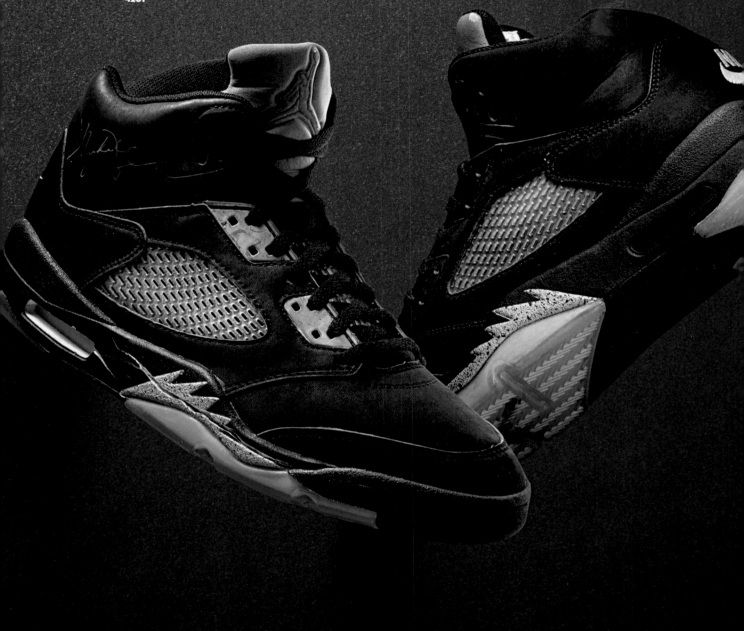

Always the thinker, Tinker likened Jordan's aerial acrobatics to fighter planes performing dogfight manoeuvres. Mimicking WWII fighter jet nosecone art, the Air Jordan V flaunted jagged shark teeth on the midsole and a more aggressive vibe that peaked with its towering tongue height. The AJV also introduced reflective 3M Scotchlite tongues and translucent 'icy' rubber soles, both of which became signature elements of the Air Jordan aesthetic.

The one-two punch of prominent product placement in *The Fresh Prince of Bel Air* and the ongoing Mars Blackmon campaign launched the AJV into orbit.

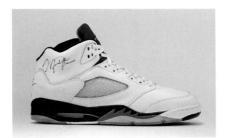

1990: Jordan V (White / Grape Ice)

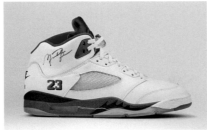

1990: Jordan V (White / Fire Red – Black)

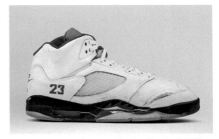

1990: Jordan V (White / Black – Fire Red) (PE)

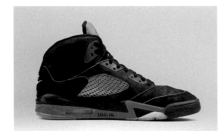

Jordan V 'Bred' (Unreleased)

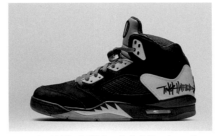

Jordan V (Black / Yellow Strike) (Unreleased)

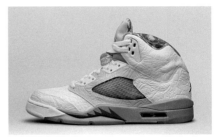

1990: Jordan V (White / Army Olive)

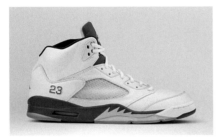

2000: Jordan V 'Laney'

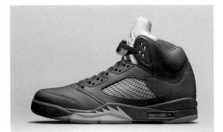

2015: Jordan V 'Hornets'

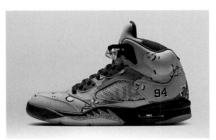

2015: Supreme x Jordan V 'Desert Camo'

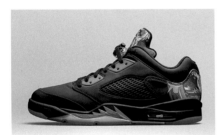

2016: Jordan V Low 'CNY'

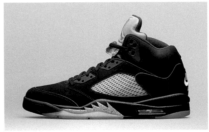

2016: Jordan V 'Metallic Silver'

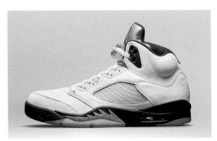

2016: Jordan V 'Olympic Gold'

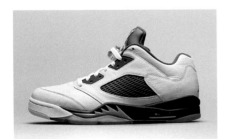

2016: Jordan V Low 'Dunk From Above'

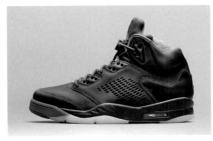

2017: Jordan V 'Bordeaux'

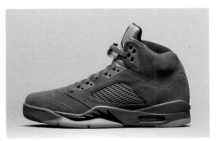

2017: Jordan V 'Blue Suede'

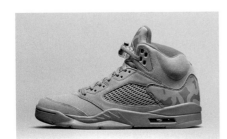

2017: Jordan V 'Camo' (Dark Stucco / University Red)

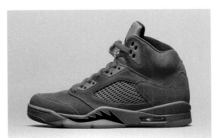

2017: Jordan V 'Red Suede'

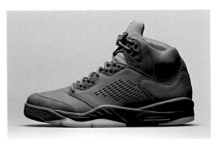

2017: Jordan V 'Take Flight'

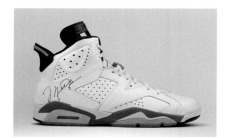

1991: Jordan VI (White / Infrared – Black)

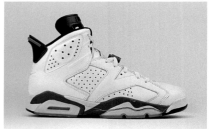

1991: Jordan VI (White / Sport Blue – Black)

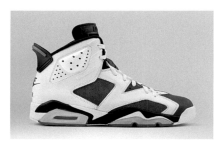

1991: Jordan VI (White / Carmine – Black)

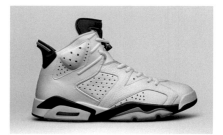

Jordan VI (White / Black – Gold) (Unreleased)

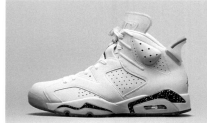

Jordan VI (White / Navy Blue – Red) (Unreleased)

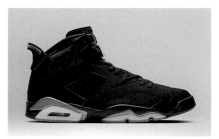

2006: Jordan VI 'Defining Moments'

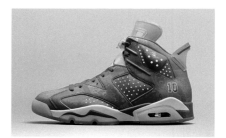

2014: Jordan VI 'Slam Dunk'

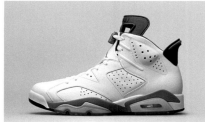

2014: Jordan VI 'Sport Blue'

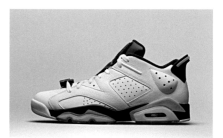

2015: Jordan VI Low 'Infrared'

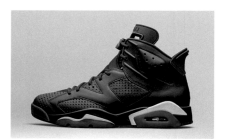

2016: Jordan VI 'Black Cat'

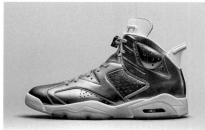

2016: Jordan VI 'Metallic Gold'

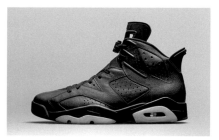

2017: Jordan VI 'Chameleon'

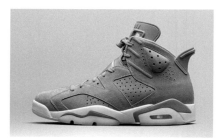

2017: Jordan VI 'Wheat'

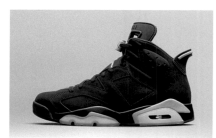

2017: Jordan VI 'UNC'

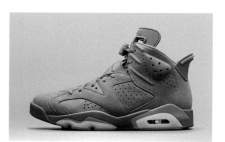

2017: Jordan VI 'Gatorade Green'

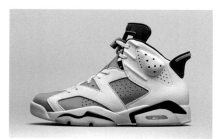

2017: Jordan VI 'Gatorade'

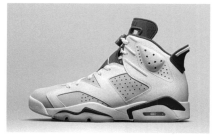

2017: Jordan VI 'Alternate'

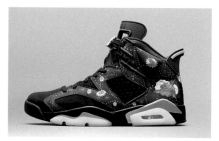

2018: Jordan VI 'CNY'

JORDAN VI

ORIGINAL RELEASE
1991

DESIGNER
TINKER HATFIELD

COLOUR
BLACK / INFRARED

ORIGINAL PRICE
$125

Jordan's love of exotic automobiles was regular inspo territory for Tinker over the years. Debuting during MJ's first championship-winning season in 1991, the Air Jordan VI drew inspiration from the Porsche 964 Turbo. On an otherwise sleek silhouette, rubberised tongues and the dramatic heel pulls were nods to the German supercar's oversized spoilers. As per Michael's specific request, the reinforced toe area was kept super clean.

The Air Jordan VI was live and direct during every one of Jordan's buckets in his incredible MVP playoffs performance. The cherished championship was a defining moment that established his undisputed dominance as a player both on and off the court.

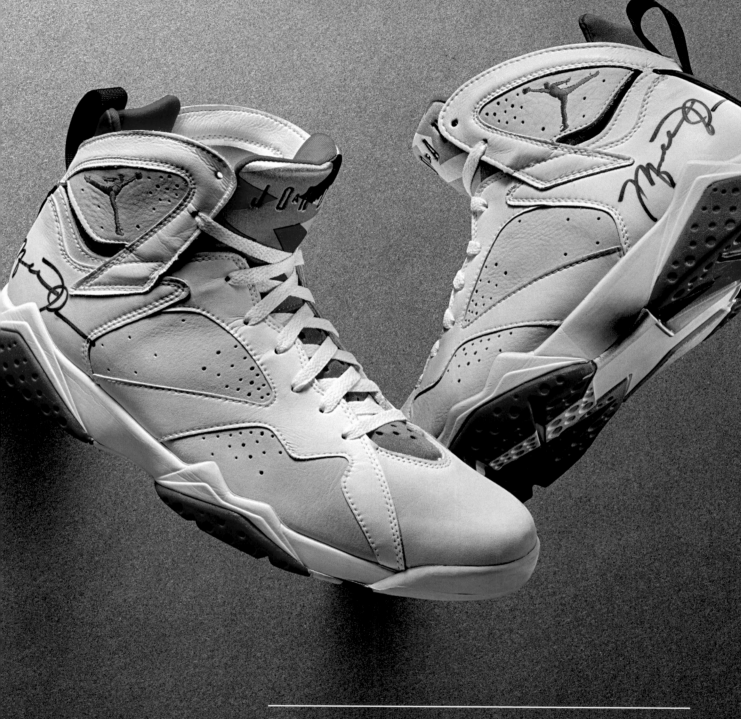

JORDAN VII

ORIGINAL RELEASE
1992

DESIGNER
TINKER HATFIELD

COLOUR
WHITE / LIGHT SILVER
– RED

ORIGINAL PRICE
$125

The Air Jordan VII was heavily influenced by Tinker's other big project in 1991, the Air Huarache. Light, fast and dramatic, the AJVII tucked Nike's Air units inside the sole for a sleeker surface. The jagged sole design raced across the upper, with West African-inspired patterns on the neoprene tongue adding cultural depth. Grainy YouTube footage of Michael Jordan with Michael Jackson (the other iconic MJ!) wearing the Air Jordan VII can be seen in the 'Jam' music video. One more thing. Jordan also led the Dream Team to gold at Barcelona's 1992 Olympics wearing 'Team USA' Air Jordan VIIs.

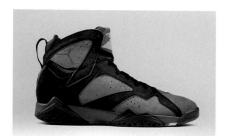

1992: Jordan VII (Black / Bordeaux)

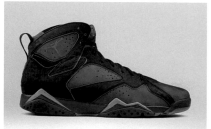

1992: Jordan VII (Black / True Red)

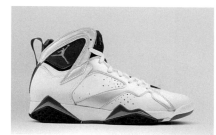

1992: Jordan VII 'Olympic'

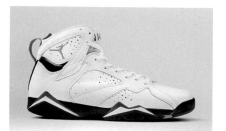

1992: Jordan VII 'Cardinal'

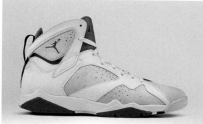

Jordan VII (White / Red) (Unreleased)

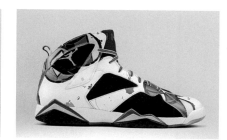

2008: Jordan VII 'Miro Olympic'

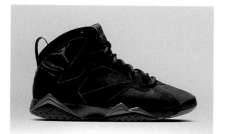

2012: Jordan VII 'Raptor'

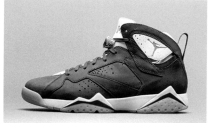

2015: Jordan VII 'Cigar'

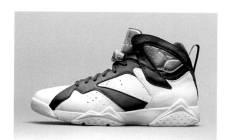

2015: Jordan VII 'Champagne'

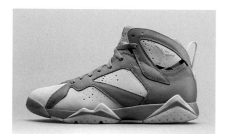

2015: Jordan VII 'Barcelona Days'

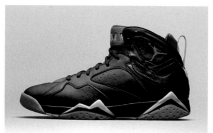

2015: Jordan VII 'Marvin the Martian'

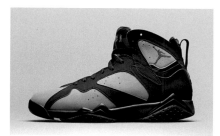

2015: Jordan VII 'Bordeaux 2015'

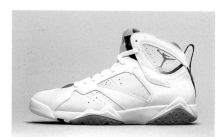

2015: Jordan VII 'Hare'

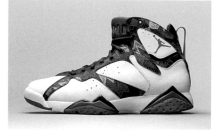

2015: Jordan VII 'Nothing But Net'

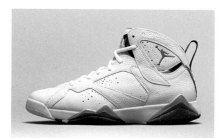

2015: Jordan VII 'French Blue'

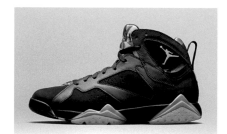

2015: Jordan VII 'Barcelona Nights'

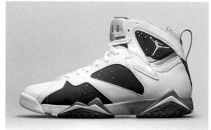

2016: Jordan VII 'Olympic Alternate'

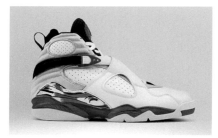

1993: Jordan VIII 'Bugs Bunny'

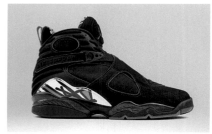

1993: Jordan VIII 'Playoff'

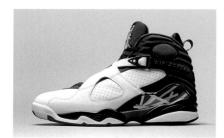

2015: Jordan VIII 'Three Peat' (White / Infrared)

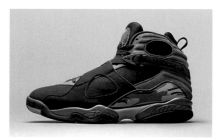

2015: Jordan VIII 'Aqua 2015'

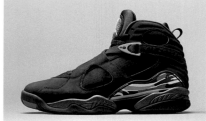

2015: Jordan VIII 'Chrome'

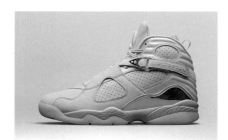

2016: Jordan VIII 'Champagne'

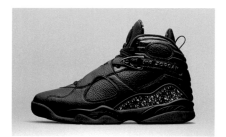

2016: Jordan VIII 'Confetti'

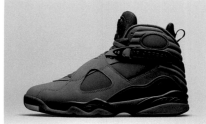

2017: Jordan VIII 'Take Flight'

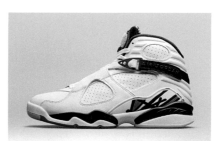

2017: Jordan VIII 'Alternate'

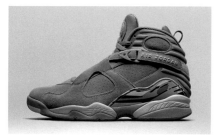

2017: Jordan VIII 'Cool Grey'

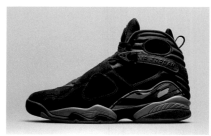

2017: Jordan VIII 'Bred'

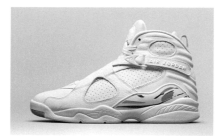

2018: OVO x Air Jordan VIII (White)

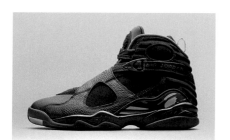

2018: OVO x Air Jordan VIII (Black)

JORDAN VIII

ORIGINAL RELEASE
1993

DESIGNER
TINKER HATFIELD

COLOUR
**BLACK / BRIGHT
CONCORD –
AQUA TONE**

ORIGINAL PRICE
$125

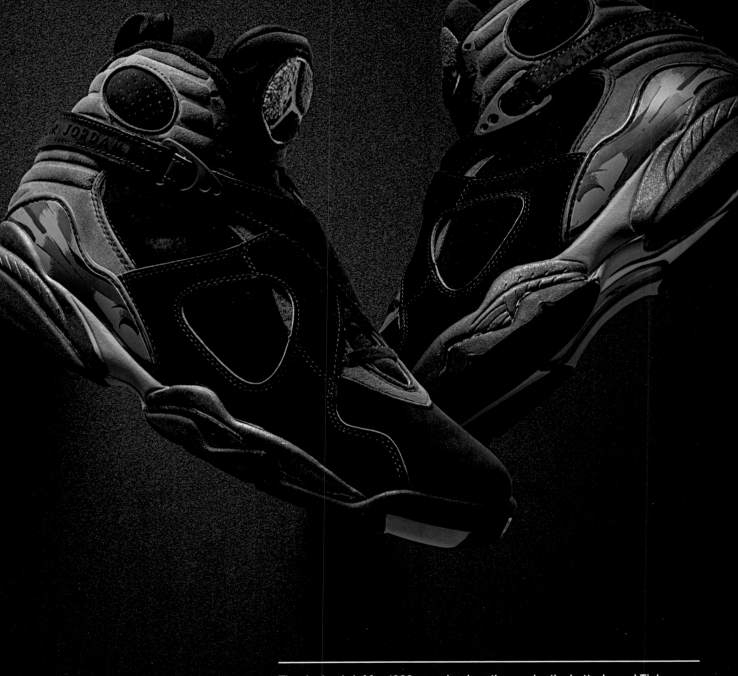

The design brief for 1993 was simple – *the crazier the better!* – and Tinker was more than happy to oblige. The inner bootie carried over from the Air Jordan VII, but the minimalist approach was left in the past. Bold crisscrossing straps provided lockdown and the high-cut collar gave the AJVIII generous new proportions. Multiple textures were applied to the upper. Perforated leather, nubuck, neoprene, Velcro and even a splash of chenille on the tongue logo – not to mention the graffiti-inspired pattern that covered the heel and polycarbonate torsion plate – made this the most complex and visually arresting Jordan to date. The AJVIII is also fondly remembered by fans as the shoe that helped Mike complete the first 3-Peat run by the Bulls.

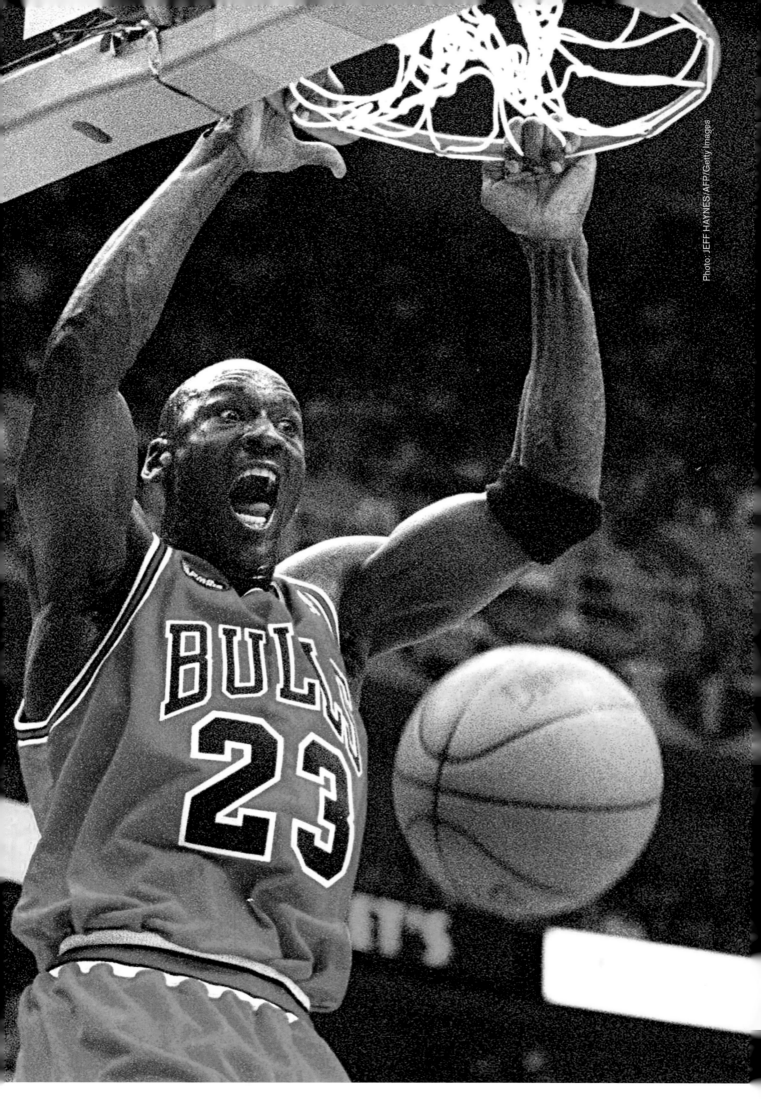

Photo: JEFF HAYNES/AFP/Getty Images

JORDAN IX

ORIGINAL RELEASE
1993

DESIGNER
TINKER HATFIELD

COLOUR
**WHITE / BLACK –
TRUE RED**

ORIGINAL PRICE
$125

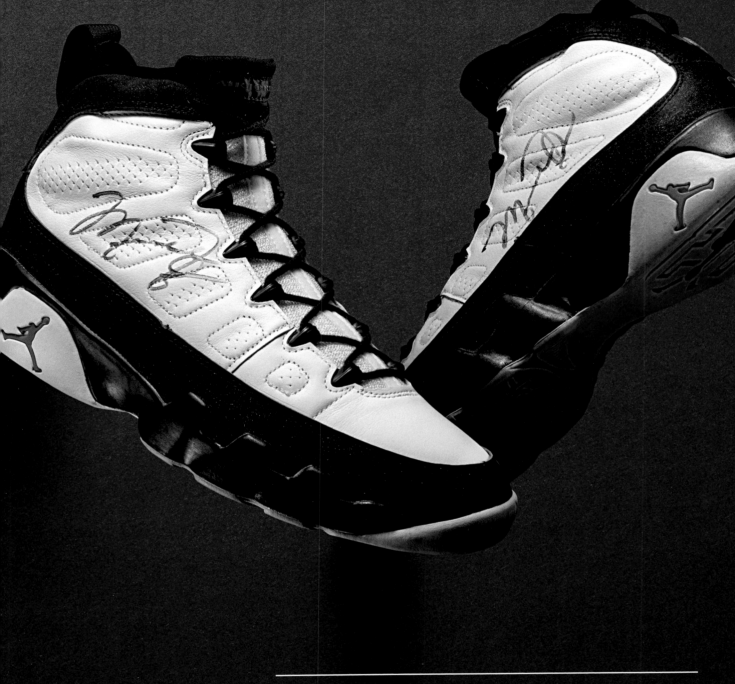

The Air Jordan IX arrived in a bittersweet period for fans. Citing burnout and stress relating to the death of his father, MJ retired at the height of his career to pursue baseball. To celebrate MJ's achievements, Tinker tapped Nike designer Mark Smith to decorate the Air Jordan IX's outsoles with a story honouring MJ's global influence. Foreign words such as 'hope' in Swahili, 'force' in Spanish, 'freedom' in Russian, and 'dedicated' in French are inscribed into the shoe.

Unfortunately, the Air Jordan IX's blocky design lacked pizzazz and as a result, the model still polarises fans today. Jordan may have been on an indefinite sabbatical, but his story was far from over.

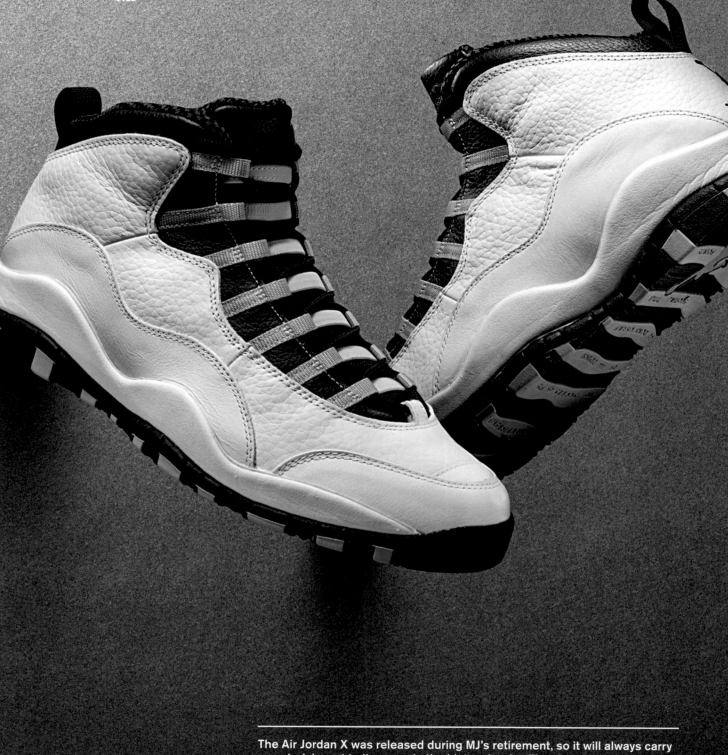

JORDAN X

ORIGINAL RELEASE
1994–95

DESIGNER
TINKER HATFIELD

COLOUR
**WHITE / BLACK –
LIGHT STEEL GREY**

ORIGINAL PRICE
$125

The Air Jordan X was released during MJ's retirement, so it will always carry an asterisk next to its name in the history books. The shoe itself is a visual celebration of MJ's NBA achievements. A series of stripes partition the outsole, each highlighting Jordan's accomplishments during his 10 seasons. In March 1995 Jordan announced his return to the NBA through a famously succinct press release: 'I'm back!' Less than two weeks later, MJ dropped a lazy 55 points against the Knicks wearing the unfamiliar number 45 jersey on his back and the AJX on his feet.

1994: Jordan X 'Powder Blue'

1994–95: Jordan X 'Seattle'

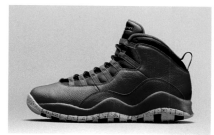

2015: Jordan X 'Bulls Over Broadway'

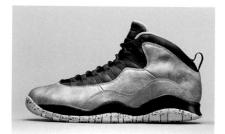

2015: Jordan X 'Lady Liberty'

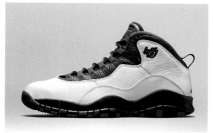

2015: Jordan X 'Double Nickel'

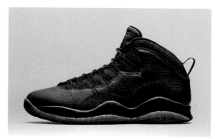

2016: OVO x Jordan X

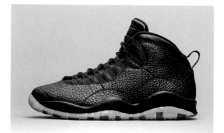

2016: Jordan X 'Paris'

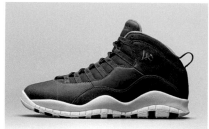

2016: Jordan X 'Los Angeles'

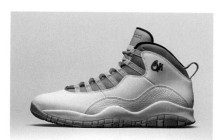

2016: Jordan X 'Chicago'

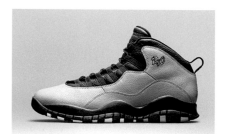

2016: Jordan X 'Rio'

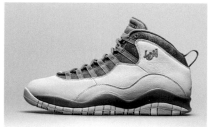

2016: Jordan X 'London'

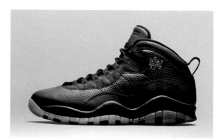

2016: Jordan X 'Shanghai'

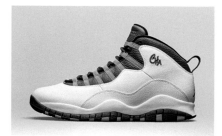

2016: Jordan X 'Charlotte'

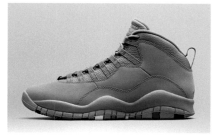

2018: Jordan X 'Cool Grey'

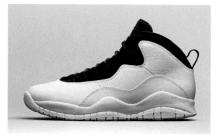

2018: Jordan X 'I'm Back'

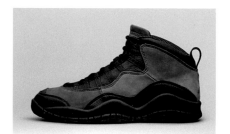

Jordan X (Black / Dark Shadow) (Unreleased)

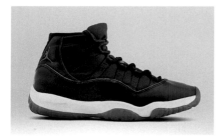

1996: Jordan XI 'Bred'

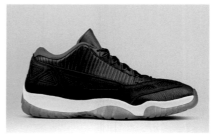

1996: Jordan XI Low IE (Black / True Red)

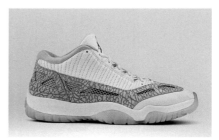

1996: Jordan XI Low IE (White / Light Grey)

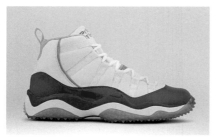

Jordan XI PE 'Deion Sanders'

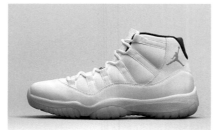

2014: Jordan XI 'Legend Blue'

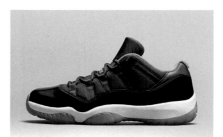

2015: Jordan XI Low 'Bred'

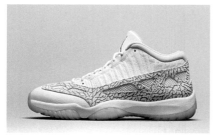

2015: Jordan XI Low IE 'Cobalt'

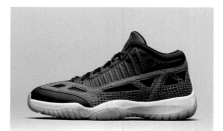

2015: Jordan XI 'Croc'

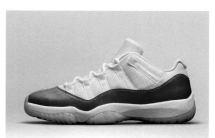

2016: Jordan XI Low 'Cherry'

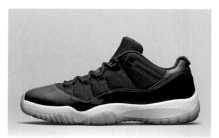

2016: Jordan XI Low 'Navy Gum'

2016: Jordan XI Low 'Closing Ceremony'

2016: Jordan XI 'Grey Suede'

2016: Jordan XI 'Space Jam'

2017: Jordan XI Low 'University Blue'

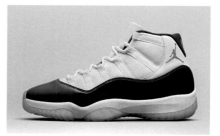

2017: Jordan XI 'Win Like 82'

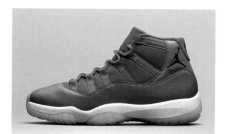

2017: Jordan XI 'Win Like 96'

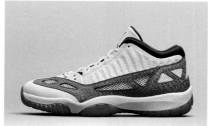

2017: Jordan XI Low IE 'Gym Red'

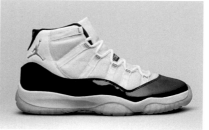

Jordan XI (White / Black) (Unreleased)

JORDAN XI

ORIGINAL RELEASE
1995

DESIGNER
TINKER HATFIELD

COLOUR
**WHITE / BLACK –
DARK CONCORD**

ORIGINAL PRICE
$125

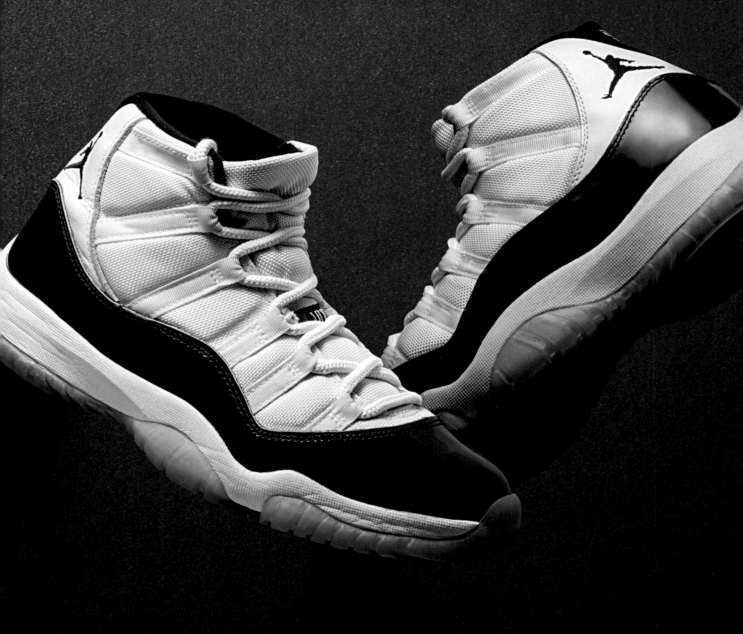

The Air Jordan XI is considered the *crème de la crème* of Jordan sneakers. The design concept reportedly came to Tinker while he was mowing the lawn. Glossy patent material wraps the bottom half of the shoe to protect the polymer-coated ballistic nylon upper, satisfying Jordan's request for a shiny sneaker that could be worn with a tuxedo. Translucent soles exposed the innovative carbon fibre shank that underpinned the construction.

The AJXI is Tinker's favourite design and arguably the most hyped model in the entire Jordan canon. With sparkling white uppers and black patent leather, the 'Concord' edition resembles 'spats', the dressy footwear fad that went out of fashion in the Al Capone era. Back in 2011, American malls erupted into scuffles and riots when the 'Concord' retro released – a level of pandemonium no Jordan release has inspired since.

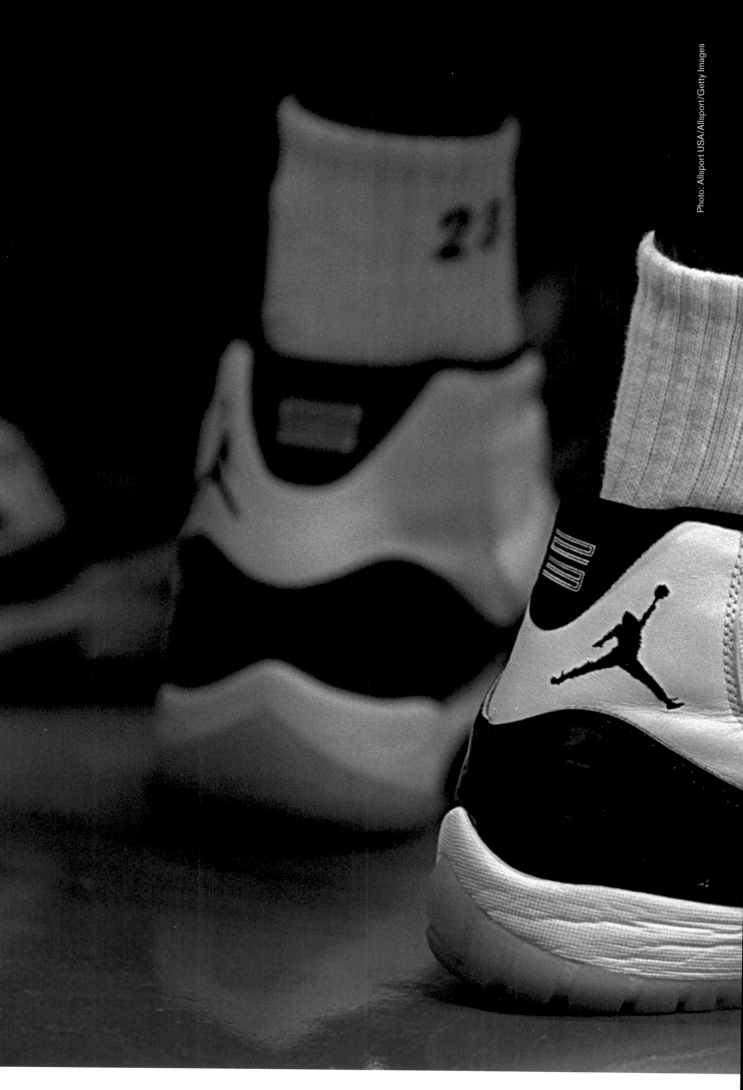

Photo: Allsport USA/Allsport/Getty Images

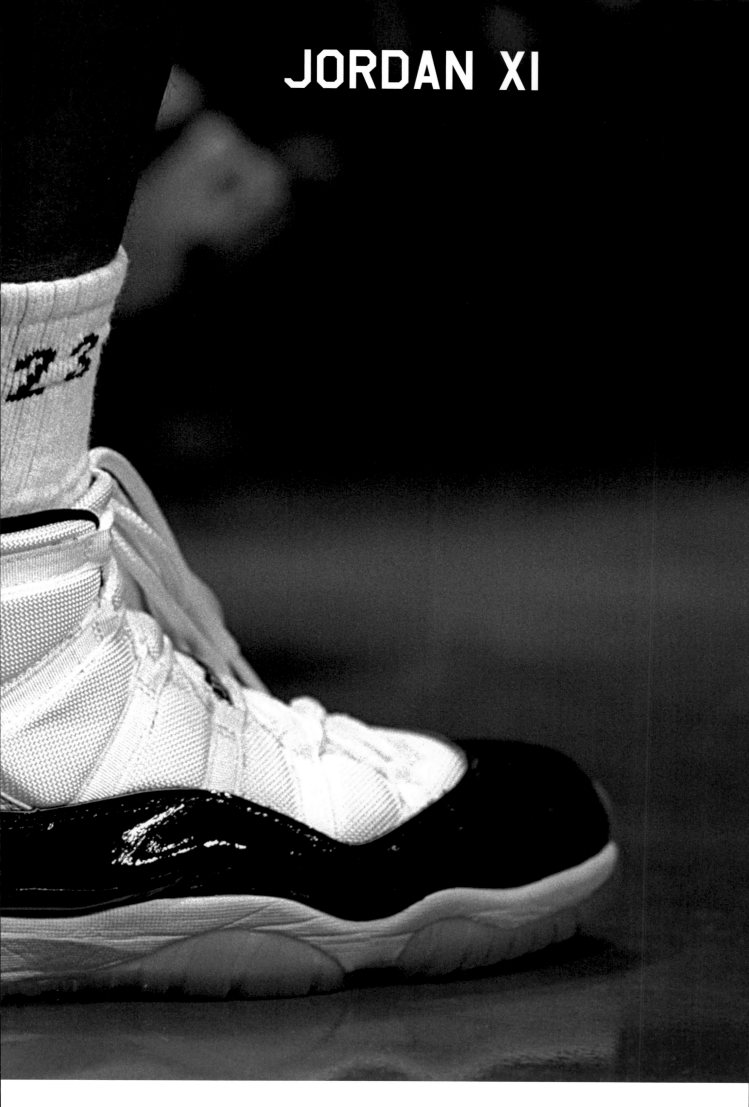

JORDAN XI

JORDAN XII

ORIGINAL RELEASE
NOVEMBER, 1996

DESIGNER
TINKER HATFIELD

COLOUR
WHITE / BLACK – TAXI

ORIGINAL PRICE
$135

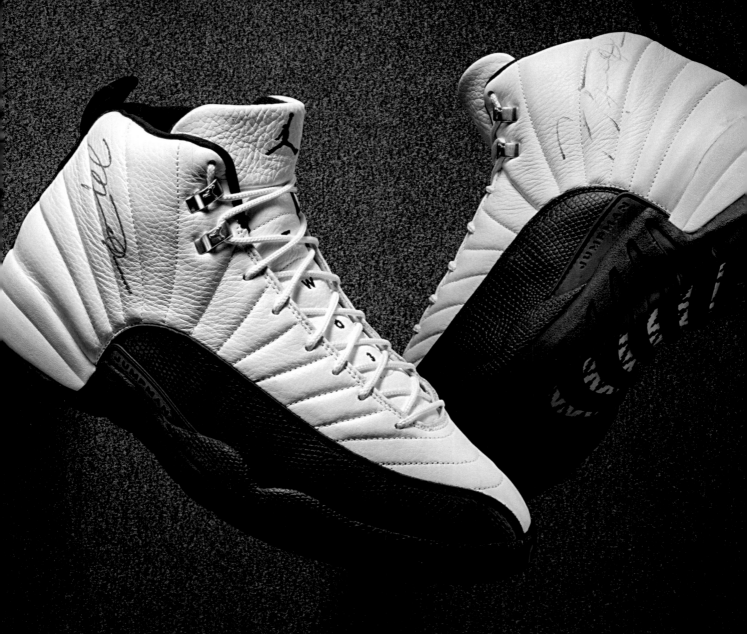

Made famous by Mike's legendary 'Flu Game' appearance in the 1997 final that clinched the Bulls' championship, the Air Jordan XII combined inspiration from the Japanese 'Rising Sun' flag and women's shoes. The quilted full-grain leather contrasted with large metal eyelets to create a premium finish. Adding invisible comfort to the equation, Zoom Air was used for the first time in Jordan soles. The pull tabs on the heel were inscribed with a humble message: 'Quality inspired by the greatest player ever.' The legend of the GOAT was bubbling away…

1997: Jordan XII 'Cherry'

1997: Jordan XII (Obsidian / White – French Blue)

1997: Jordan XII 'Bred'

1997: Jordan XII 'Playoff'

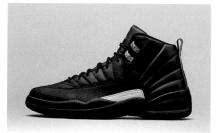

2016: Jordan XII 'The Master'

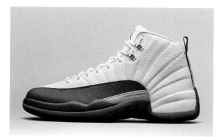

2016: Jordan XII 'French Blue'

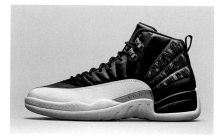

2016: Jordan XII 'Wings'

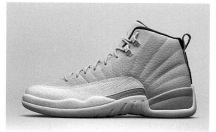

2016: Jordan XII 'UNC'

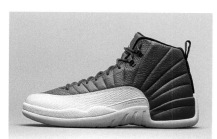

2016: Jordan XII 'Gym Red'

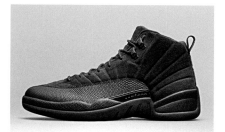

2016: Jordan XII 'Deep Royal'

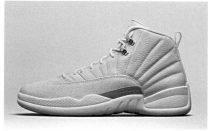

2016: OVO x Air Jordan XII (White)

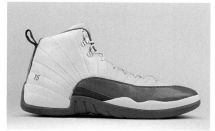

Jordan XII (White / Powder Blue) (PE)

2017: PSNY x Air Jordan XII 'Milan'

2017: PSNY x Air Jordan XII 'Paris'

2017: PSNY x Air Jordan XII 'NYC'

2017: Jordan XII 'Bordeaux'

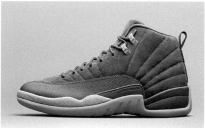

2017: Jordan XII 'Dark Grey'

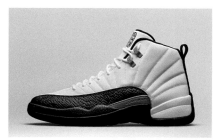

2017: Jordan XII 'CNY'

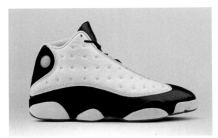

1997: Jordan XIII (White / True Red – Black)

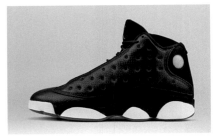

1998: Jordan XIII 'Playoff'

1998: Jordan XIII (Black / True Red)

2014: Jordan XIII 'Barons'

2014: Jordan XIII 'Infrared 23'

2014: Jordan XIII 'Grey Toe'

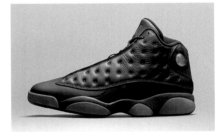

2014: Jordan XIII 'Dirty Bred'

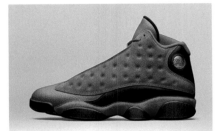

2016: Jordan XIII 'Singles Day'

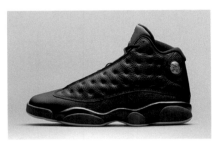

2017: Jordan XIII 'Altitude'

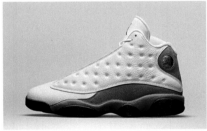

2017: Jordan XIII 'Chicago 2017'

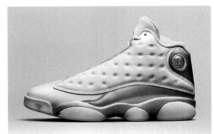

2017: Jordan XIII 'Defining Moments'

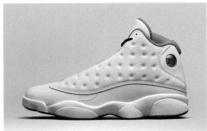

2017: Jordan XIII 'History of Flight'

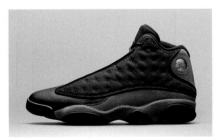

2017: Jordan XIII 'Bred'

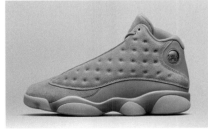

2017: Jordan XIII 'Wheat'

2018: Jordan XIII 'Olive'

2018: Jordan XIII 'Hyper Royal'

JORDAN XIII

ORIGINAL RELEASE
NOVEMBER, 1997

DESIGNER
TINKER HATFIELD

COLOUR
BLACK / RED

ORIGINAL PRICE
$150

As a nod to Michael's instincts as an athletic predator, Tinker laced the quilted Air Jordan XIII with multiple references to big cats. The sole design resembled paws while the hologram logo on the ankle represented the all-seeing eye of a panther. The AJXIII carried Jordan through his final season in a Bulls jersey and his tenth as the leading scorer in the NBA. It was also the first official release under Nike's newly formed Jordan Brand subdivision.

ORIGINAL RELEASE
OCTOBER, 1998

DESIGNER
TINKER HATFIELD

COLOUR
**WHITE / BLACK –
VARSITY RED**

ORIGINAL PRICE
$150

JORDAN XIV

Mike's beloved Ferrari 550 heavily influenced the Air Jordan XIV. Every design element was considered by Tinker and Mark Smith to evoke the feeling of extreme speed. Supercar tyres inspired the rubber heel panels, deluxe quilted uppers referenced Ferrari's Italian leather interiors, and Jumpman shields echoed the prancing horse fender badge. Each pair sported no less than 14 different logos!

Jordan's famous 'Last Shot' against the Jazz wearing the AJXIV locked down the second Chicago 3-Peat and marked the end of the dynasty. Jordan's second retirement was announced shortly afterwards and the AJXIV went down in history as the last shoe MJ laced up as a Bull.

JORDAN XV

ORIGINAL RELEASE
DECEMBER, 1999

DESIGNER
TINKER HATFIELD

COLOUR
FLINT GREY / WHITE

ORIGINAL PRICE
$150

Tinker Hatfield looked to the skies again for the Air Jordan XV, designing a model inspired by the X-15 fighter jet that broke speed and altitude records – just like Mike. While the plane was an impressive feat of engineering, the AJXV was a turkey that failed to get off the ground. Zoom Air, woven Kevlar uppers, Pebax-reinforced heel counters, herringbone traction pods and a hidden speed-lacing system sounded high-tech on paper, but there no getting away from the ugly dimensions and that awkward ankle collar.

JORDAN XVI

ORIGINAL RELEASE
FEBRUARY, 2001

DESIGNER
WILSON SMITH III

COLOUR
BLACK / VARSITY RED

ORIGINAL PRICE
$160

Tinker Hatfield stepped away from the franchise for the first time in over a decade, handing the reins to Nike designer Wilson Smith III. The Air Jordan XVI was Wilson's tribute to the legacy of Jordan Brand. The design borrowed elements from Tinker's greatest hits and incorporated them into Wilson's vision of Jordan as the CEO. Full-length Air (almost) and the removeable shroud design was better received than the AJXV, but the model still perplexes Jordan fans today. Perhaps Wilson's design will mature into a bona fide retro classic, but for now it has fallen out of rotations and continues to haunt the #ntdenim hashtag.

JORDAN XVII

ORIGINAL RELEASE
FEBRUARY, 2002

DESIGNER
WILSON SMITH III

COLOUR
WHITE / RED

ORIGINAL PRICE
$200

In 2002, MJ came out of retirement for the second time and Wilson was again drafted to oversee MJ's first shoe as a Washington Wizard. The mood board for this model was certainly eclectic, referencing everything from freeform jazz to luxury Aston Martins, golf course bunkers and fairways. Nike's Tuned Air technology was packed into an impressive sole design that featured TPU heel stabilisers and a full-length shank plate. But the AJXVII's most memorable feature wasn't the shoe itself, but rather the metal briefcase used to justify its lofty $200 price tag, the highest of any Jordan model. MJ averaged a creditable 23 points per game and the AJXVII was worn by Ray Allen and Kobe Bryant among others.

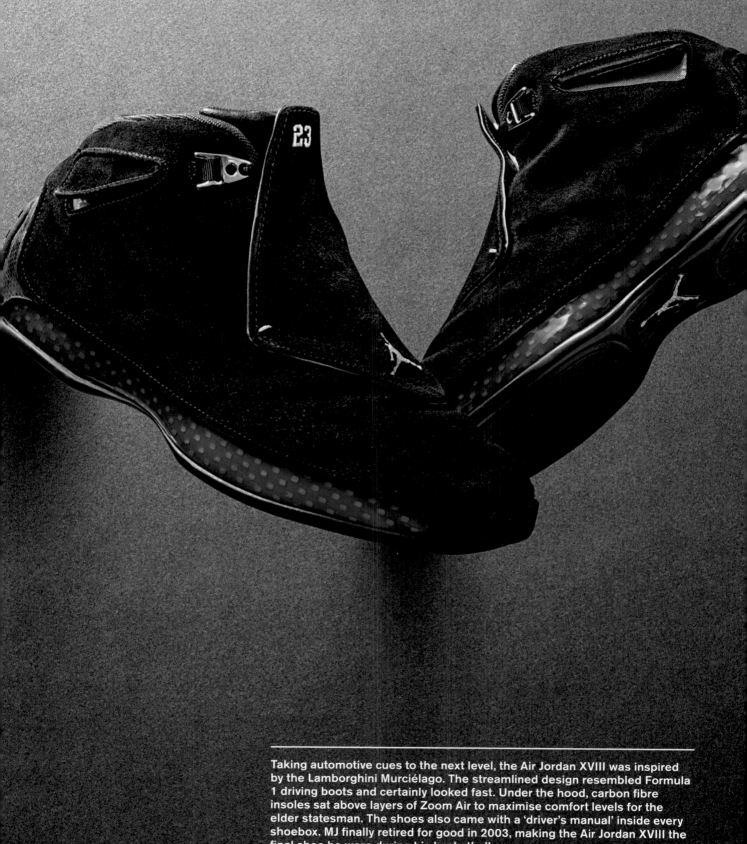

JORDAN XVIII

ORIGINAL RELEASE
FEBRUARY, 2003

DESIGNER
WILSON SMITH III

COLOUR
BLACK / BLUE

ORIGINAL PRICE
$175

Taking automotive cues to the next level, the Air Jordan XVIII was inspired by the Lamborghini Murciélago. The streamlined design resembled Formula 1 driving boots and certainly looked fast. Under the hood, carbon fibre insoles sat above layers of Zoom Air to maximise comfort levels for the elder statesman. The shoes also came with a 'driver's manual' inside every shoebox. MJ finally retired for good in 2003, making the Air Jordan XVIII the final shoe he wore during his basketball career.

ORIGINAL RELEASE
MARCH, 2004

DESIGNER
TATE KUERBIS

COLOUR
WHITE / RED

ORIGINAL PRICE
$165

JORDAN XIX

Long before Kobe assumed the 'Black Mamba' nickname, Tate Kuerbis and his team of Jordan Brand designers saw similarities between the deadly serpent and Mike's attack on the basket. The Air Jordan XIX riffed on the theme to create a technologically advanced model with the latest Air Zoom cushioning technology and unique Tech-Flex material that gave the upper a reptilian texture. The AJXIX was a significant model and marked the start of the post-MJ generation of Jordan Brand athletes.

ORIGINAL RELEASE
FEBRUARY, 2005

DESIGNER
**TINKER HATFIELD /
MARK SMITH**

COLOUR
WHITE / BLACK – RED

ORIGINAL PRICE
$175

JORDAN XX

Known for their love of an anniversary, Nike made sure to pull out the big guns with the Air Jordan XX. Tinker was back in the hot seat to deliver a fitting finale. The design was an ostentatious trip down memory lane for the Jordan faithful. Giant oversized lace covers were laser-etched with Mark Smith-designed iconography representing 200 memorable Jordan moments, while the rest of the shoe featured subtle and not-so-subtle MJ references.

Aside from the visual overload, the AJXX is best known for pioneering the Independent Podular Suspension (IPS) sole technology. Ssshhhh… let's not mention that god-awful ankle strap!

JORDAN XXI

ORIGINAL RELEASE
JANUARY, 2006

DESIGNER
D'WAYNE EDWARDS

COLOUR
WHITE / BLACK – RED

ORIGINAL PRICE
$175

D'Wayne Edwards' Air Jordan XXI design was all about cushioning customisation. Evolution of the IPS system (as seen on the AJXX) allowed ballers to choose between Air Zoom or Encapsulated Air in the heels. Not to be outdone on the automobile references, D'Wayne favoured the Bentley Continental GT as his vehicular muse. To counteract the proliferation of counterfeit Jordan product, a cryptic 'Authentic' message was applied to the ankles that was only visible under black light.

JORDAN XXII

ORIGINAL RELEASE
JANUARY, 2007

DESIGNER
D'WAYNE EDWARDS

COLOUR
WHITE / BLACK – RED

ORIGINAL PRICE
$175

The fighter jet theme was back in the hangar for the Air Jordan XXII in the form of the F-22 Raptor. Referencing the plane's distinctive camouflage panelling, reflective 3M wrapped the heels of D'Wayne Edwards' otherwise understated design. Visuals aside, the AJXXII was a high-performance beast that flexed a seamless bootie, double-stacked Zoom Air, hidden IPS and lightweight titanium-coated shank plates. By 2007, a roster of talented players had been handpicked to represent Jordan Brand in the NBA, and the Air Jordan XXII was treated to a solid series of Player Exclusives.

JORDAN XXIII

ORIGINAL RELEASE
FEBRUARY, 2008

DESIGNER
**TINKER HATFIELD /
MARK SMITH**

COLOUR
BLACK / RED

ORIGINAL PRICE
$185

With such a significant number up for grabs, it's no surprise the highly anticipated Air Jordan XXIII was entrusted to Tinker. Energised by the idea of fusing Mike's DNA into the shoe, Tinker went to work designing outsoles that resembled MJ's thumbprint and hand-stitching his initials on the upper. Tech-wise, the new Articulated Propulsion Technology – a fusion of Zoom Air and IPS – took care of business underfoot, while a new TPU chassis held the 3D-stitched upper in place. The new Nike Considered design concept used production processes aimed at minimising waste, providing a sustainable template for the AJXXIII that would also guide Jordan Brand into the future.

The Air Jordan XXIII was a showcase of advanced construction techniques and innovative technology, and the design still holds up today as one of the most legit models since Mike's retirement. Nike's strategy of dropping 23 pairs of the 'Titanium' edition in their top 23 doors for $230 was the icing on this landmark cake.

Troop/SPX

Published in *Sneaker Freaker* Issue 8, July 2006

EDITOR'S NOTE: WOODY

Laced with 'urban' flavour and repped by the likes of LL Cool J, Troop exploded in the late 80s. And it sank just as fast – a demise fuelled in part by malicous rumours that the company was owned by the Ku Klux Klan. But that's not what this feature is about. Back in 2006, I was contacted by Mike Rhodes, who had produced logos and shoe designs for Troop's UK distributor. After the interview was published, Clive King – Mike's old boss and the original owner of SPX – let us know he was less than impressed. As you'll read in our back-to-back features, there are two sides to this pound coin and no love lost between the former colleagues. Funnily enough, both Mike and Clive were far from budding hip hop impresarios back in the day, making this an even more culturally bizarre story. The interview with Clive was lost for many years, so this is the first time his response has been published.

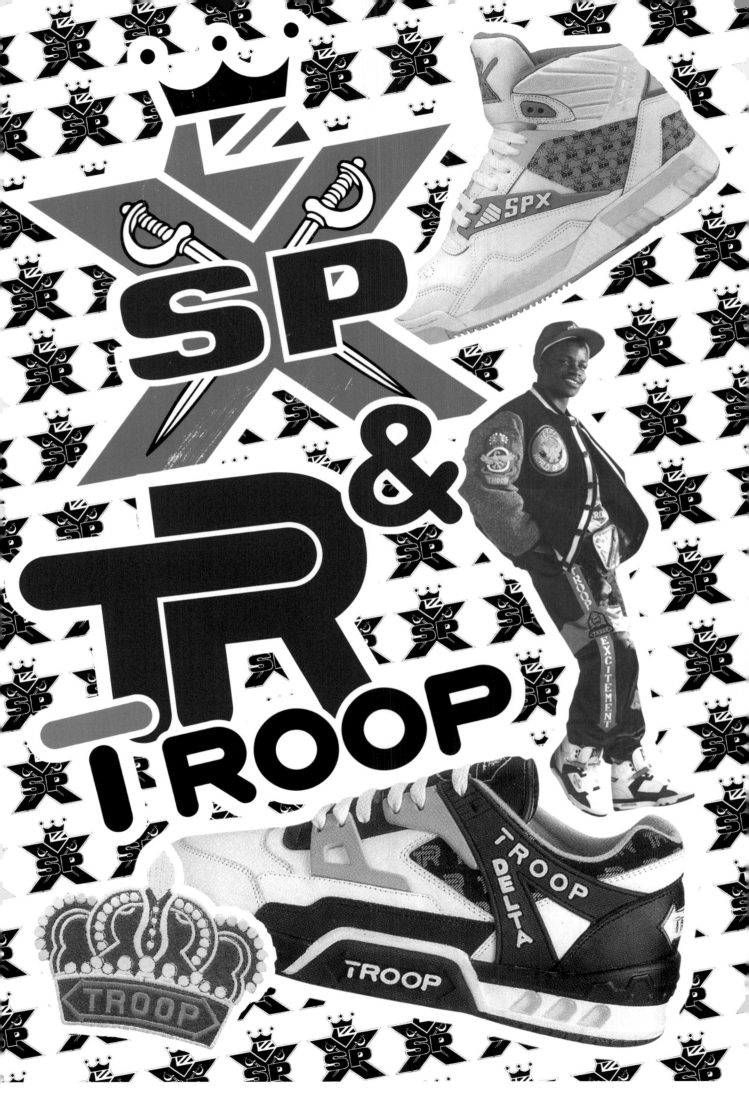

SP X & TROOP

PART ONE
TROOP
MIKE RHODES

Regular readers will know *Sneaker Freaker* has a soft gooey spot for the old Troop and SPX sneakers. If they aren't the craziest shoes ever released we'll eat our Kangol! Since both brands sank without a trace some years ago and photos and information are scarce, their histories remain mysterious. Back in 2006, we were introduced to Mike Rhodes, who did design and art direction for both brands from his UK office. Mike has some great stories and thankfully he kept loads of original design sketches and photos from the era. Amazingly, Mike was no spring chicken at the time and had no background in shoe design at all.

I understand you were heavily involved in Troop and also the creation of SPX. When was this?

I first got involved with Clive King, who owned the business, in 1988. I was running a design group in London and he was a neighbour of mine. He'd been working on Troop and wanted to launch SPX. He asked me to design the SPX logo, and from there I designed some of the product as well. My own business went a little bit wonky around that time, so eventually I joined him.

So you didn't have any experience in footwear design? Does it seem strange now to look back on that time and think about how you got into this crazy business?

It is very, very weird. I mean, I was already an old guy then. [Laughs]

We'll get to that. I've always had a soft spot for Troop because it just seems so outrageously of-its-time. How did you feel about the product you were developing?

Ummm... It was designed strictly to fit the brief and it worked very well. Troop was happening and I think it was putting the wind up the established brands quite a bit. I thought it was exciting. I don't claim it to be fantastic design, but it was right on at the time, you know?

I think it worked well and obviously appealed to the people who were buying the stuff. I found it easy to be quite honest. I had no experience in footwear design, but the technical stuff was done by the team in Korea. I knew what I wanted it to look like and they were able to interpret it within the technical boundaries of the time.

It's a very different world these days.

Yes, I don't know what else you can do with trainers really. At the time we were limited in terms of technical ability, because you could only do so much with the sole units. Once the manufacturing issues were solved it just seemed to go crazy. People are trying to put a bit more interest in shoes, like some of these more boutique designs. At the time, we were designing for high production numbers, and I'm not talking 400 or 500 pairs – it was thousands of units.

The set-up costs for a new design are bananas. Troop sneakers were quite complex and the costs must have been high when you were a small company.

I remember it cost about $80,000 for a set of sole units for something like the Street Slam back then. Goodness knows what it is now.

PATRIOT

Unreleased designs supplied by Mike Rhodes

That's a huge investment so it has to be right.
That's why the Portuguese factory helped ease SPX into the market. It was just an off-the-shelf sole unit that did the job. The factories just weren't up to producing the shoe as we wanted it. They kept breaking the needles on the embroidery on the side and they had all sorts of quality-control problems. Once it took off we had to go elsewhere to Korea; obviously it's all in China now.

Were you surprised to see the SPX Street Slam resurface?
I couldn't believe it but there they were as a full-page story in *FHM*. We were down in Covent Garden and I saw them in the size? store. They were a bit crisper than the Korean models, and much, much better than the Portuguese ones.

You must have wondered how the brand was resurrected all of a sudden?
It did surprise me. I think people think the shoes are older than they are. People have the impression they're a 70s thing when it was really a late-80s thing, which doesn't seem that long ago to me. Hence the boombox packaging used in the relaunch. You wouldn't have done that in 1989 because a boombox was already history then. So, yes, it did seem a little bit strange.

They were retailing for about £50 to £60 in the beginning.
I think you're quoting trade prices. Some of those shoes were selling for well over £100, which was one of the reasons why they stopped selling when the economy went a bit wonky. People just couldn't afford them.

Was the hefty price tag aspirational?
Well, obviously it made them desirable, but if no one can afford to buy them, the market tends to die a bit.

What was the reaction at the time?
It always amazed me when I saw somebody wearing the shoes. [Laughs] We deliberately targeted the hip hop crowd. We did a lot of PR through music magazines. It just took off. We were doing competitions with schools in London and we ran a competition for kids to design trainers. We were very involved with the rap thing. At the trade shows we had this rap artist there known as JC001 who was supposed to be the fastest rapper in the world.

You also had boxers on the team.
Yeah, that was a little bit later. Gary Mason, the British heavyweight champion at the time, was doing Troop. We got involved in a lot of sponsorship deals with up-and-coming boxers. I personally don't think the boxing scene, even with Lennox Lewis, was such a big deal. I think the music thing, with the rap and hip hop connection, was much stronger promotion.

Looking at the photos of the team that Clive assembled to run SPX and Troop it just seems so incongruous. You didn't exactly look like a bunch of hip hop gangsters.
Well, the people who were buying the stuff were 10 to 20 years old, I guess. All Clive's guys were middle-aged salesmen. Clive had a very incisive mind into what was wanted in the marketplace. I'd been in advertising and design from the late 50s through the mad 60s, so nothing surprised me. For that newspaper article I was dressed up exactly like they were. As I say, I was an artist and a designer, so really, my style would have been more casual than it was represented there. I was trying hard to be a businessman I suppose. [Laughs]

I have read that SPX stands for 'Sports Performance Extreme'.
Well, Clive was the guy and obviously when I got involved, one of the first questions I asked was, 'Well, what does SPX mean?' And what he said to me was, 'It doesn't mean anything. It was a sticker on a freight package.' He was sitting in an airport somewhere and he saw this sticker that was for something like Special Express something-or-other. Whatever, anyway, it didn't actually mean anything at all relating to the sports shoes. Where they got that from, I don't know!

MIKE RHODES
DESIGN & MARKETING DIRECTOR

Mike 47, has been in advertising and design for all his working life. Having worked for two of the biggest international ad agencies he branched out and ran his own design company for 15 yeras until joining Triple Three Leisure in 1989.

Mike is also responsible for all the design work on SPX footwear and clothing and for Troop footwear.

TOM CONGERTON
EUROPEAN AND UK SALES EXECUTIVE

Tom Congerton aged 42, began his career in the sports trade in 1981, starting out as a Sales Representative for London and major accounts for another leading brand in sportswear.

He has been with Clive King and Triple Three Leisure since its birth.

He now enjoys an office based job at Triple Three as European and UK Sales Executive.

Mike Rhodes back in the late 80s

Troop Archive

From the collection of Ben Weaver Photos: Alan Weaver
(Not designed by Mike Rhodes)

Major Low

Power Slam Low

Flag Series

Destroyer

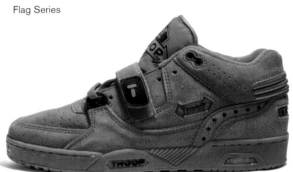

Factor MC Low

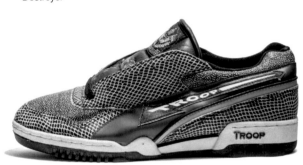

Acid Tiger

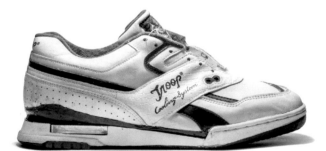

Cooling System

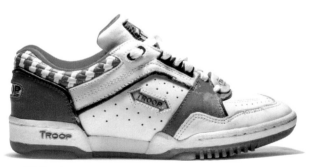

ES Court

Rapid Fire

Ice

Supreme

Smash

(Unknown Model)

Driver

Tracker

Slick Series

Transporter

Air Support

Factor High

(Unknown)

ROWDY

Unreleased designs supplied by Mike Rhodes

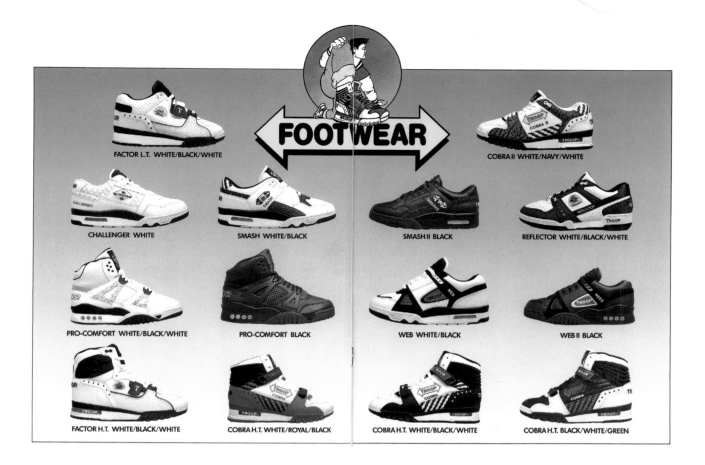

FACTOR L.T. WHITE/BLACK/WHITE

FOOTWEAR

COBRA II WHITE/NAVY/WHITE

CHALLENGER WHITE

SMASH WHITE/BLACK

SMASH II BLACK

REFLECTOR WHITE/BLACK/WHITE

PRO-COMFORT WHITE/BLACK/WHITE

PRO-COMFORT BLACK

WEB WHITE/BLACK

WEB II BLACK

FACTOR H.T. WHITE/BLACK/WHITE

COBRA H.T. WHITE/ROYAL/BLACK

COBRA H.T. WHITE/BLACK/WHITE

COBRA H.T. BLACK/WHITE/GREEN

The unifying thing was the lack of subtlety. You had hikers, aerobic shoes, basketball boots, urban hip hop styles. Did the shoes actually have any performance features at all?

I think they did actually. We gave them to a few basketball teams, no one big, but we were told that they worked very well. Everything was made to the highest technical standards. The HSS Corps in Korea were making Reebok at the time and they were making our shoes as well. So the stuff was being made with all their machinery and all the flex-testing and stuff was going on. Some of it was bullshit to be quite honest but the shoes were pretty good. I remember a cross-brace system that just happened to accommodate the 'X' in the SPX. So I wrote a load of bullshit about allowing lateral movement and all this sort of stuff. People just liked to think there was some kind of advanced system going on. [Laughs]

You weren't the only one bullshitting about their shoes.

One thing I wasn't too keen on was that Air Support System. I tried to make the most of it, but I think it caused a lot of problems.

With the air bubble in the heel?

No, it was more like a pump. It was an air cushion with valves in it to – supposedly – pump fresh air into the sole unit. It never really worked. I think it caused a lot of problems with returns because it would rattle about inside. In fact, I've still got a pair that I use for gardening which let in water and goodness knows what. I still occasionally wear some of the stuff I designed. Not as a fashion thing but just to go out in the garden.

Which shoe had the air system?

The Hiker editions mainly. There was a basketball shoe called Air Support, or the Air Support System. I think there's a drawing of it I can send you. I designed that particular boot in the Golden Sands Hotel in Penang. We were having a bit of a jolly out there after a tour – I think we'd been to Hong Kong – and I sat in the hotel one day and drew the shoe. As you've probably noticed, it's not quite as finished as the others. It was faxed from there to Korea for sampling.

It's amazing you could just sketch a shoe after a few pints and the factory would finish the design. I can't imagine that now.

We had some very good agents out there. Often they'd say, 'Oh, you

can't do that!' And I'd say, 'Course you can!' Sometimes it didn't work out, but a lot of the time it did. You've got to keep pushing the boundaries.

It's brilliant that you've actually kept a lot of the sketches because so much stuff has been lost.

We didn't think anyone would be interested in the future. I did throw away an awful lot of samples. I've got hundreds of drawings here that were virtually destroyed by a flood at my home. It was only a shallow flood, but because I had all this stuff laying around on the floor in one particular room – and they're all drawn with magic markers – the water destroyed them and they're all blurry. There's an awful lot that's been lost.

You always sketched by hand?

I've done that all my life. I can do that 'til the cows come home. I can just sit down and draw, it's so easy for me. What's difficult is messing around with computers.

Do you think Nike and adidas were worried about Troop?

Yeah, no doubt. You can't point fingers at anybody in particular but Troop was killed dead in America because of the rumours that were put about by worried competition. They were saying that the Ku Klux Klan financed the brand and that we'd put these racist messages in the heel. I was forever fighting off comments and questions about it. All nonsense of course. So yeah, I think the big brands were very, very aware of what we were doing and it shows in some of the stuff they were doing.

Troop loved 'elephant skin' leather texture, which is generally considered a Nike signature nowadays. Who was copying who?

We took inspiration from wherever we could find it. And if we saw a trend developing with Nike then sure, we'd have a go. I mean, some of those shoes – the later ones I was working on – were based around Nike's Mowabb. Unashamedly.

No wonder they looked so good!

We were doing our versions of things and they were doing the same. I'm pretty sure that Troop in America, the original brand, were first with that kind of elephant skin and textured leather look.

Carding. 2/11/92

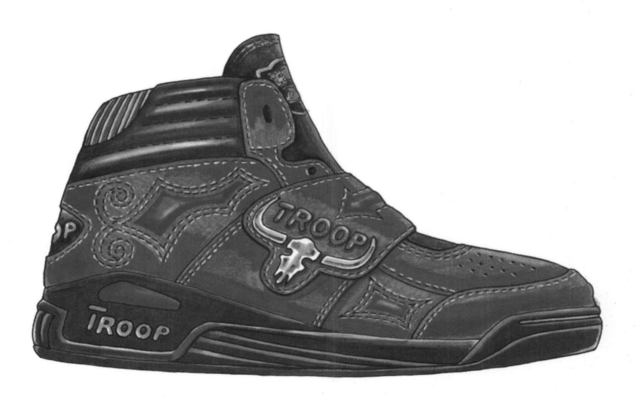

Unreleased designs supplied by Mike Rhodes

Opposite: Original SPX catalogue

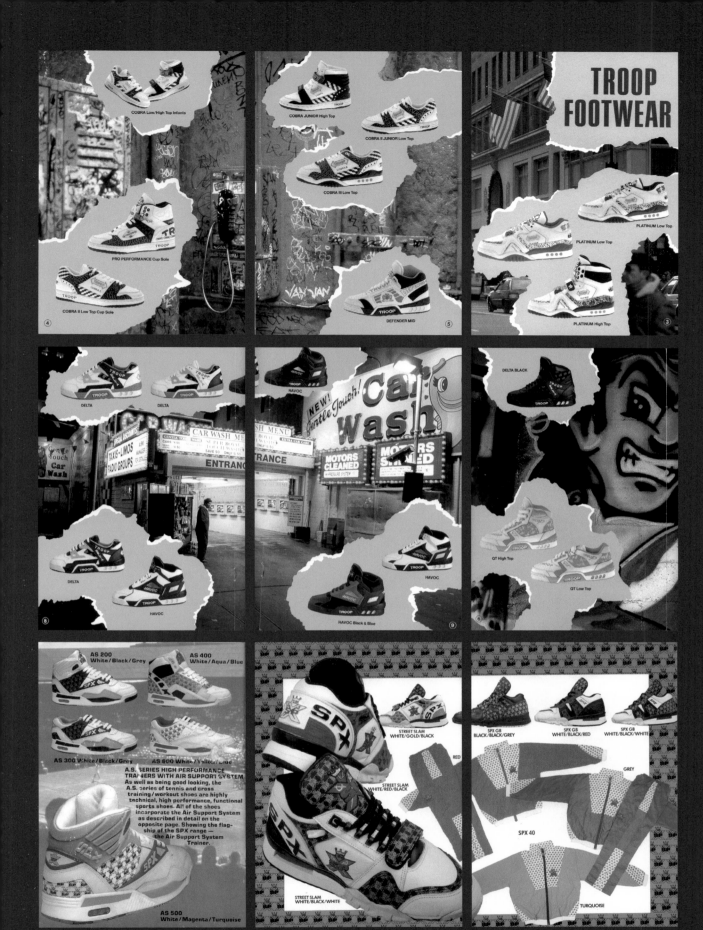

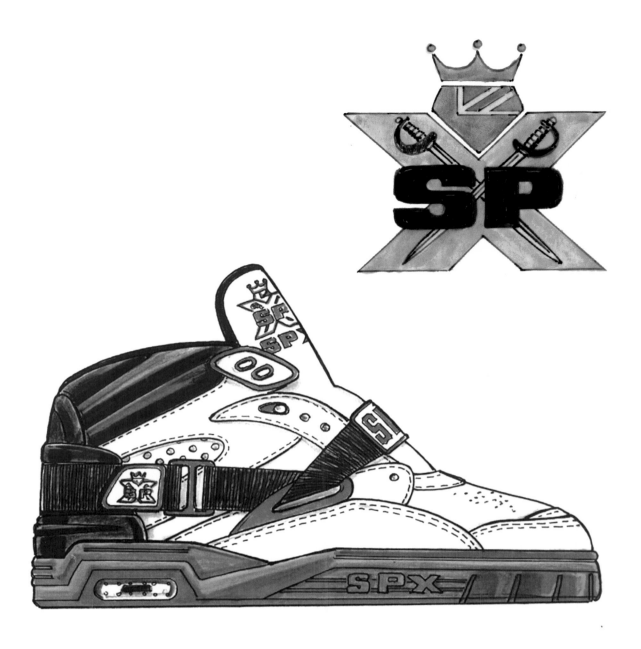

Unreleased designs supplied by Mike Rhodes

Did SPX ever try and crack the US market or was it just an English thing?
Oh yes, we did. We had distributors over there. The whole idea was to try and cross the British Knights heraldic look with the bling thing. And it did go down quite well over there, I must admit. It all went a little bit wonky not long after though. I carried on working on Troop for the Dutch distributor, did a whole range of stuff, but the brand was slowly being trashed.

You mentioned British Knights. How did they fit in with what you guys were doing with SPX and Troop?
That was really the brand that gave Clive the inspiration to do SPX. It was an American brand, even though it was called British Knights, and it was the inspiration for SPX. Clive was directly attacking that. And his brief to me, with the SPX logo, was to make it a heraldic type of thing. It was a big influence, but I think we blew them out of the water.

Did the similarities in design cause any friction between BK, SPX and Troop?
No, I think it was always Clive's intention for Troop to remain very much a street brand and to try and take SPX forward into more

of a performance brand. Troop was trashed in the end – shame, really – but you still see it around in the weirdest places. We came across a load in a bin outside a cheap shop in Spain for some ridiculous amount of money – the equivalent of six or seven pounds for a pair of shoes.

I saw them in New York a while ago, someone had bought the licence to make them again. The shoes were a bit crap to be honest and they released some of the more boring styles, which was odd.
I don't know who was making them. It could be anybody to be honest. When we were getting the stuff made in Korea, it turned out the guy was making extra stuff and selling it to South America without us even knowing and using some of our designs, presumably adding some of his own. He was doing the same with SPX. It's a cut-throat and very crooked business, the shoe game. Other people were just turning the letters around and instead of SPX, it was SXB or DSX or something like that, but the styles would be exactly the same.

Were the gold badges on the laces intended to look like a police badge or something?
That's one of the original Troop styles. I didn't actually design that,

27th Nov 1989

FOR TRIPLE THREE LEISURE LTD

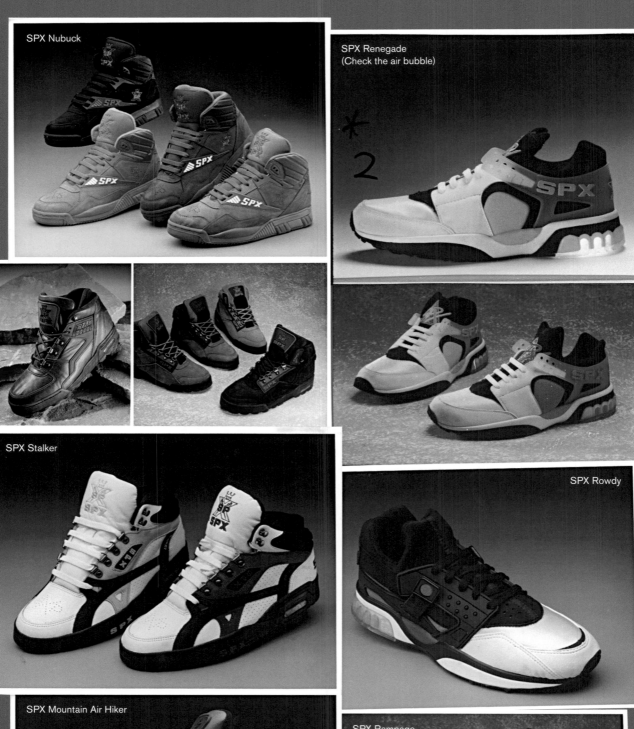

SPX Nubuck

SPX Renegade
(Check the air bubble)

*2

SPX Stalker

SPX Rowdy

SPX Mountain Air Hiker

SPX Rampage

	WHITE/GREY/BLACK	WHITE/BLACK/WHITE	BLACK/TAN
A	WHITE	WHITE	BLACK
B	WHITE WITH GREY PRINT	BLACK WITH GREY PRINT	TAN WITH BLACK PRINT
C	WHITE E.P.	BLACK EP	BLACK EP
D	SILVER OUTLINE EMB	SILVER OUTLINE EMB	GOLD OUTLINE EMB
E	WHITE PU	BLACK PU	BLACK PU
F	WHITE/BLACK SPX & LOGO	WHITE/BLACK SPX & LOGO	BLACK/WHITE SPX & LOGO
G	BLACK EMBOSSED & PRINT	BLACK EMBOSSED & PRINT	WHITE EMBOSSED & PRINT

GREY – PANTONE COOL GREY 2
TAN – AS TIMBERLAND SAMPLE

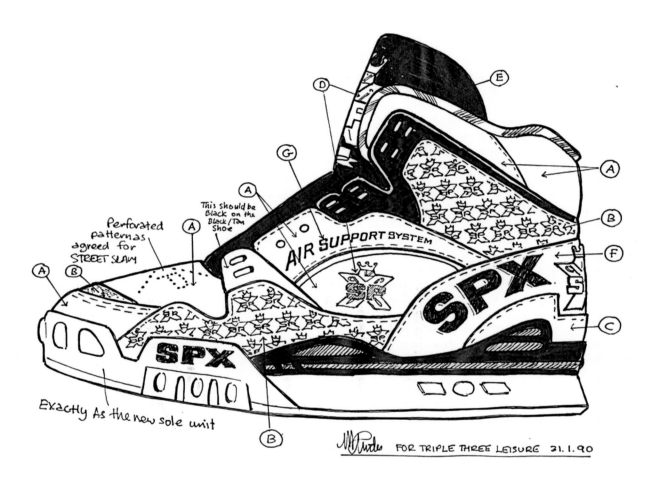

Original SPX design sketch

but I would say that was almost certainly the case. The Troop logo itself is a double-ended arrow. That's taken from a street sign which means 'both ways' or something like that in New York. The brand is based around New York so that, I'd say, is almost certainly intended to be like a police badge. I reworked some of those designs and updated them, but basically those early styles came from America designed by this young guy Theo in the warehouse.

Do you have any other funny stories from back in the day?
Funnily enough, as you rang I was going through a lot of old stuff and I came across a whole load of photos when we were out in the Far East. Clive was wearing these weird clothes and the whole gang was out there in Korea going around all the factories to get stuff sorted. You're not interested in the clothing, are you?

Of course! The big embroidered patches and the all-over prints and the monogrammed effects are mad.
See, you're still a young man. You're younger now than I was then. [Laughs] You can do the maths. Yeah, it was just a mad, crazy time and I look back on it with affection. It's sad it all went wrong, but there you go, these things don't last forever, do they?

No, they don't.
It was very much a faddy thing. Whether it would have carried on, I don't know. I could go into all sorts of personal reasons why the brand failed but I'm not sure that's a good idea.
•

British boxer Lennox Lewis

Photo: Clive King

PART TWO
TROOP
CLIVE KING

After the interview with Mike Rhodes appeared in *Sneaker Freaker* Issue 8, we received an interesting email from Clive King, Mike's boss back in the days of SPX and Troop. It seems Mike may have overplayed his role somewhat. By quite a bit. Whoops! Mike's employment was terminated with extreme prejudice for reasons unknown, and bad blood remains. At this point, we also have to admit that this interview was lost; well, it may be more precise to say we forgot about it for many years. It was only during the making of this book that we rediscovered the transcript. Enjoy part two of our Troop feature!

How did you get started in footwear?
When I left school I had an engineering background and then went into the motor industry. One day I saw an advertisement in *Sports Trader* for Sergio Tacchini, which hadn't been sold in the UK before. So I started working with Tacchini and took the sales up from zero. Originally, they wanted to put the product into places like Harrods and Selfridges. But I actually put the product into the small local shops and that created a football following. Lacoste, Ellesse and Sergio Tacchini were the three hot brands on the street. Pricewise, you could sell a tracksuit for around £100, which was very, very high.

How did that lead you to Troop?
Tacchini decided to distribute their own product so I started producing my own brand called Skywalkers. The Skywalkers sold really well and I had to go to the Far East to look for a bigger producer. That's where I saw Troop for the first time. Also, I did get a letter from George Lucas saying I couldn't use the Skywalker name [laughs].

He's well known as a litigious person.
Yeah, he is. I've got a few letters from different people over the years for producing things with a similarity in some way or another.

Now, the reason we're talking is that you saw our feature with Mike Rhodes. I understand you were a bit miffed. Do you want to set the record straight?
Well, just to set the record straight, the original Street Slam shoes were actually developed by me. Mike made the logo to my brief. I said to him, 'I've got S, P and X. I want the X like this, I want the swords in the middle, I want the crown on top. I want it just like that. Can you do that?' It's a misconception that he actually developed the brand when he didn't. Also, he actually said that 'All Clive's guys are a bunch of salesmen'. I think that's very unfair. Basically, the company existed for 10 years and he only worked with us for two! When you've got a small company and you start from scratch, and you're trying to innovate and be creative and do something different that no one else has done before and then for him to say 'All you guys are a bunch of salesmen!' is unfair.

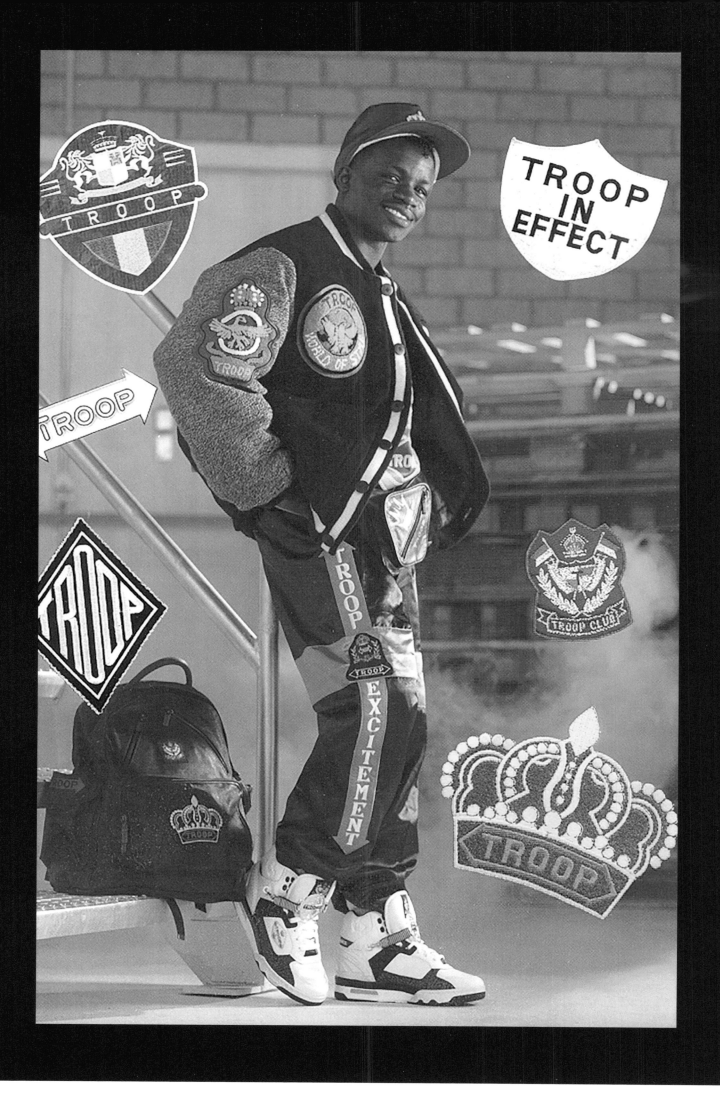

Clive King

Mike never developed any of the original Troop gear. They sold because they were actually designed and developed in New York. And they sold fantastically well everywhere. And when we tried to adapt things, it didn't work in the same way. One of my big lessons actually in the whole experience of doing this is to *never* take your eye off the ball. If you think someone else can do it only because they say they can, you have to watch very carefully.

You must have been surprised to read the story.
Yeah. There's quite a lot of bad feeling between us. Mike was actually sacked. He was only with the company two years and he was fired.

I'd love to know why but I won't ask.
Yeah, yeah. I see you put in your editorial that you were going to do another big Troop story? Did that ever work out?

Actually that was a joke. I never thought we could actually keep the story going and then all of a sudden you popped up. Then the day after we spoke, I got a package from the USA with some crummy new Troop shoes, which was a weird coincidence. Let me backtrack for a minute. What did you think when you first saw Troop?
When I saw the Cobra for the first time I thought 'Wow! This is something special!' So I contacted Troop in New York and started a very difficult negotiation with William Kim and Harvey and Teddy Held. They said I could have the European distribution but I had to place an order for $1 million!

Sounds like Dr. Evil. And did you make it?
Not having a million dollars in my back pocket I just said, 'Yeah OK, I'll go for it!' I understood the product. They had probably four very

good shoes that seemed to be perfect for the UK market. It was really buzzing in New York. Then they got into Foot Locker and they were doing some really big numbers. I think they'd taken the brand to about $30million in about 18 months. I had to go back probably three or four times to secure a contract and once I thought I'd secured the European market, Herman Gazan popped up and said, 'Hello, I want a contract as well!' In the end we decided that we'd try and work together.

The photo of your team from that era is classic. There's at least one Ferrari in the car park and a big Mercedes as well. You had a bright blue blazer and were sitting up front.
Yeah, I think that stunt was an editorial for *Harper's Magazine*, which was sold in the UK to trade people. That story was actually the history of Triple Three, trying to hype the brand up for the coming year. I think it must have been 1990.

You can never quite tell the year sometimes when you look at it.
I think it was around 1990 because it was 88 when I started working with Troop. Within maybe six months, Downsport ran into problems because of all the bad press with the KKK. And there was a lot of in-fighting between the two brothers and they had problems financially. So I just took as much product as I possibly could out of America and started getting the production rolling in Korea to bring back into Europe.

Do you really think the rumours finished Troop off in the end?
Yeah, I think it did. Wesley Mallory was the sales manager and he had to go down somewhere in the Deep South and in front of 400 or 500 people start cutting open shoes to see if there were racist remarks inside. I think it was on CBS News.

Photo: Alan Weaver

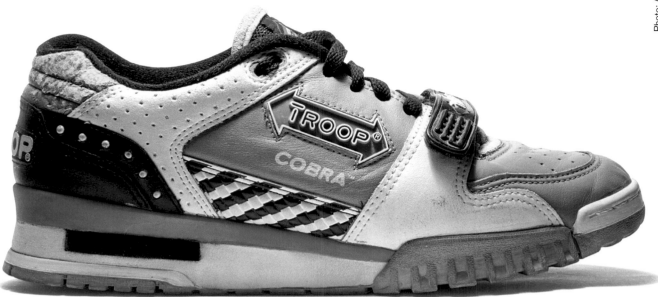

Cobra Low

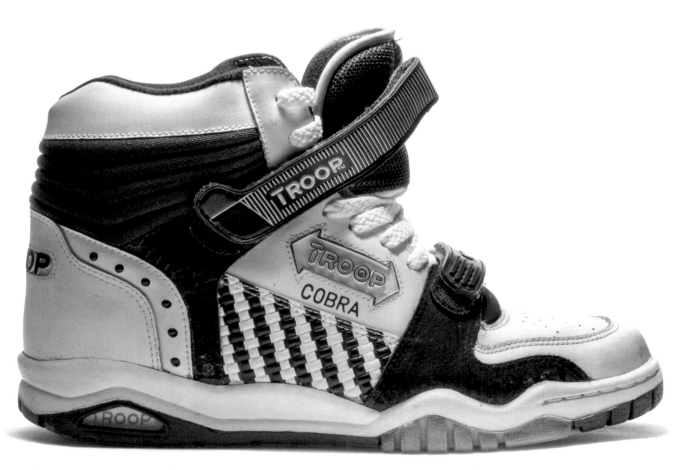

Cobra High

When I saw the Cobra for the first time I thought 'Wow! This is something special.' So I contacted Troop in New York and started a very difficult negotiation with William Kim and Harvey and Teddy Held. William said I could have the European distribution but I had to place an order for one million dollars!

Clive King

1988: Troop booth at London trade show

How does something like that get started? Nowadays I guess you'd have a team of PR people working out some strategic spin, but it's very hard to turn something like that around with word of mouth.

I don't know. I think it could even be something as simple as the YKK zips they used. When we first saw the product and they said, 'We're being accused of being KKK' I told them to change the zip producer! Simple as that. They say it was started by another brand and the only people who will ever know that would be Teddy and Harvey Held because they were on the frontline.

It must have been heartbreaking to watch your own business destroyed by something untrue that you can't control.

Yeah, I think it grew very, very quickly and it also went down very, very quickly. There's a lot of financial implications when you start a brand from a small base, you need to bring in partners to help finance the whole thing. We actually carried on after Downsport went into Chapter 11 in 1989. We went to Korea and bought the moulds from the factories and carried on producing the products.

The shoes were very expensive.

They were the most expensive sneakers you could buy. All the materials were top-end. The factories we were using were the best. I don't think I actually thought about what it cost, I just wanted it to look right. In all fairness, the original Troop product was the best. When we started to develop and design Troop footwear it never sold through the same way. Obviously Theo got it right, he was the original designer and he actually came from the warehouse. They had the right product at the right time. They had probably five models which were all good sellers and it was really crazy.

Troop had such a vulgar aesthetic. Did you see it as a long-term business?

Well I was probably quite cheeky because I got the Troop distribution and then I met Larry and Jack Swartz who ran British Knights. I was trying to set up distribution for BK to cover my backside and make sure I had something else to sell if the thing fizzled out. Larry and Jack told me I couldn't have BK because it competed with Troop.

I can see that. It's also 'Summer of Love' in Manchester, so you had a lot of new things happening in England at that time. But the UK's not particularly known for picking up American trends.

I've never seen anything to this day as outrageous and that was what was unique about Troop. A brand that changes the look of everything only happens probably once every few decades. They just got it right for that moment you know? We had massive TV exposure because we employed somebody in the music industry who placed the product in the latest music videos by people like EMF, Technotronic, Beats International, Norman Cook and Cash Crew.

Let's rewind back to SPX, because that was totally your baby.

I actually designed the first Street Slam shoe for SPX. This was probably in 1988 and the Street Slam shoes came from when I was working with Sergio Tacchini. There was a big influence from the likes of Vuitton and MCM, the luggage people. SPX actually was formed from the concept of a top-end luggage brand, but with a sort of street look.

Can you clear up the mystery of the SPX name?

SPX actually derives from Skywalkers – it's the 'S' from Skywalkers, the 'P' from Performance and the 'X' from Xtra. We couldn't use

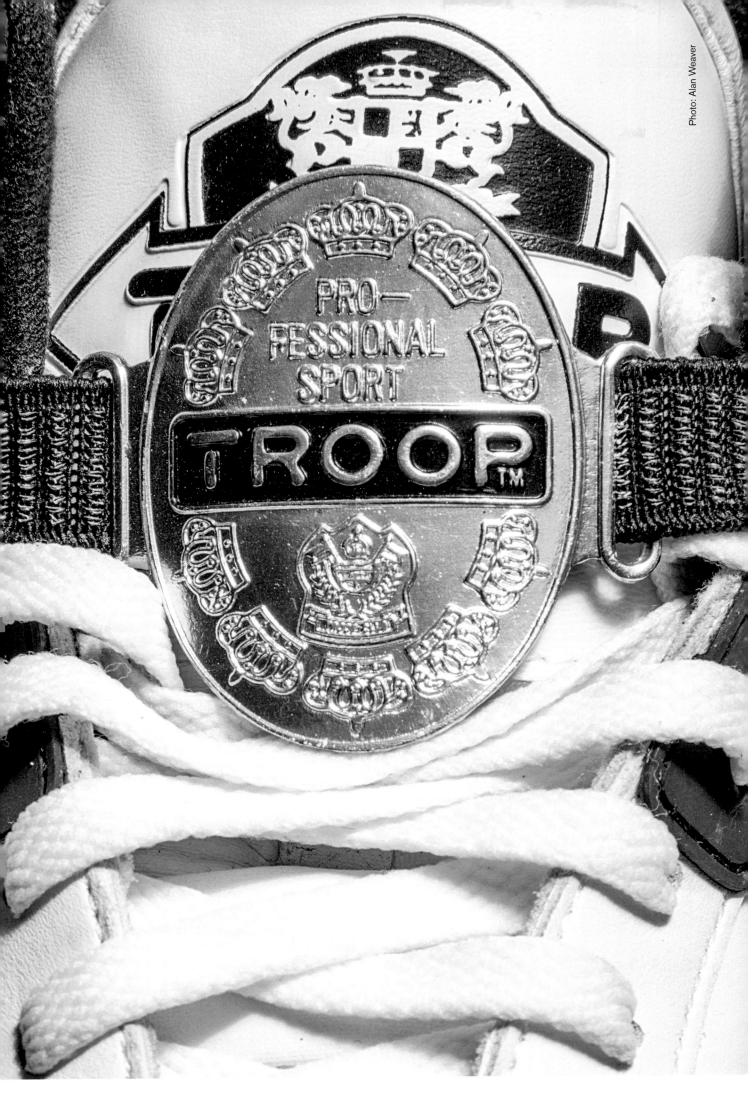

PRO—
FESSIONAL
SPORT

TROOP™

Clockwise from top left:

Tom Chang

Clive King and Mike Rhodes

SPX 'Castle' booth at Atlanta tradeshow

Synchronised dancers at SPX
Sports pavillion, Chicago

SPX Sports pavillion, Chicago

Lennox Lewis at Atlanta tradeshow

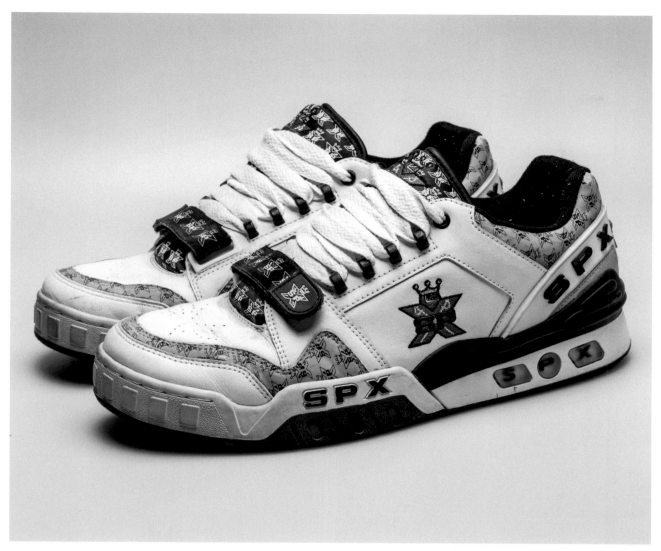

SPX Street Slam Lo

Skywalkers so I shortened it to SPX, which seemed to work quite well. It's not easy bringing in a new brand, but when I look back on SPX I saw how one model can make a brand. We sold over 300,000 pairs of Street Slam shoes in a two-year period. Although I was also doing Troop at the time, we were distributing SPX to probably 15 countries in Europe. We were selling into Japan strongly and we had meetings with Foot Locker in the States.

So what happened?
We started producing the Street Slam in Portugal. After that we had to find a bigger producer, so I went to Korea. But around the end of 1991, the market changed. The GB sold relatively well, as did the Stalker, but we never really moved forward with the actual product development to keep sustained interest. It's like music. You've got one good album but you've got to keep producing the next album. The original concept and product development I actually did myself. Everything about it, down to a small detail, was exactly how I wanted it.

I employed Mike Rhodes and he never really got to grips with the brand because he wasn't actually coming from a sportswear background. He was a graphic designer. I let Mike design some of the shoes after that and it just didn't work. In the end we had a situation where we had 150,000 unsold pairs in the warehouse. So it was a big problem!

Some of the shoes still look good.
Well, the main reason SPX came off the market from our point of view was financial. It's ironic actually that you're speaking from Australia – we were actually financed by Westpac, an Australian bank. We had an overdraft with them for around £4 million. And they just said to us, 'We're pulling out the UK market and you have six months to repay your overdraft facility.'

Any regrets you couldn't keep it afloat?
Yeah for sure. I've seen they relaunched SPX with the Street Slam and a couple of other products in the European market. When the company closed in 1994, the new bank appointed a receiver to sell any assets and unfortunately all the trademarks were registered with the company so they were sold to somebody in Taiwan.

Footwear is an addictive business isn't it?
Even for me now. Footwear is something that's in your genes, you know? Once you've done it and you've been there with a brand, it's such an exciting thing when a brand takes off. If you create something that works, then you know you've got to do it again.

Can you leave us with a funny story?
When I visited Korea one time I had a stopover in Seoul. I'm in a hotel bar on my third Jack Daniels, passing time as my flight was booked at 9:30am. I'm just about to leave my seat and a person I knew from the shoe biz walks in. That was it! Three more hours of Jack and I remember waking up, racing to the airport and the nice check-in person told me that the gate had closed and I had to buy a new ticket. As I boarded the plane or the 'Garlic Express' as we called it, I noticed all the Korean passengers were making a lot of noise. As we lifted off, in the field down below, the fire service was putting out the flames of what I thought was some sort of training exercise.

When I arrived in Pusan, my agent, Mr. Chang, and his assistant, Miss Chung, were in tears and I was somewhat bemused by the massive amount of hugs and gestures. I knew the orders given to them were big, but then Mr. Chang told me that the 9:30am plane from Seoul had crashed, and of course I had not told them I missed the flight due to alcohol abuse. Thanks, Jack!

•

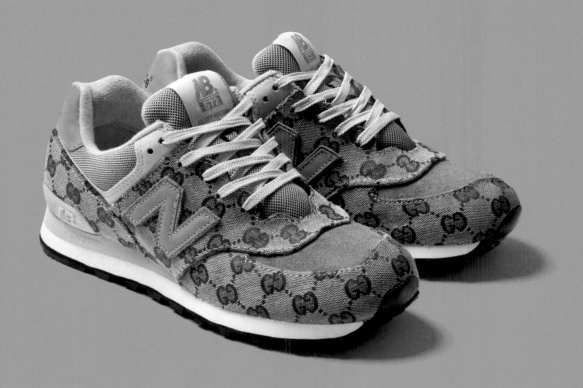

Dapper Dan

Published in *Sneaker Freaker* Issue 26, April 2013

EDITOR'S NOTE: WOODY

It might seem incongruous that Dapper Dan is included in this book, but his unique role in the evolution of street culture is undeniable. My unlikely connection started when I bought a pair of New Balance 572s wrapped in a Gucci-style jacquard. Though billed as the custom work of 'Dapper Dan', I was sceptical of their provenance and kept them on ice for future reference for more than a decade. Some 20 years after he mysteriously walked away from his business, Dapper Dan popped up again in 2013. Using my Newbies as collateral, I managed to secure the second interview after his comeback. Today, Dap's place in history is assured, and he even stars in the current Gucci window campaign. Order restored for the grand master of Harlem fashion!

DAPPER DAN

THE ORIGINAL HIP HOP TAILOR

PORTRAITS **PETER RAD** OTHERS **DAPPER DAN**

From his eponymous store on E 125th in Harlem, Dapper Dan (real name Daniel Day) presided over a unique fashion emporium in the 80s and 90s. His Uptown clientele was a heady mix of hustlers, street cats and hip hop royalty, all of whom shared a mutual love of what Dap himself called a 'macho type of ethnic ghetto clothing'. That's Harlem shorthand for streetified luxury, a glorious melange of status symbols such as mink, ostrich, crocodile and python married with his own trademark 'reappropriations' of Vuitton, Gucci and MCM yardage.

LL Cool J, Big Daddy Kane, Salt-N-Pepa, Run-DMC, Fat Boys and Public Enemy publicly repped Dapper Dan hard and his fame spread beyond the local hood. Peep Eric B and Rakim's Follow the Leader and Paid in Full for classic Dapper Dan outfits in full effect. Mike Tyson famously punched out opponent Mitch Green in front of the store while on his way to pick up his classic 'Don't Believe the Hype' jacket. The place was notorious. Jackets, bags, hats, two-tone jumpsuits with all-over prints – there was nothing Dapper Dan wouldn't cover in acres of hand-printed and embossed leather.

Gucci seat covers, LV-inspired upholstery and a famous convertible lid for Rakim's Jeep showed Dap's talent for entrepreneurial diversification. Another iconic ensemble was a Louis Vuitton jacket with huge gold Mercedes badges. Less known were the sneakers that matched his jackets, but shoes were definitely on the menu at Dapper Dan. The Fat Boys for example repped Nike Air Force 1s with Gucci Swooshes on the cover of their long player Crushin'. Nearly everything was a one-off designed for an individual, making Dapper Dan one of the original customisers. As his fame and fortune grew, the European fashion houses swooped. Infuriated by the very public knock-off of their trademarks and inflamed by their utter rejection of African-American urban culture, they took legal action against Dap and he went underground.

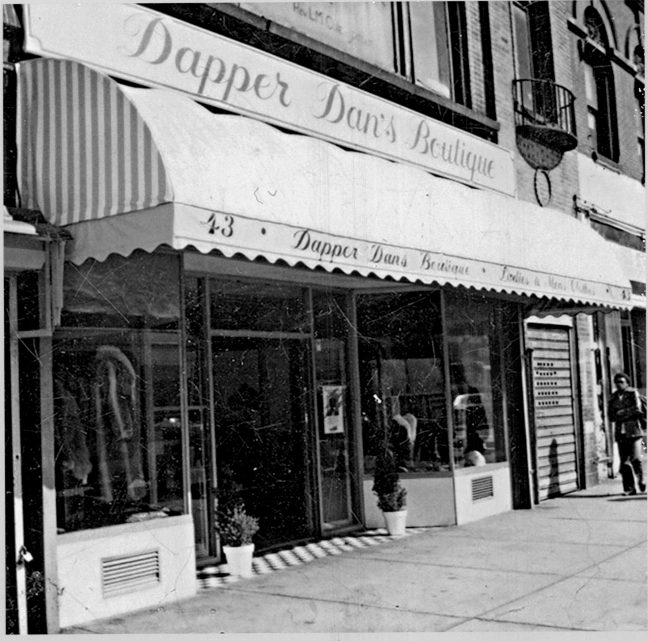

1984: Dapper Dan's Boutique in Harlem

Fast forward. A few years back I scored a pair of sneakers that were purportedly made by Dapper Dan. At the time I thought I'd struck solid gold, right up until I was overcome by a niggling lack of proof. Could they be counterfeit Dapper Dan? The thought made me laugh. The shoes were well made and looked right as far as the era went, but all I had was a few random Google crumbs to piece together the story. Without any solid evidence of Dapper Dan tricking-out New Balances, I reluctantly retired them to the Sneaker Freaker archive.

I had a feeling I'd finally get to hear their story one day. The only problem was that Dapper Dan hadn't done an interview for 20 years. The trail was cold. Until now.

In late 2012, JAY-Z's Life+Times video channel popped up with a brilliant interview to kick-off the launch of Dap's new website. Still a natty dresser, hip hop's original gentleman was back in the limelight and loving it. Charismatic and ice-cool as ever, Dap swapped stories with his good friend Pee Wee Kirkland as they reminisced about Harlem and the good old days.

It's a contradiction, but Dapper Dan is one of street couture's most influential and most mythical characters. Twenty years of flying way below the radar might have dulled his stature among young folk who barely recall the previous day's blog roll, but it has also bestowed an enigmatic, almost grandfatherly imprint on his stage name. Judging by the recent hashtag trail, he is once again being name-checked and courted by the new school of New York street aristocracy.

Dapper Dan changed fashion forever. In fact, his legacy runs deeper now than it did even at the height of his outré fame. Intimidated and threatened by the implications of hip hop's glowing admiration in the 80s, the European fashion houses now actively court the affection of Pharrell and JAY-Z. The same brands that once tried to put him out of business now owe him a monumental debt. Kanye's love affair with Louis Vuitton is just one example of how interconnected the two worlds have become.

And those New Balances I bought years ago? Turns out they are Dapper Dan. Happy days!

Diane Dixon

How did you get started in the fashion industry?

I've always liked dressing and fashion, but I'm a guy from the street who didn't want to be in the street, so I decided since I knew all the hustlers in Harlem that I would open up a store. In the beginning I was buying brands then I discovered that some companies wouldn't sell to me. So I decided to teach myself how to produce garments. After that I learned different techniques and how to do things that nobody else was doing and that's what took me over the top.

How do you describe the Dapper Dan style?

I would attribute my success to making sure I was never defined. I would do what you would call personal collaborations. I'd tell a person what's possible and how we can just mix it up. I never wanted to do like Cross Colors did or Karl Kani, being boxed in and noted for just one thing. I wanted everything separate from everything else. Each customer had their own idea and that's what kept me around and generated excitement for so long.

What's your take on Harlem style right now?

Right now it's a bit challenged. We got our style from the older guys on the corner, but now, what's happening is the younger set are influencing the older guys. They still want the things that Harlem always liked. Alligators and lizards and minks and things like that.

That's always a mainstay here, always popular, but the younger guys are experimenting, pretty much with that skateboard look, like Pharrell and Kanye.

Were you a hip hop fan or was it just fashion?

Well, you know what? A funny thing about my generation is we consider ourselves the first hip hop guys. They say hip hop started in the Bronx, but we were already doing it in Harlem. We would have house parties and somebody would come along and start MCing to get the party all pumped up, making up rhymes to go with the music. I would consider myself a hip hop fan right away, especially with the exciting things the Fat Boys were doing and Jam Master J.

It must have been cool to have those personalities coming in your store all the time.

Oh, yeah, it was great. My nephews and nieces who I had working around the store were very excited.

You mentioned mink and crocodile. Your reputation was founded on the way you adopted symbols from luxury brands and brought them into Harlem.

Well, you know, it was actually all about the bags. When Louis Vuitton bags was out and the little clutches, it was a status symbol.

Above: Eric B & Rakim (Follow The Leader)
Left: Dapper Dan with LL Cool J
Opposite: Dapper Dan x New Balance 572

To give them more status you got to give them more of the symbols. So I said, you know what, maybe I'll just make jackets and vests and pants and boots. Eventually that led to me doing car interiors and tyre covers for their Jeeps. But it was all about status.

I was always curious whether you saw any political significance in the way you used those symbols?
More importantly, I actually saw it as a challenge because I was shut out. I never thought that I would be accepted and I wanted to make a statement that I could do it. And on a street level, I wanted to make a statement that I could do the same thing that they're doing, but even better, and it would be more attractive to my ethnic group and to the inner city people. It was also an opportunity to thumb my nose at those big houses that wouldn't sell to me anyway, you know?

You got into a little legal tangle with those brands eventually though.
Yeah. They sued me, so I had to start all over again. I was getting too much publicity with Mike Tyson and all the rappers naming me in all the songs, so that's why I went underground.

You gave those brands a different kind of fame, a street credibility. They obviously didn't see any value in what you'd done for them.
They didn't. They really, truly didn't. They didn't wake up until the other brands started seeing the impact of urban wear and how hip hop took it around the world. I'm happy for that and I'm happy for what's going on now with Kanye and Pharrell working with the big houses that would not take me on early on, you know?

Did you see Kanye's shoes for Louis Vuitton?
Yeah, I saw the red sneakers. I've been trying to follow him closely and I'm excited about what he's been able to do. I hope I had something to do with him being able to be where he is today, as far as fashion's concerned.

I'd say you definitely did. Now I wanted to ask you about sneakers. It's probably the least well-known element of the Dapper Dan story. How did you get started in footwear? Was it a customer's idea?
In Harlem, we always wanted our shoes to match our jackets. So even in the very beginning, I got requests from guys to do sneakers. And if you look on the Fat Boys *Crushin'* album cover they got Gucci jackets on and the Nike sneakers with the Gucci on it. After that everybody wanted either their boots or their sneakers to match their jackets. Even the hustler who popularised it the most –

Alberto Martinez, better known as Alpo, one of the main characters in the movie *Paid in Full* – had the espadrilles that matched his jacket. So, it's a thing I always did because it increased the sale of the jackets. It had to be a top and bottom hit, you understand what I'm saying?

I do! What did you think when brands like Troop started to appear?
You know what? Troop did not have the status of Louis, Gucci, or Fendi, so it was never really popular in Harlem. It was popular outside of Harlem because of LL Cool J. Then the word went out that Troop was owned by a supposedly racist company (the KKK) and controversy erupted. When my shop was open, nobody was interested in Troop. It wasn't rich enough and it didn't send out the type of signal that my clientele wanted.

I always saw Troop as a mutant imitation of that luxury look, and I know LL Cool J was a customer, so I had to ask. Now, I bought a pair of New Balance 572s two years ago, and they were sold to me as Dapper Dan customs. I have never shown anyone these shoes. Did you make them?
Yeah, yeah, I did! New Balances was popular and I used to wear New Balances to jog in. New Balances was popular among a certain group of guys who wanted to break away from the norm. So yeah, we did a lot of New Balances for customers.

That's funny, I'd have never associated NB with Dapper Dan 'til I bought them, but I'm glad they're not a copy. How physically involved would you have been in making these?
Oh, I made them! We would buy the shoes or the customer would bring them in and I figured out how to cover them in fabric. I got a special kind of glue and I would take that glue, cut a pattern out to fit that sneaker and then we would glue it on. Then, to ensure that it would never come apart, I used the sewing machine to tack the fabric on. That worked out great.

This pair is from 1991 but it still looks in remarkable condition and I'm sure I could still wear them now. Your technique held up.
Yeah, we took our time. The special glue we used is the glue that was developed especially for the leather business. We were very successful at doing that.

I also wanted to know where you got the fabric from. Is that something you actually had made?
Originally we were getting the fabric by taking bags and garments and cutting them up. But then I came up with a way to print onto

Dapper Dan x LV Air Force 1

1988: MCM & LV custom jumpsuits

1987: Custom Gucci and Fendi

leather. And that's when the business just went through the roof because Louis doesn't print on real leather, even today I don't think. So I was printing Louis and Gucci and Fendi on real leather. That was unheard of. And nobody could copy me, because nobody could figure out how I was getting the ink to stick. Even when you look at the interview that I did for JAY-Z's Life+Times blog, I have a jacket that's 25 years old and the ink hasn't faded yet. After that I started embossing leather, way before the major companies were doing it. Now you see Louis Vuitton embossed bags. It was cutting edge. I tried to stay on top of the technical things that could be done with fabrics and stuff like that.

There's a massive counterfeit Nike industry in China. They did the same thing you did, using LV prints on Nike Air Force 1s. Did you ever see them?
Yeah I did. Way back, there were these guys from a store in Chinatown in New York that would send people around to buy my jackets, send them to China to be duplicated and then bring them back. One of them even admitted it to me later on that he copied so many things that I did. I was familiar with what they was doing. I had a window, because the Chinese would copy what I was doing. I might make 700 pieces but they would make 70,000 pieces and flood the whole world.

What happened to all the jackets that you made, especially from the 80s? They must be worth quite a bit now.
Yeah, absolutely. They're collectors' items. In fact, Bill Gates' friend got in touch with me about buying some for a hip hop museum.

Microsoft Bill Gates?
Yeah, Bill Gates. The billionaire. He put up some money and had someone go around to try and find original pieces that I made.

Thanks so much for your time. From everyone who's admired your handiwork but never got to hear your story first hand, it's been great talking with you. I'm quite chuffed to know I have a pair of Dapper Dan New Balances.
Oh look, thank you for the interest you have in me and thank you for getting the story from me about what it was all about and where it came from. So I appreciate everything you guys are doing at *Sneaker Freaker*!
•

Air Force 1

Published in the Nike 25th Anniversary AF-1 zine, 2007

EDITOR'S NOTE: WOODY

This story was originally published in a Nike fanzine to celebrate the Air Force 1's 25th anniversary. At the time, the AF-1 dominated the streets of the Big Apple. Downtown to Uptown, West Village to the Lower East Side – every second New Yorker seemed to be rocking white-on-white Airs. My favourite memory was Nike's 'One Night Only' celebration. Kanye, Nas, Rakim and KRS-One appeared live on stage and Stash's 'Nozzle' collaboration was voted the greatest of all time. I also met Bruce Kilgore for the first and only time. That was one helluva party!

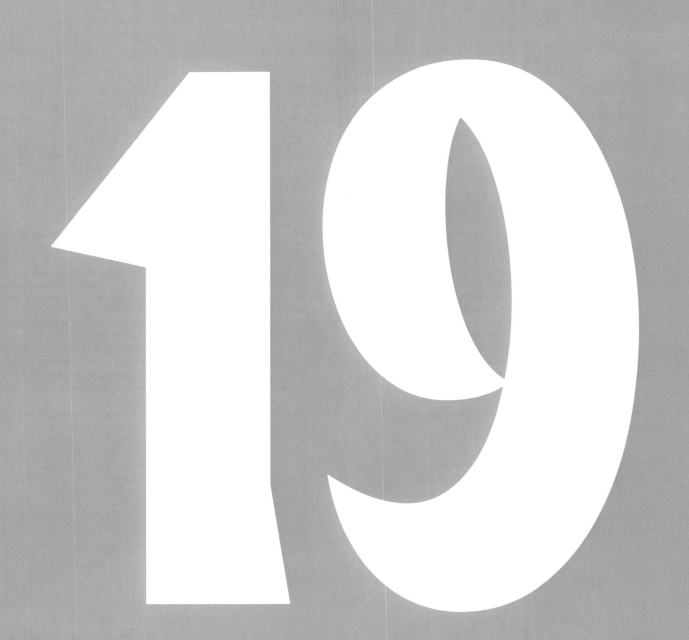

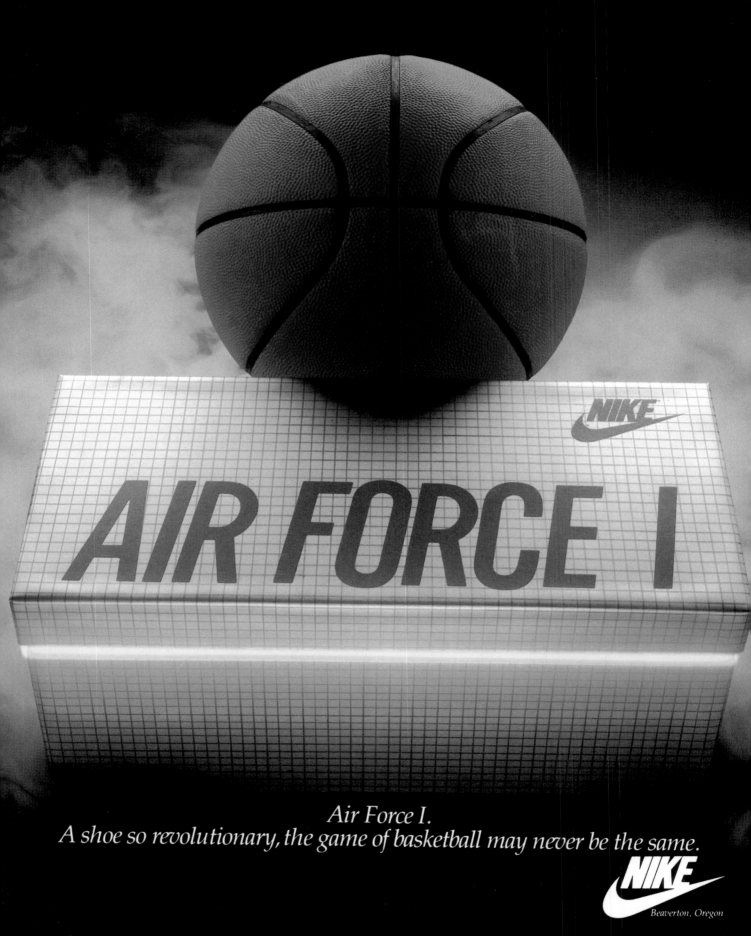

STARTING THIS SEASON,
AIR WILL BE SOLD BY THE BOX

Air Force I.
A shoe so revolutionary, the game of basketball may never be the same.

Beaverton, Oregon

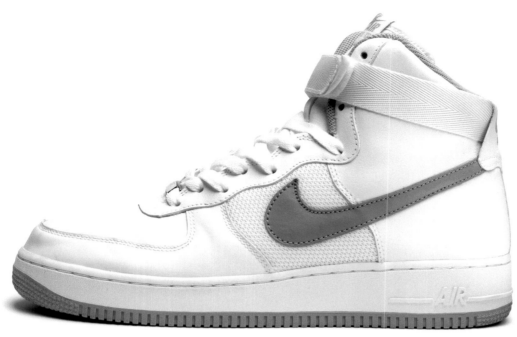

1982: The original Air Force 1 was a high-top only

AIR FORCE 1

THE PERFECT ONE

The year is 1979. A young and ambitious engineer by the name of Bruce Kilgore is pondering his future. Having studied the art of sculpture before moving on to design tennis courts, microwave ovens and robotic assembly lines, Bruce noticed an interesting recruitment ad for a position over at Nike.

With no previous sneaker experience, joining Nike was a leap of faith. But Bruce was ready for a change of scenery and the idea of moving from Detroit to Exeter, New Hampshire, sounded like a neat idea. There was something about Nike that piqued Bruce's interest. He'd heard they were a somewhat maverick company, and besides, they had a new shoe called the Tailwind, which mysteriously had 'Air' in the soles.

Fast forward. Thirty-five years later, Bruce is still at Nike, still designing and building innovative shoes. His influence within the athletic industry has been profound, though he's a modest character and rarely grants interviews or acknowledges accolades. His resumé also includes the earliest Air Jordans, the Air 180 franchise, Sock Racer and the Shox system. All in all, it makes for a quality highlights reel. Among a lifetime's worth of achievements, Bruce will always be known for a little something he drew up way back in the early 80s, a Nike basketball model with radical Air cushioning and the chunkiest midsole known to man. Yes indeed, Bruce Kilgore designed the Air Force 1.

Released in a mindboggling 1700+ colours over the past 35 years, Bruce's humble design transcended its original sporting purpose to become a wardrobe staple everywhere from Harajuku to Berlin, a pillar of style for hip hop, as well as an icon for an entire city: New York. The Big Apple will always be the spiritual home of the Air Force 1.

Cinderella Shoes, Baltimore

SETTING THE SCENE

Before they could join the Air Force in 1982, Nike's squad of pro-ballers in the late 70s and early 80s had a choice between the Bruin, Franchise, Blazer, Dynasty and the 3 Pointer. Shoes from this uncompromising era were built as simply as the manufacturing technology of the time allowed. They were merciless on the feet, not to mention players' ankles and knees. By today's standards, they are ridiculously primitive. Respected New York streetball legend Bobbito Garcia notes that the ride quality was so harsh they used to wear 'three, four, even five pairs of socks' to soften the impact of hardwood and ashphalt. Until 1982.

If comfort is the first objective for performance, then the Air Force 1 was literally a huge step forward. Designed with the explicit intention of 'making athletes' lives better', Bruce was quoted at the time as saying, 'It better work!' and he wasn't just talking about recouping the significant development costs. Imagine the sneaker world without Air? Simply unfathomable. Nike's Tailwind runner may have predated the Air Force 1 by several years, but this was the first time Air arrived in basketball trim.

Nike's product catalogues have never been immune to hyperbole, and with the Air Force, they reached for the Roget's with both hands. Aside from Air, the official tech-sheet claimed that the Air Force 1 was loaded with hinged eyelets for ankle mobility, a Variable Width Lacing System™ for adjusting the upper using staggered eyelets, Permafoam™ which moulded to the foot for a better fit, Spenco Rearfoot Padding and of course, the fabled Concentric Circle Outsole, which delivered 'optimum traction' as well as 'minimal resistance'. The distinctive pivot-point outsole would also become a signature Air Force visual motif.

THE FACADE

Kilgore's exterior design was simplicity personified. There were as few and as many pieces as were required to be efficient. It got the job done with minimum fuss, but it also had its fair share of quirks. First and foremost, the design featured a towering midsole over an inch and a half high at the heel. The radical construction was necessary to house polyurethane airbags internally.

Worried about how the stacked heel would be perceived, Kilgore added some embellishments intended to camouflage the sky-high

elevation. The first was the two-tone effect of having the toothy outsole moulded in a contrasting colour. Reminiscent of the raised white letters on late 60s and 70s muscle car tyres, Bruce added an 'Air' logo that literally advertised what was inside the shoe. For Nike, it was a breakthrough, though one they would not put into total effect until the 'Visible Air' bubble was added to the Air Max running franchise in 1987.

Another defining feature is the 34 circular perforations in the toe box. The first Air Force 1 model (sometimes called Air Force Zero) featured an unperforated leather toe box, so it wasn't until the second iteration of Air Force that the distinctive perforated holes became a common feature.

Using mesh in the sidewall was another radical choice. Many at Nike felt the upper needed to be 100 per cent leather to command a premium price point, as mesh was seen as a vastly inferior material seen only on lowball runners. But with the leather of the day undoubtedly being as 'thick as shit', according to Bobbito, mesh helped deliver a shoe that was more pliable and allowed a little aeration into the equation.

The ankle strap is another standout feature of the OG high-tops. Known as the Proprioceptus Belt, the strap was designed to add a little pressure to the base of the fibula and tibia and therefore help prevent ankles from rolling over, a fairly common occurrence at the time. When you're six-foot-eleven and weigh two hundred and fiddy pounds, that's quite a pressure drop on the only ligament that keeps you fixed to your feet. More importantly, the strap added a fashionable dimension, as ballers could take it off or leave it dangling down the back for added panache.

Despite the prehistoric nature of its immediate competitors, the Air Force 1 didn't immediately blow up. Legend has it that the initial reaction to Bruce's shoe was muted bemusement. It was innovative for sure, but its futuristic stance was a little too chunky for some palates. Perhaps the immediate benefits of this new 'Air' fandango were not easily comprehended, despite its declaration on the heel. The irony, of course, is that all these aspects, so hard on the eye in 1982, are the very same ones that make the AF-1 so distinctive and universally popular today.

Meanwhile, in three East Coast American cities, the Air Force 1 was quietly carving out a loyal niche as a bona fide basketball shoe

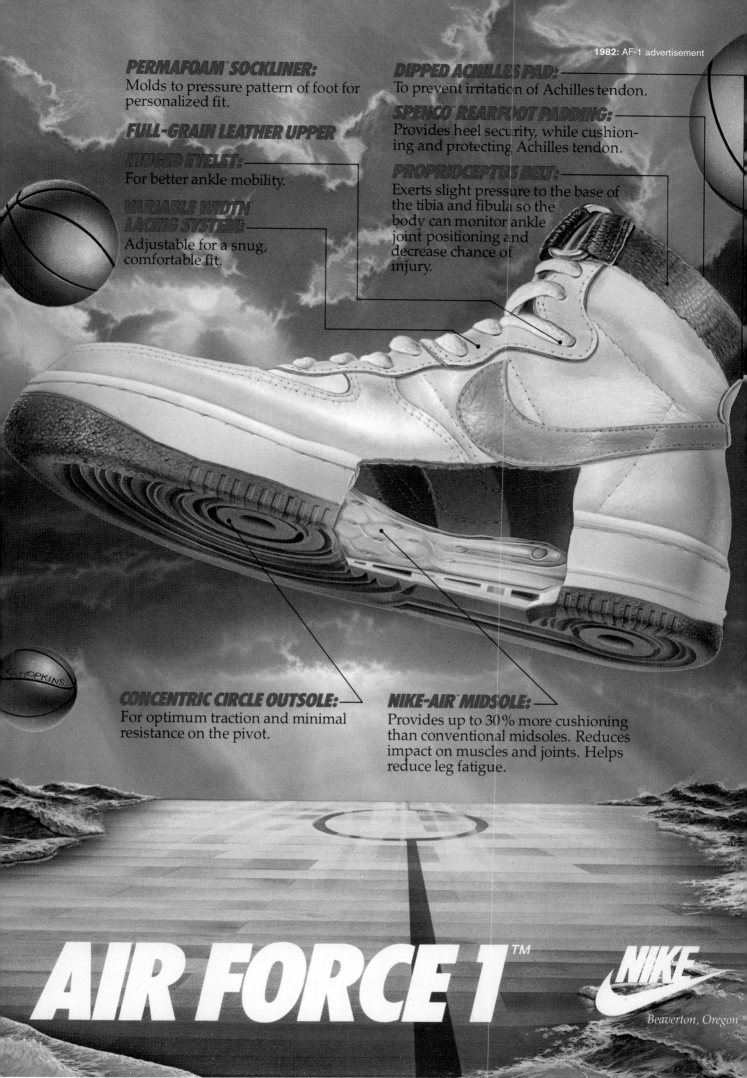

First published Nike 25th Anniversary AF-1 zine – 2007

<u>M E M O R A N D U M</u>

TO: Bob Levesque FROM: Brad Johnson

RE: Perforation for toe DATE: August 23, 1982
 of Air Force I's

--

After meeting with the sales people and court product line
management on Thursday, the attached is the design we would
like to incorporate into the all leather Air Force I. This
is my own free-hand sketch, but I think you can get the idea!
Please send some samples when you receive. Depending on the
size of the holes, you may want to sample one as per the
drawing and one with one less set of dots near the tip.

The white-on-white, that's it!
Just the lines and the purity
of the white. When you open
up a box of Nikes, right, if you
listen closely you can hear
angels in heaven sing!
You open the box slowly and
it's like '*ahhhh!*' and you got
these beautiful, pristine
white-on-white Ups with not
a scuff on 'em. It's like 'Oh my
God!' That's, that's what it is,
what it is B. That's what it is!

GRAND MASTER CAZ

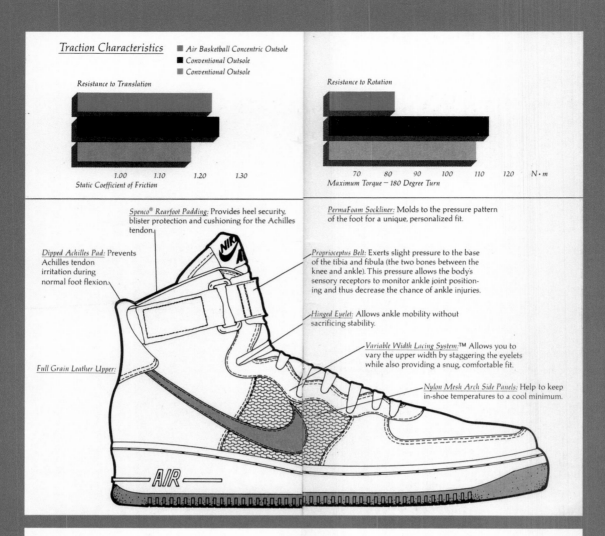

Traction Characteristics

■ Air Basketball Concentric Outsole
■ Conventional Outsole
■ Conventional Outsole

Resistance to Translation

1.00 1.10 1.20 1.30
Static Coefficient of Friction

Resistance to Rotation

70 80 90 100 110 120 N·m
Maximum Torque – 180 Degree Turn

Spenco® Rearfoot Padding: Provides heel security, blister protection and cushioning for the Achilles tendon.

Dipped Achilles Pad: Prevents Achilles tendon irritation during normal foot flexion.

Full Grain Leather Upper:

PermaFoam Sockliner: Molds to the pressure pattern of the foot for a unique, personalized fit.

Proprioceptus Belt: Exerts slight pressure to the base of the tibia and fibula (the two bones between the knee and ankle). This pressure allows the body's sensory receptors to monitor ankle joint positioning and thus decrease the chance of ankle injuries.

Hinged Eyelet: Allows ankle mobility without sacrificing stability.

Variable Width Lacing System:™ Allows you to vary the upper width by staggering the eyelets while also providing a snug, comfortable fit.

Nylon Mesh Arch Side Panels: Help to keep in-shoe temperatures to a cool minimum.

The Advantages of "Air":

Studies show that the larger the player, the more cushioning is needed since the increase in force generated against the bottom of the foot during play exceeds the increase in the sole area that is absorbing the impact. Scientists have shown that the Air-Sole® provides up to 30% more cushioning than conventional basketball shoes.

In addition to providing superior cushioning, the flow of gas throughout the Air-Sole® unit during foot contact creates a conforming foot bed, providing stability for side-to-side maneuvers.

Moreover, studies show the Air Force I to be 20% more resilient than conventional basketball shoes. A "resilient" material is one which returns energy that is put into it. The resiliency of the Air-Sole,® with its return of energy to the player, reduces fatigue and makes possible those important fourth quarter rallies. And, unlike conventional midsoles, the Air-Sole® will not lose its cushioning, resiliency or stabilizing capability with use. The Air-Sole® contained in the Air Force I is with you every step of the way.

Strap yourself in and take to the sky. The Air Force I...it's earned its wings.

FEATURES

Concentric Circle Outsole:

The concentric circle outsole pattern is designed for two purposes: To provide optimal traction during side-to-side and front-to-back maneuvers, and to provide minimal resistance to pivoting movements that apply large and potentially injurious pressures to the ankle, knee and hip joint.

In tests done in the NIKE Sports Research Laboratory, the Air Force I was compared with conventional European shell outsole patterns. Results show that while having similar resistance to side-to-side and front-to-back movements, the NIKE concentric circle outsole demonstrated a lower maximum torque, or lower resistance to twisting movements. This study indicates that while performing as well, the concentric circle design may be safer than conventional outsole patterns.

Concentric Circle Outsole:

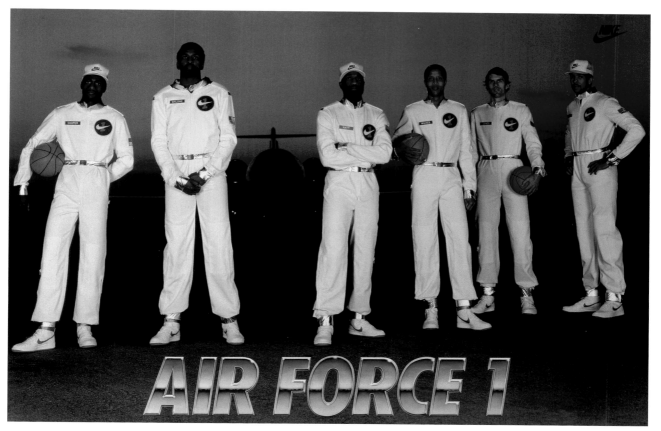

'Original Six' poster

that earned mad props on the street. Inch by inch, player by player, court by court, the shoe began to infiltrate the psyche of an entire city. The Air Force 1 had bounce!

SAVED BY THE 3 AMIGOS

Amazingly, the Air Force 1 story almost didn't happen. In the early 80s, the standard retail life-cycle of a model was generally a year or two at best. The idea of a retro release was decades away. By 1984, consistent with how they usually did things, Nike simply stopped releasing the shoe. Cold turkey. No big deal, there were always new models and styles to fill the void. Except they hadn't counted on the Air Force 1 junkies, the kids who had embraced the shoe as their own. And Nike may never have known about the phenomenon if it wasn't for three Baltimore retailers.

Cinderella Shoes, Downtown Locker Room and Charley Rudo's Sports patiently listened to their customers and then petitioned Nike to save the Air Force from a one-way trip to the sneaker crematorium. They agreed to order 1200 pairs in each colour, which was unheard of at the time and officially crazy as a coconut. The Baltimore stores would become known as the '3 Amigos' and along with two stores in Philly and another in New York – the-insanely-politically-incorrect-these-days Jewman's – they were about the only places you could purchase Air Force 1s. Even before the interweb, good news travelled fast, and through word of mouth sneaker fiends began arriving by car, train and foot to nab their beloved Airs, often bringing home multiple colours in triplicate.

By this time, the 3 Amigos and their compadres couldn't keep up with demand, so they started ordering fruit colours such as white on green, pale blue and burgundy. It drove the heads that knew nuts and started battles on the streets as kids competed to have the most meaningful and illest Air Force 1 colours.

It's not overstating the case to say that these retailers are responsible for the Air Force 1's survival. Perhaps Nike would have twigged to the game, who can say? From a New York perspective, the fact that the only store carrying the shoe was located Uptown cemented its fabled status, as well as birthing the shoe's original nickname, which survives to this day. You knew or you didn't. Either way, you literally had to go Uptown to buy your pair, leading to all sorts of skullduggery as locals protected their pot of gold by sending kids on wild goose chases rather than right to the door of Jewman's.

It's interesting to consider what else was happening in basketball and at Nike at this time. While the 3 Amigos were hopping with Air Force, Nike also bet big with the debut of Michael Jordan's first shoe. MJ's stellar rookie year, not to mention his innate flair and charisma, combined with the fact that his shoes were banned by the NBA, created the perfect sales and marketing storm. It could have been a suffocating presence but it wasn't enough to choke the life out of the Air Force 1. Coincidentally, both shoes were designed by Bruce Kilgore.

If you ever need an illustration of the raw power of Nike creativity, look at the expansive years immediately following this period. Vandals, Dunks, Delta Force, AJKO, Terminator, Big Nike, Air Force II and Conventions among others all appeared before Air made it into the soles of the Jordan III. So it's no understatement to say that the Air Force was swimming upstream against a heavy current, even from within Nike.

ZERO ADVERTISING

With one eye on the street, Nike never thought to replicate the East Coast sheen by going gangbusters with advertising or athlete endorsements. In fact, only a handful of advertisements to promote the shoe were ever made. The most famous happened when Nike picked six of the NBA's elite defensive players to launch the model. Michael Cooper, Calvin Natt, Jamaal Wilkes, Bobby Jones, Moses Malone and Mychal Thompson were branded as 'The Original Six', and their iconic campaign image was shot on the runway at John Wayne Airport in Orange County.

Aside from the interstellar white jumpsuits with massive Swoosh badges and matching caps, it's the impassive, steely gaze that lingers in our memory. Rugged as Easter Island statues and tougher than teak, the Original Six unwittingly instigated the essence of Nike's 'Force' insignia, even if it wasn't strictly promulgated until the arrival of Charles Barkley, who became as famous for his curmudgeonly grit as for his impeccable career statistics.

Aside from the 'Original Six' poster, the most widely known AF-1 image doesn't even reveal what the shoe looks like. Instead the shoes are shown locked-up with a glowing neon light and the headline 'Starting this season, Air will be sold in a box'. The other memorable image shows a cutaway diagram revealing the shoe's gizzards, neatly illustrating the presence of Air.

NIKE x MEDICOM 'ORIGINAL 6'

As part of the Air Force 1's birthday celebrations in 2007, Nike and longtime partner Medicom Toy faithfully recreated a limited edition release of the Original 6 players. The highly detailed and poseable action figures were packaged in a special edition box that paid homage to the famous image of Moses, Michael, Bobby, Calvin, Mychal, and Jamaal standing on the tarmac of an airstrip.

Michael Cooper

The 80s were a time of change in ball. High-flying players and new rules introduced a new array of offence. And then there was Cooper, the one man who could step up and shut them all down. With his trademark knee-high socks, 'Coop' received all-defensive team honours an incredible eight years in a row. He also helped lead the Los Angeles Lakers to five championships between 1980 and 1988.

Moses Malone

The first player to go straight from high school to the pros, Moses continued to set trends as a scorer and rebounder at centre, with a record of success spanning three decades. After two MVPs and taking a losing Houston team to the finals, Malone found a new home in Philly. He didn't waste any time, helping them go 12-1 in the playoffs and sweep Los Angeles for the championship.

Calvin Natt

At six-foot-six, Calvin Natt was never the biggest player on the court. But you'd never know that from the way he applied the pressure. Natt made his presence known through the 80s, and fans from that era remember him as one of the game's most intimidating forwards. In his years with Portland, Natt made his mark with a mean inside game and voracious appetite for the ball.

Jamaal Wilkes

With a baseline shot that floated through the air and seriously impressive offence and defence skills, Jamaal Wilkes was a legend of West Coast basketball from the 70s to the 80s. After netting a couple of college championships, 'Silk' entered the league on a high note, winning Rookie of the Year and helping Golden State pull off a 4-0 sweep of Washington for the title.

Bobby Jones

Bobby Jones was immortalised on his signature Nike poster as the 'Secretary of Defence' for good reason. His no-nonsense work ethic earned him eight straight appearances on the all-defensive first team. Following two strong seasons with Denver, Jones made the move to Philadelphia, where his skills helped Philly to the playoffs every year that he played there.

Mychal Thompson

Picked first in the 1978 draft, the Bahamas-born Thompson was known for his toughness and valuable contribution to team success. Thompson wasted no time in his first season with Portland, earning all-rookie status and proving himself as a big scorer and rebounder. He continued to put up strong numbers in the early 80s alongside fellow Force alum Calvin Natt.

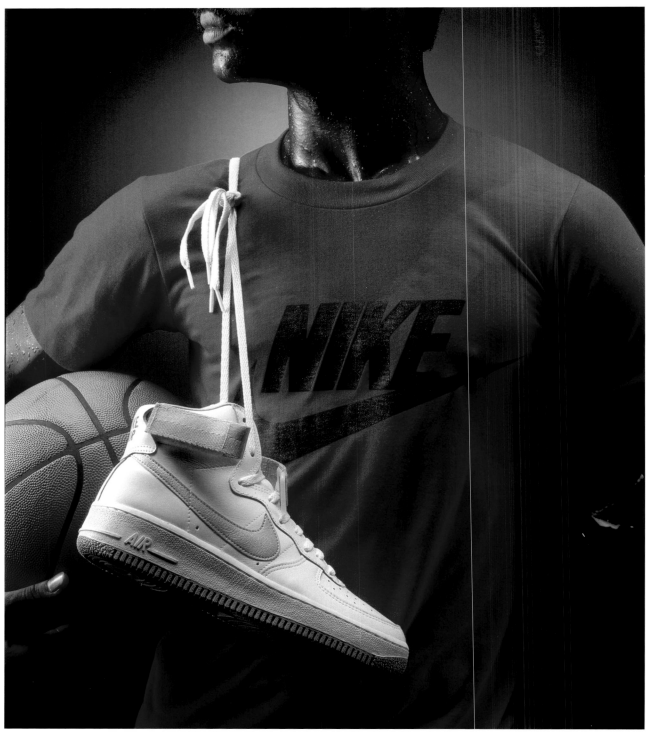

1982: AF-1 promo

Compare that restraint to the next era of Nike advertising as Mars Blackmon became the face of the decade and television became the medium for the message.

YOU DON'T STOP

For a shoe designed purely for sport, the connection with basketball is only one piece of this cultural puzzle. It might be the biggest piece, it might be the bedrock, but it doesn't alone rationalise the net worth of Kilgore's masterpiece. You simply don't need to dunk or dribble to fall in love with the Air Force silhouette.

I doubt anyone can say for sure the moment it happened, but at some point, hip hop discovered what ballers already knew and it was love at first sight. Hip hop's inherent habit of reflecting what's fresh on the street, combined with a symbiotic relationship with basketball, made for a deep-rooted love affair that survives to this day. Timing is everything, and 1982 was a good year for both Nike

and rap. Grandmaster Flash delivered The Message and Bambaataa dropped the futuristic Planet Rock. Music and sneakers would never be the same.

So it's not surprising that the Air Force 1 became hip hop's shoe of choice, even if Run-DMC in their adidas Shelltoes would fight to the death for the title. As with other examples of American pop-cultural imperialism such as Hollywood, junk food, slang and violence, so has the mass appeal of the Air Force been exported. As noted basketball journalist Anthony Gilbert said, 'Even Martians wear Air Force!'

NIKE TOWN

Nike amplified the party sometime around the turn of the century when they released a bounty of models based on US cities. It seems unsophisticated now, but at the time, adding a NYC embroidery to an AF-1 was considered officially bananas.

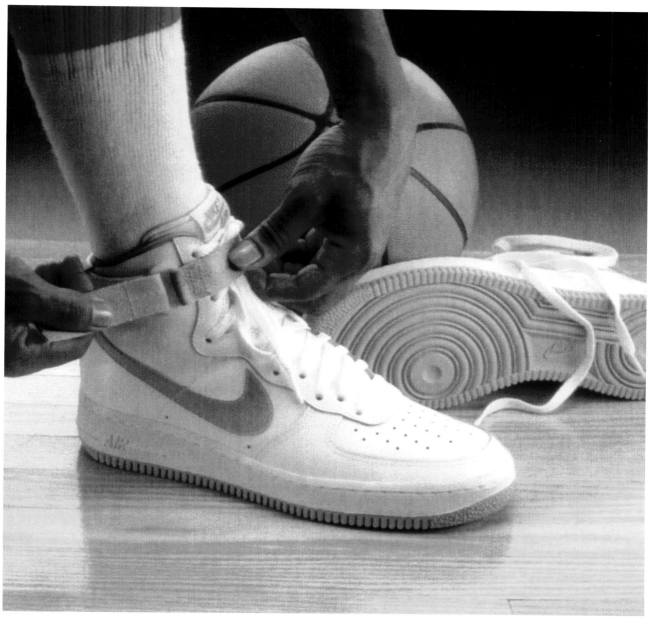

1982: Original AF-1 catalogue

Special editions for Philly, LA, Bronx, H-Town, D-Town and Chi-Town upped the ante. That morphed into celebrating countries, events and holidays such as the Notting Hill Carnival, Valentine's Day, Puerto Rico, West Indies, Halloween, St Patrick's Day, the Super Bowl and Easter, to name a few. Hookups with designers, superheroes and artists such as Stash, Futura and Mr. Cartoon celebrated the shoe's enduring appeal.

And it wasn't all about New York City. Some of the best Air Force 1 colours were provided in the early 2000s by the English retailer JD Sports, which peeled off a blistering series of SMUs that are still personal favourites of aficionados. The same can be said for Japan exclusives, which brought a penchant for colour and madness, long before dodgy Ice Cream all-over hoodies and plastic plagiarised Bapestas appeared.

The Far East also brought us restraint and taste through the Orca Pack and HTM series, which imbued the Air Force with simplicity, premium leather and upscale packaging. From there, it was only a hop, step and dumpling to the Asia-exclusive Zodiac series, commemorating the Year of the Horse in 2002 through to the flamboyant Year of the Dog model complete with pony hair and an outrageous orange and red paint job.

And to think we've made it this far without mentioning the most iconic release – the most made, most loved and most worn of all time: the immortal white-on-white Air Force 1. A shoe that is so crispy and clean that it matches any outfit, can be worn casual or boss smart, night or day, in good times and bad, in sickness and health, 'til death do us all part.

Like the *Mona Lisa*, whose eternally intriguing smile keeps visitors steaming in day after day to the Louvre in Paris, the key to the Air Force 1's appeal is simple. There are no secret herbs and spices, nor is it driven by hype alone. You don't need a degree in Sneakerology or be a paid-up member of Mensa to get it. For Rasheed Wallace and a hardcore handful, it's still a righteous basketball shoe, but for most, it's simply a dope shoe, so perfect that it's irresistible. It's also the most copied and bootlegged shoe of all time, but that's a whole other story. Thirty-five years of history and it seems like we're just getting warmed up. Rakim is right: it's still the illest Nike sneaker ever made. See you all in 2032!
•

1987: Bobbito with the first Air Force 1 reissue in 'White/Royal' at his parent's crib on 97th in Manhattan

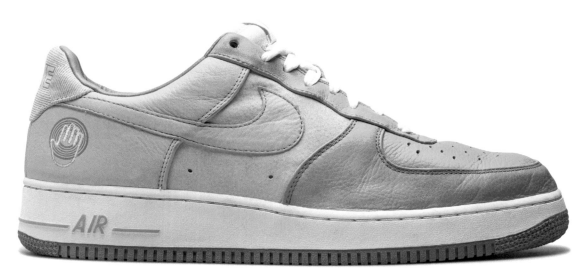

2007: Air Force 1 'Kool Bob Love'

BOBBITO GARCIA
KOOL BOB LOVE

Those who know, know. And those who know, know Bobbito Garcia knows. DJ, writer, radio host, hip hop encyclopedia, basketball nut, play announcer for EA Sports and star of Nike campaigns, Bobbito is also the author of *Where'd You Get Those?* – the only guide you'll ever need to New York sneaker culture from the 1960s to the 80s. Time for a lesson from the maestro himself!

Legend has it you always looked at a kid's shoes first and then made eye contact after.
Sometimes it's still the case now. I had to wean myself off that. I don't know how well you read my book, but when I was in high school I could tell you by row and seat every sneaker that every classmate of mine had. We had eight classes a day. I was weird for that time. These days the kids are out of control. I can't keep up. That's one of the joys of writing a book about 1986/87, because it was such an unheralded time. You maybe had a new model come out once a year and a different colour here and there. Whereas now it's this release

in this country and that country and the kids on the internet know all of it, but I can't keep up. But I know the mentality. If I was born now, I would be that kid reading *Sneaker Freaker* from cover to cover.

Thanks for the plug! Now tell our readers about the Air Force 1.
I was always someone who, while playing ball, yearned for the things that made me play the best, and also for the best-looking sneakers. Only the best players got the free colours. It's not like nowadays where the shoes are sold in boutique shops. If you wanted green and chocolate brown you had to be on the team that had those colours.

When the Air Force 1 came out, it was so far above and beyond everything that had came out as a ball sneaker. It wasn't a fashion statement. I mean, I didn't wear Air Force 1s to chill off the court. And you have to put them in the context of the time and compare them to the Nike Legend or a Franchise or a Blazer, or even a Puma Clyde or adidas Shelltoe. Air Force 1s were a lot bulkier than any of those. So to wear them out casually was a weird idea at first, but the power of them on the court was so strong that eventually they got their dues as casual shoes. I always expected they would have a long life as a basketball sneaker just because the Air technology was so ridiculously different to anything else that came out, but I would never have guessed in 1983, when I got my first pair, that they would become the whirlwind that they have.

Like all good ideas, maybe it was that little bit ahead of its time.
Yeah! The first time I saw Air Forces in 1983 on the shelf, I thought they were kinda ugly, like, 'What the fuck are these shoes? They look like hiking boots!' But as a player, my high school team wore them and it was like, 'These shoes are mad comfortable.' And the leather grain? I don't think they have ever redone it to that level. What I call the AF-Zeros, the ones with no perforations in the front and nylon mesh on the upper with the grey Swoosh, the leather on those is thick as shit.

I didn't know the story behind the Philly and Baltimore connection. It's not a widely known piece of trivia, is it?
It's not at all. I heard about it years later, but I wasn't travelling at that time so I'd never been down there. I was born in 1966, so by the time they resurfaced in NY in 1986, I was already in college. The thing is that when they came out in 1982, they didn't fly off the shelves. So you could still get a pair in 84 or 85 if you were lucky. What everybody calls 'deadstock' now, we didn't call 'em that. We just said 'Nike Airs'. They were still around and about but they were kinda extinct by 1985, so when they came back in 86 it was like 'Whoa! Holy fucking shit!'

At what point do you think the Air Force 1 became a hip hop shoe? Is there a pivotal moment?
It's a difficult thing to ask me, because to me they will always be basketball. Hip hop is known for redefining things, like now you hear 'tattoos are hip hop'. Tattoos are hip hop? Tattoos have been on sailors for decades! Because hip hop is so freewheeling people now associate tattoos with hip hop. It's just like wearing ill sneakers – it's not hip hop per se! Talk to some old cats from the 50s and 60s and Chuck Taylors were their shit. It's just that hip hop got so popular and the Air Force 1 was the shoe of choice for the hip hop generation that people grade it that way now. One of the joys of writing my book was to change the perception of where all of these sneakers started, which is on the ball court.

For everyone not from NYC, can you explain the 'Uptown' nickname?
As far as New York went, they were only available Uptown, at least initially. The one store that was most renowned for having them exclusively was Jewman's, which was up at the Bronx. We used to take the train and walk up the boulevard. It was a secret society in those days, you either knew about it or you didn't. And when you went Downtown, you would be sure to get the question, 'Yo! Where you get those?' Sometimes you told people, sometimes you didn't. That was the stamp of a kid from Uptown rocking some Air Force 1s. When I say Uptown, I mean Harlem, Washington Heights and the Bronx. By the late 80s a lot of players were wearing them, and it was still their sneaker of choice to play; but now you have dudes that were going to Latin Quarter and Union Square to dance, so it became a hip hop shoe.
I started doing consulting work for Nike in 1993/94. They released the Air Force 1 in LA and they were totally dead. Nobody was buying them. So they were always an East Coast phenomenon. It was the Uptown kids who gave it the legs, if you will, to take them to hip hop artists, who gave 'em exposure in videos, which eventually made the whole rest of the world be up on it.

How do kids who don't come from a basketball background still pick up on the shoe? I had my moment when I came to New York in the early 90s and I said, 'That's the shoe!' right there.

You get it! If you have an eye for sneakers, you get it. You get it right away without having to be trained in hip hop or sneaker vernacular. You can look at the Air Force 1 and go, 'Yo! It's a hot shoe!' I've always thought that people over-intellectualise the whole thing. It's so simple. They look dope!

Do you have any golden Air Force rules?
As long as they use the right colours, I think patent is hot. I remember when the 'Scribe' Force came out in 83, that was the first Nike sneaker to come out in patent. I was definitely feeling them. Nike didn't do more patent till like 95, when they came out with the Jordan 11s, so it was a long time in between.
As far as general rules with Airs, the first thing I'd take off is burgundy and red. Those two don't go together. I've actually designed a couple of AF-1s over the years. One of them was called 'Kool Bob Love', so that was represented on the shoe. I worked very hard with Nike designers to pick out fabrics and I mixed a lot of colours, but they all make sense with each other.

A lot of your ideas were formed back in the 80s. Do you feel like you're still open to changing your mind?
I'm always open to innovation. I mean, if I wasn't open to innovation I wouldn't have been that kid that was early on the block wearing Air Force 1s. I can say this – I was way the fuck ahead of my time when I was painting three-colour combos in the 80s, even Nike wasn't doing that shit. And then they brought out the red/white/blue Barkleys in 86 and they did some nice three colour joints for the Dunks in 86/87, but other than that, they never really finessed three colours. I was freaking people the fuck out! Now everyone is painting their sneakers, but I could never do what the kids do now with the paints. I was just painting the whole shoe or the Swoosh, just to make it look different to what was available.

Did you paint them to freak people out?
It was a big dilemma because sometimes when we got sneakers, there was a phobia to paint them fresh out of the box. Because what if you fucked up? So what we mostly did was paint old sneakers to give 'em a second life. Especially with the Air Force 1, the midsole and outsole would last forever. My best customised joints were always right out of the box because the leather was tighter and wasn't cracked.

What was the favourite pair you ever painted?
I would have to say my pumpkin and choc brown joints. I bought white/choc Lows, so the outsole was choc, the midsole was white, the upper was white and the Swoosh was choc. Then I painted the whole upper pumpkin brown like the Texas Longhorns. I razored off the stripe so I had a white stripe with a pumpkin brown upper, white midsole and choc brown outsole.

Any Air Force memories related to a specific player?
Nah, nothing back then was related to any player. The Celtics wore the all-green Air Force 1 with the white stripes because those were always hard to get. Most stores normally had white uppers with a coloured Swoosh, but to get a coloured upper with a white Swoosh was way more difficult. There were also light blue joints.

You mean Carolina Blue?
Nah man, we didn't call it 'Carolina Blue.' This thing with people saying 'colourways', that shit is so fake to me. The sneaker industry says 'colourways'. Nobody said that 10, 20, 25 years ago. So to me, I don't like it when the industry is influencing what kids are saying. It should be the other way around. This was, after all, just a shoe that kids went crazy for and they are the ones that turned it into a hero – not expensive marketing. In fact, there were only two or three ads for the shoe in its entire life. Even when they brought me in to consult for this project, the first thing I told them was, 'I'll do no fucking ad for the Air Force 1. I'll kill you!' Just let that shit be what it is.

So back to the shoe, was it pale blue?
Nah, it was light blue in durabuck. They were low-cut, white check, light blue outsole. Super hot. And there were the choc and cream joints. That's when Nike started to get really freaky with their shit.

I don't associate brown with basketball shoes.

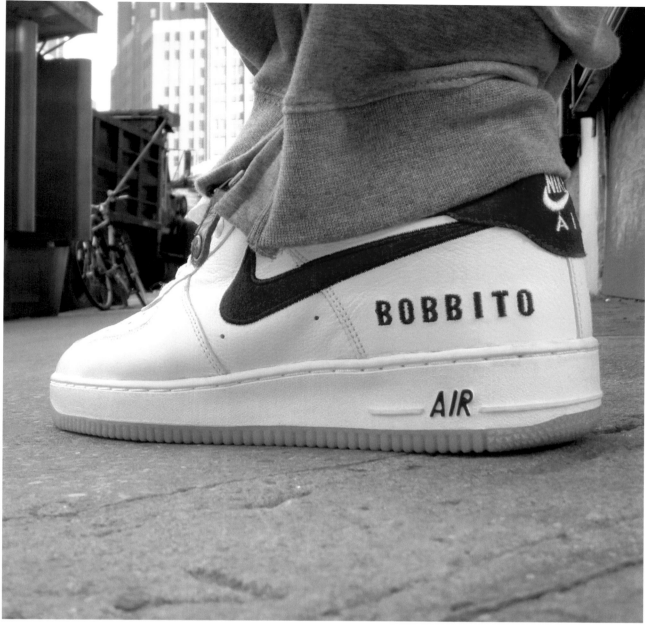

2002: Air Force 1 'Bobbito'

I mean brown is a basketball colour, but when you freak brown with off-white, I can't think of a basketball team that has brown and off-white as their team colours. And when they did that shit it was like, 'Oooohhh, here it comes!' That's the first thing I can really remember that Nike did that was awesome.

Any other colours?
Yeah, the straight white with gold was so fucking mean. Oh and the low-tops, the forest green with the white check. Those were all like hot early joints and they told people whether you knew Air Force 1s or you didn't.

Coming from your sporting background, is it all about high-tops?
Honestly, I was a cat that never wanted to have anything to do with NBA players wearing low-tops. Moses Malone wore low-tops, Kareem Jabaar wore low-tops. In New York, ball players wore high-tops. Even at a young age I was cool wearing low-tops. I didn't really have ankle problems and I always felt that the low-tops were slick because you could wear them after the game and look chill.

What about your white and burgundy Air Forces with your name on them – I heard they took three years to arrive?
I did a lot of consulting with Nike in the 90s. In 1999 they said, 'As a way to thank you, we're gonna make you a sneaker, so which

one would it be?' And I said, 'Air Force 1, low-top, burgundy suede, gum bottom and put my name on it!' thinking they were never gonna do it. Because even back in 1994 Nike was like, 'We gonna put out a sneaker for sale with your name on it!' But then it never happened.

Three years later I was at the Nike Battleground comp in New York and I was the announcer. Chris Amen from Nike came out with a white box. I had 32 of the best 1-on-1 ball players in NYC all standing around me. 'Hey Bob, we didn't forget you!' I didn't know what was in the box, but when I opened the box I was like, 'Oohhhh sheeettt, them muddafukkas have my name on 'em!' Forget the burgundy suede and gum bottom, you gotta remember Nike iD did not exist at that time. To have my name on a pair of shoes when I wasn't an NBA player, platinum musician or recording artist – just a kid who is an underground icon and who plays ball everyday who was dedicated and considered a veteran – I was like 'OH SHIT!'
•

First published Nike 25th Anniversary AF-1 zine – 2007

IT'S THE SHOES

DIAL 1-700-AIR-FORCE

The memory is a bit foggy these days, but here's how I recall things. Back in the early 90s, I was in New York City wandering around the Canal Street area when I found the gulliest-looking sneaker spot. The general vibe was low-rent at best. When I walked inside, it was a revelation. Something like 30 different Air Force 1s graced the wall. With limited funds and an even smaller backpack, choosing a single pair of Uptowns to haul around on my travels was a sweat-inducing nightmare.

Several hours later I finally settled on black canvas with a maize Swoosh, still my all-time favourite combo. We did a lot of miles together but sadly, they went to sneaker heaven many years ago. The toes had come through, the rubber had worn away in the heel, the midsoles had yellowed, the canvas was faded like an old bummy's whiskers and the original laces were now half their original length. They were still functional though! I regret binning those bad boys, even if they were totally junked. In a spooky coincidence, my sister gave me her own pair of the exact same model when she cleaned out her closet recently. Order restored!

Gimme a pair of classy Air Force 1s every day of the week and I'll be a happy man. Call it heresy, but I've never been mad for the classic white-on-whites, though the 'Anaconda' release is seriously hard to top. I'll always have a soft spot for canvas Airs, even if it is a rather unfashionable fabric. I dig anything in gum rubber and the Le Bron 'Hypes' for their vivid lilac suede. I love the leather lining and insoles of the premium editions, even if they squeak with every step. I've bought Airs in the US, UK, Japan, NZ, France and HK. I've bought women's colours by the dozen. I've paid too much and been sent plenty for free. I've swapped them, eBayed them and bush-bashed more than one fresh pair to an early demise.

It's funny to look back in time and see how things have changed. When Nike plonked 'NYC' embroidered tags on Forces back in the late 90s, I remember thinking it was the coolest thing I'd ever seen. I still have mixed feelings about the 'Jewel' Swoosh editions, but there's no doubt they have grown on me all these years later. I've never been into a double-layered Swoosh either, although it's hard to argue with Mita's AF-1 from 2004. Other suspicious innovations include the 'seamless' model with a one-piece upper, and anything in patent leather, which is mega corny. Embellishments like these have always been gratuitous distractions from the real game, but that's also what's great about the Air Force 1 – there's endless variety, even if it never seems to change.

Over the years, a few big ones got away – some I got over, some still rankle to this day. The 'Orcas' slipped through my fingers. The 'Sakura' with the wooden box is one I'd swap my left nut for and the 'Notting Hills' in orange is another oddball I slept on. The 'PlayStations' might be worth a fortune, but hype over beauty means they'll remain a solid pass. I love the HTMs with the big cardboard box and premium leather. The 'Linens' in cream and pink are a work of priceless beauty. Then there's Mark Smith's handmade 'Laser' Air Force 1s, which were only given to the crowd who attended the launch in NYC. UK retailer JD Sports also produced some belters over the years. My favourite is the all-white with gum midsoles, rumoured to be a random sampling mistake.

Nike has done some heinous things to the Air Force in recent years, but the new NikeLab editions in solid colours and premium leathers are just about perfect. I say 'just about' because I wish they would stop replacing the real airbags with a fat wedge of squishy foam. And someone has to tell Nike to stop releasing those cheap Ultra editions, especially the crummy Ultraforce Mid. I'm all for progression, don't get me wrong, but why mess with perfection?

When you look at this selection, it's crazy stuff like the 'Invisible Woman' and 'Savage Beast' that makes eyes pop out, but I still come home to the clarity of the 'Year of the Horse' that featured on the cover of *Sneaker Freaker*'s first edition. White leather with a red tick is 100 per cent Marty McFly, but classic Nike all the same. And that right there is the perpetual charm of Air Force. They're perfect. They will always be the first shoe I look for when I enter a sneaker store.

Woody
Sneaker Freaker Editor

First published Nike 25th Anniversary AF-1 zine – 2007

NIKE AIR FORCE 1

From exotic anaconda leather to orange pony fur and Travis Scott's detachable metallic Swoosh, the Air Force 1 is a shape-shifting chameleon. Here are a few notable releases from the past two decades.

2007: Air Force 1 (JP Exclusive)

2015: Bespoke Air Force 1

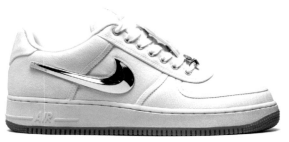

2017: Travis Scott x Air Force 1

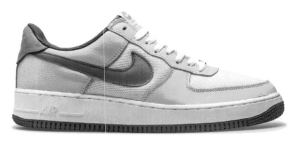

2003: Air Force 1 'Carnival'

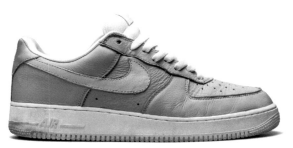

2016: Air Force 1 'Linen'

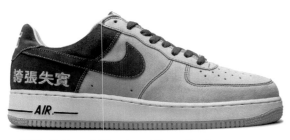

2005: Air Force 1 'Chamber of Fear – Hype'

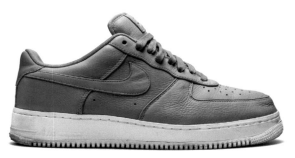

2016: Air Force 1 (Purple Stardust)

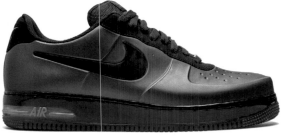

2013: Air Force 1 Foamposite Pro 'Game Royal'

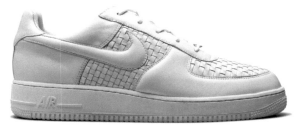

2004: Air Force 1 'Lux White'

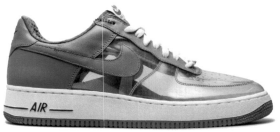

2006: Air Force 1 'Invisible Woman'

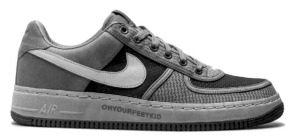

2006: Undefeated x Air Force 1 'Insideout'

2008: Air Force 1 'Talaria'

2009: Undefeated x Air Force 1 'Livestrong'

2002: Air Force 1 'Year Of The Horse'

2005: Air Force 1 'Escape'

2009: Air Force 1 'Savage Beast'

2004: Air Force 1 'Silver Olympics'

2003: Air Force 1 'West Indies'

2012: Medicom x Lunar Force 1 'Bearbrick'

2004: mita sneakers x Air Force 1

2013: Air Force 1 'Anaconda'

2008: Air Force 1 'Year of the Dog'

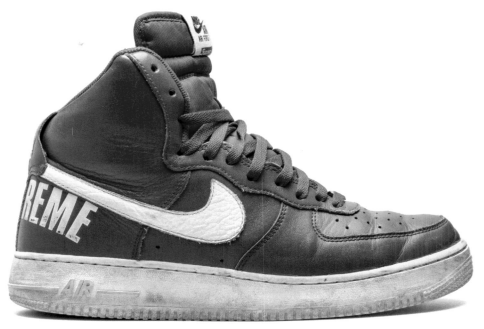

2014: Supreme x Air Force 1 High

2002: Air Force 1 High 'Rose'

2004: Air Force 1 Mid 'NYC'

Reebok Freestyle

Published in *Sneaker Freaker* Issue 14, November 2008

EDITOR'S NOTE: WOODY

It's a shame that the history of footwear has such a lop-sided ratio of male memories, but Reebok's Freestyle was one femme fatale that revolutionised the industry. Launched in 1982, the slimline sneak arrived just as aerobics articulated the 80s fashion zeitgeist. As the saying goes, imitation is the sincerest form of flattery, and in this case, every brand from Nike to LA Gear lined up to flatter the Freestyle with extreme vengeance. This kind of blatant plagiarism wouldn't happen in the sneaker industry these days – or would it?

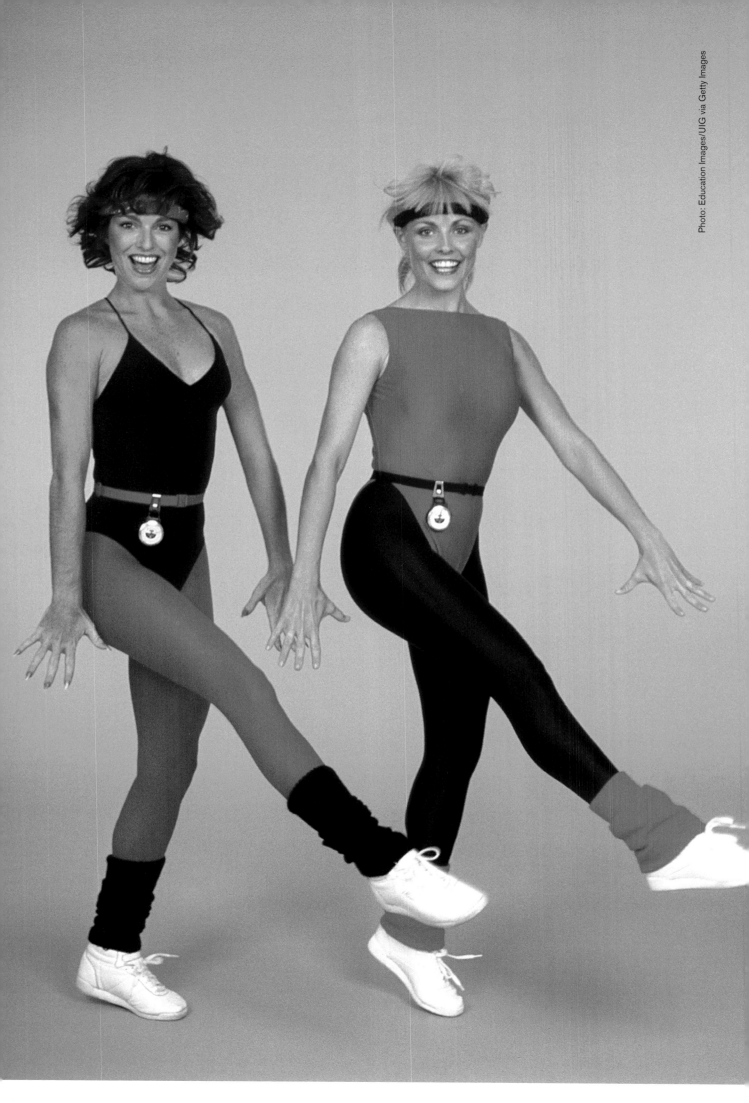

Photo: Education Images/UIG via Getty Images

REEBOK FREESTYLE FOREVER

The 80s were a notoriously fresh time for fashion. You'd see shoulder pads on lads and ladies alike, and a flood of fluoro that puts today's nu-rave hipster festivals to shame. Tees and sweaters had their arms hacked off and thong-thin leotards teamed with tights, leg warmers and sweatbands began to blur the sweaty crack between sport, dance and streetwear. Aerobics fever hit the world harder than Cindy Crawford's buns, inspiring everything from music videos to flicks and, of course, kicks.

Until the dawn of the Spandex era, sporty femme footwear hadn't made a huge mark on society. This left few options for getting girly other than patronising pink/purple colour combos and scaled-down versions of chunky men's shoes. Until the Reebok Freestyle. Inspired by the aerobics craze, yet street enough to take you from the gym floor to the nightclub door, the Freestyle was the battering ram high-stepping ladies longed for.

Let's break this trendsetting sneak down. The Freestyle is a rounded-toe design with a slimline shape that works up into ribbed ankles packing a pair of Velcro straps. It's kinda techy, but kinda not; it snugly fits the foot, and, like all classics that really hit tipping point, it's pretty much inoffensive while possessing a certain zing. The cultural factors that made this shoe 'tip' are complex, but here's the deal.

Flashdance

In the early 80s, Madonna was getting all 'Material Girl' and saucy scenes from *Flashdance* personified the combination of sports and fashion, with Lycra a potent new innovation. You also had celebrities left, right and centre releasing their own 'Do it at home!' aerobics videos, and Jane Fonda – the obvious queen – glistening with sweat on the cover of her workout videos.

With its half-dance and half-gymnastics moves, aerobics required athleticism, but what made it so goddamn hot was its anything-goes repetitiveness. Your average Joan Blow with two left feet could master the weave-step in a few minutes. In essence, aerobics was giving the un-b-boys and un-b-girls of the burbs a chance to get physical in the comfort of their own lounge room. Straight-up cyclic moves were the order of the day.

SIZZLIN' HOT NEON.

Neon <u>Freestyle Hi-Tops.</u> Perfect for aerobics and for the fun of it all.
Kick up your heels in soft Reebok garment leather. Now in bold new colors that
make even a rainbow blush. Also available in red, black, grey or white.

Reebok®

Because life is not a spectator sport.™

2016: Freestyle Hi reissue

Reebok was the first footwear company to capitalise on the craze by designing a new shoe specifically for aerobics. Released in 1982, (the same year as Nike's Air Force 1), the Freestyle was a revolution. The original version was a white low-top characterised by Reebok's nameplate in baby blue lettering and a mini British flag. It was the first shoe to put the brand on the big screen and it saw Joe and Jeff Foster's shoe company soar to wild heights of success. By 1984, the shoe single-footedly accounted for more than half of Reebok's sales.

Punky Abdul

Celebrity endorsements for the Freestyle were ahead of their time. Everybody wanted a piece of the action. Cybill Shepherd rocked up to the 1985 Emmys in a killer black gown paired with bright orange Freestyles. And who could forget the iconic Reebok Dance ads featuring Paula Abdul, which stated: 'Millions of girls want to be in her shoes, but she wants to be in ours.' Cindy Crawford starred in later Reebok ads, and the brand also sponsored the Laker Girls.

My personal fave Freestyle fad was coined by none other than the 80s teen queen herself, Punky Brewster. Known for her crazy hats and out-there style, Punks was the perfect poster-girl for the younger generation of Freestyle followers. Her trademark was mismatched Freestyles.

Another notorious piece of Freestyle trivia can still be bought on eBay for about 20 bucks if you know the right keywords. 'All American Barbie' was released in 1989 and came packaged with two pairs of Freestyles and official 'Bok branding on the box. That wouldn't cause a ruckus today, but in 1989 it was nuts. Even Barbie wanted to Freestyle!

New York City can also lay claim to the Freestyle's underground code name. The '5411' handle came from the $49.99 price tag, plus tax – which yup, you guessed it, rounded out at $54.11.

The Freestyle came in leather initially, but as the years passed, Reebok designers experimented with nubuck, canvas, synthetic materials and patent varieties. When Reebok realised they'd really rocked the market, waves of colour tried to satisfy demand. After the all-white edition there came red and navy, backed up by hot pink, orange, turquoise and purple.

Over the years, Reebok released several Freestyle spinoffs under the names Princess, Empress and Duchess, but none made a love bite quite as deep as the original. Men weren't forgotten; Reebok released a macho version of the Freestyle known as the Ex-O-Fit, as well as the Workout for all manner of fitness freaks.

Copycats

Needless to say, Reebok's rivals were green with envy thinking of that juicy money-spinner. Unfortunately for the footwear game, all is fair in love and war, and every mega-successful design is copied to some degree. Some call it homage, others call it outright theft. And while shoe-lovers loathe the practice, history is littered with diluted imitations and direct copies. No brand is immune.

In 1986, adidas released the male-targeted Powerphase, which came in all-over red, navy blue and white. Sound familiar? The 'Phase featured an embroidered adidas label on its side (much like the Freestyle) and logos on the midsoles and heels. But the adidas model's main difference was its single strap where the 'Bok had Siamese-twin Velcro. Taking things one step further, each Powerphase came with a gym membership! The swing-tag was actually an invitation to join Club adidas free of charge.

Nike, a late bloomer, released the Aerofit in 1987. It was a design scarily similar to the Freestyle with a Swoosh slapped on the side. Nike attributed the Aerofit shape to a hybrid high-top Cortez. Hmmm. Some say that the Aerofit wasn't a success, although it did resurface in 2008, as did the Freestyle. Hmmm x 2.

Circa 1988, LA Gear calmly cut out the Reebok nameplate and replaced it with their own silver-stitched logo. The brazen tag features a wannabe Jane Fonda perched perkily in her sweatbands and leggings! Credit where it's due: at least LA Gear had a few hit models and substantial success in the category where others had failed.

Reebok were still flying into the late 80s and continued to pump out new colourways and concepts in hope of keeping tight with the market. The Dubble Bubble is hands down this writer's favourite version of the Freestyle. With three Velcro straps, it made ankles look like the Michelin Man!

Despite the Freestyle crossing successfully from fitness to fashion, the death of the aerobics era signalled a steady decline. As the 90s loomed, slimline gym getup lost fans to Calvin Klein and bulky, high-tech gear. Nike fought back hard with its compelling cross-trainers and detours for women into myriad categories such as cheerleading, walking, volleyball (Air Digs!) and a thousand new models designed to catch the eye. Even Reebok struggled. After a decade of success, the 'Bok just couldn't deal with the change in mood.

In a last-ditch attempt to relive the glory days of 1982, Reebok swallowed their pride and produced a platform version of the Freestyle, complete with patent glitter. The brand's days as the

1996: Freestyle Hi Workboot Canvas

1996: Freestyle Hi Rise Candy

1987: Reebok Freestyle Hi

1982: Reebok Freestyle Lo

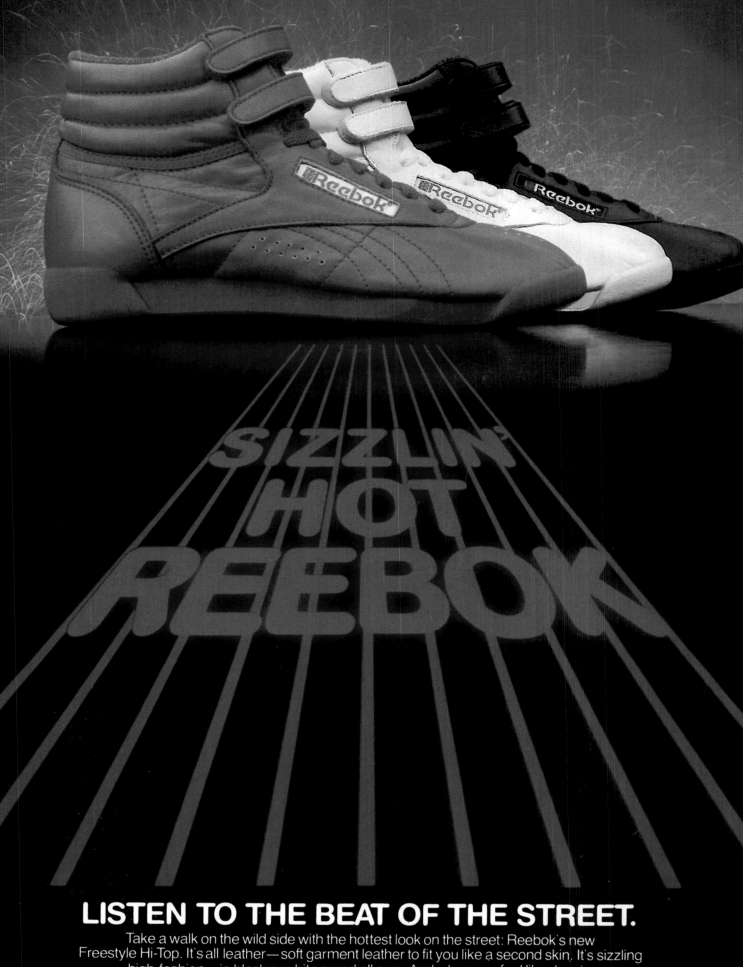

LISTEN TO THE BEAT OF THE STREET.

Take a walk on the wild side with the hottest look on the street: Reebok's new
Freestyle Hi-Top. It's all leather—soft garment leather to fit you like a second skin. It's sizzling
high-fashion—in black or white or red all over. And when you feel like dancing
or strutting your stuff, it'll make your every move magic!

Reebok®
FREESTYLE HI-TOP™

1998: Reebok Freestyle Lo 'Lava Girl'

1997: Freestyle Hi Dubble Bubble

Photo: LGI Stock/Corbis/VCG via Getty Images

1987: Freestyle Lo

1992: Freestyle Hi

hottest of hot were over and things remained dim with virtually no new Freestyle releases until 2007 (by which time the once mighty 'Bok was owned by adidas).

Freestyle Forever
For the Freestyle's birthday party in 2007, the world's fave femme sneaker made a comeback. The 25th anniversary series dusted off the original 80s baby for the actual babies of the 80s to have their turn. Birthdays ain't birthdays without a massive party, and Reebok threw the ultimate bash in NYC's Culture Club hosted by Downtown Julie Brown and DJ Spinderella. With 'Freestyle Forever', Reebok was back in the big leagues and ready to reclaim the throne.

The first releases included all-over prints like '25 Candles', 'Dog Bone' and 'Queen of Hearts', with additional contributions from friends such as Rolland Berry and Basquiat. However, the sellout moment came from a fresh line of fluoro editions neatly

named the Reign-Bow: a limited run of yellow, green, orange, pink, purple and blue Freestyles. Uffie was snapped rocking them, NY babes were blogging about 'em and stores were selling out! The World Tour collection was inspired by Tokyo, Paris and Madrid. Reebok teamed up with some fresh faces in female fashion to launch the series. New lines also rolled out in pastel, patent, suede and metallic gold with silk laces. Colabs with Married to the Mob, Colette and Alife raised the bar for Freestyle hype.

It seems that fashion is circular and sport is not, because while we've seen the rebirth of the Freestyle at least once, aerobics was RIP 4eva. The early 80s was a remarkable era for sneaker design and credit must go to Reebok for revolutionising female footwear. Long live the Freestyle!

•

Hip Hop & Sneakers

Published in *Sneaker Freaker* Issue 36, July 2016

EDITOR'S NOTE: WOODY

From Lexicon's 'Nikehead' to Nelly's 'Air Force Ones' and Raekwon's name-dropping anthem 'Sneakers', waxing lyrical about a footwear fixation is littered through hip hop history. These days, you can't call yourself a legit rapper unless you've also inked a juicy sneaker endorsement deal, but there was a time when displays of public affection were organic rather than commercial transactions. Craig Leckie cranked up his Walkman to press play on the ultimate guide to sneaker references in hip hop lyrics.

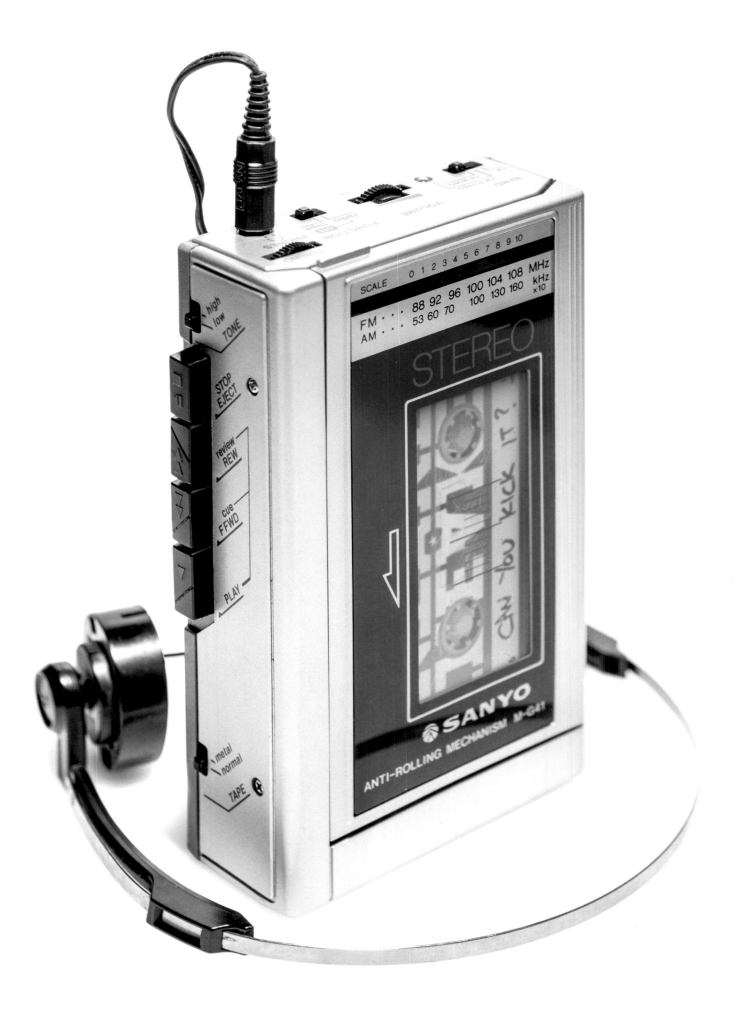

1985: Sanyo M-G41 Pocket AM/FM Cassette Player

WAX LYRICAL

A **ACOUSTIC CASSETTE** CAN YOU KICK IT? N.R. [] ✓IN ☐OUT

Text: Craig Leckie

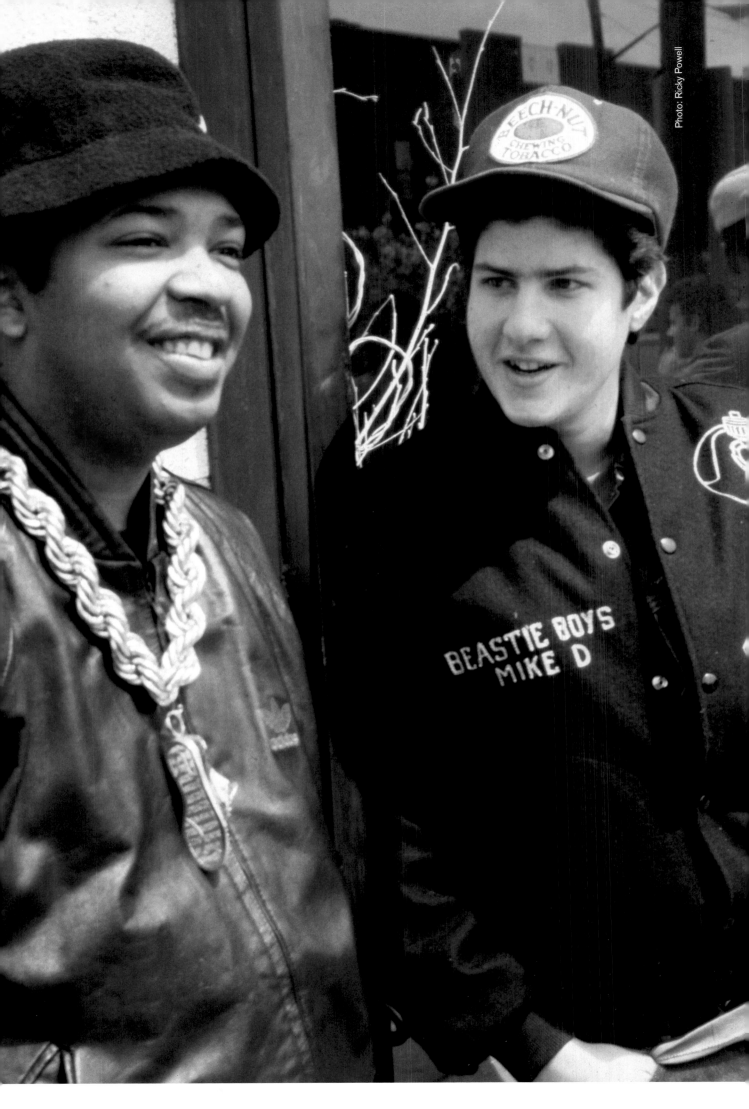

Photo: Ricky Powell

RAISING HELL—RUN D.M.C.
1. Peter Piper 2. It's Tricky 3. My Adidas 4. Walk This Way
5. Is It Live 6. Perfection
Original Sound Recording made by Profile Records Inc.
℗ 1986 Profile Records Inc. Licensed to London Records Ltd. for the U.K.

LONC 21
(828 018-4)

ALL RIGHTS OF THE MANUFACTURER AND OF THE OWNER OF THE RECORDED WORK
RESERVED UNAUTHORISED HIRING, LENDING, PUBLIC PERFORMANCE BROADCASTING
AND COPYING OF THIS RECORDING PROHIBITED FOR FULL COPYRIGHT DETAILS
SEE INLAY CARD MADE IN ENGLAND BY THE DECCA RECORD COMPANY LTD.

2 x 45 min.

B **80s: PROPS AMONG PEERS**

Made in Germany

The sneaker scene exists within a paradoxical universe. Brand ancestry, craft, marketing, design and desire coalesce into a sprawling vortex of cool. We know that the association between music and brands is one of the simplest ways to engage consumers. It can stir individual passions and deepen a buyer's connection to a label. But why do we want the latest, greatest kicks co-signed by rappers in particular? Being a movement born of the street, there's an intrinsic power in seeing your favourite artist rocking an attainable pair of sneakers. That relationship is a symbiotic one – the brands help define an artist's identity, and in turn the artist fuels the hype for the brands.

From the formative days of hip hop right through to today, the ambassadors that you'll find referencing sports-footwear in their bars illustrates just how perennial these brands are. King Kendrick teamed up with Reebok then Nike, while Drake and Minaj are signed to Jordan Brand. Kanye switched lanes from Nike to adidas, and now he's name-checking Vans (Damn!). Tyga ran with the idea that working with LA Gear was a good thing, hell, even R&B twerp Chris Brown is getting in on things by teaming up with ASICS. We know that a lot of the time rappers are just swapping their snapbacks for a marketing man's hat. But where did it all begin? What about the early days, when the passion for sneaker brands paid nothing more than props among your peers?

Babylon Beginnings
The earliest reference to sneaker brands in lyrics that I can uncover comes via reggae singer Freddie McGregor. On his 1980 song 'Jogging', he mentions 'Jogging on the sand in a Babylon land / Keeping fit, to conquer creation'. Freddie references brands like

Puma and adidas as well as the lesser known North Star by Bata. In the 'Jogging' universe, people were 'Preparing themself for Armageddon / And without even knowing / They're keeping fit (fit for the fire)'. Whereas nowadays brand name-checks are ubiquitous in the hip hop landscape, this was a rare and prescient example of an artist referencing sports-footwear actually being used for sport – something that has become conspicuously absent in more recent years.

When I was growing up in the UK in the mid-80s, the concept of following a trainer trend was unimaginable beyond the area that I lived in. At that time, my peers and I were all trying to impress our mates who lived on the same street – let alone the same estate. The notion of seeing a pair of kicks and wanting them was a pretty straightforward one. You'd see someone cool in a video on MTV, or you'd clock a shoe design in a publication like *Runner's World*. Maybe a French exchange student was staying with a friend from school, and they had some rad Le Coq Sportif kicks on. You might even remember spotting Boris Becker's red flash Pumas during the 1985 Wimbledon final. You didn't really understand why you

c.1980s: Sanyo MR-X20 'Big Ben'

liked them – you just did. Visuals aside, the most popular point of reference for young minds were the records of the time – either played on the radio or sold in stores.

My first direct exposure came via a compilation of US hip hop on a British release called Street Sounds Electro 8. A kid at school had a fresh cassette copy and rocked it on a boombox in the street outside his house. My friend dubbed me a copy the next day, and one classic line by a rapper by the name of MC Donald D (of The B-Boys) jumped out at me. It's a typically raw drum machine track with some tasty keyboard action, wherein Donald describes his countless interactions with females around his way – appropriately titled, 'Girls'. 'I went to Spring Valley / Met a girl named Sally /She took me to the store / Bought me leather Ballys.'

In 1985, Swiss brand Bally was money – serious drug dealer money. A year later, Doug E. Fresh rocked a Bally vest in the 'All the Way to Heaven' video. The clip also features a stop-motion rap battle between a pair of the aforementioned sneakers and adidas Superstars, replete with laces that fire bullets. Doug continued to show his brand allegiance by rocking white and red leather Bally Competition Lows on the cover of his LP, *Oh, My God!* in July 1986. Comp Lows were a staple in the hood at the time, but only if you were 'running thangs' as it were.

On May 15, 1986 Run-DMC's breakthrough third album, *Raising Hell*, was released in the US. But in the UK, the 'My adidas' single had already been getting nationwide airplay thanks to a show presented by iconic BBC DJ, John Peel. The cut was already becoming something you could actually rap along to – and that was cool – especially if you were wearing adidas with your crew when the song came on. Ah – those naive teenage minds!

The fact that the beloved footwear fashions of hip hop's infancy continue to assert themselves as some of the most commercially favoured on the planet still surprises me. No matter where in the world you are, just take a look around and keep a mental tab for sightings of the adidas Superstar. That shoe was released in 1969. Consider its lasting acclaim and ask yourself to think of six letters to describe why. Without Jason, Joseph and Darryl, could this silhouette have possibly been as successful?

Run-DMC may have kicked things off with the first track to use a brand in the actual title of a song – but it wasn't long before a response record arrived. Super producer Patrick Adams got in on the act with a flip released by Mutt and Jeff, simply titled 'adidas'. Rapped to the cadence of the original song, it took well-aimed pot shots at the three MCs from Queens.

By mid-1987, another four records were released with the brand names of the flyest sneakers on the streets of New York in their titles. And let's not forget the Converse TV spot that featured a rapping Larry Bird and Magic Johnson! Bally's lyrical prominence faded, as three of the four 12" releases were about Fila. Take a look back at the earliest releases from Dr. Dre's N.W.A, specifically the front cover of N.W.A and the Posse, and you'll see Converse, Reebok and Fila. In fact, if you know a rapper by the name of The D.O.C, you should be able to pick him from the line-up thanks to his role in the Fila Fresh Crew. Fundamentally, brand name references were becoming more and more popular on record – and by association more and more teens were being exposed to brands for the first time.

At this time, the trend of using a brand in the title of a song was waning – but plenty of rappers were still dropping one-liner gems about kicks. MC Mitchski was rapping 'You moved to Queens / What does that mean / Ya still wearing Pumas and faded old jeans', on 'Brooklyn Blew up the Bridge' – a canonical entry in the notorious 'bridge wars' saga regarding the true birthplace of hip hop. Similarly, on Boogie Down Production's 'Dope Beat', KRS-One proudly announced, 'I take one step to adjust the mic / I get around the whole city so I do wear Nike'.

In October of the same year, the late Heavy D proclaimed the importance of Nike on his Living Large LP. 'Run to the store, go get a pair / Guaranteed to be the number one sneaker of the year', he raps on 'Nike'. Heavy D also underlined the transparency of his comments – 'We didn't do this 'cos we had to, we did this 'cos we wanted to / All we wear is Nike, I sleep with Nikes'.

•

THE DANCE·DECADE 1973-1983

10 years of Classic Nostalgic Dance tracks, comprising the definitive DISCO Collection. 170 full length original versions guaranteed to bring back memories and stir a soul. Available as 14 Albums or 9 double play cassettes.

Album Cat. No. DEC 7383
Cassette Cat. No. ZCDEC 7383

SIDE 1
1. THE BATTLE
SPARKY DEE vs. THE PLAYGIRLS
2. THE DMX WILL ROCK (RAP MIX)
DAVY DMX
3. CONFUSION
ALEEM
4. D.E.F. FEATURING D.J. THREE D

SIDE 2
1. MARLEY MARL SCRATCH
MARLEY MARL
2. GIRLS
THE B BOYS
3. WRONG GIRLS TO PLAY WITH (DUB)
PAPA AUSTIN with the GREAT PESO
4. D.J. CUTTIN
N.Y.C. CUTTER

ESSENTIAL ELECTRO
The Business

A 5000 limited edition Boxed Set featuring 8 StreetSounds ELECTRO albums and an album available nowhere else – BONUS BREAK. ESSENTIAL ELECTRO is the definitive HIP HOP collection.
Available only on ALBUM – HBOX1
(All original full length versions)

LOVE BALLADS

The world's greatest anthology of Love songs. Love Ballads will make you laugh, cry, kiss and remember. LOVE BALLADS is the definitive LOVERS collection.
Available as 14 albums or 7 double play cassettes.
Album Cat. No. LVBAL 1
Cassette Cat. No. ZCBAL 1

ELECTRO 8 VARIOUS ARTISTS

STREET SOUNDS

ALEEM
DAVY DMX
MARLEY MARL
D.E.F. FEATURING D.J. THREE D
PAPA AUSTIN WITH THE GREAT PESO
SPARKY DEE vs. THE PLAYGIRLS
N.Y.C. CUTTER
THE B BOYS

MIXED BY MASTERMIND

COLBY STEREO

ELECTRO
SPECIALLY MIXED FULL LENGTH VERSIONS

1986

My ahhh-didas, walk through concert doors
And roam all over coliseum floors
I stepped on stage, at Live Aid
All the people gave, and the poor got paid
And out of speakers I did speak
I wore my sneakers but I'm not a sneak
My adidas touch the sand of a foreign land
With mic in hand, I cold took command
My adidas and me close as can be
We make a mean team, my adidas and me
We get around together, we down forever
And we won't be mad when caught in bad weather
My adidas... my adidas...Yo, whassup?

My ahhh-didas, standin' on two fifth street
Funky fresh and yes cold on my feet
With no shoestring in 'em, I did not win 'em
I bought 'em off the Ave, with the black Lee denim
I like to sport 'em, that's why I bought 'em
A sucker tried to steal 'em so I caught 'em and I fought 'em
And I walk down the street, and bop to the beat
With Lee on my legs and adidas on my feet
And so now I'm just standin' here shootin' the gip
Me and D and my adidas standing on two fifth
My adidas... my adidas...

Now the adidas I possess for one man is rare
Myself homeboy got 50 pair
Got blue and black, 'cause I likes to chill
And yellow and green when it's time to get ill
Got a pair that I wear when I'm playin' ball
With the heel inside, make me ten feet tall

Photo: Ricky Powell

A Tribe Called Quest 'Can I Kick It?'
(C) 1990 Zomba Recording LLC

'Disco' Dave Hamilton

As told to **Craig Leckie**

'Disco' Dave Hamilton's hip hop credentials are impeccable. A native New Yorker, Dave grew up as the music emerged in the late 70s and was immediately gripped by the movement. By the late 80s, the genre had a firm grip on the cultural landscape, and at the same time Dave had transitioned from a fan to an authority in the hip hop universe. As a contributor to iconic magazine *The Source*, he bore first-hand witness to the golden era of rap in its heartland. Oh, you can also spot him goofing around in the background of A Tribe Called Quest's seminal 'Can I Kick It?' video. Here, David recalls one fateful summer spent in the Big Apple – the music, the cars, the radio shows, the fashions, the 'fly girlies' and of course – the kicks.

The summer of '88 had a pivotal impression on me – one season shaped how I actually purchased kicks from that point on. I spent it hitting different parts of town – parlaying, partying, and of course relaxing with some choice females. In the Bronx, Fridays and Saturdays were the definitive prime time. The weekend would offer up premieres of all the 'brand news'. New kicks, new hats, new jeans and jewels. As well as recently acquired mixtapes and albums, on the airwaves Kool DJ Red Alert and Marley Marl were blasting out of the speakers of every car. If you were rocking the same brands on your feet that were name checked on the tracks that were bumping out the backseats of kitted out Honda Accords, Nissan Maximas and Volkswagen Jettas, then you were unquestionably the king of the street. Everyone gauged how formidable your wardrobe was by the brand selection you rocked. Nike, Puma, New Balance, SpotBilt, Benetton, Starter, Coca-Cola and Mickey Mouse. As well as the luxury brands – Guess, Fendi, Louis Vuitton, Bally and of course Polo by Ralph Lauren (the unofficial sponsor of most Brooklyn cats). I lived Uptown, where the original counterfeit king, Dapper Dan, had the street dudes on smash. The ladies wore Bubblegum and acid-washed denim, but the litmus test for most females was spandex. Either way, no matter what you did with your ensembles, or how tight your jewelgame was, everything was hinged on what was on your feet. I personally had my best foot forward, so to speak, because I was working in a sneaker store on 86th street.

The relevance of that summer, culturally, socially and sartorially – was huge. It was a distinct shift in pop culture aesthetics. Hip hop was still the underdog as far as mass-media went, but it was gaining more and more traction. A quick recap of some of the classic albums that dropped from Spring that year, over a six month period: Marley Marl's *In Control, Volume One*, Eric B. & Rakim's *Follow the Leader*, Boogie Down Productions' *By All Means Necessary*, EPMD's *Strictly Business*, MC Lyte's *Lyte as a Rock*, Jungle Brothers' *Straight out the Jungle* and the generational polemic – Public Enemy's *It Takes a Nation of Millions to Hold Us Bac*k. The impact this had on working class kids on the block was tremendous. And the first thing that a lot of people paid attention to was what exactly each rapper was rocking on their feet in the latest videos.

The quantity and quality of fresh-out-the-box sneakers and clothes was ri-dic-ulous. Take your pick. Nike had come out with the Air Max 87 with the navy blue for men and the light blue and pink for women – classic. Then there were those that rocked the Windrunners or the Court Force in ginormous numbers. The ladies were repping with assorted Tretorn, K-Swiss and Ellesse, as well as the hood staple, the Reebok Freestyle Hi, in way too many flavours. The technology was groundbreaking and the only way to go was up. If you peep some of the colour schemes that Nike was using then – and then add the youth factor – it starts to look like a revolution was going on.

Obviously in mentioning summer kicks, you can't avoid talking about tennis. In New York they've got the US Open at the end of the summer, and of course everybody peeps Wimbledon at the end of June. The seminal tennis sneaker has always been adidas' Stan Smith. You could walk down any New York City block at any time of day and see at least one pair. Motherfuckers wear suits with theirs, I swear to God. One warm night I headed to the Apollo to see EPMD, and a crew of fly girls pulled up front in a fully kitted Jeep Cherokee bumping Heavy D's 'We Got Our Own Thang'. They were all sporting complementary tennis outfits, and every single girl was rocking a pair of crispy white-on-white Stan Smiths. Needless to say, they all got in with the quickness.

I remember the night I went to check *RoboCop*. An old friend, who is sadly no longer with us, Kahali, pulled up outside the movie-house in a mean VW Corrado pumping 'Put Your Hands Together' by Eric B. & Rakim. He had on the ASICS GT2s – most dudes didn't rock ASICS because they were more of a specialty running shoe – but my man pulled it off smoothly. One of the weirder moments came at the flicks again. This kid got in line and asked for a small cup of – very specifically – ice-water. Just so he could get his toothbrush out and clean his SpotBilt's before the movie! Seriously. Moments like that were synonymous with that summer for me.

•

1987: Heavy D and the Boys *Living Large*

1988: EPMD *Unfinished Business*

1990: The Geto Boys

INDEX 90s: BRAND LOYALTY

By 1988, old school pioneer Busy Bee jumped on the opportunistic brand-wagon with the release of his 'Converse' cut. A year later, the California-based outfit One Def Clan, who had previously released tracks alongside West Coast pioneer Rodney-O, rapped about how they had a jones for one label. 'I wear Nikes cos they make me jump higher / I wear Nikes cos they make me look flyer,' they rapped in 1989. How many of you have a similar outlook and the same form of brand loyalty today?

On the classic 'Read These Nikes' of the same year (co-produced by the legendary Rick Rubin), Geto Boy Willie D offered a warning to listeners. He explained how the streets were a cauldron of confrontation, and to avoid any unnecessary 'conflict' the best thing to do would be to avoid The Geto Boys altogether. If you didn't, the alternative would be catching a beating – during which you'd probably be able to read the fine print underneath the perpetrator's soles.

In 1991, the late Phife Dawg of A Tribe Called Quest rapped about New Balance on the full-lengther *Low End Theory* – 'I sport New Balance sneakers to avoid a narrow path / Mess around with this you catch a size eight up your ass.' In '93, Snoop released his *Doggystyle* album, which included a cover version of Doug E. Fresh & Slick Rick's 'La Di Da Di'. Snoop didn't hesitate to rep his crew's hue with the rhyme 'Now I'm fresh, dressed, like a million bucks. Threw on my white socks, with my all-blue Chucks.' In 1994, the one and only Nas was clear about his brand loyalty with the iconic 'I'm a Nikehead, I wear chains that excite the Feds,' line from the seminal *Illmatic*. Nothing had changed, rappers were still keen to map their fashions in their footwear.

The mentions continued through the decade with more Nike love from Diggin' In The Crates Crew representative Big L, on the '95 track 'I Don't Understand It'. Big Lamont is evidently so unhappy with some rappers that he calls them out for bringing their crappy raps on tour. 'Your raps border wack / And you went on tour with that crap / I don't understand it / 'Cause rhyme skills you lack / I got more soul than Nike Airs / Givin' MCs nightmares.' Can't argue with that! And so it continued – even Tupac Shakur got in on the act with 'California Love', a further acknowledgment of the West coast footwear staple – 'In L.A. we wearing Chucks not Ballys.'

In '97 Mos Def voiced his views on the clientele that had been caught up in the fashions of 'the street' on the Reflection Eternal song, 'Fortified Live'. 'Ghetto red hot, man that shit is like bubblin' / Can't get no peace 'cause the beast keep troubling / Youth, they oppose and the blows they be doubling / Nikeheads is trife and the shots, they be thundering.'
•

FAT BOYS
"FAT BOYS"

SUC 1015

FAT BOYS
"FAT BOYS"

JAIL HOUSE RAP — STICK'EM — CAN YOU
FEEL IT — FAT BOYS — THE PLACE TO BE —
HUMAN BEAT BOX — DON'T YOU DOG ME

A SIDE:
JAIL HOUSE RAP (K. Blow/K. Reeve/M. Morales/D. Robinson/S. Abdallah/D. Wimbley) 8:30 (Fools Prayer Music, Inc.
Too Much Music/Kuwa)-STICK'EM (M. Morales/D. Robinson/D. Wimbley) 4:28 (Fools Prayer Music, Inc. (BMI) / CAN YOU
FEEL IT (K. Blow/M. Morales/D. Robinson/D. Wimbley/Green Ogre (ASCAP) / Fools
Prayer Music, Inc.)

B SIDE:
FAT BOYS (K. Blow/W. Waring/K. Miller/M. Morales/D. Robinson/D. Wimbley) 6:50 (Kuwa/Fresh Ideas/Mofunk (ASCAP) /
Fools Prayer Music, Inc. (BMI) — THE PLACE TO BE (M. Morales/D. Robinson/D. Wimbley/K. Blow) 4:26 (Amber Pass Music, Inc.
(BMI) — DON'T YOU DOG ME (K. Blow/M. Morales/D. Robinson/D. Harris 5:50 (Amber Pass Music, Inc.)/ Kuwa/Stickey

black moon
enta da stage

black moo

enta d
stag

POWAFUL IMPAK! 4:02
MAKE MUNNE 4:23
SLAVE 2:47
NIGUZ TALK S..T 4:18
I GOT CHA OPIN 4:10
S—T IZ REAL 3:53
ENTA DA STAGE 2:49
HOW MANY MC'S 3:53
U DA MAN 4:18
SIX FEET DEEP
BLACK SMIF
SON GET WREC 3:26

FIRST STAGE

SECOND STAGE

NRV 9101-02002-4 BLACK MOON
ENTA DA STAGE. WRECK RECORD

PRODUCED BY DA BEATMINERZ

EXECUTIVE PRODUCERS. M.W. AND BIG DRU HA

Manufactured by Max Entertainment, Inc. 1501 Broadway suite 2900 NY, NY 10036.
Distributed in the United States by MAX / EMI. P & © Max Entertainment Inc. 1993. Made in USA. All rights reserved.
Unauthorized duplication is a violation of applicable laws.

0 9101-02002-4 5

PARENTAL
ADVISORY
EXPLICIT LYRICS

PARENTAL
ADVISORY
EXPLICIT

GETO BOYS
Till Death Do Us Part

SIDE ONE
1. Intro
2. G.E.T.O.
3. It Ain't
4. Crooked Officer
5. This ___ 's For You
6. Street Life
7. Bring It On

SIDE TWO
1. Raise Up
2. Murder After Midnight
3. Straight Gangstaism
4. Cereal Killer
5. No Nuts No Glory
6. Six Feet Deep
7. Murder Avenue
8. Outro

© 1993 Rap-A-Lot Records, Inc.
℗ 1993 N-The-Water, Inc. ASCAP
Manufactured and Distributed by
Priority Records, Inc.
P O Box 2186
Hollywood, CA 90078

RAP-A-LOT RECORDS
P4 57191

GETO BOY BIG MIXIN
TO GET THE CHAIR
AT 12:01 A.M.

"Bring It On!"
— Bushwick Bill

"There's go
Murder Afte

TOP STORY: CROOKED OFFICERS

5th Ward Chronicle

FREE March 9, 1993 FINA

GETO BOY

Till Death Do Us P

0 4992-57191-4 7

HIP C117

A TRIBE CALLED QUEST
THE LOW END THEORY

GRAM 1
...CURSIONS
...BIN' OUT
... PROMOTER
...TTER
...SES FROM
... ABSTRACT
... BUSINESS
...ES AND STUFF
GRAM 2
... INFAMOUS
...E RAPE
...CK THE RHYME
...RYTHING IS FAIR
...Z (WE'VE GOT)
...Y PAGER
...AT?
...NARIO

JIVE

Manufactured
in the EEC
Distributed by
BMG (U.K.) Ltd
℗ 1991
Zomba
Recording
Corporation
© 1991 Zomba
Recording
Corporation

DOLBY SYSTEM

DRMC-50055

CHRIS ROCK
BIGGER & BLACKER

...t Lounge #1
...Nuff
...D.O.W. #1
...White Kids
...Interview
...PSA

...D.O.W. #2
...Glover
...Pace
...nt Lounge #2
...Fly Girl

...yo

...D.O.W. #3
...omen
...Zapp
...Choke
...DB

...works Records, 9268 West Third
...Beverly Hills, CA 90210
...comworks.com
...by Universal Music & Video
...ation, Inc. © 1999 SKG Records
...de in U.S.A. All Rights Reserved
...zed duplication is a violation of
...laws.

6 0044-50055-4 9

PARENTAL
ADVISORY
EXPLICIT LYRICS

MCAC-11102

BIG DADDY KANE
Daddy's Home

DADDY'S HOME
BROOKLYN STYLE LAID OUT
IN THE PJ'S
SHOW & PROVE
LYRICAL GYMNASTICS
THAT'S HOW I DID 'EM

SAS ACCORDING TO THE PRINCE OF DARKNESS
3 FORTIES AND A BOTTLE OF MOET
THE WAY IT'S GOIN' DOWN
SOMEBODY'S BEEN SLEEPING IN MY BED
W.C.O.N.R'S
LET YOURSELF GO
DON'T DO IT TO YOURSELF

Executive Producers
Ernie Singleton and Andre 'Big Fish' Fischer

DADDY'S HO

MCA

DOLBY SYSTEM
HQ

PARENTAL
ADVIS
EXPLICIT

0 08811 11024 6

BIG DADDY KANE

1988
MC Shan – 'I Pioneered This'
Puma is the brand
'cause the Klan makes Troop

Boogie Down Productions – 'Nervous'
So right about this time
You should throw your hands up in the air
How many people got Nikes on?
If you got your Nikes on,
put your feet up in the air
If you don't got Nikes on
I think you need to keep your feet down
'Cause the party is live
We're in total stereo, know what I'm sayin'?

Sir Mix-a-Lot – 'Buttermilk Biscuits'
Now I'm your big maul dropper,
mud duck stopper
Fila on the bottom and adidas on the topper

Derek B – 'Bad Young Brother'
We dress in black, never, ever touch crack
We wear fresh fly adidas, not Nike
– they're wack!

Three Times Dope – 'Straight Up'
Superwack nuts cold killin' me with boredom
Tryin' to be fly, I'm in the Air like Jordan

Public Enemy – 'Night Of The Living Baseheads'
My man Daddy-O once said to me
He knew a brother stayed all day in his Jeep
And at night he went to sleep
In the mornin' all he had was sneakers on his feet

1989
Beastie Boys – 'Shadrach'
More adidas than a plumber got pliers
Got more suits that Jacoby & Meyers

Geto Boys – 'Read These Nikes'
I kick ass, you want evidence
Look at the bottom of my goddamn shoeprint
Muthafuckas done donated blood to the kid
Now do you wanna make a bid?
I didn't think so, 'cause I'd have yo
Ass screamin' just like a damn ho
When I hit ya in your goddamn mouth
And show you what a real nigga is all about
When I dispose of your ass like waste
And nothin' but my shoe in your muthafuckin' face
You're readin' these Nikes

Donald D – 'On Tour'
In the limo in the back, champagne in the glasses
People are askin Dee for stage passes
Autograph seekers steppin' on my sneakers
I sign, then I rhyme through the speakers

Biz Markie – 'A Thing Named Kim'
I took a hot bubble bath, instead of a shower
Got rid of the dragon, it took me an hour
Decided on a sweatsuit,
Gucci red and white
Some rings and some ropes, then I'm on for the night
The Gucci sneakers some cologne, I think Aramis
I looked in the mirror and said,
'Biz you look marvellous!'

1990
Boogie Down Productions – 'Breath Control II'
It's KRS-One, yes the teacher
I wear Clarks and only Nike sneakers

Brand Nubian – 'Slow Down'
Hey baby your hips is getting big
Now you're getting thin you don't care about your wig
Now Woolie Willie got a pair of my sneakers
I wonder where he got 'em 'cause
I hid 'em behind my speakers

Kool G Rap & DJ Polo – 'Money In The Bank'
I'll kick you in your ass
and your breath'll smell like sneaker soles
Now how's that for a fixin'?
You'd better rather go to Roy's,
'cause I ain't kickin' science fiction
I kick a size nine sneaker

1984
Fat Boys – 'Jailhouse Rap'
So I put on adidas
Headed out the door
As I pictured myself
Eating more and more
But the store was closed
I busted into a rage
So I went to the crib
And got my twelve-gauge

1986
Ice-T – '6 in the Mornin''
6 in the morning, police at my door
Fresh adidas squeak across
The bathroom floor
Out my back window I make a escape
Don't even get a chance to grab my old school tape

Run-DMC – 'My adidas'
Now the adidas I possess
for one man is rare.
Myself homeboy got 50 pair

1987
MC Lyte – 'Cram To Understand U'
We dipped and we dapped
And we chit and we chat
About this and that, from sneakers to hats

Boogie Down Productions – 'Word From Our Sponsor'
I represent my DJ Scott La Rock
D-Nice, the beat box
I only wear Nikes, not adidas or Reeboks

Boogie Down Productions – 'Dope Beat'
My name is KRS-One, I'm still kinda young
I don't wear adidas 'cause my name ain't Run
Got Nikes on my feet and to be complete
I can rock an American or reggae beat

LL Cool J – 'I'm Bad'
Calling all cars, calling all cars
Be on the lookout for a tall light-skinned brother with dimples
Wearing a black Kangol, sweat-suit,
gold chain and sneakers

Juice Crew All Stars with MC Shan – 'Juice Crew All Stars'
Never say a rhyme that's less than hoopin'
Beauty queens are the girls I'm scoopin'
This is just a small rap representation
Down with the Juice since the foundation
Bullet-proof sneakers and a bullet-proof vest
Killin' like a villain from the old Wild West

Ice Cube – 'A Gangsta's Fairytale'
Got a shot in the ass, and he was on his way
To make some money, why not?
Down on Sesame Street, the dope spot
There he saw the lady who lived in a shoe
Sold dope out the front, but in back, marijuana grew
For the man that was really important
Who lived down the street in a Air Jordan

Boogie Down Productions – 'The Kenny Parker Show'
Gimme a chance and I'll rock the house
But don't let a sucker try to take me out
Cause male or female, I will strangle
If it's a crew, they'll have to untangle
adidas, Nikes, arms, mics
Turntables, suckers in the wheel of my bike!

1991
A Tribe Called Quest – 'Buggin' Out'
Styles upon styles upon styles is what I have
You wanna diss Phifer but you still don't know the half
I sport New Balance sneakers to avoid a narrow path

Heavy D – 'Letter to the Future'
Yeah, sure you go to school, but you go to be cool
To sport sneakers that you took from somebody
To talk about the kid that you bucked at some party

Ed OG & Da Bulldogs – 'I Got To Have It'
We didn't get in here so you can get in with us
You wasn't down when we was riding the bus
So put on your adidas and step off
I got to have it
No need for me to run away, brother, put the gun away
You wanna take my life away as if we were in combat
You can buy some adidas but you can't buy my life back

1992
Ice Cube – 'We Had to Tear This Muthafucka Up'
Oh what the hell, throw the cocktail, I smell smoke
Got the fuck out, Ice Cube lucked out
My nigga had his truck out, didn't get stuck out
In front of that store with the Nikes and adidas
Oh Jesus, Western Surplus got the heaters
Meet us, so we can get the 9s and the what-nots
Got the Mossberg with the double-eyed buckshot

1993
Black Moon – 'Who Got The Props'
Bust a move, I get smooth like Roadie
Kick it like the Four Horsemen, you know me
Booming like a speaker with my hundred dollar sneakers
Baggy black jeans, knapsack and my beeper

Geto Boys – 'Bring It On'
Ain't nothing changed since the 70s
I'm hellbound nigga, my life ain't never been heavenly
Never slippin' punk, no a nigga don't lag
Game tight replace a nigga's Nikes with a toe tag

1994
Lord Finesse – 'Shorties Kaught in the System'
Material things is what they want to scoop
They can't get shit like that, workin' for no Summer Youth
They got clients, they livin' like giants
They got the whole drug shit to a science
They got jewels and beepers, hundred dollar sneakers
Lexus coupe, windows down boomin' the speakers

Nas – 'Halftime'
I'm an ace when I face the bass
40-side is the place that is giving me grace
Now wait, another dose you might be dead
And I'm a Nikehead, I wear chains that excite the Feds

1995
Big L – 'I Don't Understand It'
Your raps border wack, you went on tour with that crap Don't
understand it, 'cause rhyme skills you lack
I got more soul that Nike Airs, givin MCs nightmares
Rappers frontin' hard, and rhymes they don't write theirs

Kool G. Rap – 'Fast Life'
Fakers get used as shootin' targets,
soon as the dark hits,
Front on the drug market, bodies rolled up in a carpet
Those that cheat us try to beat us
we got hookers with heaters,
That'll straight pop and put more shells
in your top than adidas

Mobb Deep – 'The Start Of Your Ending [41st Side]'
Obey me or get sprayed with the sweeper
Cause I'm my brother's keeper
The Grim Reaper holdin' with nothin' but big batters
And big heaters
Blow ya three times leave a mark like adidas

1997
Mos Def & Mr. Man – 'Fortified Live'
Ghetto red hot, man that shit is like bubblin'
Can't get no peace cause the Beast keep troublin'
Youth, they oppose and the blows they be doublin'
Nikeheads is trife and the shots, they be thunderin'

Rakim – 'It's Been A Long Time'
I heard the word on the street is
I'm still one of the deepest on the mic since adidas
Who wouldn't believe this?

Master P – '6 'N Tha Mornin'
6 'n tha mornin' police at my do'
Fresh Nikes squeak across my bathroom flo'

1998
Pete Rock – 'Tru Master'
We had the bass pound speakers, shell-toed adidas
Original rap with new school leaders
Graffiti art names with fat gold chains
Shock the world cousin, this hip hop remains

Big L – 'Ebonics'
My weed smoke is my lye
A key of coke is a pie
When I'm lifted, I'm high
With new clothes on, I'm fly
Cars is whips and sneakers is kicks
Money is chips, movies is flicks

Public Enemy – 'Politics of the Sneaker Pimps'
200 a pair but I'm addicted to the gear
They make me do things on the court to amaze ya
I heard they make 'em for a buck eighty in Asia
They came a long way baby since Clyde Frazier had Puma is pullin'
mad consumers
Them Filas I'm feelin, but I can't touch the ceiling
Them New Balance hits 120 million
The last thing I need is adidas terminatin' my contract
For wearing those old pair of wack
Reebok low tops covered up by floppy socks

2000

XS I LEXICON 'NIKE HEAD' Normal Bias 120µs EQ 90 Scotch

Everybody has an addiction, mine is shoes
It started with my very first pair of Kangaroos
Even now if I only got forty bills
I'mma buy a sack of weed and go straight to Marshalls
Cause one time at Ross I found Nike Zoom Airs
Fourteen bucks – what – I bought two pair
I always do that there so there's no need to despair
If my kicks get ugly from some wear and tear
I know it's sick, my addiction, I'm addicted, I admit it
Like an alky to his liquid, I ain't tryin to kick it
Alternates, duplicates, hard to find colors – check it
I got four pairs of Air Force Ones high and low
All in all white, one with a gum sole
Buyin' Air Max runners since they first came
Before wearin' neon colors was a G thang
That's when I go on the internet
To the Japanese sites, where I can't read a word of it
But the pictures taunt, tell me to max out my Mastercard
Deal with it later these shoes are hard
I got a problem, and I need salvation
So at this time I'm accepting donations
Cash is fine, or anything in size nine
But please don't send no Jordans
Send 'em to someone else, I'm not the only one on this Earth
Who will buy food second but a pair of shoes first

c.1980s: Cougar J-8181 K

A 1999: MEMORY LANE . ◻◻

NR ☐ ON ☐ OFF

By the turn of the millenium, two tracks stood out. Both were exhaustive and mentioned shedloads of older brands, some no longer in production. In November 1999, the ultimate name-dropping track regarding the imprints, labels and brand names of sneakers had arrived – Raekwon's 'Sneakers'.

The track was produced by the legendary DJ Pete Rock for the 1999 LP, *Immobilarity*. It has become possibly the rap track that people associate with brands being name-checked via song. For an older audience, it's a revisionist throwback, while for a younger crowd it serves as a sonic education in the brands of yesteryear. In terms of product, Rae highlights the diversity of loyalty in some disparate corners of the sports-footwear oeuvre. He manages to list more than 30 brands and sneaker models in the three-minute track – which surely earns him the all-time crown as the king of sneaker raps.

The street epic opens with a transaction in a sneaker store, with young Corey Quontrell Woods attempting to swing the tax for the kicks he wants to cop. 'I'm not paying $140 for them. I'm telling you, I'm only paying $90,' he insists before reciting the name of every single sneaker brand that has ever delivered daps in the hood. In terms of the construction of the track, it's not unlike a classic by Wu contemporary the GZA who made reference to dozens of rap and hip hop record labels on his 1995 release, 'Labels'. There are

names here that you might not be familiar with like SpotBilt, a popular Saucony-produced basketball trainer. Or how about the athlete's classic, Etonic? It's as much a memorial tribute as it is a walk down memory lane – as a lot of the brands referenced have since bitten the dust. Still, if you can remember wearing Pony, Patrick, Lotto or Prince – it's sure to conjure some warm feelings.

Then the very next year, the equally entertaining 'Nikehead' by Lexicon was released. Sampling the famous 'I'm a Nikehead' line from Nas' 'Halftime', Lex explains in great detail how the desire and need for kicks can have its pros and cons. He discusses having colorways of dope shoes and talks about wearing sports shoes for any reason – other than for sports. 'The Ellesse, made for tennis / I play none of it / But I owned 'em in brown and black suede', he rapped. He also references his 'obscene spending' at stores like Sportie LA and Marshalls, and admits to having a problem due to his reckless consumption.

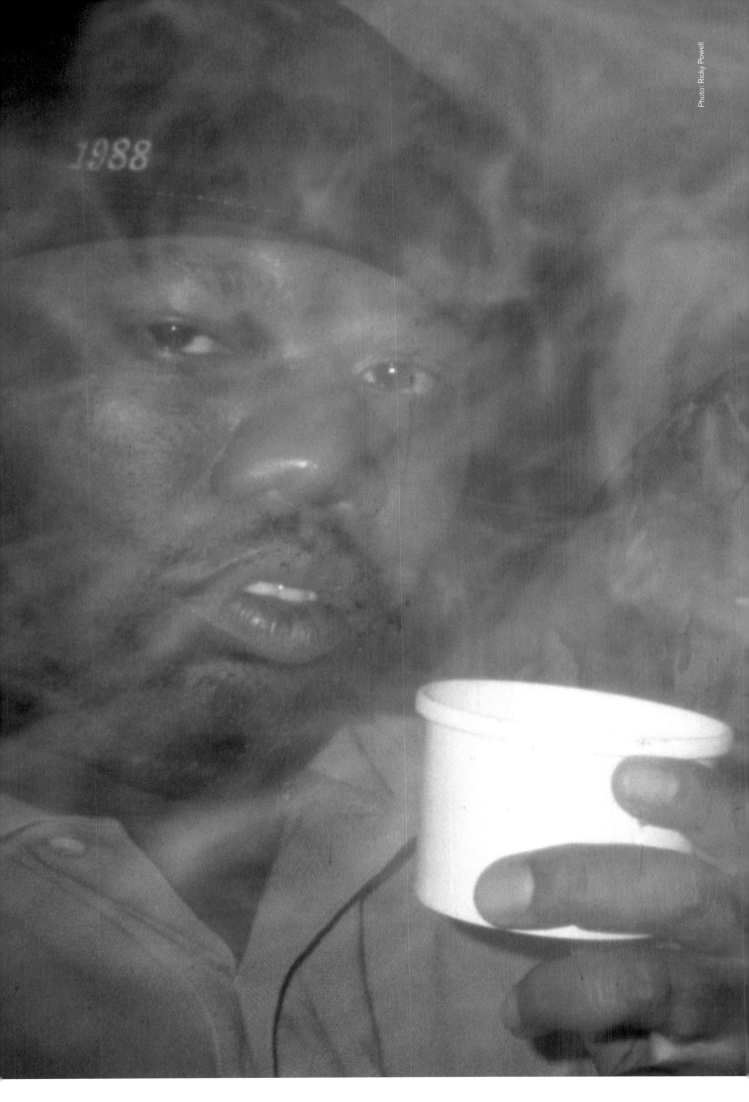

1988

Photo: Ricky Powell

1999

I'm not payin' $140 for them (size 8 and a half)
I'm tellin' you I'm only payin $90
(that's what you keep spendin' your money on)

Ayo, ayo
Who wear it all, I'm an adidas freak
Multi thousand pair of sneak freak
Real fly physique that'll look yeah, fat watch, live footwear
Have the white folks displaying my gear
C'mon son let's keep it movin' right footwear, check out my book yeah
Stop, look, stand and you stuck but don't stick
Come aboard now, we got the Georgetowns, it's on now
So many fat styles, make a kid head fall out
Filas, those too, pah I suppose to
Always keep it real with the selection, holdin' you
Prince black Jordans , K-Swiss gear, remember Lottos?
Stash mad bottles, in the fence ooh Diadora
Anita place me your order, slow your speed down
Buyin' food for your daughter
Stan Smiths, handlin' whips, gravel pits, Travel Fox yo
Ready to cop more shit

Fly Royals, got love for 'em. Remember ASICS? We do the basics
Stood out, slide 'em on, taste it wild lace in these
Sauconys and Ponys, SpotBilt mix with Le Coq velour shit
Keep it real, heavy set, head set, intellect set
Black Mutombos, Columbo on the set, internet
Plus Pumas and Patricks, Infrared shit, switch up the black shit
Green Huaraches, unattached shit, 575 New Bals, blue bals
Bo Jacksons grey and black, ready to throw my hands flashin'
Ewings, Barkleys, Lex use an entertainer, forget Air Cross Trainer
Free container, Polos, Mark 5s and Elleses, the fly pieces
Shit be on the back, mad features
Hoyas, Cortez, and Etonics, feeling bionic
Designer with my fly garments, what up!

First published *Sneaker Freaker* Issue 36 – July 2016

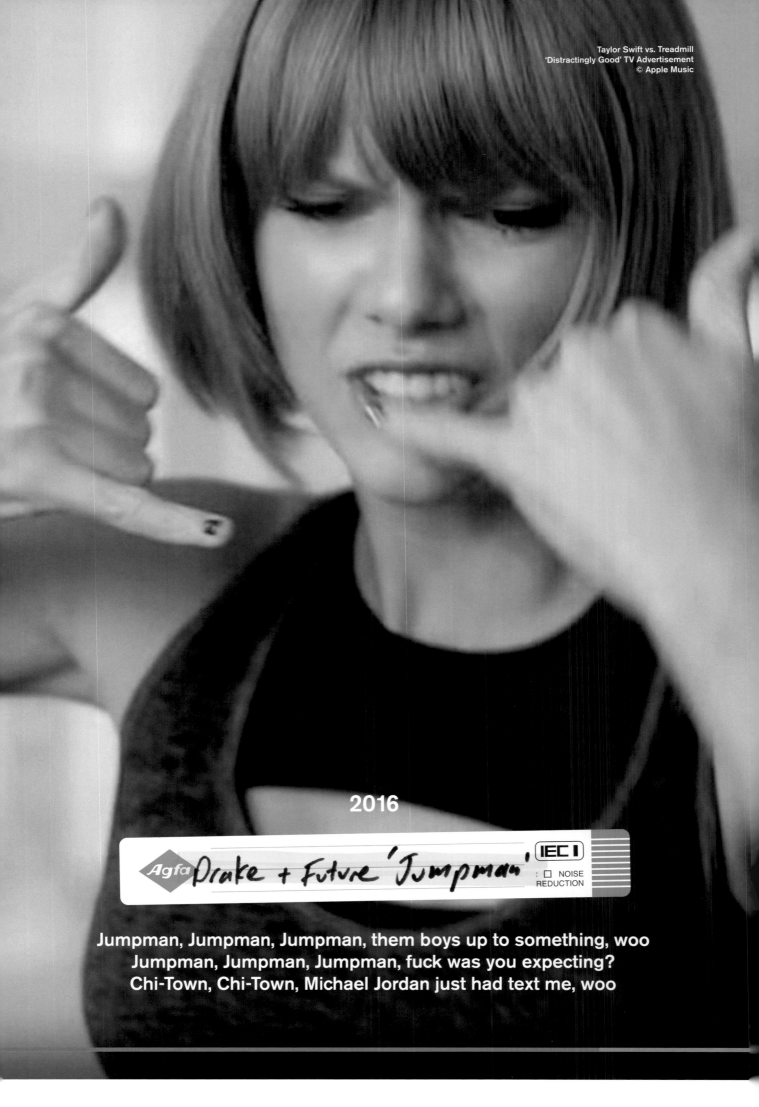

Taylor Swift vs. Treadmill
'Distractingly Good' TV Advertisement
© Apple Music

2016

Agfa Drake + Future 'Jumpman' IEC I
: ☐ NOISE
REDUCTION

Jumpman, Jumpman, Jumpman, them boys up to something, woo
Jumpman, Jumpman, Jumpman, fuck was you expecting?
Chi-Town, Chi-Town, Michael Jordan just had text me, woo

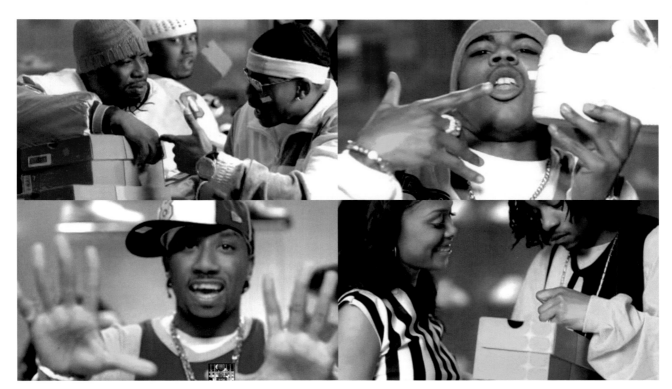

Nelly - 'Air Force Ones' ft. Kyjuan, Ali, Murphy Lee
© 2002 Universal Motown Records

▲ HF-S 90

B TYPE I (NORMAL) POSITION NORMAL. BIAS 120μs EQ NR ON OFF *(2000)* JAYS ON MY FEET

So where to go from Raekwon and Lexicon's genre-defining sneaker cuts? As we transitioned into a new century, hip hop's identity began to shift and morph – as did the notion of brand allegiance. It's hard to ignore Nelly's effort, 'Air Force Ones', from his 2002 album *Nellyville*. The love letter to the Swoosh charted, reaching number three on the US Billboard Hot 100. That's a pretty impressive feat, considering the lyrical content of the song is literally limited to rapping about shopping for AF-1s.

Nelly and his fellow St. Lunatics Kyjuan, Ali, and Murphy Lee go verse for verse – comparing and contrasting the merits of various colourways. In case you somehow forgot about this track, here's a quick rundown of the styles mentioned – all white with the gum bottom, lime green and kiwi, khaki and army green, red and white, white and blue, purple and gold, orange and blue, white on white, black and platinum, and grey leather. Impressive!

Although notable, this wasn't Nelly's only foray into the world of sneaker-raps. He also recorded an ode to the greatest indignity a Jordan fan can suffer – with 2008's 'Stepped on My J'z'. Despite being the second single on his *Brass Knuckles* LP, the track just scraped into the Hot 100 at a rather unassuming 90. With lyrics like 'Patent leather number 11s / We call 'em Space Jams / You in my space man / I'mma make you jump man', it's not hard to see why it didn't set the charts on fire.

It's not all about the love of purchasing though. In terms of cornball entries to this list, Macklemore and Ryan Lewis' 'Wing$' is an unparalleled standout. The saccharine-sweet sermon may seem like an endorsement of the brand on a casual listen ('I wanted

to be like Mike, right'), but its agenda quickly becomes apparent. The ever-demure Macklemore takes swipes at Nike with all the conviction of a de-clawed kitten. 'I look inside the mirror and think Phil Knight tricked us all / Will I stand for change, or stay in my box / These Nikes help me define me, but I'm trying to take mine off,' he preaches in his insipid radio-friendly flow. Perhaps we'd take his anti-consumer stylings a little more seriously if he didn't lend his name to a 'Friends and Family' release of the Air Jordan 6. Sucker!

Of course, if we're going to talk about Jay songs there's definitely an elephant in the room that needs addressing. In 2013, super-producer Mike WiLL Made-It did the statistically and logistically improbable, when he united an OG member of Three 6 Mafia with Wiz Khalifa and Disney alumni Miley Cyrus for '23' – a bold tribute to the Jumpman. While Cyrus' hip-hop pedigree is questionable (in a 2009 interview she admitted that she'd 'never heard a JAY-Z song,' despite name-checking him on 'Party in the U.S.A'), she actually manages to out rap Khalifa on the cut. The accompanying video shows Ms. Cyrus in a custom Bulls miniskirt as she lurches through the bars, 'I be in the club / Standing on the couch / In them Wolf

2013

maxell C90

I'm in the club
High on purp with some shades on
Tatted up, mini skirt with my Jays on

Jays on my feet (you know it)
Jays on my feet (you know it)
Jays on my feet (you know it)
So get like me
Jays on my feet (you know it)
Jays on my feet (we trippin')
Jays on my feet (we trippin')

Put on my Jays
and dance the whole night away
I'm naughty by nature like hip hop hooray
My hands in the sky
I wave 'em from side to side
My feet on the floor
I'm 'bout to turn up now

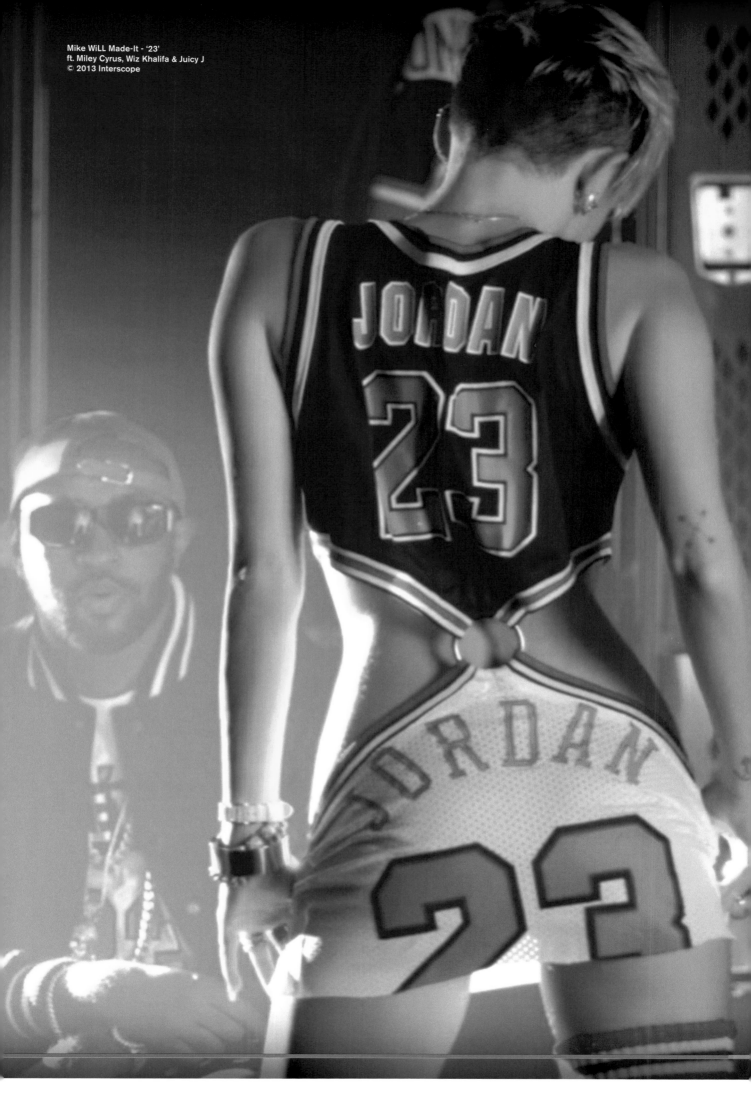

Mike WiLL Made-It - '23'
ft. Miley Cyrus, Wiz Khalifa & Juicy J
© 2013 Interscope

2016

Image: Mafia

Ⓐ KANYE WEST 'FACTS' | LN 60
maxell | POSITION · NORMAL

Yeezy, Yeezy, Yeezy, I feel so accomplished
I done talked a lot of shit but I just did the numbers
Herzog and adidas, man you know they love it
If Nike ain't have Drizzy, man they wouldn't have nothin', woo!
If Nike ain't have Don C, man they wouldn't have nothin', ooh!
But I'm all for the family, tell 'em, 'Get your money'
Yeezy, Yeezy, Yeezy, they line up for days
Nike out here bad, they can't give shit away

Yeezy in the house and we just got appraised
Nike, Nike treat employees just like slaves
Gave LeBron a billi' not to run away
10 thousand dollar fur for Nori, I just copped it
Your baby daddy won't even take your daughter shoppin'

Yeezy, Yeezy, Yeezy just jumped over Jumpman, ah!
Yeezy, Yeezy, Yeezy just jumped over Jumpman

Nelly – 'Stepped On My J'z'. ft. Jermaine Dupri, Ciara
(C) 2008 Universal Motown Records

Greys, like it's my house,' in a stilted cadence. Awkwardness aside, it's clear that Hannah Montana is down for the cause – and with a staggering half-a-billion views on YouTube it just might be the most successful sneaker song of all time.

More recently, we had Drake and Future team up on a collaborative entry to the Jordan-tribute canon courtesy of 'Jumpman'. Title aside, it's actually rather lacking when it comes to specific sneaker callouts. Still, it's worth mentioning here largely by virtue of a US Apple Music advertisement that features illuminati-robot Taylor Swift gleefully singing along with the song as she stretches her twiggy legs on a treadmill, before face planting after some particularly enthusiastic rap-hands. (See! She's just like us! Definitely not a soulless corporate puppet!) Perhaps the most compelling part of the track is Future meditatively chanting the word 'Nobu', like Japanese-fusion cuisine is the key to a transcendent spiritual awakening.

Amazingly, we've managed to make it this far without mentioning Kanye West. Although he has a few kicks-related bars ('Reeboks baby? You need to try new things', on JAY-Z's Rihanna-assisted 'Run This Town' being a particularly barbed example) it's hard to go past 'Facts'. Originally released on Soundcloud before receiving official billing on his *The Life of Pablo* album, it pulls no punches when it comes to sledging his Portland-based former-collaborators. 'Yeezy, Yeezy, Yeezy just jumped over Jumpman', he intones over pounding Charlie Heat production, before claiming 'Nike out here bad / they can't give shit away'.

'Facts' is an interesting development in the sneaker-rap saga by virtue of the fact that Kanye is endorsing not just a particular model, but one that he had a direct hand in creating. As an artist, Yeezus always straddles the line between cultural curator and creator – so it's not surprising to see him play both sides here. His bars become a self-fulfilling prophecy as he fuels the fire of his own hype – 'Tell adidas we need a million in production / I done told y'all all I needed was the infrastructure / Now we hottest in the streets it ain't no discussion'. You only need to consider the crowd at the Yeezy Season 2 premiere at Madison Square Garden passionately chanting 'Fuck Nike' as the track came on to get a read on Kanye's cultural influence. Regardless of your feelings about the dude, he's certainly a savvy businessman.

In the space of just over three decades we've witnessed a rapid evolution in the relationship between hip hop and sneaker culture. From signifiers of street, to paid endorsements, to active corporate-collaborators – we've come a long way. As the influence and reach of the genre has ballooned, so too has the potential revenue to be made from a well-positioned co-sign. To their credit – by and large – contemporary audiences are savvy enough to parse through the nuances of corporate interests and recognise authenticity. For a prescient example, look no further than Kendrick Lamar's blistering verse on Big Sean's 'Control' from 2013. Not only does Lamar annoint himself as Tupac's spiritual successor – he makes a pointed statement via footwear selection. 'I ain't rocking no more designer shit / White tees and Nike Cortez, this red Corvette is anonymous', he spits through a palpable sneer.

The shout-out to a classic, inauspicious shoe is a carefully selected metaphor. A return to basics, if you will. Much like the clean lines of the aforementioned model, Kendrick's verse is stripped of bells and whistles. Compare it to the brashness of, say, Yeezy's Red Octobers: they both belong to the same genre but they serve a very different purpose. One is about defining the era in which they exist, while the other is focused on building within a well-established framework of tradition. Even when Kendrick engages with commerce directly, his goals are more philanthropic than aspirational. Last year's ongoing collaboration on Reebok's Classic Leather sought to unite LA's warring gang factions – a corporeal manifestation of his music's messages.

So, where to from here? Hip hop as a genre feeds on the energy of the youth, so as long as the kids keep lusting after kicks it's unlikely that brand names will fade from prominence. In the same fashion, keeping footwear front and centre lyrically drives consumer hype and keeps kids hitting the stores. Still, if you find yourself lamenting the state of the scene, picture the ink drying on Run-DMC's adidas contract back in the 80s. Just as the rhymes have matured, so have the marketing schemes. The rappers of today didn't invent the art of the sell – but they certainly perfected it.

•

Starter

Published in *Sneaker Freaker* Issue 22, September 2011

EDITOR'S NOTE: WOODY

Like Airwalk and Vision, Starter was a champion – and victim of – the yo-yoing entrepreneurial madness experienced by streetwear companies in the early 90s. Starter's stalled line of sneakers barely deserves a mention, but the S-Star's heady mix of pro-sports style and uber fan loyalty made their hats and silky satin jackets incredibly powerful. As Anthony Costa details in his interview with founder David Beckerman, Starter was a 'strange phenomenon' that came unstuck after Nike tried to buy the company and the leagues jacked up royalty demands to ludicrous heights. Hold on, I think I'm having a hat attack!

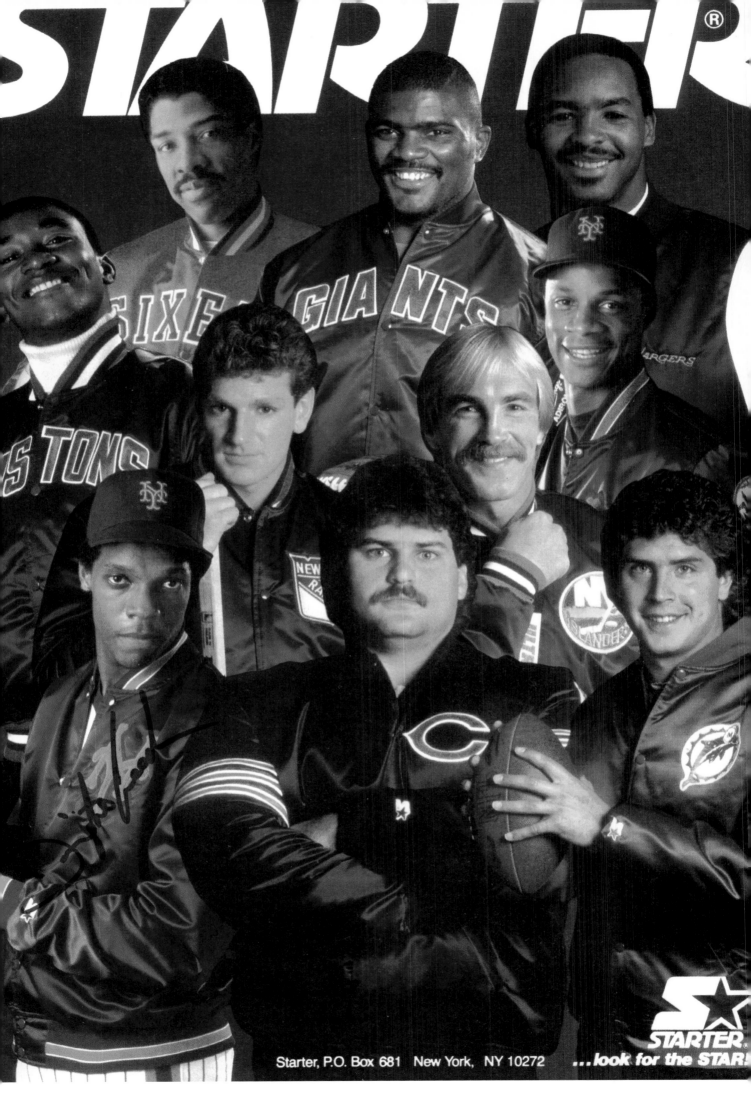

STARTER®

Starter, P.O. Box 681 New York, NY 10272

STARTER.
...look for the STAR!

492

SNAP BACK! TO STARTER

SPORT x STREET

TEXT Anthony Costa

While the 1990s pro-sports licensing boom spawned plenty of me-too mimics, Starter will always be the originator, standing head, snapback and shoulders above the rash of imitators. Led by shrewd sports-mad visionary David Beckerman, Starter grew from kitting-out local Connecticut teams to become a corporate giant gripping the reins of a $13 billion industry.

Beckerman built his success on a simple premise: what if Joe Schmo supporter could buy authentic sports apparel and feel like they were part of the team? Starter cracked its first pro-league deal in 1976, signing on with Major League Baseball. Always the innovator, the brand caused a stir by introducing dugout jackets cut from swishy satin rather than standard nylon. This revolutionary concept helped sow the seeds of modern sports marketing, although none of the major leagues quite knew it at the time.

In another first, Starter jackets were branded on the sleeve with the S-Star, further emphasising their quality and originality. By the late 80s, Jordan fever had slam-dunked the globe and US sports were red hot. Within minutes, Starter had deals with everyone from Manchester United and the giants of European soccer to Aussie Rules football.

Starter was the champion's choice, endorsed by an all-star roster of athletes and coaches including Dan Marino, Emmitt Smith, Dwight Gooden, Karl Malone and Bill Belichick. Always the innovator, Starter made the first team championship hats, now seen in every title-winning locker room. Perhaps their greatest on-field moment came in 1996 when the Green Bay Packers lifted the Lombardi trophy after steamrolling the Pats in Starter jerseys.

Ironically, the face of Starter wasn't an athlete, but a young DJ by the name of Jeffrey Townes – aka Jazzy Jeff. Starring in the legendary 'breakdown' ads, Jazzy cemented hip hop's affinity for the brand. Raiders caps suddenly ruled MTV, rocked hard by the likes of NWA and Public Enemy's Chuck D, while pop culture magnet Spike Lee took matching your sneakers and snapback to the next level. Such was Starter's pull on youth culture that by 1994 it was the most recognised brand among kids aged nine to 13. Nike was a distant second.

But, as with all champions, the glory days would soon fade. A saturated marketplace, money-hungry leagues, player lockouts and a maturing youth market all took their toll. Following a successful public float in 1993, brokers Raymond James & Associates had this to say when awarding Starter the highest buy rating: 'The fabulous growth comparisons of the past several years will certainly not be repeated, but at the same time, the business will not disappear.'

Within five years Starter filed for bankruptcy. Ownership of the brand has passed through many hands since (including Nike's), but the Starter legend will always belong to those who rocked the S-Star hard in its heyday. With vintage Starter booming on eBay, we tracked down the brand's founder David Beckerman for a one-on-one history lesson. Hold on to your snapbacks, we're taking the Starter story to overtime!
•

Throwing Rodney Dangerfield, Janet Jackson and Jazzy Jeff into the Starter TV ads was nuts. As Jeff lectured kids on how to 'smooth' their hat, Dangerfield bugged out 'I think I'm having a hat attack!' before ending with a variation on his classic line 'Now I'll get some respect!'

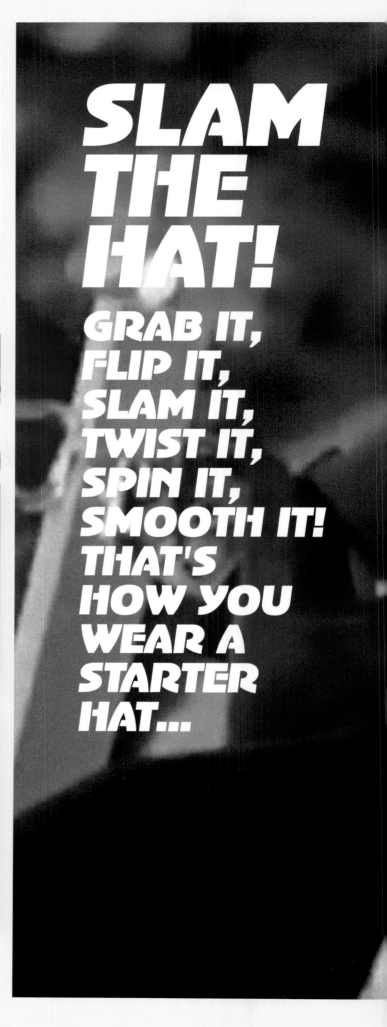

SLAM THE HAT!

GRAB IT, FLIP IT, SLAM IT, TWIST IT, SPIN IT, SMOOTH IT! THAT'S HOW YOU WEAR A STARTER HAT...

THE OWNER

DAVID BECKERMAN

David Beckerman is a persistent fellow. Having mortgaged everything he owned to found Starter in 1971 with a $50,000 loan, it took him an astonishing 33 fruitless trips to NFL headquarters in New York before they would sign a deal. However, it wasn't enough to save the company from bankruptcy in 1999. Though as Beckerman explains, the reasons for that were complex.

How did your interest in sports develop?
When I started, I looked at softball as a major sport that was developing, and I noticed that participants were willing to spend a great deal of money on equipment, regardless of their skill level. One of their problems – it seems simple today, but it really was the catalyst – was that most windbreakers at that time were made with an elastic cuff. That meant that if you had a big wrist, the elastic would cut off your circulation. If you had a small wrist the wind would go right through it. So I had the idea of saying 'Hey, why don't we put a knit cuff on there?' I bought some material at a local haberdashery store and had a sample made, then I took the sample to a local sporting goods store and said, 'What do you think?' Most of them thought it was a very simple but revolutionary idea.

That was the beginning of Starter. We made jackets for clubs and schools, building the business and our reputation for fine quality for the first four or five years until we got into the licensed business in 1975.

Was that with Major League Baseball?
Yeah, Major League Baseball came first, then basketball, then hockey and then 250 colleges. Football was the last of the licences. At the time, the NFL had another licensee and they pretty much had a monopoly on it and didn't want us in the business. Finally there was a change in management at the NFL and they were looking for new ideas. I called on the NFL for eight years before I was accepted!

I always liked the simplicity of the name. Starter was perfect.
People have a tendency to remember a one word name. Nike. Polo. Ford. Chevrolet. Heinz. So I knew that I wanted a one-name company. Secondly, I always wanted to be a 'starter'. I didn't want to be a substitute on a team. We were in sports, and everybody strives to be a starter – you wore it because you wanted to feel like the pro!

Starter was the innovator of a variety of things that brought fans and product together. We were the first to put a logo on a hat. We invented the championship t-shirt and the championship hat. Today in the NBA or Major League Baseball you see players wearing a hat after they win a championship – Starter invented that. Whether we did Juventus in Italy or the New York Yankees, Starter symbolised a connection between the sport and the players.

Starter also formed a bond with the hip hop community. Were you aware how influential that connection was?
When the brand began to take off, the first thing we wanted was an identifiable logo – the 'S' and the star. And we wanted to invest in what we believed were conduits to the youth, like music. The leagues at the time never valued this as an important ingredient. We were able to have a relationship with a variety of budding stars who were in the music business and rap groups. You have to understand that the African-American community are a real catalyst to building any brand in the USA. They have buying power and a 'feel' for your brand. But you can't design stuff for them. It has to be something they subtly become aware of.

There was definitely a right way and a wrong way to rock Starter. How did the complete look come about?
I think it was a variety of things. First off, Spike Lee, who attended Knicks games, was a fan of Starter and was always wearing our apparel. Then there was the concept of the hook-up, where the hat had to match the jacket that matched your shoes. It wasn't necessarily a team allegiance as much as it was a colour allegiance. When my son finished college he worked in Philadelphia where he befriended Jeff Townes, who later became known as Jazzy Jeff. We did a commercial with him that was an education on how to be

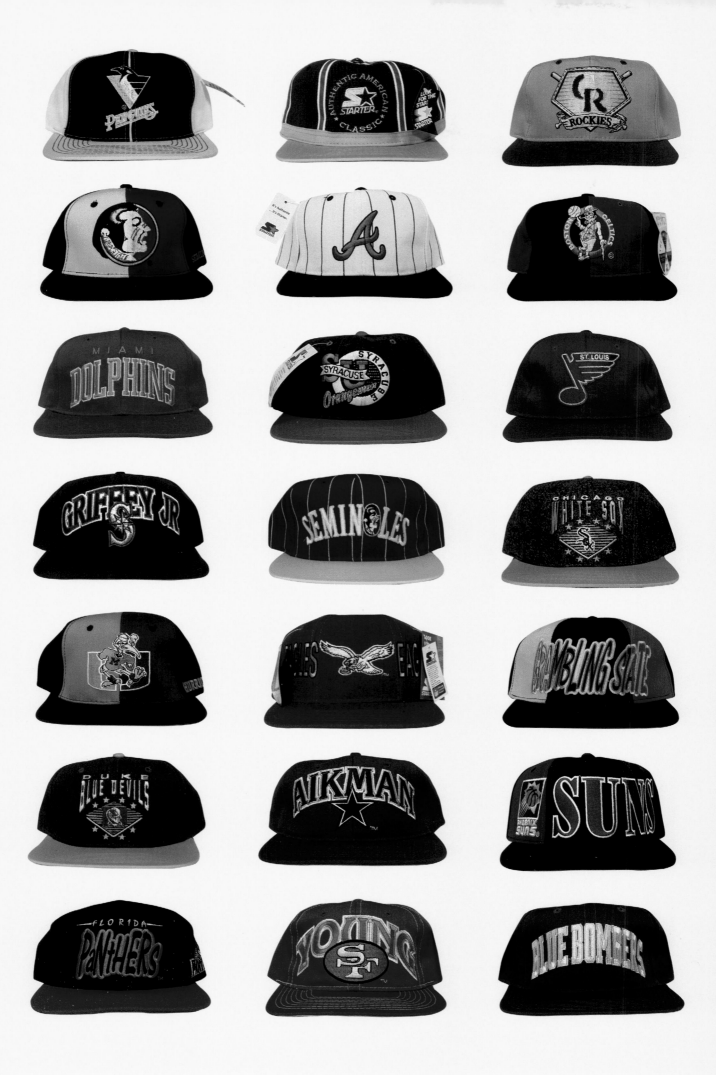

1987: L.L .Cool J

cool and hip while wearing the hat. There was a similar commercial with Rodney Dangerfield and a host of celebrities ranging from Flo Jo to Lenny Dykstra to Cal Ripken and Karl Malone in a classroom with Jazzy Jeff as the professor. It wasn't just simply putting the hat on, it was the way you put it on and the way it was flexed. The way that it presented itself… it sort of gave that air of independence, of being a little different.

An early-1990s *Sports Illustrated* survey had Starter as the most recognisable clothing brand for kids. Way ahead of Nike, which was number two. Do you believe that the company could have built on that loyalty and become as big as Nike had it stuck around?
Well, first of all, the brand is still around. That's number one. There's no question that we had a loyal following. In fact, today Starter products even sell on eBay for 10 times what they originally sold for. We had a clear understanding of value. We over-made our products. We gave more value for the price. Our products – at least under my management – were made to stand the test of time. Do I believe we could have done some things differently? Yeah, probably. But that's part of the learning process.

Hats and jackets will always be Starter, but you also had plans for footwear.
Very much so, but the problem wasn't that we didn't want to do it – we had a lot of requests for it. Rather, there was a legal issue with Converse around the use of 'S' and the star logo. They had a star on their sneaker that led to a legal battle. We came close to considering paying a royalty to Converse, but it got to a point where it just didn't make sense. We always felt that there was a market, a little bit different

than the standard athletic look – what I would call 'athletic casual wear' rather than performance. There were plenty of sneakers around, but where were the shoes for the coach? Where were the shoes or sneakers that an adult would wear to a ball game for comfort? You either had a leather shoe or you had sneakers and there was nothing in between. But we never pursued it, because we were involved in too many other things.

Speaking of which, how did the playing field shift for Starter?
The leagues got greedy. They changed royalty rates dramatically and brought in more and more competitors. Instead of four or five brands, there were 30 or 50 in the category. They all ended up cutting prices to a point where nobody could make any money. It was a chain reaction. Players want more money, therefore the owners had to look for ways to raise it, so they said, 'Let's turn around and do it through licensing!' I remember in the latter days we gave the NFL royalties in excess of $15 million one year. I wanted to give them $150 million for a 10-year guaranteed contract. When I wanted exclusive rights, they said they wouldn't do it. But 10 years later they did it with Reebok, a company whose priorities are clearly shoes, not outerwear.

What led to Starter's bankruptcy?
First, Nike came to buy us. Phil Knight wanted our company. At the time we didn't want to sell. We recognised that we'd just turned the big giant down, and Nike was going to come after us. That's why we went public. After a few years things were going along well, but the leagues wanted more and more. Royalties were no longer 5 per cent; now they were 12 per cent. And no longer were there $100,000 marketing requirements, there were $1 million marketing requirements.

1991: Another Bad Creation

1986: The 2 Live Crew

I was out of the company for about two years. I was chairman of the board and we appointed a new president. During that time I don't think we recognised changes in the marketplace, which ultimately led us into a difficult position. I came back to take the reins on a day-to-day basis again. I believed in the company so much that I put up $11 million of my own money and had an agreement with the bank that they would help us for three years.

About a year into it I guess they were feeling the pressure so they pulled the loan. But I can tell you that not one dollar of the vendors' money was lost. In fact, when the banks pulled the note on us – which was $22 million, 11 of which was mine – 100 per cent of the vendors were paid. And that only goes to show that our inventory was good, that our receivables were good and that it wasn't a typical kind of financial transaction where a company was in trouble. Usually creditors have to accept 10 cents out of a dollar – that did not happen with Starter. It's a shame the banks didn't have a little patience because over 500 people lost their jobs. It didn't make sense. I tried to explain that to the leagues. All the years of innovation, all the years of sales and profits, that was suddenly yesterday's news.

You moved on to other commercial ventures after Starter. What do you get up to nowadays?
I'm really involved in high school varsity basketball coaching. I did that in Connecticut at Hamden Hall. Now that I'm not as active, I'm at a school in Fort Lauderdale, Florida, called Pine Crest, and this is my seventh season. We won the state championship two years in a row and have been to the state finals four times. Working with youngsters combined with some real estate development has been quite rewarding.

Does being a CEO make you a hard-ass coach?
Being a CEO or a coach is the same as being a parent. Be firm, be fair and be consistent.

It's as simple as that?
It's as simple as that! I think people try to complicate things by changing things outside the basics. You know that you can't be late for practice, can't be late for your job, you've got to do the right thing and you know what the right thing is. It's basic. At the end of the day, the more we understand that as a team and as people, the better off we'll all be.

Thanks for winding back the clock, David – we have a lot of great memories of Starter.
Well, you know what? Starter was a very strange phenomenon. People really connected with the brand and there was an emotional bond between players, fans, teams and sports heroes. It represented something that was in conflict with itself being commercial. It was really a terrific opportunity and I'm quite proud of what we built.
•

TOP FIVE STARTER VIDEOS

#1. Another Bad Creation *IESHA/PLAYGROUND*

You've really never seen Starter steez quite like this. In their two videos, BBD's mini-mes wore a countless amount of Starter beanies, caps and jackets. The highlights include matching pinstripe Mets and Michigan Starter caps (with the tags still on) with airbrushed pinstripe tees in the Iesha video, or riding the subway in Starter Knicks beanies and …. Well let's just say the entire *Playground* video is a highlight. It's funny that Starter gained notoriety on the back of the West Coast's hardcore rap artists and is often remembered that way, but nobody went as hard on Starter as a bunch of five kids who sang about giving girls lollipops and playing on the monkey bars.

#2. Kris Kross *JUMP*

Kris Kross went out of their way to distance themselves from A.B.C., warning us not to compare them to another bad little fad, so if you see them around, don't tell them I put them next to A.B.C. on this list. But how could I not include them? Not only did they wear a TON of Starter, they wore it all backwards! Mac Daddy and Daddy Mac rocked Starter beanies and kept the tags on those Eagles and Yankees Starter varsity jackets. The sad part is that 20 years later I still dress like these two rapping ten-year-olds.

#3. Method Man *BRING THE PAIN*

It don't get more ghetto than this. In between rapping in some sort of dank cellar and riding drunk on the back of a tagged-up bus, Meth also finds time to rob a convenience store. The store clerk ain't havin it though, threatening the crew with a baseball bat, dressed in a button-up and puffer vest with a Lakers Starter cap. This one is special because even though he may be old and white (always a dangerous combination in a rap video), the convenience store clerk ain't goin out like a chump. Why was this guy so gully? It's a simple explanation: always look for the S!

#4. Ice-T *NEW JACK HUSTLER*

Sweet Jesus. You want 90s fashion? You came to the right motherfuckin place. While Mike Tyson stands beside him talking on a car phone, Ice-T rocks the shit out of his Raiders beanie, gold chains and locs in this one, even taking time to crouch beside his gold Dayton rims to show just how real it gets. As night falls, Ice slides into a supersized and supersteezy Starter Kings jacket, before we cut back to daylight where we see the New Jack Hustler walking with his posse draped in vintage sportswear, including a dope black Knicks Starter jacket.

#5. Ice Cube *STEADY MOBBIN'*

As an impressionable kid looking for an alternative to New Kids On The Block, Ice Cube's *Steady Mobbin'* basically became the blueprint for the rest of my life. Rollin' in the drop-top 64 with the homies, slappin' asses, carrying a Sky Pager and most importantly, wearing the dopest LA Kings Starter jacket known to man. Cube had it figured out. If I can do just one of these things each day, I know I'm living my life right. Thank you, Ice Cube.

Apologies to Bel Biv DeVoe...

PUMA Clyde

Published in *The Clyde Book,* 2010

EDITOR'S NOTE: WOODY

With his customised Rolls Royce and mink-lined circular bed, Walt 'Clyde' Frazier was a prominent 'player' back in the 70s. That outré veneer, however, was at odds with his hardwood personality. A finesse baller with a mean defensive streak, he hated losing as much as he loved walking into discotheques with a lady on each arm. Speaking to Clyde back in 2010 – from the Virgin Islands no less! – his warmth and relaxed charisma were palpable down the phone line. What I wouldn't give to be resurrected as Clyde Frazier for one week back in 1969, the year the New York Jets won the NFL, the New Jersey Mets won the MLB and the New York Knicks took home the NBA crown. As he admitted in the interview, 'Man, I couldn't buy a drink for five or six years!'

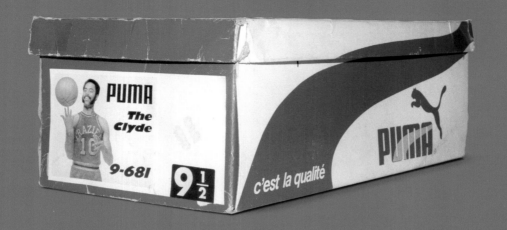

ICE COLD SWAGGER

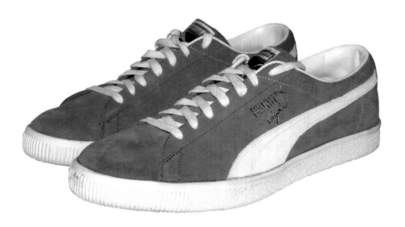

There are two principal reasons why Walt 'Clyde' Frazier is regarded as royalty. Firstly, the man was coolness personified and one of the greatest basketball players of all time. Secondly, Clyde was coolness personified on the street, famous for a Siberian-grade steez that exemplified his unflappable sporting nature. Clyde never looked in a hurry and never broke a sweat. When PUMA broke new ground by creating the first signature basketball shoe in 1973, they put all of that icy swagger and then some into a simple suede sneaker. The dynamic result was the eponymously titled 'Clyde' model, a low-top baller with elegance for days, just like its namesake.

Walt Frazier grew up in a modest family, the eldest of nine kids. But even in a busy household, Walt was known for his impeccable presentation, which involved scrubbing every speck of dirt from his shoes on the daily. Walt once said that 'money can't buy style', probably because he knew better than most that even without two nickels to rub together, you could still be cool. But in the end, he didn't have to wait long for fame and fortune to arrive.

As soon as he joined the NBA, Walt began building a reputation for personal flash. After his rookie year, he decided to juice himself up, arriving at games in nothing less than a Rolls Royce and full-length mink over his impeccably tailored suits. It was an era when African-American athletes were assuming the mantle of style

ambassadors, influencing language, fashion, pop culture, and later, music and culture on a global level. At the same time, 'Blaxploitation' films like Shaft, Foxy Brown, Super Fly and Cleopatra Jones cemented the allure of power dressing.

The cinematic link was enhanced when Walt was christened with the enduring handle, Clyde. Like Warren Beatty in the film Bonnie and Clyde, Walt had a penchant for flamboyant Borsalino hats. Furthermore, the film's Clyde Barrow famously proclaimed, 'I steal for a living.' As a player, Walt was renowned for his uncanny ability to 'steal' the ball from opponents, so it's not hard to see why the nickname stuck.

Photo: Focus on Sport/Getty Images

First published *The Clyde Book* – 2010

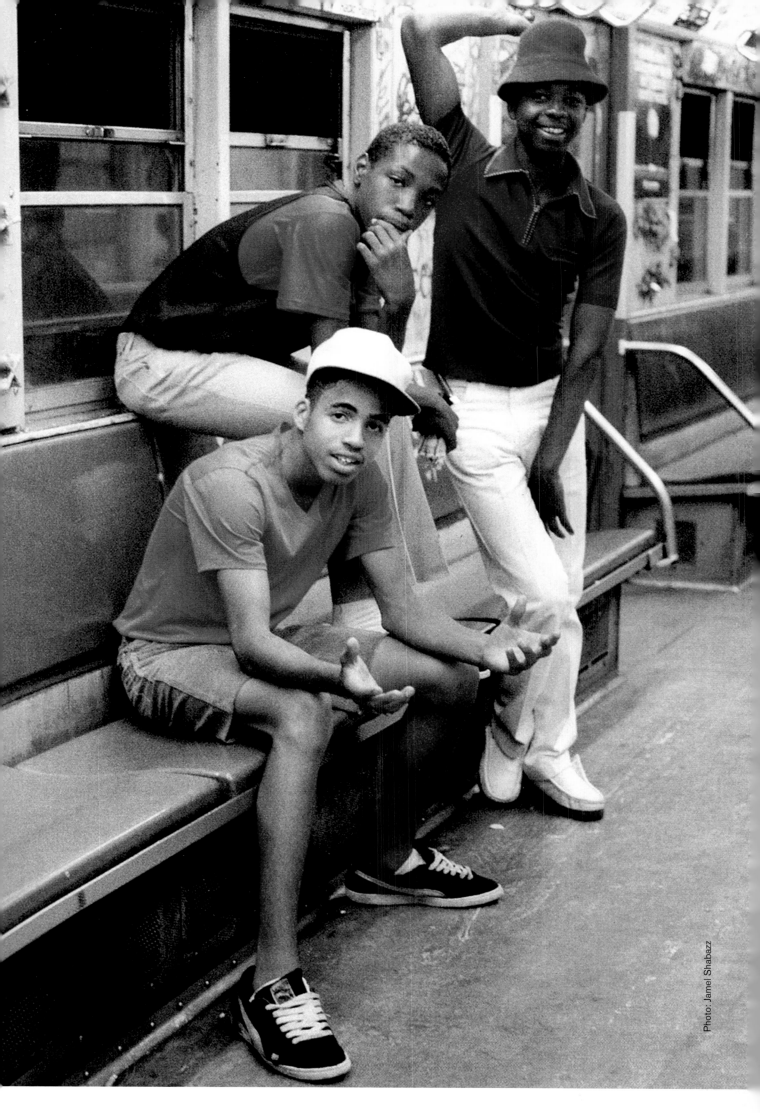

Photo: Jamel Shabazz

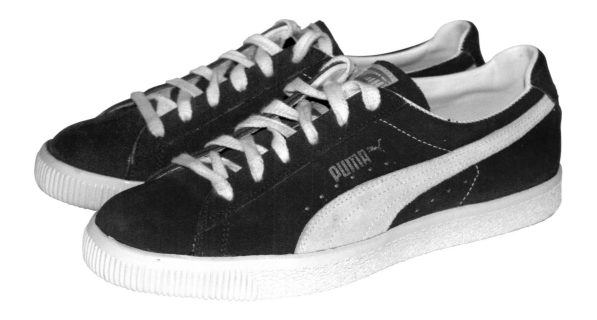

On trains, cats would stand in front of the doors in a b-boy stance with their heels touching but their toes pointing as far opposite as possible. Then the hard rocks would take up two seats with their legs open. People would be scared to ask them to close their legs so that they could sit. The sneaker which best exemplified this bravado was the Clyde.

Bobbito Garcia

Extract from *Where'd You Get Those? New York City's Sneaker Culture: 1960–1987* (Testify Books)

No. 9681K No. 9681G No. 9681R No. 9

No. 9681 CLYDE by WALT FRAZIER
- Uppers of top grade suede leather in bright colors
- Heavy sponge insole and arch support
- Wide last — white non slip rubber sole
- Padded at heel and ankle
- Achilles Tendon Pad

Sizes 5-15

In stock in the following colors all with white PUMA form stripe.

No. 9681K — Kelly green with white stripe. No. 9681G — Gold with white

No. 9681R — Scarlet with white stripe. No. 9681B — Blue with white

No. 9679W — White with white stripe.

Puma present

FOR THE "CLYDES" TO BE ...

No. 9671 CYLDE III — A New Shoe in Walt Frazier's Team Colors
Specially designed for the Younger Players
- Uppers of tough blue suede
 lined for added strength
- Orange PUMA stripe with orange trim
 at collar and orange ATP
- Heavy duty rubber sole

Sizes 3-12

No. 9677 Same construction as the #9681
- Uppers of black suede leather with
 green form stripe and green trim
- Bright red tongue
- Wide last — White non slip rubber sole
- Padded heel, ankle and tendon pad

Sizes 5-

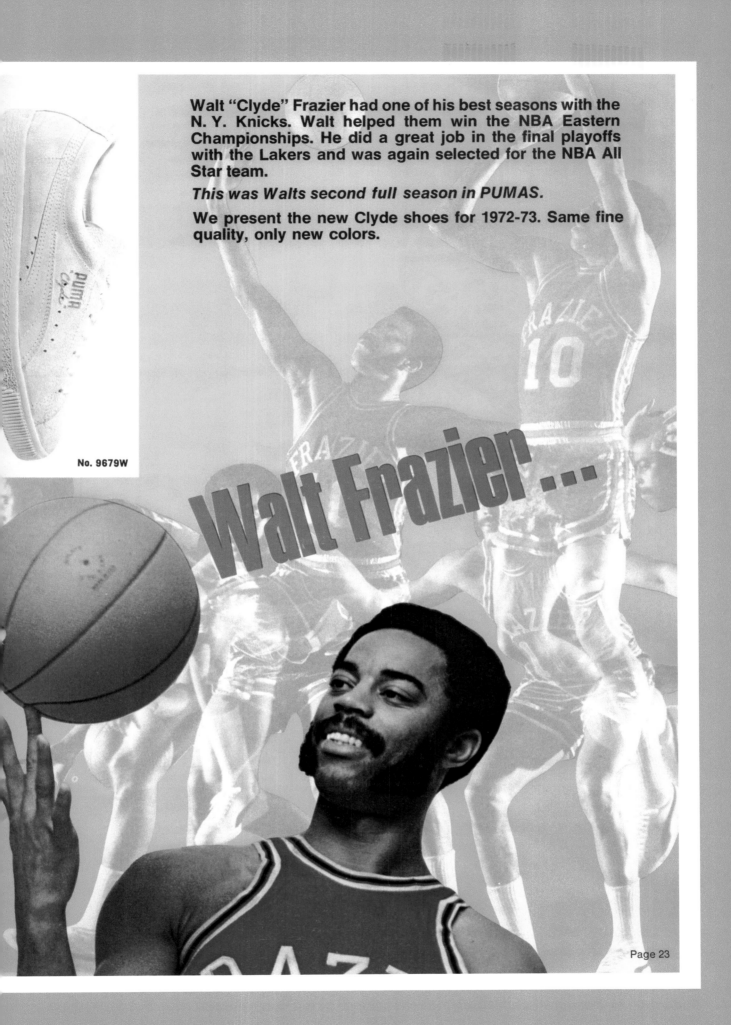

Walt "Clyde" Frazier had one of his best seasons with the N. Y. Knicks. Walt helped them win the NBA Eastern Championships. He did a great job in the final playoffs with the Lakers and was again selected for the NBA All Star team.

This was Walts second full season in PUMAS.

We present the new Clyde shoes for 1972-73. Same fine quality, only new colors.

No. 9679W

Walt Frazier...

Page 23

2006: *Yo! MTV Raps* x Clyde 'Forever Fresh'

From 1988 to 1995, *Yo! MTV Raps* defined hip hop's commercial rulebook. Featuring every music artist worth their Dookie-ropes at the time, this weekly one-hour broadcast quickly became a cultural juggernaut thanks to its charismatic presenters, Ed Lover and Doctor Dre (not to be confused with music producer Dr. Dre). In 2006, PUMA created a heartfelt dedication to the show by collaborating with a bunch of hip hop pioneers.

2006: *Yo! MTV Raps* x Clyde 'Forever Fresh'

2006: *Yo! MTV Raps* x Clyde 'Cash Money' (unreleased sample)

2006: *Yo! MTV Raps* x Clyde 'Big Daddy Kane'

2006: *Yo! MTV Raps* x Clyde 'M.C. Shan'

2008: Clyde 'Poison Dart Frog Pack'

Although he'd been wearing PUMA sneakers for years, Clyde's signature model wasn't released until 1973. It was an adaptation of the original Suede that had come to prominence during the 1968 Mexico City Olympics when sprinters Tommie Smith and John Carlos made their famous black power salute on the podium after winning gold and bronze respectively in the 200m dash. The iconic photograph shows the athletes' PUMAs beside them as they accepted their medals in black socks: a protest against endemic racial poverty and inequality. It was an explosive moment that made headlines around the world and caused their expulsion from the Olympic Village. It was many years before the pair's courage was properly recognised and honoured.

Clyde made history of his own by asking PUMA for a wider version of their standard model. The Clyde was an instant sensation. Made from combed suede at a time when cheap canvas cuffs ruled the courts, the sneaker was heaven-sent for anyone seeking a slice of Clyde's signature style. To sweeten the deal,

each pair came with the superstar's slick nickname stamped on the side in gold letters. PUMA sold two million pairs in a single year, confirming that Frazier's influence reached far beyond the streets of New York.

As renowned writer and OG sneakerhead Bobbito Garcia put it, the Clyde was: 'Unequivocally the most sought-after shoe of this period and one which would later become one of the staple shoes for hip hop enthusiasts'. Those enthusiasts included rappers such as MC Shan and human beatbox Doug E Fresh, and many cite the 1984 hip hop classic *Beat Street* as the jump-off point for their fetish. The alluring fat laces and lush, suede finish of the Clyde became a b-boy favourite in a subculture where looking fly was a competitive sport in itself. Games like 'stepsies' – a rite-of-passage for new kicks – were strictly out of order as street cats would go to the ostentatious lengths of carrying a well-used toothbrush in their pockets to buff their Suedes. Furious Five's Scorpio likened it to taking a poodle to the show: 'You gotta keep them groomed!'

2018: Diamond Supply x Clyde

2017: Manhattan Portage x Clyde

It wasn't just b-boys who dug the Clyde. The shoe has priors with graffiti writers including STAY HIGH 149, who repped Clydes because they held up when escaping New York's finest. Skateboarders also embraced the shoe, with Scott Bourne famously proclaiming: 'They couldn't have designed a better shoe for skating if they'd tried!'

Suedes and Clydes also became associated with passionate followers of the 90s UK music scene. At that time the Brand New Heavies, Incognito, James Taylor Quartet and Jamiroquai splintered funk, disco, rare groove and northern soul to form 'acid jazz,' which in turn became the musical launching pad for the seminal Mo' Wax label that kicked off a decade of blunted trip hop. Corduroy and musical retro-futurism was a marriage made in heaven, coining the hybrid 'acid jazzuals' tribe that ruled Notting Hill and Hoxton, circa 1995.

By the late 90s, however, modern basketball shoes had morphed into increasingly complex contraptions necessary to support players who were heavier and taller than ever. For a minute, it seemed that the Clyde's understated aesthetic was destined to become a footnote in sneaker history. However, with Walt's unwaveringly cool character so heavily imbued in his signature shoe, the Clyde was able to rock on into the next century, gaining a new kind of street cred in the process.

With pop-cultural credits like the aforementioned *Beat Street* and books like *Spraycan Art* by Henry Chalfant, hip hop's so-called golden age was still inspiring a new generation of diehard kids and footwear addicts. By this time, the irresistible mashup of basketball, hip hop and sneaker culture (as defined in Bobbito Garcia's book *Where'd You Get Those?*) had swept around the globe from its New York birthplace, spawning a sneaker boom fuelled by the launch of *Sneaker Freaker* in 2002 and the subsequent proliferation of footwear obsessives revelling in the digital realm.

The first new Clyde off the rank was the luscious 'Chase' pack which was based on Frazier's original Knicks colours and had

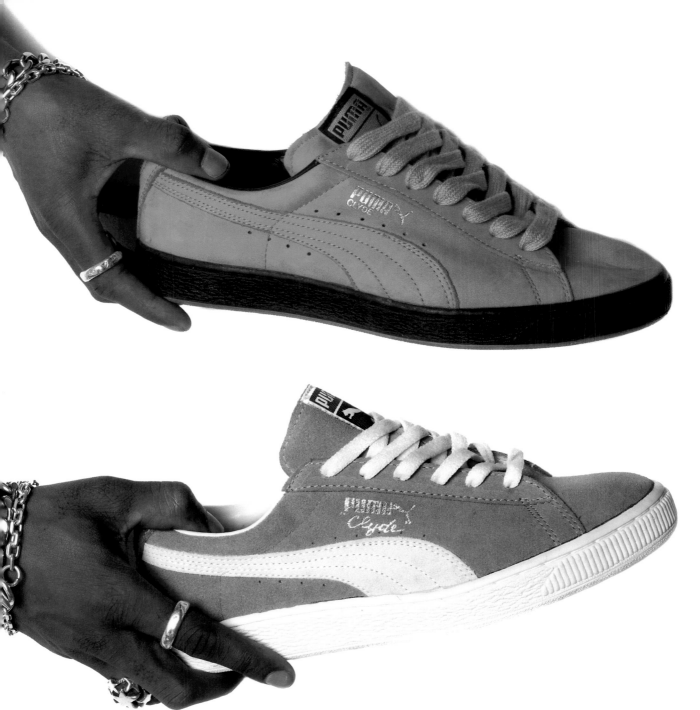

Photo: Errol Thomas

the phrase 'I steal for a living!' stamped in gold on the insole. The restrained palette was refreshing in a world saturated with showy kicks and set the bar high for a series of banging collaborative Clydes. Some of these editions cleverly appealed to a more knowledgeable breed of sneakerhead who wanted to stand out from the new kids on the block. Rocking the *Yo! MTV Raps* edition and the eyeball-enthrallin' Bode Clydes was the quickest way to express your heartfelt appreciation of retro cool. Once again, the Clyde had stolen the spotlight so fast its namesake would have been proud.

Not content with merely looking to the past, the Clyde was given the colab treatment by some of the most prominent names in the sneaker game. A snakeskin PUMA Formstripe and golden sockliner from Berlin's Solebox store gave the Clyde a killer, modern feel that put its younger competition to shame. Crooked Tongues produced a colour-drenched triple threat of Clydes that became instant classics among collectors, particularly the 'Money Green' edition. Japanese retailer atmos also threw down some of the most daring designs yet with their 'Endangered Species' pack, while Mita's fiscally sedate Clydes became instant collectibles.

Then there was the out-of-sight lunacy of 2009's the 'Terror King' pack, which took PUMA to a new realm of footwear categorisation. Later that same year, Sweden's Sneakersnstuff produced one of the classiest instalments of all time: a super-soft Suede made from premium goatskin. All of these collaborations proved that the Clyde's beauty – and staying power – lay in its simplicity and innate ability to lend itself to the most creative transformations.

In essence, the Clyde has a sporting legitimacy and titanic street credibility beyond compare. Forget about marketing hyperbole and grandstanding claims to cult status – very few sneakers deserve to be called a classic, but after 40 years in the game this grand old man still shows the young guns a clean pair of heels. While flashy pretenders come and go, both Walt Frazier and his humble sneaker prove that at the end of the day, you really can't fake the funk.

•

2007: Solebox x Clyde 'Faux Snake'

2008: Rob L x Clyde 'Archipelago'

2007: Sneakersnstuff x Clyde 'Reindeer'

2007: mita sneakers x Clyde '$1000 Bill'

SUEDE FAMILY TREE

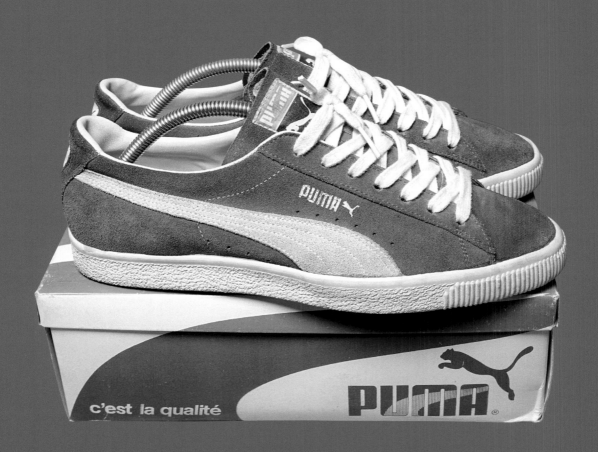

c'est la qualité **PUMA**®

Photo: Steven Prince @ Forever Fresh

CLYDE

The most famous member of the Suede family is undoubtedly the Clyde. Endorsed by Walt 'Clyde' Frazier, one of NYC's basketball greats, the Clyde is a subtle variation from the original Suede. However, Walt's charisma and talent means his shoe has also become the most coveted of all PUMA models.

STATES

The States were introduced in the 1980s and are largely a UK phenomenon. Nicknamed because you could only get the originals 'in the States', the only alteration is the branding which called out the model's name – just another of the quirky occurrences in the history of the Suede family.

BASKET

The Basket is essentially identical to the Suede and the Clyde. However, it came in a high-top and a low-top, and was commonly made in durable leather, which also added slightly to the shoe's bulk.

PUMA 'S'

Don't be confused. 'S' stands for 'Skate', not Suede! Released in 2008, the PUMA S was a hopped-up version, a Suede on roids. With its generous padding and chunky look, it quickly found a niche with skaters. Fat laces were another nod to the Suede's b-boy legacy.

FIRST ROUND

Released in 1987, the First Round is technically considered a mid-cut. It shares the same sole unit as the Suede but adds a reinforced padded collar, making it eminently suitable for skaters (who also appreciated the First Round's vertical aesthetic and performance attributes).

SUEDE

Introduced in 1968, the Suede can rightfully be considered the grandaddy of this PUMA family. The basic design rendered in a single coat of premium suede is pure simplicity in effect. Throw in a trademark stitched cupsole, fat laces and gold-letter branding and you have a cultural juggernaut that still rolls deep today.

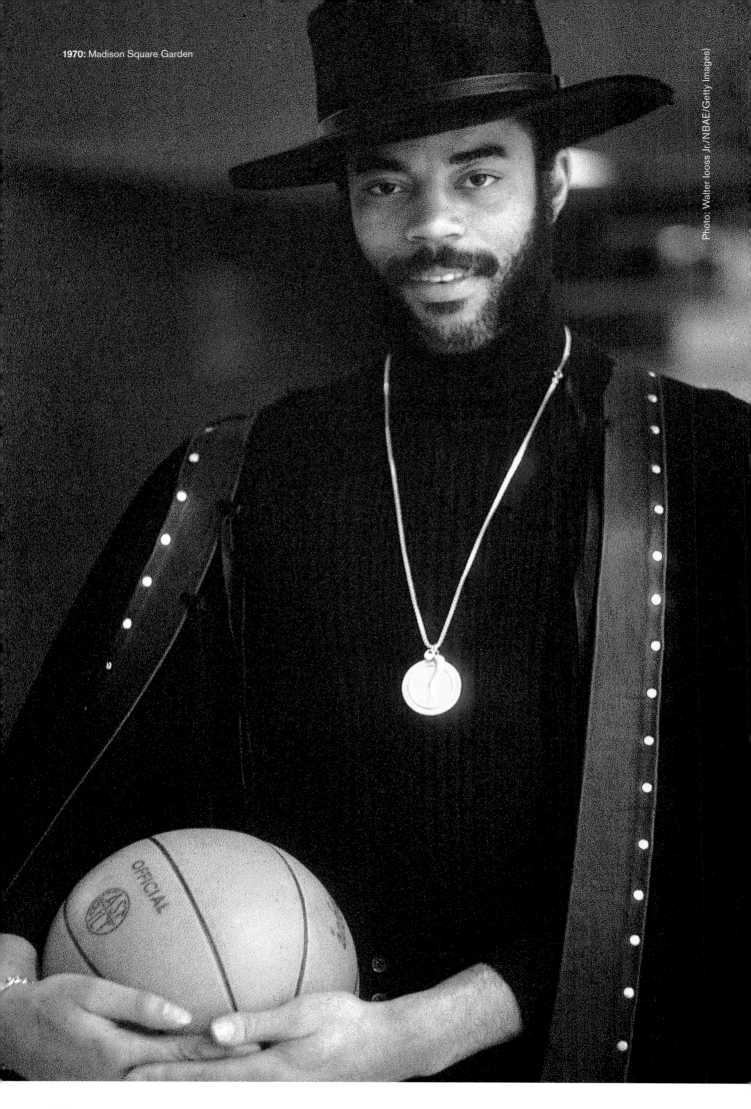

Photo: Walter Iooss Jr./NBAE/Getty Images)

KING
OF NEW YORK

As floor leader of the famously unselfish New York Knicks, Walt 'Clyde' Frazier exemplified the notion that both gritty substance and effortless style can be sporting bedfellows. During his 13 seasons in the NBA, Frazier guided the Knicks to two historic championships. A finesse player with a colossal basketball IQ, Frazier combined efficiency with agile hands, which helped him become the master of the 'steal', while his wide brim hat and Rolls Royce made him the game's original godfather of style. Now a commentator for the Knicks, Clyde's infectious enthusiasm and million-dollar modesty remain intact. Who better to ask about the Clyde than Clyde himself?

Let's wind the clock back to 1967 when you were nicknamed Clyde.
Everybody still calls me Clyde! If you call me Walt, it's someone who knew me from my childhood, but everyone else calls me Clyde. Actually it was our trainer at the Knicks who gave me the name. I had purchased this wide brim hat about two weeks before the movie *Bonnie and Clyde* came out. Once I wore that hat, everybody was like, 'Hey! Look at Clyde!'

Part of the mythology was that you both 'stole' for a living.
Right! He was a bank robber and I was feared for stealing the ball from my opponents. It was also synonymous with my style – the fur coats, the Rolls Royce, the man-about-town who's always seen out with different ladies having fun!

Did you ever meet Warren Beatty? You guys had a lot in common.
No, I've never met him, but I should give him 10 per cent of what I've made. [Laughs]

Can you explain what a big deal it was for you to endorse your own sneaker?
There really wasn't a lot of hoopla when I started wearing PUMA because they were giving sneakers to a few players. But they weren't paying any of them cash! Clydes quickly became popular, especially in New York, and the blue suede with the white stripe was the favourite. Then PUMA and I did this advertisement where I had on my mink coat, Clyde hat and my own shoes. After that all these people started seeing it as a dress shoe and were like, 'Wow, Clyde was all dressed up and has his PUMAs on!' So that's when they became more than just a basketball shoe.

PUMA obviously saw more in you than just your immense sporting talent.
Yeah, it was my creativity, my individuality and my coolness. On the court I was unflappable and I rarely showed emotion, so a lot of people related that to my style off the court. Whenever anyone saw Clyde they could say, 'Hey, he was dressed down, dressed to kill!'

Was playing it cool your natural disposition or something you actually worked on?
I realised that when guys showed emotion on the court, I could distract them from their game. If you're all over someone defensively and they're totally ignoring you, you're not putting them off. Likewise, when guys would pressure me, I didn't show any emotion and they couldn't tell if what they were doing was working.

Photo: Bettmann Archive/Getty Images

First published *The Clyde Book* – 2010

I steal for a living
by 'Clyde' Frazier

The art of the steal.

There is a time and a place for stealing.

If you miss, your man should not be able to go in for a basket or create a two-on-one situation. So a good place to steal is just when your man is crossing half-court—in the outside corners. The sideline plays like an extra man for your team. If you go for the ball and miss, the guy can only go out of bounds.

There are times early in a game when I could make a steal, but I might prefer to keep the other guy feeling complacent. Then he's easier to steal from later, when the game gets tight and everything is crucial. A steal then could really crush the other team.

Heads-up dribbling.

You'll never be a good dribbler if you watch the ball.

While your head is down, you're out of touch. Guys are coming open, and you can't see them to make a pass. When you look up, everybody is moving and it's hard to figure out what's happening. It's chaos.

It's not chaos to me because I can see the whole court while I'm dribbling. It's like my symphony, and I'm the guy who's controlling the movements.

I've got the ball, and the guys are moving to my beat.

Why I play it cool.

Most guys show strain on their faces. If I'm applying pressure, I can see they don't like it. So I do it even more. Whereas if you pressure me, I still look the same way. You don't know whether to keep it up or back off.

On the inside, I'm just like everybody else. But I've developed a technique of not showing any emotion. So you can't read me. That's why people say I'm cool.

One big mistake.

If you face-guard your man, you won't know *when* the ball is coming to him. Or *which side* it's coming from.

He could fake you to one side, take the pass on the other side, and just walk in back-door.

So always see the ball *and* your man.

Traction & action.

I always tell kids to go for the best in a basketball shoe. Some of it is psychological. If the shoes feel right on your feet, then you're going to feel better playing in them.

I wear Puma.® They give me the traction and action I need. I like the grip of them, the way you can cut…you can *move* in them. They're a part of you, so you feel *ready*.

I have a wide foot. When it smacks down on the court it gets even wider. The guys at Puma think about things like that. They build their shoes on a wider last—for athletes.

Should *you* wear Puma? Listen, it's going to cost you. But if you're good enough—if you've earned your stripes— a shoe this good can make a difference in how you play.

The Puma 'Basket' Imported by Beconta

puma ®

You've earned your stripe

© Beconta, Inc 1977

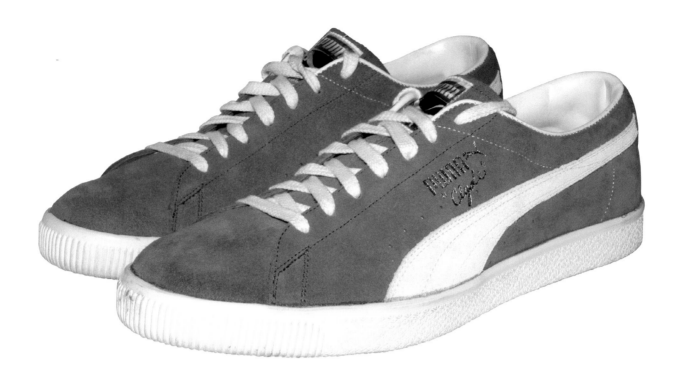

Off the court, I used to wear my mink coat and my big hat and I'd have my Clydes on. They thought it was cool. If you wore Clydes you were cool, you knew what was happening!

Walt 'Clyde' Frazier

First published *The Clyde Book* – 2010

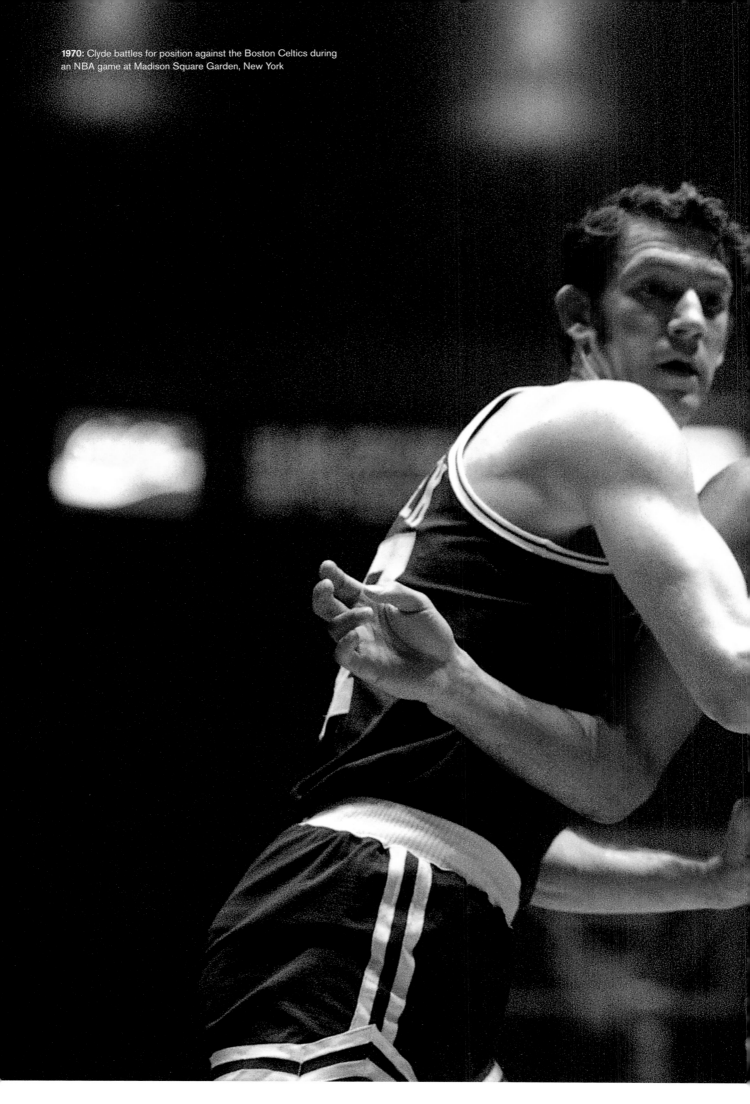

1970: Clyde battles for position against the Boston Celtics during an NBA game at Madison Square Garden, New York

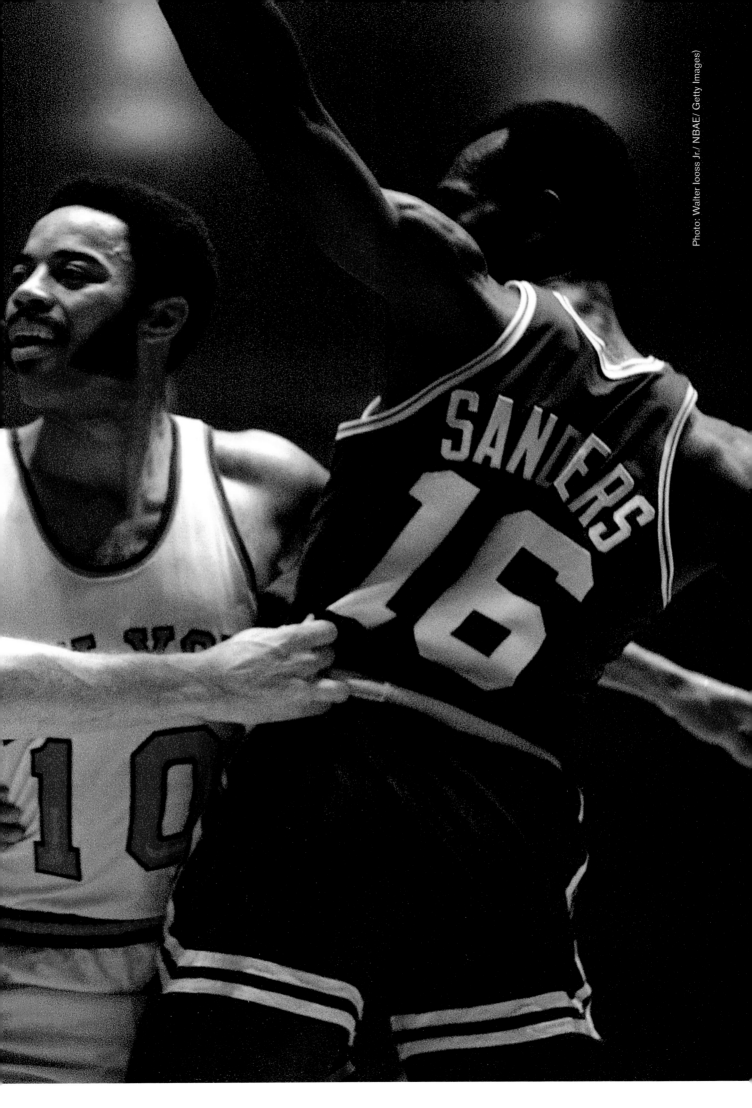

Photo: Walter Iooss Jr./ NBAE/ Getty Images)

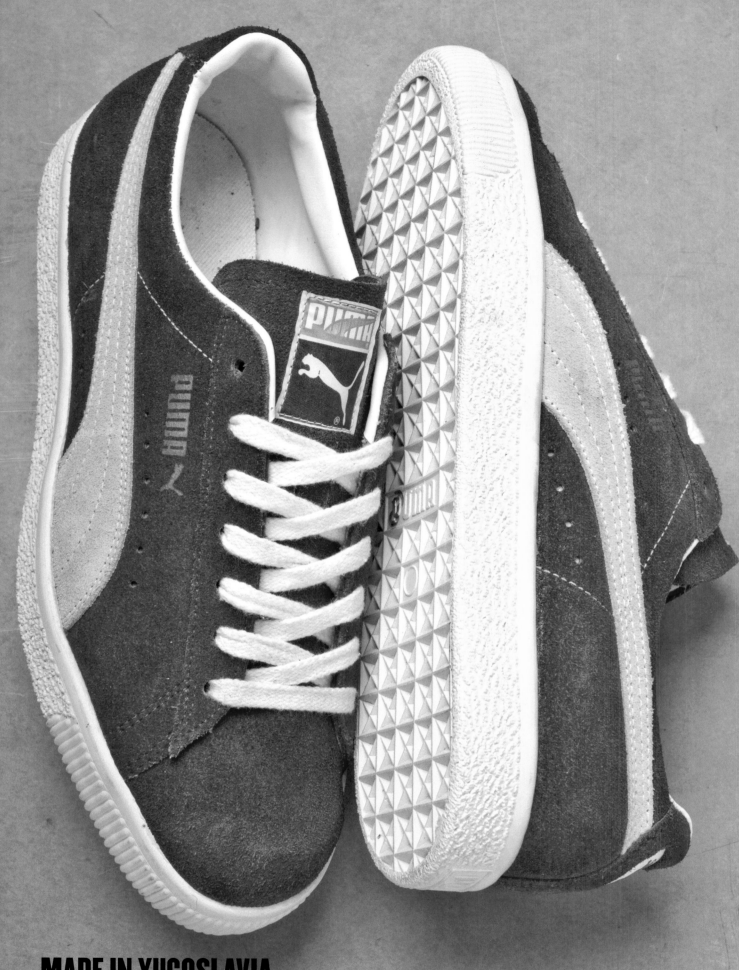

MADE IN YUGOSLAVIA

This vintage pair was made in Yugoslavia. Quality is generally much the same as other Clydes of the era, but they're rare as hen's teeth, so naturally they're a PUMA collector's Holy Grail and worth a small fortune!

Clyde's game was musical, one defined by a drummer's innate sense of rhythm. For his 10 years as a Big Apple hero Clyde showed the world his inimitable game style, combining athletics, fashion and music with his gliding stride and conductor's instincts. That's why his signature sneakers are as symbolic of that era as funk records and platform shoes.

Nelson George

But I was also renowned for my tenacity on the defence. If I'm guarding you and you're pushing my hand away, I became more aggressive because if you're losing your cool, you can't shoot or pass as well.

It must have been quite an odd feeling to look down and see your name on the shoes. Do you remember when they gave you the first pair?
It was right after our championship in 1973. They came out with the Clyde and it was a matter of pride because at that time I knew I was the only guy who had a shoe named after him. They couldn't keep them in the stores in New York City! I tell you it was an ego trip to have that shoe named after me.

I'll bet! Let's talk about the mink coat and the Rolls. Those old images must bring up incredible memories.
It was a 1965 Rolls Royce, Silver Cloud Three. I had never liked Rolls Royces because the colours were always too dull for my tastes. Then one day I was walking down the street and there was this Rolls parked next to the kerb. I really liked the way it looked so I went to the guy and asked if I could get a different colour and he said he would paint it any colour I wanted. So my Rolls was painted bright burgundy and the hood, top and the trunk were beige. I added a little pizzazz with the colour, but still, something was missing. When I put the white wall tyres on it I was like, 'OK, this is the Clyde-mobile now!'

What happened to the car?
You know what, I sold my car only five years ago. The guy was a collector and he actually restored it back to its original colour and everything. He made it look like new! My problem was I wasn't using it anymore and it was just sitting there deteriorating. I couldn't even be there when the guy came and picked it up because I knew I wouldn't have been able to sell it. I had such an attachment to that car. My license plate was 'WCF' – Walt Clyde Frazier – and that car was synonymous with New York City. That car was like my wife.

Did you always drive to the NYC games?
Yeah I did, I drove it everywhere but I used to get tickets all the time for double parking. If I wanted to go inside a club, I would just park and get all these tickets and my agent suggested I hire a driver because it would be cheaper. I knew this guy from college who lived in New York and he used to drive for me while I'd hop into the club, check it out, then come straight out if nothing was happening. He would get so many phone numbers from girls – just from sitting in my car – that he started asking for time off because he had so many women to see!

Sounds like a dream job. Do you still have your mink coats?
Yeah, can you believe it, I still have those coats to this day. Obviously I'm not the same size but a tailor can make coats wider by adding fur pelts and make it a perfect match. I still have a black mink that I got when I purchased the Rolls Royce. Then I ended up buying a white one. I have a raccoon coat that goes down to my ankles! I also had an elephant skin coat. It looked like suede but it was very heavy. One of my favourites was a sea otter coat that I wore every day in the winter, rain, sleet or snow. It was indestructible. I also had a white mink spread made for my bed. At the time, I had a round bed with a white mink on it – it looked like a big fluffy cake.

Oh man, I can only imagine. Can you explain what basketball means to New York because the Knicks never had success 'til you arrived.
Well, it was a big deal because it was the first championship ever for the New York Knicks and the fans waited a long, long time. You know what else happened that year? In 1969 the New York Jets (American football), the New Jersey Mets (baseball) and the Knicks all won the championship. Man, I couldn't buy a drink for five or six years! When I went to eat, somebody was always picking up my tab or sending me a bottle of champagne. I would walk into a restaurant and the guy would tell me that my money was no good. That's the beauty of New York: when you're winning, there's no place better. They know how to treat champions and they know how to treat celebrities.

First published *The Clyde Book* – 2010

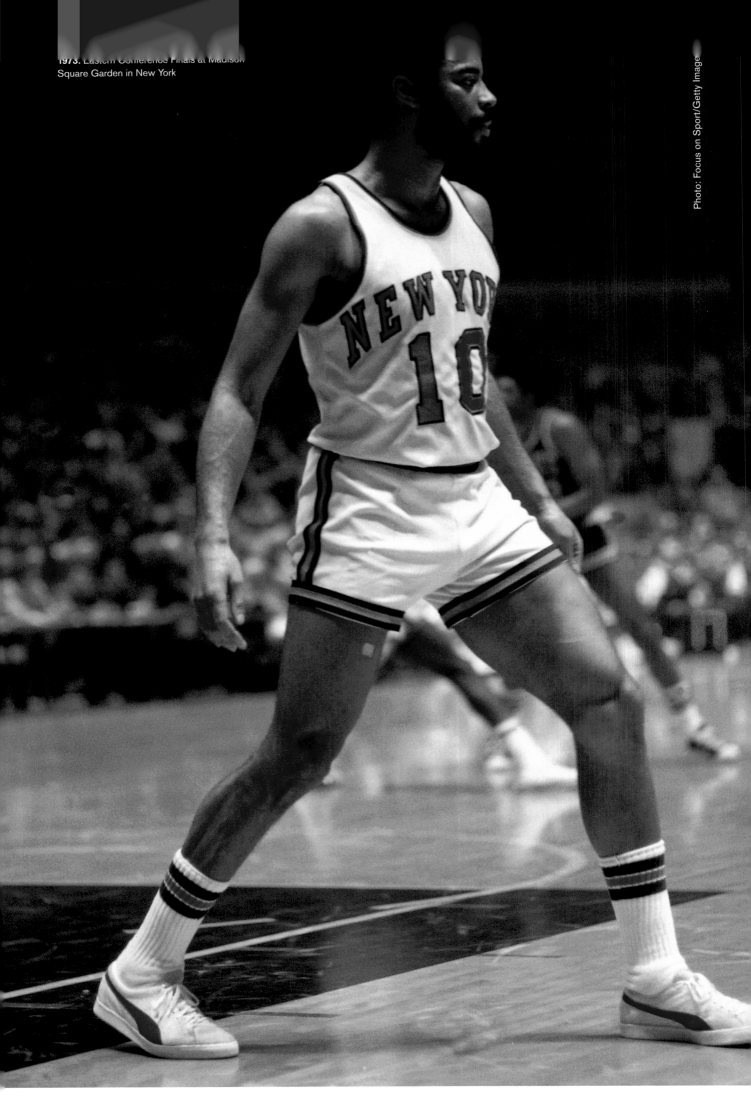

Photo: Focus on Sport/Getty Image

Photo: Walter Iooss Jr./NBAE/Getty Images

But on the other hand, whenever you walk out of the house, people are talking to you about the Knicks. Some athletes don't like the perpetual pressure and the constant badgering because you have zero privacy once you leave your house.

You have a huge list of accomplishments: two Championships, All-NBA, All-Defensive Teams, you're in the Hall Of Fame and regarded as one of the 50 Greatest NBA Players. Any accolades that stand above all others in your eyes?
Individually, it would be defence. I consider myself the complete player. I don't have a weakness. I can play defence, I can rebound, I can shoot, I can defend and I can do everything, so I prided myself on my versatility and being a complete player. I took a lot of pride in being able to stop a guy from scoring on me. I actually enjoyed playing defence more than offence.

Do you ever think about running out against today's generation? These guys are a lot bigger than in your day, right?
Yeah, I was six-foot-four, which was big for a guard in the 70s, but today I would be a point guard. To answer your question, only in the playoffs do I feel like throwing my boots on again. That's when the pageantry and the hoopla starts – that's when you earn your fame! Currently I'm a broadcaster for the New York Knicks, which I've been doing for 21 years. During the regular season the game looks familiar to me but I can't figure out why. But in the playoffs I have flashbacks, and I think about my days as a Knick. The playoffs are like a different season. The guys are more focused, there's no hocus pocus, everyone has one goal and that's to be the champion.

One last question. Do you have a particularly fond memory of wearing your own shoes?
Yeah, when we came out with the Clyde, the other players knew that was quite an honour. No one else in the NBA – not Wilt Chamberlain, Bill Russell or Kareem Abdul-Jabbar, none of these guys – had a shoe named after them, much less were getting paid to endorse them. I had a lot of respect from the players, I saw them staring at me, looking down at my shoes and admiring me for that accomplishment. I've been affiliated with these shoes for decades. It's an incredible honour to be with one company for that long. Every time I'm interviewed it perpetuates the legacy of the shoe. The shoe itself is timeless.

Agreed. It is incredible that more than 40 years later we're still talking about it.
I thought it would endure as long as I was playing but I never thought it would continue once I left the game. I know that at one time breakdancers wore it and it became popular again when rappers started wearing it, and that gave it another life. Then retro shoes were in vogue again so it just keeps going on and on – and I think PUMA has done a great job promoting the shoe internationally.

A few years back when we did some promo, I went to London and New York and I heard all these rappers talking about how I was the guy who started the bling in the NBA. I was the first guy with the fur coats, the Rolls Royce and they admired that and they were giving me kudos. It was fantastic.

•

Pony

Published in *Sneaker Freaker* Issue 24, May 2012

EDITOR'S NOTE: WOODY

I must admit, I didn't know much about Pony when we were given the job of detailing their history for a book project in 2012. After buying up every vintage shoe I could find on the 'Bay and scouring the web for obscure information, I lucked out when Roberto Muller, the wily Uruguayan founder of Pony, appeared on our radar. This is the funniest, most entertaining and most balls-out crazy interview ever recorded in the pages of *Sneaker Freaker*. From punching Sly Stallone at the premiere of *Rocky* to bribing Olympians with cash and being kidnapped by the Japanese secret police on behalf of Pelé, Roberto's anecdotes are the stuff of legend. Sadly, Pony went bust (again) not long after our interview. The brand's status remains unclear, but there's no doubt about it – Pony was a major innovator back in the day.

73

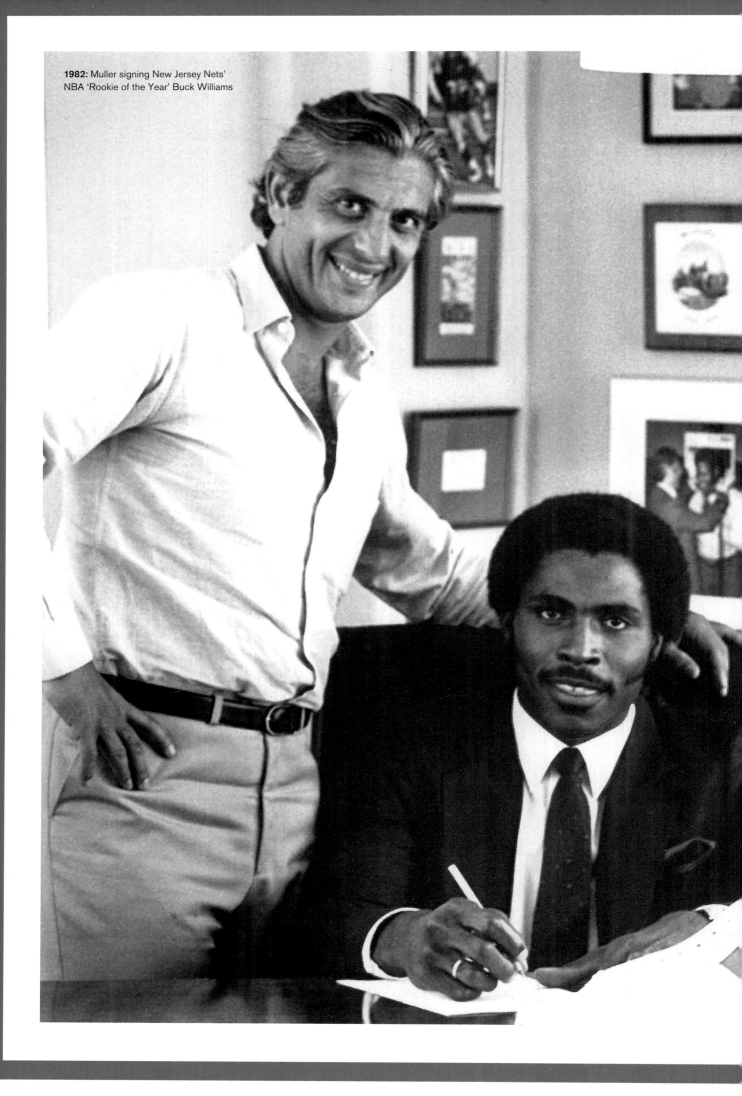

1982: Muller signing New Jersey Nets' NBA 'Rookie of the Year' Buck Williams

534

PRODUCT OF NEW YORK

Interview: Anthony Costa

In 1972, years before anyone gave a flying Swoosh, Pony was founded in Manhattan by Roberto Muller, a maverick who lived life flying by the seat of his pants. The heart and soul of the company, Muller created Pony in his own image, which is to say it was equal parts energetic, rambunctious and oh-so ambitious. With a lifetime spent in the company of athletes such as Pelé and Muhammad Ali, Muller is an amazingly charismatic raconteur. Whether it's rumbling with Rocky Balboa, signing Larry Holmes or bribing players with stacks of hundred dollar bills sawn in half, Muller was a 'player' with cajones to match. His passion for life burns as brightly today as it did in 1986 when he reluctantly sold the company. Put simply: 'I put a lot of me in Pony'.

Tell us a bit about your background.
I was born in Montevideo, the capital of Uruguay. Our passion for sports and our desire to go out and win is unbelievable. It comes from the native Charrúa Indians, who were never defeated. That underdog spirit helped us win the World Cup twice!

And you played junior soccer for Uruguay as well?
Well I did, but I never actually played in serious tournaments. I was in the selected squad and I played for Club Atlético Peñarol (Montevideo) as a youngster. I got to do some friendlies.

How did you make it as a teenager from Uruguay to the United States?
In Uruguay, I was a little rebellious. I even occupied my school because I believed in Fidel Castro's revolution! A lot of South America was in turmoil at that time. If I'd known the kinds of problems it would cause in the future, I certainly would not have done it. My father sent me to Europe to be educated; he thought I'd end up a bum otherwise.

I didn't know a word of English, but I graduated and was fortunate enough that sport was my outlet. Somehow I passed and got my chemical and textile engineering degree. I then came to the States to research synthetic fibres, ended up at Harvard University, and within a few weeks they wanted to send me to Vietnam. So I flew back to Uruguay, leaving behind my worldly possessions, which consisted of a 1956 Mercury sedan and a record player.

Montevideo was obviously not a place you could launch a career, so I chose Argentina and started at DuPont. At 26, I became general manager of a petrochemical company. For some reason that is beyond me, I was headhunted to become the president of Levi Strauss in Argentina. Back in the 60s, if Coke was the drink of the world, Levi's was the dream. It was a very progressive company. All the managers worked for three weeks in the factory learning how to make jeans – to respect the quality and hard work involved – which is something I carried for the rest of my life. This is when the seeds of Pony were planted.

What happened next?
Well, executives were being kidnapped in Argentina, so I was moved to Miami and ran our Latin American operations from there. Within a year, I was in charge of diversified product development. Australia was considered 'the same as California 20 years ago', and so I decided to launch the first Levi's sneakers there and sold one million pairs in one year. The entire company was in awe! I don't think Australia had 10 million inhabitants in 1971!

Now you have to understand the context. At this time, adidas were turning over maybe $12 to $18 million, Nike didn't exist, and the largest company was Keds, who were making all different types of sneakers. There was no apparel, because the first tracksuit was only done for a Peter Sellers movie. Before that, the national team of Germany had one tracksuit and a bag, but they never marketed them. Look at the photos of the Olympics in the 1930s, 40s and 50s – there were grey sweats made by Champion and Russell with USA or Australia written on them.

So here was what I believed would be the next revolution: the application of sport into leisure time. I told the Levi's board that we should create Sports Inc. in 1971. They chose to focus on their core denim business, but offered to help me go it alone in the American market. I said 'Great!'

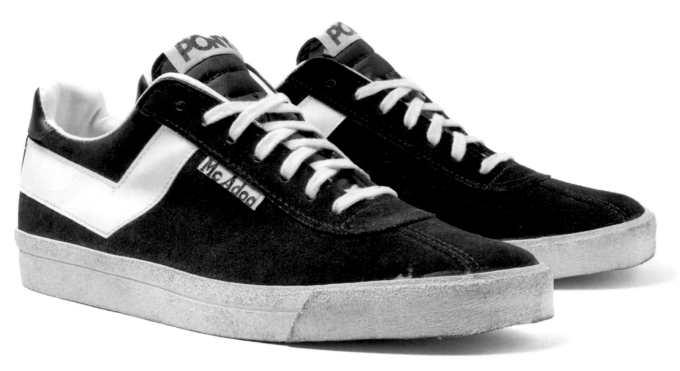

Bob McAdoo x Pony

At 6ft 9in, Bob McAdoo was tall timber, well endowed, with a very cool name. Starting his pro career with the Buffalo Braves, McAdoo won the 1973 NBA Rookie of the Year Award and earned three consecutive NBA scoring titles. He was a scoring machine who played with the Knicks, Celtics, Pistons and the Nets before winning titles with the Lakers in 1982 and 85. These 'McAdoo' Ponys seem to have only been produced in navy suede, an unusual choice for this era.

1986: City Wings 'Spud Webb'

The City Wings model was made famous in 1986 when Spud Webb routed Dominique Wilkins to win the NBA Slam Dunk. Most people remember the high-tops, but a low-cut was also released, and it's this version that was actually worn by Spud in the final. Any similarity to Jordan's first shoe from 1985 must be a coincidence!

Was there a catch?

No, no catch. The owner Walter Haas was very supportive. They were a great company. It was my school – I learned about marketing, business decency, respect and the team. One of the best things about the creation of Pony was that it was set up as a team. I was an entrepreneur who came from corporate life, and I understood that you cannot do everything yourself; making the shoe, selling the shoe, producing the shoe, marketing the shoe and putting it on players – it just doesn't happen. The management team was built when I moved to New York (after I realised that San Francisco was not a mecca where a sports company could be built). Bob Schott, my first senior executive, was the head of Uniroyal, the absolute premier sports and sneaker company. They had real distribution with PRO Keds and their famous 69er.

What made you believe that Pony, this new upstart New York brand, could take on Adi Dassler and win?

I was absolutely crazy! I was 30 years old and thought I could do no wrong. I felt we had something unique. Sometimes you really have this faith in your destiny, even though we were eight months in and weren't paying salaries and owed money to the IRS. I even got stuck in the bank one time because I needed some money and the guys locked me in. They forgot and I slept there all night! I always believed that we would make it. When one financier dropped us, someone else would come in and save the day. I thought there was a huge market opportunity. When you come from South America with 1000 per cent inflation, volatility is not something you are afraid of.

How did you build Pony's identity?

Pony sounded great, like a real American horse in the wild, and the four letters reminded me of 'Levi'. We placed them [the logo] at the back of the shoe and made sure that it captured the consumer's imagination. If you see adidas, PUMA and Nike shoes, they all have logos and icons at the front of the shoe. That's also why we picked boxing [to sponsor], because for two hours you have that Pony chevron in your face. Many of those things were done strategically and thoughtfully – they weren't happenstance.

We were a brand born out of creating something counterculture, but at the same time with value, with the right characteristics and the right DNA. We didn't want to be adidas, which was the institution, and we didn't want to be crazy Nike, who only serviced running. We wanted to be street. But at the same time, we were all about performance. You saw this at the Montreal Olympics where Pony was number two on the medal tally.

Why is New York so important to the Pony story?

The first Pony office was on Madison Avenue and 59th, then we moved to 250 Park Avenue South. In the 60s, it was all about the West Coast; but in the 70s, the trends were coming from New York. In sports, you had the rise of the Jets, the Knicks and the Cosmos. It was an international city, which allowed us to form a relationship with Mitsubishi, who went on to manufacture our shoes. Being close to Europe helped us sign an agreement quickly with Hutchinson-Mapa, the largest French company in sneakers at the time. We signed in Italy, and with Pentland in England. We were in over 100 countries after a few years! That made us the second most distributed athletic brand in the world behind adidas. We were really pioneering! In France, we were number two, ahead of PUMA. Armin Dassler, son of PUMA founder Rudolf, had to give up France in bankruptcy because he couldn't compete with adidas and Pony.

Do you remember the very first Pony sneaker that rolled off the assembly line?

We had two at the same time. The Starter – one of our best models – was a vulcanised version of a leather shoe. We also had the McAdoo. Very early on we made running shoes, then basketball, and in the second season, we made cleats for baseball and American football. We felt that 'team' was the thing that brought the qualities of sport to life. The individualism of running and tennis is great, but it isn't what gives quality to sport. So basketball and cleats were the core of the brand and that's what we stood for. Yes, we had running and tennis and we were the number one shoe in badminton and squash, handball and women's hockey, but we also had a phenomenally successful football shoe that became a fashion shoe.

Was the success of Pony's football shoe a happy accident or part of a deliberate strategy?

We were trying to capture the imagination of the high school kids and influence them to not buy Nike, Reebok or PUMA. So we made a studded shoe with a black chevron. We did it in suede so that you could match it with the colours of your school. We gave it to the captain of the high school team for free and we sold one million in each style!

Anyone outside the US might not understand how big of a deal high school sports is.

Football is a religion in Texas. High school football is the ultimate religion; it is not college, it is not NFL, it is the state high school championship and it is unbelievable! If you've seen *Friday Night Lights*, well it's nothing compared to the real thing. They play the finals in front of 75,000 people at the Astro Dome. These kids are selected to go to some of the greatest schools, and once they started to wear our AstroTurf shoe, it became a rage. Foot Locker and Foot Action were driving us nuts. We couldn't make enough shoes. We were flying – it was crazy. We sold a million and a half pairs of those shoes. It was a phenomenon.

You had similar success with softball too?

The Challenger was a softball shoe that sold in huge numbers in the Midwest. It was a time of economic turmoil and labour disputes, and softball became a regular pastime for striking workers. Pony was the blue-collar, hard-working, value-for-money sneaker of America.

Athlete endorsements were always a key part of Pony's approach. Who was the first athlete that Pony signed?

The very first serious signing was Earl 'The Pearl' Monroe from the Knicks. Following the idea of Clyde Frazier (Monroe was equally famous), we made a shoe called the MVP as Monroe was Most Valuable Player the year the Knicks won the championship. It was a huge contract at the time – $5000! Subsequently, we had a very interesting episode at the Olympics. Converse had exclusive rights and adidas and Pony were thrown out. Our shoes were literally thrown out into the parking lot.

Montreal in 1976?

Right. I actually talked to a guy who was a former athlete and he was able to get into the changing rooms and speak to the two best Olympic basketball players. I gave them envelopes with 500 hundred-dollar bills cut in half and said that I would give them the other halves if they wore Pony sneakers in the last game! So they switched shoes just four minutes before starting the game.

I heard there's also a great Pony story about Darryl Dawkins.

In the 1976–77 NBA playoffs, Portland won and Darryl Dawkins (aka Chocolate Thunder) became famous for smashing the backboards when scoring points. And he personally calls me and says, 'You know I have a Converse contract, but it doesn't say shoes, it says "the Converse shoe company", so I think that means only 'one shoe'. Do you mind if I have a Pony shoe on one foot and a Converse shoe on the other?'

Darryl played the game in which Portland became champions with a Pony on one foot and a Converse on the other! We looked for that kind of personality, guys who were willing to do something different. Michael Richardson came and then David Thompson, the Skywalker. He could have been bigger than Jordan and you and I wouldn't be talking today because I'd be still at Pony and I'd be the $10 billion man! But such is life.

Reggie Jackson was a larger-than-life personality.

Mr October! Controversial, not a guy who breaks the law, but is willing to go against the grain – he says what he says and means what he means and stands for what he wants. And that's important. We always believed that we [Pony] were different. As I told you, I left Uruguay because I was rebellious. I probably would have ended up in jail. A lot of people will tell you that I was an asshole. Obviously that kind of personality doesn't go well in corporate life where you don't make waves and you play nice with everybody.

Pony's roster of athlete talent was eclectic

Speaking of personalities, how did you take Pelé away from PUMA?

We maintained relations when I was in Argentina working at Levi's and we went out and partied. By the way, Pelé kidnapped me for his 40th birthday in Japan. It was a very, very unpleasant experience being taken off my flight by the Japanese secret service police and locked up. How he pulled it off I don't really know! I ended up in Los Angeles because he wanted me at his party. Anyway, I heard Kissinger was going down to negotiate with the Brazilian government, so I called Pelé to ask if he was coming and he said yes. So I asked, 'What's the story with PUMA?' and he said, 'Well, they want to do something.' I told him: 'You're not doing anything with them, you're signing with me. Don't say anything, we'll make a deal.' And we signed for $50,000. I know PUMA were offering more, but he was upset with them for some reason. I came in and gave him the $50,000 up front and made him part of the New York Cosmos, and then we signed almost everybody in the team. We all thought it was the beginning of football in America. We thought that this could start something and we made Pelé feel that he was a big star in New York.

Muhammad Ali is an all-time great who wore Pony.

Ali wasn't one of our favourites. There were boxers like Larry Holmes and Kenny Norton who loved Pony. They would do anything for us! Ali was a guy that only cared about Ali. He wasn't getting anything from adidas and had heard that we were paying Larry. We gave Larry $1000 even though he was under no contract at all. He was still

a nobody. He came to us at the office in New York all the way from Philadelphia. He said, 'Nobody has ever given me any money for anything!' The whole story went around, everybody heard it.

For us, boxing was all about promoting the Pony chevron. Back then, it was very snobbish to be in the front row of a fight. It was a celebrity event, like a Lady Gaga concert. When Carlos Monzón fought in Monte Carlo it was the greatest event in Europe. Prince Rainier and Grace Kelly were there along with Jean-Claude Bouttier, Brigitte Bardot and Jean-Paul Belmondo. It was all very elitist. We even signed up Sylvester Stallone for *Rocky IV*, but then adidas got very upset and they sued him. I talked to him a few times but he got very aggressive with me. We ended up getting into a fist fight in a club in Los Angeles.

You and Stallone had a stoush? I'd buy a ticket to that!

I think the big guys separated us before any serious punches. He had promised to wear the shoes and everything, but then in the actual shots he wore adidas.

The jogging boom took America by storm. Could Pony have done more in this category?

It definitely was a mistake, but it was a mistake committed by adidas, PUMA and Pony. You have to understand that running was perceived by the entire world as full of crazy masochist guys up in the north-west of America willing to run 40 kilometres. It was a small group of fanatics before the New York Marathon [increased running's exposure]. What changed the running world wasn't Nike, it was

GUARD
DAVID THOMPSON
NUGGETS

'David Thompson, the Skywalker. He could have been bigger than Jordan and you and I wouldn't be talking today because I'd be still at Pony and I'd be the $10 billion man! But such is life.'

I was absolutely crazy! I was 30 years old
and I thought that I could do no wrong.
When you come from South America with
1000 per cent inflation, volatility is not
something you are afraid of.

To be here, giving you this interview, it is
one of the most emotional experiences in
my life. I put a lot of me in Pony. I think it's
a legacy that deserves better than what
it's got. It was a pioneer in many, many
aspects. No other brand went global
from scratch. It took 30 or 40 years for
adidas to do that and we did it in
a matter of two, three years.

Roberto Muller

1975: Starter Lo

1975: John Havlicek Pro-model

1982: Court Hi

1975: Starter Lo

1984: Astro Leather

1985: Retton Hi

Runner's World magazine and its founder Bob Anderson. He made the competition between Brooks, Saucony, New Balance and Nike. He put Nike at the bottom and made New Balance number one. That created the battle and people started talking.

During the 70s and 80s, one of the great social conversations was sports sneakers. They were the fashion of the moment. So whether you were a Pony fan or you were a Nike fan depended very much on your personality. If you were a geek and you were thin and you liked to run, you chose Nike, Saucony or Brooks. We had running shoes, but we weren't treated as part of the running community and neither were adidas. To be honest, we missed the revolution of eight million runners. I was much more focused on the team, that's my sphere. I think if Michael Jordan hadn't been who he was, Nike would still be a running company. Phil Knight is still a running guy. And John McEnroe really helped, but he wasn't into team sports.

New York in the early 1980s: hip hop starts to grip. When did you begin to take an interest in the streets?
We were born on the streets! Not only were we cognisant of the teams and the players, but we – even ahead of signing star players – had a basketball team in the Harlem League. We had teams in the Lower East Side and the Bronx. Then when breakdancing came we sponsored 90 per cent of the breakdancing crews and all the events that happened on the streets of New York. And we became the number one skateboarding shoe, way before Vans and everybody else! We held inner-city skateboarding and breakdancing events.

The very first hip hop guys were all Pony. Russell Simmons and his group, Run-DMC, went to adidas. But during the initial era, on the streets you could say it was 70 per cent Pony. There was no Nike, it was only adidas or us: the Superstar or the Pony Legend or the MVP. Whether it was double-dutch tournaments, breakdancing or hard-fought, crazy basketball tournaments in the Rucker League where we won the championship. You know we actually brought NBA players in during the off season? We let them grow beards and shave their heads so people couldn't recognise them and we won championships! I have three or four Rucker League championship trophies in my garage because I played two or three minutes, just to say that I played! Not that I can play. I can't do basketball.

Who did you recruit to the Rucker tournaments?
Peter Vecsey was our coach and he wrote for the *New York Post*. He's the premier writer in basketball in America today and he also wrote the *Pony Express*. We had guys like Maurice Cheeks from Philadelphia and Orlando Woolridge play a couple of times. At one time we had 200 to 250 NBA players, so it's hard for me to remember specifically who we recruited. Whenever there were strong inner-city tournaments in LA, in Watts and so on, we had tournaments sponsored by Pony.

What did Pony Express do for the company?
At that time there were no communication systems like today. You didn't have an intranet in your company and you couldn't

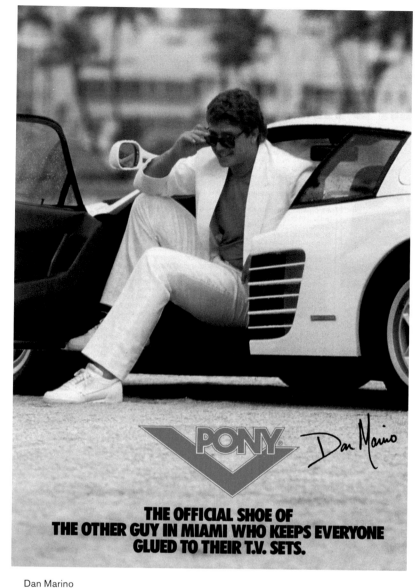

Dan Marino

Reggie Jackson

Spud Webb

communicate with retailers through websites. The idea was to create a magazine that combined Pony athletes with a little bit of gossip. Not only the stats, but what they're doing, where they were going out, are they going to get married etc.? There were no sports magazines so the retailers were really eager for it. We were sending 20,000 issues a month and it was a very, very efficient vehicle to showcase new models, campaigns and posters, and to highlight our athletes. We were competing consistently against campaigns that were much larger than ours.

In the 80s, technology became essential to the sneaker industry. Was Pony able to compete in the escalating tech race with other brands?
We were so advanced that the first shoe with air in the world was made by Pony! Spud Webb's shoe was an inflatable design that I patented. Now the problem is you couldn't play a whole game with it, but it had a valve and you could inflate it to 40 psi. So when you talk about the first patent of an inflatable shoe, Pony did it. When you talk about the first double-mesh shoe, we did it. When you talk about the separation of tongues, where we could have a tongue that was baseball or rugby using Velcro, we invented that.

Chevron logos that were removable?
We invented that too. We had three labs when Nike didn't have one! We had one in New York, one in Taiwan and one in Korea. We also searched for materials in Germany and Japan. We looked

for new components, new compounds, new breathable materials. We invented the first snow shoe for football. Every time it snowed, it didn't matter whether they were with Nike or anybody, players would switch to our shoes. I think I made as good a running shoe as anybody else, but the perception – the image of Pony – was not there unfortunately.

You obviously have a great deal of pride in what you created. Now that the brand is coming back with its New York roots intact, how do you feel?
Elated… hopeful. I've tried this twice before, but never put my name to it. I've never done this interview for anybody else ever since I sold the company. Of all the things I have done, nothing matters to me except Pony. I always regretted selling it. I always regretted signing the option for the sale. I did that out of friendship and out of being grateful, because I really needed $20 million then. To be here, giving you this interview, it is one of the most emotional experiences in my life. I really am… I'm sorry. I put a lot of me in Pony. Pony was my life, it was my family's life. I think it's a legacy that deserves better than what it got. It was a pioneer in many, many aspects. No other brand went global from scratch. It took 30 or 40 years for adidas to do that and we did it in a matter of two, three years. I'm grateful that I had the opportunity, because I'm more humble today. I was an arrogant son of a gun! I'm very proud to have been a part of its inception and to have been invited to participate in its future.

•

New Balance

Published in New Balance *Craftsmanship & Imagination* zine, March 2011

EDITOR'S NOTE: WOODY

It's surprising to learn that New Balance has been around since 1906, but the real history of this remarkable brand starts in 1972, when a young Jim Davis purchased the company. At that point, New Balance was making 24 pairs of shoes a day by hand. Charting their growth through the 80s and 90s, the brand's personality becomes apparent. From making shoes in different widths to choosing grey as their corporate crest, not to mention their 'Endorsed by No One' athlete philosophy, New Balance has always been fearlessly independent. Today, Jim Davis still proudly oversees shoe production in the New England area, and in the UK at their factory in Flimby. Credit where credit is due, New Balance has done what no other brand has had the balls or ability to accomplish.

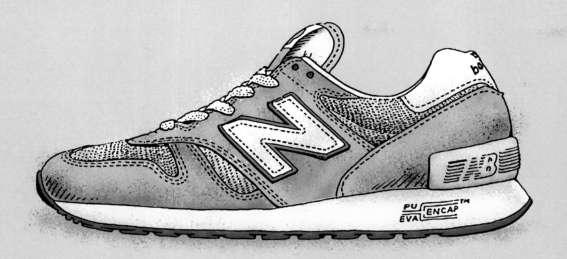

TEXT WOODY **ILLUSTRATIONS** JAMES ROGERS

Chicken or the Egg?

new balance

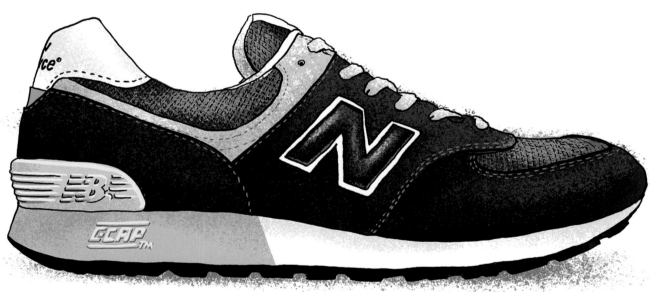

574 'Lost Prototype'

New Balance is over 100 years old – an amazing achievement for such an independently minded company. Strangely enough, in this day and age of marketing-driven heritage hoopla, the origins of the brand are still clouded in obscurity, not to mention a certain slapstick hilarity. Aficionados might be well versed in NB-101, but that's indicative of a peculiar spirit in itself. New Balance has always fostered fans who sweat the details and in their own iconoclastic way, are a mirror image of the brand they admire. Quiet, devoted, stubborn, polite and modestly confident, New Balance have never needed a megaphone to make themselves heard.

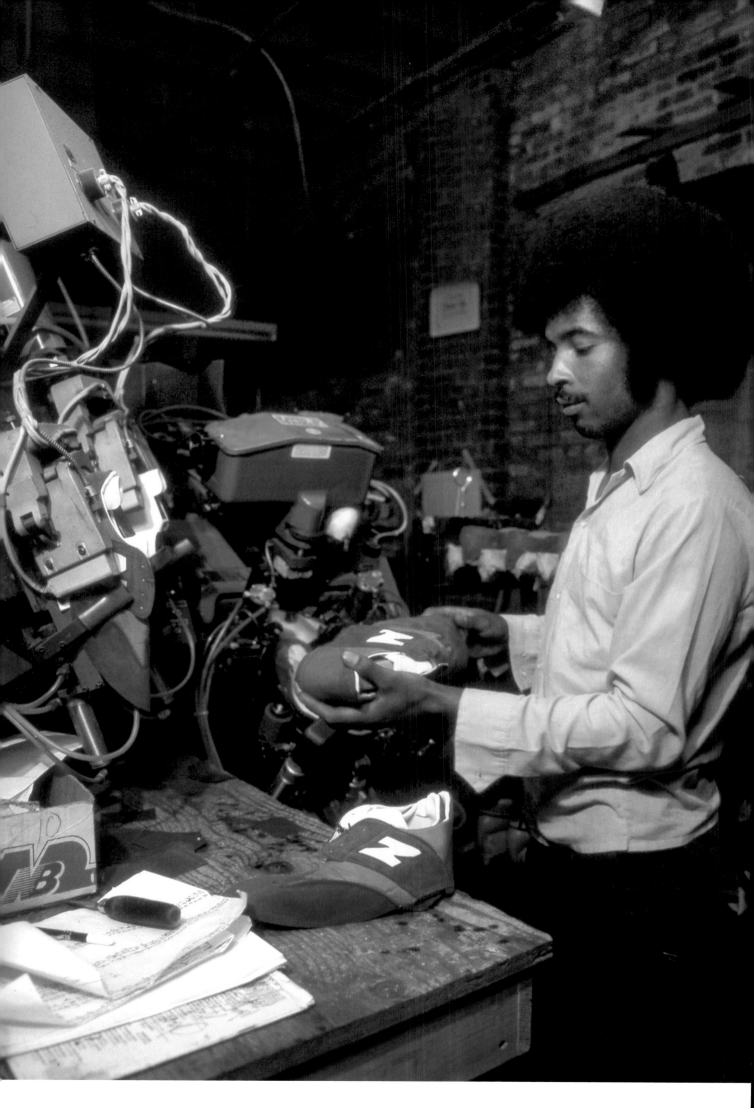

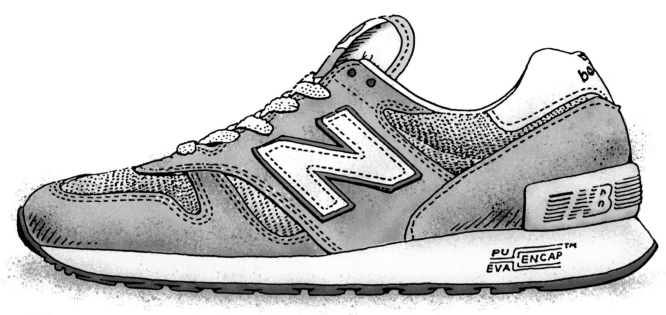

1300

Grey Scale

New Balance have never needed overpaid and ungrateful athletes on their books. Their longtime 'Endorsed by No One' mantra combined with a single-minded devotion to making the best runners offers a refreshing vision of untainted idealism. Even their choice of corporate colours is profound. Grey hardly promises a utopian future, but it does cloak the brand in a gutsy, fashion-defying pragmatism. No bells, no whistles, no fuss. There isn't a single New Balance shoe that doesn't look utterly perfect in the Pantone chart's most dignified colour.

When the going gets tough, the tough get going.
New Balance Athletic Shoes

Such a serious, possibly moody, outlook might indicate an anaphylactic allergy to glamour and frippery, but as mentioned, there is a whimsical side to NB, one that has embraced the bio-mechanics of chickens for inspiration and produced vintage advertising that still raises eyebrows today. Who else would feature Ronald Reagan and Mikhail Gorbachev discussing politics in honour of 'stability'? Or a wino with a cigar, a chihuahua and a dozen bottles of moonshine above the banner 'When the going gets tough, the tough get going.'

Conversely, for a brand with strict scruples, New Balance have never been shy about plugging the merits of their shoes. The 620 was cheekily pitched as the 'Lightweight Champion of the World!' and 'Lighter than Air!', a clear dig at their cross-country rival. The 990 was also the first runner with a $100 price tag, unheard of in the early 80s.

New Balance might be humble as apple pie and operate strictly on the DL, but they also possess a steely belief that their shoes do everything they say they do. Now let's wind the fob watch back to 1906 and get this story started.

TRADE **NEW BALANCE ARCH** MARK

William J. Riley Inventor

300 CANAL ST.

PACIFIC MILLS

550

The Trackster is the first shoe officially released by New Balance.

1906

In 1906, a waiter and budding shoemaker named William J. Riley had a vision. Apparently inspired by his finger-lickin' dinner, Riley observed that chickens used their three-pronged feet to achieve 'perfect balance'. Parlaying his lightbulb idea into a marketable product, Riley developed a series of arch supports that he shopped around America under the compelling name of 'New Balance Arch'.

Such beginnings were modest, but Riley was smart, ambitious and a serial forward-thinker. His obsession with the notion of comfort and custom fit was also decades ahead of his competitors, although his first patents didn't arrive until 1929. In 1933, salesman Arthur Hall signed on as Riley's partner and together they introduced innovations such as the highly technical 'pedegraph box'. As radical as it sounds, this magical device consisted of two pieces of tracing paper used to record the shape of customers' feet.

Once outlined, the mailman delivered perfect custom shoes to happy feet all over the USA.

The first serious NB running shoe, made for a local club known as the Boston Brown Bag Harriers, came in the late 1930s. Riley was so confident in his kangaroo leather runners that he provided a money-back guarantee on the $7 price tag. By 1953, Hall's daughter Eleanor Kidd was in control of the company. The first truly modern New Balance model arrived a few years later. Dubbed the Trackster, it was a revolutionary

NEW BALANCE. MADE FOR RUNNING.

1300

Three good reasons why New Balance makes running shoes in different widths.

lightweight runner that seemed to touch down direct from the future. The ripple sole was a remarkable piece of design and promised to release the 'Go Power' in athletes from start to finish. More importantly for New Balance, it was the first time a runner was made available in multiple widths – a pivotal moment in establishing the brand's philosophy and point of difference. Even today, NB shoes are made in a snug size known as 2E (or X-Narrow), right up to 6E which is more your King Kong Bundy style of ample fit.

The same idiosyncratic approach has informed the naming system for models released since the Trackster. Salutations to gimmickry and trend-chasing are banished in favour of a matter-of-fact set of numbers, generally starting low and ending on a high note as technical features are added. No unnecessary flourishes or tricks from the marketing department are tolerated. That's not to say the system is immune to lapses in logic, but as the aficionados know all too well, sometimes it's the quirks that make life intriguing.

One urban myth suggests that the numbers refer to the debut price of the shoes. The 1300, for example, did sell for $130 back in 1986 (some reports have it at $150), but this explanation, however charming, doesn't stack up.

THE LIGHTWEIGHT CHAMPION OF THE WORLD.

The New Balance 620 is the lightest training flat on the market today.

But what makes it even more impressive is the fact that, instead of making it light at the expense of support, we made it light *in combination with* support.

HOW WE MADE IT LIGHT.

Working with Vibram of Italy, we developed a revolutionary outersole for the 620 made of an ethylene vinyl acetate and rubber compound. And for our wedge and midsole, we used 100% E.V.A.

The result is a training shoe lighter in weight than many racing shoes

(229 grams in a standard size 9D). With better shock absorption and flexibility than most training shoes.

HOW WE MADE IT RIGHT.

The 620 wouldn't be drawing accolades from runners and running magazines alike if it didn't offer all the benefits you've come to expect from New Balance.

Like the snug, *critical fit* of our patented Extended Saddle. The added support and motion control of a pre-molded Stanbee™ counter, extended along the medial and lateral sides of the shoe. The comfort and protection of our Volara™ collar.

YOU MIGHT EVEN WANT TO RACE IN IT.

Given the superior features of the 620, it's no surprise that more and more runners aren't only training in it, but racing in it.

The New Balance 620. The lightweight champion of the world.

New Balance Athletic Shoe Inc., Boston, Massachusetts 02134, which is where our shoes are made.

NEW BALANCE
WE'RE WITH YOU EVERY STEP OF THE WAY.

Men's sizes 6-13 (widths B, D, EE and EEEE). Women's sizes 4-10 (widths AA, B and D). Made in U.S.A.

THE NEW 620

A better width-sizing fit, increased comfort, greater performance — the spectacular new 620 from New Balance represents a major breakthrough in the evolution of training flats. The combined sole of black Lotus Extra expanded rubber (a New Balance exclusive from Vibram of Italy) and wedge/midsole of E.V.A. Mighty-Lite are thicker and softer, yet lighter in weight, than any training sole we've offered before, weighing only 7.9 ounces in size 9D. The new Extended Saddle™ provides a snug, tightened-down fit; the new pre-molded Stanbee™ counter has been extended along the medial side of the arch for added support and motion control; and the new two-way stretch Volara™ collar lining and Achilles tendon pad truly embrace the heel. Moreover, both the 620 and the women's W620 are shaped on new, improved athletic combination lasts with broader toe boxes and close-fitting heels — in fact, the W620's heel is two sizes narrower than its forepart. Initially available in men's sizes 6-13 (widths B, D and EE) and women's sizes 4-10 (widths AA and B).² Men's model in Pearl Grey with Ebony; women's model in Pearl Grey with Electric Blue.

*Men's 13½-15 and Women's 11-12 available at extra cost.

new balance

LIGHTER THAN AIR*

New Balance Athletic Shoe, Inc., 38 Everett Street, Boston, Massachusetts 02134.

*lighter than competitors' shoes using the air bag or air inner soles

YOU'D NEVER KNOW WE PUT TECHNOLOGY AHEAD OF FASHION.

No doubt you'll look terrific in New Balance running wear. But the real beauty of our shorts and singlets is how they move in harmony with your body. They're designed with functional, breathable fabrics and cut to minimize chafing and maximize freedom of movement. So you can concentrate on your running without giving your looks a second thought.

CaproLan™ nylon

© 1984 New Balance Athletic Shoe, Inc. The marks New Balance, NB design and N design are trademarks and registered trademarks of New Balance Athletic Shoe, Inc.

new balance®
RUNNING WEAR

On a scale of 1000, this shoe is a 990.

In the Spring of 1978, our R&D people came to us with an ambitious proposal:

They wanted to develop *the very best* running shoe they were technically capable of. Regardless of the time it took or the money it cost us to do it.

As it turned out, it took longer than anyone expected. But, then, the New Balance 990 turned out better than any of us dared imagine.

A RUNNING SHOE THAT ACTUALLY APPROACHES THE IDEAL.

Every running shoe manufacturer strives to build into their shoes both flexibility and support. Trouble is, one is usually achieved at the expense of the other.

Slip-lasting results in an upper with the flexibility of a slipper.

The New Balance 990, on the other hand, offers extraordinary flexibility *without the*

slightest sacrifice of support.

The 990's upper is constructed just like a slipper. This technique of slip-lasting demands more technical skill than other techniques, but the results are worth it. The shoe fits better, feels better and gives you more flexibility.

The 990 also features a unique new stabilization device—a patented Motion Control Device that cradles your heel for maximum support.

NEW FOR 1983: ENHANCED DURABILITY.

When you're paying as much for a running shoe as the 990 costs, you have a right to expect it to wear well.

Tests show that our new Superflex outersole wears nearly 30% better than conventional soling materials. And an innovative carbon rubber heel pad makes the rearfoot exceptionally durable.

Our patented Motion Control Device is made of strong, yet supple, polyurethane.

WIDTH-SIZING: A NEW BALANCE EXCLUSIVE.

Like every New Balance shoe, the 990 is available in a variety of widths, for a more perfect fit.

As it happens, New Balance is the *only* running shoe company that makes its shoes in different widths. But that shouldn't surprise you.

After all, isn't the 990 proof that we'll go to almost any lengths to achieve perfection?

New Balance Inc., Boston, MA 02134.

new balance
990

New Balance advertising

Jim Davis originally planned to study medicine. However he took the advice of one of his professors and switched to sales, before buying New Balance in 1972.

420

1972

After close to 20 dedicated years at the helm, Eleanor Kidd and her husband decided to sell. In 1971, a cheeky youngster called Jim Davis had just purchased a pair of the Tracksters, and like Victor Kiam, he was so impressed he bought the company. Davis would turn out to be a visionary leader, but at the time, he was a greenhorn in the sporting goods business. To put the deal into perspective, New Balance in 1972 consisted of six people making a couple of dozen shoes a day.

Jim Davis

Davis immediately set to work, assembling a team of thinkers and tinkerers. One of the first and most visible innovations came in the form of the now classic 'N' logo applied to the side of the shoes. As Jim Fixx inspired runners on a global scale by writing *The Complete Book of Running*, Davis had somehow arrived in the right place at exactly the right time.

The basic Trackster III arrived shortly thereafter, quickly followed by 1976's groundbreaking nylon 320 model, which set a new benchmark for style. Light, bright and built with performance in mind, its highfalutin outsole made from 'Astrocrepe' signalled the looming tech-sneaker era. Sales accelerated when the 320 was named the number one shoe in 1976 by *Runner's World*. New Balance was suddenly on fire and producing over 500 shoes a day. Business was booming.

By the 80s, NB designers had seized on a new direction, tested it with the 620 (the first shoe to break the $50 barrier) and then nailed it with the debut of the seminal 990 in 1982, which retailed at the stratospheric price of $100. Davis was told it would never succeed in a million years, but runners clearly wanted the best shoes money could buy.

With quality pigskin leather and mesh upper, Motion Control and ENCAP cushioning, the 990 was a breakout success. From this foundation, a fleet of design updates and technical innovations launched the classic 574, 576 and 577 models, each with its own sole-embedded tech. New Balance was on its way to global distribution.

574

576

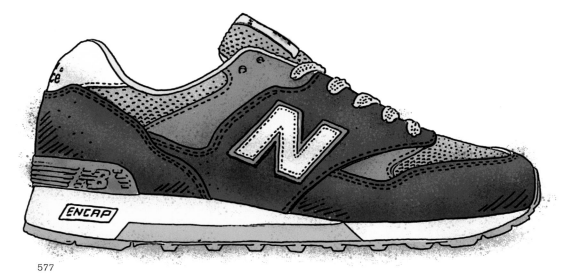

577

The 5 Series

The 5 Series of NB runners covers a lot of models. Many look externally similar, so it's tough to pick them unless the tongue label is visible. Aside from paneling updates, the main distinction is hidden inside the sole. All 5 Series members feature different variations of cushioning foam. As with all NBs – with a few notable exceptions – the higher the number the higher the specification. Regardless, they always look their best in basic grey, proof you don't have to reinvent the wheel if you've created a stone-cold classic.

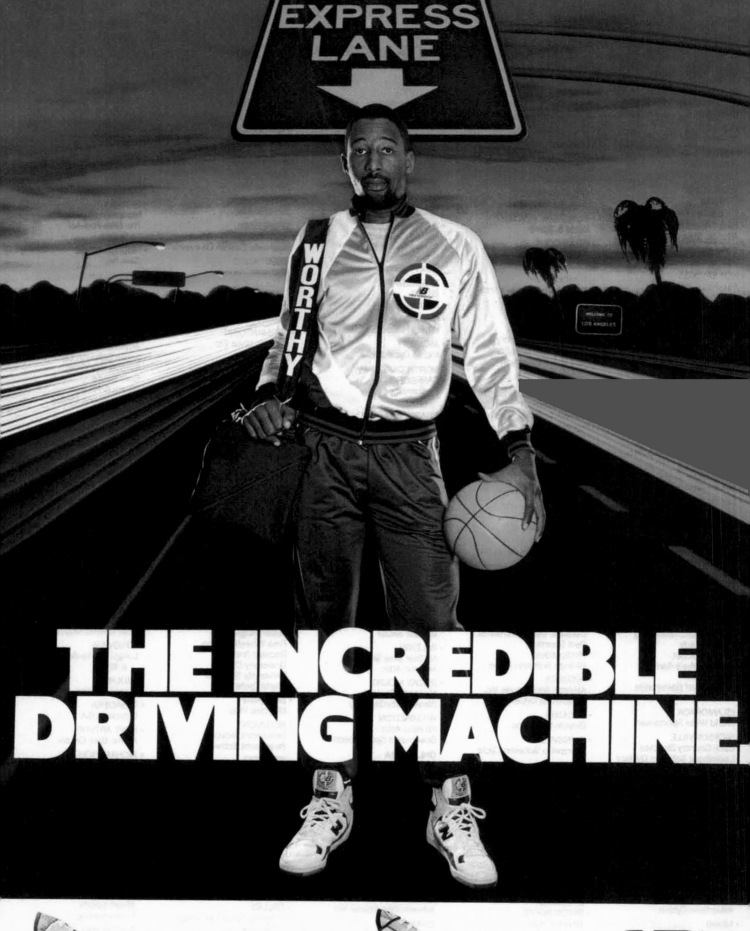

THE INCREDIBLE DRIVING MACHINE.

P600 P700 P800

new balance®
Worthy Express™

P600 and P800 are also available in kid's sizes. All shoes available in a variety of widths.

558

*Nicknamed 'Big Game James',
James Worthy was a #1 draft
pick for the Lakers in 1982.
Voted one of the '50 Greatest
Ball Players of All Time', he also
played a Klingon named Koral in
Star Trek: The Next Generation.*

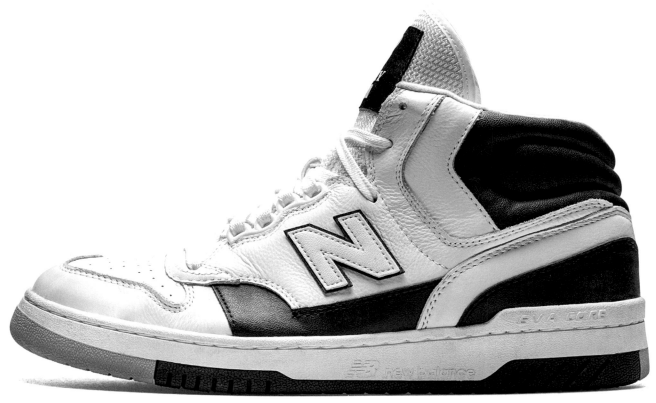

2015: 740 Reissue

Trust Worthy

Detours were made from running shoes into soccer boots and basketball with high-tops repped by superstar baller James Worthy, who in 1989 signed to NB with a contract reportedly worth a million dollars. The moral downfall of the 'Worthy Express' would prove a pivotal experience for the company.

As a result, Davis introduced a policy known as 'Endorsed by No One'. In theory, it meant NB no longer paid pro athletes to rep the brand, though they still leveraged their expertise to help develop product. At a time when the sneaker industry was lusting after high-priced names with huge cheques, this was a ballsy move and proof that Davis had the courage of his convictions.

The policy stayed in place for several decades before it was quietly retired. Today, New Balance has a strong commercial presence in tennis, athletics, cricket, soccer and baseball. 'Endorsed by No One' might be a relic of a bygone era, but NB still adheres to the same values, only working with those willing to share the philosophy that doing good is just as important as doing well in business.

'Made in the USA' is no idle boast. New Balance still produces approximately 20% of all their shoes in the United States. The English NB factory in Flimby was launched over 20 years ago. It currently employs over 200 staff and produces around 30,000 pairs of shoes a week.

355

Home Made

'If we can make great athletic shoes in America, why can't our competition?'

New Balance's unique business vision is also exemplified by their commitment to domestic manufacturing. Unlike their counterparts, New Balance can still proudly declare they produce a full line of shoes in the United Kingdom and the United States. As their advertising proclaimed, 'If we can make great athletic shoes in America, why can't our competition?'

Renowned for quality workmanship and outstanding materials, the 'Made in USA' and 'Union Jack' tongue logos are statements of sneaker superiority. In the UK, the shoes are made in the unlikely location of Flimby, a tiny village in the remote borough of Allerdale in Cumbria. In the US, New Balance has five factories in the New England area, the traditional home of American shoemaking.

Photos: Bryant Naro

Since 2011, New Balance's NB1 programme has offered the general public the opportunity to bring their own custom designs to life as true one-of-one creations. These NB1 574s are being made at the factory in Lawrence, Massachusetts.

First published New Balance *Craftsmanship & Imagination* zine – 2011

IN THE INTEREST OF A MORE STABLE WORLD, NEW BALANCE HAS BROUGHT SOMETHING SPECIAL TO THE TABLE.

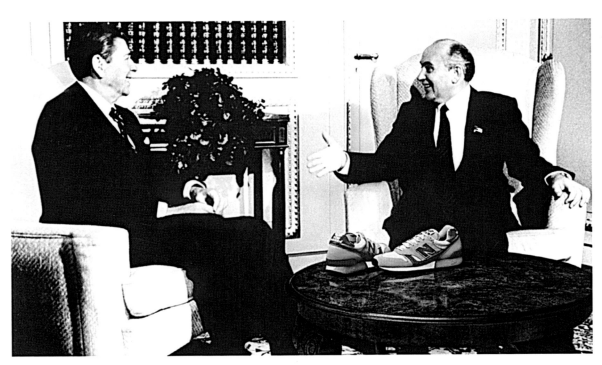

Once again, New Balance is displaying its S.D.I. No, that doesn't stand for Strategic Defense Initiative. It stands for Stability Development Instincts.

We've never demonstrated them more convincingly.

Presenting the New Balance 675.

Of the many features that make it one of the world's more stable running shoes, the most noteworthy is a remarkable new midsole made in our exclusive V-Channel design. The medial and lateral sides of the rearfoot of the midsole are made of a firmer C-Cap© compression-molded EVA to limit overpronation and oversupination. At the same time, the softer C-Cap EVA in the center of the heel provides added cushioning.

The 675 also boasts a newly designed insert unlike any we've ever offered. Double-density EVA/polyethylene foam in the forefoot provides superior cushioning and memory. But the big news is the 675's firmer EVA polyethylene horseshoe in the rearfoot, which provides improved stability during heel strike.

To reduce excessive pronation and supination, the 675 employs a thermoplastic urethane stability device that wraps around the heel. And the 675's highly durable, high-grade carbon rubber outsole provides excellent traction and exceptional stability from heel strike through toe-off.

Achieving stability in the world may be out of your hands. Fortunately, achieving stability when you run is well within the grasp of your feet.

Like most New Balance running shoes, the 675 comes in a variety of widths—B, D, EE, EEEE —for a more perfect fit.

© 1987, New Balance Athletic Shoe, Inc. New Balance, NB design, N on saddle, and C-Cap are registered trademarks of New Balance Athletic Shoe, Inc.

There's no official record of how this print ad featuring Ronald 'Raygun' and Mikhail Gorbachev came about. The link between politics, 'stability' and the NB675 is something you wouldn't ever see these days, but in the 80s, the Cold War was all too real.

990

1500

991

HECTIC was started in 1994 by Yoshifumi Egawa and Naotake Magara. Every month the pair flew to the US to find stuff to sell in their store. Aside from labels like Subware and Sarcastic, HECTIC developed their own imprints including PKG, SeeSaw, Mad Hectic and MasterPiece.

2003: Stüssy x Mad Hectic x MT580

Cult Status

Opposite page
2011: Concepts
x NB999 'Kennedy'

As the spandex-clad 80s gave way to 90s grunge, NB refined their approach by releasing their most technical and streamlined collection to date. Known as the 990 series, the range built on tech such as Motion Control and ENCAP by adding the ABZORB cushioning system.

Another standout at the close of the decade is the 580, which snapped necks thanks to its lunatic heel height, a result of the towering ROLLBAR innovation. The 580's legacy is also closely connected with the influential Japanese sneaker scene in Harajuku. The shoe became the model of choice for collaborators including Stüssy and Hectic, conferring cult collector status on a well-credentialled trail runner.

From promotion through to production, New Balance remain a fiercely maverick force in the athletic shoe game. They simply make the best of the best, and in locations where no other brands have the balls or the acumen to do so. They refuse to follow fashion for the sake of it, and above all else – after 100 years of battling to do things their way – they have kept their dignity, methodology and vision intact.

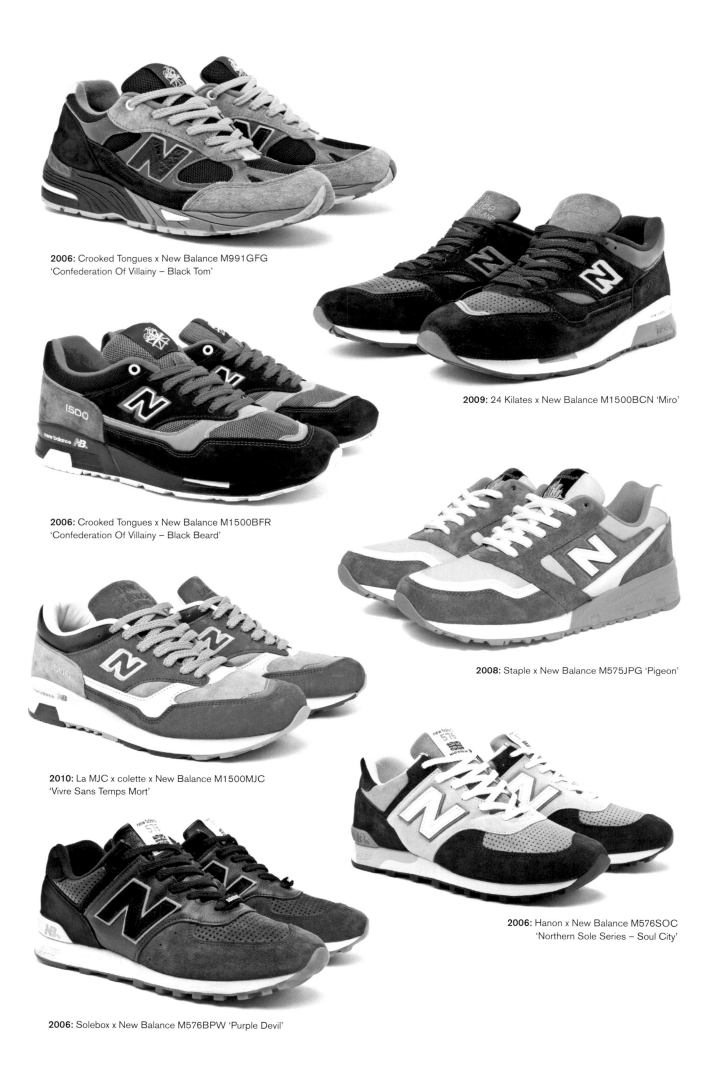

2006: Crooked Tongues x New Balance M991GFG
'Confederation Of Villainy – Black Tom'

2009: 24 Kilates x New Balance M1500BCN 'Miro'

2006: Crooked Tongues x New Balance M1500BFR
'Confederation Of Villainy – Black Beard'

2008: Staple x New Balance M575JPG 'Pigeon'

2010: La MJC x colette x New Balance M1500MJC
'Vivre Sans Temps Mort'

2006: Hanon x New Balance M576SOC
'Northern Sole Series – Soul City'

2006: Solebox x New Balance M576BPW 'Purple Devil'

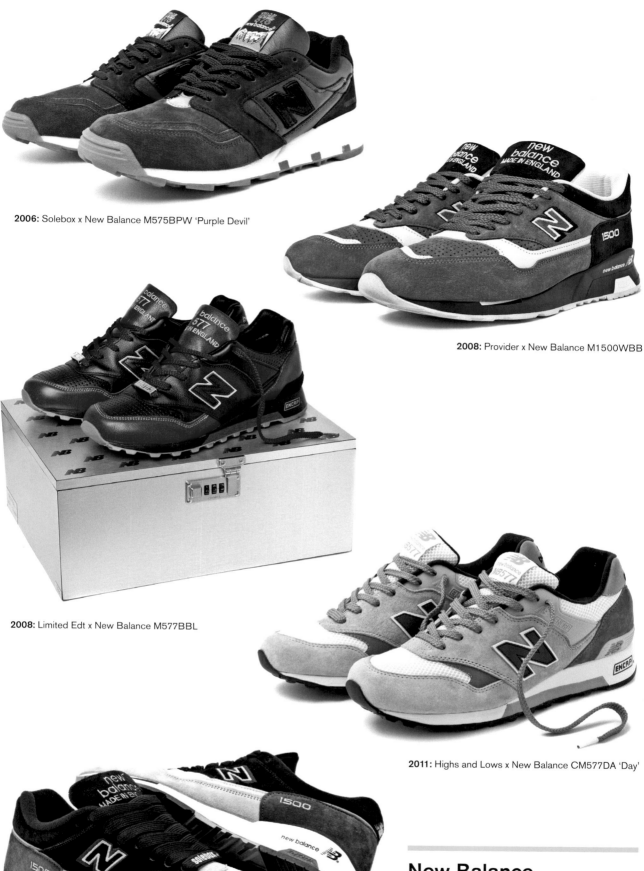

2006: Solebox x New Balance M575BPW 'Purple Devil'

2008: Provider x New Balance M1500WBB

2008: Limited Edt x New Balance M577BBL

2011: Highs and Lows x New Balance CM577DA 'Day'

2005: Solebox x New Balance M1500GGB '1 of 150'

New Balance Collaborations

The MT580 colab between New Balance, Hectic and Stussy is arguably the first sneaker colab of the modern era. There have been far too many collaborations since then to present a complete folio, but here are a few from the *Sneaker Freaker* archive.

adidas Superstar

Published in *Sneaker Freaker* Issue 32, January 2015

EDITOR'S NOTE: WOODY

This was a labour of love, in more ways than one. Written in conjunction with the supremely talented Gary Warnett, this history of the adidas Superstar – aka the Shelltoe – is a genre-spanning narrative that speeds through five decades of sport and street culture. Sadly, Gary passed away in 2017 after a brief illness. On behalf of everyone who knew him and admired his elegant prose, enjoy this love letter to a masterpiece. RIP Gwar.

A LOVE LETTER TO

SUPER

Words: GARY WARNETT

A MASTERPIECE

STAR

From its humble sporting equipment origins through to its present-day stature as a global streetwear staple, the Superstar is arguably the most instantly recognisable sneaker design of all time. Following a fine career in top level basketball in the 1970s, the shoe's golden era arrived in the 80s, when it found itself at the nexus of urban fashion and hip hop. The people had spoken and athletic shoes were not just for athletes anymore. Over the course of four-and-a-bit decades, the Superstar has managed to bypass the fickle boom-bust cycle of fashionable trends, effortlessly changing lanes between sub-cultural movements. Chalk that up to its impeccable sporting pedigree – or the purity of its timeless silhouette – either way, the Superstar is in it for the long haul.

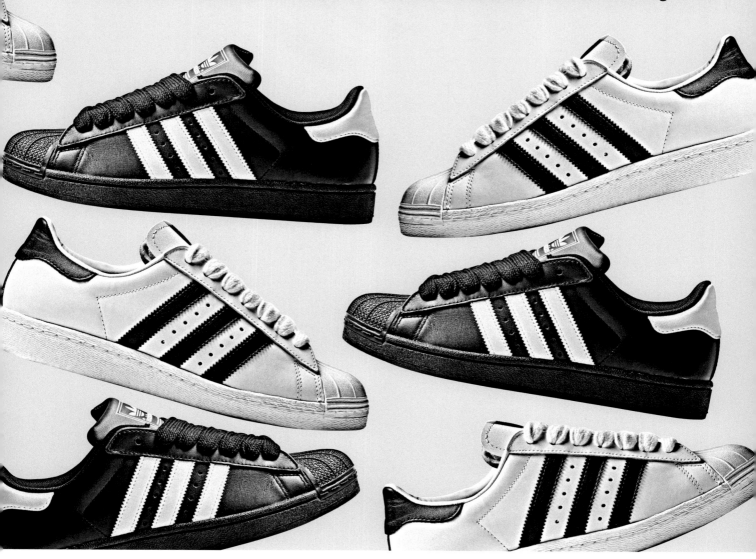

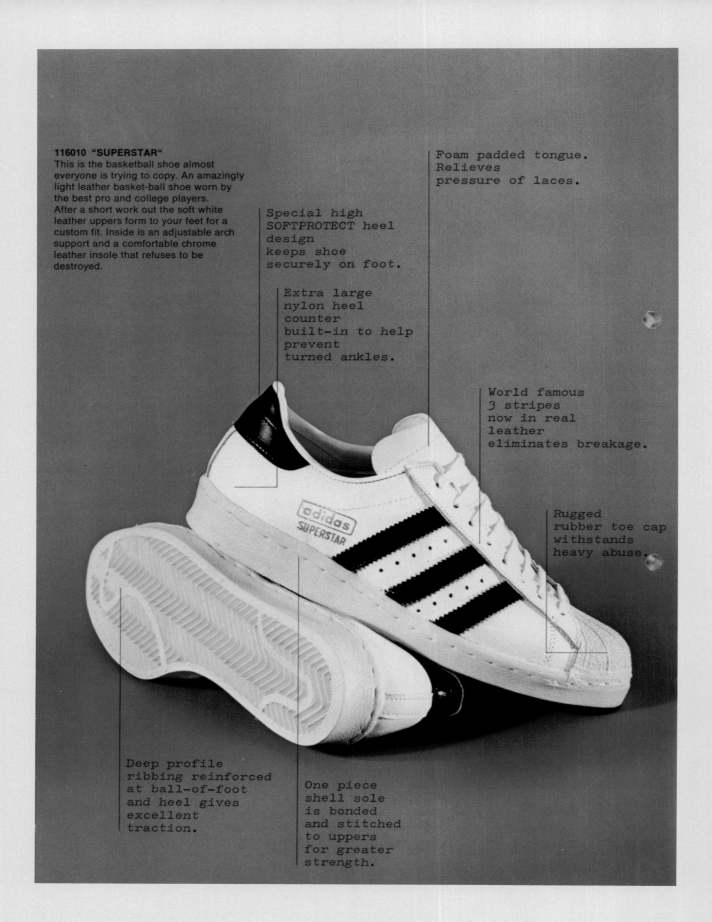

116010 "SUPERSTAR"
This is the basketball shoe almost everyone is trying to copy. An amazingly light leather basket-ball shoe worn by the best pro and college players. After a short work out the soft white leather uppers form to your feet for a custom fit. Inside is an adjustable arch support and a comfortable chrome leather insole that refuses to be destroyed.

Special high SOFTPROTECT heel design keeps shoe securely on foot.

Extra large nylon heel counter built-in to help prevent turned ankles.

Foam padded tongue. Relieves pressure of laces.

World famous 3 stripes now in real leather eliminates breakage.

Rugged rubber toe cap withstands heavy abuse.

Deep profile ribbing reinforced at ball-of-foot and heel gives excellent traction.

One piece shell sole is bonded and stitched to uppers for greater strength.

1970: adidas catalogue

574

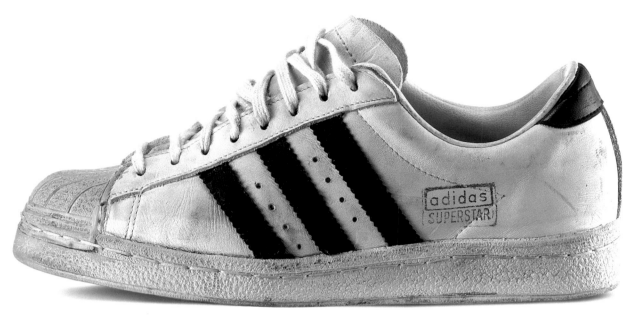

1969: The original Superstar

THE TOE TO KNOW!

Adi Dassler created adidas from his pure desire to build shoes for specific athletic purposes. Track and field, football and winter sports were the main game from day one, but Adi also produced 'Spezial' models for boxers, cyclists and tennis players. The brand's German heritage and basketball's niche status might suggest that hardwood and backboards didn't figure in the original master plan, but a heavy-duty leather boot known as the Trainingsstiefel did appear in adidas catalogues under the 'Basketballstiefel' category as far back as 1949.

As the American presence in post-war Europe broadened the game's appeal, adidas updated their offering in the 1950s with the Allround model, which remained the benchmark until 1965 when the Supergrip debuted. Compared to the Allround, the Supergrip's herringbone outsole, cushioned heels, foam insoles and padded ankles were seriously state-of-the-art innovations. It was a quantum leap forward into modernity by any standard.

Also hitting retail shelves that year was the Superstar's elder brother, the high-cut Pro Model. The first Pro Model incarnation was strictly an all-leather affair, it didn't feature the distinctive rubber 'shell' toes until a few years later. Speaking of which – credit must be given where it is due – the rubber-toe concept originated in adidas' tennis department, where designers had been experimenting with reinforced panels on Tom Okker's and Wilhelm Bungert's signature models.

So where did our iconic Superstar spring from? A French adidas catalogue from 1968 includes the earliest glimpse of our future classic. Over in the handball and volleyball section you'll find the Supergrip updated with that familiar rubber toe. A year later in 1969, the Superstar finally debuted as an official model. adidas catalogues reveal that the presence of a honking rubber toe cap was barely noteworthy as a major feature. Rather, it was billed as an 'amazingly light' shoe for the best college and pro players with full-grain oxhide leather, padded tongues, arch support, nylon heel counters, excellent traction and a 'Softprotect' padded heel design.

1949: Trainingsstiefel

1955: Allround

1969: Pro Model (Leather Toe)

1969: Superstar OG

1975: Half Shell

1976: Superstar II

2001: Superstar Crystal

2001: Superstar Crepe

2002: Superstar Canvas

2002: Pro Model 2G

1965: Supergrip

1968: adidas Tennis

1970: Pro Model

1970: Wilhelm Bungert 'Wimbledon'

1979: Pro Model II

1983: Superstar (Made in France)

2002: Superstar Ripple

2002: Superstar CLR

2004: A3 Superstar Ultra

2006: Superstar Skate (Mark Gonzales)

Made in France

HARDWOOD AND
BACKBOARDS

The Superstar may have technically hit the court late in 1969, but 1970 is widely acknowledged as the shoe's official rookie year. It immediately set a new benchmark by which all other shoes would be judged. By the mid 70s, it was worn by something like 75 per cent of pros in the league, including Kareem Abdul-Jabbar, George Irvine, Rick Barry, George Gervin and Bob Verga.

Perplexingly, Superstars were strictly for the pros and were not freely available to the general public. Kids fiending for what was on the top players' feet were SOL, as team colours on the Three Stripes were reserved strictly for college-level and above athletes. The Superstar would therefore remain an unattainable vision for American sports fans in the very early 70s.

The same can be said in Germany, as the Superstar didn't make it to adidas' home market until 1972. Oddly, it's a French-made version of the shoe that takes centre stage from day one. At the time, France was a significant base of operations for adidas under Adi Dassler's enigmatic son, Horst. The Superstar would be made there for most of the decade, leading to random discoveries that delight Superstar collectors today.

As the dawn of the slam dunk arrived, basketball was changing rapidly and increasingly dynamic athletes justified a shift to more flamboyant footwear. adidas' sponsorship of the major league kept the pinnacle performance pieces coming, such as the patriotic Americana from 1971. Following the theory of natural evolution, the Superstar should have faded into graceful retirement, but its destiny had only just begun to unfold.

In 1974, the Half Shell made its debut, potentially the first quasi-official use of the term 'shell toe'. Spotted on feet in a handful of suede colourways, the Half Shell was frustratingly difficult to track down, as was its sibling, the Pro Model Half Shell. By 1976, the Superstar II appeared (not to be confused with the Superstar II from the 90s). Intended as a genuine attempt at technical progression, the Superstar II updated the franchise with Cangoran synthetic leather, a reinforced leather toe and a vulcanised sole application. A similarly updated Pro Model II arrived in 1976. As sequels go, let's just say neither of them lingered long. Are you confused yet? Just embrace the glorious minutiae and contradictions, because they keep coming thick and fast.

Photo: Focus on Sport/Getty Images

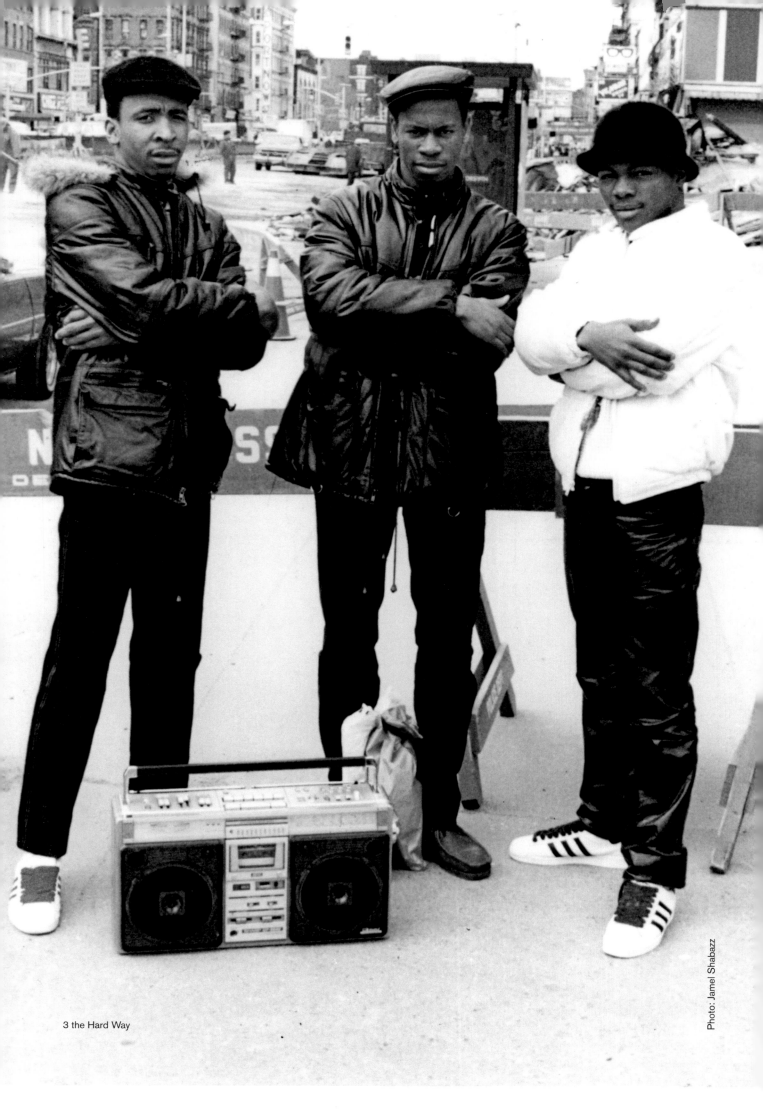

3 the Hard Way

Photo: Jamel Shabazz

1987: *Christmas Rap*

THE HIP HOP CONNECTION

At the end of the 70s, the Superstar and Pro Model were visible in catalogues with gold branding on foam tongues and the shoe's contemporary visage was starting to coalesce. adidas catalogues included a modified Superstar with both felt and leather stripes and a reconfigured shape with a more relaxed fit aimed at the American market. This 80s version is considered the definitive Superstar by purists. It's at this point that a nascent hip hop scene in NYC gravitated towards the silhouette based on the shoe's raw aesthetic and b-boy resilience. More crucially, adidas had prestige. The exotic otherworldliness of a European sportswear brand seemed to resonate harder than comparable American-made alternatives.

We can also assume that, despite some presumed usage of the nickname back in its basketball days, the Superstar truly becomes known as the 'Shelltoe' around this time. 'Shelltop' was another handle that had some currency, though whether that's born from a typo or a reference to the Pro Shell or Pro Model high-tops will never be known.

In the South Bronx, the pioneers and party starters of the era were wearing Superstars and giving them a street credibility that adidas never envisaged or actively encouraged. While the Pro Model was still billed in a 1981 catalogue as a basketball shoe, the Superstar was pushed into the Indoor Court category in favour of the Top Ten and Rebound models. Its sporting days were surely numbered, but it was about to take on a new life. The quest for the ultimate profile – in the form of the stance and attitude that defined b-boy style –

was seemingly ingrained in the Superstar. Paired with a set of juicy, fat laces, one of the definitive elements of hip hop's wardrobe was conceived.

Photographer Jamel Shabazz's snapshots of NYC street style in his *Back in the Days* book reveal the shoe's impact among the sheepskin and Cazal-wearing hood influencers of the time. A store window shot by Shabazz around 1983 reveals that the Superstar and Pro Model commanded a higher price than the Top Ten that had superseded both of them.

In black-on-white, blue-on-white, red-on-white, green-on-white and the all-time classic white-on-white, the Superstar flourished. Finding itself at the junction between New York's Downtown and Uptown districts, where cultures converged in the early 80s, the shoe was visible in promo shots for Charlie Ahearn's seminal art-meets-hip-hop collision, Wild Style. The tales of Run-DMC are well documented, but when the boys from Queens brought gold chains, leather goose down coats and unlaced Shelltoes together, it definitely forged a more authentic dress code for rap. They were even spotted on Madonna's feet complete with fat red laces, back when she was just a material girl with lofty ambitions and Futura's phone number in her black book.

Confirmation of the 'Shelltoe' nickname's visibility beyond the hood was present in the 1984 introduction of the Pro Shell, a new look for the Pro Model that merged the look of the Superstar with 1983's ankle-strapped Concord. Print ads at the time include the Superstar next to the freshly released Pro Shell with the tagline, 'The toe to know'.

RUN DMC

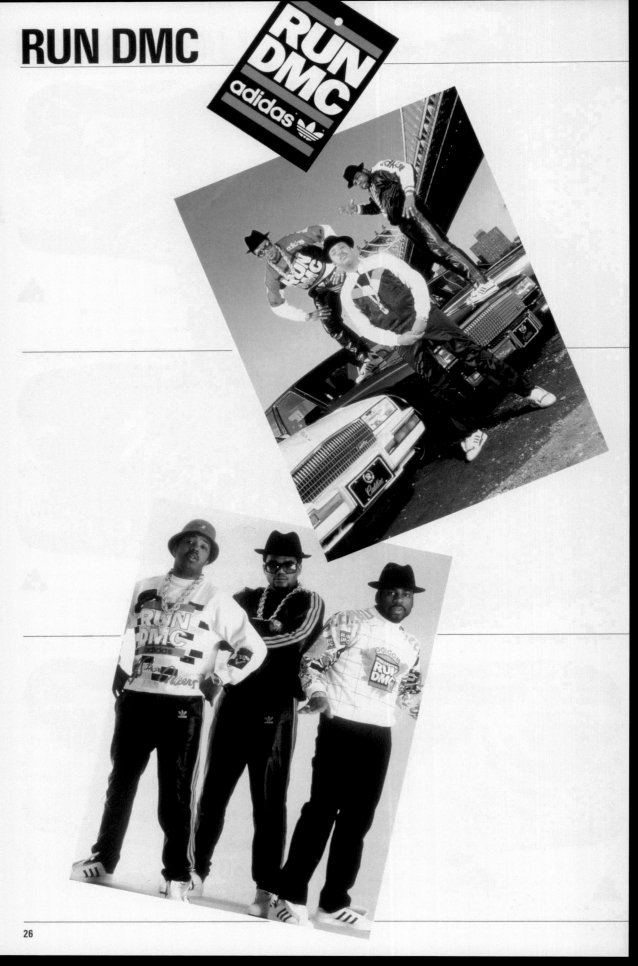

1988: Run-DMC x adidas Ultrastar catalogue (Japan)

26

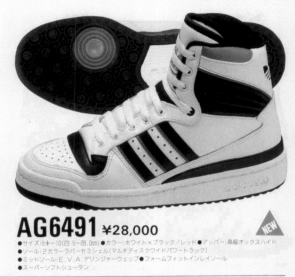

AG6491 ¥28,000

- サイズ:5½〜10(23.5〜28.0cm) ●カラー:ホワイト×ブラック／レッド ●アッパー:高級オックスハイド
- ソール:2カラーラバーセミシェル(マルチディスクワイドパワートラック)
- ミッドソール:E．V．A．デリンジャーウェッブ ●フォームフィットインレイソール
- スーパーソフトシュータン

AG6460
●カラー:ホワイト×ブラック

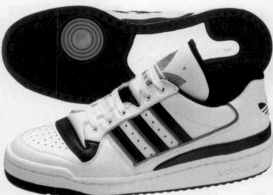

AG6525 ¥24,000

- サイズ:5½〜10(23.5〜28.0cm) ●カラー:ホワイト×ブラック／レッド ●アッパー:高級オックスハイド
- ソール:2カラーラバーセミシェル(マルチディスクワイドパワートラック)
- ミッドソール:E．V．A．デリンジャーウェッブ ●フォームフィットインレイソール
- スーパーソフトシュータン

AG6532
●カラー:ホワイト×レッド

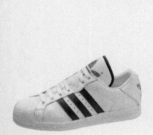

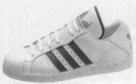

AG6185 ¥14,000
ウルトラスター

- サイズ:5〜10(23.0〜28.0cm) ●カラー:ホワイト×ブラック
- アッパー:高級オックスハイド
- ソール:スーパーパフォーマンス
- スーパーソフトシュータン

AG6587
●カラー:ホワイト×グリーン

AG6453
●カラー:ホワイト×レッド

27

R.I.P. JASON MIZELL
(JAM MASTER JAY)

January 21 1965–October 30 2002

ON OCTOBER 30TH, 2002, RUN-DMC'S JAM MASTER JAY
PASSED AWAY. TO MARK HIS CONTRIBUTION TO THE CULTURE AND
THE ENDURING POPULARITY OF SHOES WITH A SHELL, ADIDAS
RELEASED THE JMJ ULTRASTAR IN EARLY 2003, WITH PROCEEDS
DONATED TO THE JAM MASTER JAY FOUNDATION.

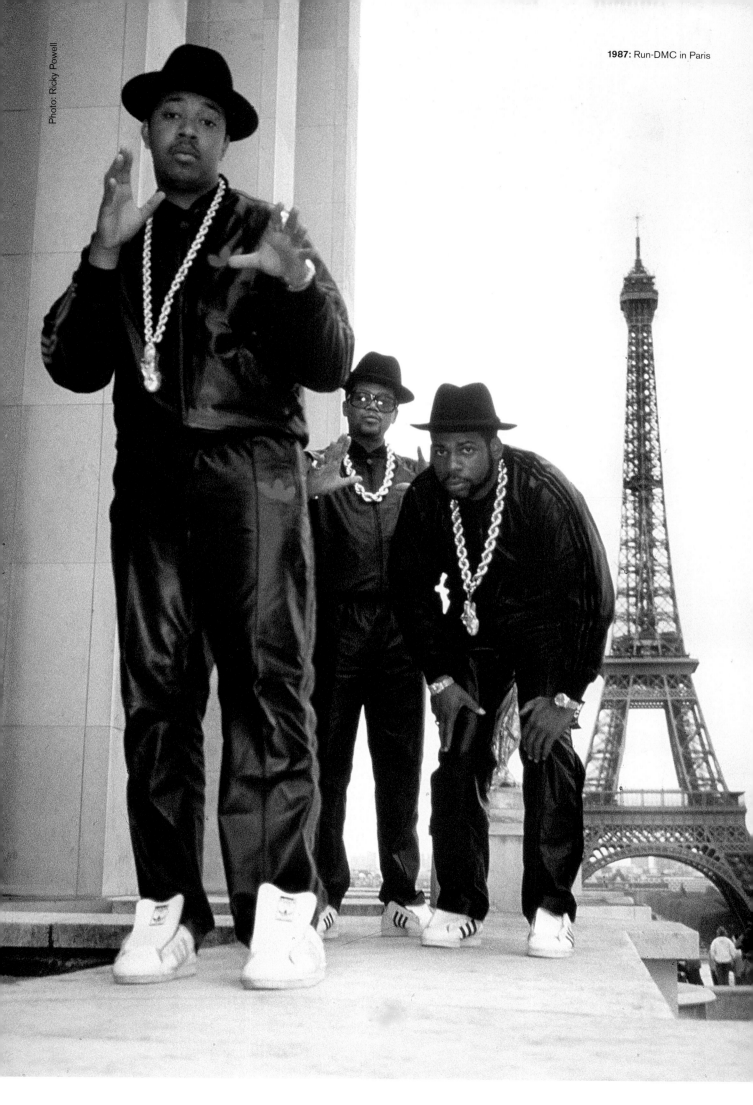

Photo: Ricky Powell

1987: Run-DMC in Paris

1983: Rock Steady!

Photo: Janette Beckman

586

Photo: Angelo Anastasio

Run-DMC concert at Madison Square Gardens

In Japan in the 1970s, the Superstar suffered from an eye-watering price tag due to its European-made status. By the early 80s, the price had blown out to butt-clenchingly bonkers levels. The Plaza Accord of 1985, where governments worked together to depreciate the US dollar, was important in allowing the shoe a little accessibility. As a result of the Accord, the retail price was slashed by over a third. Between 1981 and 1992, outside of the USA, Japan was the only market in which the Superstar survived.

Run-DMC's 1986 inclusion of 'My Adidas' on the bestselling *Raising Hell* LP, coupled with Russell Simmons' video demand to adidas for $1,000,000 and the subsequent Madison Square Garden call for fans to hold their adidas aloft, would result in a pioneering endorsement deal for the group. Beyond the corporate involvement, it would also assist in instigating a Three Stripe boom in Boston, a town that overnight became known for its love of the German brand.

The 1987 Christmas Rap compilation, with 'Christmas in Hollis' as the opener, makes graphic use of Superstars on its cover. A year later, adidas released the Ultrastar as part of the Run-DMC line, with an oversized Trefoil logo and elastic straps to make unlaced usage a little less treacherous.

When their *Tougher Than Leather* platter failed to hit quite as hard, Run-DMC's popularity dipped. It seemed logical that the next generation would grow tired of the Superstar and gravitate towards something a little more ostentatious. So that was the end of that, right? Not quite.

In California, as the West Coast streetwear scene blew up, the Superstar was remarkably still omnipresent as a signifier of laidback cool and an aspirational lifestyle. Influential 1988 advertising in the skate press included Superstars as part of Shawn Stussy's photocopied *mise-en-scène*. Over in Tokyo, otaku-like levels of sneaker collecting culture were already in place. Skaters, journalists and DJs like Hiroshi Fujiwara – always on the perpetual quest for authenticity – were hunting for French-made Superstars, especially in black leather with a white toe.

In London, rare groove club nights that would birth acid jazz created an escalating appetite for blunts, corduroy flares and 'old school' footwear as a clubbing staple. Duffer of St. George, London's trend-leaders and masters of capitalising on anything cool, made the most of it after a 1989 trip to New York, where they scooped up Superstars on sale for knockdown prices. Refreshed with a set of fat laces, they flew out at a significant mark-up from the Duffer's legendary Covent Garden store.

Opposite – 1993: Sofia Coppola outside the X-Large store New York City
Photo: Ricky Powell

1989: The first coloured Superstar stripes were introduced in 1978
but it took until 1989 for a black Superstar to arrive

2009: X-Large x adidas Originals Superstar 'Snakeskin'

DEADSTOCK CLASSIC

**What had been set in motion in the late 80s would escalate
in the early 90s. The 'old school' movement would career into
the mainstream with a vengeance and just as the Superstar
ceased its manufacture in France, it became an *objet d'art* to
the kind of people who love sweating the details. The shoe
would later be made everywhere from South Africa to Hungary
and Czechoslovakia.**

Music's love affair with the Superstar continued to flourish
and mutate. The Beastie Boys – original superstars themselves
– repped throwback adidas on the cover of 1992's *Check Your
Head*. The opening of the Mike D affiliated X-Large store in 1991
on Vermont Street, Los Angeles, would create the legend of
a mythological 'sneaker pimp' character sourcing deadstock
basketball and tennis classics. A shelf of heavily marked-up
European editions in the X-Large store was a shrine to their
passion. For the girls, the X-Girl spinoff with Sonic Youth's
Kim Gordon evened out the score.

London stores such as Soho's Passenger and Acupuncture
(a punk-inspired spot that harked back to Malcolm McLaren and
Vivienne Westwood) traded in resold Superstars, preferably
French-made specimens. American newspapers even ran ads
asking residents if they wanted to make some money selling attic-
found French-manufactured Superstars for up to $100 to Japanese
fanatics, who'd happily have paid four to five times that price.

In the early- to mid-90s, the Superstar II was born, followed by
the Pro Model II. With its relaxed girth and extra padding, it was
a bestseller in big chains globally throughout the decade and well
into the next. An early prototype of what would become known as
'adidas Originals' was created to respond to the appetite for classic
shoes with subtle tweaks for lifestyle appeal. Black Superstars with
white stripes and some other curiously appealing suede editions
for foreign markets appeared. In Japan, the steel-toed Safety series
included reinforced versions with American city names, taking the
forefoot protection aspect of the Superstar to its logical conclusion.

NIKE

We found this oddball Nike 'Shelltoe' close to a decade ago on a digging mission in Germany. At the time we figured it was a counterfeit, but it turns out this was a legit Nike release known as the Blazer Low!

ONITSUKA TIGER

Even Onitsuka Tiger got in on the Superstar hustle, producing their own rubber-toe model in the mid 80s.

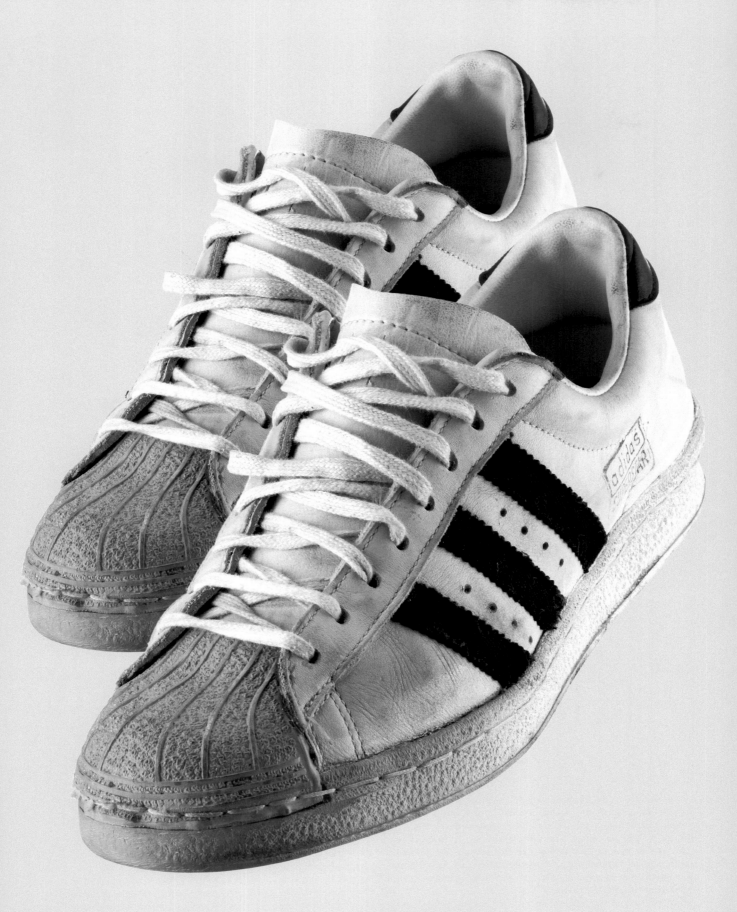

YELLOW TOES

Now for a spot of science. Literally. The original sole and toe of the Superstar was made from rubber injected with polyurethane. That meant the rubber was softer and non-marking, but clay fillers, calcium carbonate and magnesium carbonate meant that it would yellow in UV light, harden and crumble over time. Not so good for collectors, as anyone who has had a treasured pair dissolve on their feet or in the box can attest. Subsequently, a purer non-marking rubber was introduced to the Superstar shell in the early 90s.

First published *Sneaker Freaker* Issue 32 – January 2015

2006: Mark Gonzales Superstar Skate

FLIP-TRICK EVOLUTION

On the skate side, the flip trick evolution created new cult heroes. Despite the rise of skate-specific footwear brands and an anti-establishment mindset, the German-engineered Superstar became a skate-vid fixture. Voted one of the 'top 10 skate shoes of all time' in an early 2000s magazine feature, pros like Kareem Campbell, Keith Hufnagel, Carlos Kenner, Mike Carroll, Chris Hall (the shoe connoisseur's connoisseur) and Mark Gonzales skated in the Superstar and Pro Model.

By 1996, adidas was targeting the market more directly, running ads in the press featuring Josh Kalis. Signing Superstar-wearers like Gonz and Quim Cardona, the connection with skate culture was made contractual. The 1997 Originals catalogue, complete with a kickflip in motion on the cover, includes canvas and patent leather Superstars alongside the return of the Ultrastar. Oddities cropped up in the press too, like the radical double-tongued Canvas Super Modified version.

As hip hop split into two distinct schools, the throwback b-boy look represented a certain purity that was in stark contrast to the glossy new breed that was busy turning the culture into a billion dollar business. Puritans rocked the Shell, but even vets such as JAY-Z and Puff Daddy (pre-Diddy) wore the white-on-white Shells as a mark of respect for the shoe's cleanliness and its affinity with hustlers and MCs alike.

Love it or hate it, but the nu-metal x rap crossover of the era, fronted by bands like Limp Bizkit – itself an acknowledgment of the path trodden by Run-DMC's hip hop and rock experiments – made the Superstar a key element of the scene's uniform. Wallet chains, six-inch goatees and oversize workwear were optional accessories.

As the 90s drew to a close, the Superstar's aura remained strong. The Superstar Metal (never one for the purists) arrived with gleaming eyelets, and a variation with lace jewels was upgraded as the mid-priced Superstar Supreme and Millennium Supreme. For a Y2K crossover into a new century, the fact that something from 1969 was still hitting buckets is indicative of some serious stamina.

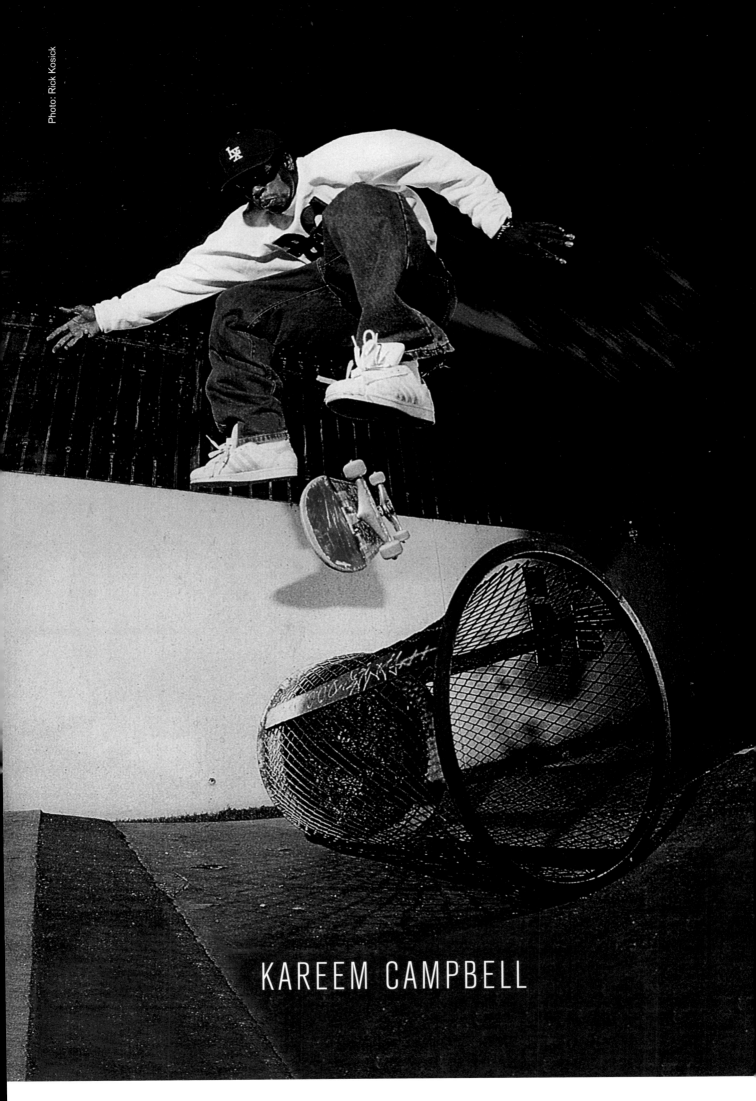

Photo: Rick Kosick

KAREEM CAMPBELL

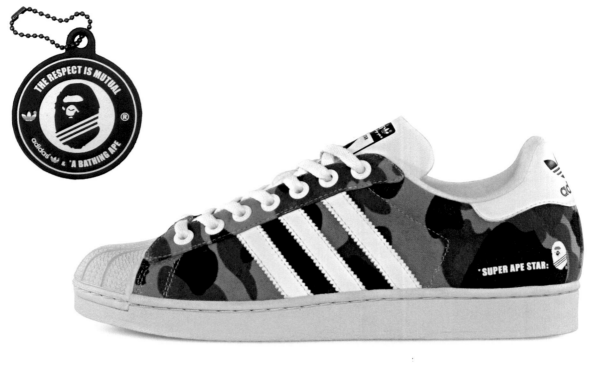

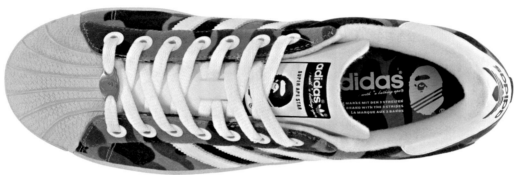

2003: BAPE x Super Ape Star

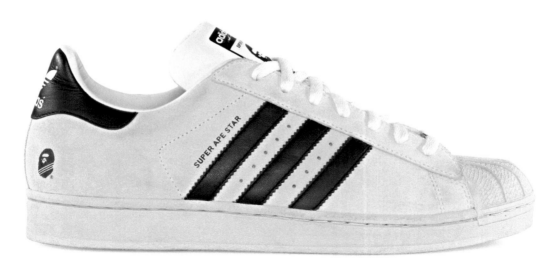

2003: BAPE x Super Ape Star

1994: Hiroshi Fujiwara's album cover featured his white on black Superstars, inspiring the next generation of Japanese streetwear

THE RESPECT IS MUTUAL

By this point, it is probably safe to confer icon status on the Superstar. But with sneaker collector culture expanding beyond a small group of diehards into a globalised digital community, the obsession with retro sneakers meant that your uncle's favourite foot accessory was suddenly your generation's fresh obsession. Noting that a cult had become a force to be reckoned with, adidas released Superstar IIs with snake stripes in white and an even scarcer black colourway alongside a red and blue striped tribute to the Americana model.

In 2001, adidas Originals was officially launched as a division. The opening of the first Originals flagship store in Berlin was duly celebrated with a limited edition of Crystal Superstars. A Lux Superstar and crepe sole edition with leather toes gave the model a semblance of upmarket formality. On court, the Superstar 2G and Pro Model 2G became the shoes of choice for future legends during their high school days. Frequently name-checked by athletes for its formidable comfort, the Superstar 2G is considered one of the finest hoops shoes of the period. In 2004, the A3 Superstar Ultra built on the legacy, but was barely recognisable as the Shelltoe's offspring.

On October 30, 2002, Run-DMC's Jam Master Jay passed away. To mark his contribution to the culture and the enduring popularity of shoes with a shell, adidas released the JMJ Ultrastar in early 2003, with proceeds donated to the Jam Master Jay Foundation for Music.

As a pivotal part of Tokyo's Urahara movement, Nigo understood the power of the Superstar well before he launched his A Bathing Ape brand in 1993. Ten years later, Nigo's introduction to adidas via Ian Brown (Stone Roses) and Kazuki Kuraishi (who eventually launched his own adidas ObyO range) led to the development of the adidas and A Bathing Ape collaboration. Premium materials, custom packaging, careful marketing and super low numbers made this a restorative affair. Following Nigo's keen eye for what made the shoe great, the Super Ape Star used the original chrome leather rather than the tumbled leather popular at the time. He also raised the heel and added a vanilla dye in the rubber formula to reproduce the yellowed effect of a vintage pair.

Sold via select stockists worldwide, the shoes ignited overnight queues and a dreaded resell rate for those who weren't willing to sleep rough or set their alarms. With the project slogan, 'The respect is mutual', the release remains pure in its organic creation, meticulous in execution (a hallmark of Nigo and a nod to adi's German origins) and an expression of genuine fandom from both parties. This was less a business model and more a love letter to a masterpiece.

A careful drip-feed followed. The Superstar Skate with a wider tongue, thicker padding and 'Soft Cell' heel cushioning appeared in 2006. The fabled Half Shell would also get a reissue and with adidas Skateboarding getting a bigger push under the Originals banner, Mark Gonzales finally got his own Superstar. A vulcanised version arrived later in the decade.

2005: Upper Playground

2005: Footpatrol

2005: Union

2005: Rocafella Records

2005: Underworld

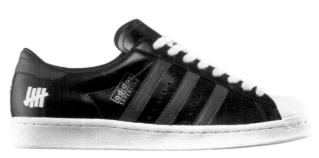

2005: UNDFTD

SUPERSTAR #35

With the Superstar throbbing on multiple fronts, it was clear to adidas that an impending anniversary year for a flagship shoe would be an opportunity to make an even bolder statement. Marking the 35th anniversary of the Superstar (on the principle that it actually hit the market in 1970), the ambitious SS35 programme was unleashed: 35 years = 35 shoes. It began with fanatics queuing outside a handful of boutiques on December 31, 2004. While the city was in full revelry mode, the midnight chime signaled the sale of the Consortium collection, a pioneering combination of top-tier doors given free reign to rework an accurate remake of the original known as the Superstar Vintage.

Built to the original specs through dissection and trial and error, it was limited to just a few hundred pairs of each design. It made sense that the #1 had to be Adi Dassler himself, with his face on the heel a reproduction of a true adidas original. London's Footpatrol, Hamburg's Tate, LA's Undefeated, New York's Union, Tokyo's Neighborhood and Hong Kong's D-Mop led the way. It's notable that several partners opted to use the contrast-toe effect beloved of skaters, b-boys and Japanese collectors decades prior.

A project of this stature needs a fitting finale, and Superstar #35 was the cherry on top and the rarest of them all. Handmade entirely from sumptuous leather, right down to the shelltoe and even the outsole, the shoe was presented in a huge white case with gold-plated hardware and an equally plush cleaning kit. Made in minuscule quantities and used as a prize in treasure hunts globally, it was a luxury celebration of a unique and innovative concept that would serve as the foundation and inspiration for the next decade of sneaker culture. It was also a migraine for anyone who'd spent the last few months frantically amassing the other 34 editions.

More than a decade later, it's still an oft-imitated way to kick off a shoe anniversary. SS35 was unique, almost disorientating in its vast scale, with hype blogs still in their infant stages, and no Twitter or Instagram to deliver a compelling minute-by-minute heads-up.

In 2008, adidas Originals released a missing piece of the Superstar story, a reproduction of the French-made 1980s shape called, fittingly, Superstar 80s. CLOT, FTC, Alife and Kazuki Kuraishi partnered up for more idiosyncratic interpretations, proving once again that the Superstar was not yet done and dusted.

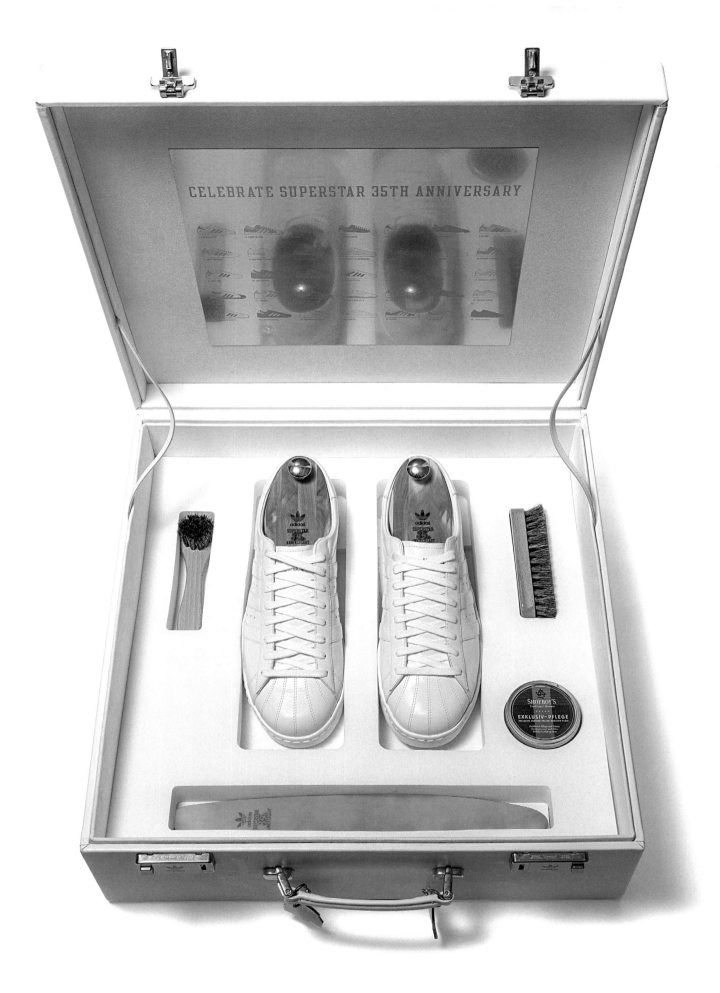

2005: Superstar #35 was handmade entirely from sumptuous leather, right down to the shelltoe and the outsole. The shoe was presented in a huge white case with gold-plated hardware and an equally plush cleaning kit.

2015: Pharrell Williams x Superstar 'Supercolor'

2017: BAPE x Neighborhood x Superstar Boost

LONG LIVE THE SUPERSTAR

Following a brief period when the Superstar was relegated to the pine for a well-earned sabbatical, adidas bounced back in the early 2010s with a reinvigorated approach to their corporate treasure. Consortium colabs with BAPE, Footpatrol, Neighborhood and Union reprised the SS35 glory days, with premium materials and grown-up vibes taking centre stage once again.

Looking after the younger and more experimental customer, camouflage patterns, chrome toes, precious metals, Primeknit, Kevlar, Xeno technology and good old-fashioned white leather kept the creativity flowing as the Superstar continued its mighty morphing mission. Licensed hookups with Kermit, Stormtroopers and Darth Vader added extra layers of pop culture cachet to the youthful mix.

In 2015, adidas delivered the 'Supercolor' pack in conjunction with superstar songwriter Pharrell Williams. The ambitious project showcased 50 colours for every mood and outfit. It was an outlandish success that maintained the Superstar's street-level relevance.

Consistent with the Superstar's evolutionary trajectory, hybrid offshoots offered new spins on the classic silhouette. The Superstar Slip-On and Superstar Bold arrived for ladies with streamlined no-lace uppers and jacked-up midsoles respectively. In early 2017, adidas added BOOST cushioning to the Superstar in an attempt to bring their past and present together into one irresistible package. The unfortunate design looked like BOOST was oozing out from the instep, though that didn't stop White Mountaineering and Neighborhood from releasing their own tweaked versions.

Everything runs in cycles, but even with the dozens of Superstar variations made, the countless countries of origin and the myriad collaborations released over the years, there's still a thousand Superstar tales to be told. Is there an argument for declaring this to be the greatest sneaker design of all time? Absolutely. It's not just the numbers shifted or the chatter of digital traffic that counts, it's about the profound impact one simple shoe can have across multiple generations.

•

Vans

Published in *Sneaker Freaker* Issue 6, June 2005

EDITOR'S NOTE: WOODY

All the credit goes to Jason Le for this expansive interview with Steve Van Doren. Published in *Sneaker Freaker* Issue 6, Jason captured Steve's avuncular bonhomie and lyrical gift. If the Van Doren name sounds familiar, it's because Steve's father Paul started Vans in 1966. After a lifetime spent on the shop floor and the Vans factory cooking up one-off custom shoes, Steve knows the legendary So-Cal brand from the inside out. Humble, humorous and refreshingly honest, this is a rich and detailed exposition of the Van Doren legacy.

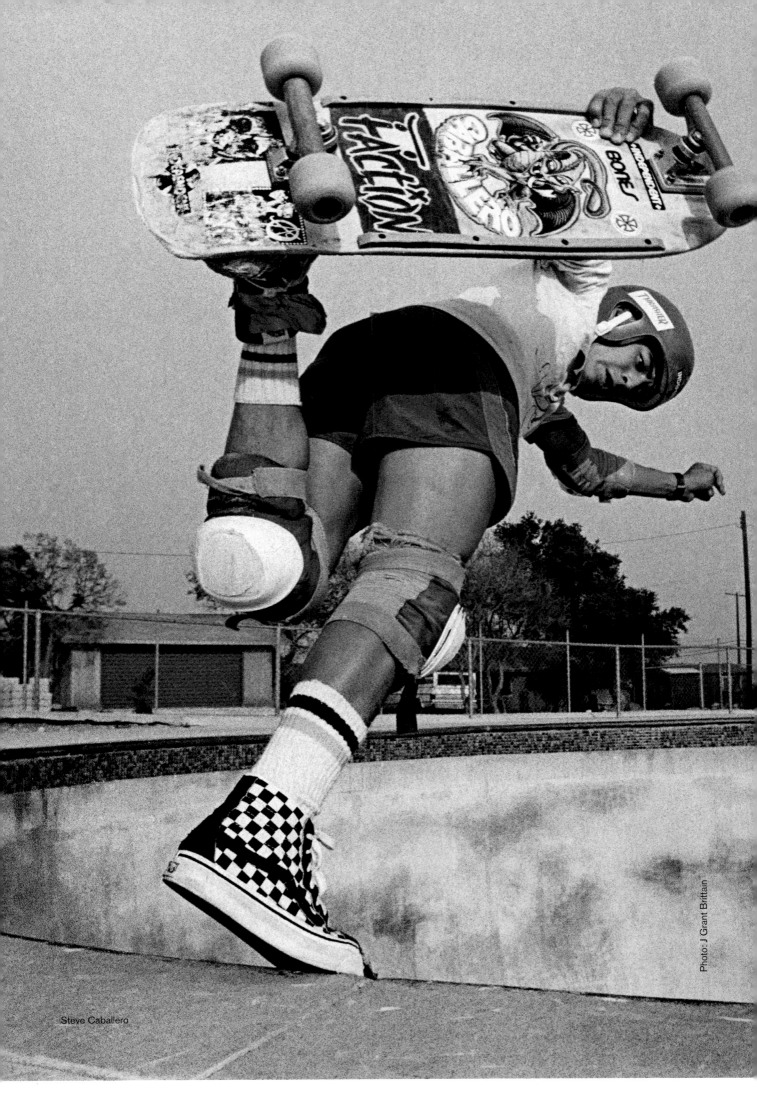

Steve Caballero

Photo: J Grant Brittain

I've found there are two common ways people remember Southern California. One is tales of traffic snarls, tourist traps, fast food and Disneyland. The other is Hollywood, Rodeo Drive and cosmetic enhancements. For me, it's always been the simple, everyday icons the locals have grown up with and take for granted: endless sunshine, double doubles (animal style) and Wahoo's Fish Tacos. These were the happy thoughts I had in my head as I strolled down Flinders Street in Melbourne on the way to learn more about another SoCal legend – the sneaker company known as Vans. I was about to interview Steve Van Doren, whose father co-founded the company in 1966. Having spent most of his life immersed in the business, this was a history lesson straight from the horse's mouth.

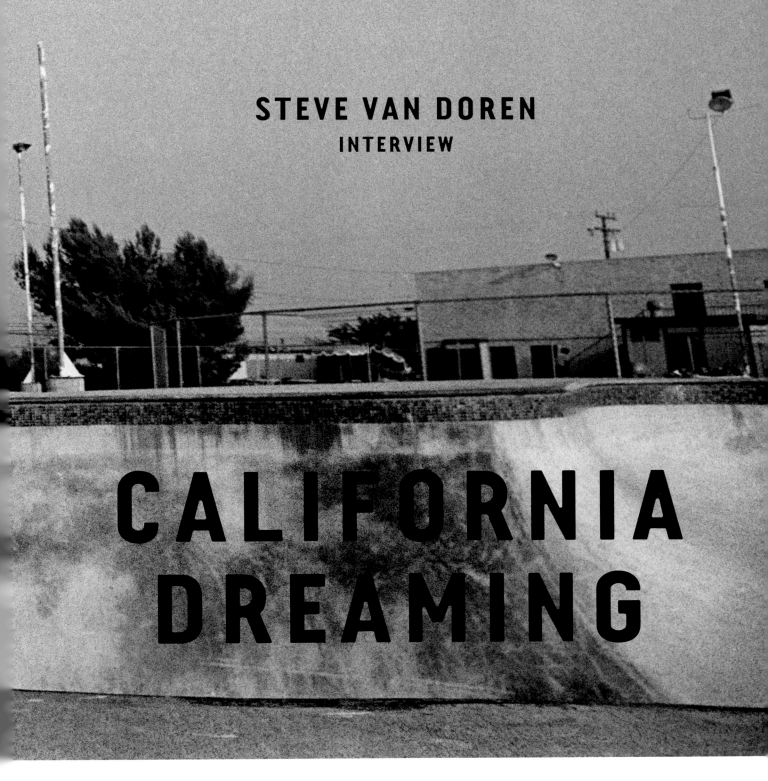

STEVE VAN DOREN
INTERVIEW

CALIFORNIA DREAMING

1966: Paul Van Doren, Jim Van Doren, Gordon Lee and Gordon's son Butch cut cake to celebrate opening day of the first Vans factory

1966: THE BIRTH OF THE VAN DOREN RUBBER COMPANY

Paul Van Doren was born in 1930 and grew up in the Boston area. When he reached the eighth grade, he realised he didn't like school and promptly left. He had a passion for horses and at age 14 he made his way to the race track where he was known as 'Dutch the Clutch'. For a buck he would give you odds on the race. Paul's mother couldn't stand the fact her son wasn't working or going to school. She dragged him into the shoe factory where she worked and got him a job sweeping the factory floor. This was to define the young Paul Van Doren's future.

1966: The first Vans factory and store at 704 East Broadway in Anaheim, California

In 20 years, Paul worked his way up the ranks to become vice president at Randy's, a Boston-based shoe manufacturer. Randy's was well known at the time and made canvas shoes for Bob Cousy, the flashy Boston Celtics legend who was later voted one of the top 50 NBA players of all time.

During the early 60s, Randy's had become the third-largest manufacturer of shoes in the US. But they had a factory in Gardenvale, California, that was losing a million dollars a month. Paul Van Doren, his brother Jim Van Doren, and longtime friend Gordon Lee were given the task of straightening out the factory. After eight months, they turned the West Coast factory around and it was doing better than the one back in Boston.

Three months later, Paul Van Doren sat his five kids down and announced he was quitting his job to start a new shoe company. 'Don't worry, we're going to be fine!' he said to his children, who weren't at all concerned. Their dad was fanatical about cleaning and they were hoping this meant they only had to wash his car every second day instead of every day.

Paul had been making shoes for most of his life and the most he ever saw the company make was a dime a pair – and they were making hundreds of thousands of shoes. Van Doren knew the retailer was the one making all the cash. His dream was to have his own factory and his own retail stores. He was a great businessman, his brother Jim was an amazing engineer and their friend Gordon was an excellent manufacturing manager. Together they formed the Van Doren Rubber Company with Serge D'Elia who had been supplying shoe uppers from Japan to the US.

The company was formed with Paul and Serge owning 40 per cent each, and Jim and Gordon owning 10 per cent each. It took a year to set up the factory at 704 East Broadway in Anaheim. It was built from scratch using old machinery they bought from all over the US. Since 1900, there had been only three companies that had manufactured vulcanised footwear in the US: Randy's, Keds and Converse. Now there was Vans.

1974: Paul Van Doren

So when did Vans open the doors for business?
Well, they were building the factory throughout 1965 and they had 'Opening January!' painted on the front, but it wasn't ready. This was the year of Maxwell Smart and *Get Smart*, so they had 'Would you believe February?' added to the sign. It actually opened, I believe, on the first day of March, 1966. The factory, the office and the retail store were all located at 704 East Broadway.

The way they had the company set up was unique at the time. How did it all work?
The very first day my dad had probably 10 racks with empty boxes on them. Blue boxes were for men, orange boxes were for boys, red boxes were for kids and green boxes were for women. My dad was always a systems guy. If you're looking for men's shoes, they were in the blue boxes, so you don't have to go any further than that.

The first day they open the doors, 16 people came in and they had a sample of all the styles. We didn't even have names, we had numbers. Style #44 was our authentic deck shoe. In the #44, my dad had navy blue, white, loden green and red. We didn't have black at first – it became our bestseller in later years.

The women's styles for Vans were smaller styles in the same deck shoes. We had a lace-up, we had a two eyelet, we had a slip-on and the styles were called #16, #19 and style #20 respectively. Then we had a leather deck shoe, a leather boat shoe, style #46, and a canvas boat shoe, style #45. These were the original styles with children's shoes called style #15. The original price on the shoes was $2.29 for women and #44s were $4.49.

My dad had never been in retail before, so it was new for him. He could basically look at your foot and say, 'Hey you're eight and a half!' so they had a shtick to make the customers feel good. They would then find out what style they wanted and what colour they wanted. Basically, those first 16 pairs had to be made that day, and the customers came back the next day to pick up their shoes, just because they wanted to get open so quick. They started filling the boxes in the store and by the third or fourth day they had filled them in.

How did the idea of making custom shoes come about?
One day a lady came in and said, 'That's a nice pink but I really want a brighter pink!' and then she picked up the yellow shoe and said, 'That's a nice yellow but it really is too light!' My dad thought to himself, 'For crying out loud, I can't afford to carry five different colours of pink. So he said, 'Lady, why don't you get a piece of fabric, whatever colour pink you want, bring it back and I'll make a shoe for you.' So it was almost the first day that they started charging extra to do custom shoes.

In the 60s, we had Catholic schools and made shoes out of their plaid uniforms. Plus we were making shoes for all the cheerleaders and drill teams all over Southern California. It was a big business for Vans.

What was the original design concept for the Vans #44 shoe?
Similar to what my dad had made before. He was too cheap to spend on marketing and his whole concept was to make, with my uncle Jim, the moulds for the waffle soles twice as thick as PF Flyers, thicker than any shoe out there. We used ten-duck canvas, which is really strong. We'd use nylon thread instead of cotton and the compound was pure crepe rubber on the outsole, so it was going to outlast anything. My dad's whole philosophy was to make shoes like Sherman tanks, they were really built tough and you'd have to tell your friends about it. We had a sign from the very first day: 'Tell a friend about Vans', and the marketing was my family and me passing out flyers. We did our very first store outside of the Anaheim area in Costa Mesa where we lived. The first manager was my mother.

So from that one store, how many did you grow into?
We opened 10 stores in 10 weeks! Within the first year and a half we had 50. My dad's accountant, who was there for 24 years, said, 'Paul, six of those 10 stores are losers.' My dad says, 'Well, I need 10 more losers then!' because his whole thing was if he made one pair of shoes and it cost him $10,000 for all the manufacturing, it was $10,000 a pair. If he made 1000 pairs it was costing him $10 a pair. If he was making 10,000 pairs it only cost him a dollar.

In the 70s I remember going to San Francisco. My uncle was on the sales side and had moved from Boston, so there was always lots of family involved. He moved up to the Bay Area and put in 13 stores. In 1973 we were stretched too far and the San Francisco stores were bleeding the company dry. At one point we decided to close them down; people knew Vans and they liked them, but it was

2005: Steve Van Doren

costing too much. So he stayed and started selling shoes to places like the Oliver Bike Shop and that's how national sales started in the early 70s. It was the first time we had sold shoes outside of Southern California.

When did the company realise skateboarders loved the brand?
Santa Monica and Manhattan Beach are where they started coming in and making custom shoes. In the very beginning we sold tons of the #44 blue deck shoes. Then the custom orders started coming in. We let that run for a few months then we came up with a stock shoe: navy blue and gold, navy blue and brown, then beige and brown. We would watch the custom orders come in and make them brown, beige and brown if everybody ordered customs in those colours. You had school colours, team colours, skaters and BMX kids who came in the late 70s and those guys really liked the wild colours.

There was no leather around until 1976 when we finally came up with the Old Skool, which had leather in the toe and heel because skaters were wearing the hell out of them. Leather would last longer than anything else. The outsole never wore out, the side wall of the material would never wear out, and they could get it down to where there was just a little bit of fabric but the sides would still be good.

Was the Sk8-Hi the first shoe Vans made specifically for skaters?
In 1975 we had the blue deck shoes, but the guys over in Santa Monica, like Tony Alva and Stacy Peralta, wanted to make customs. We decided to add padded backs, an outside heel counter and the 'Off the Wall' label, and that was our new skate shoe. It came out on March 18, 1976. The Sk8-Hi had padded sides so when the board flew off the pool and into their ankles they didn't kill themselves. That was a big thing and it saved lives – skaters loved them.

At the time, did you think skateboarding was just a phase?
It seemed big because so many of these kids started organising contests. I remember my dad had no budget, so I was driving a van bringing guys from the Valley over to a contest in Santa Monica. Tony Alva and those guys, the board companies looked after them, and we supplied shoes. The first cheque we ever wrote was to Stacy Peralta; I think we were paying him about $300 to wear the shoe and he was travelling worldwide. Each store manager

had seven or eight guys they were supplying shoes to as well. We got our first team manager, Eric, in about 1977. He had a van and a Plexiglass ramp and he would travel around doing demos and make sure the guys got their shoes. Kids were buying whatever they saw in the skate magazines.

Where did the Slip-On design come from?
The company my dad worked for before made a slip-on and he interpreted that into our own style known as #48. It was actually a generic model with a non-skid sole for boating.

The checkerboard Slip-On is probably the most recognised of all Vans styles. How did they come about?
In the late 70s I was just out of high school. I noticed kids were colouring in their Vans with a checkerboard pattern, so we started making shoes like that. We sent a box of checkerboard shoes for the movie *Fast Times at Ridgemont High*. We had no idea! They liked them so much they ended up on the cover of the film's soundtrack. And Jeff Spicoli, played by Sean Penn, was hitting himself over the head with the shoes in the movie! It was magic – we sold millions of checkerboards after the film came out!

How many times have you seen the movie?
At least 50. Doing the film *Dogtown* I got to meet Sean Penn years later. It was really enjoyable getting to say, 'Thank you so much for being Spicoli, you made my life a lot easier!'

Has anyone ordered a pizza in the middle of a sales meeting?
The theme of sales meetings a few years back was *Fast Times*. Everything was checkerboard and I ordered 10 pizzas and asked them to just barge in the middle of the meeting and bring the pizzas right up the front. It was great because after my dad left, sometimes the company may have been a little too stuffy. You know suits and ties and stuff. It was perfect and I'm bit of a prankster.

What else do you think added to Vans' success?
The thing about Vans is that we had a run from 1976 to 1980 with all the two-tone colours and that rolled into solid-colour Slip-Ons and then straight into checkerboard. We didn't rest on our laurels.

Old Skool

Old Skool Hi 'Checkerboard'

Old Skool Hi

Style 95

1979: Off The Wall

We started doing red and white, green and white, two-tones, any kind of combination, because again, we only had a vulcanised shoe. We don't have what Nike has – all kinds of athletic stuff. We had a canvas shoe and we're trying to make it look like a marquee diamond. So how do we do that? With colours and fabrics.

We also used to get kids to draw up what they would like to see on the sides of the shoes. Every month we'd pick a winner, bring them down to the factory and take their family to Disneyland. All of a sudden we had things that had 'Rad' on them, plus we had unicorns and rainbows. When you get 200 designs with strawberries, we'd do a strawberry shoe. So that's how we would do it and having our own factory, I could have a new shoe out tomorrow.

Have you ever thought about resurrecting those contests?
I'm proud to say, at least in the States, that we've brought back our custom shoe programme and it's going sensationally. We do about 2000 pairs every month.

We talked about possibly putting a page in a book with just a silhouette of the Slip-On and let kids develop patterns or designs they want and have a worldwide contest for our 40th anniversary. We will actually print the fabric, make the shoes and maybe make 500 pairs and give a royalty to the young person who designed the fabric.

During the early 80s, Vans diversified and started making basketball shoes, baseball shoes and then had that little Chapter 11 thing. What happened?
What happened was that my dad, who was a great manufacturer and a great business person, was trying to back off just a little bit. Checkerboard was flying, Vans was going great, my uncle Jim was president and he was doing a magnificent job, but he made a mistake trying to be something that Vans is not. He wanted to be Nike, you know, the next big thing.

Jim was very talented. We had a five-star running shoe in *Runner's World*. We had widths from 4E to 4A, wide to narrow in every one of the athletic shoes we had. We had basketball, baseball, soccer, tennis, skydiving shoes, wrestling shoes. I mean, we had breakdancing shoes! They weren't vulcanised, they were cold cure which was all made overseas. We were making really nice shoes but my dad kept telling my uncle, 'Hey, they're costing us a fortune and we're losing our butt!'

My uncle wouldn't listen because, you know, he guided Vans through the checkerboard era and we were flying. We were the hottest thing going. All the money we were making on checkerboard, we were wasting it on all of these lasts, dyes, materials, everything you could imagine on these athletic shoes. And it wasn't selling. People don't know Vans for that. You got big powerhouses like adidas, Nike and PUMA and we were just getting our butts kicked on the athletic shoes.

Well, eventually the bank – we had a note like when your house is mortgaged – they called up and said, 'Hey, pay my note back!' and we couldn't do it. We didn't have $11 million. So we filed for Chapter 11, my dad went to court for the first time, and the court saw what was happening and asked my uncle to leave. That was a very sad day. My dad didn't know if they were going to ask us or my uncle's side of the family to leave. The courts sorted it out and from that day my uncle has not been involved with the company. They asked my father to come out of semi-retirement, with Gordy's help and Serge as a silent partner, to get Vans out of trouble.

In 1984, my dad got the whole company together and told them, 'Hey, if you need a raise in the next three years I can't give it to you. We owe probably $15 million. I'm going to pay this back 100 cents on the dollar.' My dad was very proud of what he built. A lot of people get out of Chapter 11 by paying 10 cents on the dollar and it costs millions in legal fees. He said no to that.

So we had a plan. It started in 1984 and every six weeks my dad would go in with a business plan. He'd come back and say, 'This is what we sold, this is what we are going to sell' and he did that every six weeks. At one point he had an extra seven or eight payments and told the bank he wanted to give it to them in case something slowed down. The bank said no but they could take it from the back end. Dad at that point had a piece of land and sold it and the next week he paid the bank fully. He wanted to pay the last $50,000 in pennies but found out he would need a dump truck. He hated them because they were trying to liquidate us at every second. One thing about surviving Chapter 11, I realised that everything my dad ever had in his life, he was this close to losing it, and that wasn't fair.

They sound like tough times. What got you through?
It was back to the classics. We didn't advertise one penny from 1984 to 87 and that's when companies like Vision Street Wear

HI-POWERED HI-TOPS!

Listen to what Stacy Peralta is saying about Van's:

"You know what you need to stay on top. You need traction, fit, and comfort. Van's knows what you need too, and that's why the latest Off the Wall is the Hi-Powered Hi-Top."

Van's style #38 is the newest in the "Off the Wall" collection of super skateboard footwear. It's our highest Hi-Top ever, with extra cushioning and support in the ankle and arch...right where it counts. The new toe ventilation keeps you cool, and the leather heel, toe, tongue, and eye stays assure long wear and durability. Van's exclusive waffle design sole is constructed with

the super grip built right in. When you're skating, you can feel the difference...the difference that makes you a champ.

And now, you can get the same great "Off the Wall" dependability in Van's new slip-on. As you try on a pair of these new Van's...

VAN DOREN RUBBER COMPANY
704 E. Broadway
Anaheim, California 92805
(714) 772-8270

Dealer Inquiries Invited (except in Southern California)
Suggested Retail Prices: #38: $29.95, #98: $19.95

VANS
HANDCRAFTED AMERICAN-MADE ATHLETIC FOOTWEAR

1980: Stacy Peralta

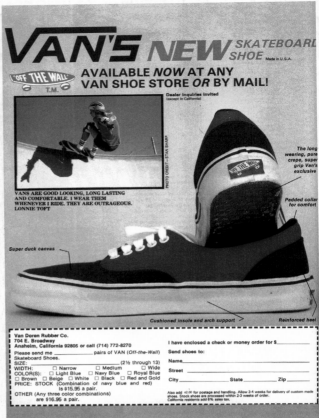

VAN'S NEW SKATEBOARD SHOE Made in U.S.A.

"OFF THE WALL" T.M.

AVAILABLE NOW AT ANY VAN SHOE STORE OR BY MAIL!

Dealer Inquiries Invited (except in California)

PHOTO CREDIT—STAN SHARP

VANS ARE GOOD LOOKING, LONG LASTING AND COMFORTABLE. I WEAR THEM WHENEVER I RIDE. THEY ARE OUTRAGEOUS.
LONNIE TOFT

Super duck canvas

The long wearing, pure crepe, super grip Van's exclusive

Padded collar for comfort

Cushioned insole and arch support

Reinforced heel

Van Doren Rubber Co.
704 E. Broadway
Anaheim, California 92805 or call (714) 772-8270

Please send me _____ pairs of VAN (Off-the-Wall) Skateboard Shoes.
SIZE: _____ (2½ through 13)
WIDTH: ☐ Narrow ☐ Medium ☐ Wide
COLOR(S): ☐ Light Blue ☐ Navy Blue ☐ Royal Blue
☐ Brown ☐ Beige ☐ White ☐ Black ☐ Red and Gold
PRICE: STOCK (Combination of navy blue and red) is $15.95 a pair.
OTHER (Any three color combinations) are $16.95 a pair.

I have enclosed a check or money order for $ _____
Send shoes to:
Name _____
Street _____
City _____ State _____ Zip _____

Also add $2.00 for postage and handling. Allow 3-4 weeks for delivery of custom made shoes. Stock shoes are processed within 2-3 weeks of order. California residents add 6% sales tax.

1978: Skateboard Shoe

came through. They started to advertise heavily and we couldn't do anything except just let them go. We couldn't pay skaters or anybody else to wear our shoes. All we could do was give some shoes away. Basically, we just put blinkers on and just tried to get the money paid back. In 1987, we finally came out of Chapter 11.

You had an ownership change at the end of the 80s and sold some shares at the start of the 90s. Was it the corporate changes that forced the end of manufacturing in the US?
In 1988, these men offered my dad $75 million for the company. He didn't owe a penny at the time. With my uncle not involved anymore, there were politics and we'd never had that in the company before. Dad didn't want to see that happening in the future and he called me up to play tennis. He didn't play tennis and he said, 'What would you say if I told you someone offered $75 million for the company?' I said, 'Sell, you're ready to retire, enjoy life. Whatever happens, I'll be fine.'

What happened was Black Monday. One of the last deals Michael Wilkin (a famous investor who went to jail) did was Vans. It was 1987 and the market fell and that messed up the deal. It was meant to happen again in December the same year but the market fell again. The deal actually happened in 1988 for $60 million. The promise was when they went public they would pay my dad the rest of the $15 million.

So in 1988 the deal went through and McConval-Deluit bought the company. The two men behind it acquire companies, grow them and take them public. They owned the company for about the next 10 years. They took Vans public in 1991 and we were a public company until 2004.

From 1988 to 1993 everything was going fine. Then things started slowing down a bit. We started buying snowboard boots from overseas and by 1994 we were sourcing everything overseas and people forgot about our classics. Trends happen, but, you know, we just went away from it for way too long.

We had a factory in Orange County and when we were public we started getting new management in. They went and built another factory in San Diego, all high-tech and stuff that my dad knew for 50 years wasn't good enough. Dad was gone, and these Harvard graduates thought they knew more and they went and spent a ton

of money on a factory that never, ever made the volumes or ran with the efficiency that the old factory did. They screwed it up. That was the point where they shut down all manufacturing and moved everything offshore.

There was also demand for new types of shoes and we couldn't do them in California for environmental reasons. We couldn't do the shoes our competitors were doing. So we changed the direction of the company from manufacturing to marketing.

The 90s arrived and Vans were getting involved with the Warped tour and skate events – what was driving that?
A guy named Kevin Lyman came to us. I said I wanted to do a skateboard contest nationwide and Kevin said his music tour was going nationwide as well. So we came up with the Vans Warp Tour. Well it was the 'Warped Tour' in year one and then the 'Vans Warp Tour' in year two.

Kevin was a hardworking guy but never had the money so we bought 15 per cent. A company bought the tour during the dot.com era, but a year later they went out of business. We got it back for a dollar, now we're the majority owner of it and it continues to go strong.

I think it's one of the best things we have ever done. Basically Vans is a company that sells to teenagers – 65 per cent male and 35 per cent female. What did a teenager do before he was 16 and could drive? He skateboards, surfs and rides bikes. Then he finds the sheilas and needs a car to go do stuff. But both boys and girls like music, so we tied ourselves into a punk rock scene because a lot of the guys that were in bands loved Vans.

Next we decided to do some skate events. At first I tied in with the Hard Rock Café and Transworld and did the Triple Crown. We made a deal with NBC that we won't do horse racing, but we'd like to do a triple crown for skateboarding, surfing, snowboarding, wakeboarding, BMX, freestyle motorcross and supercross. So for the last eight years we have done 20 events.

The first event we did was in 1995 at the Hard Rock Café in Newport Beach. There were 11,000 people. Ben Harper played and Tony Hawk won the skate event. There was an existing Triple Crown of surfing, so we bought that for a good sum of money in 1996. That was the second Triple Crown and the third one was the Triple Crown of snowboarding. Then we did BMX, wakeboarding and so on.

1984: Greg Hill looking good in the Vans Authentic

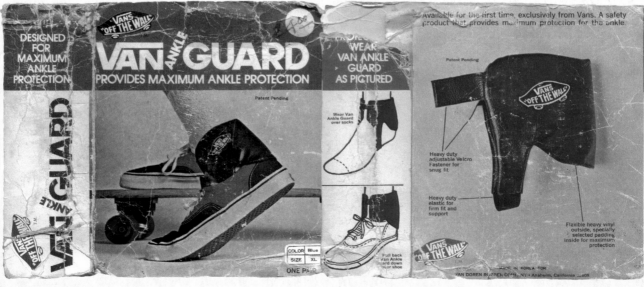

1970s: Van Ankle Guard

1977: Vans Checkerboard Era

612

In the late 70s I was just out of high school and I noticed kids were colouring in their Vans with a checkerboard pattern, so we started making shoes like that. We sent a box of checkerboard shoes for the movie *Fast Times at Ridgemont High*. We had no idea! They liked them so much they ended up on the album cover and Jeff Spicoli – played by Sean Penn – was hitting himself over the head with the shoes in the movie. It was magic because we sold millions of checkerboard VANS after the film came out!

Steve Van Doren

1970s: House of Vans

Who owns Vans now?

VF Corporation bought Vans in 2004. They are a unique company, they actually researched Quiksilver, Billabong and Vans, but they kept doing market surveys and Vans kept coming back as a cool company and that's why they bought it for $400 million. When my dad sold the company for $75 million we were doing $40 million in sales. Now our sales are around $360 million.

Vans' big movie experience was *Dogtown and Z-Boys*, which documented the Zephyr team. Was it an expensive exercise?

We dabbled in that and put out about $800,000 for Stacy Peralta to buy the rights for the music as well as do the direction and put that documentary out. In the end, we basically got our money back.

Are you surprised *Dogtown* became a Hollywood film?

I was excited about it because I thought the documentary was fantastic and that it would get to a lot of theatres, but it just didn't. I saw the director's cut a few months ago with Skip and Tony Alva and it was great.

The massive consumer thirst for retro footwear seems perfect for Vans, but was it easy to reintroduce the classics?

Back in the early 2000s people were saying, 'Why can't we get this and why can't we get that?' I was in charge of events and we had other people in charge of product and we had a problem, they weren't listening. I would just say, 'Fuck 'em! I'm going to make my own shoes and put them out there!' And you know what happened? We sold a lot of shoes and people started saying that's what I remember and love about Vans. The ball started rolling and we were getting our mojo back again with all the retro stuff.

I've had the most fun in the last year and a half. It was the first time I'd been over to China and saw where our shoes were made. Before we closed our factories in the States, I snuck 200 rolls of fabric out and hid them in the warehouse. I'd just cut the fabric in squares, go to my cousin and he'd print my material. So when I went over to China I'd have fun and go make a pair of shoes. I made up a bunch of different ideas and brought them back to show the designers. That's how it was in the old days. You could walk out the back and do a pair of shoes anytime you wanted to. It's harder now.

The last trip I went back and got them to make a mould for a size 66. So I actually have a size 66 Slip-On now and I'm going to use them to display in stores all over the world. I made up a couple black pairs, a couple of red checkerboards and some black ones too. I also made giant shoe boxes for display and the shoe actually fits inside.

It seems like every Californian remembers their first pair of Vans. It's part of the culture there, isn't it?

If I talk to people from New York and say 'Vans', older people don't know what I'm talking about. You ask a Californian and they always know. If I'm on a plane and I'm talking to someone and they ask, 'What do you do?' and I say, 'Have you heard of Vans shoes?' They always go, 'Oh yeah, my cousin had a pair', or, 'I remember my custom pair I made when I was at high school!'

I remember a lady coming in with a mink coat who had just divorced her husband and didn't want the coat anymore. She made a pair of mink Vans. I remember Jackson Brown sent some pants down to us; they were a snakeskin-looking fabric and we made him shoes out of them. People definitely loved them in Southern California. If we had the penetration of Southern California around the world, we'd be an $8 billion company. There was that kind of east versus west thing going on. Converse on the east and Vans on the west. My dad's philosophy was we took whatever the public would give us and made whatever shoes you needed. If you were size 8 in one foot and size 9 in the other, in the old days we'd give you exactly that. We'd do things the other people weren't going to do.

Do you remember the last time you actually had to pay for sneakers?

Not really. A couple of times I've bought them for friends. I remember when I was in fifth grade, I was into Hawaiian shirts – I have hundreds of them. Two surfers, Nathan and Christian Fletcher, well, their grandfather owned a Hawaiian fabric company down in Irvine. I'd get 10 or 12 different samples of fabrics and go to the factory and make my own Hawaiian shoes.

Do you have a personal stash?

I probably have 50 pairs I've kept from over the years. I wish we kept a pair of everything Vans did, but no. Maybe for the last 10 years, but not from way back.

1984: Style #438 and #439. Proof that Vans made crazy breakdancing shoes

We couldn't pay skaters or anybody else to wear our shoes, all we could do was give some shoes away. Basically we just put blinkers on and just tried to get the money paid back.

Steve Van Doren

What do you consider the most way-out pair from over the years?
The breakdancing sneakers were pretty rad. We have never replicated them. It had a big wing out the back and it was a high-top.

Have you noticed the trade of vintage Vans?
I hear about it all the time from the developers and stuff, that this shoe went for $100, this shoe went for $200. There was a pair I made for a crazy brother-in-law who was getting married for the third time. It was a fabric that you could say was R-rated and I made one pair for him and one for me, with a bow tie and cummerbund to match. They would go for a lot of money on eBay. They're great, I still have them. I actually made them at midnight, when there was no one around the factory so I wouldn't get into trouble with my dad.

Any other special make-ups that you've done over the years?
We had the guys from Pearl Jam say, 'Hey, we remember that rust-colour Sk8-Hi, can we get some?' So I made 10 pairs of those for the band. One time MTV called and they wanted a surprise band to perform at our skate park. It was the Red Hot Chili Peppers! Nobody was to know until a half hour before the show. In nine days, the art department made up a bunch of Chili Peppers designs. I had 12 pairs of shoes made between Sk8-His, Sk8-Lows and Old Skools. They were red and when they came to play I gave each guy a pair. I kept one pair and gave a pair to my daughter.

My favourite Vans are the Full and Half Cabs. Steve Caballero has been involved with Vans for a long time. Can you tell us about the relationship?
I really got to know Stevie well in 1987. He's been riding for us forever. He's my favourite athlete, we do a lot of things together.

The Half Cab started because everyone was taking the Full Cab and cutting them down. The shoes are still around today too. It's not a big number driver, but it's more successful now than it has been in the past 10 years.

What does the future hold for Vans?
We're never going to have air pockets like Air Jordans and stuff like that, so we have to get creative with materials. The thing that hasn't come back totally yet are all the fun, crazy things we did with prints. That's an area that still has a long run for us. I know Grant, our head designer, has a really great idea, but if I told you I'd have to kill you. He's got something that he's been working on for a year and a half. If he comes through with it, it's really going to be cool. There's also a new line called Syndicate. We just showed it at ASR, it was on a corner parking lot under a big army tent. It's got four or five different styles; the Half Cab is one, the Old Skool is another. There is tattoo art on an Authentic model and it looks great. These are packaged really cool and it's a special brand for our best, core skate shops.

Just to finish off, what shoe would you pick to sum up what Vans is all about?
Definitely the checkerboard Slip-On.

•

Converse All Star

Published in *Sneaker Freaker* Issue 36, July 2016

EDITOR'S NOTE: WOODY

The Chuck Taylor All Star is – by some immense googol – the highest-selling sneaker of all time. Loved by tweens, golden oldies, retro rockers, street ballers and Danny Zuko alike, the humble canvas high-top is, to my mind at least, the one and only sneaker design truly worthy of all-time icon status. While most of the features in this book are based on the 1980s through the 90s, the All Star story dates back to the 1920s, which is damn close to a century ago. It's odd then that a thorough All Star retrospective had never before been compiled before. If anyone was going to tackle this monumental task, it was *Sneaker Freaker*!

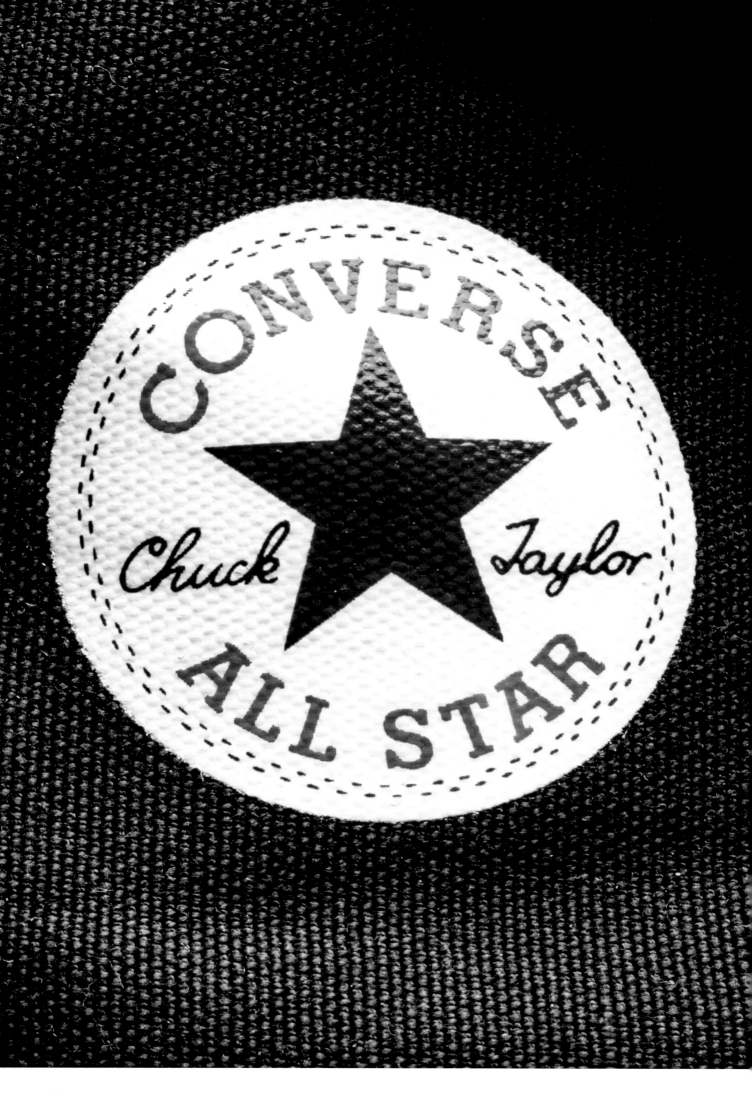

TEXT: Vinny Tang **IMAGES:** Julian Loh **THANKS:** Sam Smallidge at Converse

Pure basketball heritage

AMERICAN ALL STAR

When the Converse Rubber Shoe Company started manufacturing athletic goods in 1910, Dr. James Naismith's ideas for a recreational pastime tentatively called 'Basket Ball' were still in their primitive stages. Then, as the game began to take hold throughout the United States, demand for athletic shoes that could cope with the rigours of the new sport escalated. In 1917, Converse responded with the Non-Skid, a high-top sneaker named for the grippy qualities of its diamond-patterned outsole. Three years later, the design was retitled the 'All Star' and the name quickly became synonymous with the sport itself. For the next half-century, the All Star's on-court supremacy was indomitable. It was worn and loved by amateurs and Olympians alike.

We've been bugging Converse forever for the keys to their archive, and they finally relented, inviting *Sneaker Freaker* to Boston to witness some 3500 items carefully stored inside their temperature-controlled vault. Visitors are never granted access, so it was a real privilege to photograph these precious Converse antiquities, many of which are close to a century old. As the brand continues to invest heavily in innovation and the next hundred years of its history, it's important to acknowledge where the All Star story began. Pure basketball heritage is what cemented its status as a true American icon. Time to pay tribute to the greatest basketball sneaker of them all.

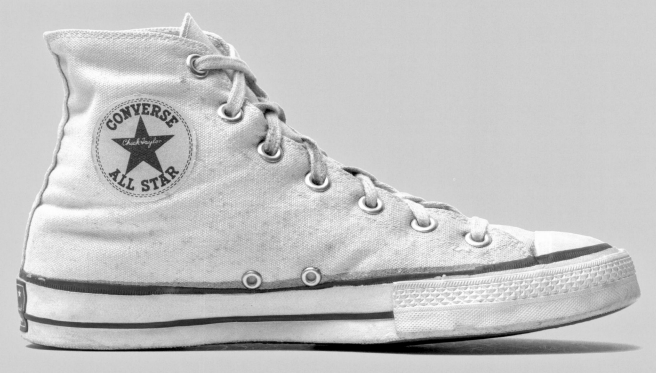

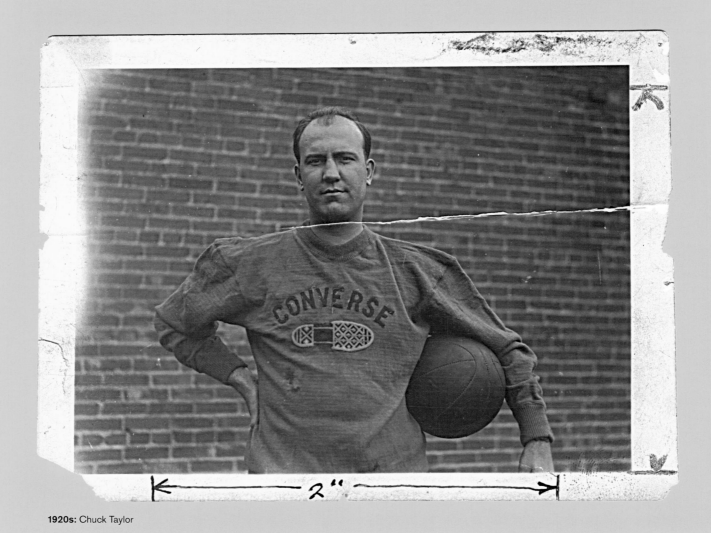

1920s: Chuck Taylor

Industrial Revolution

By the mid 1800s, thanks to the abundance of swift flowing streams that provided hydropower for large factories, New England was the epicentre of the American Industrial Revolution. By the turn of the 20th century, the area had established itself as a textiles and manufacturing hub, giving birth to a number of footwear companies that still exist today.

In 1908, Marquis Mill Converse, a New Hampshire native, decided to leave his job and open the Converse Rubber Shoe Company. At this point, it was standard practice to only open factories during times when customers were purchasing shoes. During the summer months, buying slowed down and the factory staff were laid off, then re-hired at the start of the new season.

Afraid of losing his skilled workers during the break, Marquis started making tennis shoes in the summer of 1910. With this simple stroke of genius, Converse was suddenly in the sportswear business. Meanwhile, in Massachusetts, another sporting invention was just about to take flight, one that would come to define the fortunes of the company.

Naismith Rules

In 1891, Dr. James Naismith was tasked with creating an indoor game as an 'athletic distraction' to keep his YMCA gym class active. The game he created was simple: teams would work together to throw a ball into a peach basket nailed to an elevated, 10-foot pole. Dr. Naismith named his invention after the only two things required to play the game: basket and ball.

The game grew fast. Loosely governed leagues were established but disbanded just as quickly. A demonstration championship held during the 1904 Olympics in St. Louis exported basketball internationally. It wasn't until 1906 that peach baskets were finally replaced by the metal hoops we're familiar with today. By 1910, basketball had established itself in intercollegiate sport and new industrial leagues began to spring up everywhere.

Although it was on the cusp of becoming as big as football or tennis, there was still a total lack of basketball-specific footwear for players. After some deliberating, Converse began manufacturing shoes specifically for ballers. Unfortunately, the exact launch date of those shoes has been lost to history, but the earliest surviving catalogue in the Converse archive dates back to 1916. It shows a series of canvas high-tops with different soles and uppers designed to suit individual players. The Surefoot was equipped with a thick 'suction sole' design. The Big Nine model boasted 'Nine Big Points' of performance and the Professional featured cushioning soles made from felt. But the early favourite was a style simply called the Non-Skid.

Unparalleled Grip

The Non-Skid's diamond-pattern 'Traction Sole' offered players unparalleled grip. The clever upper design also allowed for less leather reinforcement across the forefoot, making it one of the lightest basketball shoes on the market. Like the rest of Converse's basketball range, the Non-Skid sported the signature Big C-branded round leather patch that was designed to protect ankles from bruising. Yes, the ankle patch on the All Stars you wear today was born as a serious performance feature!

In 1920, the Non-Skid was given an upgrade and a new model name. Constructed from 14oz duck canvas, the white version was still known as the Non-Skid, while a brown canvas edition was renamed the All Star. Both were updated with 'Bat Wing' toe bumpers and instep reinforcement for durability. Fortuitously for Converse, the Chicago University team took home the Western Conference wearing the new All Star. The success was promoted widely by Converse and the All Star was dubbed 'The Champion Shoe of Champion Teams' in advertising material.

Chuck Taylor

That same year, Charles Hollis Taylor was playing his first season for the Firestone Non-Skids in Cleveland. During a game against the

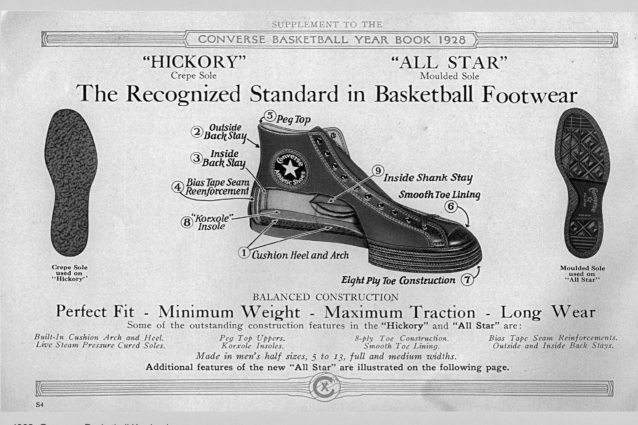

1928: *Converse Basketball Yearbook*

Akron Goodyear Wingfoots, Chuck scored the winning points with a half-court clutch shot. His exploits featured in the town papers, winning him local notoriety. Chuck eventually left the team in search of a pro sporting career.

When his basketball dreams didn't materialise, he moved to Chicago to look for work. He'd been wearing Non-Skids since his time on the Columbus High School team, and so he decided to walk into Converse's office in Chicago and ask for a job. While Chuck might not have been the best player, he was a natural salesman. With the newspaper clippings of his game-winning shot in hand, he tried to convince them he was a celebrity back in Cleveland and that he could help take the company's basketball division to the next level.

Converse hired him on the spot. Almost immediately, Chuck started hosting basketball workshops where he taught new players skills and suggested Converse shoes would give them the edge over the competition! Chuck was also appointed the player-manager of Converse's All Star Team that would showcase demonstrations at the clinics.

The next year, the company began publishing the annual *Converse Basketball Yearbook*, which featured team photos with players and coaches wearing Converse shoes. The books were also instrumental in spreading tactical game knowledge and effective training drills.

By 1925, Converse started promoting its own shoes in the yearbook with detailed diagrams explaining the performance features. Thanks to Chuck Taylor's hugely successful clinics, the All Star had become the company's bestselling shoe and was now specified as standard equipment by many teams. The All Star was also frequently used in advertorials, underscoring the shoe's presence in the collective consciousness of the basketball industry.

Player Feedback

Converse continued to refine their designs using pro players' feedback. By the time the company dropped the Non-Skid altogether in favour of the All Star in 1925, a number of significant improvements had been

made to its design. Armstrong cork insoles, double reinforced foxing, heel cushions and a narrower shank for enhanced arch support were All Star additions. Converse also patented their 'Peg Top', a refinement to the ankle collar that meant it could be tied tightly without danger of chafing across the achilles tendon.

A crepe-soled version of the All Star – the Hickory – was also included in the catalogue right up until 1933. Even a 'Featherweight' model featuring a felt insole was briefly introduced. Converse always touted the innovations as 'new features – not experiments – that were guaranteed tested by a full season's play.'

By the mid 1920s, the newly formed American Basketball League was created and the All Star was firmly established as the standard in basketball footwear. Thanks to the combined work of Chuck Taylor and the *Converse Basketball Yearbook*, almost every player in the ABL wore the All Star or other Converse shoes. Despite having a near monopoly, Converse continued to refine the design, a testament to the brand's pioneering commitment to innovation and performance footwear development.

In 1928, the All Star dropped the 'Big C' logo for its own ankle patch and outsole branding. That same year, after players complained about the outsoles wearing too quickly, the sole was updated with a pivot button. This was the first feature of its kind and variations can still be found on almost every basketball shoe. By 1929, corrugations were added to the outsole and the eight-ply toe bumper evolved into what is still found on current All Stars. An all-black All Star became the first colourway variation in 1931.

The First Signature Sneaker

For two main reasons, 1934 was a significant year. Firstly, Converse added two eyelets in the midsole and a tubed outsole that allowed the shoe to breathe to maximise underfoot ventilation. 'AIR-FLO' insoles would remain part of the shoe for over 20 years. Secondly, after more than a decade as the face of the brand, Chuck Taylor had become intrinsically associated with the All Star. Converse therefore proposed

Late-70s: Chuck Taylor All Star 'Tree' customs – made for Tree Rollins, the last player to wear All Stars in the NBA – feature the new star and chevron logo on an otherwise stock All Star

the very first sneaker endorsement deal by renaming the shoe the 'Chuck Taylor All Star'. Chuck's signature was displayed proudly on the heel's licence plate.

Global Coverage
In 1936, basketball's global presence was cemented with the game's official inclusion as a medal sport in the Berlin Olympics. Converse was asked to create the official shoe for the very first American Olympic basketball team. The result was a new all-white All Star that featured a patriotic blue and red pinstripe to match the team's official kit. To celebrate Team USA's gold-medal winning performance, Converse sold the same design to the public as the 'Olympic White All Star'. The OG design is the reason why white All Stars still retain blue and red pinstriping.

When the USA entered World War II in 1941, the majority of Converse's production was directed to supporting the country's troops. Only a small quantity of All Stars were available to the public during this time. Made with 'wartime construction techniques' that used rationed materials, the shoes did not last long under the stress of basketball. Converse has yet to track down a single example from this period for their official archive.

The Basketball Association of America was founded in 1946, then renamed as the National Basketball Association in 1949. As the game exploded in popularity thanks to advancements in broadcasting, the All Star remained the number one choice for professional players. By this point, Converse had almost perfected the shoe, but continued to refine smaller details such as underfoot support.

The All Star's next big update came about in the 1950s. As more people started to play basketball, some players requested a low-cut sneaker. Converse enlisted the Harlem Globetrotters to develop this new silhouette. The brand sent down designers with boxes of All Stars to the team, and they would chop the tops to crudely create low-cut versions. The team would run around in the prototypes to test them on-court and give feedback to the designers on how to refine the shape of the collar. It was through this trial and error development that Converse designed the Chuck Taylor All Star 'Ox' – short for 'Oxford Cut' – in 1957.

The Beach Boys
All Star Ox sales boomed in California. The spike was first attributed to Converse finally tapping into what players wanted, but in reality, it was due to the emerging 'teenager' demographic's embrace of the shoe.

TWO LEADERS

THE LEADER IN CANVAS

IS THE LEADER IN LEATHER

Improved AIR-FLO Insole

"Breathes" with every step you take. Means cool feet for hot contests.

Both "Chuck" Taylor ALL STARS

feature the AIR-FLO Insole

CONVERSE ALL STARS Bring Exclusive Extra Features

CANVAS ALL STAR

The leader 20 years ago—the leader today. Features the MOLDED OUTSOLE for smooth, effortless stopping on every type of floor. ● FLEXIBLE COUNTER prevents chafed and blistered heels. ● DUCK BACKSTAY—flexes with every motion of the foot. ● CUSHION HEEL AND ARCH SUPPORT—greater comfort and extra support at these vital points.

LEATHER ALL STAR

All the desirable features of the canvas ALL STAR but with uppers of soft, flexible leather ● PADDED TONGUE prevents chafing or binding.

● YOU expect leadership from Converse. The molded traction sole, the peg-top, the cushion heel and arch support—these and many other improvements that added to playing comfort and longer wear of ALL STAR basketball shoes were first pioneered by Converse.

Again Converse demonstrates its leadership—this time with the leather ALL STAR. Long famous for their light weight, ALL STARS in leather now weigh a full three ounces less. Non-stretching top assures permanently snug fit, no matter how often you play. As comfortable to play in as they are good to look at—as long-wearing as they are comfortable.

So now you may have your choice—canvas ALL STARS or leather ALL STARS. Either style the best possible buy in foot-comfort, smart appearance and durability.

CONVERSE RUBBER CO., MALDEN, MASS.

1935: Converse Chuck Taylor All Star advertisement

Converse
All Star Evolution

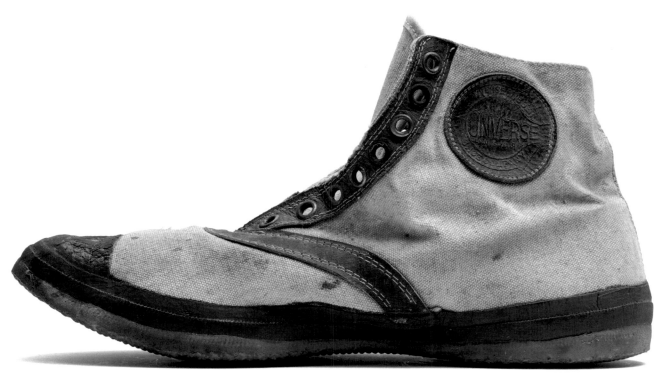

1920 – Big 9
Popular basketball shoe made by Converse in the late-1910s to early-1920s

1920 – Broncho
Children's shoe that made use of
a diamond-shaped outsole pattern

1923 – All Star

1928 – All Star

1930s – Converse Athletic Shoe
Custom leather and canvas version

1939 – Chuck Taylor All Star 'Leather'
Leather wrapped outsoles

1945 – Army Canvas
Basic training shoes made by Converse

1940s – Chuck Taylor All Star
A new ankle patch with Chuck Taylor's name
was introduced after WWII

1940s – Chuck Taylor All Star

1953 – Chuck Taylor All Star
New ankle patch with the old licence plate

1950s – Chuck Taylor All Star
Updated licence plate

1960 – Chuck Taylor All Star 'Oxford'
Early version of low-top

**1960 – Chuck Taylor All Star
'Weighted Trainer'**
Weighted version of the All Star
designed for training

1963 – Playarch
Canvas hightop featured rugged toe caps

1961 – Chuck Taylor All Star
Updated ankle patch

1960s – Chuck Taylor All Star
Updated ankle patch

1960s – Fullback
Multi-purpose cleat for football and soccer

1970 – All Star 'Leather'
Low-top leather successor to the
canvas All Star

1971 – Chuck Taylor All Star
First year of coloured All Stars

1972 – Coach
Unlike the All Star, the Coach model was sold
by Converse at non-sporting good stores

1976 – Chuck Taylor All Star
Rare prototype features the tongue tag and star/chevron logo on the foxing tape

"IT'S A BIG STATEMENT, BUT WITHOUT CONVERSE AND THE ALL STAR, BASKETBALL MIGHT NEVER HAVE BECOME THE SPORT IT IS TODAY"

Various *Converse Basketball Yearbook* covers

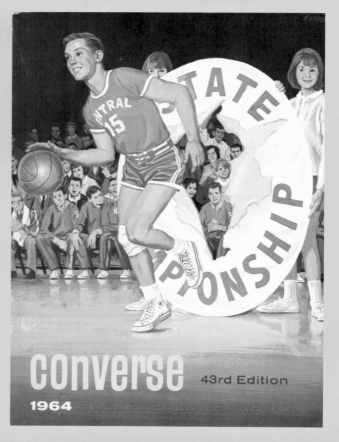

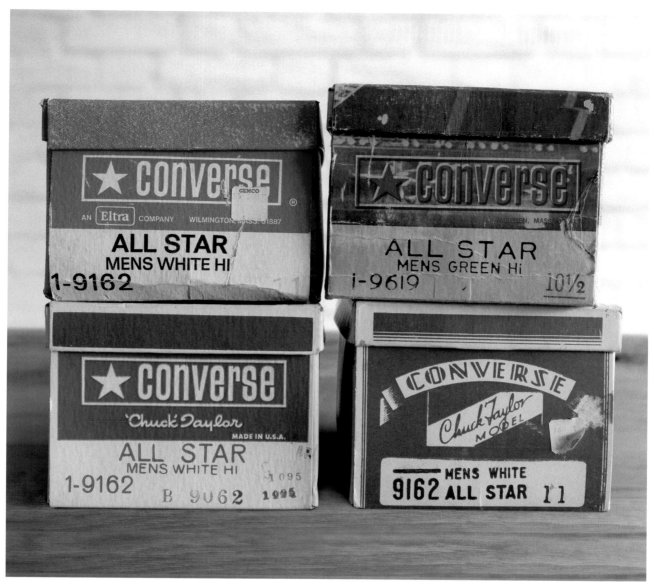

Original Converse All Star packaging

Californian teens enjoyed the casual look and the low-cut shape. Unbeknown to Converse, All Stars had become part of the new 'beach boys' subculture that helped shape the decade.

In 1962, Wilt Chamberlain played his historic 100-point game wearing a pair of white Chuck Taylors – an all-time scoring record that still stands to this day. Despite the model being more popular than ever with the youth and counterculture tribes during this period, the All Star was still marketed purely as a performance shoe by Converse. It wasn't until 1969 that the brand acknowledged the shoe's casual following with its 'Just a guy who likes the feel of the world's greatest basketball shoes' advertising campaign. Sadly, Chuck Taylor passed away shortly after retiring from Converse in the same year.

As pressure from new brands moving into the category began to mount, Converse unveiled the next iteration of their basketball line in 1970. Originally dubbed the 'Smooth Leather All Star', the shoe is more commonly referred to as the 'One Star' in modern Converse catalogues. Reaction was positive, but after 50 years of wearing All Stars, players were still loyal to their favorite Chucks.

Interestingly, it wasn't until 1971 that Converse acquiesced to demand by introducing a suite of bright-coloured All Stars into the market. This long overdue move paid immediate dividends, especially with American college teams who appreciated the opportunity to match their shoes with their team kits.

A Fine Career
The All Star's final NBA appearance was on the feet of Wayne 'Tree' Rollins in the 1979–1980 season. The towering centre had always worn Chucks and insisted on wearing them even though the shoe

was being phased out as a performance model. As a result, Tree wore customised Chucks that sported the Star Chevron logo from the then-new Pro Canvas. Though the end of the decade would mark the end of the All Star's long history with pro-ball, the shoe had already taken on a new life with a new generation of free-thinkers and creatives. But that's another story for another time.

The Converse All Star was created during a defining point in the early days of basketball, and the shoe would go on to become the most influential basketball shoe of all time. Chuck Taylor and his All Star team brought core basketball principles to every part of the United States. The innovations Converse implemented with the All Star such as non-skid outsoles, ankle patches, AIR-FLO cushioning, pivot buttons and the Oxford cut were instrumental in advancing basketball, allowing athletes to play harder and faster. It's a big statement, but without Converse and the All Star, basketball might never have become the sport it is today.

•

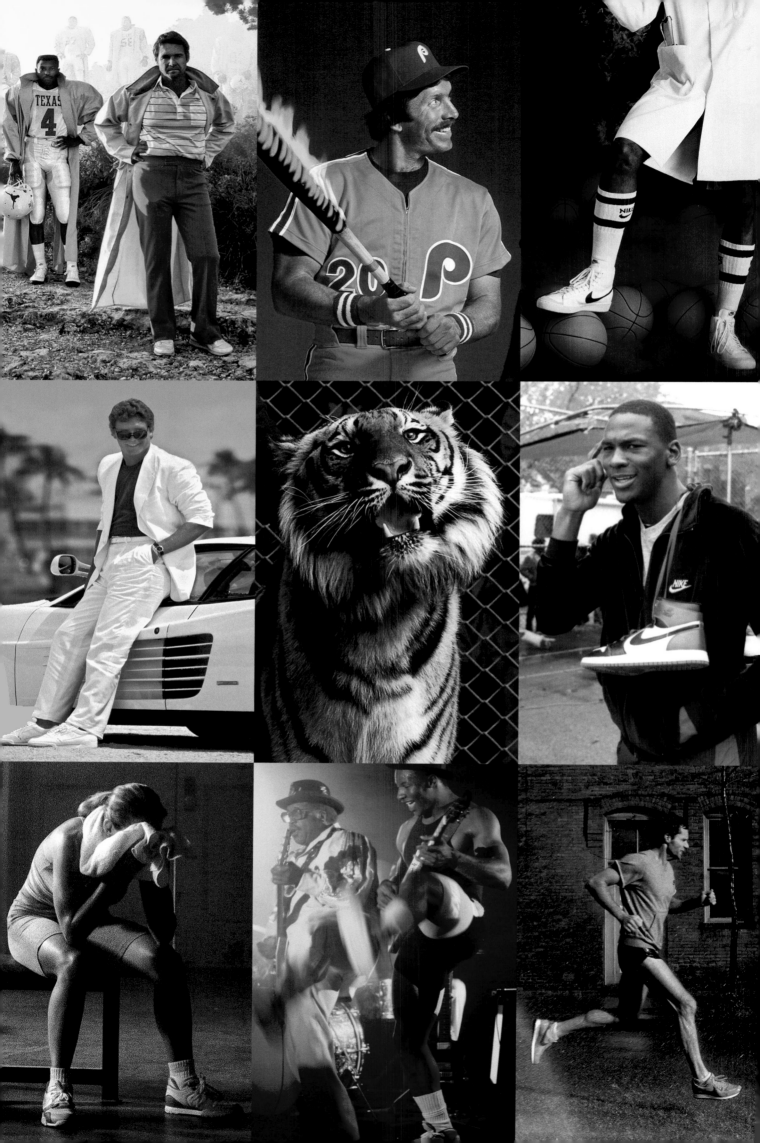

Sneaker Advertising

Before the internet revolutionised the world, sneakers were marketed primarily through TV commercials and elaborate magazine campaigns. Extrapolating the print iconography, Nike devised a series of witty posters in the 1980s that saw their big-name athletes plastered across the bedroom walls of just about every North American teenager.

As Bill Sumner, Chuck Kuhn and Bob Peterson recall in their interviews, the world was a simpler place back then. Long before athlete entourages, corporate micro-management and Photoshop, these now-legendary poster images were essentially real-world trick shots that required renegade late-night missions, elaborate props and a daring dose of risk aversion. Flaming baseball bats, 700lb tigers and potentially deadly gas leaks were all in a day's work! Enjoy our tribute to the shutterbugs behind some of the most iconic images in sports marketing history.

STEELER POUNDER

Franco Harris

BILL POSTERS
THE NIKE GUY

INTERVIEW Nick Santora PHOTOS Bill Sumner

Before the internet, the bedroom wall was the only place you could look at sneakers all day (and all night). Today, kids have Snapchat. We had posters and Fun-Tak. Thanks to *Sports Illustrated* and Starline's posters, all of my athletic heroes lived right at my house. Nike's posters were the originator of the concept. Creating an alternate universe, they humorously channelled athletes' alter-egos, exaggerating their flamboyant styles and personalities. Bill Sumner is the creative genius responsible for many of the Nike posters I idolised as a kid. Long before Adobe brought Photoshop to the masses, Bill intricately handcrafted these works of photographic art. His stories from the 80s are legendary. It was a freewheeling era when endorsement money began to flow but superstar entourages were still a decade away.

University of Texas

How did you get started doing the athlete portraits?

The 'Doomsday Defense' poster for the Dallas Cowboys was the first one I did for Nike. We had a guy in Dallas make the gravestones out of Styrofoam and shot it in the studio. I got a branch and hung it over the top of the set and lit it. We had two 55-gallon drums of dry ice and fans creating a low-lying fog. Incidentally, we had to interrupt the shoot because all of a sudden Ed Jones is saying, 'I'm really not feeling so good.' Then the other guys started saying, 'Something's wrong here!' It turned out we had displaced all the oxygen in the studio with the carbon dioxide from the dry ice. We had to clear everybody out into the street for a while before we could finish the shoot. The studio was on the outskirts of Dallas, so it didn't cause a big commotion that we had all these football players standing out in the street in uniform. Everyone thought it was funny. That was actually a limited run poster and it ended up being recreated by someone in New York who started selling it. It was originally intended to be a point-of-purchase thing. It came to Nike's attention that the poster was being sold and they weren't the ones selling it. They caught the guy and sued him. Then they said to themselves: wait a minute, maybe there's something here? That's how it all started.

It's been a long time since Nike made these posters, but I think kids would still dig LeBron and Kobe on their walls.

Nike never intended to make money by selling posters. All they wanted to do is get the kid's hero on their wall wearing Nike shoes. I think the idea would still work. Now obviously the kids are all online and I understand that, but the bedroom wall space has not gone away. I still think it's a good market to get the shoes in front of the buyers, and the mothers and fathers – they're the financiers after all.

Were athletes more approachable back then?

Oh yeah. Charles Barkley was a great guy. After a shoot one time he said, 'I need some new clothes. You're gonna have to come and tell me what I look good in.' The crew and I hopped in the back of his limo and went speeding around Philly to the Big & Tall men's stores and he was trying on this and that – we had a good time! Afterwards we went out for dinner and a few drinks and he was just a really nice guy. Now the deals are for 'X' number of millions of dollars and they're required to do five shoots during the course of a year. The shoot can only be so long and involve so many things. It's highly

specified. What happens is you get a guy in and the brands want to do everything at once. The athlete is just going this way and that way. They're saying he has to be here for this and then over there for a wardrobe change for the fashion stuff. Then they're going to be in this TV commercial and they get it all done in one day. You really don't have time to socialise or enjoy those extra things anymore. Most of these guys are really nice though. Even John McEnroe.

Your John McEnroe 'James Dean' Nike poster is one of the most iconic Nike images of all time.

Yes, I did 'Rebel With A Cause' with John. That was a fun one. We were in the beginning stages of merging images together so it looked like the athlete was there even though they weren't. This poster was a tongue-in-cheek knockoff of the famous James Dean shot in Times Square. In fact, we got sued for that shot. It didn't affect me much because I'm just the photographer, but James Dean's people contacted Nike's legal department. We shot McEnroe in the studio and my assistant was very excited because we had to make it rain on him. I found a studio in New York with a drain and we got a hose to shoot water up in the air. We also shot him in very flat light, like it would be if he was outside in the rain.

Not many people have ever hosed down McEnroe! What was the story behind that image?

I hung out in New York for a few days and stayed with some friends I hadn't seen in a while. The forecast was for bad weather so I just waited for a good shitty day and went to Times Square to do the shot. Computers were really new. Ideas would come up and then we would say, 'Well how the hell are we going to do that?' Our problem was trying to work out how to get McEnroe outside in Times Square during a rain storm. The logistics were just too much. That's when we started trying to figure out another way. We had a retoucher in Texas who was married to a computer wizard. They put the images together and did a great job. A lot of the shots got way too tricky, like Dr. K (Dwight Gooden) with the smoke coming out of the baseball. There was also Gary Carter catching an apple with the New York skyline in the background. Today it happens all the time because retouching is so easy. It's not easy to do it well though. There are some guys doing it very well whose work I greatly admire – I just keep trying to figure out how they do it!

DOOMSDAY

Dallas Cowboys

Was that a real tiger with Lance Parrish?
That was a real 700lb tiger! Lance ended the shoot when the tiger took a big growl at him! I've got a shot here somewhere of Lance going, 'Oh my god!' We were on the set out in Los Angeles and there's a guy with a whole pile of steaks. He's throwing them at the tiger to keep him happy throughout the entire shoot. It turns out that it was the same tiger as the Exxon Tiger. There were two actually. If one got nasty we could substitute him for the other one. It was an interesting shoot. When they brought the tigers to the studio, they unloaded them in the back alley and had them on long leashes with several people handling them. One of them was sniffing around, like cats do in a new place, and there was a recessed door in the alley. The tiger went sniffing in the doorway and there was a drunk passed out in there. He woke up to a tiger staring him in the face, shot straight up in the air and took off running!

Did you ever have much trouble with the cops?
With 'Power Alley', the cops came to that shoot and almost busted the whole thing up. We shot that in some alley in West Palm Beach. The glowing bat is just a Wiffle Ball bat with a fluorescent tube inside of it and wires running down his uniform. Once the cops showed up and realised it was Dale Murphy they were like, 'OK. Well, shit. Can we stay and watch?'

You can't do that kind of stuff these days.
Right! It was guerilla shooting. That's how a lot of jobs used to happen and we had a good time doing it. When we did 'Hometown' with Mark Jackson, same kind of situation. We had Mark in the limo with us and a couple of little portable strobes and we drove over the bridge a few times thinking, 'How are we going to do this?' I said, 'I'll tell you what. We're going over the bridge and we're all gonna jump out real quick and by the time you bring the car back over the bridge we'll be done and ready for you to pick us up.' That's exactly what we did. These sports posters were some of the most fun things I ever created. I had a chance to work with guys like Kirby Puckett from the Minnesota Twins. He was a hell of a nice guy. And Bo Diddley.

That's right. You shot the Bo Knows poster!
That was one where the TV spot was also going on. It would happen fairly often. We would go into a shoot and Peter Moore, creative

director at Nike Design, would say to me, 'Well we really don't have a concept so just go in there and shoot anything you can get.' So as this commercial was going on, I shot the hell out of it. They were filming it and the poster just came out of that shoot. We also shot a tonne of stuff with Bo Jackson for catalogues. They used to produce them like crazy, so I worked with him quite a bit.

When did you first photograph Michael Jordan?
He was still in college. That's how far back that one goes. He really couldn't do much then. Well, he could do it, but he couldn't get paid for it because it was the NCAA. We started the guerilla shooting because Peter Moore loved that kind of stuff. We would just go out in the afternoon and drive around until we found a few locations we liked, then we'd go back later and shoot with the athlete. I forget where that blue wall was, but it was on campus. Maybe it was a backboard for tennis or something like that. We did shoot a few other things there with him but I don't know where they are. I've got boxes in my attic that I have to get to. There's a bunch of old film up there but I need to dig through it.

The famous Air Jordan 'Jumpman' logo image – is it yours?
No, it was another guy who shot it on an outdoor basketball court up in Chicago. They asked me to do one similar, though, for the cover of a catalogue. We went up to Chicago and found a gym that we had to ourselves and Jordan did a heap of similar jumps.

They ended up cropping him onto a white background and up in the clouds and things like that. Then there's a bunch of fashion-oriented stuff I shot with him, because Jordan was doing the catalogues pretty early on.

Your Pony shoot with Dan Marino was really cool.
I remember it well. We had to go out and find a Ferrari, dress him like Don Johnson and shoot him on the beach. It was before South Beach had really taken off. You can see a couple of the old hotels in the back, sort of out of focus, in that shot. They were the renovated ones that were the beginning of the South Beach resurgence. Prior to then, it was a retirement community and a really depressing place. Then *Miami Vice* came along. After the shoot, we went and had a meal and I was sitting on a porch with Dan and a few of his friends having a few drinks and eating a sandwich.

SERIOUS HANGTIME A.C.

Anthony Carter

HOMETOWN

Mark Jackson

BO KNOWS DIDDLEY

Bo Diddley & Bo Jackson

REBEL WITH A CAUSE

'Rebel With A Cause' with John McEnroe was fun. This poster was a tongue-in-cheek knockoff of the famous James Dean shot in Times Square. In fact, we got sued for that shot. It didn't affect me much because I'm just the photographer, but James Dean's people contacted Nike's legal department. I found a studio in New York with a drain and we got a hose to shoot water up in the air.

Bill Sumner

Frank Viola

ROCKET MAN

Randall Cunningham

Mike Schmidt & Steve Carlton
Opposite: Lance Parrish

Dale Murphy

I had that kind of experience quite often. At that time I was living in Texas and had a studio in Dallas. I'd been doing some poster work for Nike, the word got around and other companies began to call me. That whole era was also the beginning of athletes getting big contracts and making more money from endorsements than from their teams. It began with Nike, then other sneaker companies followed. It all blossomed during that time.

You used so many trick photography techniques, I still have no idea what was real or what was done on a computer. I always wondered if they were actual flames on the 'MVP and CY' poster?
Those were real flames. We drilled the bat and dug a piece out of the ball. We put a little metal cup in there with cotton and alcohol and lit it on fire. Those guys were looking at each other like, 'This is ridiculous', and it was! There was no Photoshop. That's the real thing. Another one I had a lot of fun with was of someone I'm still in touch with: Franco Harris. In fact, I found a picture of Franco and his son a couple years ago, so I made a print and sent it out to his wife. We did that 'Steeler Pounder' thing and he brought his five-year-old son with him to the shoot. We had pieces of twisted steel made out of Styrofoam and footballs cut in half. Then we went cruising around. I had an old motor home in those days and we just cruised looking for a location. We came to that particular spot and said, 'This is it!' We had all these old mill buildings in the back, so we fired up the generator, set up the strobe and said, 'Here it is! We're gonna do it right here!'

What about Anthony Carter's 'Serious Hangtime'?
Anthony Carter was actually in the sky for that shoot. We rented a pickup truck and he'd stand on its cab, then jump off onto a little trampoline; he'd fly up into the air where someone would throw him the ball and he'd land on a pile of mattresses. We went to the shoot early to set that up and did a bunch of tricks with the lights to make the sky purple. That one worked out pretty good.

I could never work out if Randall Cunningham was in front of an illustration or a real building?
Randall was standing on a table in the hotel room and I shot that angle of him because there was absolutely no way to get a good angle of him in front of the actual building. The building in the shot was actually an architectural model in the front entrance of the place, so we shot it right there in the foyer. We shot the two parts and put them together.

Was Frank Viola done at the Metrodome in Minnesota?
Yeah, it was. On that shoot, we met a guy who was part of the maintenance department at the big inflatable Metrodome. He said, 'When you get done shooting, do you want to go on top of the dome?' He took the whole crew up there and it was pretty bizarre. It was like a giant trampoline where you could jump on it and bounce up in the air pretty good. It was crazy. We didn't want to get too close to the edge because you would start sliding down and that would be it! A couple of winters ago the roof collapsed in the snow and I think they realised it wasn't a good thing.

Do you still keep in contact with Nike?
There's a group at Nike in the archive. Did you know there's a whole Nike archive online? You'd flip on that one. [Laughs] The site is so full of Nike history that you would just die. I can also tell you that you can't have access to it. But it has everything. I haven't been to Beaverton in a long time, but now they have a whole Nike museum. I can only imagine what's in there, but I'm sure it would be a lot of fun to go through it.

•

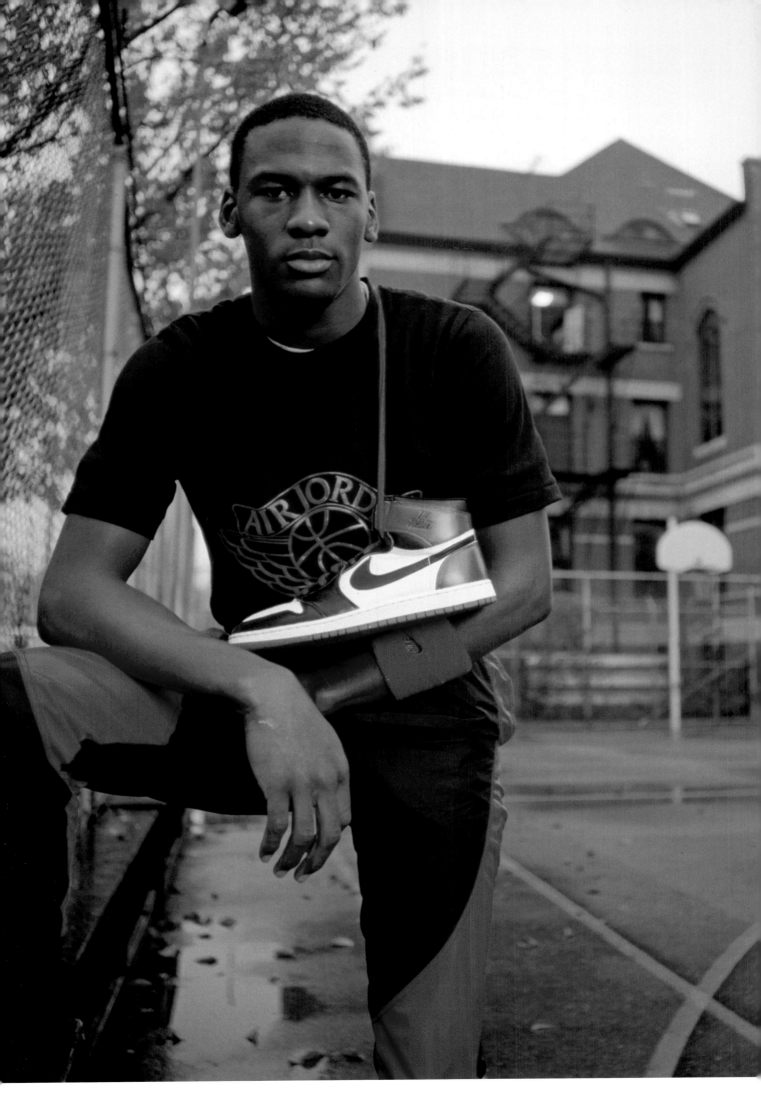

In recent years, a massive surge in demand has brought classic sports posters from the 1980s back into the cultural conversation. The $5 posters that were once plastered on bedroom walls have taken on new lives displayed in prominent museums and art galleries – even fetching hundreds of thousands of dollars from collectors at art auctions. The most sought-after images from this era portrayed childhood heroes dominating alternate universes and playing up outrageous superhero personas. Nike's first global creative director, Peter Moore, was responsible for creating the genre back in the early 80s with the assistance of Seattle-based photographer Chuck Kuhn.

Alter Ego

Interview: **Nick Santora** Photos: **Chuck Kuhn** ©**Nike**

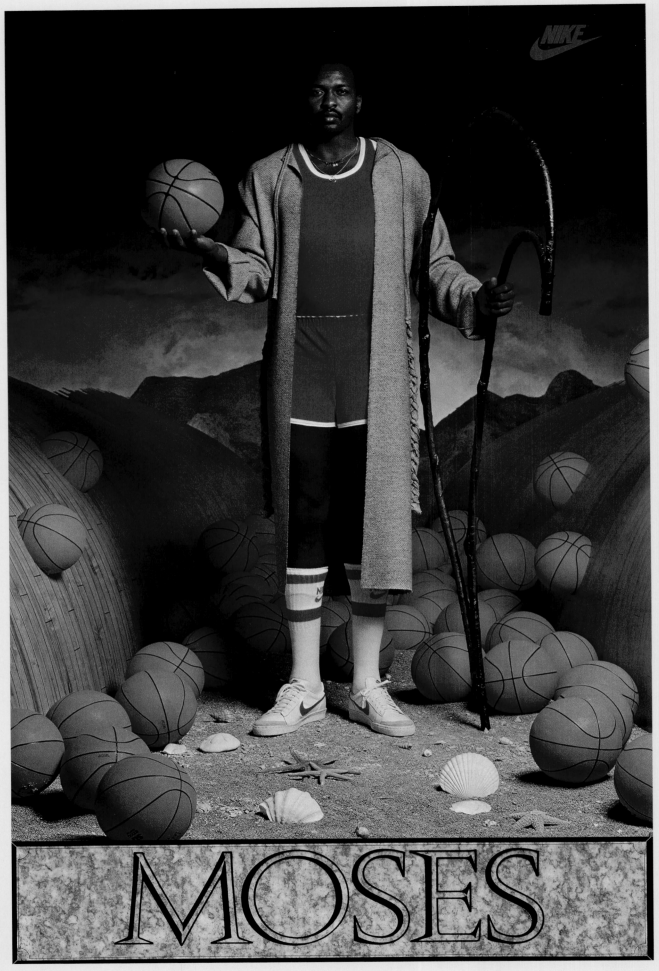

Moses Malone

DR. DUNKENSTEIN

Darrell Griffith

CHOCOLATE THUNDER

Darryl Dawkins

Instead of paying large sums of money to professional sports leagues for rights and clearances of in-game photos of Nike athletes, Moore got creative. Using an assortment of cheesy plastic props and ill-fitting costumes, he created a series of larger-than-life alter-egos – Silk, Iceman, Chocolate Thunder and Dr. Dunkenstein – that captured the imaginations of children everywhere. By 1985, these posters grew beyond their original purpose as point-of-sale material at local sporting goods shops. They were even appropriated by world-renowned artist Jeff Koons as part of his *Equilibrium* exhibition of the same year, functioning as conduits for discussion about class, race and social mobility in 80s America.

The success of Moore's 'alter-ego' formula spawned Lil' Penny, Bo Knows and the Roswell Rayguns, as well as the most powerful sports superhero in the galaxy, Michael 'Air' Jordan. For Nike's first Air Jordan campaign, Moore called on Chuck Kuhn, a photographer he had worked with previously. They spent two fast-paced days in Chicago with a young Jordan. On the second evening, at a playground framed by the Chicago skyline, he snapped a shot that is arguably the most iconic image ever taken of MJ. We tracked down Chuck Kuhn to get his first-hand account of what it felt like to make sporting history through the lens of his camera.

When did you start shooting Nike posters?
I started doing photographs for Nike through an agency in Seattle called John Brown Associates. I shot basketball, football, baseball and a little bit of tennis. I worked with Nike for around 15 years. At the time I liked sports, but I wasn't a total sports addict. Initially the posters were shot for in-store use, but then demand was so high that Nike eventually began selling them. They sell on eBay now for a good amount of money – it's really considered an art form.

I think the first poster I shot was 'Goin' Home' with Paul Westphal. We were in LA at an urban basketball court. This was in the late 1970s, before digital photography. I took all these Polaroids to adjust the lighting. These kids were there watching me take photographs, so I'd give them the Polaroids. They were real 'Wow!' moments for them. They all asked 'Mr Westphal' to autograph them, which was pretty charming.

How were these posters conceptualised?
Peter Moore was Nike's creative director and he came up with all the ideas, then we would meet and talk back and forth to see how we would implement them. I also worked with Don Dumas.

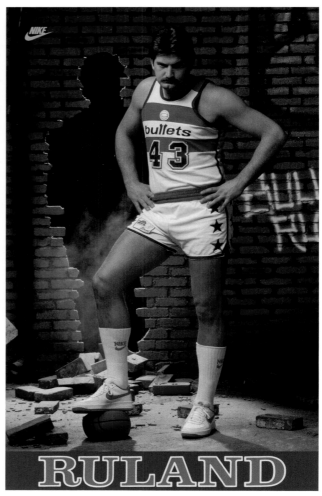

Micheal Ray Richardson

Jeff Ruland

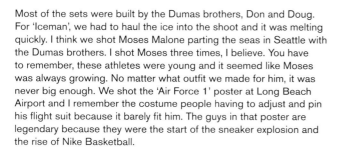

Most of the sets were built by the Dumas brothers, Don and Doug. For 'Iceman', we had to haul the ice into the shoot and it was melting quickly. I think we shot Moses Malone parting the seas in Seattle with the Dumas brothers. I shot Moses three times, I believe. You have to remember, these athletes were young and it seemed like Moses was always growing. No matter what outfit we made for him, it was never big enough. We shot the 'Air Force 1' poster at Long Beach Airport and I remember the costume people having to adjust and pin his flight suit because it barely fit him. The guys in that poster are legendary because they were the start of the sneaker explosion and the rise of Nike Basketball.

What do you remember about shooting Michael Jordan in 1985?
One thing I remember about Jordan during the few times I shot him is that more than any other athlete he loved the game. It was unbelievable how much he loved playing basketball! I usually shot the players somewhere with a hoop, either a playground or a gym, and the Nike account people would play pick-up games before the shoots – Jordan would always play with them for the heck of it. When the other players would shoot, they'd get the ball through the hoop once every few times. Jordan would get it in every single time. All of a sudden, when it was for real, something turned on and he was almost superhuman. All the other stuff, the fame and the fortune, it was all very nice, but I could tell he loved the game more than anyone else I ever shot. That was just the beginning of him going to the next level.

I shot Jordan for the Jumpman poster over two days in Chicago. The first day, we shot him at the playground with the shoes around his neck and the Air Jordan clothes. That was at a Catholic grade school that had a fence around the basketball court. More and more people heard about it and kept coming and lining up against the fence. We had a couple of hundred or so people watching. I kept throwing Polaroids over the fence and then Jordan threw his clothes over – the kids went nuts! On the second day, we were at a park

in Chicago on this little peninsula observatory place. We set up the basket with Chicago in the background and lit it in such a way that when the sun went down, we would get our shot. It was just one in a series of posters we were doing back then and no one knew where it would go at the time, but it really stepped the whole thing up. It's amazing even now how many people I talk to who had that Jordan poster on their wall as a kid. In 1988, they started using that photo as the logo for all the Air Jordan shoes and clothes.

Did you have any idea these posters would become so iconic or be considered works of art three decades later?
Everyone was really young and no one really knew where this was going to go. At the time, to me at least, the athletes were just people – not legends like they are now. They were just entering the league and trying really hard. I never knew where any of these athletes would end up in their careers. When I shot them, I just did what I was trained to do. I never thought anything was so special or my ticket to ride or anything. I never saw that at all. It was more innocent back then. But I think a certain amount of innocence in life is good because it makes you a lot more open to things.
•

Jordan
Jumpman

'I wasn't even dunking in that shot. People think that I was.
I just stood on the floor, jumped up and spread my legs and
they took the picture. I wasn't even running. Everyone thought
I did that by running and taking off. Actually, it was a ballet move
where I jumped up and spread my legs. And I was holding the
ball in my left hand.'

'Jordan on Jordan' interview with *HOOP* magazine (1997)

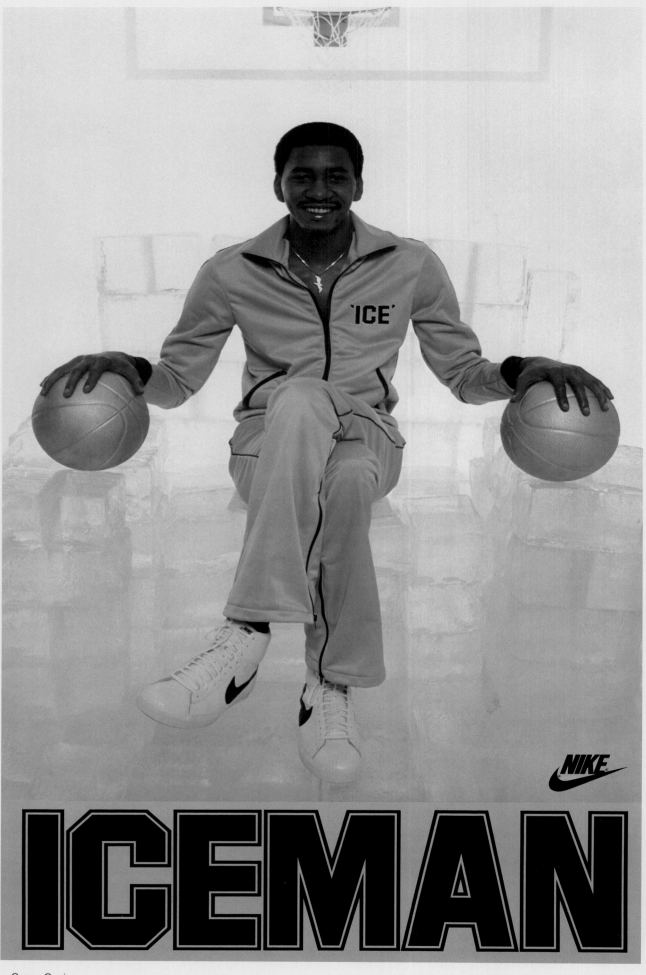

ICEMAN

George Gervin

Art imitates life

Koons x Kuhn

The images produced by Chuck Kuhn didn't just capture the imaginations of young basketball fans across the world. In 1985, contemporary artist Jeff Koons opened his first major exhibition, Equilibrium, in New York. Following in the Duchampian tradition of 'readymade sculpture' and with a keen interest in Jean Baudrillard's theory of simulacra, Koons blurred the line between art and object.

The exhibition consisted of a display case housing basketballs suspended in a saline solution, paradoxical bronze castings of flotation devices and perhaps most controversially, a series of Kuhn's Nike posters including 'Boardroom', 'Dr. Dunkenstein', 'Moses' and 'The Dynasty on 34th Street'. Recognising the powerful cultural resonance of Kuhn's imagery, Koons acquired the rights from Nike and presented them totally unaltered in a wooden frame. By simply presenting them in a white-cube gallery – as opposed to in a teenager's bedroom – Koons conferred the status of objet d'art to the series.

For the artist, the images represented a new means of social mobility for urban youth that negated issues of class and race. To go from struggling inner-city neighbourhoods to household fame by virtue of athletic prowess was the embodiment of the American dream. Still, Koons realised the potential falsehoods perpetuated by these fantastical scenes, likening them to 'sirens calling sailors to shipwreck' in a 2003 interview with ArtForum.

While Koons insists that his work 'communicates little save for their own existence', he continues to stay relevant in the art world. Recently, two Koons posters from the 1985 series sold for $146,500 and $185,000 at the largest global art auction houses. And you thought the sneaker resale game was bad!

•

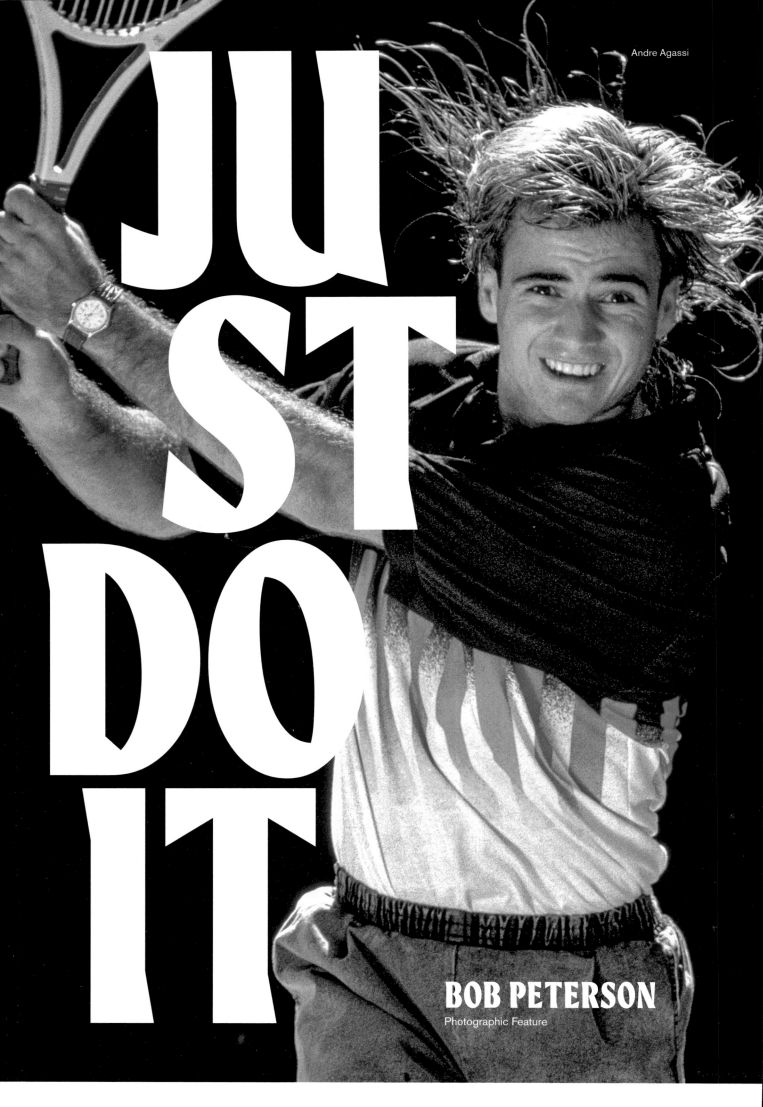

Andre Agassi

JUST DO IT

BOB PETERSON

Photographic Feature

TEXT Nick Santora

IMAGES Bob Peterson © Nike Inc.

Bob Peterson has taken more legendary shots for Nike than Kobe and LeBron combined. His photographs spawned dozens of iconic posters and advertisements featuring the Mount Rushmore of Nike athletes: Michael Jordan, Bo Jackson, Charles Barkley, John McEnroe and Andre Agassi among others. As a teenager, Bob began shooting athletes for *Sport* magazine and *Sports Illustrated*, before landing a staff position at *LIFE*, where he shot several cover stories. In the late 70s he connected with Peter Moore at Nike, when it was still a running company. In the mid 80s, Wieden + Kennedy and 'Just Do It' arrived, and nothing at Nike has been the same since. Thankfully, Bob had his camera to document this monumental time in sneaker history.

THERE IS NO FINISH LINE.

Sooner or later the serious runner goes through a special, very personal experience that is unknown to most people.

Some call it euphoria. Others say it's a new kind of mystical experience that propels you into an elevated state of consciousness.

A flash of joy. A sense of floating as you run.

The experience is unique to each of us, but when it happens you break through a barrier that separates you from casual runners. Forever.

And from that point on, there is no finish line.

You run for your life. You begin to be addicted to what running gives you.

We at Nike understand that feeling. There is no finish line for us either. We will never stop trying to excel, to produce running shoes that are better and better every year.

Beating the competition is relatively easy.

But beating yourself is a never ending commitment.

Beaverton, Oregon

THERE IS NO FINISH LINE.

NIKE

NO FINISH LINE

Originally, Nike's ad agency was John Brown & Partners out of Seattle. The first significant ad we did together was written by John. The 'There Is No Finish Line' tagline was used by Nike for years, until Dan Wieden came up with 'Just Do it'.

That line became the runner's credo and people really loved that poster. They still contact me today looking for it. The art director was a guy named Denny Strickland. He was tall and gangly. John Brown was a short chain smoker and I'm a rather large photographer. We were at a Nike party in Sun River the night before a race one time. Denny had a drink in each hand and John is lighting one cigarette off another. A guy came up and asked if we created that poster and I said, 'Yes we did, why?' He couldn't believe it was the three of us who created it and said it was a very important poster in his life.

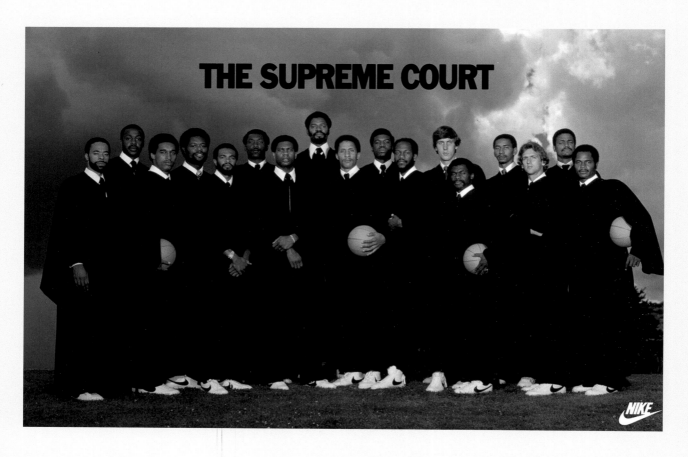

THE SUPREME COURT

'When I shot for Nike, I had no idea that 40 years later people would still be interested. As I've gotten older, I've realised that some of the stuff has become part of history. When I was much younger, and I suppose this is true for a lot of people in their 20s and 30s, you just sort of do what you're doing. You get the assignment, you try to do your job right, get your film into the lab and then you hope the editors like it. I really didn't think any more of it.'

Bob Peterson

THE SUPREME COURT

The next big poster we did was the Supreme Court, which we shot in Reno. There were dark clouds in the sky behind the players and you could see the white sneakers peeking out under their robes. This was back in the day, so I rented the robes myself and my wife took the hems out. The Supreme Court was the last thing I did with John Brown and Denny Strickland. Shortly after that poster, Peter Moore chose Wieden + Kennedy as Nike's agency. Dan Wieden and David Kennedy had just left their jobs to form their own agency and Peter gave them the Nike account. The rest is history.

For the second Supreme Court poster, we went to Washington D.C. We thought we could shoot at the actual Supreme Court building, but when we showed up they told us to go away as they don't allow any sort of commercial photography. So we went and found another similar looking building and posed the guys there. The art director and I decided to go back to the Supreme Court without the entourage and photograph the building. Now remember, this is way before Photoshop. Today you could do this so easily, but at the time I had to shoot the Supreme Court building with the same lens that I shot the guys with and on the same angle. I also defocused the background so it was just a tiny bit soft. Today you would do that all digitally, but we had to manually put that image together.

LOOK, UP IN THE AIR.

AIR JORDAN II

Nike would send me down to shoot when Joe Pytka was filming commercials. He was really a master with lighting. Whenever they finished filming I would get two minutes to shoot and I became very good at it. For the Michael Jordan shoot we went to Raleigh Durham, North Carolina. Joe was set to do a big commercial and they decided they didn't want to allow any time to do stills. Peter Moore had to pay them to come in early one day to light the gym. Michael arrived that day in his own car. Later on, the athletes wanted their own trailer and a personal sushi chef and a limo to pick them up from the airport. Michael wasn't like that. He was just a regular guy.

The first time I met him, he held up 10 fingers and said, 'Ten!' I said, 'What does that mean?' He took the ball and stuffed it. He came back to me: 'Nine!' So I said, 'Oh no, we're not even set up! You have to wait!' We set up our cameras and he was jumping and stuffing the ball. His wrists were hitting the rim, so I could see where he was coming from. You could only dunk the ball so many times before it really started to hurt. The next day during the television filming, I was able to shoot 'Look, Up In The Air', which ran as a double page in *Sports Illustrated*. I remember riding on a bus with my son's basketball team when they started running that Air Jordan commercial. It was slow-motion of Michael elevating off the ground. One of the fathers was claiming that Nike used Plexiglas stairs that Michael climbed up. I said, 'Excuse me, that's total bullshit! I was there. Michael just jumped up and dunked it!'

When I worked with Nike, I would sometimes negotiate sneakers into my contract. Once, I got my son an early pair of Air Jordans. When it came time for the second shoot I did with Michael, my son asked if I could get his shoes autographed. I never asked athletes because it put me in an awkward position. Anyway, I got to the shoot and opened up my equipment bags and there was one of my son's Air Jordans in there, so I broke my own rule and asked Michael to autograph it for him. Michael was just a real nice guy to be around and a pleasure to work with.

A Death-Defying High-Flying 360 Slam Dunk. Air Jordan from Nike.

IT'S GOTTA BE
THE SHOES!

The picture of me with Spike and Mike was on Spike Lee's roof in Brooklyn. Spike had done that movie with the Mars Blackmon character and Jim Riswold at Wieden + Kennedy was the guy who talked Nike into using him. It became a whole series. They were shooting a commercial and that was another instance where I said, 'You gotta give me two minutes, guys!' I don't remember exactly, but I'm sure it was something about Mike getting the girl, and Spike saying, 'It's gotta be the shoes, Mike. It's gotta be the shoes.' Spike was another nice, no-nonsense guy and it was a lot of fun to work with him.

LOFTON WR

CORNERSTONE

WRIGLEY FIELD

I did two interesting posters that were designed by Ron Dumas. One was James Lofton at Lambeau Field and the other was Ryne Sandberg at Wrigley. I was much younger then and didn't realise that having Lambeau or Wrigley Field all to myself was so special. James Lofton isn't the kind of guy you call Jim. You called him James. He wanted that type of respect and he earned it through his playing. Both the guys liked the idea of being featured on the posters, respected the whole concept and were very generous with their time and attitude.

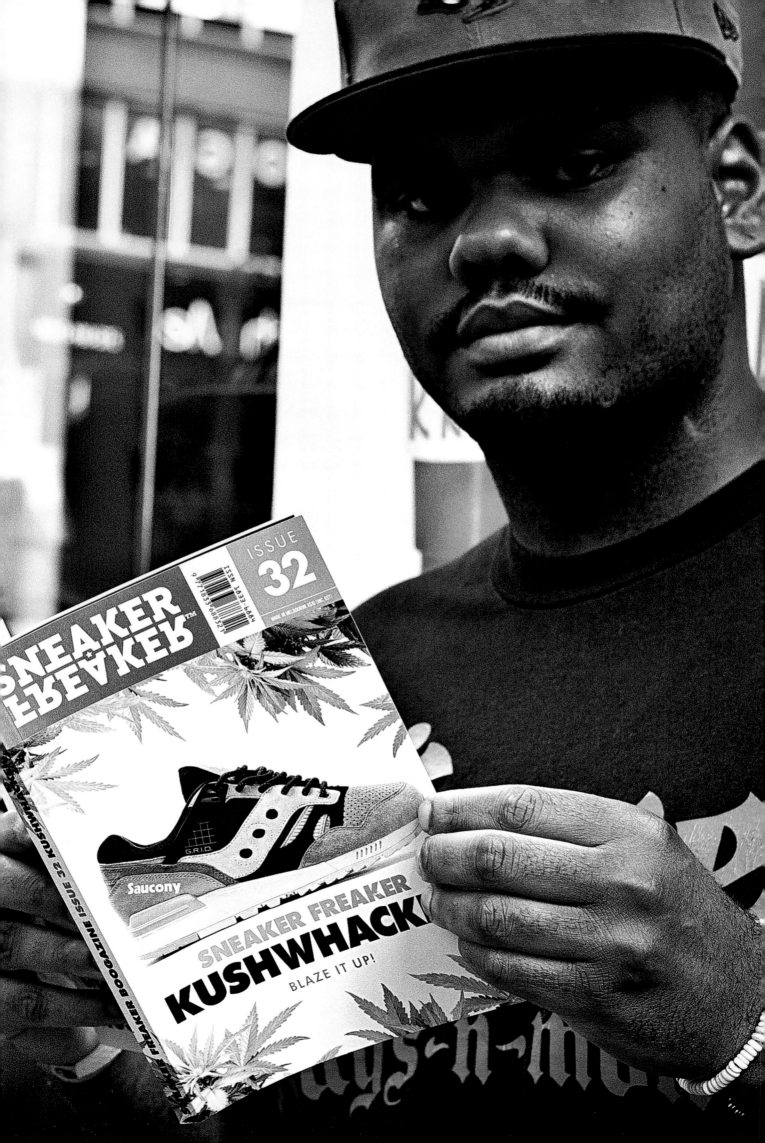

Index

SNEAKER FREAKER MAGAZINE VOLUME 5

SNEAKER FREAKER MAGAZINE VOLUME 6

SNEAKER FREAKER MAGAZINE VOLUME 7

SNEAKER FREAKER MAGAZINE VOLUME 8 SNKR FRKR MISSOURI 85

SNEAKER FREAKER MAGAZINE VOLUME 9 NIKE VINTAGE

SNEAKER FREAKER MAGAZINE VOLUME 11 PUMA BLAZE OF GLORY

SNEAKER FREAKER BOOGAZINE ISSUE 12 BLAZE OF GLORY

SNEAKER FREAKER BOOGAZINE ISSUE 13 MELBOURNE DUNK

SNEAKER FREAKER BOOGAZINE ISSUE 14 ACG ASHIKO FLYWIRE BOOT

SNEAKER FREAKER BOOGAZINE ISSUE 16 AIR MAX CURRENT 'HUF' ARACHE

SNEAKER FREAKER BOOGAZINE ISSUE 17 PATTA AIR MAX 1 QUICKSTRIKE

SNEAKER FREAKER BOOGAZINE ISSUE 18 SNKR FRKR x ASICS 'ALVIN PURPLE'

SNEAKER FREAKER BOOGAZINE ISSUE 19 SOLEBOX x ADIDAS EQT SUPPORT

SNEAKER FREAKER BOOGAZINE ISSUE 20 SIZE? x NIKE AIR STAB

SNEAKER FREAKER BOOGAZINE ISSUE 21 FOOTSCAPE WOVEN CHUKKA

SNEAKER FREAKER BOOGAZINE ISSUE 22 ASICS GEL LYTE III 'SALMON TOES'

SNEAKER FREAKER BOOGAZINE ISSUE 23 SNKR FRKR X PUMA 'BUNYIP'

SNEAKER FREAKER BOOGAZINE ISSUE 24 SNKRFRKR BUSHWHACKER

SNEAKER FREAKER BOOGAZINE ISSUE 25 SF X NB998 'TASSIE DEVIL'

SNEAKER FREAKER BOOGAZINE ISSUE 26 VINTAGE AIR MAX PACK

SNEAKER FREAKER BOOGAZINE ISSUE 27 SHAQ ATTAQ

SNEAKER FREAKER BOOGAZINE ISSUE 28 AIRMAXTRAVAGANZA

SNEAKER FREAKER BOOGAZINE ISSUE 29 REEBOK PUMP FURY

SNEAKER FREAKER BOOGAZINE ISSUE 30 BLACK GOLD

SNEAKER FREAKER BOOGAZINE ISSUE 31 LIMITED EDT. X NB

SNEAKERFREAKER.COM

SNEAKER FREAKER BOOGAZINE ISSUE 33 COLABS

SNEAKER FREAKER BOOGAZINE ISSUE 34 RETRO RUNNERS!

SNEAKER FREAKER BOOGAZINE ISSUE 35 STOMPER!

SNEAKER FREAKER BOOGAZINE ISSUE 36 OG JORDANS

SNEAKER FREAKER BOOGAZINE ISSUE 37 BAPE NMD

SNEAKER FREAKER BOOGAZINE ISSUE 38 OVERKILL

SNEAKER FREAKER BOOGAZINE ISSUE 39 RIP SF FORUM

SNEAKER FREAKER BOOGAZINE ISSUE 40 NEW BALANCE 574

SNEAKER FREAKER PRESENTS THE VERY BEST OF ADIDAS 2016

SNEAKER FREAKER x G-SHOCK 'TEMPLE OF G'

SNEAKER FREAKER x AIR MAX

SNEAKERFREAKER THE BOOK

SNEAKER DEFENCE!

MEGA HIP HOP MIXTAPE!

© 2018 Sneaker Freaker International

All rights reserved. No part of this publication may be reproduced or transmitted
in any form or by any means, electronic or mechanical, including photocopy,
recording or any other information storage or retrieval system, without prior
permission in writing from the publisher.

This book was written, designed and edited by
Sneaker Freaker International
PO BOX 1571, Collingwood, VIC 3066 Australia
hello@sneakerfreaker.com
www.sneakerfreaker.com

EACH AND EVERY TASCHEN BOOK PLANTS A SEED!
TASCHEN is a carbon neutral publisher. Each year, we offset our annual carbon
emissions with carbon credits at the Instituto Terra, a reforestation program in
Minas Gerais, Brazil, founded by Lélia and Sebastião Salgado. To find out more
about this ecological partnership, please check: www.taschen.com/zerocarbon
Inspiration: unlimited. Carbon footprint: zero.

To stay informed about TASCHEN and our upcoming titles, please subscribe
to our free magazine at www.taschen.com/magazine, follow us on Twitter,
Instagram, and Facebook, or e-mail your questions to contact@taschen.com

© 2018 TASCHEN GmbH
Hohenzollernring 53, D-50672 Köln
www.taschen.com

Production: Thomas Grell, Cologne
Editorial coordination: Martin Holz, Berlin

Printed in Italy
ISBN 978-3-8365-7223-1

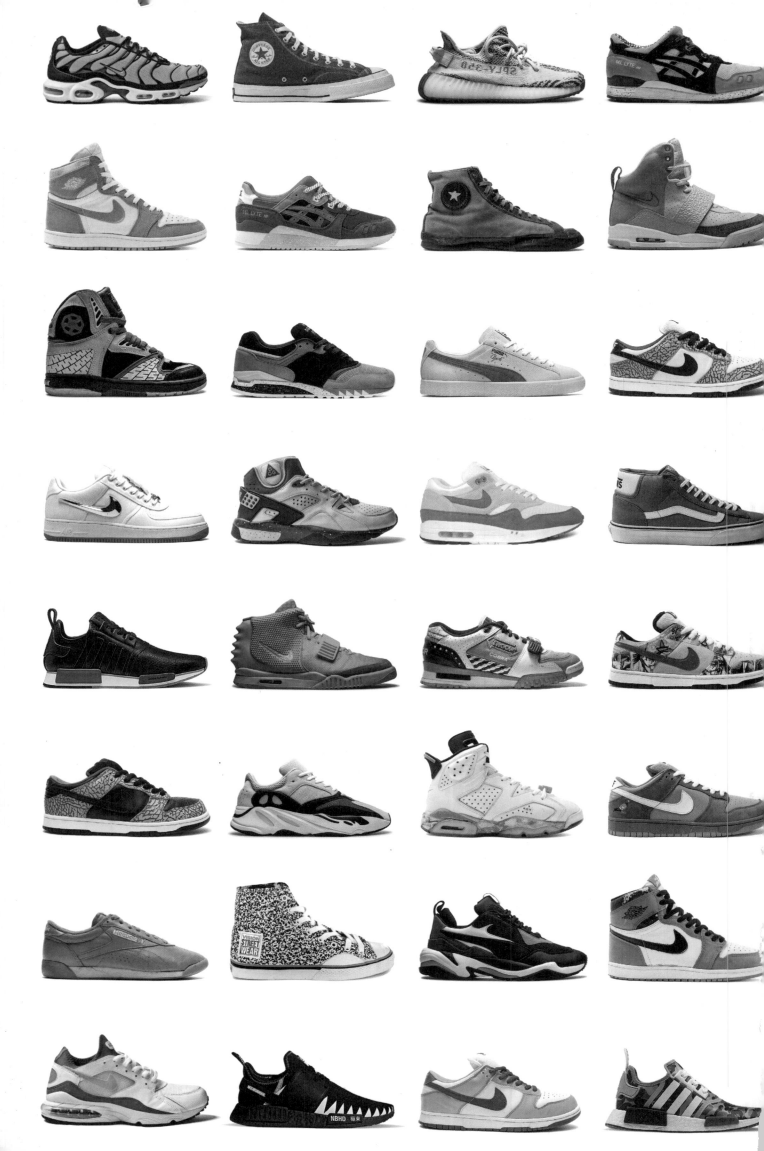